PRAISE FOR
The Guggenheims

"The indelible and intriguing story of the German Jewish patrician family who became the American Medici. Their wealth was originally derived from copper mining and then from fiscal capitalism. But in later decades, members of the family gained great distinction in painting, architecture, publishing, and archaeology. They fomented the artistic movement of modernism. This book is meticulously researched and very well written. An American saga."

—Norman F. Cantor, author of
The Sacred Chain: The History of the Jews

"The stories [the Ungers] compile are a rich and fascinating tapestry." —John C. Ensslin, *Rocky Mountain News*

"Excellent new biography. . . . The Ungers have a pitch-perfect sense of how much detail is too much detail, and their narrative moves more swiftly than any five hundred fifty–page group biography has any right to." —Francis Morrone, *New York Sun*

"Researched from the ground up, this profile of the Guggenheims depends little on its numerous predecessors and is at present the best-informed account of the clan. . . . An engaging history of the famous family." —*Booklist*

The Guggenheims

A Family History

IRWIN UNGER and DEBI UNGER

HARPER PERENNIAL

NEW YORK • LONDON • TORONTO • SYDNEY

HARPER ● PERENNIAL

FIRST HARPER PERENNIAL EDITION PUBLISHED 2006.

Designed by Amy Hill

The Library of Congress has catalogued the hardcover edition as follows:

Unger, Irwin.
 The Guggenheims : a family history / Irwin Unger and Debi Unger.—1st ed.
 p. cm.
 Includes bibliographical references and index.
 ISBN 0-06-018807-3 (alk. paper)
 1. Guggenheim family. 2. Businesspeople—United States—Biography. 3. Art patrons—United States—Biography. 4. Jews—United States—Biography. 5. United States—Biography. I. Unger, Debi. II. Title.

CT274.G84U54 2005
929'.2'0973—dc22 2004054212

ISBN-10: 0-06-093400-X (pbk.)
ISBN-13: 978-0-06-093400-2 (pbk.)

07 08 09 10 ❖/RRD 10 9 8 7 6 5 4 3

To Our Children:

Anthony and Jo, Brooke and Deborah, Elizabeth and Kurt, Miles and Jody, Paul and Eszter

To Our Grandchildren:

Kalliope, Emily, Gabriel, Layla, Rachel, Rebecca

Contents

THE GUGGENHEIMS

Beginnings

B Y ORIGIN THE GUGGENHEIMS were Jews, and their Jewishness was an irreducible reality of successive family generations. In our own tolerant and apathetic era it is easy to underrate this fact. But for the many thousands of Jewish inhabitants of Christian Europe before our own time, it was almost as fundamental, as life-defining, as gender.

Nowhere in Europe, from Portugal to the Ural Mountains, from Scandinavia to the Italian boot, were Jews treated as equals of other men and women in medieval and early modern times. Everywhere they were "the other," the despised outsider. In an age when the afterlife was more important than the present one, the Jews were irremediably cursed because they were damned for denying Jesus. Why they were allowed to live at all requires an explanation. And, of course, at times they were slaughtered. In the 1090s, as the champions of Christ passed through the Rhineland to wrest the Holy Land from the infidel Muslims, they murdered Jews as a dress rehearsal. Jews were massacred during the Black Death, the mysterious pandemic that swept Europe in the mid-fourteenth century killing millions. Although they were equal victims, they were often held responsible for the calamity. In 1348 Swiss Jews were burned at the stake for infecting the wells with plague. Jews, in a

word, were the classic scapegoats who were punished when Christian society knew no other way to relieve fear, anger, and frustration.

Yet they were not exterminated. Christians were, of course, enjoined from taking innocent life, and at times Christian mercy triumphed over Christian execration. Moreover, the Jews, in the view of some theologians, must be preserved as witnesses to the truth of the Christian faith, and their final conversion was an essential precursor of the Second Coming and the End of Days. But besides, the Jews were useful. Like the pariah castes of India, they could perform services that others would not or could not. Jews were excluded from a wide array of customary occupations. They could not own land and so were kept from farming, preindustrial Europe's chief fount of income and wealth. Forbidden to take interest on loans, for centuries Christians relied on Jews to lend money. Jews were also permitted to engage in various despised trades. They could be itinerant peddlers of cheap wares; they could run taverns and distilleries. They were employed by the landed gentry in rural Europe to collect tenants' rents. They were tax farmers who collected official levies for a share of the amount collected. Many of these occupations seem exquisitely tailored to offend and provoke Christians. The Jews could be blamed for either corrupting or exploiting their clients and customers. These restrictions on Jewish occupations and enterprise confined them to the economic margins and ensured that all but a very privileged few would remain poor.

And the economic straitjacket was not the only affliction imposed on this accursed people. They were only marginally part of civil society. Virtually nowhere in Christian Europe were Jews held to be part of the body politic. They could not be enfranchised burghers in the cities; they could not hold public office; they could not bear arms; they often could not testify in court against Christians. They could not live where they wished. Many communities excluded them totally. Jews were expelled from England in 1290; from France in 1306. At the end of the fifteenth century a reunited Spain forced its Jewish population either to convert to Christianity or to depart the realm. Many of those who converted were deemed insincere and as crypto-Jews were condemned by the Inquisition and burned at the stake. Where Jews were not exiled they

were confined to specified bounds. In the cities and towns, where most lived, they were forced into ghettos, often surrounded by walls, that they could leave only at restricted times. The authorities sought to limit the growth of the Jewish population by such intrusive means as limiting Jewish marriages and constraining house construction in the Jewish enclaves. But somehow the Jewish population grew and ghetto life became ever more congested, squalid, noisome, and toxic. As late as the early nineteenth century, Switzerland was among the less tolerant of the Christian communities. By 1490 Jews had been expelled from the original Swiss cantons. But several hundred lived in Baden, an earldom loosely attached to the Swiss Confederation. During the sixteenth and seventeenth centuries Switzerland had been a crucible of the Protestant Reformation when, for the first time, the unity of West European Christendom was disrupted beyond repair. The Swiss eventually learned how to avoid costly conflict between Protestants and Catholics, but the Reformation did little to improve the lot of the country's few remaining Jews. The Jewish remnant lived in two communities, Lengnau and Endigen, German-speaking and predominantly Catholic small towns in northwest Switzerland in what became in 1803 the canton of Aargau. They were treated with barely disguised contempt and ruthlessly exploited. They were not citizens but belonged to a category of "Tolerated Persons Not to Be Expelled." In truth they were under constant threat of expulsion and were expected to pay for their residence right every sixteen years by purchasing a "Safe Conduct and Patronage Letter" at an exorbitant price. And they were milked in other ways. Limited in the occupations they could follow, many were peddlers who traveled through the region selling "notions," trinkets, and spices. For a permit to move from place to place they had to pay a "Jew Toll" and other fees to engage in their petty trade.

The Swiss did not practice genocide; extermination as public policy remained for our own more enlightened age. But the Swiss authorities, as others, sought to prevent any increase in the Jewish population. Poor Jews were not allowed to marry, and Jewish brides were required to have a dowry of at least 500 guldens. The housing shortage was another check on population growth of the detested aliens. In Lengnau there was a

strictly limited number of houses available for Jews. These could not be expanded or improved; their roofs must be of thatch rather than tile. These demographic control measures were effective. All told there were only some five hundred Jews living in the two special Swiss enclaves in the eighteenth century.

The Enlightenment of the late eighteenth century, elevating "reason" above ancient custom and superstition, dramatically improved the lot of western and central European Jews. In 1782 Hapsburg emperor Joseph II issued his Toleranzpatent designed "to the end that all Our subjects without distinction of nationality and religion . . . shall participate in common in public welfare, enjoy legal freedom, and encounter no obstacles to any honest way of gaining their livelihood and of increasing general industriousness."[1] Later in the decade, in the first flush of revolutionary zeal for "reason" and human equality, republican France "emancipated" its Jews and made them citizens equal to the French of other faiths. In 1812 Prussia joined the list of states that sought to "normalize" the status of the Jews. The spirit of the Enlightenment left Switzerland largely untouched. In 1798 the French-inspired Helvetian Republic debated the emancipation of the country's Jews but decided to forgo the opportunity. Switzerland remained remarkably anti-Semitic well into the nineteenth century. When, during the great liberal upheaval of 1848, the drive for Jewish emancipation leaped ahead everywhere in central Europe, the Swiss almost alone "hotly and explicitly" refused to accept it.[2] Not until the 1866 revision of the Swiss federal constitution, after the Guggenheims had left for America, were the Swiss Jews finally made equal citizens of the country.

The Guggenheims of Lengnau were never very religious. They were moderately observant of Jewish ritual and law, for there was no other easy way to live in their community except by conforming to its norms in the era before full emancipation. They were also moderately loyal to Jews as a people. When, in the mid-eighteenth century, Joseph Guggenheim, an impressionable young man, was converted to Christianity by Pastor Johann Caspar Ulrich, a proselytizing Protestant minister, Joseph's father, Jacob, fought ferociously to prevent his son's apostasy. His battle offended the Swiss authorities, who, like most Christians, saw no harm

in saving another soul through conversion, however offensive the process was to the young man's family. Angry at Jacob's effrontery in challenging the conversion, they forced him to pay a 600-florin fine to renew his right of residence in Lengnau.

But however loyal to their forebears, the Guggenheims could not avoid absorbing in their bones, as all disesteemed people inevitably do, the degrading image of their kind that prevailed among the majority. For at least three generations they struggled with their own sense of inferiority. They were never "proud Jews" who proclaimed their heritage to all. With a few notable exceptions, they remained Jewish just as long as the larger society insisted that they must and escaped the limitations and penalties just as soon as they could.

Their insecurities often took a physical focus. Ashkenazic Jews form a distinctive genetic pool with physical features including hair color, complexion hue, and nasal form at least marginally different from those of the non-Jewish population among whom they live. For several members of the American-born generation of Guggenheims, these physical characteristics would become an obsession. William, the youngest son of Meyer, the founder of the dynasty in America, would boast of his non-Jewish appearance. Writing about himself in the third person in the 1930s, he noted: "Seeing Will's light complexion and the cast of his features one would not have surmised his Semitic ancestry."[3] For Jews noses were the critical signifier of Jewishness. Peggy Guggenheim, William's niece, daughter of his older brother Benjamin, despised her nose, a blobby proboscis that many of the Guggenheims would inherit from Simon Meyer Guggenheim, the original immigrant to the United States. In the winter of 1919, after Peggy had inherited money from her father's estate, she went to a plastic surgeon in Cincinnati to have her nose remade "tip-tilted like a flower."[4] Admittedly, there was an aesthetic component of this effort. As Peggy's sister Hazel noted, Peggy had "a terrible nose, like a potato."[5] Yet as some wit has noted, rhinoplasty, defined sociologically, was a process of "cutting off your nose to spite your race." At all events, in this paleolithic age of plastic surgery, the operation failed, leaving Peggy probably worse off than before.

And so the Guggenheims, or at least many of them, were never totally

comfortable in their Jewish skins, and that fact would affect their relations with the society around them on all sides.

JEWS WERE NOT "INDIGENOUS" to Europe like the Latins, Greeks, Germans, or Celts. They were part of a later diaspora that spread from Palestine in the wake of the Roman conquest of the eastern Mediterranean to France, Germany, Bohemia, and, later, Poland and Russia. We do not know for sure where the Guggenheims came from. Many German-speaking Jews, when compelled by the Emperor Joseph II of Austria in 1788 to adopt surnames,* took the names of their town or village of residence. It is entirely plausible then that the family, in their European incarnation, came originally from the town of Guggenheimb in Bavaria.

The first Guggenheim of record was Maran Guggenheimb of Lengnau, whose name appears in a Baden document of 1696. In 1702 the Guggenheims once again entered the documentary record when Jacob and Siseli Guggenheim, either sons or grandsons of Maran, were accused of claiming full ownership of their homes and a vineyard, privileges forbidden Jews. Later that year a mob burned to the ground the homes of these two upstarts. The authorities fined the villagers for the wanton destruction, but the two victims received no indemnity.

One of Jacob's sons, besides the turncoat Joseph, was Isaac, a dour but enterprising man. Born in 1723, Isaac was that classic preindustrial Jewish prototype, a moneylender. In the absence of modern banks he performed a needed function of a commercial economy by providing capital to entrepreneurs, if only in small amounts. But he undoubtedly also lent money to the improvident and the unlucky to tide them over hard times. We do not know what criteria he used for judging whether to lend or not, but he was called "Old Icicle," and could not have been a celebrated philanthropist. Indeed, he seemed to approach the harsh cliché of the Jewish usurer that Shakespeare made eponymous as Shylock.

*Hitherto, many Jews were identified by their fathers' first name as, for example, David ben Moses, meaning David son of Moses.

When Isaac died in 1807 at the ripe age of eighty-four, he was the richest Jew in Lengnau, with a fortune of 25,000 florins. The bulk of this treasure was locked in a large trunk. When this was formally opened by the Lengnau rabbi in the presence of his heirs and the community elders, it was found to contain some 830 gold and silver coins, along with valuable china, a frying pan, a brass coffeepot, four featherbeds, nineteen sheets, fifteen towels, eight nightshirts, and assorted household items including an infant's potty. These objects represented collateral for loans that Isaac had made to local people, and eventually the debts they represented were collected. One part of the final business transaction of Isaac's life represented the other side of the coin, as it were, to the aggressive accumulation of men like Old Icicle. Of the small fortune, 100 florins went to the Lengnau Jewish congregation, 50 to the Society for Nursing, and another 50 to the Brides' Dowry Fund. These benefactions displayed the Jewish tradition of Tzedakah, the obligation to perform deeds of justice, which Isaac's descendants would embrace in their own, far more affluent, lives.

Isaac's oldest son, Meyer, was born in 1775 and married a young German-Jewish woman named Vögel. They had eight children, four boys and four girls. One of the sons, Samuel, achieved local fame in 1818 as a heroic rescuer of two children from a burning house in Zurich. As a contemporary official document noted, with the house "enveloped in flames," Samuel Guggenheim, a "Hebrew . . . of [Lengnau] . . . a man full of presence of mind and honest courage, rushed into the blazing house, [grasped] both children and carried them triumphantly through the terrible heat and smoke to safety."[6] (The document, reflecting the venerable stereotype of Jews as weak and cowardly, conveys a sense of surprise at the bravery of the Hebrew Samuel.) For many years the framed original and a quaint translation proudly hung on the wall of Guggenheim Brothers partners' room. Is it stretching interpretation too far to see this gesture as an attempt by the later Guggenheims to trump the image of their ancestors as self-absorbed and timid people only capable of furthering their own material advantage?

With another of Meyer's sons, Simon, we come to the line of Guggenheims that is our subject. A tailor, born in 1792, Simon married

Schäfeli Levinger about 1815. Schäfeli died in 1836, leaving Simon with one son, Meyer, and five daughters. The situation could not have been good for Simon. In that era death of a wife left the widower with few ways of coping with the needs of daily living. If there were children, the plight of the surviving spouse was even more desperate. Simon, though he owned his own tailor shop, was a poor man with five daughters to provide with dowries. His son, Meyer, born in 1828, was able to contribute to the family income at an early age by strapping a pack on his back and tramping through the villages and small towns of Switzerland and Germany selling his buttons, shoelaces, ribbons, pins and needles, pots and pans. But he was not content. By the 1840s even the Jews of central Europe were feeling the century's new optimism, the sense that life might get better and the old ways need not prevail. Even more dissatisfied with his life in Lengnau was Simon. He had met a woman he wanted to marry, Rachel Weil Meyers,* a widow with three sons and four daughters. But the authorities would not allow them to join their lives; they did not have enough money.

In 1847 Simon and Rachel decided to escape the prison of Switzerland for the haven of America. It was a bold decision. Not that others had not made the same choice. Thousands of Europeans had streamed across the Atlantic to the New World ever since the seventeenth century. Most came from the British Isles, but Germany and Switzerland had contributed their hundreds and even thousands, many of them members of small Protestant sects fleeing persecution by the intolerant local religious majority. During the 1830s the stream had swelled. During this period restless Europeans read much of the virtues of America. Poets, historians, journalists talked about America as a "garden of the Lord," or the "blessed land of freedom and prosperity."[7] Even more effective as magnets were the letters of pioneer emigrants to their families back home. Returnees, on visits to parents and family, carried back information about the vigorous and hopeful new republic.

*Meyers is a version of Meyer (also spelled Myer and Meier), which served not only as a first name but also as a patronymic surname among German-speaking Jews—to the confusion of biographers and historians.

We do not know how Simon, Rachel, and Meyer learned of America, but learn they did, and decided to leave with their broods for the land of promise. Their destination was Philadelphia, America's second city, a major manufacturing center that had long attracted German speakers. After selling their real estate and other property, the two joined disaffected families, fourteen in all, packed their portable possessions and one spring day set off for Koblenz on the Rhine. There they boarded a river sloop for the port of Hamburg, where they took ship for America.

We have little information on the transatlantic voyage. It was probably by wooden sailing ship and monumentally uncomfortable. The novelist Charles Dickens, who crossed the Atlantic a few years before, described the trip by newfangled steamboat as an ordeal of smells, fears, and wretched sickness. How much worse it must have been for passengers like the Guggenheims and Meyerses, lodged belowdecks in a crowded, dim, airless space, at the mercy of wind as well as weather. Meyer would later remember the three-month voyage with a shudder. But there was one bright spot for him. His eye was caught by one of Rachel's daughters, the fourteen-year-old Barbara* Meyers, and according to family lore, the twenty-year-old resolved to marry her eventually. Meyer had chosen well. Barbara was a comely girl. Her youngest son would describe her as having fair skin and auburn hair. More important, as time would show, she had uncommon warmth, patience, and vitality, and would be an ideal helpmate to an ambitious entrepreneur.

On a sunny spring day in 1848, the ship from Hamburg† reached the City of Brotherly Love and deposited fourteen Guggenheims and Meyerses on a Delaware River wharf. The Guggenheims' American epic was about to begin.

* * *

*Though she was known as Barbara, the name was unusual for a young Jewish woman from her Swiss-German background, and was probably originally Babette. That, at least, is the name recorded on her daughter's marriage certificate of 1891.

†An alternative account of the transatlantic voyage has the two families landing in England, when their ship from the Continent foundered in the North Sea, and then crossing the ocean in a side-wheeler steamer first to Boston before reaching Philadelphia. See Isaac F. Marcosson, *Metal Magic: The Story of the American Smelting and Refining Company* (New York: Farrar, Straus, 1949), pp. 24–25.

IN 1848 AMERICA WAS A TURBULENT LAND pulsing with energy and promise. Early in the year two events set in motion momentous changes for the nation, changes that would shape the trajectory of the Guggenheim family. In late January, near the village of Sacramento in northern California, a New Jersey carpenter, James Marshall, working for John Augustus Sutter, a Swiss-born impresario, observed some glittering particles in a streambed while building a sawmill. They proved to be flecks of placer gold, and in a matter of weeks they began to draw a great human horde to California from the East and from almost every region of the world. By 1851 the annual gold output of the diggings in the Sierra Nevada foothills had reached $55 million. Only a week or two later than the millrace discovery, the United States and Mexico signed the Treaty of Guadalupe-Hidalgo, ending the war between the two nations commenced two years before. The treaty ceded to the United States California and the Mexican province of New Mexico, incorporating present-day Arizona, Nevada, and Utah and parts of New Mexico, Colorado, and Wyoming. The lands of the Mexican Cession would prove to be extravagantly rich in the minerals that would make the United States a resource cornucopia and contribute extravagantly to the Guggenheim fortune. At the same time the war itself would alter the balance of forces in unstable Mexico and impinge on the family's fate in unexpected, but valuable, ways.

Within a broader frame, the nation in that significant year 1848 was riding a wave of economic and political transformation that would carry the Guggenheims to unimagined heights. By mid-century the United States was evolving into a nation of mills, mines, countinghouses, and factories as well as farms. As the Guggenheims unloaded their baggage on the Philadelphia dock, the steam engine was beginning to supersede the watermill as power source for the burgeoning textile mills of New England and the Middle Atlantic states. By 1850 there were almost nine thousand miles of railroad in the country, three times the mileage of ten years before. In 1859 manufacturing, with an output of $1.9 billion, had exceeded agriculture as a component of the nation's gross domestic product. A few years earlier Samuel Morse had discovered a practical way to transmit messages almost instantaneously over copper wires. The

mining industry as well leaped ahead in the two decades preceding the Civil War, but was still confined to the eastern third of the nation where ore bodies, except for iron, were limited and operations were on a very small scale.

Philadelphia, where the Guggenheims first touched American ground—probably at the Washington Avenue dock in South Philadelphia—was close to the center of this swirl of enterprise and wealth creation. The period 1830–60 witnessed the city's most rapid historical growth in both population and wealth. Between 1840 and 1860 Philadelphia County, "Greater Philadelphia," increased its inhabitants from 258,000 to 565,000. During these years the city became a major textile center. In 1850 it sheltered some ten thousand carpet and hosiery makers, silk weavers, and sewing thread operatives. Some of these worked with new power machinery; many still operated hand looms. The city was also a caldron of business enterprise overall. Until recently the City of Brotherly Love, rather than New York, had been the nation's banking capital. It was becoming a railroad center, and its merchants and financiers, with capital to invest, looked outward for new opportunities.

Philadelphia had fewer than two thousand Jews in 1846, but in the next few years the spread of information and the social and economic upheavals of the mid-century propelled a wave of immigrants, including the Guggenheims, across the Atlantic. By the eve of the Civil War the Quaker city's Jewish population had leaped to fifty thousand. The first Philadelphia Jews had been Sephardic, the descendants of people fleeing Spain and Portugal in the sixteenth century. By the time Simon arrived with his brood it was largely Ashkenazic, composed mostly of immigrants from Germany, its leaders bearing names like Hackenberg, Gans, Binswanger, and Wolf. Over the next decades the original Sephardic population would be submerged under the sea of German-speakers. The Philadelphia Jewish community in mid-century was relatively prosperous, composed mostly of businessmen and white-collar workers. Not until about 1875 did the city begin to attract numbers of poor East European Jews with their Yiddish language, shtetl ways and appearance, and medieval Orthodox faith, overlain with premodern peasant beliefs and customs.

Not much is known about the Guggenheims' earliest years in this vital city. The family was large, as we have seen, with some fourteen adults, teenagers, and children. The head of the household, Simon, was already fifty-six, not a good age to start a new life. He also did not speak English. When he married Rachel, shortly after they reached America, he at least had a wife to care for the children and supervise the complicated and onerous chores of the household. But Rachel at forty-two was not a young woman either and must have found the adjustment to a strange environment difficult. Fortunately there was Meyer, a twenty-one-year-old dynamo.

The family settled, initially, in some rented house in a working-class neighborhood, probably in the Northern Liberties area north of Independence Hall. Simon and Rachel together brought some capital with them from Lengnau, but not enough, apparently, for Simon to open another tailor shop. Instead, the old man and his vigorous son took up where many Jewish immigrants of the period made their start: as pack-carrying peddlers of "notions." Simon confined his travels to the city itself, going door-to-door. Meyer's territory was the countryside surrounding Philadelphia, the anthracite coal region, where the good wives often found it inconvenient to visit the village general store for small household items. He started on foot but soon saved enough to buy a horse and wagon. Sometime during these early years he went into business with his brother-in-law Lehman Meyers.

One of the partners' best-selling wares was "coffee essence," made by a "patent" process possibly developed by Lehman. Coffee in the mid-nineteenth century was a relatively expensive product. It was also arduous for the consumer to prepare. Even in that era, accordingly, there was a market for what a later generation would call "instant." Cheap coffee beans mixed with chicory and flavorings and boiled down to a syrup could be dissolved in water and quaffed like the real thing. Another big seller was black stove polish made from a mixture of soot and other ingredients. This material covered up rust, scrapes, and dirt on the coal-burning cast-iron stoves used universally for both heating and cooking. Unfortunately, it was also messy, and housewives complained of their filthy fingers. Meyer soon discovered that mixing soap suds with the

powder created a cohesive paste that prevented the unsightly residue. As family lore describes it, he next realized that, rather than buying the powder from the manufacturer and collecting a few pennies per container of polish, he could manufacture the stuff himself and get a larger share of the profit. But for that he had to know what the material was made of, and so he took a sample to a local chemist for analysis. The chemist told him that the chief ingredient was black lead, and Meyer was soon buying the imported material in quantity to manufacture his own version of stove polish. While Simon stayed home wrapping the black paste in thick paper packets with a converted sausage machine, Meyer filled his wagon with the packets and peddled them along his route through the countryside.

This was the first real Guggenheim foray into industry—into production rather than commerce—and the new product helped lift the family fortunes. Prosperity enlarged Meyer's life. In 1852 he and Barbara were married at Keneseth Israel synagogue, then on Fourth near Wood Street. The couple soon moved into their own house on Green Lane in Roxborough, a northwestern Philadelphia suburb, where Meyer opened a grocery store and the couple settled down to creating their dynasty.

The union of Meyer and Barbara was a happy one. She was a warm, nurturing woman who accepted without question the duties and responsibilities of a nineteenth-century mother and wife. Her role in the family configuration was almost a cliché of the day. Meyer was the stern but just patriarch, who administered punishment for transgressions using a hairbrush, pants belt, or the most readily available paddle. She was understanding and forgiving. Her children, William later wrote, "adored her." "Her every energy was bent toward making agreeable the lives for which she was responsible." She "surrounded her boys and girls with a protective love which compensated them for the many things lacking in their early days."[8] It may jar our modern sensibility, but she did not, it seems, resent the limitations of her role. Though in 1848, the very year that the Guggenheims set foot in America, a group of women meeting in Seneca Falls, New York, launched the women's rights movement, nothing of the nineteenth-century rebellion against the traditional gender order ever affected Barbara.

Little is known of the young family's life in Roxborough. Barbara had all but three of her eleven children there. Isaac came in 1854; Daniel in 1856; Murry in 1858; Solomon in 1861; Jeannette in 1863; Benjamin in 1865; the twins, Simon and Robert, in 1867. William, born in 1868, was the first Guggenheim child born in Philadelphia proper. He was followed by two sisters, Rose, born in 1871, and Cora, the last, born in 1873.

Robert, one of the twins, died tragically from a fall from his horse in 1876, but all the others lived to adulthood, an unusual record for the day. All told there were seven surviving sons, and this demographic detail would be of major consequence for the family's fortunes. In the public sphere women simply did not count. No female child of this generation of Meyer's offspring—or for that matter the ones that followed well into the twentieth century—ever participated in the family's business affairs. It was not that the "girls" lacked ability. As far as we know they possessed as many of the native skills that high enterprise required as their brothers. But their participation would have been inconceivable in the second half of the nineteenth century. They had not been exposed to the training needed; they would not have been welcomed by business colleagues. As females, they still lacked the full legal rights of property ownership and transfer essential to business functioning. The strict separation of roles made daughters, however beloved, irrelevant to the family's public pursuits. In the case of the Guggenheims, seven sons in the third generation of Americans were a powerful family asset. Beyond this generation, however, the genetic toss would turn up daughters primarily, undermining the family's advantages and contributing to its eventual loss of preeminence in the world of business.

The Guggenheims spent more than a decade in Roxborough, where Meyer prospered moderately selling assorted groceries along with his coffee essence and stove polish. He learned some valuable business lessons during these years. At first he bought his black lead from import suppliers. Then he discovered that the crucibles used in steel production, made of refractory black lead, were discarded as valueless when broken. He soon arranged to buy these scrap crucibles and salvage the lead and graphite for his own and others' use. With increasing prosperity, Meyer bought out his brother-in-law's interest, but then took a part-

ner named Van Horn who owned a mill where the work could be done. The enterprise eventually moved beyond the retail stage. Meyer began to travel through Pennsylvania and the Northeast to sell his product to merchants and storekeepers. During his absence on one such trip, Van Horn sold off the stock in the warehouse, collecting all the accounts due, and absconded, leaving his partner with an odd cache of shoe pegs and mustard seed.

The Civil War presented new opportunities for Meyer. No one expected him to rush off to defend the Union or help demolish slavery. He was an overage father, and few of his kind felt stirred enough by slavery or secession to risk maiming or death in the Army of the Potomac. The family did contribute to the war directly, however. One relative, Barbara's youngest brother, Benjamin Meyers, apparently fought with the 130th Pennsylvania Infantry as a lieutenant. The older boys were thrilled with their uncle's exploits, and Solomon, though only three, remembered running excitedly down the street to greet the family hero when he was mustered out of service at the war's end.

Meanwhile the Crisis of the Union, like all great wars, afforded spacious opportunities for businessmen. It is now conventional wisdom that the Civil War did not accelerate economic growth, but that should not obscure its short-term stimulating effect on commerce and many aspects of manufacture in the North. For Meyer the war opened new vistas. He formed a partnership with S. Dreifuss and Jacob Loeb to establish a "general store" at Fourth and Arch Streets, near the docks, to sell "dry goods" and groceries. He also, miraculously, discovered a market for his leftover shoe pegs and mustard. At the same time, he and the partners began to import spices and to manufacture lye, an essential ingredient in soap making. They soon established their own factory, American Concentrated Lye Company, on Wood Street, selling its output through the Front Street store. Guggenheim, Dreifuss, and Loeb's success in the lye business incurred the wrath of the Pennsylvania Salt Company, the country's major commercial lye producer. Charging patent infringement, the company began suit against American Concentrated Lye, but then made a buyout offer to the partners. Messrs. Dreifuss and Loeb agreed to take stock in the larger firm in exchange for their shares of the

business. Meyer insisted on cash and received a check for $150,000, a considerable fortune in that day.

Meyer undoubtedly found the commute from Roxborough to the store onerous. The small house on Green Lane, moreover, must have seemed cramped and unworthy of a rising businessman. In 1868 the Guggenheims moved back to Philadelphia proper, where William, the last son, was born. The following year Simon, the pioneer, died, having seen his son firmly rooted in the new cross-Atlantic soil and already far beyond his own modest attainments.

Meyer's first house in Philadelphia was on Franklin Street. Apparently this dwelling did not suit the rising entrepreneur either, and the family moved again to North Sixteenth Street. As William's later description suggests, North Sixteenth Street was rather standard in looks for middle-class urban neighborhoods of the day. The avenue was shaded with mature trees. High-stooped private homes with narrow strips of grass in front lined both sides of the street. The houses were not uniform, however. Each was individual in size and façade, and the homes on the west side of the street were more elegant than those on the east, where the Guggenheims lived. As William remembered, "aspidistras and palms adorned the windows on both sides . . . , but the foliage was richer and greener, the curtains finer, the draperies stiffer, in those bigger houses to the west."[9]

Meyer, and still more Barbara and the boys, yearned to move west, as, in a manner of speaking, did many other nineteenth-century Americans. Meyer was well launched assuredly, but he could foresee much more for his family. He was a driving, acquisitive man whose life revolved around business and his family. Contemporaries and later observers would tag him the typical Jewish businessman of Gilded Age America. It was not an attractive image. Over and over in the journalistic writings and in the fiction of the day, widely circulated among literate Americans, we find the vivid image of the unscrupulous Jewish businessman. The historian of anti-Semitism in America, Leonard Dinnerstein, summarizes the evil stereotype of Jews widely held by nineteenth-century Christian Americans. "A composite portrait evolved of the Jew," he writes, "as a vastly powerful, manipulative, corrupt, devious, cunning, greedy, tricky,

materialistic, dishonest, shrewd, grasping, and close-fisted man who would do anything to acquire and hold onto gold."[10]

In reality the stereotype was not totally false. Marginality often imposes penalties on its victims that include character distortion and the victims' own tendency in turn to dehumanize and so, without misgivings, deceive the perceived persecutor. There is one mode of behavior toward "us"; another toward "them." But these qualities, it should be noted, were not particularly Jewish. Much of whatever truth the stereotype holds applies to all self-made entrepreneurs of outsider status, whether Parsees in India, Chinese in Indonesia, Indians in East Africa, Lebanese in Latin America, or Jews in Christian Europe and America. By the end of the twentieth century, when Jews ceased to be marginal in the United States, the dubious stereotype fastened itself on Koreans and Pakistanis.

In any event, Meyer was not in fact the ethnic cliché portrayed by several of his biographers. He did not look the part of a foreign-born Jewish merchant. Though he was small and bearded, he was dignified and dressed as a proper American bourgeois of his day, at least in his formal portraits from the 1890s. He was a hard driver and determined pursuer of the main chance, but he was not indifferent to learning and culture. He hoped to see at least some of his sons attend college, and in the end two of the younger ones did. If he was not a reader, he appreciated music and sought to transmit his love of the art to his children. One of the more amusing anecdotes of the Philadelphia years is of Meyer's attempt to instill a love of classical music in his four older boys. He induced each of them to take up an instrument—cello, violin, piano, and flute—as his contribution to a small chamber group. Each morning at 6 a.m., before school and work began, the boys were dragged out of bed and led to the basement to practice scales and perform simple chamber pieces. The forced-draft cultural uplift did not take. The boys hated it and showed little or no talent. Their performances, according to William, "possessed a rare degree of hideous dissonance."[11] Fortunately for Isaac, Daniel, Murry, and Solomon, the neighbors, protective of their sleep, showed better taste than their father. One of them, a lady who lived in the house to the rear, first sought to block out the cacophony by erecting an eight-

foot wall between her property and the Guggenheims'. When this did not work, she complained to Barbara, who confessed to impotence to do anything about the problem. Then the neighbor went to the police. This did the trick. The police judged the concerts a breach of the peace and ordered the quartet to desist until 9 a.m. each day. This move ended the performances, for by nine the boys were deep into their studies or tasks, and their father, no matter how much he loved music, did not intend to put pleasure, however dubious, before business.

The postbellum era brought Meyer increasing business success. He was determined to create a business dynasty that would position his sons as rich men for life, and he scouted tirelessly for new opportunities. During these years he became a major importer and dealer in spices. With a moderate pool of capital Meyer searched the stock market to see what he could pick up. Playing Wall Street in the late 1870s and early 1880s was an exceptionally risky enterprise, even closer to outright gambling than it is today. The stock market was an arena for speculators and corporate manipulators, not for trust fund managers or serious long-term investors. But Meyer got lucky. Having learned that the railroad buccaneer Jay Gould, driving to create his own transcontinental road by merging the Kansas Pacific with the Union Pacific, was interested in the Hannibal and St. Joseph, a financially strapped railroad connecting the Mississippi with Kansas City, Meyer began to buy its shares sometime in 1881. At first the stocks plunged, but Meyer continued to buy at ever lower prices until he had accumulated some two thousand shares. At this junction Gould began to buy St. Jo stock himself, but to gain full control of the road he needed Meyer's holdings. When the Philadelphian played hard to get, Gould sent one of his agents to coax him. Meyer finally relented and turned over his stake for a whopping $320,000.

With a substantial cache of capital Meyer now hunted for other investments. Fortunately, another of Barbara's brothers, Morris Meyers, an enterprising man, had opened a factory in St. Gall, Switzerland, to manufacture embroidery and lace by machine. In this fussy era everything was trimmed with lace and embroidery—ladies' undergarments, tablecloths, pillows, dresses, furniture throws, antimacassars. Lace had been made painstakingly by hand for centuries and was expensive. Then,

in the early 1880s, a German inventor learned how to produce "needle lace" by machine and revolutionized the industry. Morris Meyers' factory, using the new contraptions, was a technological wonder, but he had overproduced and wrote Barbara's husband asking if he would take some of the overstock on consignment to sell in America. Though without experience with lace and embroidery, Meyer accepted the proposal. When the goods arrived he contacted the firm of H. B. Claflin and Company, New York's largest dry goods dealer, to show the wares. So impressed was Horace Claflin with the product that he bought the entire lot, giving Meyer a generous profit.

Meyer acted quickly to turn the one-time transaction into a major undertaking. He needed help in an unfamiliar trade, but the boys were still too young to play a decision-making role in the business. Meyer turned to the young Morris Pulaski, another Jewish Philadelphian whom he had earlier employed in his spice business. Meyer had danced at Morris's wedding and liked him. Sometime in the early seventies they formed the firm of Guggenheim and Pulaski for the importation and sale of lace and embroidery, then called "white goods."* The firm prospered, and the handsome returns further swelled the family fortunes. Meyer now made Barbara and the children happy by finally moving to the good west side of North Sixteenth Street. He could also indulge himself by buying a horse and buggy. Horses and carriages would become a major extravagance of Meyer's as the Guggenheims' wealth soared in later years.

And what of the growing boys? None of the older ones—Isaac, Daniel, Murry, and Solomon—liked school. The Philadelphia High School provided the usual classical education of the day, heavy with ancient languages, the arts, and history. This curriculum seemed to have little relevance to their lives or ambitions. Only William and Benjamin, who eventually set themselves apart from the older brothers, valued higher education. As each of the four seniors attained maturity he aban-

*Another version of Meyer's entrance into the lace-embroidery business has Pulaski, rather than one of Barbara's brothers, as the catalyst in the process. See Gatenby Williams (pseudonym for William Guggenheim) and Charles Monroe Heath, *William Guggenheim* (New York: Lone Voice, 1934), p. 17.

doned education for business. When Isaac reached seventeen he joined
one of Barbara's brothers in the grocery trade. Daniel, Murry, and
Solomon were all dispatched to Europe for further education in practical
subjects and business procedures. In 1873, just after graduation from
high school, Daniel went off to Switzerland with Morris Pulaski to learn
the embroidery business and acquire fluency in German and French.*
Murry went to St. Gall, the Swiss embroidery capital, while Solomon,
the junior of the four senior sons, too young for business, was enrolled in
the Institute Concordia in Zurich to learn languages and business skills.
Even Isaac spent some months in Basle as a young man before removing
to New York. He would return to the family's ancestral home later in life
as an adult patient in a psychiatric clinic after suffering a "nervous break-
down" early in the new century.

All told, the older four, all born before the Civil War, became at least
bilingual and steeped in European culture and ways. The Guggenheims,
like other Jewish capitalists of the Gilded Age, were atypical of the
American capitalist class. With the exception of John Pierpont Morgan,
the great magnates of the late nineteenth and early twentieth centuries
were provincial men usually with rural roots. The Guggenheims were
cosmopolites who felt comfortable in Europe and later moved with ease
in every cranny of the world where business opportunities offered. Even
the younger male Guggenheims were well acquainted with Europe.
Benjamin, the oldest of the juniors, lived much of his foreshortened
adult life in France, and Simon spent two years in Spain in the late 1880s.

The boys found life in Switzerland generally congenial. In 1863 the
Swiss Confederation had finally repealed all its anti-Jewish laws, and
they encountered no official anti-Semitism. But private anti-Jewish feel-
ings remained widespread. Solomon had one run-in with bigotry that
reveals his combativeness as well as his bravery. At the Institute
Concordia, soon after his arrival in Switzerland, he was approached on

*In 1908 he would wistfully write his own son, Harry: "I was sent into a foreign land
among strangers to take up my business career." See Harry Guggenheim to Dana
[Draper], New York, July 20, 1956, Box 222, Harry Frank Guggenheim Mss., Library
of Congress.

the school grounds by a group of older students. "What's your name?" they asked. Solomon told them his name. "Are you an American?" they asked again. Solomon admitted he was. "Are you a Jew?" "That's right," Solomon replied. "We don't like Jews around here," the bullies responded. "Why not?" "They killed our Savior." Solomon now had the drift of the encounter. "I don't know about that," he retorted, "but I do know I'm going to kill you." He promptly sailed into the group intent on mayhem.[12] We don't know how much physical damage Solomon inflicted, but he soon left the institute and enrolled in a boarding school under the direction of a Dr. Birch.

The lace business did well under the guidance of Meyer and Isaac at home and Daniel, Murry, and Solomon in Europe. With Pulaski's help the boys established a factory in St. Gall and another in Pfauen in Saxony. During their sojourn in Switzerland they helped in the buying of materials and learned the marketing process, shipping the factories' output to New York, where Isaac had established an office. In 1881 Meyer bought out Pulaski and renamed the lace firm M. Guggenheim's Sons. The company would remain a partnership rather than the less common corporation, with shares divided in various ways over time.

THE EDUCATIONS OF MEYER'S SONS did not include rigorous religious training. The children, as we saw, did not deny their religion, but they did not know very much about it. Certainly they were not immersed in it the way they would have been in Europe, where, emancipation notwithstanding, it was still difficult for Jews to escape the continuing confinement within an age-old culture. America was different. There were no high walls to hold Jews within their religious borders and, in the more open milieu of late-nineteenth-century Philadelphia, the assimilation process was difficult to avoid. There were, of course, some negative forces to sustain Jewish identity in America. In the very year Meyer created M. Guggenheim's Sons, the American Jewish community was shaken by a demonstration of its remaining marginality even in open-minded America. In June 1877 Joseph Seligman, a prominent Jewish banker, was turned away from the Grand Union Hotel in Saratoga by its

manager, Henry Hilton, because he was a Jew.* Seligman fought back, denouncing Hilton and his practices publicly. A barrage of letters, editorials, and threats of lawsuits and boycotts followed. The incident became a major news story throughout the country, with the Philadelphia papers running long pieces on the event and its extended aftermath. Most editors condemned Hilton, but letters to the editor often supported him. The Grand Union affair inaugurated an era when it became the norm for resort hotels to exclude Jews. Meyer could not help noting the affair and recognizing it as a sign that the age-old prejudices were still very much alive.

The Seligman incident may have propped up the family's flagging loyalties. The Guggenheims joined Keneseth Israel, where Meyer and Barbara had been married. Originally Orthodox, it at first practiced traditional Ashkenazic rituals and conformed to age-old observances and beliefs. Then in 1855 it adopted the new "Reform" creed that sought to modernize and Americanize Judaism, aligning it with the practices of the gentile majority and eliminating what the reformers considered antiquated or even barbaric customs. Keneseth Israel abandoned Hebrew as the liturgical language; sermons and prayers were now in English. Men ceased to cover their heads. Men and women no longer were seated separately at worship. The congregation bought an organ and created a mixed choir to perform at services. It abandoned or condensed a number of the minor holidays and traditional festivals. One can be sure that members of the congregation by this time had made other changes in their lives and beliefs. Most Reform Jewish women abandoned the strict rules of ritual bathing to ensure purity and head coverings to ensure modesty. Reform Jews traveled and lit stoves and lamps on the Sabbath. They no longer heeded the Mosaic prohibitions against consuming unclean or forbidden foods.

In 1864 the congregation, composed predominantly of prosperous German Jews, constructed a striking "temple" in downtown Philadelphia.

*Whether Seligman actually arrived at the hotel with all his baggage and entourage without a reservation and unaware of the management's newly announced "restricted" policies, or whether he merely wished to challenge the policy and created a "test case" is not clear.

Unable to bring themselves to adopt Gothic or Romanesque, both Christian styles, they built it in the Moorish–Middle Eastern mode that Reform Jews often adopted in the nineteenth century. It is in this structure that the Guggenheims worshipped occasionally. Yet all told, the family's allegiance to their faith was fragile at best. The Guggenheim boys probably did not get bar mitzvahed, if only because Reform Jews in this era did not practice the ceremony. It is likely, however, that they were "confirmed" in some fashion in the faith of the fathers. Though for a time the older boys attended the Hebrew Education Society on Monday evenings to learn about their heritage, Meyer also, for a time, sent his older sons to the well-managed Catholic Day School at Broad and Columbus avenues.* Yet the family retained sentimental ties to Keneseth Israel even after they left Philadelphia. When, in 1891, Rose Guggenheim, Meyer's middle daughter, married Albert Loeb in New York, the family imported Joseph Krauskopf, the senior rabbi at Keneseth Israel, to perform the ceremony.[13]

Did the Guggenheims, once they had acquired wealth and power, experience the sting of anti-Semitism? The short answer is yes. Undoubtedly their money protected them in ways denied other American Jews. Yet early in the twentieth century, Simon, when he ran for senator in Colorado, would be a target for undisguised prejudice, and during these same pre–World War I years the family's unpopular Alaska operations would flush out latent anti-Jewish feelings among publicists and reformers. And at times, despite their wealth, the bigotry was as crudely applied to them as to ordinary Jews. Peggy Guggenheim remembered an automobile trip with her family during World War I. After touring eastern Canada the Guggenheim party stopped one evening in Vermont, where they were refused a night's lodging at a hotel because they were Jewish. The teenage Peggy later noted that "this gave me an inferiority complex."[14]

* * *

*The younger boys apparently attended local public schools. William, for one, talked of his education in the public elementary school and spoke with affection of his first teacher, Miss May. See Williams and Heath, *William Guggenheim*, pp. 21–22.

EIGHTEEN EIGHTY-ONE WOULD BE a fateful year in the Guggenheim epic. Two years before, an associate of Meyer's from the Philadelphia grocery business, Quaker businessman Charles S. Graham, decided he preferred silver and lead in Colorado to flour, soap, eggs, and spices in Philadelphia. Graham, "a big man with a white beard,"[15] joined three other easterners, George Work, Thomas Weir, and Joseph Harsh, in buying into two promising mining properties in the Colorado Carbonate District, the A.Y. and the Minnie. Their owner was "uncle" A.Y. Corman, a bearded old prospector who had come to California Gulch high in the Rockies during the 1860s. In 1869 Corman staked out the A.Y. and the Minnie, the latter apparently named after his daughter.

The mines were attractive properties. Originally the region had been a producer primarily of placer gold from local streams. But the nuggets proved sparse, and output soon declined. By 1870 the region was virtually deserted, though Corman and some other optimists stayed on. Then in 1874 two Irish miners approached Horace Tabor, the local postmaster and general store owner, and asked to be grubstaked. Tabor gave them $65 worth of supplies in exchange for a half interest in their discoveries, if any.

The investment proved an almost instant winner. Within days the prospectors discovered rich native silver deposits on Freyer Hill, where the Little Pittsburgh mine soon made Tabor a millionaire. Unfortunately, the pure metallic silver was limited. Most of the material consisted of brittle black rock and gravel that seemed to have little value, and many investors became discouraged. Then in 1877 a curious miner, A. B. Wood, sent a sample of the substance to a St. Louis smelter to be assayed. He was delighted when the experts identified it as lead carbonate with a rich admixture of silver. The news set off a rush to the region in 1877, and the community of Leadville, at the diggings, became a classic mining frontier boomtown overnight. One visitor in 1879 found the community's streets "filled to the center with a constantly moving mass of humanity, from every quarter of the globe, and from every walk of life."[16] By the end of 1879 Leadville had a turbulent population of eighteen thousand. That year silver production in the Leadville region reached $18 million and then leveled off but remained respectable until the

1890s. Already rich, Tabor would become a "silver king" and the subject of western legend when he divorced his wife and married his dance hall paramour, the beautiful, blue-eyed Elizabeth McCourt "Baby" Doe.

Alas, Corman's own properties were slow to yield. Each day he dug his shafts a little deeper, hoping to strike silver-rich ore, but was constantly disappointed. When Graham and his partners came along and offered him $8,000 for his claims,* Corman grabbed it and with the eight thousand in cash in his hands got himself a wife, a much younger lady. However happy they had made Uncle Corman, in fact Graham, Work, and Weir, the new owners, had little money of their own and had borrowed from fellow Philadelphian Harsh to buy out the old prospector. When the IOUs came due Harsh demanded payment. Unable to raise the money, Work and Weir surrendered their claims. Graham, though equally strapped personally, remembered his fellow grocer back home, Meyer Guggenheim, and came to him for help. Meyer refused to lend Graham the money but agreed to buy a one-third interest in the Minnie and the A.Y for $5,000.

We can pretty well guess why Meyer took a flyer on western mining. The 1880s was an exuberant, optimistic decade. With the 1873–79 depression past, business confidence had returned with a rush, and the country embarked on an exuberant economic surge sustained by the capacious American West and its resources. During the eighties western railroads, farms, forests, ranches, and mines—like so many powerful pumps—sucked sluggish capital from the East across the continent where returns—and risks—were high. Meyer had savings from the embroidery business and from his stock market deals and was anxious to put them to use. With the Leadville district getting such extravagant attention in the business press, why not take Graham up on his proposition?

When Meyer took the plunge the A.Y. and Minnie had been shipping two hundred tons of ore a month to the smelters, barely paying their expenses. Then, in late 1881, the shafts flooded and all ore extraction

*In fact the exact figure is impossible to determine. In one account Corman received only $1,500 for his claims. See Don L. Griswold and Jean Harvey, *History of Leadville and Lake County, Colorado: From Mountain Solitude to Metropolis* (Denver: Colorado Historical Society, 1996), p. 384.

stopped. Graham and Harsh wrote Meyer, their new partner, that the mines could be pumped, but it would require more investment. Before throwing good money after bad, Meyer decided to visit his new properties to see what should be done.

He arrived in Leadville during the summer of 1880 by the newly constructed Denver and Rio Grande railroad. The cloud-enshrouded town—ten thousand feet above sea level—was a raucous, raffish, and frenzied place. Its lanes were jammed with the standard dramatis personae of the western bonanza towns: gritty prospectors, bedizened prostitutes, dandyish professional gamblers, jaunty saloon keepers, and boastful speculators, as well as the more sedate normal inhabitants of any small growing city. The mines themselves were some distance away, but the town's streets announced its reason for existence. Horse-drawn and mule-drawn carts, wagons, and drays, carrying heavy ore loads to the fourteen smelters outside town, rumbled through the unpaved lanes and alleys. Harrison Avenue provided visual evidence of the potential rewards of silver mining. Tabor enterprises—the Tabor Grand Hotel, the Tabor Opera House, and the Tabor Bank—lined the street. It is easy to depict Meyer as an exotic in this gaudy place, but he was actually not. His muttonchop side whiskers and mustache were the facial hair of choice among many of Leadeville's other male inhabitants in 1881, and there were other Jews in town, though not yet a synagogue. Even his German accent could not have seemed alien; the town boasted the *Deutsche Zeitung* as one of its newspapers.

Harsh took Meyer to the two adjacent mines. While the Philadelphian peered into the dark vertical shaft of one, Harsh dropped a stone. A second or two later Meyer heard a distinct splash that audibly confirmed the problem. It would be necessary to buy pumps to "unwater" the mines, Harsh announced, and that would cost a lot of money. Though Harsh himself was a mining engineer, he was also an interested party, and Meyer decided to consult an independent expert in Denver. He soon hired Charles Hill to oversee the operation and bought four twenty-five-horsepower steam pumps and sent them to Leadville. He also decided to deepen the existing shafts. Leaving Hill and Harsh behind to supervise the work, Meyer returned to Philadelphia, still won-

dering whether he had not made an idiot mistake hunting for buried treasure in the West. While the jury was still out, Harsh, unable to pay for his part of the improvements, agreed to sell his ownership share to the remaining partners for $50,000, though he stayed on as superintendent of the day-to-day operations. Now Meyer had a controlling interest in the enterprise, foolish or not. With the shafts dry and deep digging resumed, the amount of ore removed from the mines daily finally increased to fifty tons a day. Still, the enterprise remained doubtful. Then, one Friday morning in August, as Meyer was working at his desk in the Front Street dry goods store, a telegram arrived from Harsh in Leadville: RICH STRIKE. FIFTEEN OUNCES SILVER. SIXTY PERCENT LEAD.[17] Excited, Meyer reached for a pencil and paper. Fifteen ounces, he quickly figured, meant almost $20 worth of silver per ton—not to mention the lead. Multiply by fifty: a thousand dollars a day! It was a bonanza! The Guggenheims were now rich!

CHAPTER TWO

Foundation

THE A.Y. AND THE Minnie would be the bedrock of the Guggenheim fortunes. Yet not all ran smoothly at the beginning. One problem was the labor force. The Guggenheims were not the worst employers of the Gilded Age. When, at the end of the 1880s, they sold their Swiss embroidery factories, as we shall see, they extended generous terms to their employees. In the new century ahead they would introduce workers' compensation and an employees' pension system in their smelters. But they were also not capitalist visionaries like George Pullman, the sleeping car magnate, or Robert Owen, the English textile tycoon, who sought to replace the harsh laissez-faire system of the era with a more humane set of labor relations.

In fact, it was difficult to avoid labor unrest in the western mining districts. The work of the miners was unavoidably hard and dangerous. During a nine-month stretch of 1879–80 the newspapers of Leadville reported scores of deaths and injuries by falls, drownings, fires, explosions, and machinery malfunctions. And hard rock mining was monumentally unpleasant. The underground mine tunnels were choked with dust, smoke, and the effluvia of mules and human waste. Further unsettling, the miners were often single men living without the civilizing presence of wives and families. Many were rolling stones without permanent

homes. But the men also had simple dollars-and-cents grievances. During the early seventies, when labor was still scarce in Leadville, the miners had gotten $5 a day. But as the new decade opened, there were now thousands of workers in the district, and many were willing to take less. The mine owners understood the changing market, and at a meeting attended by superintendent Harsh of the A.Y. and Minnie, they agreed to a uniform wage scale of $2.75 a day (of ten or twelve hours) for topside hands and $3 for underground workers. The miners reluctantly accepted the scale although they considered it outrageous. The cost of room and board in Leadville was far higher than in the East. And besides, the miners had to supply their own work clothes and tools. The Leadville miners' discontents encouraged goldbricking on a massive scale. At the Chrysolite mine, the manager accused the men of loafing on their shifts, "singing, smoking, and telling stories and having a good time generally."[1] Angry at this idleness, manager W. S. Keyes fired the foremen and issued a peremptory order threatening to discharge any man who failed to do his job. This harsh response triggered latent resentments, and on May 26 the Chrysolite miners struck and demanded not only the rescinding of Keyes's order but also $4 a day and an eight-hour work shift. The strike soon spread throughout the Leadville district. Before many days some six thousand miners were idle. The owners were apprehensive and fortified their properties with armed guards. The strike took a violent turn when irate workers fired rifles into the compounds of the Little Chief and Little Pittsburg, and the owner's guards fired back. In the end the owners hired scabs, and in little more than a week the miners returned to work at the old wage levels.

Meyer never understood the men's wage complaints. In Philadelphia $2.75 a day was ample for a worker and his family; in fact it was better than the wage of a skilled Philadelphia mechanic. He simply could not transpose the living costs from sedate old Philadelphia to the boomtown West. But Meyer was also suffering from the classic illusion of the self-made man: what he had individually achieved he truly deserved, for it was brains, hard work, and steady habits that had made you rich.

And the owners and the miners had other quarrels. Meyer clashed with the mine workers over property rights and the location of their cab-

ins. These were scattered helter-skelter across the hillsides, often on legally claimed land, making it difficult to find space for the voluminous mine tailings, the debris left over after the ore was extracted. Meyer's associates got a court order compelling the miners to vacate their shacks, but one, Mike Winters, refused to give up his twelve by twenty foot plot on the Minnie claim. The sheriff of Lake County, prizing popularity over the letter of the law, declined to enforce the court's order. At this point Thomas Weir, the mines' general manager, and a crew of tough aides took matters into their own hands. As Winters's lawyer later described it, they "forcibly and violently entered into and upon said premises and ejected the plaintiff therefrom and cut broke, tore down and entirely destroyed said dwelling house."[2] Weir sued, but apparently received no satisfaction.

Meyer and his associates also clashed with county assessors over taxes levied on their property. These, they held, were exorbitant. They also fought with the railroads that carried ore to the smelters over excessive freight rates. Seen in isolation, these encounters suggest an unusual contentiousness, but they were the inevitable price of doing business in this era and indeed in our own.

Despite the hitches Meyer and the family were getting rich. During most of the 1880s the Minnie and A.Y. continued to prosper. By mid-decade the mines employed 120 men. In 1886 a Leadville newspaper estimated that the two Guggenheim mines were among the "largest mining properties in the west." That year the gross value of their output amounted to $3.6 million "above smelting charges." This represented an increase of $1.4 million over the previous year. "This showing is truly a remarkable one," the reporter commented.[3] In the later nineties returns on the two mines declined, yet the Minnie and the A.Y. would ultimately add more than $15 million to the Guggenheim coffers before they ceased to be an important piece of the family's fortune.

Growing wealth brought growing fame. By the early 1880s Meyer had become a minor celebrity in Philadelphia, and local reporters sought him out for comments. In one interview with the *Philadelphia Press*, Meyer boasted that he had made more than $17,000 profit for the month of September 1880 alone, and that on a total investment of only $4,000!

Would he be willing to sell his mine, the reporter asked. "No, sir," he replied, "I would not sell my share for half a million cash money. I have made a thorough investigation of the property and if what geologists tell me is true, we could get three or four millions cash money out of the mine."[4]

To keep abreast of the problems at the mines, Meyer journeyed several times to Leadville, mingling with the rough miners and the local bankers and storekeepers, and consulting with Graham and his other associates in the enterprise. He also enlisted the energies of his two younger sons. He had already induced Ben to attend the Columbia School of Mines, the best place to master the technology of the emerging new business. In the summer of 1882 he sent Ben to Leadville to learn the practical side of the business. During the college vacation Ben served as a bookkeeper at the A.Y. He returned during the summers of 1883 and 1884 as well and then dropped out of Columbia permanently to work in the family business. William, the youngest son, who entered the University of Pennsylvania in 1885, attended the Wharton School initially to learn business methods generally. As the family's center of gravity shifted to mining, he changed his focus to chemistry and metallurgy.

BOTH YOUNGER BOYS WOULD be instrumental in the fateful expansion from mining to refining. Mining, of course, is only the first step in converting minerals into cash. The silver ores at the A.Y. and Minnie were exceptionally rich. They included large amounts of uncombined, native silver distributed through the ore as fine metallic wires and even as bird's nest–like tangles. But the rest of the ore was lead containing a large fraction of zinc sulphide that could only be removed with difficulty. At first the ore was sent to various small local smelters in Leadville itself. Its processing was costly. The smelter operators charged a high price to remove the impurities, especially for ores as refractory as the Guggenheims'. During the summer of 1887 manager Weir sold 3,200 tons of ore to the Globe smelter near Denver owned by Edwin R. Holden and several partners. This lot had yielded 185,000 ounces of silver, plus substantial amounts of lead and zinc. When Meyer toted up the price of these metals he concluded that the smelter would make twice as much as he

did. "The smelters are getting all the profit," Meyer complained. He was a victim of "smelter extortion."[5] Meyer decided to look into the business of smelting his own ores, to cut out the expensive middle man—as he had when he decided many years before to produce his own stove polish.

Holden would be the Guggenheims' way out of the noose. Benjamin had met Holden when he worked as an ore assayer in Leadville, and the two men had become friends. In 1886, as we noted, Holden become part owner of the Globe smelter, but he did not get along with his partners and wanted out. He proposed to Benjamin that he and the Guggenheims join to build their own smelter, and Benjamin liked the idea. In 1887 Ben and Holden came east to discuss the scheme with Meyer. In Philadelphia Holden reinforced Meyer's suspicions about the smelter companies' rates. The smelter operators, he claimed, made as much as 150 percent profit. In fact, they skimmed off virtually all the profit in the mining business. "So," Meyer asked rhetorically, "if smelters make the money . . . what's the use of having a mine unless you have a smelter?" "None at all," Holden eagerly replied.[6]

The interview apparently overcame Meyer's remaining doubts, and he offered Holden $80,000 for a share in his smelter. Holden accepted and also agreed to take Benjamin on as timekeeper at the plant. The deal with Holden was another watershed for the Guggenheims. Meyer now concluded that the family, while continuing to extract ores from the ground, would concentrate its energies and capital in the refining business. But rather than stay with the original Holden firm he decided to build a smelter of his own with Holden as a 49 percent minority partner. In January 1888 he announced the formation of the Denver Smelting and Refining Company with himself as president and Benjamin as secretary-treasurer. The new firm, he declared, would soon construct the largest smelter in the civilized world.

But where should it be located? After considering Denver and Leadville itself, Holden and Benjamin finally fixed on Pueblo, a town in central Colorado, south of Denver. The city had many advantages. It was located on both north-south and east-west rail lines and so was accessible not only to Leadville mines but to others in the Southwest and even in northern Mexico. At least as important as geography was the attitude of

local Pueblo officials and the city's businessmen. Both groups were eager to get the giant new smelter and wooed the two entrepreneurs, as in our day communities in the South and West court automobile and computer firms that promise to bring new payrolls and expanded tax bases. When, in March 1888, Holden and Ben came to Pueblo for a second reconnaissance, they were met at the station by the mayor, the county commissioners, officials of the Pueblo Board of Trade, and the town's bankers, and escorted down main street to city hall by two brass bands. But the two entrepreneurs were not seduced by public relations. They had a business proposition for the Pueblo leaders. The city must furnish the land for the plant and contribute $25,000 to the cost of its construction. Rather than proceed with this proposal without a mandate the business leaders called a public meeting at De Remer's Opera House where they read a letter from Holden and Benjamin Guggenheim outlining their proposal. Not daunted by the terms, then and there the audience volunteered contributions and agreed on a campaign to raise money from local businesses and individuals. By the time another meeting was held a few days later, all but $2,000 of the $25,000 had been raised. The organizers now telegraphed the two promoters in Denver that their conditions had been met. But Holden and Benjamin Guggenheim could see that there was still room to improve their deal, and in the end they induced the city council and the county commissioners to further sweeten the pot with a tax moratorium for ten years.

On April 10 the two promoters held a press conference and announced that the smelter would in fact go up in Pueblo. It would be ready in October, they promised. Also, the name of the enterprise would be changed to the Philadelphia Smelting and Refining Company, and the firm would be capitalized at $1.5 million.

WITH MINING AND NOW SMELTING advancing so quickly, Meyer concluded that the family should close out the embroidery business and put all its energies into the new western enterprises. Not only were minerals proving profitable, but the lace and embroidery firm, Meyer feared, could no longer compete with the efficient Swiss. The older boys were not happy to surrender the security of the embroidery business for the

uncertainties of western mining and smelting. They were even less happy with the terms that Meyer imposed for the shift. It was at this point in the family's evolution, apparently, that Meyer expressly formulated his stern dynastic principles. Each of his sons, he announced, would receive equal shares in the new enterprise, to be named M. Guggenheim's Sons, no matter how young and how limited his initial contribution.* Meyer would stick to this formula, despite resentments, as long as he ruled the nest. He once explained his rule to a skeptic. "True, when the younger ones first come in they are more bother than they are worth. During this period the older ones must carry the load. But in time all that changes. The day arrives when the older ones wish to retire. Then the younger ones must carry the load. Besides, let us not forget the wives! If the wife of one partner hears that the partner-husband of another is making more money, trouble follows."[7]

Isaac, the oldest, who by this time had been working in the family embroidery trade for ten years or more, objected strenuously. How could his father treat all his sons alike? Why, William was a mere college student and Benjamin and Simon not much older! Meyer did not often face open revolt from his sons. They were dutiful in a way inconceivable to twenty-first-century Americans. Meyer was seldom harsh with them, but he also seldom praised them. He was proud of them but, according to a later observer, "unsparing with his criticisms and relentless in having them adhere to his sense of business duty."[8] At this point, family lore has it, Meyer retorted by rehearsing the famous ancient tale from Aesop's fables of the dying father and his sons. In his office one day Meyer handed each of the boys a thin stick and asked him to break it. Each did so easily. He then passed around seven of the same sized sticks tied together and asked each to try to do the same thing with the bundle. None succeeded, of course. "You see," he exclaimed, "singly the sticks are easily broken, together they cannot be broken. So it is with you. Together you are invincible. Singly, each of you may be easily broken.

*The firm was formed in 1881, but it was not until May 31, 1893, that Meyer and his sons signed a formal copartnership agreement to provide equal shares in both profits and losses.

Stay together, my sons, and the world will be yours. Break up and you will lose everything."[9] Whether the event actually took place as described, the rule of equal fraternal partners was planted, and Isaac was forced to accede. But more portentous, the story highlights family solidarity as a core Guggenheim principle and a source of strength through three generations. The quality was widely recognized. Bernard Baruch, the financier and public servant, a close family friend, would describe the Guggenheim enterprises at full flower as a formidable business collective. "The family operated like a perfectly disciplined army under the direction of the commander-in-chief, old Meyer."[10]

Whatever their initial objections to the westward shift of interest and resources, the boys bowed to the patriarch's wishes. In 1888 Solomon, now twenty-seven, negotiated the sale of the Plauen and St. Gall factories. According to one story the Guggenheims insisted that the Swiss buyers retain the factories' original personnel and they themselves paid bonuses, a kind of severance pay, to their former faithful employees. If correct, Meyer was treating his European employees far better than he had his Colorado miners.

Meanwhile, with the family committed entirely to western resource exploitation, for a time it looked as if the doubts of the older sons were warranted. Construction of the smelter, consisting of six separate blast furnaces as well as roasting furnaces to extract the sulfur from the ores, went more slowly than expected. In part the blame lay with the inexperience and meddling of the family. As one of the engineers later noted, "the old man and Benny were, both of them, always wanting to change the plans or proposing innovations that metallurgically would have been ridiculous. The greatest work in building the Philadelphia was pester. Wherever I turned there was always a Guggy in the way with questions and suggestions."[11]

Besides Benjamin and Meyer, the construction engineers had to deal with Will, the youngest, who, during the summer of 1888, spent his vacation from the University of Pennsylvania in Colorado. Will lived mostly in Leadville that summer, supplementing his university courses in chemistry and metallurgy with practical experience at the family's mines, though he managed to get to Pueblo to view the smelter rising

slowly from the ground. By his own account, Will learned more about the girls and the saloons in Pueblo's "Peppersauce Bottoms" and Denver's *maisons de joie* than about mining and smelting.

The high hopes for the smelter soon receded. By 1889 the price of silver had dropped to 93 cents an ounce, the lowest anyone could remember. Then there was an expensive initial technical miscalculation. Acting as general manager, Holden had hired as construction superintendent a man trained as a mechanical engineer. To avoid paying royalties on standard smelting apparatus, this man experimented with a new process that dispensed with crucibles. It was a mistake. In February 1889 the Trinidad, Colorado, correspondent of the *Engineering and Mining Journal*, the industry trade paper, reported that the system being tried at the Philadelphia smelter did not work. Its furnaces, "built on a 'new process,'" had "frozen up." The Philadelphia's managers, moreover, had purchased ores "that none of the other companies would buy because of [their] refractory nature."[12] Benjamin indignantly responded in the next issue. "We have at present our entire six furnaces in successful operation," he stated. The company was "running full blast." He denied that the smelter's ores were not suitable and noted, as a mark of the enterprise's success, that the Philadelphia's capital had been increased from $500,000 to $1.25 million, "full paid in," and the operators were preparing to double their capacity.[13] But the critics were right. Before the plant's bugs had been worked out its costs had soared to $300,000, some 50 percent more than Meyer had planned. The Pueblo smelter had started to treat ores in December 1888, but profits proved elusive. The Guggenheims were soon losing $50,000 a month.

During the spring of 1889 Meyer called a family conference in the New York offices of M. Guggenheim's Sons to consider how to halt the drain and save the business. The boys could see ruin ahead and were panicky. They had taken their father's advice and left the secure, if unexciting, lace and embroidery business. Maybe that move had been a foolish mistake? Meyer sought to reassure them. He had confidence in the success of the Pueblo venture, he said. The family had always been lucky, and its luck would hold. At this point ownership of the rich mines—and

their profits—were in his name alone. The mines and the smelter, the property of the sons, were separate enterprises. But he would put all the resources of the A.Y. and the Minnie behind the smelter to get his sons over the hard transition. "This offer to toss them into the scales in their support allayed the panic . . . and clinched the point," William later wrote.[14] Meyer's paternal reassurances had worked wonders in stiffening the sons' resolve.

But still success was delayed. In 1889 William graduated from the University of Pennsylvania, and that summer he went to Pueblo to work under Holden as foreman of the yards, a job that entailed supervising the storage and distribution of ores, limestone, coal, coke, and lumber. Will soon clashed with the new smelter superintendent. The man was incompetent, he insisted. Holden replaced him and then his successor quit, charging William with interference. Meanwhile, labor troubles erupted once more. The men wanted the normal twelve-hour day at the furnaces reduced in the broiling summer to eight hours. Management accepted these demands in exchange for a wage reduction for the summer months. That fall the men demanded that the eight-hour day be made year-round. The company refused, and the smelter workers struck. The strike failed, but in the two months of idleness the Guggenheims' losses mounted.

By this time Holden himself had lost faith in the enterprise and offered to sell his minority interest to his partners. Meyer advanced the money for the buyout, and M. Guggenheim's Sons became sole owner of the Pueblo plant. When the deal was concluded Ben became general manager and Herman Kellar became superintendent of the smelter. Will, only twenty-two, was made assistant to the new superintendent. The other sons now were drawn into active on-site operations of the Pueblo smelter. Murry finally returned from Switzerland with his wife and son and came to Colorado to head the whole smelter operation, with Ben and Will under him. Murry and his statuesque European wife, Leonie Bernheim, of Mulhouse in Alsace, found Pueblo an impossible place to live. The town, sitting on a flat plain east of the mountains, was hot in summer, frigid in winter. Its steel mills and smelters belched black smoke into the air; soot covered every surface. The couple soon moved

to the gracious planned city of Colorado Springs in the cool foothills of the Rockies, fifty miles north of Pueblo.

The refining-smelting business turnaround finally came sometime in 1890. In that year Benjamin hired August Raht, a graduate of the world-famous Freiberg School of Mines in Germany, to supervise the furnace operations. A large-headed, white-bearded man known as the "king of lead smelters,"[15] Raht did not come cheap. Meyer apparently was not too happy with the expense, but Ben, as well as Murry and the other boys, concluded that they needed a real expert to do the job right no matter what the cost. To their great profit, the Guggenheim sons would extend this principle of buying the best brains available to other ventures. Raht improved the operations of the smelter immeasurably and was soon reporting a monthly profit on operations.

RAHT'S SKILLS WERE AUGMENTED by the rebound of silver prices. The abrupt shift was not produced by unaided market forces. More and more silver in these years was pouring from the mines of the mountain states and Mexico, and the process promised to continue. But the silver flood was embedded in a political matrix. It coincided with a long deflation of general prices that stressed the world economy in the last third of the nineteenth century. Many observers blamed the painful Great Deflation of these years on the adoption of the international gold standard. Tying the world's currency to gold, they said, had imposed a straitjacket on the money supply at a time when the world economy was rapidly growing and needed more, rather than less, money circulation. In the United States farm spokesmen and many western politicians held that the great monetary error had been the "Crime of '73," when Congress demonetized silver and restricted the dollar's backing to gold exclusively. Restore silver as a monetary metal at a value of one-sixteenth to gold by weight, declared these analysts, and the relentless fall in prices, grinding down debtors and "producers" alike, would cease and indeed reverse. The proposal, if implemented, promised not only to improve the lot of farmers and debtors, however; it would also immeasurably help the silver producers. Most silverites demanded the "free and unlimited coinage" of silver at the sixteen to one ratio. Eastern politi-

cians, bankers, and businessmen balked at this open-ended commitment as a certain formula for runaway inflation. But the pressure of the farm regions and the far West forced Congress to act. In 1890 Congress passed the Sherman Silver Purchase Act requiring the Treasury to buy 4.5 million ounces of silver a month at the market price and pay for it in legal tender Treasury notes redeemable in either gold or silver. The amount equaled the total output of all of America's mines and had an instant effect on silver prices. In a matter of months silver rose to $1.25 an ounce. Now both miners and refiners would enjoy the margin needed to make even a dubious venture solidly profitable.

WHEN MEYER TURNED to smelting in Pueblo he had assumed that the new facility would process more than the ores extracted from his own mines. One of the obvious sources for new metals was Mexico. Ever since its conquest by Europeans in the sixteenth century, the country had been a Golconda, whose silver and gold had financed the king of Spain's diplomatic ambitions and made his country Europe's greatest power for a century or more. Though wracked by violence and political disorder after independence in the early nineteenth century, Mexico continued to beckon mining capitalists and prospectors. In 1889 Simon traveled to northern Mexico to drum up business for Philadelphia Smelting and Refining. He was soon able to sign up several mine owners of the Sierra Mojada district to ship their lead ores to Pueblo for processing. This was the tip of what would become a very massive iceberg. Eventually the Guggenheims' foreign business would far exceed their domestic enterprises and turn M. Guggenheim's Sons and its successors into a world-spanning mining empire that would outstrip all its rivals.

Mexico would be an expanded new arena for Guggenheim enterprise. In 1889 it seemed a nation in transition to modernity, a culture and state finally catching up with Europe and "North America." We now know that it was a false dawn. In less than a generation the process would be arrested by renewed political upheaval and an anticapitalist reform agenda that put social experiment ahead of economic development. But in 1889 Mexico appeared a model for what today we would call the developing world. Under the leadership of its *caudillo*, Porfirio Díaz, and

his *cientifico* supporters among the nation's bourgeoisie and intellectual elite, disorder and banditry had been repressed, schools opened, railroads and factories constructed, telegraph lines strung. By themselves these changes would have attracted foreign investors, but beyond these policies the regime actively pursued European and American capitalists to exploit and develop the country's natural resources. Porfirian Mexico remained a poor country by U.S. standards. It was a byword of social inequalities—between peons and *hacendados*, between Indians and white *creoles*, between factory owners and wage workers. It was not democratic. The "Indispensable Caudillo" was not a Hitler or Mussolini, but he ruled, like an American political "boss," through patronage, manipulation, bribery, and occasional violence. By the turn of the century American reformers began to attack Díaz and his regime as brutal and exploitive. Carleton Beals, a prolific progressive writer on Latin America, depicted Mexico under Díaz as little more than a satellite of American business. And yet most Americans welcomed the "order and progress" the *caudillo* had brought to their southern neighbor. As Secretary of State Elihu Root expressed it early in the new century: "If I were a Mexican, I should feel that the steadfast loyalty of a lifetime could not be too much in return for the blessings that he had brought to my country."[16]

Mexico's silver proved particularly attractive to foreign investors. The Mexican ores were unusually rich and contained many of the trace elements needed for cheap and efficient refining. By the early 1880s American mining firms were scouting all over northern Mexico for profitable mineral sites and opening new mines and buying into old ones with abandon. Most deeply involved south of the border was the Consolidated Kansas City Smelting and Refining Company. Its rich ores from mines in the Sierra Mojada and Santa Eulalia districts of the state of Coahuila were conveyed to its own smelters in the United States, and some of the excess was sold to other processors. One of these was the Guggenheims who, after Simon's 1889 trip south, contracted to buy some of Consolidated's Mexican ores.

American mine operators (as opposed to refiners) were soon protesting loudly against this unfair, un-American competition. Washington

responded in its usual way. In this era of Republican ascendancy government encouraged domestic economic development primarily through high tariffs that raised the cost of imported commodities and "protected" American producers against cheaper foreign producers. Now, in the McKinley Tariff of 1890, Congress imposed a tax on all ore containing lead. This effectively excluded imported Mexican silver ores and helped the American silver mining industry, but it injured firms like Consolidated and the Guggenheims' Philadelphia Smelting and Refining that processed imported Mexican ore.

Yet there were other reasons that the Guggenheims, already attracted by Mexico's mineral riches, should move into the Mexican smelting industry. Labor costs in Mexico were far lower than in the United States. In the country as a whole the daily wage averaged only 40 cents. At Pueblo, smelter workers earned $2 a day. But the path to the Guggenheims' foreign economic empire was eased by Edgar Newhouse, a Philadelphia-born graduate of the Columbia School of Mines. In the mid-eighties Newhouse became an ore buyer in Mexico for the Consolidated company and established his home in Mexico City. He left the firm just before passage of the McKinley Tariff and became a propagandist for American investment in Mexican smelting. With the tariff bill about to pass, he clarified for readers of the *Engineering and Mining Journal* the new law's implications for the smelting industry. Its exclusion of Mexican ores from American refineries would require "the erection of smelters in various parts of the Republic with foreign capital." If Americans did not make the investments, he warned, the English and Germans would.[17] On a train ride to Colorado Springs Newhouse fell in with Albert Geist, chief metallurgist at the Pueblo smelter, and in the convivial smoking car filled his ears with his message. Geist was impressed. "Why don't you talk with the Guggenheims?" Daniel and Murry were in Pueblo looking over their property. Geist would introduce his new train acquaintance to them.[18]

The meeting soon after in the Philadelphia's office was a success. Already thinking along Newhouse's lines, Murry and Daniel decided to accompany him without delay on a tour of likely sites for a Mexican smelter. Setting off for El Paso, they crossed the border and soon found

what they wanted. Before returning to the States, they decided they would construct two smelters, one at Aguascalientes for lead and copper ores from southern Mexico, and one in Monterrey to process northern lead ores. But the decisions were conditional. Any investment would depend on favorable terms from the Mexican government.

Happily the Guggenheims had important contacts in Mexico. Newhouse knew *el presidente* himself, while David Kelley, the Guggenheims' ore-purchasing agent for the Pueblo smelter, was an acquaintance of General Bernardo Reyes, governor of Nuevo León, the northern Mexican state with its capital in Monterrey. Newhouse secured a meeting for Daniel with Díaz at the ornate National Palace in the heart of Mexico City. *El presidente*, sixty, still physically powerful, with a bushy white mustache, took to the charming Daniel, who by now, though only the second son, had revealed his ability to lead the family. Anxious for American capital, Díaz assented to generous terms for the Guggenheims. The agreement, of October 1890, stipulated that M. Guggenheim's Sons might establish up to three smelters and undertake explorations for mines to be leased or purchased anywhere in the Mexican Republic. In addition, all machinery needed for the enterprises could enter the country duty free and all capital invested would be exempt from local Mexican taxes. Later that year the Guggenheims' federal grant was confirmed by an additional agreement with Governor Reyes for the proposed Monterrey smelter. This document conferred exemption from state and municipal taxes for twenty years and required in return that the Guggenheims invest at least 300,000 pesos in a new smelter within eighteen months.

When Daniel returned to New York with the precious agreements in his briefcase, the family gathered to consider how to divide responsibilities for both the established businesses and the ambitious new ventures. The decision would define the brothers' roles for many years. Isaac, the unenterprising and emotionally fragile senior, would be treasurer of the smelting business, while continuing to liquidate the family lace and embroidery business. Daniel would remain in New York as overall captain for M. Guggenheim's Sons. Murry would be put in charge of sales; Simon, in Denver, would become head buyer of ores—

lead, copper, silver—and mining supplies; Benjamin would continue as supervisor of the Philadelphia smelter in Pueblo and also as the family expert on mining and smelting machinery. It was Solomon, thirty in 1891, short with a curly mustache, who would be sent off to the new Mexican ventures on which the family was staking its future. A man of charm and courage, he would convert into bricks, wood, steel, and cement the dreams of establishing a mining and smelting empire for M. Guggenheim's Sons south of the border. The four older brothers, Isaac, Daniel, Murry, and Solomon, whenever they were in New York, would run the company from their offices at 71 Broadway, overlooking the Hudson. These were several small rooms with the four partners' desks clustered together.

SOLOMON'S TASK WOULD BE a perilous one. Despite Díaz's strong hand and firm paternalism, Mexico in many parts remained an unruly and primitive place. Monterrey itself was a dreary adobe town of twenty-five thousand, located at the foot of eroded mountains, surrounded by rough hard-scrabble farms and ranches. By 1891 it had acquired a railroad station and an electric power plant but remained without sewers, paved streets, or a modern hotel. Solomon had help as he scouted mine and smelter sites, leased land, and arranged to hire labor and import construction material and machinery. David Kelley paved Solomon's way socially by introducing him to the local bigwigs at the flourishing Monterrey Foreign Club. The Guggenheims also hired Henry Dieffenbach, a Spanish-speaking New Jersey metallurgist, as well as various experts to design the smelters. Sol was soon joined by brother William, who arrived from Pueblo accompanied by two assistants, a carpenter named Julius, and Van Yngling, a married Scandinavian construction engineer who had come to Mexico with serious misgivings only allayed by unusually generous wages.

For weeks Sol, William, and their assistants endured the heat, insects, bad food, and general discomforts of northern Mexico while they scouted for ore and plant sites and mobilized materials and labor. Sol felt obliged to carry a revolver in his belt to scare off banditos. He eventually bought the land for the Monterrey smelter and leased four mines for

iron, lead, and silver. He returned to New York after a few months but reappeared periodically in Mexico to troubleshoot and develop additional properties. Left behind were William and his assistants to finish the job of erecting the smelter itself.

William, as he tells it, performed heroic feats to accomplish his assignment. His assistants often proved wanting, however. One, a Scottish civil engineer, was a heavy drinker who had adopted the local response of *mañana* when asked to do his job of completing railroad connections to the smelter. At one point William invited the man to dinner, hoping to generate some goodwill. The meal turned into a libation duel with Texas corn whiskey as the weapon of choice. The inexperienced Will lost and was carted away to sleep it off. The next day, after recovering, he encountered the engineer, who greeted him with an unexpected cheery message. "Well, my boy, I'm glad to see you out again. And you'll be pleased to hear that these lazy loafers I've been trying for weeks to shove along, suddenly got a little life into them and your spur-line is finished."[19]

The job required physical courage as well as social accommodation. The contractor who built the main brick chimney stack and flue chamber for the rising smelter had used inferior mortar. When a ferocious wind storm struck the region, it tilted the stack and cracked its base. The Mexican masons, fearing imminent collapse, understandably refused to enter the leaning structure to shore it up. But if the 150-foot-high chimney had to be torn down and rebuilt, the smelter would be delayed for months. Will stepped in. While the masons and others tried to dissuade him, he entered the stack at the base and laboriously climbed up using the inside foot- and hand-holds, waving to the crowd below when he emerged at the top. Encouraged by their boss's bravery, the masons entered the stack themselves and, after the necessary repairs, got it to work as designed. The chimney stood for many years and served without problems.

The months in northern Mexico would leave behind vivid memories for Will. Backward though it was by the standards of New York or Philadelphia, Monterrey itself offered some social diversion. Will and Dieffenbach could sit on a bench at the city's central plaza and, while lis-

tening to the town band, watch the nubile young women and their dueñas parade around the square's perimeter. But Will soon surrendered these delights to be at the construction site, some six miles from town. There, in a small general store–cum–office made of rough planks and tin, he stored his clothes and kept his cot. Close by was another shack where a Chinese cook prepared the workers' daily supply of rice and beans. A short distance away lived Van Yngling, the project's construction engineer, who shared the two-story farmhouse with Julius the carpenter. The gloomy Scandinavian was not proof against the charms of local women and had aroused the jealousy of a neighboring Mexican husband by his overtures to the man's wife. One evening, while reading below, Julius heard loud scuffling and screams from the bedroom above where Van Yngling had retired. Then silence. Paralyzed by fright, Julius did not rush up the stairs as a braver man would have. But then, while cowering below, he heard an ominous dripping sound. It was Van Yngling's blood oozing through the loose floorboards. Julius finally mustered the courage to enter the bedroom, where he found his associate dying of thirty stab wounds. Julius rushed to get William. "Van Yngling has been murdered," he screamed. William telephoned to Monterrey for a doctor and the police, and he and Julius rushed to the house. Van Yngling was still alive but died soon after the doctor arrived.

The governor dispatched troops to hunt down the men suspected of the murder. Criminals could not be allowed to prey with impunity on the foreigners who were promising to transform Mexico. The pursuit succeeded. The culprits were captured and summarily shot without trial.

The murder threatened to delay completion of the Gran Fundición Nacional, as the project was called. Julius refused to stay, and William had to find a replacement to fill the boss carpenter's slot. The other American staff grumbled and threatened to leave too. Sol and William had to bribe them to stay with generous perks including a sports field, a recreation hall, and comfortable permanent housing near the smelter. To further assure stability, the Guggenheims sought to extend their paternalism to their Mexican workers as well. They raised wages from the prevailing 25 centavos a day to a full peso. The effect, however, was not a more reliable labor force. Content with their former wages, the employ-

ees simply worked fewer days. To achieve their goal the Guggenheims were compelled to offer free housing and special low prices at the company store for all who worked for at least twenty-five days a month. The policy of generous paternalism in their foreign ventures, first developed at Monterrey, would be repeated elsewhere abroad in future years. Though it reflected a sincere streak of altruism in the Guggenheims, it also had a practical aspect. The Guggenheims needed a stable labor force to assure profits. In recent terminology, their benevolence was a "modernizing" force in the economies of less-developed nations.

The Monterrey smelter opened in 1892 and was an immediate success. During its first four years of operation it processed monthly ten thousand tons of ore, mostly lead. The smelter was soon expanded so that by 1900, under its manager T. S. Austin, it had ten blast furnaces with a capacity of thirty-five thousand tons a month. It would earn enormous profits for the Guggenheims.

THE AGUASCALIENTES PLANT STARTED to rise soon after the Monterrey facility was completed.* Like most smelters, it was a multipurpose processor, with more than one metal as its projected end product. By this time M. Guggenheim's Sons had bought the rich Tepezala copper mines and earmarked its output for Aguascalientes, though they also partially refined some lead ores at the new plant. To complete the lead refining process, they opened a plant in Perth Amboy, New Jersey, in 1894 where the intermediary product was shipped from their Mexican smelters by way of their own steamship line from Tampico. Much of the Perth Amboy product was sent directly to Europe.

The 1890s was the breakthrough decade for the Guggenheim business. By the turn of the century they had left lace and embroidery far behind and had become a major power in mining and smelting. They had also become a force for modernization in America's neighbor to the south, a role they would repeat in the new century in other places in Latin America. But the decade was not easy sailing. In mid-1893, after a stretch of generally good years, the economy turned sour. Early in the

*The Aguascalientes plant was finished in 1894.

year two large American firms, the Philadelphia and Reading Railroad and the National Cordage Company, failed. In May the stock market tumbled, triggering a shockwave of business liquidations. Before the year ended 491 banks and 15,000 commercial firms had closed their doors. Many pundits blamed the collapse on the 1890 Sherman Silver Purchase Act. It had, they insisted, pumped up the amount of fiat money that had to be backed by gold and undermined confidence in the Treasury's ability to sustain the gold standard. This was a self-fulfilling prophecy, and the government's gold reserve was soon dwindling at an alarming rate. The day when the Treasury would be forced to suspend gold payments seemed to be fast approaching. To prevent default, the Cleveland administration began to sell bonds to the public for gold. At the same time it pushed through Congress a measure to repeal the Sherman Silver Purchase Act. The price of silver soon plummeted to 47 cents an ounce, less than half its peak, The two moves together saved the gold standard, but the economy remained in the doldrums until 1897 or 1898 when prosperity finally returned.

The economic slowdown inevitably affected the metals industries. By the summer of 1893 producers of low-grade ores in the United States were facing bankruptcy. Mines shut down, and several thousand miners were thrown out of work. The smelter proprietors were also severely hurt. The Guggenheims fortunately were able to ride out the storm. Their A.Y. and Minnie were no longer major contributors to the family income stream. By the mid-nineties their output was down and the diggings once again needed "unwatering." But the Guggenheims leased the properties to other operators and settled for a steady fee unaffected by the price of ore. They fared even better in their smelting business. An efficiently run facility, the Pueblo smelter made a profit when others were facing bankruptcy.

The Guggenheims' exceptional situation did not endear them to other smelter owners. In the summer of 1893 Simon was present at the mine and smelter owners meeting at Denver's Brown Palace Hotel, called to concert action to stem the downward trajectory of the metals industry. "The reduction of the price of silver to about 70 cents has shut down 99 percent of the silver mines of this country and the smelters must

soon follow their example," the operators declared. There were cur-
rently fifteen thousand idle miners in Colorado alone "who know not
where to turn" for relief.[20] A majority of the delegates recommended
closing down the smelters to wait for an upturn of prices. This would
raise prices by creating scarcity but also throw many mine workers out of
work. Confident that the family's smelters could ride out the slump,
Simon demurred. When asked by someone at the meeting what the
Philadelphia's management would do in the crisis, Simon replied:
"Gentlemen, the rest of you can do as you like. Our smelters will not
close down."[21] Simon incurred the enmity of his fellow owners, but for a
time he became a hero of the unemployed, a man who seemed more con-
cerned to save jobs than preserve capital.

All told, the Guggenheims weathered the nineties and came out
stronger than ever. As the decade ended they had positioned themselves
to take advantage of the broadening opportunities of the new twentieth
century. Meanwhile, brother Simon had unexpectedly made himself a
champion of labor, and his new-won popularity would prove politically
useful.

CHAPTER THREE

New York

T HE 1880S WERE a personal as well as a business watershed for the family. In 1889 Meyer and Barbara moved to New York City, shifting the family's axis and transforming the quality and scope of its collective life. Philadelphia was a pleasant community, but New York was the undisputed commercial, financial, and cultural capital of the nation, and no businessman who aspired to, or had achieved, great fortune could afford to live and work anywhere else. During the eighties John D. Rockefeller, Andrew Carnegie, Collis Huntington, and the Armours all moved their company headquarters and themselves from the provincial centers where they had made their fortunes to the First City.

New York in the 1890s was exploding with energy. Gotham was being wired and electrified. By the mid-nineties the city had twelve telephone exchanges routing 150,000 calls a day, mostly commercial. In September 1882 Edison's Pearl Street Station began to send power to eight hundred of his new incandescent lamps, serving fifty locations in lower Manhattan. The rich soon replaced gas with electricity to light their mansions, and by 1900, though the working class continued to use gas mantles or even kerosene lamps, many middle-class householders had adopted the electric light. In 1889 the first electric elevators appeared, making feasible the new "skyscrapers" poking up all over lower Manhattan.

The city was becoming a cultural powerhouse as well. In 1880 President Rutherford Hayes dedicated the new red-brick building of the Metropolitan Museum of Art. Three years later music lovers and the city's bejeweled elite flocked to hear the inaugural performance of Gounod's *Faust* at the Metropolitan Opera's brand-new home at Broadway and Thirty-ninth Street. Carnegie Hall, the first satisfactory venue for the city's orchestral offerings, opened far uptown on Fifty-seventh Street on May 5, 1891.

New York was an expanded stage for the Guggenheims to enjoy and display their new affluence. It was where their natural circle, the German-Jewish upper crust, made their homes. This elite was composed of parvenus. Most of its members had come to America between 1840 and 1860 from villages and rural communities in Prussia, Bavaria, and the Rhineland. A few of the newcomers were assimilated, well-educated "Forty-eighters" who had supported the revolutions of 1848 in Germany and fled to America when their liberal hopes were crushed by the forces of reaction. But most were poor and had crossed the Atlantic to better their material lot. In Europe they had engaged in petty trade as peddlers and storekeepers and dealers in farm products. As we saw, they found themselves hedged in by prejudice, official and private, that consigned them to an unequal struggle. Others were the sons of artisans in the towns who were becoming obsolete as industrialization began to penetrate central Europe.

And America fulfilled its promise to some of them. A small cluster of the most ambitious, intelligent, and lucky quickly moved up in the world. Many of the leading German-Jewish families of New York—the Seligmans, the Goldmans, the Lehmans, the Strauses, the Loebs, and the Sachses—like the Guggenheims began as peddlers or small shopkeepers before making their mark as financiers or department store magnates. A few—the Schiffs, the Warburgs, the Kahns—started in finance rather than graduating to it. Others—the Lewisohns, the Belmonts, the Liebmanns—came to America as representatives of already established European businesses, often family enterprises. But whether they started at the bottom or began with a big leg up, by the 1880s the successful

German Jews of New York formed a self-conscious elite that Stephen Birmingham has dubbed "Our Crowd."

Their group cohesion was both imposed and voluntary. Earlier Jewish immigrants to New York had been Sephardim, descendants of Jewish families expelled from Spain and Portugal in the 1490s who had wandered through parts of Europe and the Mediterranean before drifting to America. Bearing names like Seixas, Lazarus, Cardozo, Constant, and Lopez, they were few in number and generally accepted socially by other prosperous New Yorkers. The Germans were not. Perhaps it was because they were less cultivated than their predecessors and too numerous to be unnoticed. Perhaps they arrived in America at a time when the gentile elite had already begun to close ranks. For close ranks it did. It was in the 1870s that Ward McAllister, a transplanted Georgian close to Mrs. Caroline Astor, first composed a sort of honors list of the New York upper crust. None was Jewish. In 1887 the first *Social Register* volumes, listing the socially "acceptable" wealthy families of a given American city, appeared. Jews were excluded. Early in the following decade McAllister published his catalog of the "Four Hundred" New York families who represented "society," in effect defining the city's upper class. None of the families was Jewish, not even Sephardic Jews.

Exclusion from the *Social Register* was not the only stigma imposed on Our Crowd. They were denied admission to most of the city's private gentlemen's clubs—the Union League, the University, the Racquet. The Grand Union Hotel incident at Saratoga in the late 1870s marked the beginnings of general exclusion of Jews as guests at the better holiday resorts. By the early years of the twentieth century "quotas" would be imposed on the admission of Jewish students to the elite Ivy League colleges and to the special exclusive undergraduate clubs and fraternities at those colleges. Even in lesser schools, like the City College of New York, the "Greeks" rejected Jews. Bernard Baruch, son of the Guggenheims' family doctor, was excluded from CCNY's fraternities in the 1880s because he was a Jew. "Each year my name would be proposed," Baruch recalled, "and a row would ensue over my nomination, but I never was elected."[1]

Though not typical, there were times when anti-Semitism actually threatened to become lethal. In the summer of 1905 "unknown miscreants" mailed small boxes containing explosives to both Jacob Schiff, the Kuhn Loeb banker, and M. Guggenheim's Sons. Neither did much harm. At the Guggenheims' a suspicious clerk put the box in a sink and doused it with water. The "infernal machine" exploded but did little damage. When the box was opened it was found to contain, as did Schiff's, loose gunpowder, some friction matches, and several gun cartridges. That the intended victims had been targeted because they were Jews was not in question. The *New York Daily Tribune* headed its piece on the event: "Bombs to Leading Jews."[2]

The New York German-Jewish upper class was undoubtedly disturbed by this hostility and ostracism. In the "infernal machine" case Jacob Schiff was reported to have laughed off the incident. But the consciousness of anti-Semitism was pervasive, and like all mistreated outsiders the victims returned the favor. The Astor-Vanderbilt-Whitney-Beekman-Schuyler-Goelet circle, said one Our Crowd member, was characterized by "publicity, showiness, cruelty and striving," whereas his own circle "was based only on family and quiet enjoyment of the people we loved."[3] But the rejectees also sought substitutes for the "restricted" gentile institutions. If the University Club would not have them, they would find the opulent hospitality they desired at the Harmonie Club. If Jewish students at Columbia or Penn were not admitted to Delta Kappa Epsilon or Sigma Chi, they would establish their own fraternities: Sigma Alpha Mu and Zeta Beta Tau. If Jewish boys and girls could not attend Willie De Rahm's dancing classes, they would go to Mrs. Viola Wolff's instead. The matter of religion itself was more complicated. A few German Jews sought admission to the upper class by conversion to Christianity. The outstanding case was August Belmont, who came to America in 1837 as representative of the Rothschild banking family. Apostasy worked for him. In 1847, at stylish Grace Episcopal Church, Belmont married Caroline Slidell Perry, daughter of Commodore Matthew Galbraith Perry, the man who "opened" Japan, and niece of another American naval hero, Oliver Hazard Perry of the War of 1812. Thereafter, Belmont was accepted everywhere and became a power in the Demo-

cratic Party. But Belmont's case was unusual in the nineteenth century. It was still almost inconceivable for other members of Our Crowd to commit creedal treason.

But that did not mean that their religious life must duplicate the medieval practices of their forebears that had set them conspicuously apart from everyone else. By the middle of the century the Reform movement, as we saw, had begun to supersede Orthodoxy among the German-Jewish elite. As members of Reform congregations Jews could remain connected with the faith of their fathers and yet come to terms with the mores of the gentiles and the demands of a secular world molded by Christian practices. In 1845 members of the New York German-Jewish community organized Temple Emanu-El ("God Is with Us"), the first Reform congregation in New York. Originally the congregation met in rented rooms downtown. It later bought an abandoned Baptist church and converted it to Jewish worship. In 1868 its members, sharing in the nation's new postbellum wealth, built, at a cost of $650,000, a new "elegant" house of worship in the favored Moorish style at Fifth Avenue and Forty-third Street. This structure remained the synagogue's home until 1929 while the city's commercial development encroached on the site, and the building became too cramped for all its members and functions. In the last year of the 1920s the congregation constructed a spacious new home at Fifth Avenue and Sixty-fifth Street. Daniel was at this time an influential member of the board of trustees and signed the 1925 report recommending the purchase of the new uptown site and construction of the elegant new edifice.

Congregation Emanu-El, during the years when Meyer, Barbara, and the younger children attended, was thoroughly assimilationist. It conducted its services in English, rather than Hebrew; it seated men alongside women; it dispensed with skullcaps for male worshippers; it dropped the bar mitzvah as the ceremony marking the entrance of Jewish males into religious adulthood. The temple was a significant meeting place for Our Crowd. Its members included Schiffs, Loebses, Strauses, Seligmans and Goldmans, Ochs, and Lehmans. Not only were the senior Guggenheims and the young daughters members; so were older sons— Isaac, Daniel, and Solomon—who had earlier moved to New York.

Daniel was the Guggenheim most active in Emanu-El's affairs, how-ever. He was elected to the board of trustees in 1903 and remained a fully participating member at least through the 1920s. Daniel was scarcely a Jewish traditionalist, but he took his faith seriously. As if referring to his own brothers, sons, and nephews, he deplored the drift of the young from Judaism and from religion generally. In the trustees' letter to the congregation endorsing the new synagogue site, he subscribed to the fears they felt of the defections from the ancestral faith. In the past, his statement noted, "a large percentage of young people have been diverted from the synagogue and many of them have become indifferent to the faith of their fathers, but also to religious thought." A new synagogue would "attract our youth to the Temple and keep them in touch with the spirit of Judaism."[4]

The Guggenheims were not the most honored members of the con-gregation. Many of the Temple Emanu-El crowd in the 1890s still spoke German-accented English, but the Guggenheims' unique Schweizerdeutsch seemed uncouth to the families from Bavaria, Prussia, and the Rhineland. They were also different because they were in mining and smelting, not in finance or commerce, considered more worthy and, well, refined. The only other Our Crowd family in mining was the Lewisohns, the brothers Adolph and Leonard, who would later be the Guggenheims' antagonists in a battle for control of the refining industry. The in-group arbiters often referred to the family disdainfully as "the Googs." Eventually the Emanu-El congregation would provide the pool of marriageable young men and women for the Guggenheim sons and daughters, but even when they had become fabulously rich the Our Crowd core considered the Guggenheims slightly vulgar. There is a famous, possibly apocryphal, story that when, in 1894, Benjamin Guggenheim became engaged to Florette Seligman, daughter of James and niece of Joseph, the Seligmans cabled their relatives in Europe: "Florette engaged Guggenheim smelter." The clerk at the cable office in New York supposedly misread the text and it was sent as: "Florette engaged Guggenheim smelt her."[5] The Seligmans never ceased snick-ering at what a later generation would consider a Freudian slip.

The Guggenheims' new home was a spacious brownstone on Man-

hattan's Upper West Side. The neighborhood itself was new and thriv-
ing. In 1874 ex-president Ulysses Grant officiated at the groundbreak-
ing for the American Museum of Natural History on Central Park
West between Seventy-seventh and Eighty-first streets. In 1879 the
Columbus Avenue (Ninth Avenue) elevated railroad (the El) had
brought the neighborhood rapid transit connections to downtown,
resulting in explosive West Side development. Riverside Drive was
opened for strolling, riding, and driving in 1880. Four years later, the
luxurious Dakota Apartments, a housing innovation for the prosperous
borrowed from Paris, opened on West Seventy-second Street. Never as
elegant as its counterpart directly across Central Park, the Upper West
Side neighborhood nevertheless was "to a certain extent fashionable,"
according to *King's Handbook of New York City*,[6] and suited a man of
means but not of ostentation.

Meyer's place was at 36 West Seventy-seventh Street, just south of
the museum, with a small garden in back. By now the boys were no
longer with their parents, of course, but younger daughter Cora, sixteen,
apparently lived with Meyer and Barbara, as did Solomon at some point.
Sometime during the nineties, Murry and his family returned from
Colorado and moved immediately adjacent to Meyer and Barbara at 29
West Seventy-sixth, with a backyard conveniently connecting to the se-
niors' house. Rose, who was at Madame Bettlesheimer's finishing school
in Paris at the time of her parents' move from Philadelphia, came back to
America soon after and married Albert Loeb, of the Kuhn-Loeb banking
family. The Loebs bought a "whitestone" house on West Seventy-fifth
Street. When Ben returned from Colorado and married Florette, he first
lived at the Hotel Majestic and then, at the end of the decade, moved
with his daughters to a house at East Seventy-second Street near Fifth
Avenue. A mile south, in the Fifties, sons Isaac, Daniel, and Solomon, all
three married, had their own brownstones. The only son not near the se-
niors in New York was Simon, who, with his wife, was living in Spain.
William, the youngest son, though often away on Guggenheim mining
and smelting business, checked in to the family home whenever he was in
Gotham.

During the 1890s the house on West Seventy-seventh Street was the

gathering place for the family core. Each Friday evening the children and grandchildren dined with Meyer and Barbara in what was, it seems, a secular version of the traditional Jewish Sabbath meal. A diabetic in the preinsulin era, Barbara died in 1900, and by that time all the boys, except William, the youngest, were married. Isaac and Daniel, the two oldest, had wed two respectable young women, Carrie Sonneborn (1876) and Florence Shloss (1884) respectively, both from moderately prosperous Philadelphia families. As we saw, Murry brought home from his Swiss sojourn an Alsatian wife, Leonie Bernheim, and in 1894 Benjamin had united the Guggenheims with the tony Seligmans. In 1895 Solomon married Irene Rothschild, daughter of a New York merchant. Three years later Simon married Olga Hirsch, daughter of a diamond dealer. The daughters too were married, Rose to Albert Loeb, as we noted, and Cora to Louis Rothschild, another businessman. Jeannette, the oldest daughter, who married Albert Gerstle, had tragically died in childbirth in 1889 and so was never part of the family circle in New York.

These Friday evenings, when Barbara was alive, were full of the pleasures and pains of the formal encounters of large families. They were occasions for the sons to discuss business with the patriarch and to joke and chaffer in the way of traditional males. For the wives it was an opportunity to compete in dress and jewelry. The women's conversation, remembered Harold Loeb, son of Rose, was not only trivial but self-centered. "The aunts talked of clothes, complained about interminable fittings. Their real bitterness, however, was concentrated on the servants who, they never tired of repeating, were inconsiderate as well as sloppy and put their own pleasures before their employers' convenience."[7] Dinner took place at the large dining table, seating as many as seventeen, lit by a large crystal chandelier. If the Guggenheims were true to 1890s form, the meals were large and heavy, with soup, both a fish and a meat course, vegetables in sauces, and several choices of desserts. After dinner the men retired to Meyer's library for cigars and coffee; the women adjourned to the parlor with Barbara for gossip and music from the player piano. The grandchildren found these family gatherings numbingly tedious. Meyer and Barbara had six grandchildren by 1900, but the

three granddaughters were all under five and the oldest grandson, Daniel's first child, M. Robert, was already a young man at fifteen. This left Harry, Daniel's younger son, and Edmond, Murry's only child, slightly older than his cousin, to suffer the tortures of listening to monotonous grown-up conversation and submitting to the rigid etiquette of formal dining. Mischief was inevitable. One day, "just horsing around" out of sight,[8] they accidentally broke a finger off a marble statue in the front parlor. They apparently liked the effect and immediately amputated another one. The mischief continued for other Friday nights—after all there were ten digits—no doubt compensating the boys for the boring adult-centered occasions. Surprisingly the vandalism was not discovered and the destructive appetite grew with the eating. Finally, one evening the high-spirited preadolescents went too far. Encountering the silk top hat of Uncle Isaac in the hall rack, they turned it into a plaything, finally putting "what was left" back on the rack, where it was soon discovered. The crimes and the vandals were now revealed and Meyer became livid. He would not tolerate such behavior. From now on only one of the boys at a time would be allowed to visit on a given Friday. Whether the decision was received as punishment or reward is not clear.

And yet Meyer also had his indulgent, grandfatherly side. When he settled in New York Meyer acquired a carriage and trotting horses, and each sunny day went for a canter in Central Park. The rig was a rich man's extravagance and, to assuage his conscience, Meyer announced that the equipage was community property, available to the entire family. We do not know whether the offer was taken seriously, but in any case the grandchildren benefited from another of Meyer's transport innovations, an electric-powered automobile runabout, which grandson Harry remembered was "in form just like an old hansom cab, even to having a place for the driver above and to the rear."[9] This novelty was a sensation among the grandsons, and they were thrilled when Grandpa took them on short rides around the block.

DURING THE 1880s and 1890s, as the family's fortunes and numbers grew, they began to find the hot and humid New York summers trying. Before the age of air-conditioning, the only escape from the heat for

prosperous New Yorkers was flight to "the mountains" or to "the shore." Although in 1906 Benjamin built a cottage, Happy Days, on Loon Lake, in upstate New York, the other Guggenheims never considered vacationing in the Catskills or the Adirondacks. Their summer refuge was the stretch of white-sand New Jersey coast extending for a hundred miles south from Sandy Hook to Cape May.

The first resort on the Jersey shore, Long Branch, attracted summer residents as far back as the 1820s, and by the 1850s rich New Yorkers began to visit in numbers. In 1867 General Ulysses Grant, the Civil War hero, began to summer with his family along the Jersey coast, continuing to come for stays after his election as president. The Grants at first rented a house and then bought a cottage at Long Branch. For a time the community became, in effect, the nation's summer capital with presidents Hayes, Garfield, and Arthur spending time there to escape Washington's subtropical summers. In the late summer of 1881, after he took an assassin's bullet, President James Garfield was brought to Elberon by train from Washington in the forlorn hope that the salt air and sea breezes would prolong his life. Jewish visitors in the 1860s stayed first at Aaron Christaler's Hotel and later at the Scarboro and the Atlantic or rented rooms in cottages. When the richer Jews of Our Crowd came on the scene in the 1880s, they leased houses in West End, just to the south of Long Branch. By the next decade they were buying and building homes of their own in Elberon, immediately adjacent.

The Guggenheims may have been drawn to the Jersey shore by the plaudits of Dr. Simon Baruch, their family physician, the summer house doctor at the West End Hotel. Or perhaps the Jersey shore was simply where their fellow rich Jews went. In any case, we know that Guggenheims were vacationers in West End as early as 1890. In August of that year the Daniel Guggenheims were living in a gingerbread-encrusted Victorian cottage when Harry Frank, Daniel's second son, was born—a "vacation baby," as such a child was called.[10] Daniel's daughter Eleanor was also born at the Jersey shore five years later. Simon too had a place at the shore. After staying in rented cottages in West End, in 1898 Albert Loeb, Rose's husband, built an imitation southern mansion in Long Branch.

Architecturally, the family vacation residences were a very mixed bag. Rose's eldest son, Harold, remembered his parents' Rosedale as "quite the largest and most beautiful house on the avenue." Though Albert was never as rich as the Guggenheim males, their place was opulent, with a stable housing four horses and three coaches—a hansom, a victoria, and a brougham—and presided over by an Irish coachman. As Loeb later observed, "evidently the brokerage business was prosperous in the late 1890's."[11]

By contrast, Solomon's house, bought from a railroad and shipping tycoon, was a grotesque pile. Called by amused contemporaries "Aladdin's Palace" or the "House of Many Gables," it was a huge eclectic eyesore with the fussy domes, towers, chimneys, balconies, and verandas that marked the architecture of the aesthetically challenged Brown Decades. Obviously determined to avoid the bad taste of his younger brother, Daniel built a place in the Beaux Arts style of the new century. His summer home at Elberon, constructed in 1902–03, was designed by the distinguished firm of Carrère and Hastings, architects of the main New York Public Library on Fifth Avenue. Named Firenze, after his wife, Florence, it was a comfortable-looking two-story wooden structure with a broad front porch, a pitched clapboard roof, and a second-floor balcony. It fronted on Ocean Avenue, which ran along the beach itself. Inside it managed to combine luxury with an informal summer cottage quality. Giving it a name was clearly intended to supply dignity to the house, but *Architectural Record*, which wrote it up in 1907, called it "a hot-weather vacation house" that did not rise to architectural distinction.[12] In 1917 Daniel and Florence left the Jersey shore for a new mansion on Long Island's opulent North Shore. Visiting Sol at Long Branch for a weekend the next summer, they concluded that their departure had been wise. "Neither mother nor I," Daniel wrote his son Robert, "have any desire to live again on the Jersey Coast. There does not seem to be anything there to tempt us."[13] In 1920 Daniel sold Firenze to Solomon for a nominal $10 and probably never saw Monmouth County again. Solomon in turn sold the place in 1929 to a local resident for $125,000.

Murry's family at first summered at a rented place and then in 1903 bought the Normanhurst Estate. Murry, however, did not intend to be

outdone by his older brother and engaged Carrère and Hastings to build a summer home for him as well. Completed in 1905, the house, also in the Beaux Arts style, was larger, more expensive, and more formal than Firenze. With a white stucco exterior and wide arcades, it boasted first-floor rooms with high ceilings, floor-to-ceiling doors to invite cooling breezes, and wood-paneled billiard and living rooms.

Summer life at these establishments was placid. The men of the family, in the traditional way, spent summer weekdays in the city, tied to their desks. They commuted on Friday afternoons either by steamboat from Manhattan or by the New York and Long Branch Railroad, completed to Hollywood Station in 1884, or by a combination of both. Meyer and Barbara never had a place of their own at the shore but they visited their children's summer houses frequently. Barbara spent the days there sitting quietly on whichever porch was available. Meyer was more animated. His grandson Harold vividly remembered the old man stomping along the porch of one of the houses, squishing caterpillars on the ceiling with his cane. At the shore Meyer was no less the stern patriarch than on West Seventy-seventh Street, subjecting the grandchildren to sharp, close questioning on their deportment and activities. He also displayed his earthy streak. Daniel had a chicken coop in his backyard, and Meyer thought the birds were too scrawny. One day, in the presence of the ladies and some of the children, the patriarch rhetorically asked why the birds were so skinny. "Too many roosters," he bellowed in reply.[14]

What did everyone do at the shore? We know what amusements the Jersey shore communities offered in these years. Adults could "bathe" in the ocean, though there is no evidence that any Guggenheim adult did. There were also croquet and tennis and horseback riding. If anyone was interested in religious services he could attend Temple Beth Mirium, an extension, everyone agreed, of Temple Emanu-El. Formed in 1885, it was located near the ocean. For children the mere release from school must have seemed enough to make the shore a happy place. But more than the adults, they also played tennis, rode horses, and romped in the Atlantic surf. As we saw, Daniel had a chicken house on his estate, and

with his help, Harry and Edmond launched a summer chicken business. The cousins tended the chickens, repaired the henhouse, collected the eggs, and delivered them to the St. Regis Hotel in New York where Daniel lived in the winter and knew the managers. After two years the enterprise was liquidated. "Father's objective," Harry later explained, "was to give us experience in business and to teach us how easy it is to lose money. He was eminently successful. We got the experience and father lost the money."[15]

But not all the grandchildren enjoyed their New Jersey vacations. Peggy, Benjamin's daughter, who stayed several summers with her Seligman grandparents in Allenhurst, considered the Jersey shore "the ugliest place in the world." She described her grandfather's two-story house as a modest affair with two porches, one on each floor. It was, from her adult fine-tuned aesthetic perspective, "a hideous Victorian house." If her memory can be credited, Peggy was already a sensation seeker with a taste for turbulence. She had little patience with the adults' sedate activities. The porches were covered with rocking chairs, and Peggy recalled that the family spent their days mindlessly rocking and gossiping. The one moment of summer excitement she could remember years later was when the hotel across the road from her grandfather's house burned down. It was a "restricted" hostelry that refused to admit Jews, and Peggy and her cousins cheered while the flames engulfed the structure.[16]

WITH THE NEW CENTURY an era ended in the collective life of the Guggenheim family. By 1900 the two younger sons, Will and Ben, offended by decisions made by Daniel, Murry, and Isaac, had moved out of the tight business orbit of M. Guggenheim's Sons and struck out on their own.* Even more disruptive was Barbara's death. In her later years she was not a well woman. Her diabetes sapped her energy, and she seldom left the house. In the evenings she retired early. Will was particularly close to his mother; in fact he seems to have been the quintessential

*See chapter 4.

"momma's boy." He remembered often visiting her room when he came home late, to see if she was awake. She usually was, and he "would sit on the side of her bed and chat with her."[17] In early January 1900 Will left for Europe in company with Ben, Florette, and their two small daughters, Benita and Peggy. They had been in Paris for only two days when they received a cablegram from New York that Barbara's health had taken a turn for the worse. Will and Ben, along with Florette and the children, immediately returned and remained in New York while Barbara went through the final throes of her illness. She died on March 20, leaving her family bereft.

Will was particularly devastated and expressed his despair in terms that seem extravagant. He felt "bitter sorrow," he recalled, with "all foundations swept away and his soul lost." He had planned, he tells us, to buy a country place where he could bring his mother often to enjoy "the peace and natural loveliness of the countryside." Now this hope "was irrevocably shattered."[18] Will's response included a spectacular episode of "acting out." The youngest Guggenheim brother had long been a sexual adventurer. While in Colorado he had generously patronized the red-light districts of Leadville and Denver. But now, driven by sorrow, he went beyond the casual indulgence of a lusty young man. On November 30 he appeared at city hall in Hoboken, armed with a marriage license, and tied the knot with Grace Brown Herbert, a young gentile divorcee from California.

Meyer too was deeply affected by Barbara's death. And so were the other children. Rose Loeb broke down and retreated to her bedroom for months. The hitherto easygoing Benjamin temporarily lost much of his joie de vivre. After his mother's death, he returned to Paris, and detaching himself by stages from his wife and children, made it his permanent home, though he came back for visits to his wife and children. Remembering Barbara's always generous, charitable contributions, the family members memorialized their wife and mother by bounteous bequests. Each of the sons contributed to Mount Sinai Hospital, the leading Jewish hospital in New York, for a total of $200,000, to erect a building in her name. Meyer, who had already donated $60,000 to the Jewish Hospital in Philadelphia, now added $20,000 to the same institu-

tion in her name. Inspired, he said, by a recent trip to Europe,* Will, act-
ing separately, gave the United Hebrew Charities an additional $50,000
for the Barbara Guggenheim Memorial Fund to aid poor Russian and
Polish Jews now arriving in the United States in large numbers. In his
donation letter, he declared that the fund should pursue its work "along
the most advanced sociological lines" to the end of making its beneficiar-
ies "self-supporting" and keeping them from "ever becoming a burden
upon the community."[19]

Meyer survived Barbara by four years. Living alone as a widower,
looked after by his faithful cook and housekeeper, Anne Poppee, he
developed a taste for Wagner, attending the Metropolitan Opera with
relatives for performances of *Das Rheingold* and *Lohengrin*. He also con-
tinued to ride in his coach through the park with a coachman and, often,
one of the boys. He had helped son-in-law Albert Loeb to get started in
the brokerage business and in his last years often went to A. Loeb and
Company's downtown offices to use a small room provided by the firm to
dabble in stock, have lunch, and take an old man's nap.

These last four years of Meyer's life were not placid, however. Will's
misalliance deeply offended Meyer and the older boys. Grace Herbert
was not only gentile; she was a social climber and a gold digger. Even
worse, they claimed to recognize her as the recent mistress of a promi-
nent New Yorker. Daniel, forceful and resourceful as ever, took charge of
cleaning up the mess. William must leave the scene of the crime and go
off to Europe, he commanded. If he refused to discard Grace he would
be disinherited. Will obeyed. Grace herself proved more stubborn.
Daniel offered her a large sum of money to get a divorce. At first she
refused. She loved Will, she insisted, not his money. She soon saw that it
was fruitless to defy the combined will of Daniel and his brothers. She
sued for divorce from Will in Chicago, where, the family hoped, the
matter would not come to the attention of the New York press. The

*After Will's divorce from Grace Herbert he spent a year in Europe. That he learned
anything about the French way of dispensing charity on this visit is dubious. Rather, he
seems to have wallowed in the sophisticated continent's famous fleshpots and had an af-
fair with a baroness.

divorce was granted in March 1901. The Guggenheims settled $150,000, which they called "alimony," on her.

This did not end the embarrassing affair. In short order Grace married a Frenchman named Wahl, and in 1908, after that marriage broke up, she sued to annul the divorce from Will, alleging fraud since neither she nor Will had been residents of Illinois in 1901. By this time Will was married to Aimée Lillian Steinberger, a friend of his sisters Rose and Cora and an eminently suitable match, socially if not personally, and had fathered a son, William Jr. If the Chicago divorce were set aside, Will would become a bigamist and little William would be illegitimate. The protracted proceedings exacted a heavy emotional toll on William. He considered his older brothers insensitive to his plight. "It is possible," he wrote them, "that you are indifferent to the torture and very great humiliation that have resulted to my wife and myself throughout these seven years of controversy."[20] Fortunately, in 1913 a Chicago judge upheld the 1901 divorce, though he concluded that in fact it had been "a fraud upon the Circuit Court in Cook County."[21] But damage had been done. The brutal intrusion of the older brothers into his personal affairs alienated William permanently. He and Ben remained close to each other but his ties with his older brothers were never the same. Before long he would be going his own eccentric way entirely.

William was not the only son who strayed from the sexual straight and narrow. Isaac may have wandered from his wife's bed. In 1905 he paid $250 to *Town Topics*, a New York scandal sheet notorious for blackmailing rich men with threats to disclose their sexual peccadillos if they did not pay up.[22] It seems likely that Isaac had been caught in their net. Ben was a notorious libertine. His daughter Peggy "adored" her father and found him "fascinating and handsome." But when she was five or six he began to have mistresses. It started with a certain "trained nurse" who gave him massages for his "neuralgia," and he continued his errant ways for the rest of his life.[23] Harold Loeb said of his uncle Ben that "of all the brothers he was the most extravagant in his amorous divagations, even introducing them into his own home."[24] Ben's spouse, the eccentric Florette Seligman, threatened several times to divorce him but her hus-

band's family, appearing in shifts, persuaded her to reconsider. Though Florette eventually yielded to the Guggenheims' pressure to remain Ben's wife, the marriage was virtually over. In 1911 Ben left her and the children and went off to Paris to live permanently. There he had an apartment and owned a business, International Steam Pump, that among other projects had built the elevators for the Eiffel Tower.

Even Ben's demise involved a sexual peccadillo. In the spring of 1912 he decided to return to New York for a visit on the occasion of daughter Hazel's ninth birthday. He originally booked passage on a French vessel from Le Havre but a stokers' strike forced him to change his booking to the luxurious White Star liner the *Titanic*, sailing on its maiden voyage to New York. Ben joined the ship in Cherbourg on April 10 along with his valet, Victor Giglio, who despite his name was English-born, and his chauffeur, René Pernot. He apparently also took with him his current mistress, a young blond charmer, Mlle. Leontine Aubart of Paris, a twenty-four-year-old singer. Benjamin and Giglio occupied first-class cabin 82; Mlle. Aubart cabin 84. Near midnight on April 14, off the coast of Newfoundland, the liner struck an iceberg that ripped out six compartments on its starboard side. The vessel, advertised as "unsinkable," quickly took on water and began to founder. With more than two thousand passengers and crew, the *Titanic* had lifeboat space for only twelve hundred and, by all the traditional rules of sea disasters, women and children came first. Ben was awakened shortly after the collision by steward James Etches, who helped him don a life jacket. Ben and Giglio, and presumably the others in Ben's party, went up on deck, where they tried to help with loading the lifeboats. It quickly became clear that there was no room for the men, and it must have been at this point that Ben gave Etches a message for his family: "If anything should happen to me, tell my wife in New York I have done my best in doing my duty."[25] At this point, the steward later reported, Ben and Giglio, seeing the inevitable, decided to make the final beau geste. They went back to their cabin, changed into their evening clothes, and returned to the deck. When he saw them Etches expressed surprise at their garb. Ben responded: "We've dressed up in our best and are prepared to go down like gentlemen."[26]

In the end Ben, Giglio, and Ben's chauffeur, René Pernot, did go

down with the ship, along with fifteen hundred others. Ben's family first learned of the disaster that evening as they left a Broadway theater after a play. They rushed to the White Star offices in Manhattan for further news. Daniel and other family members went to the dock several days later when the rescue ship *Carpathia* arrived with 675 people removed from lifeboats or plucked from the icy Atlantic water. Ben, of course, was not among the disembarking survivors, but apparently Mlle. Aubart was. According to Peggy, Daniel made her an offer she could not refuse: if she returned to France immediately she would receive a substantial sum of money. Mlle. Aubart, snatching fortune from disaster, obliged.

And the older sons, with the exception of Murry, were also ladies' men. Described by Harold Loeb as "uxorious," Uncle Murry, Harold said, never gave "another woman more than a passing glance."[27] But Ben and William were not the only other wanderers. One business associate remembered Solomon lecturing his tablemates at lunch at a Wall Street club on the subject of mistresses. They must be treated with considera- tion, he opined, clearly from his wealth of experience. "When the time comes to part, it is of utmost importance to provide generously for the lady in question."[28]

And even the patriarch Meyer himself could not escape charges of sexual transgression. In 1904 one Hannah McNamara, a forty-five-year- old woman, sued him for breach of promise. McNamara claimed that as a servant in the senior Guggenheim household, she had been "in con- stant intimate association" with Meyer for twenty-five years, and soon after Barbara's death he had promised to marry her. He had reneged and should now pay her $100,000 in damages for breach of promise. Meyer denied the charges vociferously. In an interview with a reporter for the *Long Branch Daily Record* that June, he claimed, "I only saw the woman once in my life. No one has ever seen her with me. It's a case of trying to extort money by fraud. She will get no money from me."[29] When he learned of the suit, Daniel declared that *he* had "never heard of the woman until now" and that "no other member of the family had ever heard of her."[30] Confident in his claim, Meyer offered $100,000 to any- one who could prove that he and the nonlady had ever had a relationship. In fact, it seems unlikely that McNamara was telling the truth. To have

been Meyer's mistress of twenty-five years would have meant the relationship began about 1880 when the Guggenheims were still living in Philadelphia, and that it had then continued after they moved to New York. It is hard to see how such a relationship could have been so portable. Peggy Guggenheim suggested that in fact Meyer's cook* was more likely to have been his mistress than Ms. McNamara. In any case, the suit was dismissed for insufficient evidence, and Meyer was spared the indignity of a protracted scandal.

Meyer's health deteriorated shortly after this affair. He had contracted a slow-growing prostate cancer and managed to live with it for some years. In late 1904, however, after several minor operations, he was forced to undergo drastic surgery in New York. The operation was performed at home, and Meyer, perhaps fearful of not regaining consciousness, refused to go under anesthesia. Instead he asked for a cigar and music and managed to get through the excruciating ordeal while fully conscious. Recovery proved slow, and when he contracted a cold the doctors ordered him to Florida. He survived the new year but died on March 15 in a rented cottage at Lake Worth.

The funeral was held on March 19 at Temple Emanu-El. Present were all the surviving children, fifteen grandchildren, and four great-grandchildren. Representatives of ASARCO and of Guggenex, two of the family's firms, of Mexico City, and of a number of Meyer's charities were at the services, as were a generous assortment of Seligmans, Lehmans, and Schiffs. Rabbi Joseph Silverman delivered the eulogy emphasizing Meyer's virtues of fairness, "simplicity," and "consideration for others."[31] Funeral eulogies are not expected to be astute evaluations of the deceased's life, but this one was probably less informative than most.

A truer eulogy was a magazine article that actually preceded Meyer's death by twenty months. Written for *Cosmopolitan*, then a serious muckraker magazine of the new Progressive movement, it was part sixteen of

*Or perhaps housekeeper. Anne Poppee, described as Meyer's "housekeeper," received three hundred shares of ASARCO stock. This legacy may have been worth as much as $30,000. See *New York Times*, April 1, 1905.

a series "Captains of Industry." The article found the core of Meyer's significance in his dynastic role. Meyer himself was "low-voiced, unassuming, outwardly unimpressive," but he was the source of the family's genius and success. "Meyer Guggenheim is the tree," the piece began, "and the seven sons are the fruit." Author Edwin Lefèvre sugarcoated the family's qualities. He overgenerously called all the boys "able men . . . devoted to their business." But he got Meyer himself right. He was the person "to whom they owe all." Their father, he wrote, "trained them, watched over them, guided them, advised, forbade, and commanded." "A man is known by his works, [and] to write of Meyer Guggenheim is to show why . . . his sons have succeeded."[32]

After the obsequies the funeral cortege of horse-drawn carriages departed for Salem Fields, the Jewish cemetery in Brooklyn, where earlier Barbara had been interred in the elaborate family mausoleum. Grandson Harry remembered that he and cousin Edmond, the two little vandals at their grandfather's house now in their teens, ended up in the same carriage on the way to the grave site. Still bored with Guggenheim family doings, and perhaps hungry, when the carriage reached Brooklyn they hopped out and went to a saloon for a beer and a sandwich.

Meyer's estate was valued at $2.25 million, most of it smelting, railroad, and iron manufacturing stocks and bonds. Meyer took account in his will of the unequal treatment of his daughters while he was alive. The bulk of the estate went to Rose and Cora and his granddaughter Nettie, the only child of Jeannette, who had died bearing her. Cora received $100,000 in cash and $300,000 in a life trust; Rose got $500,000 in a life trust; Nettie $500,000 in a life trust with $200,000 of this sum to become cash on her marriage. The three oldest boys were designated executors of the estate. Their memorial to their father provided a fitting closure to his life. In 1903 Meyer had donated money to build a home for aged Jews in Lengnau. For some reason the project had stalled. Now the boys contributed enough in their father's honor to complete the Schweizerisches Israelitisches Alterasyl on a hill overlooking the town in Switzerland where Meyer had been born almost eighty years before.

ASARCO

B Y THE END OF the old century the Guggenheims had achieved some local fame. Among the smelting and mining fraternity of the West they had become prominent players. Among the New York Our Crowd circle they had made enough of a mark to be eligible to marry into the Seligman clan. But the broad American public knew not Guggenheim. And then came the epic battle over the American Smelting and Refining Company (ASARCO), and abruptly the family became famous, indeed notorious. By 1904 the Guggenheims were prominent enough so that when Isaac's dachshund was run over by a car in front of his apartment on Fifth Avenue, the mishap warranted mention in the *Times*. When, in early 1909, Daniel suffered a mild heart attack while visiting Mexico City, the *Times* gave it front-page coverage.*

The American Smelting and Refining Company was a "trust," which, like other trusts of the era, sought to rule as absolute sovereign over all aspects of its particular industry. Its creation in 1899 was a segment of a nationwide movement of business consolidations that marked the years just preceding and just following the arrival of the twentieth century.

*First reported as a reaction to Mexico City's high altitude, this event seems to mark the onset of Daniel's long battle with cardiac disease.

The consolidation impulse of the day drew on both history and psychology for sustenance. Competition may be the bedrock credo of modern capitalism, but capitalists seldom enjoy it. Free markets are too chancy; they do not make for restful sleep. It is inevitable, then, that when possible businessmen will seek to contain it. During the Middle Ages merchants and master craftsmen sought to prevent unsettling competition by illegal "engrossing" and "forestalling." Adam Smith in the 1770s preached the merits of competition but, as he observed, "people of the same trade seldom meet together, even for merriment and diversion, but the conversation ends in a conspiracy against the public or in some contrivance to raise prices."[1] Unfortunately, nineteenth-century technological trends in America worked against the would-be engrossers and forestallers. The railroads created national markets and undermined the local monopolies enjoyed by small businessmen in the era of high transportation costs. At first the trend benefited consumers. The large, more distant, firms were more often efficient producers and charged less than the local ones. But by the end of the century, the new national companies were themselves battling for survival against other large firms and yearning to check the "cut-throat competition" that lowered prices and threatened everyone's profits.

Industry responded to the pressures of competitive markets by creating "trusts." In the 1870s John D. Rockefeller and his associates Henry H. Rogers, Charles Pratt, and Henry Flagler organized the Standard Oil Company, which combined in one corporation most of the competing petroleum refining interests of the nation. By the end of the decade Standard Oil controlled the production of more than 90 percent of the nation's petroleum-derived products. In 1882 the company adopted the device of a trust agreement assigning to a board of trustees the stock in many oil firms that could operate the consolidated company as a single one. Reformers and consumers denounced the consolidation movement, and the federal government passed the Sherman Antitrust Act (1890) to forbid "every contract, combination in the form of trust or otherwise, or conspiracy, in restraint of trade or commerce among the several states, or with foreign nations." But the reformers did not achieve their ends. The consolidation movement proceeded apace, employing in the 1890s and

thereafter the "holding company," a device legalized by the state of New Jersey in 1889 that allowed one corporation to own the stock of others.

After the return of prosperity in the late nineties, the combination movement surged. Between 1898 and 1904 promoters organized more than three thousand mergers in the United States. In the four years preceding 1903, almost half of U.S. manufactured goods were produced by firms created by the merger process. The Populists had passed off the political scene by 1900, but a new round of reformers, the Progressives, though more urban and less credulous than their predecessors, appeared early in the new century to raise the alarm once again over huge aggregations of "irresponsible" and "overbearing" private capital.

The merger-and-monopoly bug bit the metals extraction and processing industry in the mid-nineties when a group of Colorado smelter operators organized the Smelters Association of Colorado to uphold sagging metals prices. The Guggenheims were skeptical of the association. To recruit their support the directors offered to make William the association secretary, but, by direction of Daniel, he refused. The family simply opposed any effort by outsiders to control their business and did not cry when the association dissolved. But a more formidable challenge to their independence would soon appear when Henry Rogers of Standard Oil turned his attention to the metals industry.

Rogers was a forceful, compelling figure. More than six feet tall, with blue eyes, shaggy brows, and a heroic mustache, he was capable of ruthless behavior. During the mid-1880s, he was accused of conspiring to blow up the plant of the Buffalo Lubricating Works, to keep it from competing with Standard in the manufacture of lubricating oils. Rogers shared with many of the other robber barons of the era a brazen honesty about his drives and motives. At one point, when questioned by federal lawyers why Standard Oil had never lowered its price for transporting oil, he remarked bluntly: "We are not in business for our health, but are out for the dollars."[2] Rogers left Standard Oil when it became apparent that Rockefeller preferred William Archbold to him as his successor, but he remained active in business. In 1897 he helped put together the Amalgamated Copper Company, merging a cluster of copper properties, mostly in Montana. The new entity was notorious for the amount of its

watered stock, that is, stock that did not represent true earning assets. It eventually became the powerful Anaconda Copper Company.

That same year Rogers, along with Grant Schley and John Moore, partners in a New York brokerage house, decided to create a nationwide smelting and refining trust on the model of Standard Oil. One of Rogers's allies was Leonard Lewisohn, an Our Crowd charter member, who had started as a feather merchant and expanded into copper. The firm, Lewisohn Brothers, led by Leonard and his brother Adolph, soon became a force in the copper industry in Arizona, Montana, and Tennessee. In 1898 the Lewisohns would form the United Metals Selling Company to market copper around the world. United Metals quickly became distributor of more than half the copper produced in the United States.

In 1898, a bad year for nonferrous metals, Schley and Moore made the rounds of the mining-smelting regions of the South and West, peddling their idea of consolidation under one authority to heads of the nation's major lead-copper-silver refineries. Their message was simple: competition was lethal; cooperation was profitable. The new combination, moreover, would be able to merge the technical knowledge of all the managers and so lower costs. Also, following the lead of Standard Oil, it would be able to extract "special low freight rates from the railroads" that would "not be accorded to independent smelters."[3] By early 1899 the brokers had persuaded eighteen of the country's biggest smelter owners to join their proposed amalgamation.

The Guggenheims, though approached, declined to enroll. They had faced the issue of allowing others a share in the management of their business in the cases of Graham and Holden back in Colorado. They had then balked. Again, in 1891, when William Geist demanded a partnership in exchange for supervising the erection of the Monterrey smelter, they had confronted the problem of "outsiders" in the firm. Geist's demand seemed a dilution of their authority, and they refused. Geist had resigned. Now they were being asked to turn over control of their business to a board of trustees. Meyer declined. "No, our business is a family affair," he is reputed to have replied. "We control it and we will not enter into any arrangement that we cannot control."[4]

Despite the Guggenheims' rejection, the process of creating the

refiners' trust moved forward. In early March the promoters revealed their agreement for formation of the American Smelting and Refining Company under the management of Moore & Schley, Lewisohn Brothers, and Henry Rogers. ASARCO would be capitalized at $65 million, divided into 650,000 shares with a par value of $100 each, half common, half preferred stock. Each of the firms to be joined under the ASARCO name would be issued shares under a negotiated formula to a total of $19 million for surrender of their rights. The new corporation would "have appropriate powers for mining, smelting, and dealing in all kinds of ores."[5] The underwriters' fees were not disclosed in the formal agreement, but those in the know said that they were to receive 30 percent of the capital stock for their efforts.

From the outset it was understood that the $65 million capitalization was far greater than the actual value of the eighteen ASARCO plants. Perhaps two-thirds of it was water. As the promoters declared in justification in their official statement, "it may be reasonably assumed that the advantages accruing from a consolidation of formerly competing interests and with possible economies in the consolidated management the earnings hereafter should show a substantial increase."[6] Despite the promoters' snake-oil hucksterism, with such men as Rogers at the helm, investors grabbed the stock when publicly offered by Schley and Moore, driving the price to $115 a share.

MEANWHILE, as they watched from the sidelines, the Guggenheims were striking out in new directions themselves. In 1898, prodded by declining supplies of ore to feed their smelters, they hired mining engineer Henry R. Wagner to prospect for them in South America. Wagner went first to Bolivia, in the Andes, to investigate the Huanchaca property near Antofagasta, a mine that seemed capable of producing a broad spectrum of ores including silver, tin, zinc, and antimony. Eventually, after tortuous negotiations with Antonio de Urioste, the Huanchaca manager, M. Guggenheim's Sons agreed to buy the mine's total existing and future output for a loan of £300,000. The deal proved to be less than satisfactory. The ores were difficult to refine, and in the end the firm made little profit.

The experience convinced the Guggenheims that they needed a better mechanism than the ad hoc process in the Huanchaca case to scout out promising metal resources around the world. By 1899, moreover, they were facing the challenge of the new smelter trust. ASARCO was determined to force the Guggenheims to join by cornering the supply of ores in Colorado and Missouri. Would ASARCO be able to put them out of the refining business? The brothers' response was to create the Guggenheim Exploration Company (Guggenex).

Incorporated in Trenton, under the permissive 1889 New Jersey holding company statute, the firm was capitalized at $6 million. Its stated purpose was to "prospect, explore, and deal in lands, mines, and minerals."[7] Guggenex would eventually become the instrument for the world-encompassing reach of the Guggenheim resource extraction empire. But meanwhile it would help fend off any attempt of Rogers et al. to squeeze their remaining competitors to death.

Unfortunately, the creation of Guggenex ruptured the family unity. Worldwide prospecting was a chancy, capital-absorbing business, and to spread the risk, Daniel and Murry, the two most active directors at M. Guggenheim's Sons, decided to relax their outsider exclusion principle and invite William C. Whitney to join them. Son-in-law of a rich Ohioan, Henry B. Payne, Whitney had become a successful New York lawyer and a power in the Democratic Party. In 1885–89 he served as Grover Cleveland's forward-looking secretary of the navy. During the nineties he made a fortune from his investments in the Metropolitan Street Railway syndicate in New York along with associates Thomas Fortune Ryan and Peter Widener. William Whitney had a son named after his grandfather, but unfortunately Henry Payne Whitney was a playboy who seemed far more interested in polo and horseflesh than in making a living. What better way to find a secure and remunerative occupation for Henry than to join his fortunes to the robust comers, the Guggenheims? When approached by Daniel, Whitney the elder accepted the offer to become a stockholder in Guggenex. In return Henry Payne Whitney would become a partner in Guggenex.

The deal provided the Guggenheims with the prestige of the Whitney name and, perhaps, some of the social cachet that came with

Whitney's stylish, socialite life. Guggenex also attracted capital from Europe. Sir Ernest Cassel, a prominent British financier and friend of King Edward, bought some stock in the new exploration company, enough to provide another shot of valuable prestige.

The decision to bring the Whitneys and other outsiders into the new venture disturbed the balance of power among the brothers. Isaac, though the firstborn, was a timid man, uneasy with change. As we noted, he may also have suffered from a "nervous" disease. He had forfeited leadership to his younger brother, and by this time Daniel was the clear prime mover. "Mr. Dan," a stocky, mustachioed fire hydrant of a man, was the most forceful and creative of the brothers. Educated as much in Switzerland and Germany as in his native country, he was a disciple of systematic German business practices as a time when German industry was forging ahead of all its European rivals. Murry, the third son, was most comfortable with figures and served as what today would be considered as the Guggenheims' number cruncher. Fourth son Solomon, the most dapper and elegant of the boys, was also the firm's best contact man and salesman. Talented in personal relations, he served as the Guggenheims' ambassador to other business leaders and relevant politicians. Simon happily managed the Colorado smelter from his home in Denver.

Ben and William, the two youngest brothers, were used to these roles and niches. The proposed inclusion of Whitney dismayed them. Though the Guggenheims would retain control of the new firm, they would have to share earnings, and ultimately some management power, with outsiders. The two younger sons had not been in on the negotiations to form the new enterprise, and they raised loud objections. Already alienated from their older siblings, they now began to detach themselves from the firm of M. Guggenheim's Sons, taking their gains and individually going it alone. After 1901, according to Theodore Allen, M. Guggenheim's Sons' chief bookkeeper, "only five of the brothers continued to associate together in the business . . . Messrs. Benjamin and William withdrew and established outside offices of their own." From then on, Allen stated in 1916, "I never saw them in business conference with their brothers." They received dividends and made stock

subscriptions at various times, but these were as individuals, not members of the firm.[8]

Will spent the years after 1900 touring Europe, managing the New York alumni club of his alma mater, the University of Pennsylvania, playing with his investments, and trying to establish himself as a pundit on public questions. Ben went into the business of building mining machinery. He started a firm in Milwaukee that merged with the International Steam Pump Corporation. It was not successful and was on the verge of bankruptcy when he went to his watery grave in 1912. It went into receivership in 1914. In later years Peggy, Ben's flaky daughter, would lament that her father had dropped out too soon and so failed to become as rich as his older brothers. After Ben's death, as we shall see, Will would try to regain his position in the firm, especially after it hit big with copper in Chile on the eve of World War I.

As M. Guggenheim's Sons expanded its scope, ASARCO fell on parlous days. Aside from inexperienced management, the new combination included too many weak firms. If ASARCO as a whole was to make profits some of these would have to be liquidated. To the dismay of their managers, who apparently had not foreseen the possibility, the ASARCO directors in New York soon shut down the Grant Smelter in Denver, the Argentine Refinery in Kansas, the Great Falls Smelter in Great Falls, Montana, and the Bi-Metallic Smelter in Leadville. These closings put the fear of God into the survivors and created a frenzy of unhealthy no-holds-barred competition among them, the very condition the combination was created to prevent. To make matters worse, labor troubles soon erupted. In the spring of 1899 the Colorado legislature passed a law mandating an eight-hour day for labor. For work beyond that stint, employers would pay overtime. The ASARCO firms in Colorado responded with a new wage scale that in effect allowed the employees to work the eight hours mandated, but only at reduced pay. To make as much per day as before they would have to put in a twelve-hour day. In mid-June the Western Federation of Miners struck the ASARCO Colorado firms, shutting them all down.

Whether out of enlightenment or opportunism, the Guggenheims

accepted the new law, at least pending the courts' response to an employ-
ers' legal challenge, and kept their plants open. The strike was called off
in mid-August, soon after the state supreme court declared the eight-
hour law unconstitutional. But during this time the Guggenheim
smelters were the only ones that could process the ores from the local
mines. Already busy, they were soon bursting with contracts. The
Guggenheims were also garnering goodwill among the mine workers
and the mine operators, whether they deserved it or not. At the same
time they were competing aggressively with the trust, flooding the
American market with silver and lead and undercutting ASARCO's
prices. ASARCO was soon facing severe financial troubles. By the spring
of 1901 it was $7 million in debt, with a large inventory of ore and
refined metal that was dropping in value by the day.

In 1921, as spokesman for his brothers, Solomon would claim that
the ASARCO officials came to the Guggenheims hat in hand twenty
years before in part because they needed "the kind of successful manage-
ment" that only the Guggenheims could provide.[9] But whether it was for
additional capital or the Guggenheims' business brains, clearly it was
time to try once more to bring the Guggenheims into the tent. In March
1900 the ASARCO directors authorized exploratory buyout talks with
the Guggenheims. In September the ASARCO negotiators offered the
Guggenheims $35 million in "Smelters" stock in exchange for all their
holdings plus $7 million in cash. The Guggenheims declined but made a
counteroffer. In return for $45.2 million in ASARCO stock, half pre-
ferred and half common, they would turn over their smelting properties
to the trust and also give it some millions in cash and credit as sweetener.
To complete this deal ASARCO would have to increase its total capital-
ization some 35 percent to $100 million. All told, for about $15 million
in cash, credits, and smelter plant and equipment worth about $3 mil-
lion, the family was acquiring ASARCO stock worth $36 million on the
market. At the same time, while surrendering their smelting business,
including their plants in Perth Amboy, Monterrey, and Aguascalientes,
they were retaining ownership of Guggenex, their mines in Mexico and
the United States, and the steamship line from Tampico that hauled
Mexican ores to the refinery in Perth Amboy.

Most of the ASARCO directors accepted the terms. One of these was Anton Eilers, a German-born mining engineer trained at Göttingen University, whose son Karl would, two decades later, become the sworn enemy of the Guggenheims. Rogers and Lewisohn, Moore and Schley refused to go along. Aside from their sense that the Guggenheims were getting too good a deal, they objected to the provision in the agreement for the Guggenheims to bypass United Metals Selling Company, in which both had substantial interests, as sales agent for ASARCO. In February 1901, charging that they had been kept in the dark by the other directors, Rogers and Lewisohn resigned their directorships and soon after initiated a stockholders' suit in the New Jersey courts to halt the capitalization increase essential to buy out the Guggenheims. Hypocritically, the plaintiffs charged that the new firm would be "a gigantic monopoly in the business of smelting and refining gold and silver ores in this country," and so would "bring on the company all the wrath of the antitrust laws of the United States."[10] More significant perhaps, they charged that the Guggenheims' interests were being grossly overvalued, especially the "goodwill" item. "Will your honor believe that the good will is worth over four times as much as the real property?" the plaintiffs' lawyer asked judge Frederick Stevens of the Chancery Court.[11] The Guggenheim attorney, Samuel Untermeyer, responded that the Guggenheims' properties, considering their earnings, were well worth the $45 million being offered. This figure was actually arrived at by cooking the books, but the judge accepted it and refused to grant the injunction requested. But then Judge Stevens was reversed by the New Jersey Court of Errors and Appeals, which enjoined the issuance of the new stock and ruled that before the plan was carried out the defendants must prove that the Guggenheim properties were not being overvalued. The reversal caused consternation in the market. Many knowledgeable Wall Street observers said that if it prevailed it would call into question the vital New Jersey holding company statute. As Untermeyer noted, "every time a corporation wants to buy the stock or property of another corporation the court says in effect . . . that such a purchase can be inquired into by the courts on the application of any stockholder even if he does not claim to be injured."[12]

In the end the whole matter was settled by negotiation. The Guggenheims agreed to allow Rogers and Lewisohn to market ASARCO's output through United Metals. In return, the two protesters withdrew their suit and also agreed that they would not be part of the new combination. On Monday, April 8, after a long session in lawyer Untermeyer's office, continued during dinner at Delmonico's, the contenders emerged with smiles and announced the settlement.

Two weeks later the new firm disclosed its new directors. Daniel, Solomon, Murry, Simon, and Isaac Guggenheim would represent the family's interests on the new board. Daniel would be the chairman of the ASARCO board and Simon the firm's treasurer. At a later meeting Daniel was elected chairman of the executive committee along with outsiders E. W. Nash, Barton Sewell, Dennis Sheedy, A. R. Meyer, J. B. Grant, and Anton Eilers.

After a brief period in temporary quarters, the new firm established itself on the seventeenth floor of 165 Broadway, in lower Manhattan. In the same building, a floor above, were the offices of M. Guggenheim's Sons, the family's partnership. Daniel's private ASARCO office was connected by a back stairway to the eighteenth floor where the other Guggenheims had their desks in a large combined partners' room. Across the hall from the partners' office was the workspace for the many clerks, secretaries, typists, and bookkeepers engaged in the Guggenheim enterprises. Wearing two hats—as partners in M. Guggenheim's Sons and as directors of ASARCO—the brothers would labor daily at their desks and then, at 11 a.m., drop down to Dan's office on the floor below for a daily ASARCO conference. As the physical accommodations* suggest, the two firms, though legally separate, were in reality run entirely by the Guggenheims, an arrangement that would eventually be challenged.

The final results of the ASARCO struggle would catapult the Guggenheims into the front ranks of American business leaders. Though owning less than 50 percent of the stock, the Guggenheims

*These would be duplicated when in 1915 ASARCO moved to the Equitable Building at 120 Broadway, where the Guggenheims occupied the thirty-fourth and thirty-fifth floors.

were by far the largest stockholders and in tight control of ASARCO.*
They had also become business celebrities. While the battle between the
Rogers-Lewisohn interests and the Guggenheims was being played out,
it was front page news in the *Times* and other papers. Their new fame,
however flattering, had its price. In this era, when a new class of adver-
sary journalists called muckrakers was helping to form the political con-
sciousness of the urban middle class, they would also become a focus of
public fears. Before long the Guggenheims found themselves in the mid-
dle of one of the Progressive Era's defining battles between "the people"
and "the interests."

ASARCO PROMISED to be a highly profitable firm. But first it was
essential that the remaining independent smelters, mostly located in
the Pacific Northwest, be brought under the ASARCO roof. Having
profligately expended the resources of M. Guggenheim's Sons in
acquiring ASARCO, the brothers needed additional capital to proceed
and turned for help to Jacob Schiff, a partner in Kuhn, Loeb, the Jewish
investment bank, who proposed a complicated new financial plan to
sweep up capital from new sources. In 1905 Daniel and Schiff traveled
to London to consult with Sir Ernest Cassel, the British financier who
had already bought into Guggenex in a small way. Out of their meeting
in Cassel's home on Grosvenor Square emerged a scheme for a new
stock flotation through a separate firm to be called the American
Smelting Securities Company. Capitalized at $77 million, much of it
sold to European investors, the new company would take over the
producing assets—mines, flux ores, copper product, additional smelters
and refineries, and additional capital—mostly Guggenheim Brothers
properties, that ASARCO needed to operate successfully and turn them
over to ASARCO's use for a virtually cost-free guarantee of the new
security company's preferred stock. Essentially the security company
was a device to spare ASARCO costs it could not afford. In 1909

*Apparently, as the result of purchasing additional shares at market prices in 1902, the
Guggenheims ended up with 502,000 shares of ASARCO's 1 million, giving them for a
time absolute majority control.

Engineering and Mining Journal reported eight different mines and six additional smelters "held in fee" by American Smelting Securities Company, along with stock ownership in seven additional firms.[13] This complicated arrangement in effect left the Guggenheim "interests" in three separate packages though it did not seriously limit their control of the whole complex.

The years immediately following formation of the "smelter trust" was a prosperous time in the United States, and ASARCO flourished along with the nation. In 1903 the profits of the firm reached $7.5 million. In 1906 ASARCO earned $10.2 million and paid $6.75 million in dividends. Much of these earnings represented good management. Daniel cut operating costs and brought down the firm's fixed debts, thereby reducing overhead and at the same time consolidating the family's control.

The Guggenheims' fortune grew as much from Guggenex as from ASARCO, however. Mr. Dan, as he came to be called, believed that the family enterprises should broaden from refining ores to owning them, and over the next few years the family's investments in mines, the original basis for its fortune, ballooned. The instrument for the expansion was John Hays Hammond, a dynamic, imaginative, and flamboyant world-stumping mining engineer.

Though a mousy, mustachioed little man, Hammond seemed to early twentieth-century Americans a glamorous, swashbuckling figure in the mold of the young Winston Churchill or the celebrity reporter Richard Harding Davis. Born in California, he had attended Yale and graduated from the famous Royal School of Mines in Freiberg. After school he had scouted for ores extensively in the Rockies and Mexico as agent for various mining companies. In 1893 he went to South Africa to work for Barney Barnato, the legendary diamond and gold mining operator and speculator. Through Barnato he formed an association with Cecil Rhodes, premier of Cape Colony. Rhodes, like Barnato, had made a great fortune out of South Africa's vast mineral wealth, but unlike Barnato he harbored grandiose geo-political ambitions. Rhodes yearned to create a vast new British empire in Africa, one continuous band of British territory stretching from the Cape to the Mediterranean or, as it

was said, from"the Cape to Cairo." In 1895, pursuing this goal, he sponsored a commando raid by Leander Jameson into the Transvaal to merge the Boer-controlled sovereign state into an expanded British South Africa. Hammond joined the failed Jameson Raid and was, along with other leaders, arrested by the Transvaal authorities and sentenced initially to death and then to life in prison. Under pressure from Britain and the American State Department the Boers eventually freed Hammond and his fellow conspirators, and he returned to the mining business, making his headquarters in London and then moving to Russia to investigate its mineral resources.

Hammond returned to the United States in 1899 enveloped by a romantic and raffish aura. One of his friends was William Whitney, the Guggenex partner. In early 1903 Whitney arranged a luncheon for himself, Hammond, and Daniel Guggenheim to discuss whether his colorful friend could help Daniel with his goal of expanding the family's mining reach. Whitney wasted no time getting to the point. "This is the man I've been urging you to get for our Exploration Company," he told Daniel. "He's worth any salary he may ask."[14] Hammond preferred working directly for Whitney but, persuaded by the incomparable terms, in the end signed with Guggenex. The five-year contract was considered remarkable by contemporaries and was widely reported in the press. Hammond would be paid $250,000 annually as consulting engineer and general manager of Guggenex. He would also receive a 25 percent interest in any mines acquired as the result of his discoveries and initiatives.

The Guggenheims expected much of their new star employee. His tasks included reviewing the company's holdings to weed out unprofitable ones, replacing weak managers, administering Guggenex's mining operations, and exploring for new mines and ventures. The brothers also hoped to capitalize, literally, on Hammond's mystique and the publicity that the hiring ignited. As one western mining engineer noted: "Hammond was such a great man that if the Guggenheims made any [stock] flotation through their connection with him, basing it upon Hammond's recommendation, they could absolve themselves at any time by saying: 'we were following Hammond. . . . ' "[15] Soon after the

press reported Hammond's hiring, the Guggenheims announced a public stock offering of $10.5 million in Guggenex to increase their working capital. In a few days the shares were selling at a premium.

Hiring Hammond proved to be a wise move overall for the Guggenheims. He and his chief assistant, Alfred Chester Beatty, traversed half the globe, but especially the Americas, scouting for likely ore sites and preparing reports to be used by Guggenex as the basis for expansion. On Hammond's say, the firm acquired valuable mines, including the Esperanza in Mexico and the Utah Copper mine at Bingham Canyon, Utah. In the first year he made a million dollars in commissions. The Hammond contract also confirmed the Guggenheims' fame. Only the most powerful capitalists, men in the league of Morgan and Rockefeller, could afford to pay anyone a quarter of a million dollars a year in salary.

But the relationship was not without its bumps. Hammond had no intention of being buried in the bureaucratic trivia of the firm and protested against attending daily Guggenex board meetings, often about routine matters. On one occasion, when Murry called a meeting to discuss a long report on an unprofitable mine in Mexico, Hammond lost his temper. "Good Lord," he shouted, "don't you realize that your entire investment in the Zaragoza [mine] would only pay my salary for about a month? I'd be saving money if I bought it myself and shut it down, yet you are taking up half of my working time in these endless discussions. These post-mortems are just a waste of my valuable time and yours! I can't get anything important done if you insist on talking trivialities!" Startled, Murry replied that Hammond "certainly has a temper!"[16] Yet the Guggenheims yielded and meetings were rescheduled for only once a month thereafter.

More serious than a show of pique was Hammond's bungle with the Nippising silver mine in eastern Ontario. Silver ores were first detected in the Cobalt district of the Canadian province in 1905 by construction workers pushing the railroad into the lightly settled region. In a matter of weeks the usual gaggle of prospectors, storekeepers, saloon managers, hustlers, and mining company clerks descended on the town of Cobalt and for a brief time turned it into a typical bonanza mining camp. In sedate Canada, however, Cobalt quickly settled down into a law-abiding

community, though one marked by especially cantankerous disputes over claims' titles.

After the usual initial period of many small competing operations struggling for ascendancy, promoter William Boyce Thompson began to consolidate the Cobalt district's operations under Nippising Mines. Controlled by a Maine holding company, Nippising was capitalized at $6 million divided into 1.2 million shares listed on the New York Curb Exchange. Thompson, a skilled promoter, busily puffed his stock, soon driving its price up to $15.

The Guggenheims undoubtedly learned of the Nippising ores soon after they were discovered, but it required the prodding of Thompson to get them interested in making Nippising part of their Guggenex empire. Thompson induced the Guggenheims to send Hammond and other Guggenex experts to Cobalt, and the celebrity engineer arrived by private Pullman in late October, accompanied by a chef, a wine steward, and a clutch of reporters. When Hammond returned to New York, he reported enthusiastically to his bosses on Nippising's prospects. On October 30 Guggenex contracted with Thompson to buy four hundred thousand shares of Nippising stock, paying $2.5 million for one hundred thousand shares and agreeing to purchase the rest at a later time. The Guggenheims, as they later explained, did not intend to keep all the stock themselves; they would peddle much of it to friends and associates. News of the Guggenheim deal set off a buying frenzy. In a matter of days the price of Nippising shares soared to $40. Speculators in other Cobalt district properties were soon riding the wave that the Guggenheims had set in motion. The *Times* would later report that a new Cobalt mining stock was being floated every day in mid-November by curb exchange speculators.

Seeing trouble ahead, the Guggenheims sought to distance themselves from the expanding speculative bubble. On November 18 Daniel told a reporter for the *New York Times* that "the flimsy character of the majority of the mining stocks that are now finding a ready market cannot be too emphatically stated." Even when there were positive surface indications of rich ores, he added, only one in three hundred mines "eventu-

ally fulfill their promise." Daniel specifically warned against the puffery in connection with the Cobalt silver region. The "name of Guggenheim has been harnessed in market gossip to properties without number with which we have not and shall not have any connection."[17]

Perhaps by this time Daniel had already received warnings of disaster. Before the Guggenheims could exercise their option for the remaining three hundred thousand shares, the engineering news turned bad. Hammond returned to Cobalt in late November for a second look and reported to his bosses that the underground silver vein that had initially dazzled him and the others actually petered out after a short distance. Nippising was not a bonanza, after all! The Guggenheims acted quickly. They announced that they were withdrawing from their contract. Reluctant to bring the whole Cobalt field silver edifice down in ruins, they insisted that they were motivated primarily by the uncertainty over the Nippising Mine Company legal title. They also announced that they would pay the penalty of $1.5 million as provided in the agreement with Thompson, relieving the other subscribers of all obligation. Despite their effort to avoid a collapse of confidence, Nippising stock slumped. At first the decline was slow. But by Saturday, December 1, it closed at 18. Then on Monday panicky sellers rid themselves of a record two hundred thousand shares, dropping the price of a share by $4 in a matter of hours. According to the *New York Daily Tribune*, the sell-off was as "excited in character as it was heavy in volume . . . at times suggesting a semi-panic."[18]

The Nippising deal damaged the Guggenheims' reputation. Many Wall Street pundits assumed that the operation had been, uncharacteristically for the Guggenheims, primarily a stock jobbing speculation. As *Engineering and Mining Journal* noted, "several of the original promoters [had sold] their holdings when the stock rose above $25." But on the other hand, the *Journal* admitted, "some kept them."[19] The promise to protect actual Nippising purchasers who had bought through Guggenex provided some insulation for the family reputation. But it did not assuage the anger of the hundreds who had bought on the open market on the strength of the Guggenheim endorsement and considered themselves gulled when the Guggenheims withdrew from the deal. In fact the

charge was unfair. The Guggenheims had made an honest mistake, but their reputation undoubtedly had suffered. And, ironically, the Nippising mine proved to be a bonanza after all. The last mining report was in error. What had seemed a short underground vein that quickly ran out was actually a pinched vein that resumed after an interval. Eventually, under new management, some $30 million in silver was extracted from Nippising.

Some observers expected the Guggheneims to dump Hammond after the Nippising fiasco. According to Hammond, however, his fumble did not damage his relations with his bosses. They "stood loyally by me," he later declared. To counter rumors that Hammond would be leaving Guggenex, Daniel and his brothers issued a public statement on December 8 that was carried in the major New York papers.

> There is no foundation for the report that John Hays Hammond, mining expert for the Guggenheims, is to resign his office as a result of the Nippising episode. Official denial of the report to this effect was made yesterday.
>
> This statement may be taken as representing the views of the Guggenheims in regard to the recent Nippising developments.[20]

THE GUGGENHEIMS DID WELL to remain loyal. Despite Nippising, Hammond advanced the interests of Guggenex and ASARCO. It was Hammond's promotion of the Bingham Canyon property that made the family preeminent players in the expanding copper industry.

Until well into the new century ASARCO and Guggenex were primarily producers of silver and lead along with some gold and zinc. But the metal of the future was copper, its value surging along with the booming electrical industry. Each new factory with its electric motors, each new home with its electric lights and telephone, each chemical process employing electrolysis, called for copper wire, copper cable, copper switches, copper cathodes. Copper production in the United States rose from 130,000 short tons in 1890 to 1.4 million in 1914.

It was not until 1905 or 1906 that the Guggenheims became seriously interested in copper. Six years before, while on a reconnaissance through

the West looking for mining properties, Ben had learned of a "copper mountain" in Bingham Canyon, in northern Utah, owned by "Colonel" Enos Wall and Joseph R. De Lamar, two mining entrepreneurs. But the ore was a low grade "porphyry" copper sulfide with at most a 2 percent metal content. There was no way in 1900 that such ore could be profitably mined by the usual tunnel and shaft process. Daniel refused to consider the Bingham property for M. Guggenheim's Sons.

He changed his mind when Daniel Jackling, a brilliant metallurgist trained at the Missouri School of Mines, entered the picture. In 1899 the pleasant-faced Jackling and a colleague, at De Lamar's initiative, had made a survey of the property and reported the ore could be profitably exploited if extracted by "open pit" methods. Rather than sinking shafts into the mountain, the low-grade ore should be removed by giant steam shovels of the sort that would soon be digging through Panama for the isthmian canal. Once removed, the ore could then be concentrated by the new flotation process and the metal extracted from the enriched material. Jackling induced two other promoters to buy out De Lamar and take 55 percent of Wall's interest. In 1903, along with Charles McNeill and Spencer Penrose, Jackling organized the Utah Copper Company, capitalized at half a million dollars. Wall retained a one-fifth share in the property.

Jackling proved to be a business dynamo as well as an innovative engineer. Under his direction Utah Copper constructed a three-hundred-ton experimental extractor to test the feasibility of his process for dealing with porphyry ore. He also acquired land for a mill and a site for dumping mine tailings. But he needed far more capital than he had for successful launching of the new technology. In early 1904 McNeill and Penrose reorganized the company as the Utah Copper Company of Colorado with a great new issue of stocks and bonds. Some of this was distributed to Jackling, Wall, and other insiders. But sales to outsiders with capital went slowly. One buyer was Bernard Baruch, the young Wall Street speculator who was close to the Guggenheims, but few other capitalists were willing to take the plunge on the untried process. Unable to raise the money they needed, in early 1905 Jackling turned to Hammond and proposed that Guggenex buy into the venture. There was little in the

mining industry that escaped Hammond's attention, and he knew of the property and its promise through a friend. Hammond went to Daniel with figures and arguments and convinced him that Guggenex should follow up. But Daniel insisted on a thorough investigation of the property first. Hammond now dispatched two of his staff, Seeley Mudd and Chester Beatty, to give the property a close inspection including an elaborate drill test. Their report in October, which cost Guggenex $150,000, was highly favorable. The property could yield forty million tons of ore and perhaps twice that much, it said. Impressed, Daniel directed Guggenex to buy. In short order Guggenex underwrote a $3 million issue of convertible bonds, while the American Smelting Securities Company, an ASARCO subsidiary organized in 1905 to take over the parent company's silver and lead properties, bought 232,000 shares of Utah Copper at $20 a share. This was only a 25 percent minority interest for the Guggenheims, but Daniel and his brothers were satisfied since ASARCO was awarded a contract to process all Utah's output for a full twenty years at a price that, critics said, was worth at least $5 million to ASARCO. Hammond was made managing director of the reorganized firm. Also in 1905 Daniel, hitherto head of the executive committee, succeeded Nash as president of ASARCO.

Utah Copper proved to be another bonanza for the family. The fresh capital enabled the firm to build the Magna concentration plant composed of 30 "ball mills" and 575 flotation tanks to separate the copper sulfide from the dross. Simultaneously, the firm constructed a giant smelter for the processed ore in Garfield, Utah, four miles away, on the south shore of the Great Salt Lake. When opened in August 1906, the Garfield facility was the largest copper mill in the United States. That same month the first steam shovels bit into the ore mountain at Bingham. By late 1908 eight giant steam shovels and seventeen locomotives were digging and hauling ore. The shovels eventually created an enormous hole with stepped sides like a giant Greek amphitheater. Hammond later estimated that the amount of earth eventually removed at Bingham equaled the total for the Panama Canal, one of the greatest engineering projects of the twentieth century. From mid-1907 to December 1908 Utah Copper produced 27,000 tons of metallic copper.

In 1910 this rose to 42,500 tons. At its peak during the war years 1916–18, output would average 95,000 tons a year. Earnings were commensurate with the physical scale of the enterprise. Through 1918 the firm earned $142 million in profits and paid out $92 million in dividends, retaining the rest as working capital.

Yet there were glitches along the way even at Utah Copper. The firm quickly ran into space limits. There was no physical room on its own property to maneuver its digging equipment, and it was in danger of being forced to resort to costly shaft mining. The solution was to merge with the adjacent Boston Consolidated Mining Company, just a bit higher on the mountain and with space enough for the giant shovels. The Consolidated firm, predominantly British-owned, was in deep financial trouble, and the Guggenheims anticipated that they could snap it up for a song. But they had not reckoned with Eugene Meyer, Jr., one of the company's American-born officials. A Wall Street broker who had taken a flyer on Consolidated's stock, Meyer did not intend to let the Guggenheims achieve a coup. Joining with William Boyce Thompson, Meyer bought up much of the remaining Consolidated stock from owners eager to sell out and made it known that he would close down the operation and just sit tight, indefinitely depriving Utah Copper of the space it needed. When Daniel heard of the scheme, he asked Meyer to come to his office. The two men quickly arranged a deal to merge the two companies, with Meyer named a director of the new firm. In January 1910 the shareholders of Utah Copper voted to increase its capital and use the addition to buy Boston Consolidated. Enos Wall objected on the grounds that the merger would hurt minority stockholders like himself. Wall secured an injunction, but it was soon vacated, and the deal went through. In December 1909 Utah Copper acquired Boston Consolidated for some of its 310,000 newly issued shares. The acquisition of the Consolidated firm tripled the size of Utah Copper. It now owned the largest copper ore body in the world.

The success at Bingham propelled the Guggenheims into other copper mining projects—in Nevada, Colorado, Mexico, and Chile. The Nevada Consolidated Mining Company property near Ely, Nevada, organized in 1906, would prove to be richer than Bingham. Chuquicamata,

in the foothills of the Chilean Andes, acquired in 1910, proved to be the richest copper source of all. Formerly considered "silver princes," by the eve of World War I the brothers Guggenheim would become known as "copper kings."

The years from 1902 to 1907 were boom times for the Guggenheim-controlled firms. In September 1906, the *New York Times*, under the column heading, "American Smelting Co. Shows Heavy Profits," reported net earnings for ASARCO alone at more than $10 million for the preceding fiscal year and dividends of $6.75 million.[21] At the same time, during this prosperous period, the firm accumulated a large surplus that it invested in new plant and new mining properties.

No one could doubt the family's success in exploiting the nation's resources. But had they also contributed to society's well-being? Hammond believed they had. As he saw it, the investment by the Guggenheims in the low-grade porphyry copper ores had made the red metal cheap and helped create the giant new electrical industry. The radios, kitchen appliances, and automobiles of the mid-twentieth century, he later wrote, "were made possible only by the free use of electricity and it, in turn, could come only with an assured large supply of copper."[22] The porphyry copper made available by Guggenheim enterprise thus conferred a giant boon on the world. On the other hand, viewing their enterprise through the lens of modern environmentalism, the judgment must be different. The pit mining process they introduced scarred the earth far more hideously than the narrow, hidden shafts of its predecessor, and to this day the colossal wounds it left on the landscape testify, as do few other vestiges of human enterprise, to the rape of the land carelessly practiced by our forebears.

On the other hand, if the Guggenheims seem indifferent to the environment by our standards, ASARCO was more sensitive to the concerns of local victims of the refinery airborne pollutants than other smelter firms of the day. In 1906 some four hundred farmers in the Salt Lake Valley brought suit in federal court against a group of refiners, including ASARCO, for releasing miasmic sulfur compounds into the atmosphere and harming their livestock and crops. In November of that year the judge decided for the plaintiffs, prohibiting three smelter firms, includ-

ing ASARCO, from treating any ore that contained more than 10 per-
cent sulfur or producing smelter fumes containing arsenic. The smelter
companies appealed the case and lost. At this point ASARCO opened
direct negotiations with the farmers and succeeded in arranging a com-
promise. The company would only process ores containing 6 percent
sulfur or less and would compensate the farmers to the extent of $60,000.
Further, it would provide "a bag-house system and cooling chambers" to
filter out dangerous components of smelter smoke.[23] Unlike ASARCO,
the independent companies, rather than negotiate, closed their plants,
leaving ASARCO without local competition. Thus did virtue—or at
least flexibility—provide its own special rewards. As the *Engineering and
Mining Journal* observed: "the outcome of the smelter-smoke question
in Utah must be a source of amusement to the American Smelting and
Refining Company . . ."[24]

THROUGH 1907 ASARCO PROSPERED mightily. Undoubtedly, as the
Guggenheims maintained, the profits of the company and the other
Guggenheim affiliates during this period were gleaned by efficient man-
agement, economies of scale, and improved technology. But they were
also tied to rising prices for metals. In the half decade 1902–06 silver rose
from 52 to 67 cents per ounce; lead from 4 to 5.6 cents a pound; copper from
11.6 to 19.3 cents per pound. It was hard not to squeeze a profit out of
such surging prices. ASARCO's balance sheet also grew by further acqui-
sitions. Among other properties incorporated into the firm were two suc-
cessful smelters in Washington state acquired for $5 million, in part to
round out its holdings, in part to forestall the rival Rockefellers. Another
property ASARCO acquired was the profitable National Lead company.
The cumulative effects on the family fortunes were dramatic. As we saw,
in 1906 ASARCO's net earnings were more than $10.2 million on its cap-
ital of $100 million. In 1907 they reached $11.5 million. Meanwhile, the
1905 smelter purchases along with National Lead pushed up ASARCO's
stock, already rising in the Wall Street bull market of those years. In
January 1906 ASARCO stock reached 174, having surged from 130 in
August 1905. Stock gains further swelled the family's coffers. By one esti-
mate, by the end of 1905 the Guggenheim family was worth $100 million.

The good years ended abruptly in the fall of 1907. In October the Knickerbocker Trust Company, a major New York bank, failed, jolting the economy as a whole. The Panic of 1907, though brief, was sharp. Markets plummeted; business slowed; unemployment rose. Prices of ores and metals dropped sharply in 1907 and with them the profits of ASARCO and its affiliates, as well as the value of their shares. Indeed, for a time, ASARCO stock went into a steep dive. During the week ending October 11, noted the *Times*, ASARCO shares were down 12 percent from just the week before. For the whole year ASARCO had plummeted from a high of 155. When interviewed by a *New York Times* reporter soon after the dramatic descent, Daniel declared the economy basically sound and blamed the panic on "shrewd long-headed bear operators" who had sowed "hysteria" among the public. He predicted that the flight to cash would soon end. As for the stock of "Smelters," it had indeed taken a beating. But ASARCO's properties were as "valuable now as it was when shares sold at 171."[25]

Though the economy soon rebounded, for the next two years Guggenheim profits lagged; 1908 was a particularly trying year. In February 1909 Daniel admitted to ASARCO's stockholders that "the business and earnings of the company" had "declined from the beginning to the end of the [previous] fiscal year."[26] During these hard months speculators shorted ASARCO stock, and rumors were soon circulating that the Guggenheims were themselves selling their holdings and pulling out of the corporation. If so, it was said, the Standard Oil interests, or the Amalgamated Copper Company, both connected to Rockefeller, would take control. The family emphatically denied the gossip. One "of the most prominent officers and directors of the company," probably Daniel, admitted to an interviewer that the company was not "doing business of the boom times of a year ago." But "there is no liquidation on the part of any of the Messrs. Guggenheim and not the slightest prospect that they will lose control of the company."[27] The rumors would not die, however. In May 1908 Solomon, just before leaving for Europe, told a *New York Herald* reporter that if Rockefeller and his associates had indeed acquired ASARCO stock through purchase, they had not asked to be represented on the company's board of directors. The

rumors that the family had sold the bulk of its interests and was allowing others to take control of the firm was "a man of straw, to be used alternately in bearing or bulling the market for Smelting shares."[28]

In fact, the Guggenheims were indeed quietly selling off shares of ASARCO stock. They had no intention of surrendering control of the company; they believed they could continue to run the firm without holding an absolute majority of the stock. But they were cash-starved and needed money badly. Several ventures had drained their resources. Besides the collapse of metals' prices and the Nippising fiasco, they had embarked on a highly speculative venture in the Yukon through a new firm, the Yukon Gold Company. The property on Bonanza Creek near Dawson had already yielded others $100 million in gold. In 1905 Alfred Beatty, Hammond's right-hand man, went to the region and concluded that at least an equal amount could be extracted before the gold-bearing sands were depleted. The enterprise appealed to the Guggenheims. Besides the profit from the gold itself there was the gold from the sale of stock. More than virtually all the other Guggenheim ventures, Yukon Gold was a stock speculation. The company would issue five million shares at $5 a share. At this price it would be sold on the lax curb exchange rather than the stricter, though more prestigious, New York Stock Exchange.

In the winter of 1908 the firm turned over 3.5 million shares to Thomas Lawson, a flamboyant stock promoter who had achieved fame by his 1902 exposé of financial speculation in *Frenzied Finance*, a classic piece of Progressive Era muckraking journalism. Paid $100,000 by Guggenex, Lawson advertised widely in the press, claiming immense potential profits from the Yukon gold sands. When the shares were finally offered for sale they rose from 5 to 6½. Then, despite public assurances from Solomon, they dropped, leaving many investors angry at the Guggenheims. The brothers denied that they had authorized Lawson to use their name in his puff pieces. Besides, a family spokesman noted, Lawson had also bandied about the "name of J. P. Morgan & Co and other names equally prominent."[29] But this denial did not rescue the Guggenheims from criticism. *Engineering and Mining Journal*, usually pro-Guggenheim, declared that shady dealings were expected from

Lawson, but "the amazing thing is that the Guggenheims should have appeared in this association with him."[30] Three years later Beatty sued the Guggenheims for $300,000 for commissions on the Yukon Gold project that he claimed had never been paid.

Disappointed with the proceeds from their stock maneuvers, the family also found Yukon Gold a burden. Extracting gold in the Canadian north proved to be expensive. This was a dredging and hydraulic, rather than a "deep mining," operation. Guggenex would have to supply dredges, machinery, sawmills, food and fuel for the enterprise, a million dollars in supplies and equipment to be carted to the Arctic for spring operations. In the summer of 1906 Daniel left his vacation place in the Adirondacks, picked up Solomon on the way to Seattle, and with Hammond in tow, traveled by boat along the scenic inside passage to Skagway, the portal to the Yukon goldfields.

What he and Sol saw warmed their hearts, but they also realized that the enterprise had stretched their finances to the limit. In the end Yukon Gold was a disappointment. In a few years it was merged with other family enterprises in Alaska, and in 1915, with copper at a war premium, the operations were discontinued.

Overextended in the middle of a financial storm, by 1908, not surprisingly, the Guggenheims were selling assets. But rumors of their stock dealings undercut ASARCO's shares and made the family's financial position worse. At this point an act of generosity by Daniel to Bernard Baruch paid dividends.

The Pacific Northwest deals and the National Lead acquisition had been negotiated for the Guggenheims by the young stockbroker-speculator. Son of Dr. Simon Baruch, the Guggenheim family physician at the Jersey shore, the tall, virile young man had first found himself drawn into the Guggenheims' business orbit in 1889 when, as a recent graduate of the City College of New York, he nervously went to see Daniel to ask for a job. Daniel put the young man at his ease "with a smile, a wonderful smile." "How would you like to go to Mexico for us as an ore buyer?" Daniel had asked.[31] Bernard was willing; the job must certainly have stirred his nineteen-year-old blood. But Momma Baruch,

reluctant to see her beloved son rush off to such a distant and uncivilized place, vetoed the deal.

Not until sixteen years later, when they engaged him as their agent to negotiate the West Coast smelters deal, did Baruch finally become closely allied with the Guggenheims. Baruch traveled to Tacoma and San Francisco and purchased the two plants from right under the Rockefellers' noses. The deals clinched, he submitted a bill for a cool million to the Guggenheims' lawyer, Samuel Untermeyer. The startled Untermeyer asked if Baruch was trying to "hold up" ASARCO. Insulted, Baruch snapped back: "No, Mr. Untermeyer, I had not thought about that until now." Baruch marched out of Untermeyer's office in a huff. Untermeyer turned the matter over to Daniel who settled it quickly. "If Bernie says he ought to get $1,000,000, that is what he will get."[32] Baruch also helped buy the National Lead Company for the Guggenheims through quiet stock purchases that did not attract the speculators' attention. In one day Baruch acquired a controlling interest in National Lead for ASARCO while raising its price only $8 a share.

Now, one afternoon during the 1908 crunch, Baruch appeared at the ASARCO offices at 71 Broadway to offer the brothers help. He would deposit in their account, he said, a half million dollars as a mark of his confidence. Daniel accepted "with tears in his eyes." When Baruch asked if he could help in any other way, Daniel replied that he could "assure the people that the company is right." Baruch decided that the best way to express his confidence was to advertise his intention to buy ASARCO stock, which he promptly did.[33] Grateful for his help, the Guggenheims offered to take Baruch into the firm "just like one of the family."[34] Baruch declined, though he agreed to serve on ASARCO's board of directors for a three-year stint.

Bernard Baruch also played a role in one of the more unfortunate Guggenheim ventures of the pre–World War I era. The automobile's advent early in the twentieth century created a vast new market for rubber. Raw rubber latex was then extracted almost solely from naturally growing trees in the Amazon basin. The Brazilian rain forest could not meet the growing demand, however, and promoters were soon chasing

alternate sources. For a time it seemed that guayule, a Mexican shrub, might augment the latex supply, and Baruch, at the behest of Senator Nelson Aldrich and promoter Thomas Fortune Ryan, went to Mexico to investigate. He was impressed with the plant's possibilities and returned with a favorable report. In 1905 Aldrich, Baruch, and Ryan joined with Daniel to form the Continental Rubber Company to exploit the rubber potential of the desert plant.

The next foray into rubber threatened to tarnish the Guggenheims' reputation as humane employers. They had, by the standards of the day, been generous to their employees. Besides their support for the Colorado eight-hour law and their largesse toward their Swiss workers when they left the lace business, they had launched a profit-sharing system for ASARCO workers that in 1904 distributed $100,000 among the company's employees. Now, ignoring public opinion, they invested in the Congo Free State, a personal fiefdom of Leopold II of Belgium that had cruelly exploited African farmers and laborers to line the king's personal pockets.

A flamboyant roué, Leopold could not live on his income as sovereign of a small European country and had turned to Africa for riches when the "Dark Continent" was being carved into colonies by Britain, France, Italy, and Germany. By the time the Guggenheims became involved in the Congo, Leopold had already established a brutal system of forced labor for extracting rubber and other wealth from the Congo basin, a large stretch of central Africa still unclaimed by the European powers. The charges against him and his agents of treating the indigenous population sadistically came under investigation in 1904–05 by an international Commission of Enquiry, which confirmed the accusations. By the time the Guggenheims became entangled in the Congo its raw rubber was called "red rubber," describing both its natural hue and the black workers' blood spilled to produce it.

In 1906, to appease world opinion and improve his image, Leopold approached Ryan, a Catholic famous for his piety, to take over production of Congo rubber and to prospect for minerals in the Free State, the colony he had carved from central Africa. Ryan liked the deal and sounded out his guayule partners, Baruch, Aldrich, and Daniel Guggen-

heim, for support. Proud of his reputation as a friend of labor, Daniel at first balked, but then agreed to join the enterprise. In early 1906 the Guggenheims sent Chester Beatty to Brussels to negotiate with the aging king. Under the terms of the agreement reached in early 1907 with Ryan and the Guggenheims, the Société Internationale Forestière et Minière du Congo, capitalized at 3.5 million francs, received concessions in a tract of 2.5 million acres, plus additional parcels along the banks of the Congo River, to explore for and develop minerals and to plant guayale shrubs. The promoters were to pay $150,000 as a down payment on an eventual $1.5 million fee.

Somehow the Guggenheims avoided criticism for the Congo deal. Within days of the announcement, reformers attacked Rockefeller for his participation. The oil magnate denied any connection with the enterprise though he was in fact involved in a roundabout way through his interest in the Continental Rubber Company. But the Guggenheims were spared. Fortunately, they were not yet the lightning rod that the infamous founder of Standard Oil had become.

The Congo venture was not wildly profitable. The rubber scheme, finessed by the development of productive rubber tree plantations in Malaya, never took root. The mineral enterprise worked out better. Hoping for gold, Guggenex technicians found diamonds instead, but never, unfortunately, in the abundance of the South African diggings. The company, generally called Forminière, hired thousands of local laborers to dig for diamonds, but unlike Leopold's personal companies, treated them well. As in Mexico and later Chile, the Ryan-Guggenheim firm acted as a benevolent patron. It built villages for its employees, established farms for them stocked with cattle, and charged commendably low prices at its company stores. By the 1920s the venture was almost forgotten but then, in mid-1925, the company abruptly declared a dividend of 50 percent. The announcement took Wall Street by surprise. The younger traders and brokers had "heard little of the Guggenheim-Ryan Syndicate or its operations," the *Times* reported.[35]

THE YEAR 1908 marked the end of the Guggenheims' association with John Hays Hammond. The celebrity engineer had served the brothers

well in many ways. He had brought to the Guggenheim ventures the glamour and publicity they needed during the opening years of the new century, when they were courting the investment public. Beyond this role Hammond located some valuable properties for Guggenex and ASARCO. But he had also made mistakes, most notably Nippising. And Hammond's services had been very costly. Through salary and royalties he had made an extraordinary $1 million a year during his five years with Guggenex, a sum that imposed a drain on Guggenex resources.

Hammond's five-year contract expired in February 1908, and the Guggenheims chose not to renew it. It is clear that the break was not amicable. In his autobiography Hammond praised the family gener-ously. He also remained in an advisory capacity to Guggenex for a few years after his original contract expired.* But soon after his departure he hinted to his colleagues in the mining fraternity that he had been dis-mayed by the Guggenheims' stock speculations. Someone in his posi-tion, he noted, owed his primary responsibility to his employer, of course, but such a person also assumed a "sacred trust, obligating him to safeguard the interests of a wider and more important clientele," that is, the investing public.[36] Daniel Guggenheim had a different view of Hammond's departure. In June, after returning from a three-month vacation in Europe, he told a reporter that businessmen had "scattered money too freely" during the boom; they had paid employees too gener-ously. The past eight-month slowdown had resulted in "a cleaning of the Augean stables." Daniel put these remarks in the passive voice and refused to discuss at this point how specifically ASARCO and Guggenex had retrenched, but he told another reporter that he and his brothers had cut their own salaries and reduced their overall payroll by $750,000 a year. Their personal sacrifice was not the major story, however. As the *Times* reporter noted, it was understood "in well-informed quarters . . . that the heavy engineering expenses of the Guggenheim Exploration Company had been radically cut."[37]

Hammond's withdrawal ended an era in the Guggenheim saga. He

*Hammond retained a connection with Guggenex until mid-1913 when he resigned without explanation.

arrived when the family was scarcely a part of the American public's consciousness and only secondary players in American industry. He departed as the Guggenheims, though temporarily strapped, were recognized as a dominant power in the resource extraction industry. Regrettably, the next few years would see more troubles for the Guggenheims as the public, in the grips of a reform frenzy, began to identify them as "malefactors of great wealth," along with Rockefeller, Morgan, and Harriman.

CHAPTER FIVE

Malefactors

H AROLD LOEB, oldest son of Rose Guggenheim, Meyer's second daughter, first learned about the Ballinger-Pinchot affair while an undergraduate at Princeton. Harold's father, Albert, was a stockbroker from an Our Crowd family affiliated with the powerful investment banking firm of Kuhn, Loeb and Company. As we saw, the Albert Loebs lived in a townhouse on New York's Upper West Side, close to Meyer and Murry Guggenheim, and summered, like most of the Guggenheims, at the Jersey shore. Harold often played with his cousins Harry and Edmond. But the Albert Loebs never felt part of the Guggenheim "inner circle." Rose, after all, was a daughter, not a son. Like her sisters she missed out on the surging prosperity of her brothers as they became "silver princes" and "copper kings." Though Albert Loeb was a rich man by the standards of the day, as Harold later remarked, his mother's "pearls were smaller than those of her sisters-in-law, her dresses less numerous, her horses not so thoroughly bred."[1] Albert's death of a heart attack in 1902, when Harold was eleven, confirmed the family's relatively modest circumstances.

Yet Harold went to Princeton where he palled around with Roger Straus, son of Oscar Straus, former ambassador to Turkey and Theodore

Roosevelt's last secretary of commerce.* Strolling together on campus one day, either in late 1909 or in early 1910, Roger mentioned to his companion a current political scandal, the bitter dispute between Interior Secretary Richard Ballinger and Chief Forester Gifford Pinchot over the disposition of federally owned coal lands in Alaska. Suddenly Roger stopped and asked Harold: "Did you know that the Guggenheims are trying to steal Alaska?" Harold had heard of the dispute, of course; by this time every literate American had. But he did not realize his own family was deeply involved. "Conditioned to hear the worst about the family," Harold remembered, he just shrugged his shoulders and continued to listen as Roger described the Guggenheims' iniquities. Since the heroic Pinchot, everybody's model whistle-blower, was against the family's Alaska ventures, Harold decided, "I was against it too."[2]

THE BALLINGER-PINCHOT AFFAIR was an emblematic Progressive-Era morality tale that, as told, pitted spotless public servants against corrupt officials and private villains, the latter two in evil embrace. The epic battle was over use and misuse of the nation's vast natural resource heritage. By 1909–10, after two centuries of careless and wasteful chewing up of its animal, vegetable, and mineral endowment, the American public was in a panic over resource depletion. Would the nation have the means to meet its future needs? Would it be enfeebled by becoming dependent on others? A few Americans, with an Edenic vision, had also developed an aversion to all trespass on the pristine natural environment. Together the two attitudes formed the underpinnings of the powerful new "conservation" movement.

Though the conservation panic preceded Theodore Roosevelt, the rambunctious young New Yorker who became president in 1901 transformed it, through his "bully pulpit" of the White House, into a broad popular movement. At TR's right hand in the conservation struggle was

*Roger, as we shall see, would marry Harold's cousin Gladys Guggenheim, Daniel's daughter, in January 1914, soon after he graduated from Princeton, and so become a member of the clan himself. In 1915 he would also join ASARCO and rise to high executive rank in the firm.

Gifford Pinchot, a blue-blooded fellow New Yorker who had improbably taken up scientific forestry as his vocation and become a zealot for prudent and selective exploitation of the nation's timber, soil, and mineral resources. In 1898 President McKinley appointed Pinchot to head what became the U.S. Forest Service, a division of the Department of Agriculture, which administered the vast publicly owned timberlands. As chief forester, Pinchot became a friend, mentor, and ally of Roosevelt when he became governor of New York in 1898. His influence inevitably expanded when Roosevelt succeeded McKinley in the White House.

The conservationists sought to reverse traditional policies of private use of valuable public lands and their indiscriminate transfer to corporations anxious to cut, dig, and herd under a poorly administered and tangled mesh of federal laws dating to the mid-nineteenth century. As chief forester, Pinchot imposed fees on ranchers who employed the national forests for cattle grazing. He sought to limit the giveaway of water power rights on federal lands to electric generation companies. Pinchot became czar of a great empire. Under Roosevelt the government converted to national forest status almost 130 million acres of timberlands. These were closed to "entry," that is, transfer to private hands. Not surprisingly, the conservationists and their supporters clashed with private corporations engaged in the extractive industries, and inevitably the struggle merged with the larger battle of the Progressives against what Roosevelt in 1907 would call the "malefactors of great wealth." Though Roosevelt himself distinguished between "good" trusts and "bad" trusts, many Progressives were hostile to all trusts and, indeed, drawing on the nation's venerable "antimonopoly" tradition, they were often suspicious of big business generally. All told, given the charged antibusiness mood of the day, it would have been a miracle if the Guggenheims had managed to avoid becoming targets of public outrage over their Alaska enterprise.

The focus of controversy was a small corner of an ambitious operation by the Guggenheims and their allies to exploit the resources of America's final frontier, the half-million-square-mile northwest corner of North America acquired from Russia in 1872. The family, as we saw, had begun to probe the value of Alaska's resources in 1905. The Yukon

Gold venture was an embarrassment and had not proven very profitable. But copper was another matter. Alaska copper would be another Golconda that would enhance the family's wealth and influence.

The rich copper resources of Alaska were discovered by two veteran prospectors from Arizona, Clarence Warner and Jack Smith, who had come to the territory during the Klondike gold rush of 1897–98. Neither had struck gold, but in August 1900 they stumbled on a copper lode in south central Alaska, some 195 miles northeast of what is now the town of Cordova. The diggings, called the Bonanza mine, included a mountain of chalcocite copper ore near Kennicott* glacier with a metal content of an extraordinary 70 percent in places. As usual the finders needed capital, and Smith and Warner sold their options to a Stephen Birch. He, in turn, sold the property to the Alaska Copper Company, one of whose directors was the prominent head of the "sugar trust," Henry Havemeyer. The claims were disputed by another group, the Chitina Exploration Company, but in 1906 were settled in favor of the Havemeyer firm by Judge James Wickersham of the Third Alaska Judicial District. Havemeyer chose not to develop the property himself but turned to George W. Perkins of J. P. Morgan Company, the powerful investment bankers, to share the risk and profits. Not knowing much about copper, Perkins consulted the Guggenheims, and in July 1906 the Morgan firm and the Guggenheims formed an "association," or informal partnership, under the name the Alaska Syndicate. The syndicate bought the claims for $2.9 million and set about developing the mine and providing needed transportation connections to process and market the copper. In 1916 the Guggenheims would merge the syndicate's holdings in Alaska with mines in Utah, Nevada, California, and Chile under the name Kennecott Copper Corporation. All told, the syndicate would plow between $30 million and $40 million into the enterprise, a vast sum for a territory so undeveloped.

Alaska awakened imperial visions in the Guggenheims, already intrigued by Yukon gold deposits. In April 1906 an expansive Daniel told

*This is the correct spelling for the geographical features, not for the company that exploited the region's copper resources.

a *New York Times* reporter of his majestic plans for Alaska development. "We want to go into the territory and build railroads and smelters and mining towns and bring men there and populate the country where it is habitable and do for it what the earlier figures in American railroad building did for sections of the great West." Daniel went on to describe the need for a railroad to exploit the Copper River ores and called attention to nearby valuable coal deposits to provide fuel for locomotives and smelter machinery.[3] In late July 1906, accompanied by his wife, brother Solomon, several friends, and Guggenex engineer Chester Beatty, Daniel left New York for a tour of the Pacific Northwest, Canada, and Alaska. On return to New York in September he once more touted the opportunities of Alaska for settlers and investors.

The Alaska of 1907 had a total population of seventy-six thousand. It was, in fact, an empty wilderness with few roads, developed ports, or railroads. The rich copper mountain that Smith and Warner had discovered was inaccessible. To bring the ore to market the syndicate would have to construct a railroad southward to the port of Cordova across two hundred miles of difficult terrain and then transport it to the ASARCO refineries at Puget Sound. The syndicate solved the easier part of the problem by purchasing the Northwestern Steamship Company, later renamed the Alaska Steamship Company, to carry the ore to Washington state. The more difficult part was construction of the Copper River and Northwestern Railroad from the coast at Cordova to the chalcocite ore deposits. By the summer the press was reporting that three shifts of construction workers were laboring night and day to complete the road before the fierce winter weather descended. The task was stupendous. There were bogs, glaciers, forests, and the rugged Chugach Mountains to cross. The crews had to pound thousands of wooden piles into the boggy land of the Copper River delta, assemble a 1,150-foot bridge to hurdle two glaciers, and chop through miles of near-impenetrable forest for the right-of-way. Though driven remorselessly by railroad contractor Michael Heney, a snub-nosed, aggressive Irishman, the men could not complete the road during the brief northern summer, and winter brought temperatures of sixty degrees below zero, with bitter winds that froze the crew's faces, hands, and feet. Building slowed to a crawl. Wags

were soon saying the railroad's initials, CR & NW, meant "Can't Run and Never Will."

The difficulties the enterprise faced, however, were as much manmade as natural. Another company, the Alaska Home Railroad, organized by promoter H. B. Reynolds with the backing of the town of Valdez, was also trying to connect with the Copper River region and battling Heney for the right-of-way. In September 1907 the two construction crews collided when the Alaska Home Railroad engineers dynamited their rival's property. The syndicate induced the authorities to provide two U.S. marshals to protect its operation. When, on the morning of the twenty-fifth, some two hundred Home Railroad crewmen advanced on the syndicate workmen, one of the marshals fired on them, killing one and maiming another. The syndicate's enemies immediately denounced the affray as murder and proposed a "number of lynchings" if the perpetrators were caught.[4] Reporters sought to question the Guggenheims about the incident but were unable to run down any of the brothers and had to settle for Chester Beatty. Beatty denied that Guggenex had any connection with the railroad. It was purely an ASARCO venture, he insisted.

In the end the Alaska Home Railroad went bankrupt and shut down, having constructed all of six miles of road. With quiet restored, the Copper River road was finally completed in 1911, at the cost of $22 million. Heney himself died in the great construction push along with thirty of his men. Early that year ore trains started to roll into Cordova. Ore continued to move over the railroad until 1938, when the exhausted mines were finally closed. In all, almost $260 million in metal would be extracted from the great copper hill.

THE POLITICAL PIVOT of the Ballinger-Pinchot affair was the syndicate's need for coal to fuel its locomotives and mine machinery and to heat the community that would house the miners. Alaska, except for wood, was fuel poor. Imported coal brought from the "lower fortyeight" cost $12 or more a ton, a high price. The territory had coal deposits, but these were undeveloped. If they could be made available, they would substantially reduce costs for the syndicate. Isaac Guggen-

heim would estimate in mid-1911 that Alaska coal "could be mined and distributed [in the Pacific states] for $5 or $6."[5]

In mid-1907 the syndicate signed an option agreement in Salt Lake City with a consortium led by Clarence Cunningham, a western business promoter, who had bought twenty-two claims to Alaska coal deposits from squatters. Unlike many other speculators in Alaska coal, the Cunningham promoters had complied with the law, filed their papers, and paid the government some $52,800 in fees for the mineral lands. At Salt Lake City they agreed to sell coal to the syndicate for a twenty-five-year period at a specified price. In return the "Morgenheims," as popular journalists would later tag them, agreed to pay $250,000 to help develop the mines and to lend the Cunningham people additional money if needed.

All looked well for the deal until an idealistic and impetuous young employee of the United States Interior Department's General Land Office, named Lewis Glavis, got wind of it. Glavis's boss was Richard Ballinger, a Seattle attorney who had served under TR as head of the General Land Office and then, after a stint in private law practice, had been appointed secretary of the interior when Taft succeeded Roosevelt. Ballinger was not a mossback in the pockets of the private resource exploiters, but neither was he an ardent conservationist. Glavis, however, was a dedicated defender of the "people's interests" and considered the Cunningham coal lands claims a criminal giveaway. While in private practice in Seattle, Ballinger had represented the Cunningham group, and now, Glavis insisted, the Interior Department was about to legitimate their coal lands claims as part of a corrupt, or certainly ethically dubious, bargain. The Interior Department, in effect, was allying itself with the Morgan-Guggenheim Syndicate to despoil the public lands.

In righteous wrath, in July 1909 Glavis turned for support to Chief Forester Pinchot, the man who epitomized the conservation policies of TR. Pinchot needed little encouragement. He was already angry at Ballinger for restoring to public-sale status both water power sites and parcels of land reserved for ranger stations that TR had removed from entry. He advised Glavis, however, against making his charges public before going to the president with his complaints. Glavis complied, and

in a meeting with Taft at his summer home in Beverly, Massachusetts, laid out his indictment. Taft sent the charges to Ballinger for his response. In early September the secretary of the interior met with Taft and defended his actions in both oral and written form.

Taft now bitterly disappointed Glavis and Pinchot. Rejecting the young whistle-blower's charges, he exonerated Secretary Ballinger. In a long letter to his cabinet adviser he assured him that the "case attempted to be made by Mr. Glavis embraces only shreds of suspicion without any substantial evidence to sustain his attack." "From the time you entered upon the duties of Secretary of the Interior," the president noted, "you have studiously declined to have any connection with the Cunningham claims." In this same communication the president ordered Glavis fired from public service "for impeaching the official integrity of his superior officers."[6] Taft hoped to prevent a blow-up by Pinchot though he considered him "a good deal of a radical and a good deal of a crank."[7] The chief forester was Mr. Conservation himself and a vital link between Taft and his popular predecessor. The president could not afford to alienate TR's devoted followers and bring down the wrath of the ex-president on his head.

But neither Pinchot nor Glavis would be placated. In November the chief forester wrote the president attacking Ballinger as an enemy of conservation. In January he sent a letter to Senator Jonathan Dolliver of Iowa, a leading progressive Republican, admitting that he had helped Glavis formulate his indictment of Ballinger and that two of his subordinates in the Forest Service had been abetting the growing press attack on Ballinger. Dolliver read the letter on the Senate floor.

Meanwhile Glavis had turned to the press himself. On November 13 the weekly magazine *Collier's* published Glavis's article "The Whitewashing of Ballinger," in which the young critic defended his actions and laid out his case against the secretary of interior. The Guggenheims were barely mentioned in the body of the article, but just below the title was the subhead "Are the Guggenheims in Charge of the Department of the Interior?"[8] In later weeks *Collier's* editor Norman Hapgood commissioned the popular journalist Mark Sullivan to follow up with other exposés of the Guggenheims' role. *Collier's* was read by half a million

people weekly, and the articles positioned the Guggenheims directly in the center of the Ballinger-Pinchot vortex.

During the next year the family suffered growing contumely as the rest of the muckraker horde, smelling blood, rushed to attack the greedy Morganheims. None was more relentless than Benjamin Hampton, editor and proprietor of *Hampton's Magazine*, an important muckraking journal of the day. Hampton trumpeted an uncomplicated devotion to virtue. "We are going to expose evil wherever we can," he wrote; "we are going to expose it calmly and truly; we are going to expose it in order that it may be replaced by good."[9] The balding, bespectacled editor found the Guggenheims worthy of his moral scrutiny. In mid-1910 Hampton wrote two long articles for his monthly on the "rape" of Alaska and the Guggenheims' role in the foul deed. The first, in April, was called "The Vast Riches of Alaska: Will the Morgan-Guggenheim Combination Acquire Them, or Will They Benefit the Whole People?" The piece touted Alaska as a treasure trove. Its riches, Hampton declared, "are colossal, fairly paralyzing the mind's attempt to grasp them." If the territory's wealth were equally shared among Americans they would each have an estate of $80,000. But instead, he pronounced, the Morganheims were gaining control of this enormous public good. Hampton absolved the developers of actual criminal behavior. "We will not advance the cause of the whole people by alleging that the Morganheims and the others who are working with them are crooks and grafters." In fact, judging from personal contact, they "are energetic broad-gauged business men." But his praise was faint indeed, for in his view the Alaska coal lands affair, in the end, represented a "corrupt bargain" between the "business men and politicians."[10] In the next month's issue of his magazine, Hampton asserted that, based on recent testimony before Congress of Syndicate officials, it was clear that "the Morganheim grip on Alaska's incalculable treasures was as near perfect as human beings could make it."[11]

In January 1911 a joint House-Senate committee opened an investigation of the Ballinger-Pinchot dispute. Meanwhile, coincidentally, the Senate Committee on Territories took testimony on a Taft administration–sponsored bill to revise Alaska's territorial government. Both sets of hearings further demonized the Guggenheims.

For four months the joint committee heard the opposing views of Ballinger and his defenders and the chief forester and his partisans. Several of the witnesses had attorneys to help them with their testimony. Glavis, backed by *Collier's* money, hired the prominent Boston labor lawyer Louis D. Brandeis, later the first Jewish associate justice of the Supreme Court. Brandeis's brief for Glavis made the Guggenheims the chief villains of the piece. For years, it charged, the industries of Alaska had been "in the hands of a great and oppressive monopoly, the Guggenheim syndicate, which has kept out other capital and held Alaska at a standstill in spite of its enormous wealth." If the syndicate were allowed to monopolize the territory's coal as well, it would "merely strengthen the power which today holds Alaska in its paralyzing grip."[12] At one point in the hearings James R. Garfield, former interior secretary, accused his successor, while land office commissioner, of having submitted an affidavit by Cunningham denying any Guggenheim interest in his coal claims when, in fact, Ballinger knew this statement to be false.

The Senate hearings on the new Alaska government law in some ways were more damaging to the Guggenheims than the Ballinger-Pinchot investigation itself. The syndicate's chief tormentor was James Wickersham, the former federal judge, now Alaska Territory's Republican delegate to Congress. Wickersham was a passionate antimonopolist who considered the syndicate "the Guggenheim vampire which has already started its blood-sucking operations and is laying its plans for the complete subjugation of the country to its will."[13] Besides his antimonopoly bent, Wickersham may have had a grudge against the Guggenheims for turning him down when he had applied for the job as their general counsel in Seattle. Wickersham's testimony to the Senate committee focused on the issue of Alaska's transportation system. There were three railroads in the territory, and the Guggenheims either owned or controlled all of them, he affirmed. Moreover, they owned the steamship lines running to Alaska and from Alaska. In effect, they had a near monopoly of entrance and egress from the vast region. Under the proposed bill, Wickersham stated, the revised government of Alaska would be controlled by a council of nine men appointed by the president. That body would have the power to grant franchises, concessions, and other favors,

and Wickersham feared they would be dominated by the predatory corporations anxious to exploit the territory. In summing up his views. Wickersham noted: "The people [of the territory] are especially concerned in this bill, because if this bill passes, the Guggenheims will have advantages that they cannot possibly get in any other way." It was not that the "people of Alaska" did not want the Guggenheims to invest in the territory, he declared. "We want them to develop the country. We want the coal mines and the copper mines opened. . . . But we do not want the whole country turned over to one great corporation merely to get it developed."[14] Already primed to depict the Guggenheims as villains, the press gave Wickersham's testimony wide circulation.

The steady tattoo of publicity made the Guggenheim name a hissing and a byword. *Current Literature*, a contemporary monthly, noted how during the course of the congressional hearings there had been a motif, like a musical theme, repeated over and over in the background. The theme, as parodied from the James Whitcomb Riley poem about goblins, was:

> *The Guggenheims 'il get you*
> *Ef you*
> *Don't*
> *Watch*
> *Out!*[15]

The Guggenheims fought back. They sent John Steele, one of the syndicate's attorneys, and Stephen Birch, its managing director, to the joint committee hearings, to defend them against the charges raised. Reputedly "a ruthless and unscrupulous man,"[16] Birch bridled at the suggestion of Representative Graham that control of the Alaska coal lands would give the syndicate domination of the whole territory. He rejected another congressman's statement that there was "a giant scheme on foot to control a great part of Alaska." When given his chance to cross-examine, Brandeis "turned fiercely upon the witness" and demanded to know if the Guggenheims had not tried to use undue influence to get the Cunningham claims validated. When Birch denied the charge, the

Boston attorney sarcastically rejoined: "Do you mean to say that, with all the influence and power of the Morgans and the Guggenheims in this country, they made no efforts in this direction. . . . Is that what you wish this committee to understand?"[17] Steele told the joint committee that his clients had been the targets "of gross abuse and misrepresentation" in the press and before committees of Congress. "We have been accused of gobbling up Alaska, closing the markets of the world to Alaska and what not." He emphatically denied these charges. Contrary to Wickersham's claim, the syndicate owned only one railroad and had "no interest in any other in Alaska." It had only one copper mine and "had no interest in any other." It actually owned no coal lands at all. Its interest in the Cunningham claims was established "when those claimants had full legal rights to deal with their holdings." The charges that the Guggenheims were attempting to "gobble up" Alaska was "without . . . foundation in fact."[18]

The family did not rely solely on delegated spokesmen to defend them. During these years Daniel, plagued by bad digestion, made frequent trips to Carlsbad to "take the waters" for his health, and whenever he boarded or debarked ship in New York, the press interviewed him. During the Alaska controversy the family chieftain used these occasions to explain the Guggenheim position. Returning with Isaac on the *Lusitania* in late March 1910 from six weeks in Europe, Daniel told the reporters that in Germany businessmen and political leaders considered odd the opposition in America to "combinations of capital." In Germany they were doing everything they could to encourage such combinations. The effect of the "agitation against capital" in the United States, he warned, would be to discourage foreign investment in the country.[19] At the end of May Daniel was off to Europe again, and before sailing he answered questions about the impact of the congressional investigations. Having absorbed some bitter public relations lessons, Daniel adopted a conciliatory tone. "Alaska must ultimately benefit from these investigations for they have brought to the attention of the people of the United States, as nothing else could, that there is a great sleeping empire of enormous wealth at our very doors." But now it was time for the government "to stop talking and do something which will give the people an

opportunity to go to Alaska and take part in the work of development."
There had been "a lot of talk about syndicate control of Alaska because a
syndicate happens to be building a railroad there," but if the public
objected to the way railroads were being built in the territory, let it
approve direct government construction or joint government-private
enterprise. Daniel hardly believed Americans would be willing to accept
a paternalistic government. "America has been developed by enterpris-
ing people, and largely through corporations. Therefore they should be
assisted, not deterred, from doing their work."[20]

The Guggenheims were not without their outside defenders. The
New York Times, in a late May editorial, "The Development of Alaska,"
denounced the "unreasoning and passionate animosity to corporations"
that had been amplified by the Ballinger-Pinchot affair. The *Times*
praised the Guggenheims for their willingness to "spend millions for the
development of our distant and much-neglected province of Alaska" and
warned that if the government continued to intervene in private invest-
ments as they had, "American capital will presently shun industrial
investments."[21] Several newspapers in the Pacific Northwest defended
the Guggenheims as well. In Alaska itself, opinion was divided. Despite
the views of the territory's anti-Guggenheim congressional delegate,
many supported the syndicate. In mid-1911 the citizens of Cordova and
Katalla burned Pinchot in effigy in protest against his antisyndicate
stand. In Cordova they staged a "Cordova Coal Party," in imitation of
the tea party in Boston a century earlier, dumping imported Canadian
coal into the bay. These protests can be dismissed as narrowly self-
interested; both towns were integral parts of the syndicate's projected
mining empire. But Alaskans in other parts of the territory were also
hostile to the conservationists. When Pinchot visited the territory that
September, though most Alaskans were courteous, he encountered rag-
ing antagonism. At Seward his critics greeted his arrival with a banner:
"Conservation Prices . . . British Columbia Coal, $17 a ton . . . Wood $7
a Cord . . . But You Must Not Mine Your Own Coal, Nor Cut Your Own
Wood . . . All Reserved for Future Generations . . . Signed . . .
G. Pinchot . . . 'Pinhead.' "[22]

Pinchot himself learned to forgive the Guggenheims personally for

their transgressions but refused, self-righteously, to accept blame for their indictment in the court of public opinion as monopolists and male-factors. In early 1917, long after the noise had died away, he and Daniel met, apparently at Daniel's request, to discuss the events of 1910. Daniel gave his version of the syndicate's doings and pleaded with Pinchot to abandon his harsh judgment of the Guggenheims' role in Alaska. Pinchot was willing to accept Daniel's facts, he told him, but insisted that what had been done in the family's name "was to produce the impression that an effort was underway to monopolize the resources of Alaska." Hence he refused to accept that "the fault lay with myself, rather than with you, whose acts, directly or indirectly, caused that belief."[23]

The House hearings ended in late May with a committee majority, all conservative Republican "stalwarts," absolving Ballinger of all wrongdo-ing but agreeing with Glavis, Pinchot, and the other critics of the Guggenheims that "it would be the height of unwisdom to permit these great coal fields to be monopolized, or gathered into the private own-ership of a few for speculative purposes."[24] Eventually, in mid-1911, after Ballinger resigned—though officially vindicated—the Department of the Interior canceled the Cunningham claims. But that did not end the charges that the Guggenheims were determined to seize Alaska's coal resources. In 1911 an article in a Philadelphia newspaper, headlined "Taft Secretly Gives Control of Alaska Coal to Guggenheims," accused Taft of helping the syndicate to impose a monopoly on transportation to the territory's coal lands that would restore their attempt to monopolize the territory's coal.[25] That June a muckraking reporter repeated these charges in a number of other newspapers.

Nor was Ballinger-Pinchot the only instance when the Guggenheims fell afoul of the anti–big business mood of the era. At one point they were also threatened with federal antitrust action under the Sherman Act of 1890 forbidding combinations "in restraint of trade." Under Roosevelt, and even more under Taft, the federal government would go after the "trusts" as exploiters of consumers and dangers to free government with a vengeance. ASARCO, the smelter "trust," was an obvious target, and in 1911 a federal grand jury seriously considered indicting the company for antitrust violations. Fortunately, the family was spared further assault

when the grand jury decided to drop the investigation in July. Reinforcing the image of the Guggenheims as malefactors was their inclusion in the 1913 list, compiled by the House of Representatives' Pujo Committee, of business leaders whose "interlocking interests" constituted a dangerous "money trust." On this roll of dishonor Daniel Guggenheim found himself in the company of Morgan, Rockefeller, Gould, Astor, Schiff, Armour, Grace, and Frick.

Meanwhile, on the ground in Alaska itself, it did not take long for the engineers' estimates of the Bonanza mine's wealth to be vindicated. In February 1912 the syndicate declared a dividend of $1 million on its $2.5 million in capital stock. In October it declared another dividend, this time of $2 million. On October 25 the *New York Times* called the Bonanza "the richest copper mine in the world."[26]

However rich the lode, the syndicate found the cost of amortizing and running the Copper River railroad excessive. In 1912 Simon approached President Taft and offered to sell it to the government for $20 million as an addition to Alaska's neglected infrastructure. Taft declined. Two years later Morgan himself approached the government with no greater success. Fortunately for the Guggenheims, world history would soon make the losses from the railroad seem a minor problem.

DURING THESE PRE–WORLD WAR I YEARS the Guggenheims' "malefactor" reputation was amplified by the scandal of brother Simon's election to the United States Senate. Simon was the second youngest son, born after Ben and before William. All three younger brothers felt like outsiders to some extent, and Ben and Will, as we have seen, had expressed their disaffection by distancing themselves from the family. Simon's way of dealing with junior status was to prove himself the equal, if not the superior, of his older brothers.

By the mid-1890s Simon was living in Denver, where he was chief ore buyer for M. Guggenheim's Sons. For a time all three younger brothers lived in the Colorado capital while attending to the business of the Pueblo smelter and making forays into Mexico to scout for new mining properties. Ben and Will soon moved back east, leaving Simon alone in Denver.

with passage of the Seventeenth Amendment to the Constitution. Senators, rather, were selected by the legislatures of each state, an arrangement that opened the field wide to rich men who could buy and sell the farmers, teachers, shopkeepers, and small-town lawyers who made the laws in the state capitals. Many took advantage of it. For good reason the United States Senate in this era was called alternately a "rich man's club" or a "millionaire's club."

Yet seldom would jobbery be as brazen as during the campaign in 1906 that won Simon his Senate seat. Simon began his seduction of the Colorado legislature in 1904 when he opened a campaign office in Denver. Here his managers planned strategy and met with politicians to distribute favors and funds. During the legislative elections in 1904 and 1906, Simon's organization blatantly financed the campaigns of men who promised to vote for the smelter king if elected. One of his candidates, Morton Alexander, a farmer from outside Denver, later told about encountering John Vivian, secretary of the Republican State Central Committee and a Guggenheim lieutenant, in 1906. Vivian told Alexander that he could make him a state senator. But "what about the people?" the naive Alexander asked. "I'm not well known around here." "To hell with the people," Vivian responded. A few weeks later Alexander again bumped into Vivian. "Well, we nominated you today," the Republican leader declared. "But I haven't any money," responded Alexander. "Don't worry about that," was the reply; "we'll take care of the money."[29] Alexander was elected to the office, along with Republican majorities in both houses of the legislature, but in the end he betrayed his benefactor by leading the anti-Guggenheim forces in the state senate.

Fortunately for Simon there were few Alexanders among the Republican majority when the party caucused on New Year's Day, 1907, to choose its senatorial candidate. Simon delivered a brief speech to the Republican legislators and legislators-elect emphasizing how he would work to procure more federal money for the state. "I stand for a greater Colorado," he said. He would get federal funds for irrigation canals and for post office buildings.[30] Alexander and Merle D. Vincent of Delta County resisted his blandishments, but Simon won the nomination by a landslide.

The decision of the Republican caucus outraged leading Democrats and many Republicans. Editor Edward Keating of the *Denver News* would conduct a vigorous campaign in the weeks before the formal final balloting to stop the Guggenheim juggernaut. The *News* filled its pages with denunciations of Simon by hostile legislators. Democrat John H. Crowley of Otero, it reported on January 12, "threw a bombshell into the senate chamber" with a resolution declaring that Simon had bribed the Republican Campaign Committee with $50,000 to be "used in corrupting [the] assembly." In "return for this donation he received the promise . . . to assist him . . . to gain a seat in the United States senate at the election now about to take place." The Crowley resolution recounted how Simon's money had paid many legislators' campaign expenses and how he now had these men in his pocket. Crowley denied that he was opposed to Simon "because of his religion," but he was undoubtedly revealing one of the magnate's weaknesses.[31] Over the debate regarding Simon's candidacy there hung a persistent cloud of anti-Semitism.

As the final balloting drew near, the *News* sought to use the nation's popular president to beat Guggenheim. On January 14 it carried reports from Washington claiming that Roosevelt was about to order an investigation of the "smelter trust" to see if it had illegally sought rebates from the railroads for its ore and metal shipments. Just recently Rockefeller's Standard Oil refining monopoly had been indicted on this very charge, and editor Keating was obviously linking Guggenheim with the unpopular petroleum trust. Beyond this, the *News's* Washington dispatches claimed that "Mr. Roosevelt is known to be very much opposed to the election of Simon Guggenheim. He believes the smelter magnate is not in sympathy with any of his important policies and would merely swell the number of senators who may be depended upon by the 'interests.'"[32] When this appeal to the Republican legislators fell on deaf ears, the *News* lamented that the Colorado Republicans' "campaign slogan of 'Stand by Roosevelt' [had] been abandoned pretty early in the game."[33]

Vincent too tried to stop the juggernaut. The day before the formal election, he rose in the assembly to present his own Republican candidate, Frank C. Goudy, and to excoriate his party's caucus for agreeing to

support Simon. Their choice, he said, ignored the will of the voters. "Strip the state committee of the wealth it has received from him [Simon] and you would laugh to scorn the man who would suggest his name for the office he has been nominated for." Guggenheim was "absolutely unqualified . . . to sit in the United States senate."[34]

Nothing availed. By a vote of sixty-eight to twenty-seven, with only four dissenting Republican votes for Goudy, Simon was chosen over Democrat Charles S. Thomas to succeed Patterson in the U.S. Senate. Appearing before the joint assembly to thank his supporters, Simon said that he had "withdrawn from all active business" and pledged to render "loyal and efficient service to all the people." He also called himself a progressive. He was, he said, "in hearty sympathy with the progressive achievements of our party and President Roosevelt." He favored "all legislation adopted by Congress to correct industrial evils and abuses" and would support further reform "as necessary."[35]

The state's chief Republican newspaper applauded the result, though with reservations and qualifiers that make it sound tainted to modern ears. The "muckrakers charge that he bought his seat," acknowledged the *Denver Post*. Yet he deserved credit for winning against serious odds, including his religion. Simon Guggenheim would now have to "prove that there is no better American than the Jew Senator from Colorado."[36] But outside regular Republican circles, the election created an uproar. Senator Patterson called the choice "without parallel in the history of senate-making in the United States." Colorado had "reached the nadir of her political life."[37] From his Nebraska home William Jennings Bryan, the great populist chieftain, pronounced the election a victory for "the smelters and other corporations."[38] These attacks by Democrats were predictable. But, despite Simon's progressive pledges, the election also offended progressive Republicans. The *Colorado Springs Gazette* called Simon's presence in the U.S. Senate "a most discreditable joke on Colorado." The *Pueblo Chieftain* called "the system" by which Simon won the election "undemocratic, dangerous, and contrary to the principles of popular self-government."[39] Simon never denied that he had bought the election. At one point he defended his gifts to the men who voted for him. "The money I have contributed has helped to elect these

men and naturally they feel under obligation to vote for me. It is done all over the United States today. I do not consider it wrong and neither do I think that it can in any sense be called bribery."[40] Mark Twain, the beloved novelist, found this statement abhorrent. "By his public utterances," he rejoined, "it is plain that the general political rottenness has entered into him . . . and he is not aware that he has been guilty of even an indelicacy, let alone a gross crime."[41]

Simon took up the duties and privileges of the United States Senate with gusto. In September he visited Washington to look for a house for the family. Asked by a local reporter his opinion of the already flagging national economy, he opined that the country would "suffer from a financial recession for some time." On the more relevant subject of house hunting, he denied that he intended to rent one of the many fine mansions available. "My aim is to live modestly."[42] But he did not. In late January Simon and Olga closed up the Sherman Street house, boarded their private railway car, and, with sons John and George, left Denver for Washington. The Guggenheims rented a red-brick mansion on Massachusetts Avenue and enthusiastically joined the capital's social whirl. Olga "received" at home regularly on Thursdays, where she entertained other congressional wives. In the winter of 1909, along with Mrs. Fairbanks, wife of the vice president, and Countess von Bernstorff, wife of the German ambassador, she served as "patroness" of the lavish charity ball for the benefit of the George Washington Hospital.[43] Simon gave small stag dinners for fellow senators, one attended by brother Murry, visiting from New York. Clearly they enjoyed the recognition that came with the U.S. Senate. Simon extracted particular satisfactions from the senatorship. For the remainder of his life he would bask in the standing achieved by his election. Ever afterward he was referred to respectfully, in the family and out, as "Senator."

But Simon was never a power in the Senate. At forty he was the youngest man in the body, and overawed, perhaps, by his seniors, he seldom spoke. His longest speech was a eulogy of his junior colleague Senator Charles J. Hughes, Jr., a Democrat, who had died in January 1911. The rest of his recorded remarks were brief comments on bills of local Colorado interest such as the proper fees for use of land in Mesa Verde

National Park or an appropriation for a new post office in Colorado Springs. Despite his promises, the new senator bucked the progressive drift of the day, especially pronounced among western Republicans. In 1909, in the great conservative-progressive debate that swirled around the Payne-Aldrich Tariff, he defended the mineral interests of Colorado against the Republican tariff reformers who fought to lower the walls against foreign competition.

He was also, predictably, on the conservative side of the conservation issue. In early 1909, some months before the most sensational charges of Glavis and Pinchot had turned the Guggenheim-Morgan Alaska coal lands into a national scandal, the Senate debated the Forest Service appropriation bill. Simon questioned the attempt to raise the service's budget. Why was the increase requested? Some weeks earlier, he noted, he had introduced a resolution to have the Committee on Agriculture and Forestry investigate Pinchot's bailiwick. Simon denied that he and fellow Coloradans disputed the forest reserve policy of Pinchot as such. But they were "opposed to the unwise and unjust regulations imposed by the Forester and his satellites."[44]

At one point Senator Guggenheim intruded into the battle over immigration that raged in these years of extraordinary transatlantic population movements. Many early-twentieth-century newcomers to America, before the open doors to Europeans were slammed shut in the mid-twenties, were Jews fleeing poverty or prejudice in the Hapsburg and Romanov empires. The Dillingham Immigration Commission, appointed by the Senate in 1907 to consider the pattern of the "New Immigration" of these years, was a xenophobic body that ultimately disparaged the newcomers and recommended literacy tests to exclude them as less desirable immigrants. Among its other proposals was that the decennial census takers classify Jews as members of a separate race. Simon objected before the Senate Census Committee in early 1909. Jews were members of many races, he insisted; they were distinguished by their religious views, not their biology. This view was strongly supported by Jewish assimilationists and denied the position of the emerging group of "scientific" racists who would help inspire Hitler a generation later.

Simon's senatorial career did little to help the family's reputation. In

fact, his political foray probably further damaged the family's standing. For months after he left to take up his Senate duties, he was savaged by his opponents back home led by F. G. Bonfils and H. H. Tammen, editors of the *Denver Post*. The *Post* had supported Simon during the senatorial campaign because "it was essential *at that time* that a Republican Senator should replace Senator Patterson," editorial writer Hugh O'Neill explained. But since then the *Post* had come to understand how pernicious was "the influence and power of the Smelter Trust on the state of Colorado."[45] In fact, Bonfils and Tammen were unsavory characters who used blackmail to force leading Colorado businessmen to advertise in their paper. One citizen who had resisted, and so became their victim, was Simon Guggenheim, noted the *Denver News*, a paper that had opposed Simon and deplored his election.

Having said not a word about them the year before, the *Post* reviewed in ever more colorful detail the corrupt shenanigans of the 1907 election. The paper denounced ASARCO's supposed squeezing of the independent mine owners by rigging smelter prices and charged that it had attempted to assess its workers to pay Simon's campaign costs. The Guggenheim trust, it blustered, was "the most powerful enemy of legitimate mining in the West [that] the world has ever known."[46] O'Neill also insulted Simon personally, conveying an ill-disguised anti-Semitism in the process. Simon, he asserted, had always employed "subtle, subterranean, and secret" methods. His manner "of attaining his ends" was "more oriental than American."[47] Surprisingly the *Post* shared some enemies with Simon. The editors disliked Gifford Pinchot and his forest reservation policies. These were bad for Colorado and should be reined in. "Down with Gifford Pinchot," was one of the paper's rallying cries.[48] Yet the paper somehow managed to link the Guggenheims with the detested chief forester. Pinchot's efforts to close off vast stretches of western mineral lands from prospecting and exploration had, it said, reduced potential competition and abetted the monopolistic drive of ASARCO and Guggenex.

Yet Simon's evaluations were not all bad. One Denver newspaper, just before Simon left the Senate, gave his performance at least a passing grade. Senator Guggenheim had helped enact some fifty pension bills

for Colorado veterans and their widows, the editor noted. He had secured appropriations for a flock of federal buildings in the state and gotten an additional judge for the Denver-based U.S. District Court. He had induced the government to enlarge the Rocky Mountain National Park and secured additional funds for Mesa Verde, a new national park in Colorado. A member of the Military Affairs Committee, he had helped in the passage of generous appropriations for support of the U.S. Army. Former Democratic governor Charles Thomas, writing in 1927 as a historian of Colorado politics, noted of Senator Guggenheim: "He attempted nothing beyond his capacities, responded to all requests for assistance by his constituents without regard to politics or class, and in all particulars upheld the standards fixed by his predecessors."[49] Faint praise! All told, then, Simon was not a Senate star but a useful utility player.

One term proved enough for Simon. He did not feel esteemed. As Daniel wrote his son Harry four years into his term, Uncle Simon was "dissatisfied with his constituents because there is a great lack of appreciation on their part." Voters in Colorado, Simon felt, were "trying continually to tear him down [and] abuse him orally and in print." He was also weary of politics. "He wants to get back to the financial arena again."[50] More important, he had achieved his goal of recognition in the family and had little reason to continue. In December 1911 he informed the chairman of the Colorado Republican State Committee that he intended to leave the Senate when his term ended in March 1913. The family business, he said, required that he leave political life. As he explained to President Taft when he visited the White House to make his farewells, his brothers wanted him back. Now approaching sixty and suffering from heart problems, Daniel needed help in the daily running of the family enterprises, and Simon had been summoned back to New York to serve as chairman of the firms.* In 1913 Simon left Washington, moving to New York, where he would live the remainder of his life.

*Actually, in ASARCO the chairman was second in command; the president was the top officer. Daniel did not relinquish the presidency to Simon until 1916.

THE ATTACKS ON THE GUGGENHEIMS during the Progressive Era left bruises that never fully healed. The family was already insecure because of their religious origins and the abuse of the politicians and the media seem to have confirmed their self-doubts. They must have wondered during the Alaska uproar why they, and not Morgan, had borne the brunt of public outrage. Would it be too much to see their charities, their foundations, their public benefactions as an effort to prove that Jewish capitalists like themselves were not, as portrayed in the years before World War I, heartless parasites and princes of exploitation? Is it significant that the brother most abused, though himself ultimately a defector from his faith, was the one most charitable?

Meanwhile, however shaky their public standing, the Guggenheims would soon begin their period of greatest prosperity, borne along by a crisis of world dimensions.

Profits and Patriotism

THE DECADE FOLLOWING the Alaska venture was the golden age for the Guggenheims as industrialists. Demand for copper surged as the Western world turned to electric light, electric motors, electric appliances to accelerate industrial output and ease the lives of ordinary men and women. World War I would then kick the metals industry into overdrive to meet the voracious needs of the grappling armies and navies. During this same period the Guggenheims' luck would pay off once again. The Kennecott mine, as we saw, would fulfill its promise as a treasure trove. In 1911 M. Guggenheim's Sons would acquire equally fabulous copper mines in Chile. The family's total worth would reach its absolute peak. By one estimate, the Guggenheims' collective family assets by 1929 would top $200 million, making them the second richest Jewish family in the world, just behind the legendary European Rothschilds.

The war period was also a testing time for the Guggenheims' reputation. They had emerged from the Ballinger-Pinchot affair smarting from the criticism heaped on their heads. The war brought bounding new profits, but skepticism toward wealth continued, and much of the public doubted whether profits and patriotism could mix well. The

Guggenheims would be called on as never before to prove their civic worthiness.

THE GUGGENHEIMS' CHILEAN COPPER venture would bring them more wealth than any other single undertaking. But at first their business instincts seemed to fail them. In 1900 a Guggenheim mining expert prospecting at a site in northern Chile, previously worked by the Chuqui Indians and then by the Spanish conquerors, rediscovered a rich copper lode. It was at a location called Chuquicamata at the edge of the Atacama desert, nine thousand feet above sea level. When first offered the properties for £45,000, the Guggenheims turned it down. The profitability of porphyry ores was still unproven and the deposits were ten thousand miles away, on the Pacific Ocean, still a very long distance from New York at the beginning of the twentieth century. In 1911, after Utah Copper proved that porphyry ores could be profitably worked, Albert Burrage of Boston, a mining entrepreneur with an option on the property, recommended that the Guggenheims buy the claims and develop them. After the favorable report of Pope Yeatman, M. Guggenheim's Sons' consulting engineer, the company decided to proceed. In April 1912 they began digging at the Chuquicamata site with metallurgist E. A. Cappelin Smith in charge. Though they encountered difficulties, they decided to make the needed investment. Burrage received $25 million in stock in a new Guggenheim venture called Chile Exploration Company, or CHILEX, while the family retained the remainder of the shares, worth $70 million. In 1913 a new firm, the Chile Copper Company, a holding company incorporated in Delaware, took over CHILEX and two other corporations running the Chuquicamata mines.

It soon became clear that the Guggenheim foray into Chilean Copper had been a wise, even brilliant, decision. The deposits at Chuquicamata contained an estimated 303 million tons of porphyry ore with 2.3 percent metal content, making it one of the most extensive copper lodes in the world. Mining it would require techniques similar to those at Bingham Canyon in Utah—open-pit extraction using giant steam shovels. Fortunately, by 1913, the mighty Panama Canal had been almost completed and these gargantuan machines, along with railroad

locomotives and gondola railroad cars, could be bought as surplus from the U.S. government. In a ceremony at the presidential palace in Santiago on May 15, 1915, various Guggenheims along with American and Chilean dignitaries assembled to watch President Ramón Barros throw the switch sending current to Chuquicamata hundreds of miles to the north. The mine was now officially open.

Harry, Daniel's younger son, became the developer-in-chief of Chuquicamata. Under his direction the site was transformed. The isolation and aridity of the location required major outlays for infrastructure. The company built a port on the Pacific, ninety miles to the west, and erected an oil-fueled power plant to transmit electricity to the mine site. It built a small city at the bottom of Chuqui Hill with housing for both workers and managers. Ideology and good business sense reinforced physical needs. This was the era of "corporate liberalism" when enlightened American business leaders sought to apply the humane labor-management principles of the Progressives. But in Chile the company also faced a restless labor force without the internalized work ethic it could count on in Colorado or New Jersey. Chilean *rotos* were rootless migratory workers from the humid southern parts of the long, attenuated nation. They could not easily be bent to the company's schedules and needs. The twin urges of philanthropy and self-interest led to major innovations at Chuquicamata as they had in Mexico. The Guggenheims replaced the normal twelve-hour miners' day with an eight-hour workday and a system of pensions for long-term service. They instituted a program of safety education and established a hospital with five doctors in attendance. The company also built churches, recreation halls, schools, and a library for the residents. In 1916 it created a welfare department "to provide for housing, healing, educating and amusing a total of 10,000 souls."[1] These were intended to forge loyalty and reliability by reward, but to reinforce good work habits, the company also outlawed the sale and consumption of liquor and insisted on drastically shortening the list of time-wasting holidays and festivals the workers normally celebrated.

In creating a new community at Chuqui the Guggenheims undeniably acquiesced in the social distinctions of the era. There were separate

classes of housing for managerial staff and workers. Company executives received six-room cottages with two baths; the Chilean workers got houses with two or three rooms with one-fifth the floor space. Still, from the Guggenheims' perspective, the amenities offered the Chilean workers had the desired effect. As Harry noted in 1920: "The Chilean laborer, who five years ago lived in a hovel in filth . . . today lives in a small but comfortable home, enjoying the fundamental facilities that modern hygiene affords. Instead of the ragged, barefooted, irresponsible laborer of five years ago, there is a well-dressed, well-shod workman, with a spark of ambition burning within him."[2]

Harry clearly exaggerated. It proved much more difficult to eradicate ingrained habits among the *rotos* than he claimed. Workers predictably evaded the ban on liquor and managed to sneak off on holidays. They deserted Chuquicamata en masse at Christmas to celebrate the birth of Jesus in their traditional exuberant ways. In late 1919 discontented miners, urged by leaders of the *federación obrera*, walked off the job in support of striking railroad workers. Chilean troops, called by the company, forced forty families of the strikers to leave Chuqui and arrested several of the union leaders.

Chilean intellectuals, even more than the *rotos*, found the Yankee regime objectionable. The left-leaning writers Eulogio Gutierrez and Marcial Figueroa condemned with special passion the dual system that provided better housing, wages, and recreational facilities for "the bosses" than for the workers. Their indictment of the company and its practices derived as much from bruised racial pride as from rage at economic exploitation. The Yankees considered themselves "members of the privileged race and us as the backward, unadapted indigenous race," they charged.[3] The accusation was valid up to a point. The hierarchic labor system applied to Chuquicamata resembled that of other Guggenheim ventures abroad and also the great Panama enterprise where, under U.S. government auspices, white Yankee managers were a privileged group separated from the black Caribbean workers who dug the canal. It offends our modern sensibility, but it is hard to imagine how any group of Western capitalists could have overcome the cultural differences between themselves and the predominantly illiterate workforce

they employed, or how they could have transcended the system of class and race preferences of this era. All told, Chuquicamata was a benevolent, if paternalistic, system that benefited the Chilean workers and the Chilean economy. The Chilean government, anxious to encourage economic development, was more than content with the deal; the expropriations of foreign holdings, including Chuquicamata, under Marxist Salvador Allende were still far in the future.

The Guggenheims also invested in another Chilean copper mine, the Braden, located at Rancagua. Bought in 1908 from William C. Braden, a former ASARCO employee, the Braden property's ores were not as rich as Chuquicamata's, but they too proved highly profitable when Guggenheim ingenuity was deployed. At El Teniente, as the Braden refinery was named, they first employed the breakthrough flotation process to concentrate low-grade ores that made the enterprise profitable and, incidentally, opened to successful exploitation around the world ores formerly considered worthless. The Guggenheims sought to apply their benevolent labor policies at Braden too. At El Teniente they created a safety-first department that ran classes in safety practices and gave out awards for following safety rules. They offered the Braden workers prizes for the most attractive backyards and created community Boy Scout and Girl Scout troops. Despite, or perhaps because of, these policies, in 1919 the El Teniente workers struck for an eight-hour day and an end to Sunday work. The Chilean government dispatched troops and then arranged a compromise between the company and the workers.

IT WAS THE GUGGENHEIMS' good luck, though humanity's tragedy, that Europe, soon followed by the rest of the world, burst into flame in the summer of 1914. The United States entered the conflict in April 1917. The "Great War" of 1914–18 ate up people and resources at an appalling rate and profoundly affected the Guggenheims both personally and financially. Family members would make their individual contributions and sacrifices to the American war effort, but meanwhile they could not avoid hauling in profits in bucketfuls.

World War I was copper-plated. The battlefields of France were crisscrossed by miles of copper telephone wire connecting command

posts and trenches. Cartridge casings, expended by the millions from rifles and the lethal new machine guns, were made of brass, a copper-zinc alloy. Every motor vehicle, every ship, every airplane used pounds of copper for wiring, bearings, and engine parts. It was inevitable that profits for ASARCO, Guggenex, Kennecott, Chile Copper, and indeed all the Guggenheim copper enterprises should soar during the war years.

But not at first. In 1911 reformers, social visionaries, and power-hungry opportunists combined to overthrow the Guggenheims' patron Porfirio Díaz. Mexico now entered a turbulent phase of its history marked by the shifting regimes and ideologies that had made the pre-Díaz era such a misfortune for the country's economy and people. For years liberal and left reformers had attacked the Díaz regime for its generosity to foreign interests. In Mexico, as elsewhere in Latin America, social reform often took on an anti-American color. Given the linkage of political reform with anti-Americanism, it was no surprise that the family's Mexican ventures soon became the targets for the contending revolutionary factions struggling to replace the Díaz regime.

Initially, however, under the short-lived Madero government, the mining and refining business continued to prosper. In urgent need of money, the Maderistas proved surprisingly friendly to ASARCO. They even used government troops to suppress strikes among miners and smelter workers. Daniel reported in 1912 that ASARCO's Mexican department had contributed more than $3 million to the company's $11 million annual profit. Victoriano Huerta, Madero's immediate successor, was not so amiable. When the United States refused to recognize the Huerta regime, he suspended ASARCO's privileges and imposed forced loans and new taxes on the *Americanos*. Nor did the company's fortunes improve after Huerta was overthrown in turn by a coalition led by Carranza, Zapata, and Pancho Villa. Villa, among his other bandito tactics, stole silver ingots from ASARCO smelters and warehouses and compelled the company to pay protection money to continue operations. But in the succeeding years of turmoil sheer physical destruction was added to extortion and theft as blows to the company's profits.

Reporting to ASARCO stockholders on 1914 losses, Daniel noted that "the condition of affairs in Mexico continues to cause the Directors

anxiety." In August he and his colleagues had expected most of the firm's Mexican plants and mines to resume operations, but had been disappointed. "The cost of such damage as has been inflicted on the company's properties" had been absorbed, but it was reflected "in the decrease of earnings" for the year. During the rest of 1914 the war in Europe, Daniel noted, had done little to offset these setbacks.[4] Six months later markets and profits remained depressed. Mexican turmoil still plagued the company, and the uncertainties of the European war still undercut international metal prices.

The dramatic turnaround came in 1915 when huge war orders from the Allies finally flooded in. Profits leaped, and in May 1916 ASARCO declared an extra dividend to its stockholders of half a percent on the common stock. Soon after, Kennecott, reorganized in 1915 to incorporate Utah Copper, raised its dividends as well. In early fall the *Times* business page headlined a column on ASARCO: "Smelters' Earnings Break All Records."[5] The total income of the first six months of 1916, ASARCO reported, was twice as much as in the entire year 1914. The annual statement for all of 1916 placed gross earnings at $25 million, almost $9 million more than for the year before. And other Guggenheim copper properties reported equivalent jumps in output and profits. Kennecott, now the corporate name for the Alaska Syndicate operations, reported earnings of $43 million in 1916, or $14 per share. Analyzing the overall picture in early 1917, an industry newsletter noted: "the entire copper industry in this country is on the best footing ever known in its history."[6]

In August 1916, six months before the United States entered the war, the Wilson administration, as part of the "preparedness program," established a Council of National Defense to help mobilize the nation's economy for the anticipated crisis ahead. The president appointed Bernard Baruch, the Guggenheims' friend and protégé, to head its Commission on Raw Materials, and, recognizing the critical need for copper, in early 1917 Baruch turned his attention to the growing copper crunch and the high price of the red metal, likely to go still higher when the United States entered the war. Baruch solicited the advice of his former associate in western copper ventures, Eugene Meyer. At loose ends

professionally, Meyer had joined the Raw Materials Commission as a "dollar-a-year man" to help the war effort and soon become its resident expert in nonferrous metals. Meyer proposed a scheme to Baruch to fix the price of copper for defense industries at the average price for the previous ten years. This worked out to 16⅔ cents a pound, far below the current market price. Would the industry accept such a cut? Baruch wondered. He could not have been surprised when Meyer suggested that he consult his old friend Daniel Guggenheim and John D. Ryan of Anaconda Copper, one of the Guggenheims' perennial rivals.

Baruch and Meyer went to see Daniel at the St. Regis Hotel, now his New York residence,* where Daniel held a sort of open house at designated times to discuss business with callers. The visitors told Daniel that it looked as if the country would be drawn into the war and many families would be sending their sons to fight in France. These families "should not feel that the war was being fought so that rich men or big corporations could take large profits." The price of copper must be set low enough "so it would be clear that industry was ready to bear its burdens." Daniel listened and said he would have to speak to his brothers and the other copper producers. Baruch and Meyer should drop by the next day and he would have an answer for them. When the two brokers drove by the St. Regis the next morning, Daniel got into their car for the ride downtown and told them: "I think I can get you your copper [price]." Baruch later explained that he related the story "to illustrate the Guggenheim family character," by which he presumably meant their patriotism.[7] He later appointed both Daniel and Ryan to his agency's subcommittee on copper.

Though it was publicized in the press as a public-spirited act, not everyone was convinced that the copper deal, guaranteeing forty-five million pounds of copper at 16⅔ cents a pound, was a triumph of disinterested patriotism. In May 1917, after war was declared, House Speaker Champ Clark of Missouri attacked it on the floor of Congress. The copper magnates, he contended, had not sacrificed much. The Utah Copper

*Daniel had given up his Fifth Avenue home in 1907 and moved into a suite at the St. Regis Hotel. Meyer himself lived at the St. Regis.

Company, for one, had admitted at a stockholders' meeting that it could, if necessary, put copper "free on board cars at 5½ cents a pound." Why should Baruch think the government had gotten such a great bargain at 16 plus cents?[8] The sense that the copper industry leaders were profiteers grew as the government allowed the price it paid for copper to inch up beyond the original figure in the months ahead. In September it set a limit of 23½ cents a pound on the red metal and raised it to 26 cents in June 1918. Even though these prices were clearly below what the war-driven free market would have paid, the Guggenheims could not escape the charge of profiteering. As for Baruch, he was said by his enemies to have arranged sweetheart deals for the copper magnates and to have stolen "$50,000,000 in copper alone."[9]

Nor did the war's end stop the critics. After 1918 they charged the copper companies with overcharging the United States government some $350 million. The profiteering indictment against the copper magnates took a particularly vicious turn in 1920 when Henry Ford's notorious anti-Semitic book-length tirade *The International Jew: The World's Foremost Problem* devoted a whole chapter to the issue of wartime copper profits. Entitled "Jewish Copper Kings Reap Rich War-Profits," it called the Guggenheims, along with the Lewisohns, "the copper kings of the planet" and recounted the deal forged by Baruch with the copper magnates in 1917. In Ford's version, however, the arrangement was not a patriotic gesture but a conspiracy to rig copper prices to maximize profit of the copper kings at the expense of the nation at war. The copper magnates "made tens and hundreds of millions out of the war," the author concluded, and the nation consequently was forced to bear burdens it never needed to carry.[10]

In fact, the copper industry had indeed made generous profits during the war. By the end of 1918 the Guggenheim copper companies had paid out dividends of $200 million. Had these gains been legitimate? In every war the contrast between the profits of capitalists and the sacrifices of soldiers, between making money and dying, raises acute moral issues. But unless the private economy is nationalized in wartime and subjected to government management in every detail, it is impossible to avoid incentives for both workers and capitalists to get the job done.

Undoubtedly the Guggenheims made good money, but they produced the metal the war required, and their profits were no higher than those of other American industrialists. Yet it is not surprising that in the postwar atmosphere of disillusionment and skepticism, some Americans placed the Guggenheims among the "merchants of death" who had grown fat on world disaster.

Even one of the brothers considered the family profiteers, in a manner of speaking. Black sheep William, though continuing to draw income from past family enterprises, had exercised his right to opt out of new M. Guggenheim's Sons' ventures when he wished. In January 1912 he and Ben had waived their right to participate in Chuquicamata. Ben, as we saw, went down with the *Titanic* that year, but by 1914 when the Chilean mine looked like a surefire winner, Will, strapped for cash, changed his mind and asked Dan to count him in. Profoundly disgusted with what he considered his brother's financial profligacy and personally irresponsible behavior, Daniel indignantly refused. He would allow Will to rejoin M. Guggenheim's Sons' other ventures if he would "stop his speculation and idleness," but he could not expect to get a piece of Chuquicamata.[11] In a memo of mid-1914, big brother Dan disparaged Will's refusal to contribute to the partnership's ventures. "He has never gone into any enterprise that the individuals of M. G. Sons have gone into, and . . . he gave us a waiver for all these things." Daniel complained: While the other partners had "spent and obligated ourselves for half of about $23,000,000," and had "spent thousands of dollars," he, "although asked . . . never went into a single one of them." As for Chuquicamata specifically, Daniel continued, William only "became interested in the property . . . when he heard from me in Paris that it was a good business." He still had his desk at M. Guggenheim's Sons and still had "the privileges of the office." He could, moreover, be included in any further venture of the partnership if he wished to contribute time and capital, but Chuquicamata was out.[12]

Protracted negotiations followed between William and his brothers. He was willing to settle initially for yearly payments from each of the seniors and creation of a trust in his name. He resented, however, their efforts to dictate frugality to him. They in turn countercharged that he

owed them money and any award to him must include these debts as an offset. Negotiations soon broke down, in part over Will's exaggerated claims.

In 1916 Will took his brothers to court and sued them for $10 million on the grounds that they had hidden from him the true value of the Chilean properties. The suit came before Judge Benedict in Brooklyn Supreme Court in April 1916. He denied the seniors' motion to dismiss the complaint by summary judgment, sending the case to trial in Mineola, Long Island, in late June. In court Samuel Untermeyer, the brothers' chief personal lawyer, charged that William had not participated in the affairs of the company since 1900 and thereafter had refused to join various ventures. As for concealing the richness of the Chuquicamata ores, Daniel and the other partners had not learned of it themselves until July 1912, after William had waived his rights. William's lawyers, in turn, introduced evidence that Daniel and his brothers knew about the mine's potential before William had relinquished his right to join. Especially damaging to the seniors' case was the testimony of Pope Yeatman, the Guggenheims' chief engineer, that well before 1912 he had reported to his bosses how rich the mine was. In other words, they knew the worth of Chuquicamata well before William signed off. By implication they had deceived him.

The jury never got to decide the case. In late June the two sides settled for what the *Brooklyn Eagle* reported was $5 million. Untermeyer, when questioned by the press, did not deny a deal but called the figure "preposterous." There had been "no settlement for that amount, or for any amount like it," he insisted.[13] He was right. We have found the agreement. Signed June 28, 1916, it was for $2 million in cash, plus release of William from a half-million-dollar claim against him by M. Guggenheim's Sons. William was also to receive dividends, if any, from several minor Mexican properties. In 1923 the brothers gave William what he acknowledged as a "splendid and munificent gift" for reasons unknown.[14] Thereafter, as we shall see, William went his own way with few if any contacts with the other family members. A descendant of Daniel later described how, though he often visited the North Shore homes of Daniel and Harry, he and his relatives never stopped at William's adjacent estate.

It was in this same year, 1916, that the Guggenheims decided on a general overhaul of their enterprises. In March they created the Kennecott Copper Corporation out of the merged Alaska properties and that fall joined it with the Utah Copper Company, Braden Copper, and the Chile properties. As part of the restructuring, the Guggenheims liquidated Guggenex after sixteen years of operation. On the occasion of its dissolution, the press reported that the stockholders had received a total of more than $24 million in dividends, amounting to "a large profit on their capital."[15] At the same time M. Guggenheim's Sons, the partnership that had functioned as the family's managing company for so many years, was disbanded and replaced by Guggenheim Brothers, another partnership, limited by agreement to a five-year period subject to renewal. The partners in the new firm included the surviving brothers, minus William, but including Daniel's son Harry and Murry's son Edmond, to whom the seniors lent the capital to become full partners.

Including the two sons was a well-considered decision. Conscious of the passing years and their own infirmities, the seniors were determined to integrate the juniors into the family enterprises. As Daniel later expressed it, he and his brothers "wanted to interest the Juniors in the work and because they wanted to rely upon the Juniors to do the things that the Seniors could not do, or did not choose any longer to do."[16] But an exception was made to the revered family-only principle. In addition to Harry and Edmond, William C. Potter, a former ASARCO official in Mexico, recently vice president of the Guaranty Trust Company, was made a partner.* Potter would be in charge of the firm's Chilean operations and would mentor Edmond and Harry, who would officially be designated his assistants. Whether intentional or not, creation of Guggenheim Brothers finally severed the connection with Meyer, the fabled founder of the firm.

THE WAR WAS a profound personal experience for the Guggenheims. Daniel was in Germany in July 1914 when the European powers were

*In a curious way Potter's name would be joined to the family when his wife, Carol, divorced him years later and married Harry Guggenheim, Daniel's son. See chapter 9.

hurtling toward war. Florence had accompanied him to Europe, but she had stayed over at Aix-les-Bains in France, a stylish resort, while he went on to Ebenhausen, near Munich, for treatment of his chronic indigestion. In late July, as Europe tottered on the edge, Daniel concluded he should leave Germany and join Florence in France. On Saturday, August 1, he hired a car and chauffeur and set out for Berne, in neutral Switzerland. His auto was stopped near the border and again at Uberlingen in Baden. No foreigners, the nervous guards told him, would be allowed through. Daniel was forced to abandon the car and proceed by train for some miles before hiring another automobile. At every crossroad and railway crossing Daniel and his chauffeur were stopped by soldiers who officiously examined their papers before letting them continue.

When Daniel arrived in Switzerland he heard that the French army was mobilizing and that he might not be able to cross into France. He rushed off to the American consul in Geneva and explained his plight, but the consul expressed doubts that the French military would let him and his automobile through. Somehow Daniel prevailed on him to issue a special pass, however. When Daniel finally crossed the Swiss-French border, he and his fellow refugees found themselves driving behind a truck filled with French soldiers singing the "Marseillaise." The driver refused to let them pass until the party joined the patriotic chorus. That did the trick, and the refugees shot by on the road to Aix, reaching the town, and the worried Florence, at 7 p.m. on Monday evening.[17] Daniel had experienced a vivid, if tiny, bit of world history.

Through the war period the Guggenheims felt more vulnerable to hostile public opinion than other industrialists. German-speaking, Jewish, already tagged as economic malefactors, they worked hard to establish their patriotic credentials. Even before the United States declared war, they had rallied to the Allied cause. In November 1915 Florence donated $12,000 to a pro-Allies organization in Paris run by the American novelist Edith Wharton, to buy "hospital cars" for the French army. William, who labored the hardest to assimilate as a true-blue American, joined the American Defense Society, a super-hawkish group within the larger preparedness movement. Organized in September 1915

by anti-Wilson hawks, it was, in William's own words, "a patriotic organization of the deepest dye." Once America declared war on the Central Powers it campaigned "to excite allegiance to the American cause and to exterminate all manifestations of pacifism or pro-Germanism." In 1918 its handbook proclaimed that it was "fighting the widespread campaign in this country today by Pro-Germans, Socialists, Pacifists, Anti-Militarists, Anarchists, I.W.W.'s,* and similar organizations."[18]

The American Defense Society carried its superpatriotism and anti-Teutonic position to preposterous extremes. It demanded that the German language be dropped in the schools and recommended renaming American towns that bore German names. William chaired the society's Vigilance Committee, its Publication Committee, and its Teachers' Loyalty Committee, and contributed money generously to the organization. In March 1918 he heatedly attacked pacifists as "pro-German and slackers."[19] His role in the Defense Society not only proclaimed William's superpatriotism; it also enabled him to hobnob with high-status Americans. He would later boast of an encounter with Theodore Roosevelt, the society's honorary president, who greeted him warmly at a testimonial dinner when he learned of William's work for the group. William was also the promoter of a curious wartime campaign to donate the wood from black walnut trees, suitable for airplane propellers, to the government. Charging that German agents had bought up all the black walnut trees on Long Island before America joined the Allies, he recommended that estate owners on the island patriotically sacrifice their shade trees for the war effort. He himself volunteered the trees on his Port Washington property on the North Shore.

Other Guggenheims, though not as fiery as William, also scrambled to establish their patriotic bona fides during the war period. In the early spring of 1917, with America's entrance imminent, Solomon sponsored a great patriotic march by New York City schoolchildren for the Memorial Day holiday. Floats, flags, bands, and all the usual parapherna-

*That is, the Industrial Workers of the World (the "Wobblies"), an anticapitalist labor organization especially influential among western miners and lumber workers. Its leaders opposed the war.

lia of such occasions would confirm the polyglot city's commitment to the nation's heritage and goals. Solomon agreed to solicit his rich friends for needed funds and guaranteed to make up any deficit.

Once America joined Britain, France, and Italy as a combatant in April, the Guggenheims became major supporters of the war effort. Daniel, the family pundit, assured reporters at his St. Regis apartment in early June that America would win the war quickly if it fought it with vigor. "I predict the end of the war before 1918," he opined, "because . . . I have complete confidence in the determination and ability of the American people to carry on the war as they have started it, to fight with all of their might and not to stop fighting it until German autocracy is no longer a menace to the world." Daniel went on to prophesy—accurately as it happens—that victory would come through German and Austrian internal collapse rather than military conquest and, far less accurately, that the postwar world would be peaceful owing to the triumph of democracy.[20]

The Guggenheims also put their money where their mouths were. Days after war was declared Florence sent a thousand dollars to the National League for Woman's Service, a patriotic group of society women dedicated to mobilizing female support for the war effort. Hers was the largest contribution during the league's drive. In June Guggenheim Brothers contributed a half-million dollars to the American Red Cross, a sum only exceeded by the amounts subscribed by J. P. Morgan and Company and First National Bank, a Rockefeller affiliate. Each brother contributed an equal share of the total. The Guggenheims also made large contributions to the Liberty Loan bond drives. In his June 1917 interview Daniel had urged Americans to subscribe to the Liberty Loan to help defeat the enemy. In the third Liberty Loan campaign of mid-1918 Guggenheim Brothers bought a million dollars' worth of bonds. The family not only bought bonds themselves; they also actively promoted the sale of bonds to others. By the end of the war Florence had sold nearly $6 million during the four Liberty Loan campaigns. According to the press this was "a record for an individual, so far as is known." Florence was also a magnificent publicist for the family's patriotic efforts. As she explained to a reporter, her "heart and soul" were

"in the Liberty Loan work." Her two sons and her son-in-law were in "active service abroad" and their sacrifices made it much easier for her to make her pitch to people who did not understand the absolute safety of the bonds.[21]

Florence's inventory of the family's military commitments was neither detailed nor complete. Her older son M. Robert had enlisted in the New York National Guard in June 1917 as a private. Mustered into federal service, he was sent to France later that year as a first lieutenant in New York's famous "Fighting Sixty-ninth" infantry regiment. Harry became a naval aviator, almost the first of that breed. Her son-in-law, Roger W. Straus, became an intelligence officer on the staff of Major General William S. Graves, the commander of the U.S. expeditionary force sent to Siberia in 1918 after the Bolshevik revolution. Besides Florence's sons and son-in-law, other Guggenheims served their country. Edmund Haas and Louis Josephthal, sons-in-law of Isaac, were both in uniform by war's end. Haas, husband of Helene Guggenheim, Isaac's youngest daughter, became a captain in army ordinance; Josephthal, husband of Edyth Guggenheim, joined the navy, where he eventually rose to the rank of commodore. Also in uniform during the Great War was Murry's son, Edmond, who as a draftee spent a few months at Camp Meigs at the Motor Training School, and Harold Loeb, son of Rose, also drafted, and stationed as a clerk close to New York during his few months in the army.

There are no detailed sources of information about the young Guggenheims' war experiences—with one exception. We have a surviving cache of letters from Daniel to his older son with the AEF in France, though we learn more from them about the family's homefront life in wartime than about Robert's military adventures.

Despite all the past discords, Daniel is affectionate toward Robert as befits a father writing his soldier son at the battlefront. He tells him that his two little boys, Daniel II and M. Robert Jr., then nine and seven, are prospering and enjoying visits to their grandparents. In June all six grandchildren come for a two-week visit and are kept happy and occupied by instruction in shooting, swimming, and golf. "When the time comes for them to return home, I am sure," Daniel writes, "they will leave with a heavy heart."[22] Daniel praises the state of American war

morale and the country's determination to beat the Germans. He also notes, in January, that his brothers, Robert's uncles, are all preparing to go off on vacation to the South to get away from the harsh winter weather. He assures his son that his mother is "by no means a slacker. On the contrary she is actually engaged in many directions having to do with the war."[23] He describes her work on the Third Liberty Loan and his own as a captain for the second Red Cross drive. He gives details of the venture of Robert's wife, Margaret, with Uncle Sol into potato farming on the island to help meet the government's food drive. The news on that front is bad, he confesses: "the lowest loss will be about $5,000."[24]

It is clear from the letters that while Florence was busy with volunteer war work and Daniel was frequently in Washington on Guggenheim Brothers' business, they continued to enjoy the diversions of the rich. "We have a great many Sunday luncheons at 'Hempstead House'" (his mansion at Sands Point on Long Island), Daniel tells his son. And he manages to play golf on the weekends, an activity that is "the best thing for keeping [him] on his pins and in good condition."[25] As summer approaches Daniel tells Robert that he has rented a cottage in Long Beach, on the south shore of the island, to use if the weather should become too hot at Hempstead House.

Daniel also discusses business with his son. In July he writes apologetically about impending increases in copper prices. Despite the agreement of the copper people to hold the line, the government is about to authorize a rise in price. The change, he explains, "is made necessary by the increased cost of labor, increase in the freight rates, and, in fact, the increased cost of everything that goes into the production of copper." He acknowledges that higher copper prices would be particularly advantageous to the Chile and Braden companies because they have not been subject to the same increasing costs of production as American firms. On the other hand, ASARCO's long-term contracts are too low and the firm is suffering.[26]

Daniel writes at length about the larger issues and strategies of the war as suits a man in his prominent business position. He discusses global war plans and how Allied munitions superiority will guarantee German defeat. He suggests how to deal with Germany when it is beaten

militarily. Daniel predictably denounces the Bolsheviks whose with-drawal of Russia from the war has been so advantageous to the Germans.

Robert was primarily a staff officer, but he faced danger and encoun-tered hardships. We learn that he was hospitalized with some sort of infection in early 1918 and that he spent some time in Paris recuperating afterward. He also hurt his knee, possibly by being thrown from his horse. Robert's unit, the Rainbow Division, saw action in March 1918 and was "giving a good account of itself" in the battle to stop the German spring offensive.[27] He writes in April: "The damn Boche has been making quite a drive but we all hope it is only temporary."[28] Robert wrote more frankly to Uncle Solomon than to his parents about the dis-comforts of war. At one point he told him, "We work like hell all day and sleep like hell all night."[29] Robert even found himself in combat during the summer of 1918. As he wrote a friend, Eddie Ochs, in June, he had been assigned to the Thirty-second Division, composed of Michigan and Wisconsin National Guard troops and was with the 127th Infantry during the Alsace campaign. There he "conducted several raids; com-manded a platoon that was on post in an isolated spot when we were raided by the Boche one night, and lost six men." Soon after he became aide-de-camp to General W. D. Connor, a real fighting general, he explained, who "likes to get right up there in the thick of things." His division was "in the big fight from Chateau-Thierry to Fisms," and he "had a number of miraculous escapes." Fortunately, he "got through the entire campaign without a scratch (knock on wood), and was only gassed slightly" because he was "a little slow" in putting on his gas mask.[30]

John H. Davis in his biography of the Guggenheims belittles Robert's wartime service. His good reports from his commander, he claims, came from Robert's talent "as a party giver."[31] But the record suggests a solid military performance. Robert was recommended for promotion to cap-tain twice though these were denied. At the end of August 1918 General O'Connor proposed Robert's promotion to major, an unusual two-rank boost. Lieutenant Guggenheim, the general wrote his superior, has "been of more assistance to me since my arrival here than any other offi-cer in the Base Section and has shown remarkable grasp of the work to be done."[32] In late September the promotion was granted.

Robert "found a home in the army," as the expression goes. For the rest of his life he was active in the reserve and enjoyed his association with military men. As a reserve officer he took courses at the Army War College and received a certificate in 1925. We know far less about Harry's military experience than about his older brother's but it was the more consequential for the nation.

Harry Guggenheim was a brave, enterprising, and responsible young man, much more like his father than his scapegrace, unambitious older brother. He was attending Sheffield Scientific School at Yale in 1908 when he met Helen Rosenberg and fell in love. When he told his father he wanted to get married and leave school, Daniel was not happy and shipped him off to the ASARCO smelter at Aquascalientes to earn his bride price, as it were. In what seems like a package deal, Harry returned home in 1910, married Helen in November, and resumed his higher education, this time at Pembroke College in Cambridge University, where, in 1913, he received a B.A. degree.

A varsity level tennis player, Harry had often paired with H.C. "Carly" Webb of Christ's College on the Cambridge courts. When World War I broke out in the summer of 1914 Webb enlisted in the British army and died in action. Harry was dismayed by his friend's death and in early 1917, with the United States about to declare war on Germany, decided to join the service. It is not clear why he chose to go into naval aviation. One factor was surely a sense of adventure; aviation was an untested, hazardous enterprise. But there were also social considerations. In early 1917 a group of Ivy Leaguers led by Frederick Trubee Davison, son of a Morgan partner, organized a volunteer aviation unit recruited primarily from Yale. These young men created "The First Yale Aviation Unit" and prepared to serve their country by taking private flying lessons. Although a married man of twenty-seven, Harry joined this group and learned to fly in Palm Beach, Florida. When he returned to New York he bought a flying boat, and when a friend crashed this plane he finished his training on a twin-engine Curtiss craft. In September 1917 Harry and his group joined the Naval Reserve Flying Corps. Sent overseas, they took further training at the bombing and gunnery school near Bordeaux in France. Harry was assigned to the western front in

France but was also sent to Italy to buy Caproni bombers for the navy. There he met another American military pilot on government assignment, Major Fiorello La Guardia, a former Republican congressman from New York City.

Harry rose to the rank of lieutenant commander before being discharged from service in late 1918. The experience of the war years burned itself into his consciousness. Like his older brother, he made friendships among aviators that lasted for many years and helped define the rest of his life. But in Harry's case the experience would also help transform the nation.

IT IS NOT TOO MUCH to see the Guggenheims' labor policies during the war as another attempt by an insecure family to avoid criticism. The Guggenheims' record on labor before 1914, as we saw, was mixed. At times they seemed benevolent bosses; at other times, like many mine and smelter owners, they fought to preserve the harsh labor status quo. Most recently, they had deeply offended liberals and friends of the workingmen by their response to a violent labor spasm in Perth Amboy when, in June 1912, four thousand angry Hungarian and Slavic workers in five different Perth Amboy mills and plants, including ASARCO's, walked off their jobs to demand better wages and improved working conditions. The men, "aflame from drink," according to the *New York Times*, clashed with the town's small police force, forcing the local sheriff to call for reinforcements from New Brunswick.[33] Twelve hundred of the strikers were ASARCO employees.

There is evidence that the radical IWW had a hand in igniting the fire. But there was fuel enough without their connivance. At the ASARCO smelter, for example, the men received an essential bonus only if they worked twenty-eight consecutive days without a day off. These days were grueling. When one newly hired worker asked a manager how long the workday was, the boss replied: "You start at seven o'clock and work until you get through."[34] Such a regimen, the men said, was not only punishing; it was dangerous. They would not accept it. Rather than shut down their plant, ASARCO officials quickly brought in five hundred strikebreakers from New York by boat and landed them at the com-

pany dock on State Street. To protect the "scabs" from the strikers, they hired fifty armed guards from a private security agency. On the second day angry strikers attacked E. M. Faircloth, ASARCO's assistant cashier, when he tried to leave the plant. They also pummeled the two gang foremen who came to his assistance. All three men were badly beaten. When strikers charged the company gates, the Waddell-Mahon security guards let loose a fusillade of rifle shots from plant roofs and windows. The attackers retreated; four were wounded. On the third day four men throwing rocks at armed ASARCO guards died when the panicky deputies fired at them.

On June 15 ASARCO officials and a committee of strikers began negotiations to achieve a peaceful settlement. The violence had jolted the Guggenheims badly and they capitulated, accepting most of the men's demands. They agreed to abolish the bonus system and to pay an extra fifteen cents day to the lowest-paid men. Higher-paid workers would get smaller increases.

The bitter experience of Perth Amboy softened the Guggenheims' attitudes toward labor, though not toward unions. These they always opposed, ferociously at times. In 1913 Daniel established an Employees Welfare Department and hired Franklin Guiterman to undertake a study of ASARCO's labor force in mining and smelting, with particular attention to safety and health. In 1915 a new company Safety and Labor Committee began to issue a magazine, *Safety Review*, to educate employees to the many dangers in the mining and smelting industries. The editor of the new publication was Roger Straus, Daniel's son-in-law. By this time ASARCO had also established a limited pension fund for longtime employees. As fully developed during the war, all male employees over sixty-five and all female employees over sixty who had worked continuously for ASARCO for twenty years would be entitled to a pension based on their annual pay for the ten years preceding retirement. The scheme was enlightened for its day but not wildly generous. No pension could be greater than $200 a month (or less than $20). By the end of 1919 the pension fund had paid out $353,000 to 356 pensioners, making average annual pensions just under a thousand dollars. Almost all the beneficiaries were better-paid white-collar employees or skilled workers. These

were virtually the only ones who stayed at the job for the twenty years needed to be eligible.

Daniel explained his labor philosophy to the United States Commission on Industrial Relations when it held hearings in New York in January 1915. Created by Congress in 1912 to investigate labor strife and the conditions of American workers and recommend remedial legislation, the commission, chaired by Frank Patrick Walsh, a liberal Kansas City lawyer, held meetings around the country in the immediate prewar years, interviewing laboring men, labor leaders, economists, and industrialists. On this occasion the commission focused on "the relations that exist between the centralization of wealth and power . . . and a feeling of unrest among wage earners."[35] Besides Daniel Guggenheim, Walsh also interviewed John D. Rockefeller; George Perkins, the Morgan partner who had collaborated in the Alaska Syndicate; and Edward Berwind, an important coal company executive.

Daniel gave his testimony under the crystal chandeliers of New York City Hall's Board of Estimate room. He described ASARCO's effort to give "the men better living and working conditions" through its workmen's compensation scheme. Defensive about Perth Amboy, he noted that the workers there were also insured by the company in case of accident, with an injured man receiving $500 and his widow, in case of fatality, $1,000. Walsh asked Daniel what he would do if he heard that some of his workers and their families were not receiving "enough to support them." "I should order an investigation and, if the facts were proved," Daniel replied, "I should do everything in my power to alter conditions." Walsh asked Daniel about the Perth Amboy strike. What had caused it? Daniel refused to accept blame for ASARCO's policies. It had been triggered by the high cost of living. That condition, not the company's actions, had inflamed the men's feelings.[36] It was not unknown in this era for large employers to provide benefits to their workers as tokens of benevolence. It was quite another thing, however, to endorse unions, autonomous workers' organizations that, they held, often incited employees against their bosses and reduced employers' freedom of action. Daniel admitted the right of his workers to organize. But he would not condone a "closed shop" where employees were required to

become members of a union. Every man who worked for him had the right to join a union, but "we will not let any union organizer walk into our plant and tell us what we shall do. . . . We have the interests of our stockholders to share."[37]

Daniel was obviously sensitive to the contemporary public anxiety over the excesses of unrestricted capitalism. Capital, he noted, was likely to get arbitrary with too much power. He held that envy often triggered workers' discontents but insisted that there had been "a great awakening in the last few years and employers are seeing that it does not pay them to grind down labor." His solution was not the offsetting power of organized labor, however. Drawing on his European experience, he favored instead adopting for America the same sort of social safety net recently installed by Britain and Germany. Moving still further left, Daniel must have astounded the commission and the large audience of labor leaders, reformers, and social workers who had turned out for the hearings. The "State should furnish work for men who lack employment," he announced. "You may call me socialistic, if you like," he went on, "but it is the job of the United States to look after its people." He acknowledged the high costs of the sort of welfare system he was describing, but thought the needed money could be raised "by taxing the estates of the rich."[38]

All told, it was a bravura display of conciliation and public relations. Even Ida Tarbell, the journalist whose impassioned muckrake of the Standard Oil Company had permanently besmirched the reputation of John D. Rockefeller and his associates, approved the performance. Daniel Guggenheim, she wrote, had been "earnest in his sympathy for the laboring men and radical in his ideas of what should be done to improve their lot." But she did disapprove of his views on inheritance taxes. They were too radical; not sound economics![39]

America's actual entry into the war in the early spring of 1917 inevitably tightened the labor market and gave extra bargaining leverage to labor organizers and "agitators." Meanwhile, leaping consumer prices, outstripping wage increases, eroded workers' incomes. Nation-wide, the inevitable occurred. During 1917 there were 4,450 strikes nationally, the largest number on record. Many erupted in the West,

where, as we have seen, miners, lumberjacks, and smelter workers were steeped in a tradition of militancy. Anticipating labor troubles that could hobble the war effort, the Wilson administration early on recruited Samuel Gompers, president of the American Federation of Labor, as a conciliator of wartime labor-capital disputes. As head of the Committee on Labor of the Council of National Defense, Gompers called a meeting in Washington in May to bring together representatives of labor, capital, and government "in an effort to bring about full cooperation . . . for the more efficient prosecution of the war." Gompers invited to the conference at the AFL's Washington headquarters five money men, including John D. Rockefeller, Jr., and Daniel Guggenheim. The participants apparently spent most of their time listening to visiting English and Canadian trade unionists discuss labor management relations during wartime, drawing on their experience of their countries' economic mobilization against the Central Powers. Neither Rockefeller nor Daniel Guggenheim, of course, had a spotless record on labor. Just three years before, Colorado militia, protecting Rockefeller's Colorado Fuel and Iron Company, had fired on striking coal miners at Ludlow, killing more than forty miners and members of their families. The public outcry against Rockefeller was deafening. But now, moved by patriotism and flattered by the honor of the occasion, both men fervently pledged their support for the administration's policies of labor peace.

For Daniel the hearings uncovered a surprising pool of social compassion and self-awareness. When called on to speak, he announced that the meeting had been a revelation and had "inspired" him. In a confessional mood, he described how he had believed for some time that his working life was winding down. After forty-five years of striving he finally felt he could turn his business over to his sons and son-in-law. But now, with the war emergency, he had decided to stay on and allow the younger men to serve their country rather than the business. When he received the invitation to the meeting, he went on, he felt that there was enough on his shoulders, but after listening to the trade unionists and the other speakers he was "prepared to do anything I can—just so long as I am able to carry it out." The committee was "on the right track," he

enthused. It was "doing the right thing." In the afternoon the partici-
pants went to the White House to meet President Wilson, who congrat-
ulated them on their edifying spirit of cooperation.[40]

In the event, the Guggenheim firms could not avoid several damag-
ing wartime labor disputes In June, barely a month after the Washington
conference, Kennecott miners in Alaska went on strike for higher wages.
The company initially refused to yield and evicted the men from their
company-owned housing. Meanwhile the Kennecott officials spread the
report that the strike had been instigated by German agents. In the end
Kennecott settled, granting the men 25 cents more a day in wages. The
men returned to work. ASARCO also made wage concessions to the
refinery workers in Perth Amboy. Faced with the prospect of another
strike, the company agreed to a 2-cent-an-hour wage increase.

But, again, these concessions did not imply acquiescence in the men's
right to join trade unions and engage in collective bargaining. In early
1918 Kennecott officials demanded that all their employees sign a
"yellow-dog" contract. This device, a common management weapon of
the day against organized labor, required as a job condition that each
employee pledge not to join a union and asserted the company's right to
fire any worker who violated this provision. In a notice posted for the
men to read, Kennecott management claimed that it was placing unions
off limits to protect the men against coercion by union organizers and
"preserve the friendly relationship between the company and its
employees."[41] Of course the policy undoubtedly had the opposite effect.
Inevitably, union leaders attacked Daniel for hypocrisy, comparing his
prolabor statement to the Walsh committee with his behavior toward his
employees in Alaska.

ASARCO was plagued by wartime labor troubles in the West as well.
At Utah Copper the ten-hour shift was a chronic grievance. The men also
complained of the two hours they spent coming and going to the mine
site in wet and muddy clothes. When union organizer Ben Goggins
appeared on the scene, the miners rallied to his side. Faced with the
prospect of an organized rebellious labor force, the management threat-
ened to do Goggins bodily harm if he did not leave. Goggins appealed to

Gompers: ask his friend Dan Guggenheim to call off the company's toughs. Gompers dispatched federal mediators to Bingham to hold hearings at which the company's officials denied making threats. But local law enforcement agents were not so reticent. They had no intention of permitting the organizers to stay, they said. "And little technicalities of the law [would] not be permitted to stand in the way."[42] Goggins, though a brave man, decided to leave without ceremony. The rebellion was over.

WORLD WAR I ENDED in the fall of 1918 with the overthrow of the German, Austrian, Russian, and Turkish empires. The years following also marked a retreat of the Guggenheim industrial empire. Copper prices fell precipitously in 1919, as did the prices of zinc and lead, two other Guggenheim metals. The normal response of businessmen to falling prices was cutbacks, of course, but the government urged the mine operators to continue production to avoid drastic layoffs in the industry and so preserve labor peace. Inevitably, unsold copper ore piled up in vast amounts. Forced to buy unwanted ores, ASARCO had to borrow large sums from the banks. Meanwhile, unrestrained by a similar government mandate, the smelter operators shut down. With no copper reaching the market, for a time the *Engineering and Mining Journal*, the standard forum for price information, refused to quote a price for the metal. When it resumed its reports in February 1919, copper sold for 15 cents a pound, a little more than half the wartime level.

The postwar metals depression hit the Guggenheim hard. The Utah and Kennecott mines cut their labor force and slowed output to a fraction of their wartime levels. Several Guggenheim smelters were shut down entirely. In 1919 ASARCO cut its dividend by one-third, and in May 1921 passed over a dividend on its common stock entirely for the first time since 1904.

The copper producers responded to the postwar slump by organizing a consortium, under the terms of the 1918 Webb-Pomerene Act,* to market the copper surplus aggressively abroad. In January 1919 a group

*This measure exempted firms from provisions of the antitrust acts in the case of products sold overseas.

from the Copper Export Association, including Solomon Guggenheim, sailed for Europe to drum up business for American copper. In the months after the Armistice the continent was still suffering from the devastation of war and was still not able to buy American copper. European buyers rejected out of hand the price of 23 cents a pound the Americans wanted. As a discouraged Solomon declared on his return, "Europe is sick, very sick and, while reconstruction will mean big demands for products of all sorts, this will not develop for some time to come."[43] Soon after, the Export Association established a fund to extend credits to European buyers of copper. This scheme was at best modestly successful. At the beginning of January 1921 the press reported that the producing companies were "endeavoring heroically to extricate themselves from the bad position," largely through the export market, but as yet foreign buyers were scarce.[44] That same month ASARCO announced a 15 percent cut in the wages of all employees who received less than $5,000 a year. In April the other shoe fell when the executive force in all ASARCO plants, from Simon down, took a 20 percent cut in their salaries. Still another wage cut was imposed in January 1922. Fortunately, the association was able to neutralize the depressing effect of its surplus copper by issuing $40 million of debentures, in effect warehouse receipts, against the stored ingots, and inducing the bankers to buy them. Through this plan the copper surplus was removed, at least temporarily, from the active market, thus relieving its depressing effect on prices, while the infusion of cash from the banks rescued the industry from the threat of immediate bankruptcy.

Meanwhile, the Guggenheims' relations to the industries that had thrust them into world prominence changed. In January 1919 Daniel finally retired from ASARCO and from American Smelting Securities Company, as did Murry and Solomon. Simon became president of ASARCO. Edgar Newhouse, a mining engineer whose connection with the firm went back to its founding, became chairman of the board and second in command. On the occasion of this transfer of power, Daniel announced that it was time "to turn over the management and control to younger and more aggressive men." He introduced Simon to the stockholders as the "Honorable Simon Guggenheim, formerly United States

Senator . . . , a very capable merchant, experienced in the smelting busi-
ness." Under Simon's able hands, he promised, the company would
flourish.[45]

It did not, according to Karl Eilers. Vice president of ASARCO and a
major shareholder, Eilers in December 1920 petitioned the courts for a
writ of mandamus requiring that ASARCO allow him to inspect the com-
pany's stockholder list so he could solicit the nineteen thousand share-
holders' proxies. Eilers believed the company's board of directors, almost
all ASARCO employees, were puppets of the Guggenheims and must be
replaced. As the *New York Times* noted, "the suit is regarded as prelimi-
nary to a campaign by Eilers to take the management of the company out
of the hand of the Guggenheims at the annual meeting in April next."[46]

Eilers had long been associated with the Guggenheims and
ASARCO. Son of German-born metallurgist Anton Eilers, one of
ASARCO's original directors and a large stockholder in the corporation,
Karl himself was a rival to Simon when both young men had been ore
buyers in Colorado. He later became a metallurgist for ASARCO and
chairman of the firm's construction committee. In 1916 he was elected to
the board of directors and became vice president of the company. Eilers
was a substantial stockholder in the firm.

Despite his success at ASARCO, Eilers never worked well with the
Guggenheims. He resented their domination of the firm his father had
helped found. He believed that, with a few exceptions, all the good jobs had
been reserved for Guggenheim family members, with nonmembers largely
excluded from the decision-making process. Even though he was well paid
himself, he claimed that the salaries paid by ASARCO to individual
Guggenheims had been exorbitant. Moreover, his old rivalry with Simon
had never been resolved. He often locked horns with the brothers and had
been rebuked and criticized by the firm's executive committee. At the end
of March 1920 Simon wrote Eilers telling him he was fired as vice presi-
dent. From the beginning he had not been "in sympathy with" Simon's
administration, the senator noted. Simon had hoped that "time would
work a change and bring about a better accord," but a year had passed and
there was "no prospect of such a result." With "deepest regret" because of
their "long association" Eilers was being removed from a management role

at ASARCO. If Eilers wished, he might take the initiative and resign voluntarily before the upcoming directors' election on April 6.[47]

Eilers refused to resign and instead demanded that Simon himself leave the company in the interests of the stockholders. Meanwhile, an ASARCO official, interviewed at the company offices at 120 Broadway, told reporters that if Eilers had complied with company rules he could have inspected the stock lists without interference. The suit was entirely unnecessary. Soon after, the company charged that Eilers's suit was the vengeful act of a disgruntled, discharged employee. It denied a charge in the Eilers complaint that the Guggenheims owned only a small bloc of stock in ASARCO. Simon's holdings in the firm amounted to $3 million and his brothers had substantial additional amounts. Simon's official stock holdings on the books might be only a hundred shares but in fact he owned much more in the names of other stockholders.

In arguing the case before the New York court Eilers's attorneys insisted that the promise of cooperation was not sufficient; the company could withdraw at will the right to inspect the list of stockholders. In response, Edgar Newhouse denied that ASARCO had been conducted for the benefit of the Guggenheims without regard for the other stockholders. Newhouse stretched the truth shamelessly in defense of his bosses. In the years that he had been associated with the firm, "the Messrs. Guggenheim have not dominated nor controlled the action of the [ASARCO] Board of Directors, but have advised or consulted with the officers and other members of the board upon the various matters of business policy that have arisen." In his estimate "they have only exercised such influence as they possess by reason of their experience and ability in the business of smelting and refining and particularly they have not made use of the company to further and benefit their own selfish ends."[48] Several weeks later Simon sent ASARCO's stockholders a pamphlet defending the family's management of the firm over the years. ASARCO had been a highly profitable company, he noted. All told, since its founding, the company had achieved net earnings of some $250 million. It was regrettable that Eilers's suit "should be brought in a period of drastic readjustment of all security values." It had caused "a needlessly severe and unjustifiable fall in the market price of the stock of the company."[49]

The court dismissed the petition for mandamus since the company had opened its stockholder list voluntarily, but the aggrieved former vice president proceeded with his campaign to oust the Guggenheims. Eilers formed a committee of stockholders to validate his charges and bombarded the remaining stockholders with letters claiming that the Guggenheims had dumped their ASARCO stock years before and no longer had substantial financial interests in the company. How could they be expected to manage an enterprise in which they had only marginal ownership? They had also excluded ASARCO's stockholders from the profits of Kennecott and Chuquicamata when they purchased and developed these firms, the indictment continued. Stockholders friendlier to the Guggenheims, or at least neutral, formed their own investigatory committee of outside business executives headed by Henry Evans of the Continental Insurance Corporation. Simon agreed to cooperate with the Evans committee, but the family also asked ex-president Taft to serve as a mediator between the factions. Taft accepted.

The showdown came on the day of the 1921 stockholders' meeting in Jersey City. Eilers and his allies counted on the sharp drop in the firm's shares on the market to induce independent stockholders to vote for his slate of directors. The Guggenheims were confident that their record and their incumbency would carry the day. Their slates had never been successfully challenged before, but to meet Eilers's criticism and improve their odds, they selected as their candidates prominent bank directors and some of the firm's largest stockholders. Many were respected independent businessmen rather than family members or company employees.

All told more than a hundred stockholders crowded into the company's New Jersey headquarters on April 6, forcing the managers to adjourn to St. Peters Hall. There the Eilers forces, anticipating defeat, proposed an adjournment to October while in the interval the management would be required to provide detailed information about the company's affairs to the Evans committee. That group, the Eilers resolution specified, should look particularly into claims that the Guggenheims had subordinated the interests of ASARCO to their own private ventures.

The family responded through Solomon, a smoother, suaver speaker

than Simon. To establish his credentials, Solomon noted that he owned more than eight thousand shares of the firm's stock and had served as a director and chairman of its executive committee. He was there today, he stated, "to demonstrate the unfairness of the reckless attacks that have been spread broadcast." He rehearsed the past history of ASARCO and described how the Guggenheims had come to its rescue soon after its formation. Then "its very life was problematical." But since the Guggenheims had taken the helm the company's net current assets had risen from $7 million to $54 million, and in the intervening years it had paid out $103 million in actual cash dividends. In 1920 its total cash receipts had exceeded $308 million.

Stretching the truth more than a little, Solomon denied that the family had totally dominated the firm's management. They had always "believed in the development by the Company of an efficient corps of young experts drafted from the best universities." They had encouraged the development of these young men until their "abilities have landed them into position of highest rank and greatest responsibility." The Guggenheims "have never believed in despotism or nepotism." Solomon defended the choices for board members under the Guggenheim aegis.

Solomon personalized the dispute, as had Eilers and his partisans, of course. Getting off a shot at Eilers, he noted that only "in a single instance" had the board committed "an error of judgment" in its choice of officers. For a long time it believed in the ability of "a man whom it encouraged in every respect" and had made him vice president. Only "when confronted with indisputable proof of inefficiency, insubordination, and willful extravagance did the Company sever that relation." It was being asserted that Eilers had been fired only because he openly defied the Guggenheims. In fact, he had been incompetent. He had, for example, secretly countermanded orders from ASARCO's managers costing the company millions of dollars. As further refutation of Eilers's claims, Solomon noted that only two years before, the insurgent had signed a directors' statement praising Daniel, Murry, and Solomon as the men whose "devotion, constructive imagination, great ability and untiring industry" had made the company's success possible.

In response to Eilers's charges that the Guggenheims now possessed only a small minority stock interest in ASARCO, Solomon claimed that most of the Eilers family stockholding had dwindled as well. That the company's shares had recently fallen owing to mismanagement did not reckon with current realities. "General market conditions, widespread financial depression, huge financial problems, and all the many depressing influences would alone have served to lower the shares." But in addition, Solomon added sarcastically, the current parlous state of ASARCO stock also "needed . . . the kindly and indulgent treatment Mr. Eilers has given."[50]

After Solomon's brief for the defense, Eilers's partisans bombarded Francis Brownell, a Guggenheim ally, with hostile questions. Eilers himself reported that Brownell, who now so adroitly defended the Guggenheims, once told him in his office that he did not fully approve of all of the Guggenheim board, "but what are you going to do when you work for a man." By "man," Eilers noted, Brownell meant Simon Guggenheim. When Brownell denied that he had ever made such a statement, Eilers shot back: "one of us is not telling the truth."[51] When the vote was taken the Eilers resolution was defeated by 660,000 shares to 204,000—by three to one. Shortly after, the participants returned to the company's New Jersey offices at Exchange Place. There William Loeb, Jr., a company official, formally nominated the Guggenheim ticket. With the result a foregone conclusion, the Eilers people did not challenge the Guggenheims with their own slate.

The results pleased neither side. The Guggenheims had won, but they were dismayed that their opponents had gotten so far. And they were upset that they had been forced to admit so many outsiders to the company's directorate. Meanwhile, the dispute did not die. Eilers soon hurled new charges at the Guggenheims for serving their own "personal and selfish ends."[52] The stockholders now turned to the Evans committee to resolve the dispute once and for all and asked former president Taft, who had already agreed to mediate, to evaluate their report. When President Harding appointed Taft chief justice of the United States, he withdrew from the Guggenheim suit in favor of Elihu Root, the distinguished former New York senator and secretary of state. Root was an old

friend of Daniel* and a former colleague of Simon in the Senate, but he
could not prevent the majority of the Evans commission from criticizing
the family. The 142-page majority report in mid-May made no charges
of graft or peculation and praised the Guggenheims for making the com-
pany profitable. ASARCO had "made large earnings, that it stands today
with a great and valuable plant and organization." Moreover, "the busi-
ness management of the company has been successful and a highly effi-
cient organization for the conduct of its business has been built up." But
it went on to condemn the payout of large dividends during the war years
without attention to capital reserves. More telling, it criticized the fam-
ily's adroit manipulation of ASARCO's finances to their immense per-
sonal profit. The brothers had run the company well but had profited
obscenely. To prevent further profiteering there should be a new board
of directors totally independent of family influence. Root wrote the
minority report, a virtual whitewash. It lavishly praised the Guggenheim
management. "The Messrs. Guggenheim are entitled to a very large
share of the credit for the company's prosperity . . ." it stated. In the
twenty years since ASARCO's formation the stockholders had realized
more than 6 percent a year. The company had paid out to them $118
million on a cash investment of $47 million. If not for the collapse of the
copper market with the war's end, "the management of the company
would probably be receiving testimonials of gratitude from the stock-
holders." "My conclusion," Root summarized, "is that the management
of the smelter company is not subject to just criticism . . . but is entitled
to high credit for its devotion to the interests of the company and the
fairness and integrity of its management."[53]

In the ensuing weeks both sides solicited proxies for the next board
meeting scheduled for June 1922, when the dissenters would have
another opportunity to replace the Guggenheims' board of directors.
Yet at the actual meeting, rather than contest their opponents' slate, the
Guggenheims agreed that a new board be chosen, "a majority of whom
will represent large independent stock interests who have had no official

*He had been associated with the Guggenheims in the Alaska Syndicate and would be
an honorary pallbearer at Daniel's funeral in 1930.

connection with the company prior to the last annual election." With this concession, the Eilers dissenters finally dropped their challenge, having achieved their ends, they said. The election to the board of six independent men like George Goethals, one of the heroes of the Panama Canal, and Lewis L. Clarke, vice president of the Guaranty Trust Company, satisfied their objections to Guggenheim control.[54]

In fact, the new board would be a mixture of the old and the new. The Guggenheims got to choose ten of the twenty-eight members from among ASARCO employees. That meant that they no longer had a rubber stamp. But they remained the most influential voices in the company's affairs. Simon, for one thing, remained president of the company, and Newhouse remained chairman of the board.* There would be a new advisory committee to guide the board of directors, but its members included Simon and family allies Brownell and William Loeb, Jr. The family could no longer treat ASARCO as an unchallenged fiefdom, but the Guggenheims remained the firm's acknowledged leaders and, as owners of Guggenheim Brothers, still the first family of American smelting.

IN 1923 Guggenheim Brothers sold Chuquicamata for an enormous sum to Anaconda Copper, the leading smelter firm in the American Northwest, and shifted the family's interests to nitrates. By 1922 the postwar world depression was lifting, and demand for copper had begun to revive. ASARCO reported profits for the year of almost $6 million, $4 million more than the previous year. The world price of copper was still far below the level of 1916–18, but Chile Copper's rich deposits and low costs of production still enabled it to rake in the profits. For its part Anaconda, which had acquired the American Brass Company shortly before, was seeking to become a vertically integrated firm, extracting and refining copper and also fabricating copper and brass products. Its traditional sources of copper ore in Butte, Montana, were diminishing after years of heavy exploitation, and it was anxious to find a replacement. For the Guggenheims it was a deal made in heaven. Aside from the sheer size

*Until Simon's death in 1941 the president was the chief executive officer of ASARCO. Thereafter the chairman of the board become the top executive.

of the offer, they could benefit from a recent change in the federal tax laws that allowed investors to sell assets they had kept for more than two years and pay a lower tax than previously imposed.

Anaconda's proffer in late 1922 was more than generous. It would pay $35 a share for two million Guggenheim shares of Chile Copper, or $70 million, a sum it would raise through a large new bond issue. The senior members of Guggenheim Brothers, reflecting the new mood, all approved the transaction.* Seventy million in one lump sum was too dazzling to pass up. (The framed canceled check would hang on the walls of Guggenheim Brothers and its successors for many years and until recently was on display in the offices of the Harry Frank Guggenheim Foundation in New York.) But the next generation, Edmond and Harry, disagreed. Both had become partners when Guggenheim Brothers had superseded M. Guggenheim's Sons. Both had worked hard in the field in Chile helping to manage Chuquicamata. Now they balked at the sale. In a stormy meeting in the partners' room on lower Broadway the two sides thrust and parried. Daniel led the "yes" faction; the two juniors, allied initially with Solomon, vehemently pushed for "no." Daniel rehearsed the risks the family had faced in developing Chuquicamata. Now was the time to cash in. The sons saw the move as a virtual abandonment of the family's primary business. And they were not entirely wrong. Under the terms of the Anaconda deal the Guggenheims would retain a substantial stake in Chile Copper, but they would cease to be majority shareholders and would no longer run the firm. Edmond and Harry saw no future for themselves in the depleted company and threatened to resign. On March 1, 1923, six weeks after the sale was finalized, that is just what they did.

Their departure provoked deep resentment. Daniel, for one, believed that Harry and Edmond were under "a very great obligation toward the Firm . . . and [should] not . . . quit us in the lurch."[55] Daniel threatened to punish Harry by appointing someone else executor of his estate and by partial disinheritance. To replace Edmond and Harry as partners in Guggenheim Brothers, in early 1925 the seniors elected two nonfamily associates, John K. MacGowan and Norwegian-born metallurgist E. A.

*Isaac had died in October while on a visit to England. See chapter 7.

Cappelen Smith. The incident might have damaged the good relationship between Daniel and Harry, but the trouble was weathered and the two remained good friends. But it would always be remembered as a family crisis that triggered a near disaster.

DURING THE REMAINDER OF THE 1920s and the "low, dishonest decade"[56] that followed, the Guggenheims remained a force in American industrial enterprise. In the mid- and late-1920s ASARCO, like other smelting firms, was swept along on the wave of prosperity that followed the rebound from World War I. But besides the revival of European economic growth and spread of electrification into the "developing world," ASARCO, with help from the era's probusiness Republican administrations, was able to stabilize its relations with the Mexican government. In 1927 President Coolidge sent Dwight Morrow, the Guggenheims' good friend, as ambassador to Mexico to calm the choppy political waters. Current president Plutarco Calles was a ferocious anticlerical and enemy of foreign capital, but Morrow was able to negotiate an agreement legitimizing all foreign property acquired before 1917. The Guggenheims were effusively grateful. "I must take this occasion to express to you," Simon wrote Morrow in October 1928, "the universal feeling of approval of the great things you have accomplished during your Ambassadorship."[57] Simon couched his praise in broad terms of good relations between the two hemispheric neighbors, but he was primarily gratified that ASARCO's mines and smelters had been saved from expropriation. In the now more favorable climate ASARCO launched a major modernization program for its Mexican properties. But then, at the end of the 1930s, Mexican politics once more turned radical and antiforeign. Having nationalized the country's foreign-owned petroleum companies, in 1938 the Mexican government under Lazaro Cardenas allowed the miners' unions to seize ASARCO mines and operate them as workers' cooperatives. It also imposed a 12 percent tax on all exports from Mexico, including raw materials. ASARCO officials protested. Reproaching the Mexican government, ASARCO chairman Francis Brownell noted that several presidents, including Cardenas, had assured the company that it welcomed foreign capital investment. But protests did little good for the

company's balance sheet. In March 1939 Simon told his stockholders that the company's earnings in Mexico had "been drastically decreased by reason of that country's policies." "The immediate future of Mexican operations" was, he said, "clouded with uncertainty and doubt."[58]

Yet during the twenties the family continued to invest in copper, as well as lead and tin. In Bolivia they expanded their tin investment. In Chile they still owned Braden Copper, the second largest copper firm in Chile. They were also the largest stockholders in Kennecott. ASARCO remained a major refiner of copper and other ores. All prospered. In 1924 ASARCO declared a generous $6.47 dividend per common share, higher than for most recent years. By 1926 it had soared to more than $23. Kennecott did even better. As one observer noted, for Kennecott in 1929 "fortune not only smiled, but laughed out loud."[59] In that glorious year the firm produced 500 million pounds of copper for a gross profit of $110 million and a net profit of $50 million.

The worldwide depression of the 1930s would be a heavy blow to ASARCO and the other Guggenheim-run businesses. Still considered important financial leaders, the Guggenheims, in the days following the stock market collapse of October 1929, joined the combination of elite business magnates hastily assembled by J.P. Morgan to slow the securities-selling panic by buying major company stocks abandoned by other traders. The $240 million Bankers' Consortium checked the market free fall momentarily. But it was soon clear that the scale and momentum of this collapse was far greater than anyone anticipated. Morgan and his colleagues quickly got out from under, having made, it seems, a small profit from their intervention. The slide quickly resumed, eventually bringing down the whole international equities markets and dragging the world economy behind it.

The Guggenheims, like their associates, certainly lost nothing from their brief gesture of civic virtue, but the general health of their firms, and the size of their personal fortunes, was another matter. The stock market crash abruptly deflated their wealth. ASARCO common stock, at 130 in 1929, dropped to 5⅛ three years later. As the largest individual share-holder in ASARCO, Simon in November 1929 had urged his fellow investors to hold on to their shares. He, for one, he told them, intended to

do so. *Time* magazine would later criticize Simon when ASARCO announced a 25 percent cut in dividends.[60] The whole nonferrous metals industry reeled from the crackup of the international economy. The bottom fell out of copper in 1930. In 1932 the red metal was selling at 4 cents a pound, compared to 22 cents three years before. In late 1933 a Wall Street observer noted "that no group of major companies [has] felt the wave of depression to a greater extent than those engaged in the mining and smelting of non-ferrous metals. They have been almost hopelessly caught in the wedge of excessive stocks, falling prices, and declining demand."[61] That year ASARCO processed only half the ore of the year before and registered its only actual annual loss. But it also paid no dividends on its common stock in 1931 and 1932, and it cut employees' pay by 5 percent. Lead mining too deflated. Lead prices were so low in 1931 that ASARCO shut down two of its lead mines in the mountain states.

Then came the turnaround. Copper and lead prices improved over the next few years as Western governments rushed to rearm in the face of the growing threats to world stability by Germany, Italy, and Japan. By the end of 1935 Kennecott stock was paying returns of about 80 cents a share. ASARCO too rebounded, reporting $5 a share on its common stock in 1935, the first since 1931, though far below the 1929 level of $8.60. In 1936 ASARCO announced a net income of $17 million, the best since 1929.

During the Depression years Simon proved to be an adept businessman and successful crisis manager. He adopted a winning strategy of shifting ASARCO's emphasis from smelting and refining to mining. He bought valuable new mining properties at low, Depression-level prices, anticipating returning prosperity shortly down the road. The firm continued to be run from the Guggenheim offices at 120 Broadway, with Simon benevolently presiding as the politician he was. But he worked only eight months a year, spending the other four in Europe and taking only a half salary of $50,000. Interviewed by a financial reporter in early 1936, "the Senator" exuded optimism. How did ASARCO "manage to make so much money" in the past year, the reporter asked. "First," Simon replied, "we have a very live-wire mining department and it is our most important branch." "Our live-wire boys . . . there have accounted for at least 50 per cent of our good showing." He had also been able to "make

[the] company very highly diversified and this diversification" would allow it "to cash in . . . in the future as the business of the country speeds up." Simon went on to predict that 1936 would be a better year than 1935, and full prosperity would return in 1938. The reporter was clearly impressed with him. He was a "born story teller," the reporter noted, who reminisced amusingly about his early days in mining and refining and was willing to discuss frankly, though off the record, American and Mexican politics. Though a Republican, Simon seemed less upset by the New Deal than many tycoons of the day. Prosperity would return in 1938, he opined, no matter who was in the White House. He had only one complaint. In 1934 federal taxes were more than $3 a share of ASARCO common stock, some 30 percent of net income. In 1926 it had been only 21 percent of net income; in 1913 only 6 percent.[62]

In fact, though the mining division of ASARCO expanded during the 1930s, smelting and refining remained the company's chief business. A 1939 survey of the firm listed its seven active metal mines—one in Peru and six in Mexico—along with leases on, or partial ownership of, seventeen others in Newfoundland, Canada, Mexico, Bolivia, Australia, Nicaragua, and the United States. The firm owned and operated eighteen smelting plants producing lead, zinc, and copper. Much of its smelting and refining business was on order for mining companies that dug the ores. The company, a reporter noted, was "closely knit and efficiently controlled." Its "management ability and technical skill" was outstanding as was its managers' "entrepreneurial courage and foresight." These qualities "led it into new fields of activity during the worst depression in history while the rank and file of industry were content merely to hang on and survive."[63]

Meanwhile, the Guggenheims were facing daunting problems in Chile. Their copper interests in South America, like the copper industry globally, fell on hard times as the fog of world depression descended. But well before the Crash, they found themselves struggling to avoid disaster over their large investments in nitrates. With Daniel in near retirement, the impresario of the nitrate venture was Murry, but the other brothers approved of his initiatives. Even Harry, though he still smarted from the sale of Chuquicamata, believed the nitrate venture a shrewd move.

Besides their use in explosives, nitrogen compounds were the chief

ingredients of agricultural fertilizers. Before the late nineteenth century their major source was animal waste—bird guano, barnyard manure, even human excrement. By the post–Civil War period deposits of the mineral sodium nitrate, in Chile's Atacama Desert close to that nation's copper ore, became important. Chile soon became the world's major source of nitrates. In its initial form the industry was inefficient. The "Shanks" process used hand labor to break up the "caliche" rock, and employed a costly method of boiling the ore in large tanks to extract the sodium salts. The nitrate firms, many British owned, were all small and run like feudal baronies.

It was undoubtedly the proximity of the immense beds of sodium nitrate to the copper ores that first attracted the Guggenheims' attention. On each trip by rail from the coast to their Chuqui site they could observe the inefficient *oficinas*, as the small refineries were called. If the industry could be rationalized and modernized, they concluded, it could produce profits as magnificent as Chile's copper mines. What was needed was Yankee capital and Yankee ingenuity. In 1916 Daniel contacted Morgan partner Dwight Morrow and proposed that Morgan and the Guggenheims join forces, as they had in Alaska, to forge from Chilean nitrates "a modern up-to-date, American industry, capable of yielding a greatly increased profit upon a greatly increased capitalization."[64] For a number of years J. P. Morgan and Company actively participated in the nitrate venture, though by informal agreement. Then, in 1924, it transferred most of its interest to Guggenheim Brothers in exchange for reimbursement of all outlays and expenses already incurred. Under terms of an agreement between the seniors and Harry and Edmond, the juniors would retain, with small exceptions, their interests in all ventures Guggenheim Brothers was involved in at the time they left the firm. But whether Edmond and Harry would share in the transferred Morgan assets remained a bone of contention for a time between them and their seniors calling forth long exchanges of legal documents.

Though Morgan had bailed out of the venture, with a technological fix up their sleeve, the Guggenheims forged ahead. They had owed part of their success at Chuquicamata to E. A. Cappelen Smith. During the war he had become interested in the nearby caliche deposits and devised

a method to extract nitrate that improved yields dramatically over the Shanks system. Steam shovels would remove the rock in great gulps and the material subject to cold leaching. Not only did the "Guggenheim process" save labor; it could be applied to rock with a lower percentage of sodium nitrate. Smith's breakthrough inevitably stirred visions in the Guggenheims of a nitrate bonanza equal to Chuquicamata. In 1922 the Guggenheims built a small pilot plant using their new process near the port of Antofagasta.

The sale of their Chuquicamata copper properties to Anaconda for a spectacular $70 million provided the capital to draw the Guggenheims further into the Chilean nitrate business. In late 1924 they bought out a British firm, Anglo-Chilean Nitrate and Railways Company, for £3.6 million and transferred its assets to a new company, Anglo-Chilean Consolidated Nitrate Corporation, fully owned by Guggenheim Brothers. The new firm also absorbed nitrate-rich lands, the Coya Norte properties, a thirty-five-square-mile slab of desert real estate bought at auction from the Chilean government. On this site they would soon erect Maria Elena, a much larger plant than the pilot, to employ the new technology. The multitalented Cappelen Smith would be the president of the new firm, with Murry and Simon as directors. In April 1925 Cappelen Smith was made a full partner in Guggenheim Brothers. The original plan was to include the Chilean government in the syndicate, but this was dropped when it was learned that the Chilean constitution forbade such an arrangement. In 1929 the Guggenheims deepened their stake in the Chilean nitrate business by buying out a British firm, Lautaro Nitrate Company, which owned twenty-six extraction plants in Chile. These used the obsolete Shanks process but they could be converted to the improved Guggenheim system without excessive cost. By the eve of the Crash, the Guggenheims had bet millions on an industry that was already in decline.

The family failed to convert their nitrate venture into the triumph they had achieved in Chilean copper. As at Chuquicamata, they sought to improve the material lot of the workers. They paid their employees 20 percent more than they had received from the bosses of the old refineries. They replaced the workers' floorless, corrugated iron shacks with

concrete houses equipped with piped-in water and electricity. The company-built towns acquired schools, athletic fields, and gracious plazas with trees and flowers. As at Chuqui, the improvements and innovations were motivated as much by a need to stabilize a rootless, itinerant labor force as by plain benevolence.

The workers, however, benefited more than their employers. During the twenties economic boom the fertilizer market had grown faster than the world economy. Unfortunately for the Guggenheims, the chemists had superseded the miners. Much of the increased output was supplied by new chemical technology developed by German chemical giant I. G. Farben, which employed electricity to convert atmospheric nitrogen into solid nitrogen compounds. Between 1913 and 1929 the Chilean proportion of world nitrate consumption declined from 58 percent to 23 percent. Not surprisingly, the Guggenheims' anticipated large profits did not roll in. In May 1927 president Cappelen Smith reported 1926 income for Anglo-Chilean Nitrate of $1.1 million, but also acknowledged a deficit that year of more than $2 million owing to capital outlays. Toward the end of 1927 he reported a disappointing net income of $119,000 for the first half of 1927. Clearly the nitrate venture was not prospering. Indeed, it was deeply in debt, and with world prices sinking, it was unlikely to make a profit in the foreseeable future. The Guggenheims blamed Chilean export restrictions and the 20 percent export tax imposed on nitrates by the Chilean government for part of their difficulties. They also blamed the high price set by the Association of the Producers of Chilean Nitrates, a government consortium, for making natural nitrates uncompetitive. According to Daniel, fertilizer made from the synthetic European product was notorious for "souring" the soil where it was applied. But the export tax and the artificial price more than canceled out the advantage of the natural product.[65]

In 1927 the producers' association loosened its control over Chilean nitrate prices to make the natural product more competitive. Solomon hailed the action, but it was not enough to restore the market. Late the following year U.S. president-elect Herbert Hoover, a former mining engineer himself and a friend of Harry's, visited Chile and proposed to president Carlos Ibáñez a joint enterprise between the Chilean govern-

ment and the Guggenheims to lower costs and stabilize prices. In 1930, after the Wall Street Crash, the deal was consummated. Meeting in Paris in May, the participants formed a holding company with a $375 million capitalization, half representing the stake of the Chilean government. The Chilean export tax would be rescinded, and prices formerly set at $42 a ton by the producers association lowered by a fourth. The new company would merge the interests of the private firms, including the Guggenheim interests, and the government at Santiago under one entity, the Compaña de Salitre de Chile (COSACH). The new firm, financed by bonds, would buy out the assets of the private companies, including Lautaro and Anglo-Chilean Nitrate, and assume their debts. The combination would be run by four directors appointed by the Chilean government and eight by the private stockholders, giving control to the Guggenheims. It would compensate the Chilean government for its loss of tax revenues by paying it $22.5 million over the next two years. It would also seek an agreement with I. G. Farben, the German chemical giant, to set world prices for nitrates.

In effect, the COSACH agreement anticipated a world cartel in nitrates. That goal was actually achieved on a temporary basis in August when COSACH concluded an agreement with the European synthetic nitrate combination to cooperate on establishing output quotas and prices. The American market would be exempt from the cartel's price settings, and Guggenheim Brothers, subject to U.S. antitrust laws, did not join the cartel. But the Guggenheims' interests in Chile were under separate company management, and they remained in COSACH. In fact, it was generally acknowledged that COSACH was de facto a Guggenheim-controlled enterprise. As *Business Week* observed, "the new set up indicates that the Guggenheims have become the dominating force, thereby controlling the natural nitrate production of the world."[66]

The COSACH agreement has overtones of the Guggenheims' dealings with Porfirio Díaz in Mexico. It was initiated by the Guggenheims but it relied on the support of President Carlos Ibáñez, another Latin American *caudillo* interested in encouraging economic development to enrich his country and his associates and bolster his regime. The new company was pushed through without a popular mandate. The scheme

was likely to have a shelf life only as long as its political protector.

Unfortunately for the Guggenheims, this proved far shorter than in Mexico. COSACH triggered an antiforeign spasm that was already a hallmark of Latin American relations with the Yanquis. Soon after the Paris agreement was concluded, Francisco Huneeus, a former Chilean senator, attacked COSACH as a sellout to the Guggenheims. The American-owned firms, Anglo-Chilean Nitrate and Lautaro, included in COSACH, he charged, had been saved from bankruptcy by having the new combination assume their debts The Americans must be treated like all the other participants in the combination or else the COSACH agreement must be vetoed by the Chilean parliament. Don Pablo Ramirez, government head of the combination, answered that unless the Chilean nitrate industry was "radically reorganized" it would "necessarily cease to exist at no far distant date" and that as a consequence eighty thousand men would lose their jobs and the republic's annual revenues would drop by 180 million pesos.[67]

In the end, despite the road bumps, the COSACH agreement was formally signed in New York in March 1931. Stockholders of Anglo-Chilean and Lautaro voted in April to issue some $40 million in 7 percent bonds to pay the Chilean government as the agreement specified. In return the Chileans agreed to guarantee interest payments on the bonds. A few days later the stockholders voted formal merger of the Guggenheim nitrate properties with COSACH. The remaining private nitrate firms soon joined the combination, and COSACH was formally in business. The Chilean parliament, a rubber stamp for Ibáñez, approved the agreement.

There still remained a permanent link with the Europeans, however, and in the end this effort collapsed. The natural and the synthetic producers when they met at Lucerne in July failed to reach a consensus. The Germans insisted that Chilean nitrate be priced higher than the synthetic product. COSACH's spokesman, Cappelen Smith, protested that this made Chilean nitrate uncompetitive, but Hermann Schmitz, I. G. Farben's head, refused to yield. In fact, Schmitz informed the participants, Germany had just placed a high tariff on Chilean nitrate. At this point the Chileans walked out of the meeting. As *Time* magazine's business editor concluded, "competition, free and bitter, [now] reigns in the nitrate world."[68]

Not only did COSACH fail to stabilize world prices; it also failed to help Chile. The greater efficiency of the Guggenheim process, added to the crumbling international prices, drastically reduced employment in the industry. In 1930 some thirty-two refineries, predominantly Shanks plants, employed fifty-two thousand workers. A year later there were only twenty thousand workers, and in 1932 only eighty-five hundred, virtually all COSACH employees. In addition, Chilean middlemen, who had flourished under the old system as nitrate sellers and supplies purchasers, were replaced by COSACH bureaucrats. In a matter of months jobless workers and bankrupt small merchants were screaming in pain. In June 1932 *Business Week* reported "whole communities [once] thrived in the northern desert region of Chile"; now they were ghost towns.[69]

But worse was still to come. In late July Chilean liberals overthrew dictator Ibáñez. The next day, ominously for COSACH, the citizens of Antofagasta turned out to celebrate, carrying signs with the words: "Chile for Sale—See Ibáñez."[70] The dictator's enemies promptly set about undoing his work. In November a commission selected to investigate the former regime, denounced COSACH as a sellout of Chilean industry to foreigners, and demanded its dissolution or major revision. The agreement, the commission charged, was primarily a scheme to save the Guggenheims. In evaluating the worth of the private properties embraced by the combination, the Guggenheims' holdings had been favored over Chilean firms. The deal had also made the lawyers in New York and Santiago rich at the expense of Chilean taxpayers. The creation of COSACH, the report concluded, "constituted the biggest crime of the military dictatorship of former President Ibáñez and it is impossible that the combination be allowed to continue to exist if Chile does not desire to commit financial suicide virtually delivering the country over to a foreign power."[71] Besides such attacks from the left, the Guggenheims became targets of an early 1930s Chilean Nazi movement centered in the nation's German-settled southern region. With the Guggenheims obviously in mind, the leader of these "Nacis" likened the Jews to "an octopus that extends its tentacles over humanity in its desire for vengeance and which now controls everything by means of its vast fortunes."[72]

The new Chilean provisional president, Juan Montero, proved friend-

lier than some of his leftist firebrand colleagues, however, and the commission's final report proved to be less antagonistic than expected. It recommended an enhanced role for the Chilean government in COSACH and scaled back some of the benefits to the private firms, especially the Guggenheims' Anglo-Chilean and Lautaro. But COSACH itself would be preserved. In January 1932 the Chilean government met with Solomon and Medley Whelpley, a New York banker and Guggenheim associate, chosen head of COSACH in December 1931, to help maneuver through the difficult financial and political shoals. In April, at Whelpley's call, delegates representing Chilean, British, and American groups met in New York to reorganize COSACH to reduce its fixed debt, cut costs, and improve the efficiency of its operation. These moves would simultaneously satisfy the nationalists and improve the combination's efficiency and so prepare it for a price war with the synthetic producers if another attempt at an international cartel should fail.

Meanwhile, in Chile, COSACH found itself coming under new fire from the leftist opposition. In early June 1932 the moderate Montero government was replaced, in turn, by a junta headed by Marmaduke Grove, that proclaimed Chile a "socialist republic." The new regime displayed all the signs of "infantile leftism." Grove sent the police into the jewelry stores to confiscate rings, watches, necklaces, and other gold items. In the first burst of radical zeal the firebrands announced that the new regime would nationalize the country's large businesses and seize its large estates. The dispatch to the *Times* conveying the news from Santiago declared the "dissolution of Cosach . . . is indicated as in prospect."[73] In the end the junta retreated from this extreme position, but the overthrow of Montero threw the already besieged nitrate industry into further chaos. Reports were soon circulating that COSACH was on the verge of declaring bankruptcy.

Unsold nitrate continued to pile up as world output of cotton and other nitrate-using agricultural production, hammered by the accelerating international depression, skidded. In 1931 COSACH lost 110 million pesos; 1932 was at least equally bad. In April the big Guggenheim Cappelen process plant, Maria Elena, shut down, not to open again until 1934. Meanwhile, Lautaro suspended interest payments on its bonds. In the summer COSACH announced a drastic price cut, agreeing to deliver

Chilean nitrate to customers at the lowest price on record. American producers of the synthetic product howled in protest. COSACH also entered the negotiations in London for a new nitrate cartel to stem the price debacle. Meanwhile, negotiations with the Chilean government over reorganization of the combination were thrown into further confusion as Chile once more descended into political disorder culminating in the election as president of Arturo Alessandri, an avowed enemy of COSACH. At the very end of the year Whelpley gave a talk to COSACH stockholders in Santiago defending the Guggenheims against attacks by hostile politicians and the Chilean press. He asked for some sort of final settlement so that COSACH officials could get back to their proper managerial jobs, "leaving the industry at peace."[74] Soon after, with liquidation reportedly imminent, Whelpley publicly defended COSACH and the Guggenheims' role in its operation. His argument was that of an economist and took little account of the nationalist and socialist impulses behind the drive to destroy COSACH. Cutting the combination's expenses, output, and labor force was dictated by the decline in world prices, he declared. Without the financial support of the Guggenheims, moreover, the Chilean nitrate industry would be in far worse shape. As for the maligned Cappelen process, it was far more efficient than the older one. In fact Whelpley's apologia was not completely valid. COSACH undoubtedly fell victim to Marxism and to world economic decline, but it was also hampered by its financial structuring. Its fixed debts, both to the Chilean government and the Guggenheims, as *The Economist* noted, were "an insupportable burden."[75]

In the end COSACH was dissolved. In early January 1933 President Alessandri signed a decree liquidating the combination formed two years before. Declaring COSACH illegal from the outset, the Alessandri regime blamed it for depressing the world nitrate industry, for defying the Chilean government, and for operating solely in the interests of its foreign investors. A commission composed of the Chilean government and judiciary, as well as representatives of the Guggenheims, would, it stated, wind down the firm's business over a two-year period.

The American State Department sought to protect the Guggenheims and American investors in Chile generally from Alessandri, who, in the

view of the American commercial attaché in Santiago, had developed "an extremely national psychosis."[76] American diplomatic pressure failed to delay the final blow, however. The dissolution proceeded with a COSACH appointee serving on the commission as representative of the foreign bondholders. Despite this presence, inevitably the foreign investors took a beating when COSACH went out of business. Interest rates on some of COSACH's bonds were scaled down drastically. Some debt was simply canceled or converted into less profitable securities.

AS ONE OF DANIEL'S heirs, Harry paid a price for the tribulations of the Chilean nitrate venture. In May 1932 Florence told her son that the "nitrate enterprise" had placed "heavy demands" on Guggenheim Brothers. As a result there would be "great delay" in payment of his father's $2 million bequest. In fact, it was not clear that his father's estate had "the ability . . . to pay you this legacy" at all. To offset his losses, she intended to create a $1.7 million trust fund for Harry at Bankers Trust Company.[77]

The Guggenheims, then, never realized their "dreams of avarice"* in Chilean nitrates. Eventually they were able to squeeze profits from their nitrate investments. Although COSACH disappeared, Anglo-Chilean and Lautaro continued to operate as nitrate producers. By the mid-1930s rearmament of the major powers increased demand for nitrates as it did for copper and lead. But the returns never fulfilled the hopes of the original nitrate investments. In 1950 the two firms were merged into the Anglo-Lautaro Nitrate Corporation with Harry as chairman of the board. The company was now only a shadow of itself, however. In fiscal 1951 its total profits were only some $7 million, a fraction of its income during the war.

All told, the nitrate venture had been a disappointment, and it diminished the family's role in the world of business. The Guggenheims soon ceased to be industrial movers and shakers and became known to the public primarily as patrons of the arts and sciences.

*This is the phrase used by the historian of the Guggenheims' Chilean nitrate venture. See Thomas F. O'Brien, " 'Rich Beyond the Dreams of Avarice': The Guggenheims in Chile," *Business History Review*, Spring 1989.

Family Affairs

I T WOULD BE SATISFYING to squeeze the Guggenheims into the family pattern described by Thomas Mann in *Buddenbrooks*, his novel about a nineteenth-century Lübeck merchant family: the rough-hewn founder who creates the dynasty is followed by the aggressive achievers who make the family truly rich, and they are succeeded by the artists, intellectuals, and playboys who enjoy but squander and dissipate the family fortune. But real life is messier than biographers would like. Some Guggenheims conform to the model, but others went their own idiosyncratic ways.

The Guggenheims' wealth and power declined relatively by the 1930s, but the family still had unexpended entrepreneurial energies well into the post–World War II era. Simon remained president of ASARCO until his death in 1941. All the surviving brothers continued to head, at least nominally, divisions of Guggenheim Brothers or other family enterprises until their deaths or final illnesses. After Meyer's sons passed from the scene the entrepreneurial urge weakened, but some sons and sons-in-law took up the business reins after their seniors had died or retired. Roger W. Straus, Daniel's son-in-law, husband of his lively and intelligent daughter Gladys, became ASARCO vice president and assistant to the president. He would succeed Simon, his uncle by marriage, as

the firm's chief executive, until he retired in 1957. Harry, Daniel's younger son, rallied his impressive managerial energies to preserve the family's leadership in smelting and in nitrates, and in the 1950s sought to restore some of its former industrial glory. He even branched out into new fields unrelated to metals and mining and helped create an astoundingly successful daily newspaper.

During the flush 1920s the surviving sons of Meyer continued to be figures of consequence in business and interest to many ordinary Americans. The papers regularly announced their transatlantic arrivals and departures from New York on the White Star, Cunard, and Hamburg-American liners. The marriages of their children were featured in the *Times*. Their summer houses, now mostly on the North Shore of Long Island—Jay Gatsby country—were lovingly and enviously described in the papers and magazines. Their deaths and their bequests were reported at length in the press. Even small incidents in their lives seemed newsworthy. The *Times* gave an inch of space to the award by the University of Colorado of an honorary degree to Simon in August 1925. An extortion threat against William by a seventeen-year-old Russian immigrant was worth three hundred words in the papers.

OF MEYER'S CHILDREN who lived past the First World War, Isaac, the eldest, died first—in October 1922—victim of a stroke while on a visit to England. Though the first son, and a little taller than the others, he was never the family leader. Perhaps more was expected of him by a traditional father than he could bear; or perhaps a trick of genetic shuffling made him more timid and retiring than his brothers, certainly more than his next younger brother, Daniel. In 1906 or 1907 he had suffered some version of what his generation called a "nervous breakdown" and went off to Europe to recover. He returned to both the United States and the family enterprises, but he seems to have remained inward and fragile emotionally.

Isaac seldom took the lead in new enterprises. He was more an accountant than an entrepreneur. Yet he happily collected his dividends and ended up with a fortune of more than $10 million. At his death he owned two houses in New York City, one on Fifth Avenue, and another

on Park. He also had a forty-room, Italian Renaissance mansion on Long Island called Villa Carola. Built in 1916, after he abandoned the Jersey shore, the house was on a 210-acre parcel overlooking Long Island Sound, and boasted a nine-hole golf course. Isaac and Carrie, his spirited, red-haired mate, had eighteen servants and employed more than a hundred groundskeepers on their estate.

After Isaac's death, Carrie sold Villa Carola to her brother-in-law Solomon and in 1924 moved to Beverly Hills. She lived there until her own death in January 1933, leaving an estate of more than $600,000.

If Isaac prospered financially, he was disappointed with his family. He obviously loved his daughters, Beulah, Edyth, and Helene. Each married well, Beulah to William Spiegelberg, a commission merchant and textile manufacturer who died in 1932; Edyth to Louis Josephthal, a successful banker who, after his wartime military service, made the navy his serious hobby and rose to became an admiral in the naval reserve; and Helene to three men, one a titled Englishman. But there were no sons; and no grandsons except one, to carry on the family name. To Isaac the solution seemed obvious: convert young William Spiegelberg, Jr., into Isaac Guggenheim II and make him his heir. Isaac convinced his daughter and son-in-law to allow the change, and William became Isaac. But not for very long. Isaac's will provided for Isaac II to receive a generous income when he reached his twenties and a large bequest in tin mine stock at thirty-five. But Isaac-William never liked his imposed name, nor did he like the mining-smelting business. In 1927 he sold his shares in the tin company for a substantial sum and changed his name back to William Spiegelberg, Jr.

William Jr. later became partner in the brokerage firm of Spiegelberg and Plohn. He married Frances Spielberger in 1931, and they remained together long enough to have two daughters, Betty Gene and Janet. Frances appeared briefly in the New York City crime reports in 1941. While riding in a car in Manhattan with a male friend, she was abducted by two armed men who took her cash and jewelry and released their captives in Queens. The robbers were never caught.

After Frances and William were divorced, she and the children went to California, where she met and, in 1947, married the world-famous

violinist Jascha Heifetz. In 1951 William escorted his daughter Betty Gene down the aisle at the Plaza Hotel as she married Jacob David Hornstein, a Baltimore lawyer. Jascha apparently stayed away from his stepdaughter's nuptials. The Spiegelbergs had retained their Jewish identity; William Sr. had been vice president of the Temple Emanu-El congregation when he died in 1932. He contributed generously to Jewish charities in his will. Rabbi Nathan Perilman officiated at his grandaughter Betty's marriage twenty years later. In 1955 William Jr.'s younger daughter, Janet, married Steven Hyman, a New York civil rights lawyer. Dr. Perilman again performed the ceremony.

Beulah had a daughter, Marjorie Bette, as well as a son. After William Spiegelberg passed away Beulah remarried. She lived in New York on Park Avenue and died in 1960 at the age of eighty-three.

DANIEL, THE FAMILY'S CHIEFTAIN, survived his older brother by eight years. He and his wife, Florence, continued to live winters in New York. In 1907 they rented a ten-room suite at the luxurious new St. Regis Hotel at Fifth Avenue and Fifty-fifth Street, and this apartment remained their city abode for the rest of Daniel's life. Shortly before Isaac left the Jersey shore, Daniel and Florence also left Elberon and moved to the North Shore of Long Island. There they would spend eight months—summer, spring, and fall—of each year.

Daniel's new North Shore place was palatial as befitted a man considered the king of copper. Built by railroad heir Howard Gould in 1912 at a cost of $1 million, it sat on 250 prime acres at Sands Point, overlooking Long Island Sound. Daniel bought the house from Gould in 1917 at a knockdown price of $600,000. There were two large structures on the grounds. The medieval Castlegould housed stables, workshops, and apartments for estate workmen. The forty-room family dwelling, of granite and limestone, was gargantuan: 225 feet long and 125 feet wide. Along with its turrets, battlements, and eighty-foot-high watchtower, its scale makes it seem inhospitable today, but it was considered by contemporaries "the most livable big house in the country."[1] Daniel and Florence lived in Hempstead House, as they named it, in true baronial style. They filled the forty-room, high-ceilinged edifice with Jacobean

furniture, paintings—mostly canvases by conventional mid-rank artists—and covered its walls with early modern Flemish tapestries. The mansion already had a large palm court on the ground floor, and Daniel adorned it with rare and exotic plantings. He added to the estate a nine-hole golf course, tennis courts, a bowling alley, and a beach house with a swimming pool. To reinforce the manorial theme, Daniel and Florence provided much of their own food at Hempstead House. Daniel ran a dairy, butchered his own steers, cured his own hams and bacon, stuffed his own sausages, grew his own fruits and vegetables, and ate his own chickens. He employed seventeen house servants, and dozens of other men and women worked on the lord's domain as farmers, animal keepers, and grounds crew.

Daniel and Florence, as their grandson Roger Straus, Jr., recalled, were "very familial,"[2] and used the house and grounds for frequent family gatherings and celebrations. Each of their children—M. Robert, Harry, and Gladys—had a suite of his own where they, and in later years their families, often stayed, visiting especially on holidays but also on many summer weekends. Appearances at Hempstead House were practically by command; refusing was unthinkable. By the mid-1920s Daniel and Florence had eight grandchildren, and while the second and third generations* talked, dined, and played tennis or golf, the young ones splashed in the pool and romped on the velvety lawns that surrounded the house. Oscar Straus II, older brother of Roger, recalls that he learned to ride and to play golf at his grandfather's estate. Daniel "took a poor view of any of us wanting anything that was not there on the property," Roger remembered, and had provided "all kinds of things for all ages and sizes." Daniel presided over meals, formally dressed in suit and high collar even in summer. Though short, he had a fine head decorated with neatly waxed mustachios. He was very much the "Mon Seigneur," Roger recalled.[3]

Even when Daniel and Florence were in Europe on one of their many trips, they encouraged their children to use the estate for themselves and

*The grandchildren of Meyer and Barbara counted the family generations from their grandparents, not from the their great grandfather, Simon, who brought the family to America in 1847. Both Peggy Guggenheim and Harold Loeb explicitly use the term "third generation" for their own age cohort.

friends. "I hope you will not hesitate for a moment having guests there, as you know the place is entirely at your disposal," Daniel wrote Harry from Evian in France in the summer of 1922.[4] That year Daniel gave Harry 90 acres of his land as a wedding gift for his second marriage, reducing his estate to 162 acres. Harry would construct on the site a faux Norman manor house where he would replicate his father's lordly style until his own death a half century later.

Though the North Shore mansion was the focus of Daniel's life in retirement, he and Florence spent the winter in the city, staying at their St. Regis apartment. They reveled in New York's cultural life as consumers and as patrons. They contributed generously to the Metropolitan Opera and the New York Philharmonic. Daniel lent the Metropolitan Museum of Art several of his paintings for exhibit. Whatever his own tastes, he sought to nourish the public's interest in popular and light classical music by sponsoring, with Murry, the Goldman Band concerts held in Central Park and at other venues around the city.

Florence was a classically dutiful wife who, according to her grandson Roger, felt that her role in life was to help oil the wheels that moved her husband's social existence. But she also, as during the war, continued to be a lady bountiful outside the home. Sparkplug of the New York section of the Council of Jewish Women, she made the problems of young immigrant Jewish women her particular cause. The rich German Jews of Our Crowd have been disparaged by historians for their attitudes toward the East European shtetl Jews who fled to America in a flood after 1900. They were said to be condescending and contemptuous of this "wretched refuse" of Europe's "teeming shore," and their charity supposedly derived from fears that the uncouth newcomers were undermining their own shaky status in gentile America. But Florence showed sincere compassion toward her clients. One of her associates in the work with young women, Rebekah Kohut, remembered that Florence "threw herself with impassioned ardor into her work and made the cause of the girls her own."[5] The Council of Jewish Woman ran a settlement house on St. Mark's Place, a Girl's Home Club at Fiftieth Street, and several facilities on Blackwell's and Randall's Islands in the East River. Much of its work consisted of Americanization. This meant, Florence said.

"securing the physical and spiritual well-being of these new Americans, making them Americans in habits, standards of living, speech and ideals."[6] To recent sensibilities this may seem like cultural imperialism and harsh disregard of the immigrants' own heritage, but in the tribal twenties, when old-stock Americans were intolerant of cultural differences and the Ku Klux Klan recruited millions of supporters to its racist policies, few questioned its necessity. It certainly seemed a compassionate alternative to exclusion from America.

Daniel remained to his end the family's head and guiding spirit. He intervened actively in family disputes in the interests of what he saw as fairness and at times overruled his brothers. On one occasion in 1926, when Murry, Sol, and "the Senator," still resentful of Harry's and Edmond's desertion of the firm three years before, sought to exclude them from profits in the tin and nitrate businesses, he lectured his brothers severely. He understood their indignation at Harry's and Edmond's apostasy, he wrote. But "we are not justified in retaliating." "Two wrongs" did "not make a right."[7] "Surely," he noted, "we do not wish to be put in the position of determining the rights of [Harry and Edmond] by the criterion of whether or not it is profitable to us to exclude them. Both legally and morally, this is a shocking proposal, and under no circumstances will I be party to the proposal." Despite the stern tone, Daniel ended the memo: "affectionately."[8]

Like Isaac, Daniel had an impaired cardiovascular system. In early January 1925 he suffered a heart attack while at his hotel suite in New York. A local doctor was summoned along with a heart specialist from Johns Hopkins hospital, Thomas Brown. For the next month Brown commuted almost daily between Baltimore and New York to attend to the ailing magnate. Daniel was soon feeling better and, accompanied by Florence and several doctors, left for Palm Beach to recuperate. For a time his health improved, but while aboard his yacht he suffered a series of further attacks and returned hastily to New York in his private railroad car.

Daniel survived this round of cardiac incidents to live for five more years. In July 1926 he celebrated his seventieth birthday at Hempstead House with a festive gala. Hundred of relatives and friends came to the

elaborate buffet lunch followed by dancing. The surprise of the day was the presence of conductor Edwin Franko Goldman and the sixty-eight members of the Goldman Band who came to serenade their longtime benefactor. In 1924 Daniel and Murry had begun to contribute some $100,000 a year as a subsidy to Goldman's open-air concerts in Central Park.* Murry withdrew after 1929 but Daniel continued the subsidy, and after his death the Daniel and Florence Guggenheim Foundation took over. In 1944, at the death of Florence, the foundation would begin the practice of annual gifts to "the people of the City of New York" to sponsor the "Guggenheim Memorial Concerts."[9] All told, the Guggenheims spent almost $3 million over thirty years to bring New Yorkers alfresco band music and transcriptions from the classical repertory. Now, on his seventieth birthday, Daniel supposedly had no idea until he appeared on the lawn to greet his guests that the musicians had come all the way from the city to salute him. He was deeply moved.

Daniel's last years were satisfying. Influenced by Harry, he took up a new interest in promoting aviation and rocket propulsion. Though his health was shaky, he traveled frequently with Florence. They visited Havana in the winter of 1930 to see Harry, then serving as U.S. ambassador to Cuba. They returned to New York in the early spring, and Daniel reported to his second son that he and Florence were in "splendid health."[10] In the summer of 1930, hoping to "build up reserve energy and strength,"[11] they took their last trip to Europe, spending three months in Carlsbad and Britain. In England he and Florence visited with Solomon's daughters, the unmarried Gertrude and Lady Eleanor, who had married a British peer. Everyone enjoyed the visits. They returned home on September 15. Daniel's health quickly deteriorated.

Daniel died at Hempstead House on Sunday morning, September 28, 1930. Florence and the two younger children, as well as Gladys's husband, Roger Straus, were at his bedside when he passed away, and the less dutiful Robert, at a War Department meeting in Washington, was summoned to Hempstead House by telegram.

*Early on Mayor Hylan tried to take credit for the concerts, and Daniel and Murry threatened to end their subsidy. The mayor soon retreated.

Daniel's funeral was featured on the front page of the *New York Times*, and obituaries appeared in all the New York dailies. The *Times* also ran an editorial column on Daniel's death. The editorialist praised Daniel for his "progressive and humane attitude" toward his workers, his "persistence in encouraging scientific study and improved processes," and his many philanthropies. He was, the writer noted, a man of "fair dealing and high-mindedness" who "warmed both his hands in the fire of life."[12] He would be both mourned and missed.

The funeral at Temple Emanu-El was a simple ceremony without a eulogy. But it was a major event to the city's citizens and its Jewish community. Three thousand people packed the handsome new synagogue that Daniel had helped build, and the crowd spilled over onto the street where dozens of police were on hand to keep order. Emanu-El's chief rabbi, Dr. Nathan Krass, conducted the services. Honorary pallbearers included many old colleagues in business and philanthropy: Dwight Morrow, John D. Ryan, John Hays Hammond, Bernard Baruch, Samuel Untermeyer, Elihu Root, and publisher Adolph Ochs of the *Times*. Charles Lindbergh, the famous transatlantic flier, looking very young among his gray-haired fellow pallbearers, helped carry the plain brown coffin. Mayor Jimmy Walker came to represent the city. Interment was at the family vault at Salem Fields in Brooklyn, where another group of mourners heard Rabbi Krass recite the Kaddish, the traditional Aramaic prayer for the dead.

Daniel left a gross estate of $20 million, about $13 million after taxes, funeral costs, and other deductions. This was not one of the great personal fortunes of the day. Pierpont Morgan, when he died in 1913, left almost $70 million. And Morgan, despite his imperial power in the world of business, was considered relatively poor. But, of course, even $20 million was an astounding sum to the ordinary American of the day. Of this amount, Daniel bequeathed $2 million each to Harry and Gladys outright. Robert was to receive the income of the same sum, the principal to be held in trust for Robert's children after his death. Daniel had already dispensed large chunks of his fortune for the advancement of aeronautics and for other charitable and civic-minded purposes, but he added another $1.5 million to the Daniel and Florence Guggenheim

Foundation and an additional $475,000 to the Daniel Guggenheim Fund for the Promotion of Aeronautics. Florence would receive most of the rest, amounting to almost $7 million, including Hempstead House and all the paintings and furniture.

Florence lived for another fifteen years, honored by foreign governments and private societies for her charitable work and civic contributions. She no longer wanted to live at Hempstead House now that Daniel was gone. Soon after his death, she wrote to Harry in Havana that she "must begin to consider the disposition" of the estate. She also must cut costs at the mansion, she noted, though keeping up repairs so that its market value did not decline.[13] Florence sold many of the house's paintings and furnishings at auction, but as the Depression took hold, found it difficult to sell the mansion itself. Eventually she built a smaller house, Mille Fleurs, on the property for herself, and in 1940 she opened Hempstead House to refugee children from Europe, some seventy-five of whom came to stay for a year. In 1942 she gave the house and the 162 acres of property to the Institute of Aeronautical Sciences, as an aviation research center.

During her last years Florence was a semi-invalid, with a heart condition. By careful management she fended off the fate of her husband but died in May 1944 at eighty, of cancer. Funeral services were held at Temple Emanu-El, with Rabbi Samuel Goldenson noting that "she was ever mindful of others less favored, less fortunate" and shared "with those others who came to her in need, in suffering and sorrow."[14]

ONE COMMON TYPE in the third generation of rich families is the playboy. Several third-generation Guggenheims were unabashed hedonists whose money sustained little high thinking or clean living. No one, however, qualified for the title as well as Daniel's older son M. Robert, the "M"—never used—for Meyer, after his grandfather. Robert made no apologies for his self-indulgence. Early in his adult life he issued his personal manifesto. "Every wealthy family supports at least one gentleman in leisure," he announced. "I have elected to assume that position."[15]

Though he retained his slender build until old age, in his later years Robert was the spitting image of his father, sharing his white mustache, strong chin, large ears, and smooth, sparse hair. But physical appearance

was virtually the only resemblance. For a brief period Robert practiced becoming a Guggenheim tycoon. After graduating from the Columbia School of Mines he worked with ASARCO and Guggenex, starting, as any exemplary heir, at the bottom, to "learn the business." In 1905 he dutifully married Grace Bernheimer, from a proper Jewish family, and fathered two sons, Daniel and M. Robert Jr. Yet from the outset Robert displayed his talent for mischief and frivolity. As a child, he was undisciplined. He habitually tormented the family's animals and mercilessly teased his sister, Gladys. He was a cutup at table, flipping spoons in the air by hitting one against the open bowl of another. He often disobeyed his parents' warnings and intruded on the servants in their private quarters. Despite his naughtiness, or perhaps because of it, he was favored by his mother over his younger brother, Harry, who was no slouch himself when it came to childhood mischief. Robert reciprocated his mother's affection. He apparently called her every day at 1 p.m. through his adult life, no matter where he was in the world.

His father was another matter. Except for the months during 1917 and 1918 when Robert served with the American Expeditionary Force in France, Daniel seldom approved of his older son. In one of those vicious family cycles, Daniel deplored Robert's behavior and Robert in turn confirmed his father's opinion of him at every opportunity. In the jobs he took with the family enterprises he performed haphazardly. When he was twenty-four, Robert became a patron of long distance automobile racing at a time when the passenger car was still a plaything of the rich. In 1909 he put up a $5,000 purse for the winner of a New York to Seattle competition to mark the opening of the Yukon-Pacific Exposition in Seattle. President Taft signaled the start by pressing a golden key at the White House. Robert so enjoyed the publicity that he resolved to convert the race into an annual event. Daniel had nothing against cars but he considered his son's interest in racing frivolous and excessive. Robert was also a deadbeat. He ran up gambling debts, as well as medical and rent bills, and did not pay them. Daniel made good on some of these, but in other cases the creditors sued Robert for recovery. Robert quit business in 1929 and thereafter lived on his investments.

Robert was a sexual adventurer as well as an idler. In 1915 Grace filed

for divorce on the grounds of adultery and asked for custody of the two children. Robert was content to accept six hours of visitation rights each month, not a sign of great paternal devotion. The cause of Grace's action was obviously Margaret Gibbs Miller Weyher, a nineteen-year-old amateur horsewoman of a Catholic *Social Register* family. Robert wasted little time—just three days after the divorce decree and forty-eight hours after Grace herself had gotten remarried to Morton Snellenberg—before tying the knot with Margaret in a Catholic ceremony at Deal, New Jersey, after first converting to Catholicism himself. The picture of Margaret and Robert in the *New York World* shows a handsome, if slightly beefy, groom in a double-breasted tuxedo, and a rather plain young woman in a white silk gown and a white picture hat. Both look apprehensive.

The marriage to Margaret was a scandal from the beginning. In 1915 the Guggenheims were at the height of their fame—or their notoriety—and the press had a field day with the double marital switch and with the religious differences between the couple. Margaret's religion and Robert's abrupt conversion to Catholicism were a shock to the Jewish community. Counting Uncle William's short-lived defection in 1900 to marry Grace Brown Herbert, this was only the second breach in the Guggenheim religious wall, and it triggered wide public comment. The apostasy seemed all the more dismaying for Daniel's own strong loyalties to Judaism. In our own day, of course, out-marriage by Jews has become almost the norm, but in 1915 it was uncommon. Many traditional Jews disowned children who married outside the faith, and Daniel was eagerly interviewed by the press on the subject. Would he disavow his older son? Daniel was asked. No, he would not. True, Robert had become a Catholic, he told a reporter, "but I have not disinherited him. Why, I haven't given such action a thought." He "didn't marry with my consent," Daniel replied, but Robert remained his son.[16] Eventually Daniel and Florence came to accept their daughter-in-law, but the incident reinforced their skeptical view of their son's morals and acumen.

Robert's parents put the best public face on their older son's behavior but had little faith in him or his judgment. As we saw, when Daniel died in 1930 he left each of his three children $2 million, but Robert's share was conveyed as a life trust, not an outright bequest. As Florence

explained to her son after he complained of his unequal treatment, the difference between Robert's portion and Harry's and Gladys's was "due to a feeling on Father's part that he wished to retain control over you, because of difficulties he had had [with you] in the past." As executrix of Daniel's estate she had tried to treat all her children equally, she said. But she then scolded Robert for his failings. "Your brother and your sister and your brother-in-law [Roger W. Straus] have always done things and worked hard. They have contributed their own money and time to charities and they have looked after their own children. You have done none of these things, and in addition you constantly worry me and accuse me of treating you less well than I treat them."[17]

In response Robert professed to be satisfied with the arrangements. He considered it a way out of his "present financial embarrassment," he told his mother. "I give you my solemn promise," he wrote, "never to get in debt again and never to come to you for help in my financial difficulties."[18] But the distinction rankled and he sought revenge. In 1933 he wrote a biography of his father. Though we would love to have it, it does not survive. But it must have been harsh, and his mother forbade him to publish it. "Instead of perpetuating your father's memory," she wrote Robert, "you would be detracting from it in a most unfortunate, even humiliating way."[19]

Robert was no more faithful to Margaret than to Grace. In 1928 his second wife secured a divorce in Paris on the grounds of adultery. Five months later Robert, now forty-two, married another horsewoman, the twenty-five-year-old Elizabeth Eaton of Babylon, Long Island, where Robert was then living. The ceremony was performed by a Lutheran minister, and no guests accompanied the wedding couple. Elizabeth and Robert divorced in 1937, and Robert soon after wed Rebecca Pollard Van Lennep ("Polly"), thirty-four, a pretty divorcee whose previous marriage had ended less than a week before. The ceremony was held aboard Robert's yacht while it was anchored at Miami Beach. Polly would be his last wife.

Although difficult to imagine how he did it, given the cascade of wives, Robert romanced other women as well. While living with Polly in Washington, Robert flaunted his mistresses. He sometimes arranged for

them to be seated at adjacent tables in restaurants when he dined out with his wife. When his son M. Robert Jr. once objected to the public display of his infidelities, he reputedly exclaimed: "Hell, I'm proud of it!"[20] Robert must have been an extraordinary lover. In 1969, ten years after he died, one of his mistresses, Frances Morris, wrote his brother, Harry, to express her continuing passion for this ne'er-do-well charmer. Apologizing for writing, she noted that she and Robert "loved each other with all our hearts." Robert, she declared, was an extraordinary man. "There was never anyone like him" and he made her "the happiest I have ever been in my entire life." Her love for him "will remain with me," she said, "until my heart beats its last, and my best thoughts will be of the man who adored me, and was *worshiped* in return."[21]

Robert had enjoyed immensely his experience in the military during the war. It undoubtedly gave him a rare sense of accomplishment, and for the remainder of his life he found military surroundings congenial. He stayed in the army reserves during peacetime and rose to the rank of colonel, and also served part-time on the War Department's staff while living in Washington. He made influential friends including Roosevelt's secretary of war, Harry H. Woodring. Despite his romantic escapades, Polly and he stayed together, living in a three-story mansion, the forty-room Firenze House, set on twenty-six acres near Rock Creek Park. Robert and Polly became figures in the Washington social scene, active in local charities and sponsors of the National Symphony Orchestra. In the 1940s Robert bought a fourteen-hundred-acre plantation in South Carolina, Poco Sabo, near Harry's place, Cain Hoy, in the South Carolina lowlands, some forty miles from Charleston. Like Harry, he used it as a lodge for his grouse and partridge shooting and for frolicking with male cronies.

Appropriately for a playboy, Robert was a yachtsman who spent as many as three months a year bobbing on the Atlantic waters, usually in south Florida. Over the years he owned five different boats, and each was named *Firenze* after his mother (as was his father's house at the Jersey shore and his own Washington home). The first seagoing *Firenze* exploded and burned while he and a party of friends were boating on the sound. The last *Firenze* was a 170-foot seagoing steel ship, flagship of the

Columbia Yacht Club of New York. The rakish, white-painted steamer was an impressive enough vessel to be featured in an Exide Marine Battery advertisement in a 1940 national boating magazine.

Daniel did not live to see his son's most humiliating misadventure. Like brother Harry. Robert was a strong Republican partisan who donated generously to the GOP. His contributions to the Eisenhower presidential campaign in 1952 earned him a diplomatic appointment when Ike won. For a time the administration considered sending him to Stockholm. The State Department feared appointing a Jew, however, and consulted the Swedes, who said that while they would "probably rather not have one," they did not find it "an insuperable obstacle." But the real problem with Robert, said one State Department official, was that he had "nothing above the shoulders."[22]

The final choice was Portugal—not a scintillating post but not the dregs either. Ambassador Guggenheim arrived in Lisbon in August 1953 and immediately praised the repressive regime of dictator António Salazar as "a singularly positive and constructive force."[23] Posthaste he committed a succession of other faux pas that neatly combined his schoolboy naughtiness and his sexual libertinism. In a maiden ambassadorial speech he insulted his hosts by telling them he really preferred to be minister to Great Britain though, he thoughtfully added, Portugal would do. Worse, one evening at a state dinner some months later, surrounded by a glittering guest list of government officials, foreign dignitaries, high military officers, and minor royalty—and their bejeweled wives—Robert reverted to a juvenile prank—flipping spoons at the dinner table. One of the spoons landed in the cleavage of an adjacent grand lady, and the ever gallant ambassador of the great republic reached over and fished the utensil from between her breasts with his bare hands.

It did not take long for the State Department to take notice of Robert's failings. He was soon included in a list of "Chiefs of Mission" who deserved poor performance ratings. In June, barely a year after his appointment, he was called back to Washington and asked to resign. Robert did not go quietly. A Republican Congressman visiting Lisbon soon after the recall reported that the bitter ambassador had reproachfully brandished canceled checks for large amounts he had made out to

the GOP and threatened to contribute to Democrat Adlai Stevenson's next presidential campaign when he returned home.

Robert and Polly arrived back in Washington in August and never talked about the Portuguese affair in public. In his formal letter of resignation, Robert claimed poor health and "personal reasons" for his departure.[24] But the recall rankled. A year after the fiasco, in a letter to Sherman Adams, Eisenhower's chief of staff, he charged that he had been victim of "a grave injustice." If "the true facts were known to the President," he insisted, "he would take some affirmative action which would demonstrate that he still had confidence in me and would put a stop to all the malicious gossip" that had circulated about him.[25] The State Department considered sending Robert on some face-saving cultural mission to Brazil or calling him in occasionally to consult on Iberian problems, but refused to reconsider its action.

Despite his embarrassing behavior, Robert was not ostracized by the rest of the family. He was hard to resist. Whatever his morals, he was charismatic, generous, and funny, and radiated bonhomie. One summer in the mid-1950s, his teenage California grandson Daniel visited him in Washington for two weeks. Daniel did not know his grandfather well but found him a delight. "To be in his presence you could not help but smile, laugh, have a good time," Daniel said fifty years later. Grandpa Robert was "a real kick in the tail."[26] When Daniel prepared to leave for his summer job back home, Robert tried to detain him by offering to pay him by the hour at the same rate as his California summer employer.

Harry for one never really forgave his scapegrace brother, but during their father's lifetime he concealed his distaste. They visited each other's homes; they exchanged Christmas presents, with Harry usually sending his brother a box of Havana cigars; they corresponded, though Harry wrote far more often to his cousin Edmond, whom he much preferred, than to his brother.

Robert had two children, both by Grace Bernheimer, Daniel II and M. Robert Jr. Daniel, with a bad heart like other male Guggenheims, died at the early age of nineteen while a student at Exeter academy. We will consider his younger brother, M. Robert Jr., in chapter 12. On November 16, 1959, Robert Sr. himself suffered a heart attack on a

Georgetown street as he was entering a taxi. He was taken to George Washington University Hospital, where he was pronounced dead at the age of seventy-four. His was not an exemplary life, but it may well have been great fun. Polly remarried in 1962 and died herself of heart failure in 1994 at the age of ninety.

DANIEL AND FLORENCE'S other two children were all that their parents could want. Harry was almost the antithesis of his brother. His life was responsible and creative and full of achievement. We shall consider it in separate later chapters. Harry had his differences with his father, as we have seen, but Daniel cherished and respected his younger son. "As your father I have derived infinite pleasure and gratification from noting the strides you have made in your development," he wrote Harry in June 1923. It had "been a constant and deep satisfaction for me to realize," he continued, "that you have ability, integrity, and industry."[27] Written to explain Daniel's position on his and Edmond's abrupt resignation from Guggenheim Brothers, the letter seems an unspoken invidious comparison between his two sons. Harry emerges as the counter-Robert.

Gladys, Daniel's youngest child, was an exceptional woman. Even as a girl she excelled. Gladys was dutiful, cheerful, and hardworking. She enjoyed her summers at Hempstead House but disliked her city home, the suite in the St. Regis Hotel that the family had moved into when she was twelve. She remembered hotel life as "all the telephones ringing in every room at once and having to order from a menu," that is, room service. It amounted to "no home life."[28] An excellent student, she attended Rosemary Hall, the sister boarding school of prestigious all-male Choate, in Connecticut. A handsome if not beautiful young woman, she resembled her mother so closely that when she was seventeen the *Times* published their pictures in profile side by side to demonstrate the remarkable similarity.[29]

Gladys was headed for Bryn Mawr when she was waylaid by love. In 1913 she met Roger W. Straus, then just out of Princeton, where he had been a classmate of her cousin Harold Loeb. Roger had a splendid Our Crowd pedigree. His uncles, Isidor and Nathan, owned R. H. Macy, the

famous department store.* His father, Oscar Straus, secretary of com-
merce and labor under Theodore Roosevelt, had been the first Jewish
cabinet officer. Oscar had also served as minister to Turkey and was an
accomplished amateur historian who had written a biography of the
apostle of religious toleration, Roger Williams. His son was named after
the seventeenth-century Puritan divine who had fought for liberty of
conscience.

Gladys at eighteen and Roger at twenty-two fell in love, no doubt to
the joy of their respective families. Daniel, who encouraged his children
to marry young, saw in his slender son-in-law-to-be not only a splendid
young man, talented and good-looking, but a possible future executive in
ASARCO and M. Guggenheim's Sons.

The wedding itself, in January 1914, was the Our Crowd social event
of the year. Held at the St. Regis with the chief rabbi of Temple Emanu-
El, Joseph Silverman, presiding, it was attended by various Gimbels,
Marshalls, Morgenthaus, Untermeyers, Adlers, Loebs, Strauses, and
others from the Jewish elite. But the guests also included many of the
gentile high and mighty: Mrs. Theodore Roosevelt, the Nicholas
Longworths, Andrew Carnegie and his wife, former Ohio governor
Myron Herrick, plus an assortment of titled English noblefolk con-
nected to Lady Eleanor. The newlyweds honeymooned briefly in North
Carolina and then hurried home so that Roger could start in the
Guggenheim family business.

The union was an unusually happy one. The Strauses had two sons,
Oscar Straus II and Roger Jr., born in 1914 and 1917 respectively, and a
daughter, Florence, born in 1922. When Captain Straus went off to
Siberia in 1918 to join General Graves's anti-Bolshevik military expedi-
tionary force, the devoted Gladys decided to accompany him to San
Francisco. As Daniel wrote Robert, then in France, "Gladys is a little
brick. As soon as she heard that Roger was to be in San Francisco she
decided to go along, to be with him until he left the country." Until she

*Isidor and his wife were passengers on the *Titanic* in 1912 and went down with the ship
with Benjamin Guggenheim. They would soon have been Guggenheim kin had they
lived.

returned, the boys would be staying with him and their grandmother at Hempstead House.[30]

Like his father, Roger was a progressive Republican who worked for Teddy Roosevelt when he ran on the third-party Progressive ticket for president in 1912. He considered the existing industrial regime in America oppressive and certainly told his father-in-law how he felt. Still smarting over the charges that ASARCO was an evil trust and the Guggenheims were among the malefactors of great wealth, Daniel shrewdly appointed his son-in-law to ASARCO's personnel division in 1914 and allowed him to create the firm's forward-looking safety and pension programs. After Daniel retired from the business, Roger advanced into executive positions, becoming in 1920 his uncle Simon's first assistant and vice president. Restless in business, in 1931 he sought the post of assistant secretary of state under Henry Stimson. Uncle Simon wrote a glowing letter for him to Dwight Morrow, now U.S. senator from New Jersey, and Morrow, who remembered Roger from Guggenheim family occasions, put in a good word for him. Unfortunately Stimson had another man in mind, and Roger lost out. He was forced to hang on at ASARCO as his uncle's subordinate. Then, in 1941, when Simon died, he succeeded to the presidency. In 1947 he became chairman of the board and remained CEO until 1957.

Roger was never content with a business career. He was a close adviser to Thomas E. Dewey, the liberal Republican governor of New York and two-time presidential candidate. In 1949, when ailing Robert Wagner resigned from the U.S. Senate, Dewey seriously considered appointing Roger his interim successor. Roger also served as American delegate to the United Nations. A longtime member of the New York State Board of Regents, the body that managed the state's educational policies at the highest level, he was chosen chancellor, its head, in 1957, just before his death of a heart attack while at his home in Purchase, New York.

Roger and Gladys remained committed, practicing Jews long after the ancestral fires had sputtered out among other third-generation descendants of Meyer and Barbara. Among the seven sons, Daniel had been the most religious. In 1901 his name is included, along with Jacob Schiff, Mayer Sulzberger, Felix Warburg, Cyrus Adler, and other mem-

bers of the German-Jewish elite, as a contributor to an endowment that enabled the Jewish Theological Seminary to survive as the pillar of Conservative Jewry. As late as 1916 and 1917 the Guggenheim boys were contributing substantial sums to Jewish causes and charities. In early 1917 Isaac, Daniel, Murry, Solomon, and Simon each pledged $5,000 for support of the Hebrew Union college, the Reform Jewish seminary in Cincinnati. But during the war period the broad Guggenheim commitment to the family's ancestral faith drained away. Daniel remained an active participant in Temple Emanu-El, and in fact was president of the congregation for many years before his death. Harry occasionally contributed to Jewish charities. He also maintained a marginal interest in the congregation his father had headed, allowing his name to be placed on a Temple Emanu-El seat endowment plaque and contributing to its building fund. He refused, however, to attend Emanu-El's high holiday services, returning the tickets to the congregation to be used for "out of town visitors."[31]

From the twenties on, the burden of being Jewish would be carried virtually alone by Gladys and her husband. During the 1920s and 1930s, she and Roger took active roles in Jewish organizations. In 1928 Roger helped found the National Conference of Christians and Jews, an interfaith body that for many years worked for the high-minded goal of fostering understanding between the two religions. Prominent Christians of liberal bent were members of the organization, including professor Carleton Hayes of Columbia; author Dorothy Canfield Fisher; Chancellor Harry Chace of New York University; Newton D. Baker, former secretary of war; and others. But at the time the organization was considered a bold departure. Many Jews, especially among East European immigrants, remained highly suspicious of gentiles, remembering public Jewish-Christian dialogs in the past as one-sided and coercive. According to the liberal Catholic publication *The Commonweal*, in an editorial of 1936, Straus had been a brave if "quixotic" man to seek to change the traditional lines of communication between the faiths when he started.[32]

In the early 1930s, with the advent of Hitler, Straus and his group, working through publications, meetings, and seminars, sought to alert Americans to the dangers of the brutal anti-Semitic campaign that the

Nazis had unleashed in Germany. In 1936 Roger received the Hebrew Medal of the organization as recognition for his work for interfaith amity. He remained the guiding hand of the conference for many years. In 1948, on the occasion of the group's twentieth anniversary, Roger was honored, along with Henry Ford II, for his contribution to the "cause of brotherhood and understanding among men."[33] Yet there was a timid and apologetic quality about Straus's Jewishness. Jewish leaders today, after the Holocaust, are less tolerant of Christian sensibilities in cases of bigotry. Straus carefully avoided giving offense to Christians. As he noted on the occasion of receiving the medal in 1936, Jews should not blame "the teachings of Christianity" for "those few occasions when intolerance and prejudice are evident and proved." Rather they should be ascribed to "the frailties of mankind and the specific motivating force that was responsible for the specific action."[34]

Gladys herself was active in Jewish affairs, serving for years as chair of the women's division of the United Jewish Appeal, the chief fund-raising body for Jewish charities. In 1940 she turned her attention to the plight of Jews in wartime Europe. "It is not enough for our hearts to be touched," she told a UJA meeting on refugees at the Biltmore Hotel in New York. Rather, we "must share some of our bounty with the suffering of the Jews overseas."[35] The Guggenheims were among the chief bene-factors of the premier Jewish-sponsored hospital in New York, Mount Sinai. It is no surprise that Gladys served for twenty years as vice presi-dent of the hospital's board of trustees. She was also active in Republican politics, serving as president of the National Women's Republican Club. From 1930 to 1945 she headed the board of the Daniel and Florence Guggenheim Foundation; she was its president in 1971–74. Gladys was aware of her susceptibility to public service. She once remarked of her many affiliations: "It seems that as soon as I get out of one, I get mixed up in another one."[36]

Gladys also had a successful private career as a food and nutrition expert. She was a good cook herself, delighting in creating fish dishes at the rustic camp in Maine where she and Roger went summers for many years. She admitted that she disliked the logistics of the cooking process, however. "I love to cook but I hate to clean up," she told an interviewer.[37]

Gladys was a cofounder in 1940 of *Gourmet* magazine and served it as its vice president and assistant editor for a decade. She wrote two successful cookbooks. In 1934 Dewey appointed her "nutrition commissioner" of the New York metropolitan area.

Gladys lived to a ripe old age. She passed away in New York at the age of eighty-four in 1980. In the Guggenheim family girls formally did not count, but maverick Peggy aside, if any female of her generation overcame her gender handicap to lead an interesting and important life, it was Daniel's youngest child.

MURRY DIED of the family affliction, a weak heart, in 1939 and was memorialized at Temple Emanu-El in a private funeral service. During the 1920s, in the absence of the ailing Daniel, he was the director of the nitrate ventures of Guggenheim Brothers. He continued in the directorships of Kennecott Copper, Utah Copper, Braden Copper, and other mining and smelting firms. Murry continued to live summers in the Jersey shore and never sought to live baronially on Long Island's Gold Coast. But he did maintain a yacht, the *Leonie*, which he often anchored on Florida's west coast. He also had an apartment on Fifth Avenue in New York, two full floors, where in 1915 he and Leonie lived with two servants.

Murry was an uxurious man, close to his Alsatian-born wife, Leonie, and always loyal to her. They shared many activities in New York. Unlike Daniel who, with piercing eyes and firm mouth, adopted the expression of a mogul, Murry, in his photographs, always wore a wispy smile as if secretly amused by the world. He probably was. Daniel bore the full weight of leadership; Murry could avoid the pressures by withdrawing to the company's "books." He was the firm's naysayer, often serving as the brake on some exuberant but shaky plan from Daniel or Simon. He shunned publicity. His son Edmond remembered his father, besieged by reporters, turning them away with a little jest. "My brothers talk to the press too much as it is. Why should I compound the crime."[38] Bernard Baruch called him "quiet, very quiet."[39] Perhaps it was this modesty that deterred Murry from relocating his summer address from the unpretentious Jersey coast to the more glamorous North Shore.

Like all the brothers, Murry was a philanthropist. He helped defray the perennial deficits of the Metropolitan Opera, joined his Alsatian brother-in-law Alfred Bernheim in building a dormitory for students at the University of Paris, and gave funds to the Hebrew Union College. He cosponsored the Goldman Band with Daniel. But Murry and Leonie were particularly interested in teeth, the teeth of New York's poor children. Their dental clinic plan was not a grandiose project; but like Murry himself, it proved quietly useful.

Murry and Leonie learned about the dental problems of the city's children from Dr. S. S. Goldwater, head of Mount Sinai Hospital. Half of the city's schoolchildren, Dr. Goldwater told them, were afflicted by tooth cavities, and many came from families that could not afford to see dentists. Something should be done for these children. Murry visited public dental clinics in Rochester and Boston before making his move. On June 23, 1929, he announced the formation of the Murry and Leonie Guggenheim Foundation dedicated to establishing free dental clinics for children and young people in each of the city's five boroughs and defraying the costs of training dental hygienists. The announcement mentioned no figure for the size of the endowment, though it estimated that the first clinic, to be located in Manhattan, would probably cost between $3 million and $4 million. Reporters clamored for more information but Murry avoided the press by conveniently hiding aboard his yacht in Florida. If Murry was personally modest, he had a grander end in mind for his foundation, nothing less than "the promotion through charitable and benevolent activities of mankind throughout the world."[40]

The announcement was greeted with extravagant press applause. It was "magnificent," a "boon to child health," "thrilling," the New York papers proclaimed.[41] In the fall the foundation announced that it had bought some tenement property on the Upper East Side with a frontage of one hundred feet on Seventy-second Street as the location of the first clinic. Early the next year it published detailed plans for the new six-story structure to be erected on the site and information on the services to be provided. The impressive building was completed in 1931, and the clinic opened for business in September. In its first year it was visited 58,000 times by parents with children and performed 143,000 proce-

dures including X-rays, extractions, cleanings, and fillings. In 1932 the foundation established a school for dental hygienists that survived into the 1940s.

Leonie continued to summer at the Jersey shore after Murry's death. When she died in 1959 at the age of ninety-three, their Beaux Arts vacation house reverted to the family foundation and then, in 1960, was donated to Monmouth College to become the school library's main building.

NEITHER OF MURRY and Leonie's children gave them great joy. In 1915 Lucille, the younger child, married Frederick Gimbel, uniting the Guggenheims, as had her cousin Gladys's marriage to Roger Straus the year before, to a department store dynasty. She divorced Fred after a brief marriage, however, and wed Jack E. Bonar. This union did not last either, and Lucille tried once more with Peter Summerer before the cycle ended.

Son Edmond was not the successor his father yearned for. He was a homely boy. His jutting nose, his cousin Harold remembered, "was much discussed by my aunts during his childhood."[42] In later life his pugnacious jaw was as prominent as his nose. As a schoolboy he was both wayward and lazy. Dr. Sachs, his headmaster, told Murry that his son was "the worst boy I have ever had in my school."[43] Nevertheless, Edmond managed to get into Columbia College in New York by dint of intense tutoring. He stayed only two years. Living at home as he did, he told his father, deprived him of a campus life, and so he might as well quit and learn the business. Murry promptly sent him off to Utah to help manage the family's western smelters. Edmond soon discovered that he was not equipped for the work and asked his father to send him to Yale's Sheffield Scientific School. Somehow he survived there and graduated in 1911. For the next few years Edmond worked at the family-owned Baltimore Copper Refinery and the Perth Amboy smelter. In 1916 he, along with cousin Harry, went off to Chile to work at Chuquicamata. As we saw, both became partners in Guggenheim Brothers when it was organized in 1916. When their seniors decided to sell the Chuquicamata mine to

Anaconda in 1923, the two young heirs opposed the deal and soon after resigned from the firm in protest.

Harry and Edmond eventually returned to harness in the family businesses. Edmond became director of Kennecott Copper and dabbled in other family ventures until he retired in 1961. He never seems to have worked very hard at any of them. He never had to. Both he and Lucille could live on the $300,000 a year from the trust funds of $6 million Murry had established for them in 1917. Edmond preferred sports to business. He looked like an athlete and was one—or at least the gentleman's equivalent: a "sportsman." He played tennis but excelled at golf, winning the President's Trophy in 1929 at the annual tournament at Pinehurst, North Carolina.

Edmond lived at various places over his long life. During the 1920s he had an estate in Roslyn, Long Island, called Ebmarna. He also maintained a summer "camp" in the Adirondacks, on Saranac Lake, called Rockledge. In 1925, acting on a tip, Prohibition agents raided the camp expecting to find hundreds of cases of illegal liquor. They were disappointed when they uncovered much less—three hundred bottles of what the *Times* described as "choice liquor." The bottles were confiscated but no one was arrested.[44] Edmond and his second wife, Jeanne Russell, poured money into their Adirondack place. In the late 1940s cousin Harry visited them there and was impressed by Edmond's "improvements," especially the "great living room" where his cousin could display his extensive hunting trophies "to great advantage."[45] In later years Edmond lived winters on a houseboat anchored off the east coast of Florida. Eventually, in his last years, he traded Florida for Scottsdale, Arizona, but spent his summers in Spring Valley, New York.

Edmond did indeed direct the dental clinic after his father's death in 1939. But he was not an energetic administrator. When Murry died, he left an additional $5 million to the Murry and Leonie Guggenheim Foundation out of an estate of about $18 million. In late 1948 the New York Board of Education announced that more than seven hundred thousand city schoolchildren had been served by the joint program of the schools and the dental clinic. This was, no doubt, a commendable

achievement, but the ambitious multiple clinic plan was never fulfilled, not to speak of the foundation's more spacious goals. No outer borough clinics were established, and the Seventy-second Street facility remained an isolated operation. The Depression, which cut drastically into all endowments, undoubtedly had a dousing effects on the founders' ambitions. But the mediocre showing seems also to have derived from lackadaisical and unimaginative administration. As president of the foundation at his father's death, Edmond spent only one day a week at his desk. When, in 1967, the state of New York took over the task of providing free dental services for poor children, Edmond might have conceived of an original alternate way to use the foundation's money. Instead he closed the clinic and donated the building and its equipment to nearby New York Hospital.

Like many Guggenheims, Edmond was a repeat offender in marriage. In 1910, while still at Yale, he wed Marron Price, an orphan, who lived with her sister on West Eighty-ninth Street. The two were married in Marron's sister's apartment with only a few family members present. It is hard to believe that Murry and Leonie approved, though it was they, obviously, who supplied Temple Emanu-El's Rabbi Joseph Silverman to officiate.

Edmond and Marron had a daughter, Natalie, who inherited her father's disposition to marry beneath her. An impetuous seventeen-year-old, Natalie fell for Tom Gorman, son of the baggage master at the Manhasset station of the Long Island Railroad, and in April 1929 married him in a secret ceremony at All Saints Episcopal Church in Great Neck. One report suggests that it was the religious difference between Natalie and Tom that led Edmond and Marron to oppose the marriage. More likely both were appalled by the class differences between their daughter and the baggage master's son and suspicious that he was a fortune hunter. Repeating the tactics of Meyer and Daniel toward Uncle William's first marital indiscretion, they succeeded in dissolving the marriage, in this case by annulment, on the grounds that Natalie was under age. As in the William Guggenheim–Grace Brown Herbert affair, money apparently changed hands—$50,000, it was said. A week after the

incident, Edmond whisked his daughter off to Europe on the *Île de France*.*

Marron divorced Edmond in 1936 after the customary six weeks' residency in Reno, Nevada. We do not know why, though perhaps it was because she became more enamored of flying than of him. Ten years later Edmond wed Jeanne Russell and divorced her after six years of marriage. His last wife was Marian Kaufmann, whom he married in 1952 at the age of sixty-four. This union lasted until Edmond's death in 1972.

In his last years, after he had moved to Scottsdale, Edmond kept in touch by letter with cousin Harry. He was a hypochondriac and worried constantly about his health. When he contracted measles in 1964, he ran off to the Mayo Clinic in Minnesota for an extensive checkup. He used a cane by this time and sprained his hand badly the next year when he got his walking stick tangled in his legs on his driveway in Scottsdale and took a bad spill. "As we get older," he observed to Harry that year, "Nature begins to take its toll."[46] Edmond died in a Phoenix hospital in March 1972, a year after cousin Harry, at a ripe eighty-four.

His will reflected his hypochondria. His two biggest bequests were to the Mayo Clinic and Mount Sinai Hospital, with another six health facilities receiving lesser amounts. The Mayo Clinic received $12 million. The Mount Sinai bequest, $22 million, was the largest gift the hospital had received in its 120-year history. He also left money to his wife and to his daughter, Natalie, and bequeathed his Saranac Lake camp to the Roman Catholic Church to be used as a seminary for training priests.

Edmond does not strike us as an exemplary character but his last wife, Marian, considered him a "beautiful human being" who deserved a solid memorial biography.[47] In the summer of 1975 she visited the campus of Monmouth College, to which Leonie had donated the family summer home, to consult with Robert Van Benthuysen, the director of the library, about finding a biographer for him. Benthuysen offered his own

*Natalie married Robert Studin in 1933. She divorced him and then married Frederick Talbert. When she died in 1981 at age seventy, she was married to B. B. Short of Honolulu. She would leave Mount Sinai Hospital $13 million, a bequest to the hospital exceeded only by her father's.

services, but warned her that there would be considerable cost, especially if she hoped to find a respectable trade publisher for the manuscript. The project never was begun, apparently, because, as she wrote, she wanted a "much more creative role to play."[48]

WILLIAM, THE YOUNGEST of Meyer and Barbara's sons, died in June 1941. After World War I William lived an improvised life. He had missed out on the great surge in family wealth that came with Chuquicamata and wartime inflation in copper prices, but he had the $2 million or so from the legal settlement of his suit over Chilean copper along with the 1923 gift. Though not extravagant, these resources allowed him to live comfortably until his later years.

His marriage to Aimee Steinberger in 1904 was not a great success, however. Aimee was a large woman who loomed over her compact husband, like a James Thurber character, and bullied him. She also encouraged his alienation from his family. For some years William and Aimée lived, like most of their family, in the Guggenheim seasonal oscillation between New York apartment or townhouse and North Shore Long Island summer house. Though the summer place was adjacent to his father's and nephew Harry's, the other Guggenheims never visited him, nor he them. In any case, this arrangement did not last. Sometime in the 1920s William and Aimée separated. In the settlement Aimée got the proceeds of a million-dollar trust fund and the Sands Point estate, which she sold to the Meadowbrook and Sands Point Clubs to be subdivided into estates of five to ten acres. William bought a townhouse, number 3 Riverside Drive, near Seventy-second Street, and lived there the rest of his life.

He spent most of his later years aspiring to be what we now call a "public intellectual." Several of his brothers were happy to parade their opinions before the public. But none was so free as William in pronouncing judgments on men, events, and policies. We have seen his aggressive public patriotism and anti-German campaigns in the years immediately preceding and during the First World War. He continued to favor the American public with his views until his final years.

None of his opinions surmounted the tediously conventional.

William was an unalloyed defender of rugged individualism and the unrestrained capitalist order at a time when both were under attack by thoughtful men and women disillusioned by the worldwide 1930s economic collapse. Like most of his brothers, William was an ardent Republican who supported GOP candidates during the 1930s, defended capitalists' profits, and opposed the New Deal. In 1934 he attacked the National Industrial Recovery Act, Roosevelt's chief anti-Depression weapon, as a "subterfuge." The country must stop "floundering in a sea of experiment." He excoriated John Maynard Keynes for his absurd view that America "could spend itself into prosperity."[49] William was also a passionate anticommunist who urged Germany just after the outbreak of World War II to "point her guns eastward, not westward, while we sever our ties with red Russia."[50] William's usual forum was University of Pennsylvania gatherings, either in New York or Philadelphia, but he also wrote frequent "letters to the editor" that the *Times* seemed happy to print. He wrote, and self-published, a flock of pamphlets, expanded versions of his public talks. One curious work was his autobiography, published by his own firm, Lone Voice Publishing Company, and written in collaboration with a journalist under the pseudonym "Gatenby Williams." The name comes from nowhere intelligible but suggests William's persistent yearning for WASP respectability.

William was a hyperactive alumnus of the University of Pennsylvania. He headed the University of Pennsylvania Club of New York located on East Fiftieth Street and provided an annual Guggenheim Honor Cup for the graduate of the university who had accomplished the most in the previous year. Born himself in Philadelphia, William chose as his hero Benjamin Franklin, the most distinguished son of the City of Brotherly Love and a founder of the university he had attended. William saw Franklin as a prophet for the times whose principles of compromise and peaceful settlement of international disputes should guide nations in a troubled era. Late in life he even sought to emulate his hero's printing and publishing career.

William apparently admired Franklin's lusty private side as much as his opinions. He had always been a skirt chaser—ever since his salad

days in Leadville, Denver, and Monterrey. Late in life he began the enthusiastic pursuit of New York showgirls. His entree with them was his interest in the theater. He was not the richest son of Meyer, but he had enough to indulge his taste for Broadway. And not just as a consumer and spectator. At the age of seventy William wrote the lyrics to several popular songs including "Crumbs of Love" and "Jubilee." He became a Broadway "angel," putting up money for plays and musicals. None of his theatrical investments paid off, but he took his profit "in trade." William "kept" a succession of chorus girls, two of them beauty contest winners, with whom he spent happy moments in the Salon d'Or of his Riverside Drive home.

William died at seventy-two on June 27, 1941, at New York Hospital and was buried at the family mausoleum at Salem Fields after a funeral service conducted, surprisingly, at Temple Emanu-El. At his death four young women were still on his string of inamoratas, and the newspapers reported that he had left them collectively a million dollars. By contrast, according to the press, he had left his widow nothing. In fact, Aimée received a substantial part of William's trust fund while the girlfriends received virtually nothing; William's own money by the time of his death had dwindled to $12,000. By one calculation he had gone through $8 million in the forty years since he left M. Guggenheim's Sons, and toward the end had been forced to rent out rooms in his four-story Riverside Drive house.

William had made his big mistake back when the century was new. Rebellious and resentful, he had drawn away from the family and, like Ben, never cashed in on the family copper bonanza. The blunder undoubtedly denied him the resources to live the life he craved. But he also suffered from the contrariness of the baby of the family, nursing a sense of grievance against his older siblings and determined never to conform. The attitude encouraged a narrow self-centeredness, necessary perhaps for survival, but often foolish and self-defeating.

WILLIAM'S SON, William Jr., enjoyed the life of a rich child even after his parents' divorce. His mother, Aimée, resented the Guggenheims and worked to alienate her son from his uncles and aunts. Aimée herself lived

well, despite the divorce. Her grandson remembered her Park Avenue apartment and her chauffeur-driven Rolls-Royce. Fortunately, William Sr. himself was proud of his offspring and subsidized his son's private education and trips to Europe accompanied by a valet. In the late thirties William Jr. married Elizabeth Newell, a young woman from the *Social Register* whose family roots on both sides extended back to distinguished New York colonial forebears including the Beekmans. William Jr. and Elizabeth had a son also named William who must have fulfilled his grandfather's wildest social dreams. His father immediately enrolled the boy in the Sons of the American Revolution, the ancestor-proud organization, the ultimate brand of the American WASP elite, for which he qualified through his mother. William Jr. himself detached entirely from all Jewish friends and acquaintances. Like his uncle Simon, he joined the Episcopal church and in his later years, according to Elizabeth, he associated with "only good Gentile society."[51]

William Jr.'s health was not good. Like other members of his family he had a weak heart, but his health problems surfaced at an early age. He could not keep his Wall Street job and was rejected for service in World War II. Yearning to help the war effort, like thousands of other middle-aged patriots, he put in a "victory garden" to meet the nation's food shortages and devoted many hours as a civil defense volunteer peering through binoculars on his rooftop to spot enemy planes if they raided New York. His son says that the constant stair climbing severely taxed his heart and led to his death in 1947, at the age of only thirty-nine. As William III sees it, his father was "not hit literally by a bullet, but he died as a result of the war."[52] Despite his shortened life, William Jr. managed to do something few Guggenheims accomplished: perpetuate the family name. He alone had male descendants who will carry on the family name well into the twenty-first century

Aimée was devastated by her only child's death. She retained a friendship with her former sister-in-law, Cora Rothschild, but cut herself off from all the other Guggenheims. After her former daughter-in-law, Elizabeth, remarried in 1952, she broke with her as well. Her grandson later said that he remained virtually her only human contact. Meanwhile, Aimée made her dead child into a shrine. Once a week—every week—

she would be driven in her Rolls to the cemetery on the island to place flowers on his grave.

IN NOVEMBER 1941, four months after brother William, Simon died of pneumonia at Mount Sinai Hospital. He was seventy-three.

In his later years "the Senator" detached himself entirely from his Jewish roots. If Daniel and Murry were part of New York's Our Crowd, Simon, who lived so many years in Colorado and Washington, had never become close to the city's German-Jewish elite. In fact, after leaving Washington in 1913, he found it hard to give up his Denver connections and acclimate himself to New York. He tried unsuccessfully to move ASARCO's home office to the Colorado capital and until well into the 1920s, as a sentimental gesture, he maintained his Sherman Street Denver house. By the time he and Olga became reconciled to Gotham, they had little connection with their ancestral faith. Olga converted to Episcopalianism, and she and Simon joined the stylish St. Thomas Episcopal Church on Fifth Avenue. Simon and Olga lived winters at the Carlton House Hotel and later at 630 Park Avenue. In their last years their social circle consisted of rich, old WASP families.

SIMON AND OLGA had two sons, John Simon and George Denver, both born in Denver before Simon won his Senate seat. Simon must have been jubilant at having sons; they had scarcity value in the Guggenheim clan, as we know. But the lives of both were tragic.

A sweet-faced lad, John Simon was sent to Phillips Exeter, where, in 1922, when he was seventeen, he died of mastoiditis, an ear infection then often fatal. John Simon had been an apt pupil and was about to begin his freshman year at Harvard. His death was devastating to his parents.

The fate of George Denver was even sadder. The handsome George was an unstable character. According to several family members interviewed by John H. Davis in the 1970s, he was "erratic, rebellious, and very high-strung."[53] He was also, probably, a homosexual, a status then usually freighted with shame and self-doubt, as well as legal and even physical jeopardy.

George Denver attended Harvard and graduated in the class of 1929. In Cambridge he was popular but seemed aimless in his goals. One of his classmates later said of him that "he was all dressed up [with] no place to go."[54] Actually, Simon sought to groom him for the family enterprises and shipped him off to Chile to learn the resource-extracting business. George did not like Chile and soon returned to New York. Simon now made his surviving son a member of the ASARCO executive committee and a director of the General Cable Corporation, an ASARCO subsidiary. But the grooming process simply did not take. With a million-dollar trust fund to draw on, George became a self-indulgent libertine who squandered his money in nightclubs and on drink and drugs. He also associated with disreputable gay men in the homosexual underground that New York supported in the 1930s. He lived in an apartment on Central Park West with his "secretary," Clarence Osborne.

Aside from all his other problems, George was a manic-depressive who had been under the care of a psychiatrist. He had received shock treatments but they had not worked. It must have been while in the depression phase of his bipolar disorder that he purchased a high-powered hunting rifle at a sporting goods store and rented a room on the ninth floor of the Paramount Hotel near Times Square. Late morning on November 11, 1939, he shot himself to death. He was thirty-two years old.

We can only imagine what Simon and Olga felt. But George was a suicide, then a disgraceful way to die, and they never spoke of his death or memorialized his inglorious life. They expressed their grief for John Simon, however, in the way that the senator knew best, a benefaction. From his Denver days on, Simon had the reputation of a genial altruist. "Have a new school on me," he used to joke.[55] In 1925, after their older son's death, Simon and Olga announced the creation of the John Simon Guggenheim Memorial Foundation, with an initial gift of $3 million, to establish fellowships for "scholars, scientists, and artists" to advance and diffuse "knowledge and understanding and the appreciation of beauty."[56] When Simon died, Olga received the yield of a $2 million trust fund from Simon's estate of $17 million. The senator also gave bequests to other relatives—his sisters Rose and Cora, his niece Nettie, his nephew Willard

Loeb, and his cousin Otto Myers. All the rest—some $13 million—went to the memorial foundation. Although in the end Simon had no surviving descendants, his name through the foundation lived on more vividly than if his two sons had survived.

Olga became an art patron, contributing a large fund to purchase modern masters for the Museum of Modern Art in New York and enabling the museum to add forty-four acclaimed pieces to its collection, including such signature paintings as Peter Blume's *The Eternal City* and Henri Rousseau's *Sleeping Gypsy*. She also contributed items from her collection to the Denver Museum and gave her favorite city other parts of her collections at her death in 1970. In 1952 the National Institute of the Arts gave her their award for distinguished contributions to the arts. She was also a benefactor of Roosevelt and St. Luke's hospitals and other benevolent institutions. She gave nothing to Jewish institutions. Olga lived to ninety-two, dying in February 1970. The funeral services were held at St. Thomas Church.

DURING THEIR LIFETIMES Simon and Olga presided over the formulation and evolution of the memorial foundation named for their son. The foundation as initially conceived was imitative. Its model was the Rhodes Scholarships that brought selectively chosen non-English students to Britain's Oxford University to educate as proper English gentlemen and, more than incidentally, transform them into friends of imperial Britain. The program had been created by Cecil Rhodes, whose grandiose ambitions in South Africa at one time, through John Hammond, had touched, if remotely and briefly, the careers of the Guggenheims. The idea emerged out of conversations between Simon and an attorney for Guggenheim Brothers, Carroll Wilson. A Rhodes Scholar himself, Wilson proposed that Simon endow a foundation with similar goals, though with an American accent. Simon liked the idea, and Wilson now turned for help to Frank Aydelotte, head of Swarthmore College in Pennsylvania, another former Rhodes laureate.

In April 1924 Wilson and Aydelotte presented Simon with a precise plan for the foundation. It changed the Rhodes model in significant ways. The new fellowships would be awarded to mature scholars, scientists,

and artists, rather than to students. Those selected would be "the biggest brains in the country," and the winners would not attend a university but be free to use the money any way they wished.[57] In October 1924 thirty-year-old lawyer Henry Moe, yet another Rhodes Scholar, became Aydelotte's assistant and de facto managing director of the foundation. The following year Simon and Olga formally announced their gift. Soon after, the foundation received a charter under New York state law.

The foundation was never one of the large ones. In 1929, noting how he and "my brothers . . . have long been engaged in commerce with many of the republics to the south of the United States," Simon added a million dollars to the endowment to fund fellowships for Latin American scholars and artists.[58] Olga and Simon monitored the foundation closely and in 1935, feeling "deep satisfaction [with] the truly notable results" achieved in the previous decade, gave it another $750,000, bringing the endowment, supplemented by capital growth, to $6 million.[59] The foundation received from Simon's estate a total of $17.5 million in 1943, and when Olga died in 1970 she gave it $41 million more. All told, by 1972 the foundation endowment had reached $115 million. Yet all the largesse and asset growth placed it only forty-second among American foundations in 1977, while its disbursements of $5 million put it only in forty-fourth place.

The foundation's individual grants were never very large. At the beginning they were about $2,000 and slowly rose with the consumer price index. The total disbursements to creative men and women from 1925 to 1979 was about $80 million in some 11,500 grants, for an average of under $7,000. Yet each year, for many years, its awards were announced in the *Times* with a fanfare almost as loud as the Nobels. And who received the foundation's largesse? Admittedly, many of the awards went to obscure academics for work that few Americans understood or cared about, but many who received money were either famous or later became famous. Forty-one recipients later received Nobel Prizes; 102 Pulitzers. Among the cultural celebrities who won "Guggenheims," typically early in their careers, were Saul Bellow, Paul Samuelson, Linus Pauling, Murray Gell-Mann, John Cage, John Berryman, W. H. Auden, Allen Ginsburg, Marianne Moore, John Cheever, Mary McCarthy,

Carson McCullers, Vladimir Nabokov, Susan Sontag, Edmund Wilson, Aaron Copland, and Lewis Mumford.

Under Moe and his successors "a Guggenheim" became the most prestigious fellowship in America. Receiving one was a mark of distinction, particularly in academic communities. The money, especially for men and women in the poorly paid arts, was often a godsend. As the wife of poet Stephen Vincent Benet recalled, when her husband applied for a Guggenheim in December 1925, he and his young family "lived entirely by his writing." Stephen wanted to write a long poem on the Civil War but could not afford it until he won one of the first grants. "To say the Fellowship meant a good deal to us under those . . . circumstances is to deal in understatement."[60] The poem, of course, was *John Brown's Body*, which won the Pulitzer Prize and became a Book-of-the-Month-Club selection and a minor classic.

Until Lyndon Johnson created two National Endowments—for the humanities and for the arts—the American government, unlike its European counterparts, did little to foster the arts or humanistic studies. The John Simon Guggenheim Memorial Foundation filled the culture gap magnificently and earned the gratitude of thousands of articulate and talented men and women who spread its fame. In the 1930s winning a Guggenheim even became the theme of popular cartoons. One depicted a befuddled young woman entering a "Madame Francine's Corset Shop" and asking for a "Guggenheim foundation"; another, from *The New Yorker*, showed a worried young man sitting at a Paris sidewalk café exclaiming to his companion: "The Guggenheims will be awfully sore at me if I don't get down to writing pretty soon."

When the Guggenheims had ceased to be leaders in American industry, the memorial foundation preserved its renown. Only Solomon's museum, opened in 1959, would equal it in sustaining the family fame.

SOLOMON OUTLIVED SIMON and William by eight years. He was the most debonair of Meyer's seven sons and lived in high style. The French painter Fernand Léger, who visited it in 1931, pronounced his home at Sands Point (Isaac's former estate now renamed Trillora Court), "the most regal thing he had ever seen."[61] Solomon also had a Greek Revival

mansion in Charleston on the Battery, and an eight-room suite at the Plaza Hotel in New York. He would maintain a hunting lodge in Scotland, a ranch in Idaho, and a plantation on the Yemasee River in South Carolina called Big Survey. To top it all, he too owned an ocean-going yacht.

Like all the children of Meyer and Barbara, Solomon was short. He was heavy-featured, but his portraits show him, dignified and benevolent of mien, in sleekly tailored three-button suits, crisp white shirts with high collars, and a pearl gray homburg. His nephew Harold Loeb recalled him as a very old man. "In his dressing gown he looked like a Renaissance cardinal."[62]

He was the most genial of the brothers. The members of the third generation found Uncle Daniel formidable, but Uncle Solomon was always kind and approachable. He was, like most of his brothers, also a lover of women. Wife Irene was a handsome lady. Although everyone called his aunt cold, Harold Loeb noted, that was "because her beauty was classic and her face didn't break too readily into a smile."[63] But Solomon was not faithful to her. He had a succession of mistresses, some of whom, his niece Gladys Straus remembered, were exceptionally beautiful women.

Solomon deserves our attention primarily for his patronage of twentieth-century art and the creation of the museum of modern painting in New York that bears his name. We shall reserve this story to a later chapter.

SOLOMON AND IRENE had three daughters: Eleanor, Gertrude, and Barbara Josephine. Eleanor, the eldest, spent much of her adolescence traveling in Europe with an instructor and chaperone, pursuing her interest in art. It was at a social function in London that she met Arthur Stuart, the surviving son of an Irish peer, the sixth Viscount of Castle Stewart.* A very tall young man who had attended Trinity College, Cambridge, Arthur Patrick Avondale Stuart had earned the British

*The difference in spelling is not a typo. The family name and the title were different for reasons that only *Burke's Peerage* can explain.

Military Cross in the Great War in which his two older brothers had died. Though a distinguished old family descended from the royal house of Scotland, the Castle Stewarts were not rich. Perhaps the couple fell madly in love. The marriage lasted for many years, and Eleanor and Arthur would produce four sons. But it is difficult to avoid seeing the practical advantages for both sides in the match. For the Castle Stewarts, obviously, here was a chance to vastly improve the family's fortunes by the venerable expedient of marrying an American heiress. For the Guggenheims, what clearer sign of arrival than a daughter married to a British peer? Whether it was for love or money, in July 1920 Eleanor and Arthur were engaged to be married. In 1921, at his father's death, Arthur became the seventh Viscount of Castle Stewart. Eleanor would be a viscountess.

The American press had a field day with the match. The union of a Jewish immigrant's granddaughter and a descendant of the royal family of Scotland was a mouth-watering event and delighted the gossip columnists and social arbiters. The wedding itself, in December 1920, celebrated in London rather than New York, supposedly in deference to the aged sixth viscount's infirmities, was widely reported. The new countess wore her mother's bridal gown of hand-woven satin brocade. Her bridesmaids, mostly friends she had made in Europe, wore white satin with sashes of crimson velvet. The wedding, the press predictably and conventionally noted, was "one of the most brilliant events of the London season."[64] Solomon gave away the bride and obviously Irene was present, but there is no indication that any other member of the family attended. Solomon handed Eleanor "a wonderful little cheque,"[65] some of which Eleanor distributed to various hospitals, and the rest of which Arthur used to buy an eight-hundred-acre estate in Sussex. In the early 1930s Arthur served in Parliament, and when he retired for ill health became justice of the peace for his county. Eleanor became a British subject but never converted to Christianity. "As a Jewess," she later said, "I could never accept the divinity of Christ."[66]

In later years Eleanor's life turned tragic. Her two oldest sons, David and Robert, were killed in World War II while serving in the British army in North Africa and Italy respectively. In 1961 Arthur, then

seventy-two, put the muzzle of a shotgun in his mouth and pulled the trigger. He suffered from severe arthritis, and the pain, according to the family, explained his self-destruction. In fact he was probably afflicted with clinical depression. Eleanor did not let these sad events destroy her morale. She continued to live at Old Lodge, near Nutley Sussex, a large Tudor mansion with eighteen bedrooms, surrounded by a thousand acres of meadows, hills, and woodlands. It was a welcoming haven for members of the extended Guggenheim family, and Harold Loeb and his wife, Barbara, visited Old Lodge in April 1969 on their way back to Connecticut from a trip to South Africa. Eleanor lived until a very old woman, as lady bountiful and gracious hostess. She died in May 1992 at the age of ninety-six.

Solomon's other daughters did not have the showy ride of their older sister. Gertrude was a tiny woman with a hunched back. She did not marry, but moved to England to be near her older sister, and lived in a large country house close to Old Lodge, bought for her by her father. She devoted her life to local charities. Her last years were sickly, and when she died in 1966, her sister considered it a blessing. "She was such a courageous and independent person," wrote Eleanor to cousin Harry, "that having—perforce—to be looked after by other people meant real frustration to her."[67] One of Gertrude's nephews, Simon, would inherit her estate, Windy Ridge.

In 1925 Barbara Josephine, Solomon's youngest daughter, rushed into marriage with another Englishman, John Robert Lawson-Johnston. A grandson of the founder of Bovril, the British firm that manufactured the popular beef extract concentrate, John Robert apparently was not rich. But he was well connected, and shortly before the wedding was appointed attaché at the British embassy in Washington. The nuptials were held at the Guggenheim suite in the Plaza with the British ambassador and a flock of the groom's embassy colleagues from Washington in attendance. Arthur and Eleanor, came and the seventh viscount was one of Lawson-Johnston's ushers.

At Solomon's urging, John Robert soon quit the diplomatic service and entered Columbia University to learn the mining business. The lessons did not take. He apparently liked the New York fleshpots too much

and soon dropped out. The two had a son, Peter Lawson-Johnston, born in 1927. Peter was destined to great influence among the Guggenheims, but his parents' marriage failed. Barbara and John Robert divorced after five years, and Barbara, herself a horsewoman, married in succession two men connected with horses. The first, Fred Wettach of Deal, New Jersey, whom she married in 1929, was a well-known polo player and owner of a riding stable. Barbara and Wettach had a son, Michael, in 1930, who himself became a horseman and a gentleman steeplechase rider, and died in May 1999. In 1938 Barbara divorced Wettach too and soon tried again. Her marriage to Henry Obre, who apparently had worked for her husband on his Eatontown estate, lasted for thirty-eight years but was not happy. Obre was never reconciled to the fact that his wife had all the money. After Obre's death Barbara Josephine lived on as a horse breeder on a thousand-acre "spread" in Maryland, Merrylind Farms, which she owned jointly with her son, Michael. She raced horses under both her maiden name and under Obre. In 1981 Barbara suffered a stroke. She died at age eighty-one in 1985.

THE THREE DAUGHTERS of Meyer and Barbara—Jeannette, Rose, and Cora—were overshadowed by their brothers all their lives. Not until the fourth generation, and the diffusion through the culture of modernism and feminism, was it possible for any woman, except the most extraordinary, to excel and be noticed. Jeannette, the oldest daughter, as we have seen, died in childbirth in 1889. The little girl who survived, Nettie Gerstle, was raised by her grandmother. Rose and Cora were both sent to Paris as young women to be educated at private boarding schools. When they returned they married into prosperous New York Jewish families, Rose to Albert Loeb, scion of a prominent banking family, and Cora to Louis F. Rothschild, a partner of Loeb in the brokerage business Meyer helped Rose's husband found. Nettie married one Samuel Knox in 1920.

Cora lived until 1956. When she died at the age of eighty-three, she was the last surviving of Meyer and Barbara's nine children. She had three children, one of whom, the boy and firstborn, died as an infant at the age of two. We know little about the two girls, Muriel and

Gwendolyn, except their birth dates. In any event, they seem to have had little to do with the family, and so, appropriately, may be passed over.

Meyer made generous financial provision in his will for his surviving daughters and his motherless granddaughter, though the sums bequeathed were not large fortunes. Rose and Cora received additional bequests from their brother Daniel when he died.

ROSE LOEB became a widow in 1900. She later married Sam Goldsmith and Charles Quicke and divorced both. Rose lived at the St. Regis Hotel in New York and died in 1945 at the age of seventy-three.

Rose had more famous and interesting offspring than her younger sister, but she was neither a good mother nor, it seems, a pleasant person. When one of her grandsons, Peter Loeb, expressed regret that he had never met her, his father, Edwin, told him: "You would hot have liked her; she was not a nice women."[68] She was at times cruel to her sons. Edwin claimed that once, when she was angry at him, she threw him into the hearth fire. Perhaps her sons' frequent marriages can be explained by their need to find some kinder, warmer woman to fill their emotional needs.

Rose's oldest son, Harold, was an enthusiastic promoter of the 1920s literary and artistic avant-garde and a founder of Technocracy, for a time an important utopian social movement. Unfortunately, he is remembered today—if at all—for having known and been disparaged by Ernest Hemingway, in the novel *The Sun Also Rises*. With Hemingway's own reputation now in eclipse, perhaps Harold's will be restored.

During the 1890s, while his father was alive, Harold Loeb and his two younger brothers, Edwin and Willard, lived near their grandparents on West Seventy-fifth Street. During the summers the Albert Loebs joined the other Guggenheims at the Jersey shore. Though one of the poorer third-generation Guggenheims, Harold was also a Loeb, a family that prized learning, and Harold's widowed mother was able to scrape up enough money to send him to Princeton. There he went out for intramural boxing and is reputed to have won the university's middleweight championship.

Though his nose had been flattened in the boxing ring, it probably

improved his Guggenheim profile. Dark-haired and trim, he was considered handsome. Soon after graduating from college, he married Marjorie Content, from one of New York's oldest Jewish families. Marjorie was the daughter of a New York stockbroker with business ties to the Guggenheims.* With two children, Harold Jr. and Mary Ellen, in quick succession, Harold needed a job. He had acquired the stylish antibusiness attitudes of the day while at Princeton and was skeptical of the family enterprise, but without a calling or a career, he turned to his uncles for help. Uncle Simon found a place for him as purchasing agent at ASARCO's Selby plant in San Francisco. Harold stayed there for two years and then, in 1918, briefly served in the army as a clerk, happily stationed close to home in New York City.

When he was mustered out of service in February 1919, Harold's family assumed that he would rejoin ASARCO, but he had had his fill of Guggenheim enterprises. As he explained to Simon, he did not like the smelter business, but he also felt uncomfortable that with his limited skills and interest, he was not really earning his pay. He wanted to write, he told his uncle, and as a first installment he had bought into a small bookstore in Manhattan. Harold was properly respectful of "the Senator." He appreciated Simon's kindness, he told him, and added generously: "You of the older generation have made it possible for us to do what we want to do."[69]

Harold's bookstore, the Sunwise Turn, was jointly owned with Mary Clarke and Madge Jenison, two players in the New York avant-garde. It was located on Thirty-eighth Street and Fifth Avenue, though considering its character, Greenwich Village would have been a more suitable site. While still in uniform, the bookish Harold had made a habit of dropping in at the shop owned by the two women. He found the atmosphere congenial and made a $5,000 investment in the wobbly enterprise. The shop soon moved to a better location near the Yale Club close to Grand Central Station and did reasonably well.

The Sunwise Turn did not stock conventional best-sellers and practi-

*The Contents, a Sephardic Jewish family, had other Guggenheim ties: Florette, Benjamin's wife, was a Content on her mother's side.

cal self-help books. Its shelves were crammed with works of the literary avant-garde, and like several other bookstores of the day, it was a magnet for artists, writers, and intellectuals, as well as casual customers. One of its patrons was Harold's cousin Peggy, middle daughter of Uncle Benjamin. Seven years younger than Harold, Peggy was looking for a job after years of travel abroad with her family, tutoring at home, and three years at the Jacoby School, a finishing school for Jewish young ladies located on the Upper West Side. She had graduated in 1916 and then— surprising, given her later rebellion against bourgeois conformity—she "came out" in a debutante party at the Ritz. During the war Peggy had done volunteer work for the army, helping young soldiers fill out forms and knitting socks. Harold took her on as a part-time clerk, floor sweeper, and occasional saleslady. She received no salary but was compensated by a 10 percent discount on all the books she bought. At Sunwise Turn Peggy would meet Helen and Leon Fleischman and get her first intoxicating whiff of the artistic avant-garde when her two new friends brought her with them to Alfred Stieglitz's 291 Gallery. There she saw her first abstract painting, a puzzling but intriguing landscape by Georgia O'Keeffe. It was at Sunwise Turn too that she met her later husband, Laurence Vail.

Harold himself was thoroughly steeped in the new esthetic Zeitgeist. College fisticuffs notwithstanding, he had an artistic and intellectual temperament that his family sometimes thought strange. After scarcely a year, he sold his share in the bookstore for $9,000 and decided to become an author himself. But meanwhile he would start a periodical that "could stimulate and disseminate good writing more effectively than a bookshop."[70] Harold's model was the *Little Review*, a literary magazine founded a few years before in Chicago that published T. S. Eliot, William Carlos Williams, and Ezra Pound, and began serial publication in 1918 of the scandalous James Joyce stream-of-consciousness novel *Ulysses*. In 1921 Harold recruited Alfred Kreymborg, a New York poet and anthologist, to assist him as editor of *Broom*, a monthly magazine that would feature avant-garde visual and literary artists. Harold and Kreymborg soon sailed off to Europe and in Paris contacted everyone who counted in the literary-artistic world of the day—Pound, Joyce,

André Gide, Jean Cocteau, Eric Satie, Marcel Duchamp, Constantin
Brancusi, Filippo Marinetti, Jacques Lipchitz, Juan Gris, Gertrude
Stein, and others. Many promised to send material to the new publica-
tion, which would be printed and edited in Rome, where costs were
lower than in Paris. The first number of *Broom* appeared in November
1921 in a printing of thirty-six hundred copies, on fine paper with wide
margins and an orange and blue cover. With reproductions from Joseph
Stella, Picasso, Man Ray, and Jacques Lipschitz, the issue was stronger as
a showcase for painting than for literature.

Broom's prospectus announced that the magazine would be "a sort of
clearing house where the artists of the present time will be brought into
closer contact."[71] And so it was. *Broom* reproduced prints and pictures of
contemporary painting and sculpture. It published stories, poems, and
novel excerpts by Marianne Moore, Gertrude Stein, John Dos Passos,
William Carlos Williams, Wallace Stevens, E. E. Cummings, Matthew
Josephson, and many other important twenties writers before they were
well known. It introduced the Dadaist painters and Picasso, Klee, Léger,
Man Ray, and Kandinsky to the circle of people of advanced tastes in the
United States and Britain. But also inevitably it displayed a flock of
mediocrities unknown today to anyone but a few cultural historians.

Harold spent 1921 and 1922 in Rome where he was often visited by his
aunt Florette and his brother Willard as well as his own mother. The
bare-legged, besandaled Peggy also dropped by with her new husband,
Laurence Vail. By this time Harold and Marjorie had separated and he
was living with Lily Lubow, a beautiful, dark-haired singer he met in
Paris. For a few months Harold and Lily moved to Berlin, an exciting cul-
tural hothouse under the Weimar regime. There they managed to meet
everyone who counted in the German literary and artistic world, as well
as intriguing refugees from the Russian Bolsheviks who were making
postwar Germany their temporary home. They undoubtedly met some of
the painters who would figure in Uncle Solomon's career as an art patron.

The *Broom* project was never a commercial success. By issue four or
five the magazine was in serious financial trouble. Harold's own
resources were limited. Rose gave him a modest allowance and an occa-
sional larger dollop of cash. In March 1922 Uncle Murry released to him

almost $9,000 from a long-forgotten wedding present from the uncles and until now held in trust. But the magazine continued to skirt the edge of insolvency, and he soon turned to his uncles for serious help. He could not have been too hopeful. Whatever their later leanings, the senior Guggenheims had not yet learned to appreciate the avant-garde.

Harold began his fund-raising campaign by sending cousin Edmond a copy of *Broom* containing two poems by Laurence Vail, Peggy's new husband. The choice was not well considered. Vail was an American-born minor painter, poet, and playwright who came from an unconventional family and, as we shall see, lived the anarchic life of the complete bohemian in Paris. Edmond showed the issue to Uncle Simon, and the two puzzled over Vail's poems "Sleep" and "Little Birds and Old Men." "I realize that this new style of so-called poetry—or whatever you wish to call it—is probably a little ahead of our times and it is certainly over my head," Edmond wrote Harold. Could Harold, as editor of the magazine, give Edmond "a statement of exactly what they mean."[72] Harold concluded that Edmond was interested in the poems because Vail, now a member of the family, was in some way ridiculing "the uncles," whom he had met on one of their recent trips to Europe. Loeb wrote back, reproaching Edmond for his formal tone and trying to explain the mysteries of modern poetry. He also reassured his cousin that no criticism of the family was intended.

Edmond showed Harold's letter to cousin Harry, who wrote to congratulate Harold for launching *Broom* and enclosing a check for a personal subscription. Potentially more rewarding, Edmond sent a copy of the correspondence to Uncle Simon with a generous note of his own. "I am more than ever convinced," he wrote the senator, "that he [Harold] is working along lines which suit him best and that he certainly deserves to be successful."[73] The correspondence between Edmond and Harold went the rounds of the brothers at 120 Broadway. Harold's own brother, Willard, wrote him at the end of December 1922 that his letter had been very successful and the uncles were seriously considering whether to form a stock company to endow the magazine. Edmond too, Willard wrote, might help financially. Harold now wrote Uncle Simon directly outlining *Broom*'s costs for paper, salaries, and printing.

Harold made a quick trip to New York soon after but stayed with his mother and avoided his uncles downtown, feeling, he later said, that Lola Ridge, *Broom*'s New York head, could plead its case better than he could himself. Harold's omission is difficult to understand. Perhaps he was still embarrassed by his earlier rejection of Simon's job offer and was reluctant to face him. In any event, the uncles did not come through. After he returned to Europe he got Simon's reply. He had discussed the idea for an endowment for *Broom* with all Harold's uncles, ASARCO's head wrote. But they had decided against it. "I am reluctantly obliged to inform you" that "we decided we would not care to make you any advances whatsoever." Simon's reasoning was that of a hardheaded businessman who saw *Broom* as just another profit and loss venture. He had asked some friends in the publishing business, he explained, to estimate the future prospects for the magazine, and they concurred that it would take many years before it could make a profit. Any profit, moreover, would never be very great. "I am sorry you are not in an enterprise that would show a profit, . . . one more apt to be a financial success, one commensurate with your ability."[74]

Harold was deeply disappointed but replied politely to his uncle. He thanked him for taking the time to consider his request and to investigate the magazine's prospects. But he also gently reproached him. "From what little I know of your early career it seems to me," he wrote, "that you have more than once chosen the daring and the visionary to the safety-first alternative, and that for you the visionary was more commensurate with your ability than that the enterprise 'would show a profit at an early date.' And why not for me?" he asked.[75] In the family mode, Harold signed his letter "affectionately," but he was clearly miffed. Later he wryly noted that soon after Simon turned him down, his uncle established a foundation that ultimately subsidized hundreds of daring cultural experiments. Simon never responded to Harold's last letter.

In January 1924, having consumed the last of Harold's patrimony and unable to pay its bills, *Broom* finally shut down. Actually Harold bowed out five issues before the end; Matthew Josephson, the historian and chronicler of the Paris expatriates, finished up in New York. Marjorie, meanwhile, had asked him for a divorce, and Harold, with small regret, had agreed. He remained in Europe, but moved to Paris with Lily. There

he merged with other members of the post–World War I Lost Generation. These were the disillusioned young men (and women) after 1918 who, in F. Scott Fitzgerald's famous phrase, "woke up to find all wars fought, all Gods dead, all faiths shaken." For the Americans among them, much of this lugubrious disenchantment surely was a pose, but they put it to good use. Clustered predominantly on Paris's Left Bank, they drank to excess, made promiscuous love, spent their days and evenings at the cafés—Deux Magots, La Coupole, Café du Dôme, Café Rotonde, and the others—in impassioned talking, drinking, and frolicking. Many dabbled in literature and the arts.

Harold joined them enthusiastically and turned to the creation of art, not merely its promotion. His first novel, *Doodab*, recounted the life of Henry Doodab, a pallid version of George Babbitt, who worked as a purchasing agent for a firm very much like Selby Smelting. Published by Boni and Liveright, a New York house with avant-garde leanings, it appeared in 1925, followed by two others, *Professors Like Vodka*, and *Tumbling Mustard*, neither of them successful. The *New York Times* review of *Doodab* called it "an inadequate story" padded with irrelevant characters.[76] In Paris Harold consorted with cousin Peggy and her new husband, Laurence Vail. On Bastille Day 1923 he was at the Rotonde when Vail and Louis Aragon, the surrealist French writer, drunkenly denounced the proprietor as a police informer. Harold was described by expatriate Malcolm Cowley on this occasion as looking on with "a pair of spectacles, a chin, a jutting pipe and an embarrassed smile."[77]

Harold made forays to England from Paris and spent time with visiting Guggenheims, including his mother. On one occasion Aunt Florette, touring England with daughter Hazel, reproached him for failing to help his mother financially. Why, the poor woman was being forced to stay at the unstylish Berkeley Hotel, rather than Claridges! Harold replied wryly that *he* actually preferred the Berkeley. On this trip Harold spent time with his favorite cousin, Eleanor, the viscountess. The visit to rustic Old Lodge, Harold later noted, was like "landing on a half-forgotten shore."[78]

On this trip to Europe Rose had been accompanied by a young woman, Betsy Stanwick, whom Harold had known as a child at the Jersey

shore. One evening, when he was alone with Betsy in London, she told him that his mother would be heartbroken if he married Lily. Harold was startled, but the remark touched some inner feeling, and to his own surprise, he decided then and there that he would break with Lily. Soon after, Harold began an affair with Duff Twysden, a short-haired, dramatic-looking, unanchored, dissolute Englishwoman whose life and looks would become icons of the Lost Generation.

The relationship with Twysden was Harold's entree into the American literary canon. In Paris Harold had met Ernest Hemingway. A civilian ambulance driver in Italy during the war, the young newspaperman had returned to America in 1919 to get married. By 1922 he was living in Paris with his wife, Hadley, drawn there by the exciting life of the American Left Bank expatriates. Harold and Hemingway met at the house of novelist Ford Madox Ford and became friends. They played tennis together, boxed, talked books and literature, and consorted with Gertrude Stein and Sylvia Beach of the Shakespeare Bookstore, the trendmakers and cultural brokers of the American expatriate community. Ernest earned money by occasional work as a foreign correspondent while pecking away at short stories and a novel. Harold used his influence to get some of Ernest's short stories published. Meanwhile, the Hemingways and their friends, including Harold, scrambled across early postwar Europe seeking experience and pleasure. At some point, Hemingway discovered the heroic joys of bullfighting and became its most effective mythmaker. In the summer of 1925 he and his friends went to northern Spain to attend the bullfights and participate in the festival of San Fermin in Pamplona, the famous "running of the bulls." Harold and Duff Twysden joined them.

These Spanish forays became the meat of Hemingway's first novel, *The Sun Also Rises*, published in 1926. It is the emblematic novel of the Lost Generation, depicting a small group of young British and American expatriates, aimless, drunken, hedonistic, and disillusioned, searching for meaning in the wake of a pointless war. The narrator of the story, Jake Barnes, is an American veteran whose war wounds make him impotent. A major character is Robert Cohn, a rich Jewish graduate of Princeton, a former college boxer, living as a writer in Paris and hope-

lessly in love with the group's femme fatale, Lady Brett Ashley. The five companions attend the Pamplona festival, where Lady Brett falls in love with a nineteen-year-old bullfighter, Pedro Romero. The insanely jealous Cohn beats up the matador, having previously battered two of his own traveling companions, and then, crying pitifully, asks forgiveness from Barnes. After the festival of San Fermin the group disperses, and the story ends on a note of ironic despair.

Harold hated his depiction by Hemingway. Not only is Cohn a bully, a social climber, a weak crybaby, a bad writer, and a man with an inferiority complex; he is also, to his distinct discredit, a Jew. Both Barnes and another character, Bill Gorton, attack Cohn's "hard, Jewish, stubborn streak." They despise him for not knowing when he "is not wanted" and call him that "damned Jew" and "that kike" and remark with contempt on how he brings out the bully in them. Worst of all, Brett despises that "damned Jew," though she lets him sleep with her. In Hemingway's portrait, Cohn is an anti-Semite's cliché of the Jew who, though rich and well educated, lacks the cool existential indifference the group prizes. The treatment of Cohn also libels Harold's social and aesthetic views. He is shown as a defender of the prewar values that the band foraging through Spain has rejected. Yet Harold's real views and those of Hemingway and his pals in fact appear indistinguishable. In essays for *Broom*, Harold frequently deplored American philistinism, puritanism, and intolerance of dissent and denounced Veblenian conspicuous consumption and worship of money.

Why did Hemingway attack Harold? Aside from a deeply ingrained anti-Semitism, Hemingway was probably prompted by sexual rivalry with Harold over Twysden, the real Brett Ashley. Harold also had, unforgivably, acquitted himself more bravely at the running of the bulls,* the ultimately test in "Hem's" eyes of manly courage. But besides these ad hominem matters, Harold offended by not sharing the flat ironic detachment of the others on holiday in Spain.

*In fact, Loeb and Hemingway did not participate in the traditional dash through the streets of the town pursued by bulls. Rather, they joined locals to interact with a flock of cows, heifers, and steers in the bull ring early in the morning before the main bullfights in the afternoon.

Harold felt betrayed by a man he considered his friend. The book, he said, "hit like an uppercut." He did not understand what led Hemingway "to transform me into an insensitive, patronizing, uncontrolled drag."[79] He refused to take the depiction lying down and launched a counterattack that stretched out for many years. In his partial autobiography, *The Way It Was*, he suggested that at Pamplona Hemingway had been a coward. Then he let the matter drop until Hemingway's insulting posthumous *A Moveable Feast* appeared, followed by A. E. Hotchner's *Papa Hemingway*, a biography in which the real names of the characters in *The Sun Also Rises* were revealed. These dissolved Loeb's reticence, and he struck back at his detractor in an article appearing in the October 1967 *Connecticut Review*. Hemingway, he charged, was envious of college graduates, the Ivy League, and the rich, and his exaggerated masculine posturing came from his fear of homosexuality. "My guess is that it was his combination of envy, suspicion, and admiration . . . that complicated his relations with Scott Fitzgerald and perhaps myself."[80] But Harold was not obsessed with getting even with Hemingway. Late in life he was pleased to preside over a celebratory retrospective of Hemingway's life and work in Paris.

Harold continued to expand intellectually after he left Europe. He wrote pro-Zionist and anti-Fascist articles for *The New Republic* during the thirties. He also helped father a movement, Technocracy, which for a time during the Depression won a following among intellectuals and threatened to become a serious contender to the New Deal. Invented by engineer Howard Scott in the early 1920s, Technocracy conceived of the economy as flows of energy and sought to replace money with energy units that could be exchanged for goods and services. The state would give each individual "energy certificates," and these could circulate instead of dollars. How this system differed from conventional capitalism except in the names it used is not clear, but Technocrats promised to put to work all those jobless men and women and idle machines that made the Great Depression the persistent scourge it was. Part of its appeal apparently was its promise to replace politicians, now seen as bunglers, with cool, efficient engineers who could cure society's economic ills by applying scientific principles. Harold had met Scott several

times and sought to cash in on the flare-up of interest in his ideas. He contributed his share to the discussion with his 1933 book *Life in a Technocracy: What It Might Be Like,* a utopian novel, a pale imitation of Edward Bellamy's famous *Looking Backward.*

During and just after World War II Harold established a reputation as an independent economist. He lived in Washington, D.C. during World War II while serving on the War Production Board, one of the federal agencies for mobilizing U.S. war output. In late December 1941 he played host to cousin Peggy and her lover, the painter Max Ernst, who were seeking a convenient place to get married to save the German-born Ernst from internment now that the United States had joined the war. Harold and Vera, his second wife, were witnesses to the marriage in Virginia. After 1945 Harold wrote Keynesian-oriented articles on the economy for *The Nation.*

After many years of hard work, in 1959 Loeb published his autobiography, *The Way It Was.* With interest in the twenties and the Lost Generation then high, he had expected to make a splash. "For a while," he later reported, as he scanned the newspapers and magazines for the critics' reviews, "there was high excitement." His hopes for a best-seller leaped when *Time* magazine interviewed him for its planned major review. The review appeared and it was favorable, but the magazine's proposed large spread with accompanying pictures was reduced and repositioned to a less prominent spot when that same day the U.S. postal authorities chose to suppress Grove Press's edition of *Lady Chatterley's Lover.*[81] Harold toured the country to push his work but apparently without great success.

He managed to marry twice more after Marjorie, and father two more children. During the 1960s he lived in Weston, Connecticut, but traveled widely. He resumed his contact with cousin Harry, and the two exchanged visits during which they discussed liberalism and McCarthyism. Harry invited Harold to several openings at the Guggenheim Museum, established by Uncle Solomon, and made his cousin an "associate" of the museum. In their correspondence Harold reminded Harry that he had published the work of Kandinsky, Klee, and other modern painters in *Broom* "for the first time in an American magazine." Did

Harry "remember the correspondence about Broom, Edmond's letter, etc.," he asked his cousin.[82]

Harold never lost interest in the family's history and, in the late sixties, after reading Stephen Birmingham's *Our Crowd*, discussed with Harry whether Birmingham had not misnamed as "Gatling" the famous Guggenheim mining engineer Daniel Jackling. He and Harry agreed that the low-grade ore extraction process that Jackling had developed was an important breakthrough and "the Guggenheim's [*sic*] risking some vast sum to prove this process out was their greatest achievement."[83] Apparently the cousins discussed the possibility that Harold might write a history of the family. For reasons the present authors well understand, Harold was skeptical of the enterprise. The subject was probably too big, they agreed. A biography of Meyer or of Harry's father, Daniel, might be more manageable. "But if the writer is good enough," Harold speculated, "I suppose he can make a good book out of the larger canvas."[84]

Harold died in January 1974 at the age of eighty-two while on vacation in Morocco. He was buried there; a memorial service was later held at his home in Connecticut. The *New York Times* obituary focused on his life as an expatriate member of the Lost Generation and on his relationship with Hemingway. It was the irony of Harold's life that he should be remembered as the butt of Ernest Hemingway, that flawed and bilious man whose resentments and jealousies so often poisoned his craft.

Edwin and Willard left behind fewer traces than their older brother and had less to do with the Guggenheim family than he. Willard is particularly elusive. Peggy Guggenheim, then living in England, mentions a visit by Willard and his wife, Mary Frank, and their two daughters, Nancy and Mary Ann, during the summer of 1934. Willard, she wrote, was "one of my favorite cousins."[85] She also describes him as "a great music lover" who owned ten thousand phonograph records and played tennis like a champion.[86] Harold in his autobiography gives Willard only a few lines touching on his help raising money for *Broom* in the early 1920s. We also know that he attended Yale and became a partner in L. F. Rothschild and Company, his uncle's brokerage firm. He died in 1958 at the age of sixty-two.

A tall, slender, blond-haired man, Edwin survived Willard. He married five times and had three children: a daughter, Barbara, and two sons, Timothy and Peter. He became a scholar who began his career as a field anthropologist among the Indian tribes in the American West. Called "the cannibal," after his doctoral thesis on stone-age tribes in the East Indies, Edmund taught much of his life at the University of California at Berkeley. He had a Ph.D., but apparently never got tenure, perhaps because he was a cold, inaccessible man. One of his sons, Timothy, claimed his father seldom spoke to him. His daughter, Barbara, recalled a lively party of sixty guests at her father's Berkeley home at which the host sat in a corner reading a book. Mary Frank Loeb, Edwin's sister-in-law, told his other son, Peter, that his father was the most "unconscious man she had ever met."[87] She apparently meant aloof.

In the 1920s Edwin wrote three well-received books on American Indian tribal customs and religious cults. His 1935 work, *Sumatra, Its History and People*, was a study of the Indonesian island and its culture that long remained the standard work on the subject. But his career transcended the usual stodgy round of lectures, seminars, and scholarly books and papers. Edwin became a modern-day Robinson Crusoe when in 1924 he was stranded on a reef 375 miles from Samoa in the South Seas and was only rescued after nine months of isolation. In 1942–43 he was one of a score of anthropologists who worked with the Office of Strategic Services, the World War II predecessor of the CIA, to find anthropological ways to undermine the Axis war effort. After his wartime experience Edmund changed his scholarly focus to southern Africa, where in 1947 he headed a field study of the Bushmen. With a natural talent for publicity, Loeb told the media that he intended to investigate the potent Bushmen arrowhead poisons in hope that they could prove useful for modern medicine.

Edwin was not close to his Guggenheim relatives during his later years. When he married for the first time in 1916 his bride, Marguerite David, was a member in good standing of Our Crowd. Marguerite in fact was a good friend of his cousin Peggy Guggenheim. The wedding, moreover, was held at the St. Regis, the hotel where Daniel and his family spent their city winters. Later wives were not of the faith; one, Lisl

Grong, was not American. And yet Edwin was not completely discon-
nected from the family web. His fieldwork in the East Indies was subsi-
dized by a grant from Guggenheim Brothers, undoubtedly justified as
part of the firm's mineral explorations in Asia. Though a stretch, another
Guggenheim connection was his fellowship from the John Simon
Guggenheim Foundation, which enabled him to complete his Sumatra
book while living in Austria and Holland. It was in Austria, in 1935, that
he married Lisl Grong, a choice that enraged his aunt Olga, Simon's
wife. According to Edwin's mathematician son, Peter, Olga, as an officer
of the John Simon Guggenheim Foundation, thereafter intervened to
make it impossible for him to receive a coveted Guggenheim grant him-
self. Edwin died in 1966 in Berkeley at the age of seventy-two.

BENJAMIN, the youngest of Meyer's sons, had three daughters. One,
Marguerite, better known as Peggy, achieved international fame and
international notoriety. We shall save her story, like her cousin Harry's,
for later treatment. The other two daughters were Benita, born three
years before Peggy in 1895, and Barbara Hazel (called Hazel) born in
1903, five years after her. The girls were beautiful children. A 1908
photo of them at Lucerne, Switzerland, wearing white dresses, wide
straw hats with ribbons, and high-buttoned shoes, is utterly charming.
Even the ten-year-old Peggy, whatever her adult looks, is adorable.
Benita already shows that she is destined to become a mature beauty.

Did their parents appreciate their attractive little girls? Benjamin
loved his daughters, but he had little talent or time for fatherhood. He
much preferred spending his evenings with his mistresses than with
Florette, his Seligman wife, whom he did not love. Peggy remembered at
seven saying to him, "Papa, you must have a mistress as you stay out so
many nights."[88] For this home truth she was banished for a time from the
family dining table. Yet Peggy loved him. "I adored my father because he
was fascinating and handsome, and because he loved me," Peggy later
wrote.[89]

Florette by contrast was eccentric and distant. Virtually all the
Seligmans were a trifle daft. One of the girls' aunts was what Peggy
called "an incurable soprano" who, while standing at a Fifth Avenue bus

stop, would loudly practice musical scales. Another, an unnamed mountain of a woman, became delusional late in life and believed that she had had a tragic love affair with a druggist. Another, Aunt Adeline, had to be institutionalized. Most bizarre of all was Uncle Washington Seligman, who constantly munched on charcoal and ice cubes that he kept in zinc-lined pockets in his suits. Uncle Washington had black teeth as a result of his peculiar digestive medication, but he managed to keep a mistress in a room in the house he shared with his father and mother.[90] Florette herself was a grade-A neurotic. Pleasant faced, blue-eyed, she often seemed mentally slow. One of her relatives who took a first aid course with her recalled that she could never learn how to make a bed. She also had a weird habit of tripling nouns that suggests some mental flaw. It got under Ben's skin when she made statements like "Ben, Ben, Ben, don't forget your rubbers, rubbers, rubbers."[91] Her nephew Harold Loeb said her speech resembled the experimental writings of his friend Gertrude Stein. Florette was a notorious skinflint. At one hotel that she and the family frequented, the porters, miffed at her cheapness with tips, marked her luggage with white crosses so that their colleagues at other hostelries would be forewarned. Peggy would inherit her mother's money predilections.

As a mother, Florette was woefully deficient. Like many upper-class women of her generation, she gave little of herself personally. The girls were raised by governesses, many of whom seem like forerunners of Nazi concentration camp supervisor Ilse Koch. Hazel later wrote: "I had no connection with my mother, who never read me a book or told me a story."[92] Florette's one motherly gesture was organizing children's parties. For her eighth birthday Hazel had a costume party at the St. Regis Hotel. Peggy came as Little Bo Peep; the birthday girl was dressed as a Gypsy.

The family lived, after 1899, in a large, gloomy mansion at 15 East Seventy-second Street, just off Fifth Avenue. Then, in 1911, after Ben more or less left them to live in Europe, they rented their house to Ben's sister Cora and moved into the St. Regis Hotel, where Uncle Daniel had his own spacious city residence. Summers, as we saw, the girls spent at the Jersey shore, which Peggy hated and disparaged with gusto later in life.

Mother and children also traipsed off to Europe frequently. Florette had many Seligman relatives in Frankfurt, London, and Paris and the girls spent weeks visiting their cousins. As small children, they were taught their letters at home, not attending a proper school until as teenagers they went off to the Jacoby School, a predominantly Jewish private, secular institution for girls in Manhattan.

PEGGY LOVED HER OLDER SISTER. Writing fifty years later she said that Benita "was the great love of my early life. In fact of my entire immature life."[93] She was never close to Hazel as a child. In fact, the two were often at odds, perhaps as rivals for Benita's favor.

Benita, according to Hazel, mysteriously foresaw the *Titanic* disaster. Florette and the girls were returning from Grandpa James Seligman's birthday party, Hazel later recalled, when they heard a paperboy shouting "Extra! Extra!" Benita begged Florette to buy a paper. "Something terrible must have happened to Poppa's boat," she exclaimed. Florette assured her that nothing could have happened to the unsinkable liner. And in fact the ship had not yet struck the fatal iceberg when Benita was seized by her sudden intuition. The reality was soon confirmed, however, and Ben's death had dreadful consequences. Whatever Florette felt, the girls had loved their father, and his sudden parting left a deep emotional void that was never filled. Sixty years later, into her seventies, Hazel still had nightmares about the *Titanic* disaster. And Ben had left his family's finances in a muddle. It took years before his assets and liabilities were sorted out. Meanwhile the older brothers silently advanced Florette money to keep the family solvent. When she found out she was living on Guggenheim handouts, Florette cut back drastically on her expenses, leaving Peggy with a permanent sense of humiliation at her comparative poverty in relation to the other Guggenheims. From that time on, Peggy later wrote, "I had a complex about no longer being a real Guggenheim."[94] In 1916 when her father James Seligman died, he left Florette $2 million from which she repaid the money her brothers-in-law had advanced. Three years later, when Ben's estate was finally settled, some $1.85 million remained. Each of the girls received roughly $450,000 in trust; Florette kept $500,000. These were large sums by the

standards of the day. And at Florette's death the girls received an additional half million each in trust from Florette's own inheritance from the Seligmans. Yet Peggy, for one, never felt rich.

Just after the war Benita married Edward Mayer, a recently mustered-out Army Air Corps pilot. She did not want to, apparently, but he threatened to commit suicide if she rejected him. Despite the inauspicious beginning, Benita settled down as a conventional New York matron. She matured into a beautiful woman, described by her sister Peggy as long-necked, with brown eyes, a tiny nose, and long tapering fingers. The marriage was a happy one though both Florette and Peggy considered Edward unworthy of his wife. He "was handsome in a flashy way," Peggy later wrote, "but superficial with no depths of passion."[95] Benita desperately wanted a family but miscarried five times. In 1927 she became pregnant again, and this time, it seemed, the pregnancy would take. Peggy visited her in New York that winter and then returned to France, promising to return in September to meet her new niece or nephew when the baby arrived. In July a telegram came for Laurence Vail in Provence, telling of Benita's death in childbirth and asking him to break the news gently to his wife. Peggy opened the telegram by mistake and was devastated. She and Florette blamed Edward for getting Benita pregnant for a sixth time. They also blamed the doctors who failed to advise her to avoid another dangerous pregnancy. Peggy never forgot Benita, and until her own death in 1979 kept on her bedroom wall the sentimental portrait of herself and her older sister painted in Vienna by Franz von Lenbach in 1903.

YOUNGEST SISTER Hazel's life was almost as tempestuous as Peggy's. A high-strung, spoiled child, as an adult she would share her mother's disconnected mental episodes. At the age of seventeen, while a student at NYU, she married Sigmund Kempner, a young graduate of Columbia and Harvard. Kempner was a remarkably callow young man who, before his wedding, had to ask his brother-in-law Edward Mayer how to perform the sex act. "How far shall I put it in?" he desperately inquired.[96] Hazel divorced him within a year, and in January 1923 she married Milton Waldman, a London-based former newspaper reporter from

Cleveland. They had two sons, but after five years this marriage foundered too. Waldman apparently had begun an affair with Marguerite "Peggy" David, an old school chum of Peggy Guggenheim and a former wife of Peggy's cousin Edwin Loeb.

Leaving Milton behind in Europe, Hazel returned to New York in 1928 with Terrence, four and a half years old, and Benjamin, fourteen months, to seek comfort from her mother. Florette could not have been very effective and Hazel was apparently in a distracted mood when she left her mother's apartment at the Plaza Hotel the early afternoon of October 19 to visit Audrey Love, a daughter of cousin Edyth and Louis Josephthal. Audrey had just moved into a penthouse apartment at the Surrey Hotel in the East Seventies, but was not at home when Hazel and the children arrived. She had left a message with the servants that she would return soon, and Hazel decided to wait. To pass the time, she went out back to the apartment's roof garden on the seventeenth floor. Reminiscing years later, Audrey told an interviewer "there was no need for her to go around the back. She could have sat in the front."[97] But Hazel did go around the back, drawn by what appeal we do not know. After passing through the gate of a picket fence that surrounded the penthouse, she took a seat by the low parapet that marked the building's edge. According to Hazel, she was holding Benjamin in her arms with her back to the street while the jealous Terrence tried to climb into his mother's lap. In his struggles, Terrence fell over the two-foot-high wall onto the roof of the adjacent building, fourteen stories below. Trying desperately to grab Terrence, Hazel lost her grip on Benjamin, and he too fell to his death.

The circumstances of the awful tragedy are suspicious. Why did Hazel leave the area enclosed by the picket fence and, with a small boy of four and a half in tow, sit so close to the edge of the hotel roof with only a low barrier between herself and disaster? Why did she herself not fall over the low parapet? Her behavior was either criminally negligent or—could it possibly be?—deliberate. Was Hazel, the rejected wife with two small sons, playing out a modern version of Medea? But there is no need to recall Euripides to find parallel cases. In recent years, unfortunately, we have met mothers who, in despair over failed marriages and deter-

mined to wreak revenge on their husbands, have murdered their young children. Was this another case?

The chief medical examiner of New York launched an immediate investigation of the tragedy. Dr. Charles Norris was initially skeptical of Hazel's story. He could not understand, he said, how she had sat on the parapet, overlooking the street, "without falling over." "I visited the scene, looked from the rooftop, and grew dizzy," he noted.[98] Dr. Norris also raised an eyebrow at the various versions of Hazel's story reported in the press and expressed his disapproval at the removal of the children's bodies from the rooftop before personnel from the medical examiner's office had arrived. From the outset there were signs of a cover-up. When two New York detectives tried that evening to interview Hazel at the Plaza, they were told that she was under a doctor's care and could not see them. Telephone calls to the Guggenheim suite did not go through, and the hotel detective declared that he had been ordered to block any attempt by reporters to speak to any of Hazel's relatives. Dr. Norris issued a clutch of subpoenas for witnesses and interviewed them at his office. Audrey Love's maid, and two workmen on a scaffold in an adjacent building who saw the children fall, confirmed that Hazel had screamed when the horrific event took place. Her physician was also interviewed, though we do not know what he said except he confirmed that Hazel was very emotional when he saw her. His observations were obviously intended to demonstrate that she was a victim, not a villain. Norris interviewed Hazel herself after she had spent several days in a Manhattan sanitarium to recover her composure. She could describe the general circumstances of the visit to the Love penthouse but claimed to remember nothing of the final moments when the children plummeted to their deaths. Before she knew it, she said, "they had both disappeared over the side of the roof."[99]

There is nothing in the reported testimony that absolves Hazel, but Norris, however skeptical at first, announced on October 26 that the case was closed. He was now satisfied that the event was "entirely accidental."[100] Was Norris really convinced, or had the wealth and fame of the Guggenheims—exerted perhaps through his boss, Mayor Walker—triumphed once again over an unpleasant reality that the family wanted

to go away? John H. Davis, author of *The Guggenheims*, reports that several days after the event Dan, Sol, Murry, and Simon held a meeting with their attorneys and collected a large sum of money to distribute to the authorities. In this era of Tammany corruption, it would not be surprising that money talked even in a crime as infamous as this one.

The family buried the tragedy deep. Peggy often referred to her younger sister, but in neither her conversation nor her writings did she ever mention the deaths of the two little boys. Relatives did not comment on it at the time, but later they would allude to their "crazy" cousin. Julien Levy, an art gallery dealer who knew Peggy and Hazel well, believed Hazel capable of almost any cruelty. He remembered an occasion when, as an adolescent, she snatched a small turtle from her boyfriend and kicked it around the floor like a hockey puck until she broke its shell and it died.

Hazel was not one to let even suspicion of a double child homicide cramp her style. Though she passed through a "fat and sloppy" phase,[101] she was a collector of men, lovers as well as husbands. Even after the tragedy she competed with sister Peggy to see who could have the most sexual liaisons. When they each reached a thousand, Peggy claimed, they lost track.

Hazel's third husband was an Englishman, Denys King-Farlow, with whom she had two more children, John, born in 1932, and Barbara Benita, named after both her deceased sister and her grandmother, born in 1934. When little John developed asthma, Florette bought the King-Farlows a seaside house near Eastbourne so they could escape the noxious London air. This marriage did not last either, and Hazel tried still again. She and her fourth husband, Charles McKinley, moved to Santa Monica, California, where Peggy; her teenage daughter, Pegeen; Max Ernst, the refugee German painter; and Ernst's son, Jimmy, came by plane to visit them in the summer of 1941. Hazel was then thirty-eight and had just had a nose operation, like her sister, to rectify the unappealing Guggenheim gene. She was already prettier than Peggy, with broad Slavic face and curly dark hair, and her revised nose augmented the advantage. The rhinoplasty procedure delayed the visitors' arrival, and they spent some time sightseeing in San Francisco before going south to

Santa Monica. The handsome McKinley, a good deal younger than his wife, was an aviation school student and expected to join the air corps when war, then just over the horizon, finally came. The marriage was warm. In fact, Peggy wrote of this visit, "it was the only time I ever found Hazel happily married."[102] Hazel was also doing her art seriously and asked Ernst if he would help her paint a jungle scene. Ernst was amused and gave her a free lesson, but said she did not pay much attention to his instruction. During the three weeks Peggy spent with her sister, Hazel introduced her and Ernst to her circle of friends in the Hollywood community and among the artists of southern California. At the end of the visit, Peggy bought a silver gray Buick convertible, and she and the others drove to New Mexico, where they all vacationed for a time. After Hazel and her children returned to Santa Monica, Peggy and her party drove on to Santa Fe, the Grand Canyon, and then to New Orleans and points east, arriving back in New York in late September.

All told these months were a happy idyll for Hazel, but it was not to last. When war finally broke out, McKinley joined the army ferry command and died in an plane accident in 1943. Inexplicably, the forty-year-old Hazel a few months later in Denver married a twenty-eight-year-old army corporal, Larry Leonard. This relationship was brief, and Hazel returned to New York soon after to pursue her painting career while living with Peggy. In mid-life, Hazel remained unstable, outrageous, and attention-getting. One observer remembers her in the mid-1940s as always wearing satin dresses with decolletage so low that her nipples showed. Another, who shared a dentist with her, recalled her walking into the dentist's waiting room and throwing a tire on his sofa to sit on with the announcement, "I've got piles."[103] By some reports she married as many as another ten times before old age finally shut down her libidinous urges.

Whenever they were together Hazel and Peggy competed—in sex, in dress, in discourse. Yet they remained friends. Hazel was a competent artist in watercolors and held several one-woman shows that received critical praise. Peggy, who considered her "a good primitive painter," even exhibited one of her sister's works at her famous Art of This Century gallery.[104]

Hazel moved to New Orleans in 1969 and died there in 1995 at the age of ninety-two.

FLORETTE'S OWN HAPPIEST YEARS were the mid- and late 1920s when she was free of a philandering husband and could luxuriate in inherited Seligman money. She spent months at a time in Europe, especially in Paris, where she stayed at the Ritz. She was an intrusive force in the lives of Peggy and Laurence Vail. Her son-in-law, though he worked hard to charm her, made fun of her in private, as he did of all the Guggenheims. She in turn, though she enjoyed their wild parties, deplored Peggy and Laurence's bohemian life. Her disapproval never stopped her, however, from giving Peggy money and each year either a fur coat or an automobile. She seemed to adore her four surviving grandchildren. Yet Peggy's children, Sindbad and Pegeen, adopted their mother's view that Florette was a dreadful bore, and despite her affection, kept her at arm's length.

In her last years Florette lived in a two-bedroom suite at the Plaza Hotel in New York with a companion. During summers, when she was not visiting Peggy and her children in Britain or France, she was with her brother, DeWitt Seligman, and his family at the Jersey shore. In the mid-1930s she contracted lung cancer and underwent several operations without either Peggy or Hazel present to provide comfort or support. She spent the summer of 1937 in Europe visiting with Peggy and taking her grandchildren to the Paris Exposition of that year. She told her daughter that she had only six months to live, and Peggy resolved to come to New York to see her mother at Christmas. She never did. Florette died at home in November 1938 at the age of sixty-six.

Neither daughter managed to get to New York for the funeral and they had to rely on Aunt Irene, Solomon's wife, for a description of their mother's final days. According to Irene, Florette's death had been painless. But Irene felt sad that "her living had not been so carefree as her dying." "There are not many mortals who suffer as she did," she wrote her nieces in England. Obviously alluding to the untimely deaths of Benjamin, Benita, and Hazel's two young sons, she described her sister-in-law's life as "ever a tragic one." Yet Irene sought to comfort Peggy and

Hazel. The funeral services at Temple Emanu-El had been "dignified and impressive," and their mother had looked "very peaceful and young."[105]

WE HAVE LEFT the stories of the two most vivid and successful third-generation Guggenheims, Peggy and Harry, to later chapters. We will start with Harry Frank Guggenheim, a man of enormous energy, practical intelligence and force of will, who made himself guardian of the family's legacy and successfully expanded that legacy into large new areas of endeavor.

Harry Augustus

As individuals none of the Guggenheims possessed a mega-fortune. In March 1918 *Forbes* magazine listed the thirty top American wealth holders of the day. Daniel Guggenheim, with a reputed $70 million, was fifteenth, behind John D. Rockefeller ($1.2 billion), Andrew Carnegie ($200 million), George Baker ($150 million), and William Vanderbilt ($100 million), though he was ahead of Pierre Du Pont, George Eastman, and Lewis Swift.[1] Yet as late as the 1930s, the Guggenheims as a clan were reckoned as among the thirty richest *families* in the United States by muckraker Ferdinand Lundberg, with a gross fortune of $190 million, still far behind the Rockefellers and now, also, the Fords, the Mellons, and the Du Ponts.[2] As for power and influence, in August 1930 former ambassador to Germany James Gerard listed fifty-nine men "who rule the United States," excluding politicians. Daniel Guggenheim was on the roll along with John D. Rockefeller, Charles Schwab, Andrew Mellon, J. P. Morgan, Henry Ford, and Samuel Insull.

As the twentieth century reached its halfway mark, the Guggenheims vanished from the radar screen of the wealthiest Americans. They are notably absent from a 1957 list of the country's richest families. The Guggenheim name remained prominent in the consciousness of Ameri-

cans, but it was their benefactions, linking "Guggenheim" with the world of intellect, technology, and the arts, rather than their great wealth, that preserved their fame.

AS A FAMILY the Guggenheims were unusually charitable and public-spirited, but one third-generation Guggenheim stood out from the rest in public service and public benevolence. Harry Frank Guggenheim, Daniel's younger son, became the family's chief almoner as well as the repository of family memory, the dedicated family patriarch, and the nurturer of Guggenheim entrepreneurial energies, all in one.

Harry resembled the resplendent Medici figures from fifteenth-century Florence in his range of interests and talents. He also matched them in his hates, loves, and ambitions. Proud of his family heritage, he lived like a prince in a world insulated from the realities of ordinary men and women. His grandson George Draper told how at one point Harry acquired a bolt of silk and had a tailor make twelve sets of pajamas for him at one time out of the material. Harry was unapologetic about his wealth, even during the Depression. According to one story, as his chauffeured limousine stopped in front of his Manhattan office at 120 Broadway, two unemployed men stuck their heads into the car and jeered: "Capitalist! Capitalist!" Harry climbed out and heckled back: "Flatterers! Flatterers!"[3]

Harry received a far better formal education than his father and uncles. He had attended Yale's Sheffield Scientific School and Pembroke College in Cambridge University where he ultimately received two degrees and played varsity-level tennis. He never lost his respect for education; in fact he probably prized formal education too much, making it into a marker of merit beyond its real worth.

Like most Guggenheims, Harry was of less than middle height. His face was a long oval with close-set ears, a strong chin, and an even stronger, fleshy nose. He spent much time outdoors, often visiting Florida during the winter, so his skin was "the color of tawny sand,"[4] making his deep-set blue eyes seem especially penetrating. In his younger years he had had a full head of light brown hair. It turned white in his fifties and became sparse on top. Women found him attractive, but

more perhaps for his courtliness and charm than his physique. He was not an imposing physical figure, but his confident, decisive bearing confirmed that he could not easily be fooled or deflected.

Harry distributed his daily living among several permanent and temporary homes. His favorite was Falaise on Long Island's North Shore—the "Gold Coast"—adjacent to his father's estate. But he also spent happy weeks each year at Cain Hoy, a shooting lodge in South Carolina near Charleston, and owned a townhouse, originally his wife Alicia's, on East Seventy-fourth Street on Manhattan's Upper East Side. For a time, in the 1920s, he maintained a winter home in Santa Barbara. Although he traveled frequently to Latin America and Europe and was often in Saratoga, Miami, and Louisville for the races and in Canada for the shooting, the three permanent eastern dwellings, plus the Guggenheim Brothers offices on lower Broadway, were the major physical settings of his life. Until his seventies he came to the Broadway office frequently during the week.

Of all his residences he loved Falaise the best. And for good reason. It impressed everyone who saw it. The famed flier Charles Lindbergh, who frequently visited both alone and with his wife, Anne, called it "the most desirable home I have ever been in."[5] Thirty years later Lindbergh was still charmed. When Harry sent him a photographic brochure he had compiled of Falaise, Lindy replied that the booklet brought back glorious memories. "I felt as if I were reliving many wonderful days of years gone by . . . the visits with Anne . . . the talks about [Robert] Goddard and rockets, the many discussions regarding aviation. . . . How well the court, the house, the rooms and carvings are held in my memory!"[6]

The house dated from the early 1920s. In 1923, soon after he divorced his first wife, Helen, Harry married Caroline Morton Potter, daughter of Teddy Roosevelt's secretary of the navy and a Guggenheim Brothers business associate. Daniel had given the couple ninety acres of Hempstead House land as a wedding gift. Harry's gift to Carol, in turn, was the promise of a resplendent new home high on a bluff overlooking Long Island Sound.

In the spring of 1923, accompanied by their architect Frederick Sterner, Harry and Carol traveled to France to scout out house designs

and buy furnishings. Whether it was Sterner's idea or their own, they chose as their dream home a seventeenth-century Norman farmhouse writ large. They called the house Falaise, after the historic Norman town and for the French word "cliff" to mark the mansion's site. The house was ready to be occupied by 1924, but Harry continued to improve it with plantings and new furnishings, and in 1936 added a small "summer house" on the sound side.[7]

The mansion was small compared to his father's place. The basic structure cost $200,000, a substantial but not extraordinary sum for the day. Furnishings, of course, were extra, very much extra. As Daniel noted, Carol "appreciates nice things," and during their 1923 trip she and Harry spent much of their time selecting furniture, carvings, paneling, pictures, tapestries, statuary, and assorted furnishings for their new home.[8]

Located on rolling terrain dotted with trees, paddocks, and small orchards, Falaise was only a few hundred yards from Hempstead House, but not visible from the larger structure. Some parents might have preferred their children and grandchildren to be at least at a modest remove, but it pleased Daniel to have Harry and his family nearby. "I am looking forward with a great deal of pleasure to having both of you so near to us," he wrote Harry and Carol, then on their shopping trip in France.[9]

The main building was approached through a tall, wrought-iron gate capped with a large initial "G." A winding driveway brought the visitor to another iron gate, this one a French antique. A large paved courtyard bordered by cedars of Lebanon fronted the house. The structure was neither symmetrical nor gargantuan. Its facing was of rustic red-brown brick; its pitched roofs covered with brown French tiles. Set a little ways off were stables that sheltered Harry's "sleek thoroughbred horses," and a garage wing full of "shining cars."[10] There were also an outdoor swimming pool and a set of marble fountains.

Falaise was as quietly opulent inside as out. The rooms were relatively small, but they were elegant. The floors were tiled and the staircase was dark wood antique French. The interior walls were textured plaster. Mantels were carved stone, and wood beams supported the ceil-

ings. The rooms were filled with art: a Paul Gauguin ceramic, a Giacometti bust, a Della Robbia terra-cotta relief, and medieval and early modern tapestries, carvings, statues, and assorted objets d'art. This description makes Falaise seem somber and heavy by the standards of today, but it managed to avoid those qualities because of the breathtaking views of the shining blue sound from several rooms and terraces as well as the beautiful cut flowers that particularly impressed Anne Morrow Lindbergh. In her memoir of Harry, "The Master of Finistère," Dorothea Straus, wife of Harry's nephew Roger Straus, Jr., would describe Falaise in the late 1960s, when she visited it, as "the most romantic house I ever knew."[11]

Falaise was not only a place to live but a place to entertain. It was Harry's favorite venue to host family and friends. As a young bride in the 1960s Madeleine Albright, the later secretary of state, often visited Falaise with her husband, Joseph, nephew of Alicia Patterson, Harry's current wife. She remembered how she and Joe "routinely shared" with Harry "a Sunday lunch of rare roast beef and Yorkshire pudding."[12] One small wing of the mansion was devoted to guest rooms, and here Harry put up many famous people. His hospitality at Falaise was often his way to reward men and women he considered worthy. Yet the mansion was also Harry's favorite site for serious discussions with business associates, scientists, engineers, educators, and people involved in his wide array of charitable enterprises. It was a locale, as Lindbergh noted, where decisions were made that had wide-ranging effects, especially on the science of rocketry and in the planning of foundation business. Falaise was intended to be primarily a summer house, but especially from 1940 on, when he became joint owner with his third wife of the Long Island tabloid *Newsday*, Harry lived there much of the year. During the *Newsday* era he often held editorial staff meetings at the mansion.

Harry's property in South Carolina was called Cain Hoy, a local Gullah corruption of "cain hay," a plant used to make rattan chairs. It was located near Charleston in the marshy Carolina lowlands between the tidal rivers Cooper and Wando. Settled early in South Carolina's history, the lowlands region had been carved into rice and indigo planta-

tions in the slave era, but by the early 1930s, when it came to Harry's attention, it had attracted many rich Yankees for use as game and wild-fowl shooting preserves. In 1934 Harry bought seventy-five hundred acres for the Depression price of $90,000. He eventually acquired a total of fifteen thousand acres including Daniel Island, a four-thousand-acre peninsula at the southern edge of the property.

The Cain Hoy house was relatively simple, one story, with only four bedrooms, a large living room, and a dining room. Yet it appeared imposing. Surrounded by broad lawns and gardens, with white columns across the front, to one foreign visitor it "looked just like Tara from *Gone With the Wind*."[13] In addition to the main house there were pleasant cabins for guests scattered on the grounds.

Besides emulating the rich sportsman crowd, by purchasing Cain Hoy Harry was following in the footsteps of Uncle Solomon* and old family friend "uncle" Bernard Baruch, who owned a hunting lodge–cum–plantation, Hobcaw Barony, near Georgetown, South Carolina. The proximity of Cain Hoy to Hobcaw permitted Harry and Baruch to visit each other and enjoy the hospitality and the bird hunting of their respective plantations. But Harry also had practical, economic goals for the place. "I am not looking for a game preserve," he told the agent who negotiated the original sale. "I want property that can be made productive enough to contribute to the security of my children and grandchildren."[14] In the years to come, Harry would raise beef cattle on the South Carolina land and cut timber from its wood lots.

In fact, Cain Hoy served many purposes for Harry. It became the family rendezvous during the Christmas season where invited Guggenheims had Christmas dinner and opened holiday presents provided by the host. It was a hunting lodge where guests, both family and friends, could shoot the quail and turkeys that Harry had begun to stock in the 1950s. Many of his guests were old military associates, in the words of one, "overage in grade turkey hunters."[15] Frequent visitors included World War II military stars Jimmy Doolittle, Emory Land,

*Solomon had earlier bought Yamassee in the same area so he could pursue the grouse hunting he had enjoyed so often in Scotland.

Nathan Twining, and Pete Quesada. The stays of the generals, admirals, and captains were often jolly, hard-drinking affairs.

The hunting lodge, like the military career that preceded it, was a measure of Harry's effort, whether conscious or not, to distance himself from his origins. Not since Roman times had Jews been warriors. For the millennium and a half following the collapse of the ancient world, the military life in Europe had been the prerogative of the Christian aristocracy; Jews had often been its victims. Hunting too was woven into the life of the European aristocracy. Every English lord and French seigneur had a shooting lodge. Jews did not hunt game unless they were poachers on some gentleman's preserve.

IN HIS MIDDLE YEARS Harry would become a formidable presence in Thoroughbred racing. By establishing a major racing stable, here too he was reiterating the flight from his roots. Horses, certainly the breeding and racing of fast mounts, had always been an avocation of the gentile aristocracy. The medieval knight was primarily a horseman. Horse racing was the sport of kings. If Jews owned horses, they were draft animals suited only for pulling a peddler's cart. Harry would name his racing stables Cain Hoy, but he kept his Thoroughbreds on a farm near Paris, Kentucky. Each summer, however, he brought twenty or so yearlings to Falaise, where his young staff of grooms "gentled" them to the bridle and saddle.

Harry began his career as a breeder and racer of Thoroughbreds in 1934 when, for $400, he bought a yearling named Nebraska City while on a visit to Saratoga for the racing season. He got what he paid for. The horse was a plug, but the purchase triggered his interest in racing. At its peak in the 1950s and 1960s, Cain Hoy Stables owned a hundred or so Thoroughbreds. Harry developed a philosophy of how to succeed at the rich man's pastime. "Breed the best mares to the best stallions, get the best trainer and the best jockey, then hope for good luck. Without Lady Luck on your side, you're done. With luck and good organization you can get somewhere."[16]

And Harry *was* lucky. In 1953 Cain Hoy Stables' Dark Star, a long-shot, won the Kentucky Derby, beating the favorite, Alfred Vanderbilt's

Native Dancer, by a nose. In 1959 Bald Eagle, another Cain Hoy horse, won the Washington, D.C., Suburban and two consecutive Internationals races. Other Cain Hoy horses won lesser meets. All told the stables bred and trained forty horses that became stakes winners on United States tracks. The purses made a tidy sum for Cain Hoy Stables. In 1959 it won more than $700,000, highest winnings of any stables in the nation. In 1960 it came in second. By one estimate horses carrying Cain Hoy's blue and white silks won more than $6 million. Besides the money won by racing, stud fees and horse sales further lifted the stables' profits. To produce winners and assure buyers that they could count on Cain Hoy Thoroughbreds, Harry's staff kept elaborate charts of equine blood lines.

In his racing operations, besides luck, Harry relied, like all Guggenheims, on the best help available. For months he pursued superstar trainer Woody Stephens to run the stables until he finally succeeded in buying him. Though he sought a first-rate staff and paid them well, Harry was not an easy man to work for, Stephens later confessed. As a horse breeder, as well as in his personal relations, he was, in modern parlance, a "control freak." Harry tried to micro-manage the stables operation and intruded constantly into the details of breeding and racing strategies. Stephens managed to stay on for nine years, however, by taking strong stands of his own when he disagreed with his boss. "I could stand up to him pretty well," Stephens told journalist Robert Keeler, "because I went there not needing the job."[17]

Despite his success, Harry was apologetic about his racing enterprises. George Fountaine, his longtime private secretary, pointed out Harry's ambivalence about Cain Hoy Stables. "He never liked to be classified as a sportsman, as a breeder and racer of . . . horses," Fountaine later said. "He tried to downplay that, apparently because he had the idea that it was a frivolous pursuit."[18] This was a public pose, however. Harry clearly preferred to be considered a high-minded benefactor of the arts and sciences, but he garnered more than cash from his horse racing venture. In 1951 he was pleased when he was admitted as a member of the New York Jockey Club, the first Jew to breach the all-gentile barrier. Three years later he led the drive to establish the nonprofit New York

Racing Association to take over ownership and management of New York State's racetracks. Racing permitted Harry, in a word, to make another breach in the ghetto walls that, however reduced, still surrounded Jews during the years just after World War II.

BUT HARRY'S FIRST LOVE was not horse racing; it was aviation. As we have seen, the Guggenheims were a charitable family. The first and second generations, still imbued by the ancestral instinct of Tzedakah, contributed to hospitals, clinics, colleges, and popular concerts. Not until the formation of the Daniel and Florence Guggenheim Foundation in 1924, however, was the family's fame as altruists firmly anchored. During its first few years the foundation scattered its resources among a number of small projects, giving money to museums, hospitals, and schools. Then in 1925 Daniel created the Daniel Guggenheim Fund for the Promotion of Aeronautics, and helped transform the world of aviation.

In the mid-1920s aviation was not in a flourishing state in America. The urgent drive of the Wilson administration during the war to produce planes and aircraft engines had been bungled. Few engines and no planes, except slow trainers, came from U.S. factories in 1917 and 1918, and American aces in France had flown either French Spads or British Sopwith Camels. After the armistice the government had abandoned its effort to build a military aviation branch and drastically cut back orders to aircraft producers. To economize, it also dumped on the market at below cost large stocks of aviation parts and equipment left over from the failed wartime programs, forcing many struggling domestic aircraft manufacturers into bankruptcy and undermining most of the stronger firms as well.

After 1919 a few preparedness enthusiasts urged the government to preserve America's military aviation, but backing for military spending of any sort was limited during the early 1920s. Support for civilian aviation was little better. The public enjoyed watching barnstormers loop-the-loop in war-surplus "Jennies" at county fairs, and braver spectators paid five or ten dollars to take short spins in the old trainers. But the public had little faith in the airplane as a safe means of getting people and goods from place to place. The one practical application of aviation was

the airmail service of the post office, inaugurated in 1918. But the airmail seemed scarcely safer than barnstorming. Thirty-one of the first forty airmail pilots were killed in crashes while carrying out their missions. Meanwhile, in Europe, commercial airlines, carrying passengers, mail, and light packages, were flourishing. By 1924 adventurous travelers could fly from Helsinki to Geneva and then continue all the way to Morocco on commercial aircraft. Two years later, five hundred commercial planes flew Europe's fourteen thousand miles of air routes on schedule. True, these airline companies were subsidized by their governments, but the disparity between the continents seemed all the more humiliating given the greater distances between population centers in the United States and so the greater urgency and value of fast transportation.

Harry Guggenheim was an aviation visionary. Social striving may have encouraged his enlistment in the Naval Reserve Flying Corps back in 1917, but his experience during the war made him a lifelong flying zealot. After the armistice Harry became the catalyst for a new American commercial aviation industry. His interest was not financial. He never made a penny from aviation. In fact he would sink millions of his own fortune into the promotion of aeronautics. Rather, he found in it a challenge that combined glamour, adventure, and public service simultaneously, and an outlet as well for his vast energies.

Harry believed that the public's skepticism of commercial aviation derived from safety fears and resolved to improve the technology of aircraft while creating procedures and operating methods to make flying a routine activity rather than an adventure. Fortunately he was not alone in his hopes. Another visionary of "full service" civil aviation was Secretary of Commerce Herbert Hoover. Hoover was a favorite of the Guggenheims. In 1921 Daniel had offered the former mining engineer a half-million dollars a year to join Guggenheim Brothers as a senior partner. Then just leaving service as a relief administrator for postwar Europe, Hoover thought over the offer for a week and rejected it in favor of a position as secretary of commerce under incoming president Harding. But friendly contacts continued between Hoover and the Guggenheims and would prove valuable when Harry launched his campaign to put commercial aviation on a sound basis in America.

In 1925 Hoover appointed a joint Committee on Civil Aviation to consider the economics of commercial flying. The committee recommended creation of a Bureau of Civil Aeronautics in the Department of Commerce to license pilots, establish air routes, maintain air navigation facilities, and register and inspect planes. Soon after, President Coolidge appointed an Air Board to investigate the state of American aviation, choosing as its head J.P. Morgan partner Dwight Morrow, the Guggenheims' longtime friend and business associate.

Harry's first opportunity to advance his cause came in early 1925 when he attended a meeting called by Chancellor Elmer Brown of New York University to consider establishing a department of aeronautics at the university's Bronx campus. Several other schools already offered courses in aeronautical engineering, but except for MIT there was none in the East. Brown wanted to create a full degree program and proposed that NYU seek out large potential donors. Harry agreed to compose a solicitation letter for the university to distribute. Whether artfully or serendipitously, one evening soon after, while visiting at Hempstead House, Harry asked his father to critique a draft of his letter. Daniel read it and slipped it into his dressing gown. Something of an aviation enthusiast himself, Daniel startled his second son at breakfast the next morning: "Well, Harry, I've thought about your letter and I've decided to endow the school myself."[19]

On June 15 Daniel publicly announced his gift of a half-million dollars to establish a School of Aeronautics at NYU. In his accompanying letter to Chancellor Brown, Daniel described his long-term interest in elevating aeronautical engineering to parity with other branches of engineering studies. He hoped to train experts "capable of building better and safer commercial aircraft and industrial engineers capable of making the operation of aircraft as a business proposition comparable to the operation of railroads." His family, he noted, had "long been identified with exploration beneath the earth," and had sought to make mining safer. Having learned from his son of NYU's similar objective for aviation, he now wished to make the goal of reliable and practical aviation possible.[20]

That October Daniel, Chancellor Brown, and four hundred assorted

dignitaries, Army Air Corps officers, and NYU faculty and students assembled on University Heights to break ground for the new school. In his remarks on the occasion, Daniel noted that he was an old man whose working days were past. But he would dedicate the rest of his life "with the active aid of my son" to the promotion of the science of aeronautics. "I shall do this," he said, "as a part of my duty to my country whose ample opportunities . . . I have had the good fortune to enjoy."[21] A photograph of the ceremony shows a smiling, diminutive Daniel with his foot on the spade he is about to drive into the ground, while a large Chancellor Brown, equally pleased, looms over him. The NYU program, which operated primarily as a department within the college of engineering, began offering a full curriculum in early 1926. In June 1927 the building housing the aeronautics school was formally opened for instruction and research.*

Once he caught the bug, Daniel was eager to endow other university aeronautics programs. But Harry had other ideas. On the advice of a friend, the renowned public relations expert Ivy Lee, he decided that a fund for publicizing and promoting aviation generally would be more useful at the moment than more schools of aeronautics. Harry took Lee's suggestion to his father and Daniel advised bringing the government into the scheme in some cooperative capacity. Though the Guggenheims, like most American businessmen of the 1920s, were skeptical of state intrusion, they realized that an industry like aviation could not avoid accepting an important role for the federal government. In December Harry hied off to Washington to meet with Morrow at the Air Board. Morrow approved of the plan and had arranged a meeting between Harry and President Coolidge. Secretary Hoover joined them for lunch at the White House and the three men discussed Harry's proposal for a fund to promote the nation's backward civil aviation. Coolidge gave his blessing to everything that Harry suggested but questioned his emphasis on the value of speedy travel. "What's the use of getting there quicker if you haven't got something better to say when you arrive?" quipped "Silent Cal."[22]

*In 1973 the NYU aeronautics program shut down after the university sold its Bronx campus to the city for the Bronx Community College.

With the government's promise to cooperate in hand, in early January 1926 Harry assembled a staff and formally announced formation of the Daniel Guggenheim Fund for the Promotion of Aeronautics. Daniel gave $500,000 to the fund for research and preliminary planning and promised to contribute another $2.5 million for its use as needed. The fund, its creators emphasized, would not be a permanent endowment. It would seek to foster the fledgling commercial aviation industry until it could establish itself on a paying basis. At that point it would be liquidated. The board of trustees, announced a few days later, was a hall of fame in aviation, science, and business, several of them old Guggenheim family friends or navy associates of Harry's: Orville Wright, the aviation pioneer; George W. Goethals, chief engineer of the Panama Canal; Professor A. A. Michelson, the first American Nobel laureate in physics; John D. Ryan of Anaconda Copper; Elihu Root, Jr., son of the former secretary of state; Dwight Morrow; Rear Admiral Hutchinson Cone, former commander of the U.S. naval aviation forces in foreign service; F. Trubee Davison, promoter of the wartime Naval Reserve Flying Corps. Later, captain Emory Land of the Navy Bureau of Aeronautics took over as vice president when Cone resigned to join the Federal Shipping Board. At their first meeting the trustees elected Harry president. He would always be the fund's guiding hand.

At the end of the month Harry laid out a tentative agenda for the new entity. He revived his scheme to aid aeronautical education by endowing several chairs in aeronautical science at universities on the Pacific Coast and in the South as well as postgraduate fellowships. He suggested funding for helicopter development, radio direction finders, and aerodynamics. He proposed establishing prizes for the best commercial planes, emphasizing safety and stability, and for improved engine design. To counter what he considered the poor and often inaccurate reporting by the press of aviation news, he recommended the fund establish an educational program for aviation.

In early February 1926 Harry and Admiral Cone sailed off to investigate the achievements of Europeans in the commercial aviation field. Harry made it clear to shipside reporters before departing that he viewed the Guggenheim Fund as a free-market alternative to European pater-

nalism. "Europe has undoubtedly made greater strides in the development of civil aviation than the United States," he noted. But this progress was artificial and temporary, created by government subsidies. The American system of private initiative should, in the end, be a great advantage. Relying on private initiative might delay a commercial aviation industry for a time, but it would put it ultimately on "a sound economic basis."[23]

Harry and Admiral Cone returned from Europe in late April and prepared a report for the trustees. They had gone, they noted, to England, France, Germany, Holland, Italy, and Spain, all then centers of aviation experiment and innovation, and interviewed several hundred officials, inventors, military experts, industrialists, engineers, academic scientists, in fact virtually all the important players in Europe's aviation circles. Their trip had modified and perfected their preconceptions. Government had a valid role to play in the development of commercial aviation, they acknowledged. But it must be limited. "Reasonable governmental control" would include development of meteorological and communication services and the setting of high standards for personnel and creating well-organized "systems of operations." This strategy resembled the approach used in America for both the railroads and internal waterways. At least equally significant was "to make flying 'fool proof' through perfection of planes' motors, and accessories for flight." While the fund might prefer the focus on the safety factor, the two points of view were not entirely incompatible. "We need . . . not overlook the necessity for organization in aerial transportation comparable to that . . . for rail and water transportation."[24] After briefly reviewing the state of aviation in the six countries surveyed, the report listed thirty-five specific activities or strategies for the fund to pursue. These included investigating new technologies like helicopters, the hybrid autogiro, all metal aircraft construction, and neon lights; promoting international scientific meetings; offering prizes for improved aircraft design and better motors; financing surveys of projected air routes; subsidizing a seaplane transatlantic service; promoting airplane "reliability tours"; and "endeavor[ing] to locate a scientist of ability bordering on genius and placing at his disposal facilities and opportunities to enlarge his usefulness."[25]

During 1926 Harry and the fund were frequently in the news. When in May Richard Byrd, the celebrity naval aviator, completed the first successful airplane flight over the North Pole, Harry, in the fund's name, sent him his congratulations. In September and October the fund sponsored a seven-thousand-mile cross country tour of the Byrd Fokker trimotor piloted by Floyd Bennett, to stimulate general public "air consciousness." In particular, Harry hoped, the tour would encourage the public to use the lagging airmail service and prod the cities where the plane touched down to establish airports.[26] Harry actually rode with Bennett as passenger at the tour's outset.

Harry's barrage of pronouncements and promotions kept the fund in the public eye all through the year. In June a press release announced that it would "direct its primary energies to the promotion of ways and means to secure *safety in flying*."[27] Soon after, Harry announced an international competition for advances in airplane safety. In August the trustees disclosed grants of $300,000 each for Stanford and Cal Tech to encourage teaching and research in aeronautics. Urged by Cal Tech president Robert Millikan, the fund also appropriated $10,000 to bring to the school the prominent European aeronautical scientist Theodore von Kármán, then at the University of Aachen. The weekend after the distinguished Herr Professor set foot in New York, Harry invited him and his sister to Falaise. Von Kármán, a squat man with a wavy head of long hair, was deeply impressed with the mansion, the first home of a rich American he had ever visited. During the weekend stay von Kármán told Harry that America's lack of a "café tradition," whereby scientists met informally in bistros and cafés to discuss their work, impeded American science. Harry stiffly replied: "I will not enter the café business, even for science's sake."[28] In the end, despite his quirky views, von Kármán proved to be a wise investment, making important contributions to the science of aerodynamics.

FROM THE OUTSET Harry deplored the indifference of Americans to the practical advantages of aviation. Yet even he understood that the public responded better to human derring-do than to the plodding advances of commercial flying or abstruse technical breakthroughs.

Though he himself was skeptical of extreme flying for record that tested the bravery and endurance of pilots, he recognized its value in making Americans "air conscious." The Byrd plane tour had been intended to capitalize on the public's thirst for aviation heroes and adventure. Then, in May 1927, Charles Lindbergh, a tall, skinny airmail pilot, flew solo nonstop from New York to Paris in thirty-three and a half hours in a custom-built Ryan monoplane. Suddenly Harry and the fund were offered a spectacular opportunity to channel the public's hero worship into the worthy cause of commercial aviation.

Harry was aware months before May 27 of Lindbergh's impending flight. Little in the aviation field escaped his notice in any event, but the competition for the Orteig prize of $25,000, offered by a French-born hotelier for the first successful flight from New York to Paris (or vice versa), had attracted vast media attention. A score of contestants, including Byrd, had thrown their hats into the contest ring, and one recent attempt by a French pilot had resulted in two deaths, further ratcheting up public interest. Several of the contestants had unsuccessfully approached the Guggenheim fund for sponsorship. Few experts believed that Lindbergh, a young loner from the Midwest, a former barnstormer and airmail pilot, would make it across the Atlantic in his overloaded single-engine *Spirit of St. Louis*. But even before he took off the boyish young man had captured the imagination of the press, and scores of curious spectators hovered around him at Curtiss Field on Long Island as he prepared to set out.

Harry came to see the preparations and shared the doubts that the young man would succeed. He later recalled looking the Ryan monoplane over carefully and thinking that very "little room had been left in the cockpit for the pilot. . . . This fellow will never make it. He's doomed."[29] While Harry was inspecting the plane with Charles Lawrence, its engine's designer, Lindbergh appeared, and Lawrence introduced the two men. Harry liked Lindbergh instantly and, however skeptical of his chances, generously remarked, "When you get back from your flight look me up."[30]

Lindbergh's flight from New York to Le Bourget near Paris is perhaps the brightest page in the epic "conquest of the air," excepting the

Wright brothers' first flight at Kitty Hawk in 1903. Overnight Lindy became an international hero, applauded and admired as no American civilian since. At the Paris airport when he landed he had to be rescued from the crush of his admirers by the American ambassador. He awakened the next day at the embassy in Paris to discover he was the subject of headlines in virtually every paper in America and around the world. When the news of the successful flight reached New York, drivers on the streets and tugboats in the harbor blasted their horns. Broadway shows interrupted their performances to announce his triumph, and in lower Manhattan office workers shredded telephone books and threw the confetti out skyscraper windows.

After a brief tour of west European cities, Lindy returned to America on the USS *Memphis*, dispatched to bring him home by President Coolidge. Landing at the Washington Naval Yard, he spent the next hectic days making the rounds of Congress and the State Department and visiting the Tomb of the Unknown Soldier, the National Press Club, the State Department, wounded veterans at Walter Reed Hospital, and other appropriate places. Lindbergh and his mother spent the night with the president and Grace Coolidge at their temporary quarters at Dupont Circle. With them, as the only other guest for dinner, was Dwight Morrow, Harry's friend and Coolidge's point man in aviation.

Meanwhile Lindy was being inundated with offers of fantastic wealth and incomparable career opportunities. Alexander Pantages, the vaudeville mogul, offered him $100,000 for fifteen weeks of appearances at his theaters. William Randolph Hearst, the press lord, proposed starring him in an aviation movie with Marion Davies, his actress-mistress, for $500,000 and 10 percent of the gross. Cigarette and cereal companies urged him to endorse their products. All told, Lindbergh's biographer A. Scott Berg has calculated, in the first month after his return to the United States, Lindy was offered more than $5 million for the commercial use of his name.[31] A shy and self-effacing man, he turned down all of these except an offer from the *New York Times* to write an account of his heroic flight.

Impressed by Lindbergh as a person, and dismayed by the mindless adulation and commotion he was enduring, Morrow telephoned Harry

for his help in rescuing the flier from his admirers and would-be exploiters. Harry was happy to oblige. In truth he was anxious himself to exploit the young hero, but it would be in a good cause, one he knew that Lindbergh himself supported. Lindy, he proposed, would do an expanded version of the Byrd circuit. Sponsored by the Daniel Guggenheim Fund, he would take the *Spirit of St. Louis* on a transcontinental tour, stopping at some eighty cities and towns and flying over two hundred smaller communities to drop messages. His fame, even more than Byrd's, could be counted on to attract large crowds. The particular goal would be to promote the public's use of airmail and prod cities and municipalities to build airfields, but the broader mission would be to heighten public interest in private aviation.

But first Harry won Lindbergh's gratitude by providing a haven for him to write the book he had promised the *Times*, or rather to rewrite the unsatisfactory hack job turned out by a ghostwriter for the newspaper. Just after the Fourth of July Lindbergh came secretly to Falaise and settled into the guest wing for hard work with pen and paper. Harry gave him a bedroom with a small balcony and a view of the sound to the north. Within hours of his arrival at Falaise, Harry reported to Morrow, he was "quietly writing his book."[32]

Harry and Carol protected Lindbergh from guests while he scratched out forty thousand words of text. During breaks, Harry and Lindy discussed the upcoming tour. In three weeks the manuscript was done and sent off to the publisher. Within a month of publication *We*, recounting Lindy's early life as well as his famous flight, had sold two hundred thousand copies. Lindbergh later thanked Carol for "those two short weeks of quiet" he had spent with her and Harry at Falaise.[33] It would be the first of many stays at the mansion on the sound.

Lindbergh began the Guggenheim Fund tour on July 20. Before he left, the fund sent out, over Harry's name, a covering letter to mayors and officials around the country, asking them to receive Lindbergh and help him achieve his goals. The letter explained that the "tour has no commercial aspects of any kind" and no expenses need be incurred by the communities visited. Its sole purpose was to "interest the American people in commercial aviation." Colonel Lindbergh wished to meet espe-

cially with two groups—businessmen and children—and the letter urged sponsors to help assemble these groups to greet the flyer. An advance man, Milburn Kusterer,* Harry promised, would arrive in the recipient's city to make arrangements for Lindbergh's accommodations and the care and refueling of his plane.[34]

Lindy's first stop, in late July, was Hartford, Connecticut, followed by Portland, Maine, and then across the northern band of the United States with stops at Pittsburgh; Cincinnati; Chicago; Milwaukee; Pierre, South Dakota; Spokane; Seattle; then south to Sacramento, Los Angeles, and San Diego; eastward across the nation's South to Jacksonville, Florida; and then north once more to New York. Lindbergh arrived back at Roosevelt Field on October 23, having flown 22,350 miles, stopping at eighty-two major towns and cities, and dropping 192 messages onto smaller communities from aloft.

The regimen was grueling. The original schedule, as drawn up by the fund, called for Lindbergh to arrive at his day's destination in early afternoon, followed by an open-air meeting at the local fairgrounds or ballpark to meet children and to give a short talk. Late afternoons he would devote to any activities the sponsors desired, followed at 7 p.m. by dinner with local businessmen and interested citizens. Addresses by the hosts would be limited to fifty minutes, and Lindy himself would speak for ten or fifteen minutes on the development of aviation. The dinner should adjourn, hosts were advised, at 9 p.m. This schedule did not foresee the constant press conferences; visits to airfield sites, hospitals, and orphanages; and flyovers of smaller communities on which Lindbergh dropped sackfuls of greetings. Host officials often ignored the fund's scheduling specifications. As Lindbergh wrote Harry from Helena, Montana, the cities often "arranged . . . an almost impossible schedule" and local officials felt aggrieved when Kusterer sought to pare down their plans.[35] Writing from Louisville, he apologized to Harry for not being in touch more often. The Louisville stop was a "continuation of the earlier recep-

*Kusterer was an employee of the Department of Commerce, as was Lindbergh's personal tour aide, Donald Keyhoe, who followed him in another plane with a mechanic from Wright Aeronautical Corporation to keep the engine of *Spirit of St. Louis* tuned.

tions and when the day is over I hardly feel capable of writing an intelligent letter."[36] The routine took its toll. In the second week of August the press reported that Lindbergh was ill. Harry phoned him in Detroit expressing his concern, but the flier denied that anything was wrong. Nevertheless, Harry asked William MacCracken of the federal Commerce Department to provide a government doctor to examine him. He also telegraphed Lindbergh's mother, who had been accompanying her son part of the way, expressing his concern. Evangeline Lindbergh wrote Harry back that she had flown with her son recently in the *Spirit of St. Louis*, and although somewhat "thinner" he "seemed . . . the same boy" who used to fly the mail planes for the post office. Harry undoubtedly knew her son "quite well," she remarked, but she knew him "a little better" and felt sure that he "will use discretion and good judgment with regard to his health and the conduct of the trip."[37] A few days later, in Chicago, Lindbergh submitted to a medical exam, and MacCracken pronounced him in "A-1 physical condition."[38] Reassured, Harry issued a press release announcing Lindy's good health and explaining that the fund would never allow the nation's hero to jeopardize his health. Nevertheless, he arranged for several stopover rest periods for the fund's star and revised the visit guidelines to be followed by local hosts to reduce the burden on him. Lindy's time between 4:30 and dinner, stated the new rules, must be "absolutely private."[39]

Was the tour a success? Lindbergh acknowledged that there had been glitches. In Minneapolis the crowd broke away from the police just as he landed, and he had to shut off his engine prematurely to avoid killing someone with the whirling propeller. A similar problem arose in San Francisco. Secretary Hoover complained that on several occasions Donald Keyhoe, Lindy's assigned aide, had mishandled the press. In Sioux City the parade from the airport was too fast and the Lindbergh party arrived at their hotel too early. Still, as Lindbergh wrote Harry from Milwaukee in late August, "as far as we are concerned the tour is giving 100% satisfaction."[40]

When it was all over Harry was certain that the circuit had been worthwhile. It had cost the Guggenheim Fund more than $68,000. Fifty thousand dollars of this sum went to Lindy himself, a figure sug-

gested by Morrow, who concluded that having relinquished many recent opportunities to make money, Lindbergh should be compensated with "a much larger payment than would be made to the normal flyer."[41] But it had been well worth the expense and effort, Harry felt. As he wrote Lindbergh in mid-October, "I feel sure that nothing has so much contributed to the promotion of aviation in America, with the exception of your own historic flight to Paris, as this tour, which you have just completed."[42]

The facts bear out the optimistic conclusions. Pilots' license applications soared in 1927, as did the number of licensed airplanes. The Ryan company, the manufacturers of Lindbergh's plane, received an avalanche of orders for new aircraft. Airmail usage surged. Much of this undoubtedly would have happened eventually; the flight to Paris by itself was certain to leave its mark. But the tour surely amplified the impact of the epochal transatlantic flight. Yet Harry, at this point, actually had reservations about Lindbergh's contribution to aviation—the sort of aviation he favored. Lindy's flight to Paris, he noted in his 1930 book *The Seven Skies*, emphasized the daredevil aspect of aviation. The plane had been single-engined, overloaded, and lacked a radio. Though the adventure had caught the collective imagination of the American people, "the science of aeronautics was not changed one whit," he wrote, by Lindbergh's flight.[43]

Beyond its effects on aviation the tour helped turn a mutually advantageous professional relationship into a close friendship. In the summer of 1927, in his letters to his sponsor from the tour cities, Lindbergh invariably addressed Harry as "Mr. Guggenheim." Harry in turn called him "Lindbergh" or "Colonel Lindbergh." By the time the tour was over, the relationship had deepened. That winter, while Lindbergh was on an extended Latin American goodwill flying visit under the auspices of Dwight Morrow, now ambassador to Mexico, he kept in touch with Carol and Harry. "Mr. Guggenheim" now became "Dear Harry." Harry in turn now called Lindbergh by his nickname, Slim. And the relationship would continue to solidify. At the end of his Latin American circuit Harry invited Lindbergh to become a trustee of the Guggenheim Fund and serve as a paid adviser. The next year, when Lindbergh was wooing

Dwight Morrow's younger daughter, Anne, Harry and Carol helped the courting couple by offering their hospitality at Falaise. For the remainder of their lives, though world events at times strained the relationship, Harry and Slim remained close, bound not just by pleasure in each other's company, but by strong intellectual rapport.

THE FUND'S WORK to promote commercial aviation went far beyond the ballyhoo of the Byrd and Lindbergh junkets. To help pilots pinpoint their location in clear weather, it launched a campaign to encourage towns to mark their names in large letters on some conspicuous local rooftop. Postmasters, veterans' organizations, and the railroads were recruited into the effort. By December 1929 more than four thousand communities had completed their roof-marking programs. More consequential was its program to accelerate formation of commercial airlines. In the late 1920s the United States had only two functioning scheduled passenger airlines. One of these, Western Air Express, flew mail and a few passengers on the 660-mile route between Los Angles and Salt Lake City. Harry deplored this backwardness and in mid-1927 called a meeting of executives of air transport firms carrying mail and freight to consider the issue. The business leaders, he discovered, remained convinced that the only way that passenger service could succeed in the United States was with government subsidies. To prove his case for private enterprise, in September Harry induced the Guggenheim trustees to establish an "equipment loan fund" and to advance Western Air Express $150,000 to buy three trimotor passenger planes. The aircraft would be used to transport passengers between Los Angeles and San Francisco, a distance of 365 miles, leaving on schedule from both city terminals at 10:30 in the morning and arriving at their respective destinations three hours later.

Opened in May 1928, the Los Angeles–San Francisco service was an almost immediate success. The three ten-passenger Fokker F-10 Super Trimotors proved reliable aircraft, and enough brave, or impatient, travelers bought tickets to make the venture profitable. In a matter of a few months the loan was repaid. In Harry's view, the fund had brilliantly demonstrated the commercial viability of airline free enterprise and was

no longer needed. "Commercial aviation in America is now established on so sound and profitable a basis," he wrote Morrow in 1929, "that further assistance of this kind is not necessary, and the public interest in aviation has been definitely and permanently aroused." From now on the Guggenheim Fund would "concentrate upon the scientific problems in the mechanical structure of the airplane and study of environment conditions necessary for the safe operation, particularly meteorology, and the problem of fog flying."[44]

AS WE SAW, Harry was a safety fanatic. As a wartime navy pilot clearly he was willing to take risks himself, but he understood that commercial aviation was different from military aviation. As he noted in a 1927 article in the *Saturday Evening Post*, "the progress of commercial aviation has been delayed by the average man's fear of the dangers involved." It was all very well to quote statistics to show how safe flying actually was, he declared, but it was "evident that one disastrous crash in which . . . heroes lose their lives has more effect on the public mind than a million miles of safe commercial flying."[45]

The fund attacked the problem of flying risk along a broad front. Commercial aviation was bedeviled by inclement weather. Flights were canceled when the weather turned bad and visibility plunged. Flights already under way became nail-biters for passengers and their families. The fund considered the existing federal meteorological services weak and pushed for a national network of weather stations similar to the system in Germany. In 1927 it established a committee "to advance the art and science of meteorology in aviation."[46] The following year it created its own weather service along coastal California in cooperation with the U.S. Weather Bureau, the Pacific Telephone Company, and the Army and Navy Air Services, as part of its effort in creating the Los Angeles–San Francisco airline.

The worst weather hazard for fliers was fog. Dense fog cut visibility drastically and often disoriented pilots. Fog, Harry wrote in 1927, was "undoubtedly the greatest danger to aerial navigation . . . just as it is to navigation at sea."[47] In 1928 the Guggenheim Fund established the "Full Flight Laboratory" at Mitchel Field, Long Island to analyze flying under

adverse weather conditions and to find ways to combat it. It earmarked $70,000 for the lab, a third of which would go for two planes, a Vought Corsair and a Consolidated NY-2. To head the laboratory Harry appointed Lieutenant James Doolittle, an Army Air Corps pilot.

The thirty-two-year old Doolittle was a wunderkind. A winner of the prestigious Schneider Trophy Race for the fastest seaplane flight, he also had a doctor of science degree in aeronautical engineering from MIT. In his later career he would lead the legendary 1942 aircraft carrier raid on Tokyo and command the U.S. Eighth Air Force in Europe in World War II. In September 1928 Doolittle took a leave of absence from the army and arrived with his family at Mitchel Field to live in a small house adjacent to the lab hangar.

Doolittle's goal was to develop the technology and the procedures to achieve "blind flying." A blind-flying pilot would be able to navigate through storms, dense clouds, and especially fog, though unable to see the horizon or the ground and unable visually to orient himself to landmarks. A successful blind flying system promised to enormously improve the safety record of aircraft and give a big boost to commercial aviation.

Doolittle turned to all the best brains in aviation technology for help. He consulted the experts at Bell Labs, at the Radio Frequency Laboratory at Boonton, New Jersey, and at the U.S. Bureau of Standards. One of his contacts was Paul Kollsman, a German-born engineer, who contributed to the quest an improved altimeter that measured with precision a plane's height above the ground. Another aviation technical pioneer, Dr. Elmer Ambrose Sperry, provided a new gyroscopic compass and an artificial horizon to show direction and the plane's "attitude" toward the ground. Doolittle himself developed several improved blind-flying instruments.

In the fall of 1929, after a year of experiment and test flying, Doolittle was ready to try out his new technology. But where was the essential fog? The season had not been foggy. Finally, on the morning of September 24, Jack Dalton, one of Doolittle's aides, looked out the window and saw a wall of gray mist rolling in from the Atlantic. Dalton quickly called Doolittle and E. C. Reader, inventor of an experimental heat-activated fog-dispersal device. He also notified Harry at Falaise, who hopped into

his car for the drive across the island to Mitchel Field. First, Reader tried out his blowtorchlike contraption but it failed to make a dent in the fog bank. Doolittle now ordered the plane readied. He climbed into the rear cockpit seat of the lab's Vought Corsair and took off, flying west straight into the fog. The plane circled the field and landed ten minutes later. Doolittle had achieved the world's first all-instrument flight under zero visibility.

Accompanied by Emory Land, Harry arrived at the field just as Doolittle touched down. He was elated by Doolittle's feat but proposed that he try again, this time, since the fog had lifted, with the cockpit covered by an opaque canvas hood. Harry scrambled onto the plane's wing and helped tug the hood over the rear cockpit. Sitting in the unobstructed front seat would be Ben Kelsey, Doolittle's copilot, who would take over if something went wrong. To avoid suspicion that it was he, rather than Doolittle, who was guiding the plane, Kelsey's hands would remain conspicuously outside the cockpit so viewers could see them. Harry wished the flyers good luck and Doolittle took off, winging westward on a straight course for five miles and then executing a 180-degree rotation to return to his starting point. As the plane came in over the edge of the field, Doolittle dropped lower. His wheels touched ground, and the plane rolled to a stop close to where it had taken off fifteen minutes before.

Jubilant, Harry clambered onto the wing and helped remove the cockpit hood. Beaming, he pumped Doolittle's and Kelsey's hands. Later that day he sent Dwight Morrow a telegram glowing with pride. "As a result of tests successfully conducted this morning at Mitchell [sic] Field I take pleasure in informing you that the Daniel Guggenheim Fund for the Promotion of Aeronautics is able to report a solution of the hitherto unsolved last phase in the problem of flying through fog under conditions representing the densest fog."[48] Doolittle's dramatic flight, as Harry had hoped, delighted the press, which perpetually craves heroes and deeds of valor. " 'BLIND' PLANE FLIES 15 MILES AND LANDS; FOG PERIL OVERCOME," announced the head over a front-page article in the *New York Times* on September 25.[49] The newspaper's Sunday supplement later that week featured a long follow-up article on the blind flying event.

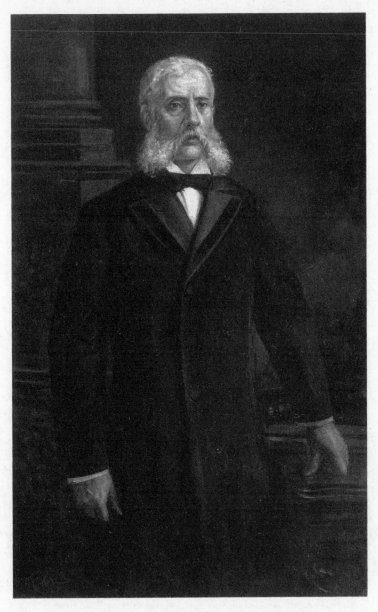

Idealized portrait of Meyer Guggenheim, about 1900.

(Courtesy of HFG Foundation)

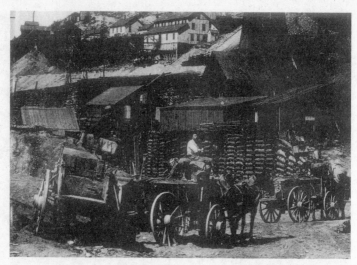

Rare photograph of the approaches to the Guggenheims'
"Minnie" mine in Leadville, Colorado, about 1880.

(From *ASARCO, 1899–1999: Celebrating a Century of Accomplishment*)

Meyer Guggenheim and his seven sons in the offices of M. Guggenheim's
Sons, about 1900 (*left to right:* Benjamin, Murry, Isaac, Meyer, Daniel,
Solomon, Simon, and William). (Courtesy of Nassau County Museum)

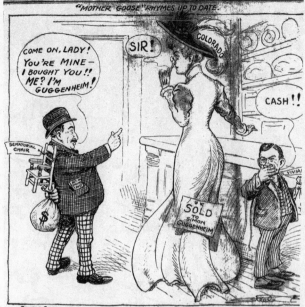

The *Denver Post* of October 6, 1908, attacks Simon's corrupt purchase of his U.S. Senate seat the previous year.

Rare photograph of Harry Guggenheim in his navy flier's uniform in World War I.

(Courtesy of HFG Foundation)

The children of Gladys Guggenheim and Roger Straus, about 1926 (*left to right:* Oscar Straus II, Florence Straus, and Roger W. Straus, Jr.).

George Denver Guggenheim, Simon's younger son, bore the name of his father's favorite city. His life proved tragic.

Ambassador M. Robert Guggenheim, the playboy, at a formal ceremony in
Lisbon in 1953. He would soon leave Portugal in disgrace.

Cover of an early
issue of Harold Loeb's
avant-garde "little
magazine," *Broom*.

Daniel Guggenheim,
about 1912, looking
as commanding as
he was in life.

(Courtesy of
HFG Foundation)

Harry Guggenheim
and Charles Lindbergh
in late 1927, soon after
"Lindy's" solo flight
from New York to
Paris. They are about
to take off from New
York in an amphibian
plane to visit the
governor of Virginia.

(Associated Press)

Harry Guggenheim, Robert Goddard, and Charles Lindbergh at Roswell, New Mexico, in 1935. Guggenheim and Lindbergh were visiting to learn what progress Goddard had made in his rocket experiments.

(Courtesy of Clark University Archives)

Cain Hoy, the South Carolina hunting lodge, where Harry Guggenheim invited his family and cronies to hunt, shoot, and celebrate.

(Courtesy of HFG Foundation)

Harry Guggenheim's beloved North Shore mansion, Falaise. The terrace overlooks Long Island Sound. (Courtesy of Nassau County Museum)

Harry Guggenheim, with jockey Hank Moreno on Cain Hoy Stables' Dark Star, in the winner's circle after victory in the 1953 Kentucky Derby.

(Associated Press)

Daniel Guggenheim turns the ceremonial first spade to mark construction of what became the Guggenheim School of Aeronautics at New York University in the fall of 1925. Chancellor Elmer Brown of NYU looks on approvingly.

(Courtesy of HFG Foundation)

A beaming Lieutenant Harry Guggenheim, U.S. Navy, embracing his WAC daughter, Joan, and his civilian daughter, Nancy, in 1942.

(Courtesy of HFG Foundation)

Alicia Patterson at her *Newsday* desk during World War II.

(Associated Press)

Harry Guggenheim with heir apparent, Joe Albright, Alicia's nephew, in 1963 soon after her death.

(Associated Press)

George Tuckerman Draper in uniform during World War II with wife, Nancy, and their two young sons, George (*left*) and Dana.

(Courtesy of HFG Foundation)

Hilla Rebay in 1935.
At age forty-five,
still fetching.

(Courtesy of
George Braziller)

Frank Lloyd Wright, Hilla Rebay, and Solomon Guggenheim inspecting the
model of Wright's innovative museum in September 1945. (Associated Press)

Left to right: Peggy, Hazel, and Benita Guggenheim in 1908.
(Courtesy of Karole Vail)

Peggy and sister Hazel in 1965, at the Tate Gallery in London. Peggy was sixty-seven and Hazel sixty-two. (Associated Press)

Laurence Vail.
(Courtesy of Karole Vail)

William Guggenheim III at his desk in Florida while writing his book, *Hello from Heaven!*. (Courtesy of William Guggenheim III)

Jonathan Paul Guggenheim, currently the youngest person still to bear the Guggenheim family name. He is studying computer animation in Orlando, Florida.

(Courtesy of William Guggenheim III)

M. Robert Guggenheim, Jr., in 1985 celebrating his seventy-fifth birthday with his son, Daniel, and his daughter, Grace Anne.

(Courtesy of Daniel Guggenheim)

A recent photo of Dana Draper in his studio at Sausalito, California.

(Courtesy of Dana Draper)

Roger, Oscar, and Gladys Straus, about 1980, receiving an award
for fifty years of family service to Mt. Sinai Hospital in New York.

(Courtesy of Daniel and Florence Guggenheim Foundation)

Iris Love in 1970, making her case that the head found in the
British Museum is the original of Praxiteles' Aphrodite of Knidos.

(Associated Press)

Peter Lawson-Johnston some years ago. He is the current head of the Guggenheim clan.

(Courtesy of HFG Foundation)

The Guggenheims on the lower ramps of the Solomon R. Guggenheim Museum, gathered for their November 1984 "reunion." (Courtesy of Wendy McNeil)

The fog breakthrough made brief headlines, but the program that received the most coverage was Harry's Safe Aircraft Contest announced in mid-1926. It set a first prize of $100,000 and five second prizes of $10,000 each for the safest planes, as judged by six prominent aviation men chosen by the Guggenheim Fund trustees.* The planes submitted would be tested at Mitchel Field and the contest would close on October 31, 1929. The criteria for evaluating safety included low landing speed, quick takeoff and braking after landing, stall-proof flight, and stability in bad weather.

While the contest officials waited for the manufacturers and inventors to submit their entries so evaluations could begin, the trustees worked on other aspects of safety. In early October 1928, jointly with the National Safety Council, they sponsored a National Aeronautical Safety Conference in New York where, over two days of meetings and sessions, aviation engineers, plane manufacturers, federal aviation officials, and European experts lectured on aspects of the aviation safety problem. One of the speakers was Lindbergh, who talked about the chief vulnerabilities of flying and endorsed the fund's safety contest.

At first the contest seemed likely to fail. Several aircraft manufacturers were intimidated by the stiff specifications and decided not to enter. Others initially submitted entries but then withdrew them. In January 1929, however, Harry was able to announce that twelve manufacturers had submitted planes that met the fund's specs and would be judged. One was Italian, five British, and six American. Harry had hoped that Juan de la Cierva's pioneer autogiro, a combination of helicopter and winged plane, might be one of the entries. But the company failed to submit its plans in time. In June he announced that entries would be closed so that the judges could select the winners by the October deadline.

Actual tests at Mitchel Field began on June 19. Lindbergh, just back from his honeymoon with Anne and staying briefly at Falaise with Harry and Carol, was present as a "special consultant" and flew the first entry, the two-seater biplane built by the Brunner Winkle Aircraft Company,

*These were Orville Wright, F. Trubee Davison, Edward P. Warner, William Mac-Cracken, Richard Byrd, and George W. Lewis.

with Harry as his passenger. Lindy told reporters that he expected to attend all the trials. In the end nine planes were tested in flight. The trials, well reported by the press, concluded at the end of October, and the results were formally announced on January 2 by trustee Emory Land, acting in the absence of Harry, who was in Cuba to take up his ambassadorial duties. The winner was the Curtiss-Wright Tanager, a three-passenger cabin biplane with antistall wing slots and trailing-edge flaps to allow it to land slowly. The Tanager had nosed out the Gugnunc, the interesting entry of the British Handley Page company. Since there were only two planes in the final test series, none of the lesser prizes was awarded.

The winning plane was not a breakthrough in airplane design, certainly not for commercial aviation, and it did not directly beget a strong line of descendants. The success of commercial aviation in the United States awaited the development of the all-metal DC-3, a twin-engine cabin plane developed by the Douglas company in 1936. Yet the fund's effort to encourage a commercially viable passenger plane was not fruitless. Certain safety elements of the Tanager were installed in the DC-3 and later planes. The contest had particular relevance to the future of STOL (short-takeoff-and-landing) aircraft, a type that has found use in modern times, especially in the military. Moreover, the Guggenheim Fund had a hand in the design work for early versions of the Douglas plane and still more was contributed by the Guggenheim Laboratory at Cal Tech under von Kármán. And without doubt, the contest usefully stirred the competitive blood of Americans and contributed to the swelling interest in commercial aviation.

The Guggenheim Aeronautical Fund was intended as a catalyst, not a permanent force in aeronautics, and it closed its doors in February 1930. By that time it had spent a total of $5 million in achieving its goals. Had these been attained? Harry addressed this fundamental issue in the final report. The fund, he asserted, had successfully "carried out the letter and spirit of its Trusteeship." The "public attitude toward aviation" had, in the previous four years, "changed from apathetic indifference to enthusiastic support." Beyond this important intangible, aviation was "now financially able to take care of itself." Finally, as a result of the fund's

grants, scattered around the country were "aeronautical engineering and research centers . . . second to none in the world."[50]

No one could have expected Harry to report failure. But he was right. The Guggenheim Aeronautical Fund had contributed to the advancement of aviation in the three significant ways he suggested. Yet much was not achieved, especially in the financial realm where Harry's insistence on private enterprise in America has had problematical results. As we know, profitability in flying passengers remains a large uncertainty in America, and many private airlines are in deep financial trouble in the early twenty-first century.

THE EXTINCTION OF the Daniel Guggenheim Fund did not end the family's contributions to the cause of human flight. The original Daniel and Florence Guggenheim Foundation, though small, survived. In 1944 it received another $1.2 million from Daniel's estate, bringing its total resources to about $2.5 million. Through wise investment, this small reserve grew over the years so that in 2003 the foundation was able to report that it had made grants totaling almost $30 million. It continued to support the Goldman Band concerts, it funded an "Institute on Man and Science" to solve "critical social problems of the evolving technological world," it helped build a rehabilitation pavilion at the Hebrew University medical center in Jerusalem, and, in later years, it worked to reform the criminal justice system.[51] But it also continued to contribute to aviation advancement projects. In 1950 it funded an Aviation Safety Center at Cornell University. In 1953 it created an Institute of Flight Structures at Columbia to help develop aircraft frames capable of surviving supersonic speeds. Four years later a $250,000 grant created the Harvard Guggenheim Center for Aviation Health and Safety. Its most audacious and innovative achievement, however, was to nurture the work of Robert Goddard, a slight, balding, obscure professor of physics at Clark University, often called the "father of the American space program."

One in the long line of inspired Yankee tinkerers who made America a leader in modern technology, Goddard took an engineering degree at Worcester Tech in 1908 and earned a doctorate in physics at Clark University. Just before World War I he began to experiment with liquid-

fueled rocket engines at Clark. In March 1926 he launched his first rocket from his aunt Effie's farm near Worcester. This device rose a puny forty-one feet before crashing to earth. Though initially unimpressive, Goddard's work soon began to attract attention, and the popular press, reaching out as usual for the eccentric and sensational, reported his continuing experiments as preposterous efforts to reach the moon. In 1929, when one of Goddard's rockets exploded a thousand feet above the ground, the alarmed citizens of Worcester demanded that the authorities forbid any further experiments.

In November of that year Lindbergh was visiting Harry and Carol at Falaise. As he remembered it, Carol called his attention to an article on Goddard in *Popular Science Monthly*. Lindbergh was intrigued and phoned Goddard. Soon after, he stopped by to see him in Worcester, where the inventor explained his work and described what he had already accomplished. Lindy asked Goddard what he would need to accelerate his research and Goddard told him he could devote full time to rocket experimentation if he were freed from university teaching. Lindbergh went to the Du Ponts for help, but they were uninterested, as was the Carnegie Institution of Washington. Lindbergh had been reluctant to solicit the Guggenheims for more money, but when his other sources proved to be dry holes, he wrote to ask Harry, now in Havana, if he might approach his father once more. Harry had no objection, and Lindbergh went off to Hempstead House to visit the patriarch. Daniel was now seventy-four and in ill health, but he was sharp in his questioning of the flier. Did Lindy believe that rockets had "an important future"? "Probably," Lindbergh replied. And was Goddard a "pretty capable man"? No one in America knew more about rockets than he, Lindbergh said. And how much money did Goddard need? Twenty-five thousand dollars a year for four years. "All right," Daniel responded, "I'll give you the money. We'll want an advisory committee. Of course you'll be on that."[52] In ten minutes of conversation in the hallway of Daniel's mansion, the fate of the American rocket program was settled.

With the assurance of $100,000 from Daniel's pocket, Goddard took a leave from Clark and moved with his family, his assistants, and his equipment to Roswell, New Mexico, to take advantage of the clear days

and dry climate of the Southwest. When Daniel died, in September 1930, Florence took over as benefactor with Harry as her adviser. Though Daniel had promised $25,000 for four successive years, in 1932, with the nation's economy in deep depression, Florence felt she could not continue the personal grants. Though he was making good progress with ever larger and higher-flying liquid oxygen rockets, Goddard was forced to return to Clark. But Harry was reluctant to strand Goddard. When Goddard asked for $2,500 to continue his research and experimentation at the university, Harry came up with the money through his parents' foundation.

In mid-1934 Lindbergh intervened again on Goddard's behalf and arranged a meeting with Harry and the rocket scientist at Falaise to consider Goddard's continuing financial needs. The visit must have been a good one. A week later Harry wrote Goddard that the Daniel and Florence Guggenheim Foundation had decided to grant Clark University $18,000 to subsidize an additional year for Goddard's work. At the end of the year, Harry wrote, the foundation would "review the work accomplished." He "sincerely" hoped that Goddard "may be entirely successful" in accomplishing his task during that period.[53]

The new infusion of money enabled Goddard to resume his experiments and test flights at Roswell, focusing his efforts on stabilization and pushing the successive model rockets into ever higher trajectories. Harry kept in close touch, writing frequently to the rocket scientist, advising him on how to handle the press, and asking for news of the test flights. When Goddard came east in late April 1935, he had lunch with the Lindberghs, Harry, and Carol at Falaise and reported his progress. Goddard wrote his benefactor long descriptions of test results, emphasizing successes for the obvious purpose of cajoling him into another year's funding. In August Harry telegraphed Goddard: "Board has not yet met but I shall recommend another year's grant which will no doubt be authorized."[54]

That September Harry and Lindbergh flew to Roswell in Lindy's private plane to see in the flesh the achievements of their protégé. A picture survives from that visit of Harry and Lindbergh posing with Goddard and his crew near the launch tower. Characteristically, Harry is standing

stiffly in suit and tie; Lindy and Goddard are in shirtsleeves. The rocket that morning failed to ignite, as did another two days later. Goddard was mortified. Still, on September 24 Harry announced to the press that "in view of the successful results so far achieved in the high-altitude rocket project" the foundation would "continue to finance" Goddard's work.[55]

Harry visited Roswell again during the summer of 1939, flying out with his third wife, Alicia, in his own private plane. This was one of Harry's periods of wavering, and the Goddards—Robert and wife, Esther—were apprehensive that their patron would defect. They had Harry and Alicia to dinner at their rustic ranch. Harry enlivened the occasion by preparing one of his famous extra dry martinis. Dinner of leg of lamb was a success, and Robert and Esther relaxed. Later in the visit the Guggenheims came to observe another scheduled launch. This time a lever stuck and the rocket did not fire. Despite the disappointment, a week later Harry telegraphed Goddard that the foundation had renewed his grant for still another year. Harry and Alicia visited once more in early 1940, but again something went wrong. In the end Harry never did see one of Goddard's rockets leave the ground, though he was the man who made virtually all of Goddard's work possible.

And the annual funding, usually of $18,000, was renewed each year thereafter in one form or another until Goddard's death. Whenever Harry wavered—as he occasionally did—Lindbergh would come to the rocket experimenter's rescue. He seemed to understand Goddard's technical problems better than Harry. All told Goddard received $183,500 from the Guggenheims, $50,000 from Daniel's personal account and the rest from the Daniel and Florence Guggenheim Foundation. This sum was by far the largest part of the total financial support that Goddard received during his lifetime.

Harry was criticized for his support of Goddard. In the university community many considered the Clark professor a fantasist and called him "Buck Rogers" after the science fiction comic-strip character. Academic scientists were also critical of Goddard's lone-wolf approach. He was reluctant, they said, to share his results with other scientists and engineers and unwilling to use others' work or technology in his projects. Harry himself felt that Goddard's isolation was harmful to his work.

But he defended his support of Goddard. "My associates and I," he remarked years later, "had simply come to the conclusion that other abilities, building on the genius of Goddard, would assure quicker success and hasten the day of space flight."[56]

A more serious charge was that the Guggenheims had crippled Goddard's work by keeping him on short rations. Lindbergh defended his friend. In a 1960 letter to Goddard's biographer, Milton Lehman, he complained that the Guggenheims' had been treated unfairly in the first draft of the book. Admittedly, compared to the millions then being spent on missile development and rocket propulsion, what the Guggenheims gave was trifling. But "judged in relation to the time they were given," Lindbergh wrote Lehman, "the Guggenheim grants were extraordinarily generous." They "showed vision, courage, and amazing confidence in Goddard as an individual."[57]

Yet the critics were not entirely wrong. Goddard never had the money and personnel needed to produce a truly effective device that would either fly long horizontal distances or reach earth-escape velocity. To achieve these required the resources of governments, and with government funding the Germans had moved past Goddard as early as 1935. As we know, in World War II the Germans leaped far ahead of the Americans and British in rocket development with the V-2 missile, and it was only by annexing the German rocket experts after 1945, and by massive federal spending, that America was able to challenge the Soviet Union in the cold war space race.

During the war Goddard worked for the Navy Department on jet propulsion for aircraft. He lived to see a captured German V-2 rocket, which he claimed closely resembled one of his own smaller devices tested at Roswell. But in truth, Goddard knew that he had been surpassed. "I don't think he ever got over the V-2," an associate later said.[58]

Goddard died in August 1945 of throat cancer. In his last years, as a result, ironically, of the German V-2, he had achieved some modest fame as a rocket pioneer. Wernher von Braun, the German rocket scientist brought to America after 1945 to jump-start the American missile program, would declare that Goddard "was ahead of us all."[59] After

Goddard's death Harry helped his widow financially and subsidized a three-volume collection of Goddard's papers that included the professor's diaries and notes and extensive correspondence with Harry, Lindbergh, and others. Esther, who in his lifetime had been her husband's collaborator as well as helpmate, served as principal editor. Out of respect for Goddard's achievements and perhaps to justify his own faith, Harry also sought to perpetuate his protégé's memory by staging a series of exhibitions of Goddard's pioneer rockets in cities across the country.

HARRY'S INTEREST IN, and impact on, aviation continued for many years. During the 1930s he appeared before congressional committees to promote air safety. He also established the Daniel Guggenheim Airship Institute to advance what turned out to be a failed flight technology but one that, until the spectacular explosion of the German dirigible *Hindenburg* in 1937, seemed to promise much for long distance passenger flight. In 1946 New York mayor Paul O'Dwyer appointed Harry, along with James Doolittle and Laurence Rockefeller, to the City Airport Authority. This new body, created through the efforts of Park Commissioner Robert Moses, was charged with overseeing the existing airport system of New York and supervising completion of the giant new international air terminal, Idlewild, under construction on the shore of Jamaica Bay. In 1948, urged on by Harry's protégé von Kármán at Cal Tech, the Daniel and Florence Guggenheim Foundation established centers for research in jet propulsion at Princeton and Cal Tech with two endowed Robert Goddard professorships. Created to encourage the development of rocket engines, the center at Cal Tech eventually transmuted into the world famous NASA-affiliated Jet Propulsion Laboratory, the sparkplug of American space exploration from the 1970s on. Meanwhile, the Daniel Guggenheim medal awarded annually to aviation pioneers encouraged innovation in aviation. Harry himself was honored a score of times with awards and honorary degrees for his role in advancing the science and business of flight.

And he—and his intellectual creations—deserved the plaudits. The senior curator of aeronautics at the prestigious Smithsonian National Air and Space Museum has recently written that the "impact of the

Guggenheim schools is simply incalculable, both in the work of the graduates of those programs and in the research sponsored and conducted at these institutions."[60]

LIKE MOST OF the second- and third-generation Guggenheims, Harry was an ardent Republican. Uncle Simon, "the Senator," was a Republican too, of course, and early in the century the family had established political ties to President William Howard Taft. They were also close to Elihu Root, secretary both of war and of state under McKinley and Roosevelt, and later Republican United States senator from New York. Dwight Morrow, the family friend, though primarily a banker, was an influential Republican who was appointed ambassador to Mexico by Calvin Coolidge and served at the end of his life as U.S. senator from New Jersey. In the 1920s the Guggenheims had special rapport with Herbert Hoover. As secretary of commerce during the administrations of Harding and Coolidge, the former mining engineer, as we saw, had shared Harry's vision of a flourishing commercial aviation industry and collaborated with Daniel and Harry in the creation of the Daniel Guggenheim Fund. Harry and Carol campaigned vigorously for Hoover when he ran for president against Al Smith in 1928. In addition, the Guggenheims individually contributed generously to Republican election campaigns. His friendship with Hoover would allow Harry to broaden his range of public service.

Harry had long been interested in Latin American affairs. He had spent many months in Chile and in Mexico on family business and spoke Spanish fluently. When Hoover became president in 1929, Harry asked for a Latin American diplomatic post, and Hoover nominated him as ambassador to Cuba.

In the fall of 1929, when Harry's nomination reached the Senate, the "Pearl of the Antilles" was in political turmoil. The United States had helped win Cuba's freedom from Spanish rule in 1898. Thereafter Cuban-American relations had been driven on the American side by a combination of avarice, arrogance, and idealism, and on the Cuban side by resentment and a yearning for independence from the colossus to the north. The Platt Amendment of 1901 limited Cuban economic sover-

eignty and allowed the United States to intervene in the island's affairs to maintain law and order. Most Cubans resented the amendment but were willing to have it invoked when it served their purposes.

In 1929 Cuban political life was dominated by Gerardo Machado y Morales, a corrupt strongman whose opponents accused him of wholesale bribery and political assassinations. He had initially been elected for a single six-year term in 1922, and by suborning the legislature and intimidating the opposition extended his reign for an additional term. In a pattern familiar to us these days, many of "El Gallo's" (The Rooster's) enemies saw the United States government as the agent of American capitalists and the abettor of Yankee imperialism. Just before Harry was due to arrive in Havana, his enemies charged Machado with instigating a "reign of terror" against them to consolidate his harsh repressive regime. Cuban-American relations were also roiled by a flock of unsatisfied financial claims by American businessmen and investors against the Havana government or against Cuban citizens. Finally, Harry would have to deal with Cuban concern that a tariff bill making its way through Congress was about to raise duties on imported sugar, Cuba's major crop and chief source of foreign exchange. Some senators, noting the convoluted Cuban-American policy concerns, questioned Hoover's choice of a man without diplomatic experience to serve as U.S. ambassador in Havana. Yet Harry's appointment was widely praised in Cuba itself, particularly by the conservative business elite. Influential Cubans, noting his long experience in Latin America and his knowledge of business affairs, hailed his nomination. The island's business class believed that Harry could check the impulse to protect American beet sugar and cane growers. In the end, despite some senatorial reservations, Harry was confirmed. The appointment seemed sufficiently notable for *Time* magazine to put Harry's face on the cover of its October 21 issue.

In mid-November, after dining with President Hoover at the White House, Harry piloted his own plane to Havana from Miami, still a bold gesture in 1929. His arrival was greeted enthusiastically by the American community. At the end of the month he presented his credentials to Machado, and the two men conferred at length. Harry refused to tell the

press what they had discussed, but we can assume that he urged the dicta-
tor to soften his repressive policies and permit more democratic dissent.
In December the ambassador rented a house in the elegant Vedado dis-
trict of Havana in preparation for the arrival of Carol and his daughters.

Harry's four years in Havana were turbulent. The American ambassa-
dor to Cuba was not an ordinary foreign diplomat. He was a proconsul.
"His slightest word," read an indictment by the anti-Machado Cuban
Information Bureau, "his faintest suggestion are filled with worlds of
meaning and so interpreted by the public. . . . His smile speaks volumes,
his bearing, his home-life, his associations, his outings, his recreation,
even his state of humor, all speak to the Cubans, watchfully scrutinizing
'on what side' is the American representative."[61] He arrived just as
Machado officials arrested several Cuban newspaper editors and a con-
gressman opposed to his regime. The friends of the victims rushed to the
American embassy and demanded that the United States rescue them by
invoking the intervention clause of the Platt Amendment. The demand
reflected what was already an anachronism. American policy toward
Latin America was changing. American firms would continue to domi-
nate the Cuban sugar industry as well as its banking and telephone,
power, and telegraph businesses. Yet under Hoover the U.S. government
explicitly eschewed the interventionist policies invoked by previous
presidents. From now on, under the new principles, the United States
would confine its intrusions in the Caribbean region to cases where
American lives were in danger. It would not intervene merely to defend
the economic interests of Americans.

The Barlow case was among the first issues that Harry had to solve.
Joseph Barlow, an American real estate developer, had sued the Cuban
authorities over ownership of thirty-two valuable city blocks in down-
town Havana. Barlow's claim was based on an old Spanish colonial grant
and at best was dubious, but he and his adversaries had kept the legal pot
boiling for ten years. Harry tried to negotiate a settlement, but Barlow
refused to compromise. Harry flew back to Washington to confer with
the State Department on the claims of Barlow and other Americans.
Basing their decision on Harry's report that Barlow had not yet
exhausted all legal remedies, and to reinforce the new hands-off policy,

the State Department refused to intervene. In the end Harry proposed international arbitration of the Barlow dispute, and when the claimant rejected the plan, the American government washed its hands of the matter. Barlow was later thrown into a Cuban prison, where he died.

Harry returned to the United States again in mid-July for a two-month leave of absence during the humid Cuban summer. He saw Lindbergh at Falaise during his visit and came to Washington to confer with the president on Cuban affairs. He returned to Havana in October with Carol just as Machado, fearing former president Mario Monocal and his followers were planning an uprising, declared martial law and suspended remaining civil liberties. Harry sought to negotiate peace between the strongman and his opponents, but he insisted, in conformity with the new American policies, that only the Cubans themselves could settle their problems. In fact, the rebellion and the resulting repression escalated. Machado soon imprisoned a flock of insurgent Havana University students along with middle-class adult supporters of Monocal. Harry's intervention did help force Machado to make concessions to his opponents in April 1931. But these provided only a brief peace, and by May the Cuban oppositionists were again threatening armed revolt.

Despite Harry's attempt to remain neutral in the turbulent Cuban troubles, the anti-Machado forces in Cuba and their American supporters accused him of being too friendly to the strongman. Though he represented the government of the United States, he was attacked for lunching with president Machado and being photographed with him. Cuban oppositionists accused the ambassador of "functioning as the axis of a plot hatched by private banking interests of the United States" to promote "an illegitimate government" in order "to crush the Cuban people."[62] The State Department defended him, Secretary of State Henry Stimson declaring his full confidence in Ambassador Guggenheim. At a press conference in May 1931 the acting secretary of state, William Castle, Jr., pointed out to those who believed Harry associated too closely with Machado that the ambassador could not be expected to ignore the government to which he was accredited. In Washington Harry conferred for two days with Stimson and State Department offi-

cials and undoubtedly received instructions to avoid taking sides. Back in Havana later in the week, he conferred with Machado, hoping to prevent violence. He failed. In August fighting broke out in Havana's suburbs and in the interior between rebels and the Machado military. The oppositionists once more accused Harry of opposing them and protecting the regime. Guggenheim, they charged, had tried to get the rebels to agree that Machado could stay in power until 1933 in exchange for minor concessions. If the ambassador had "used his power in the interest of justice rather than in the interest of continuing President Machado in power, the present fighting might have been avoided," declared oppositionist leader Domingo Capote.[63] The American ambassador, he said, was violating the spirit of the new hands-off policies the United States had announced.

In fact, in his own view, Harry was upholding the new nonintervention policy. It was the rebels who were inconsistent. Monocal's supporters, for example, had asked him to intervene on their behalf against Machado the previous April. Harry had warned Monocal that an uprising, even if the rebels won, could only hurt Cuba. Already feeling the ill effects of the slump in sugar prices that accompanied the onset of world depression, the country would be plunged into economic crisis. The new regime, moreover, would be forced to cope with a counterrevolutionary movement. But in any event the United States could not "intervene to prevent even such a serious situation."[64]

In the end the revolt was crushed. The rebels put up a brave fight but were put down by superior military force. Yet they seemed to win concessions. Under American pressure, Machado agreed to constitutional reforms and promised to leave office two years before his term officially ended. The oppositionists were now pleased with Harry. According to their paper *El Mundo*, the ambassador had "acted with the utmost delicacy in order not to wound our national pride, abstaining from the least tendency toward intervention."[65]

But this happy state did not last long. Machado reneged on his promises, voided the reforms, and instigated a reign of terror against his enemies. The oppositionists were soon charging the ambassador again with failing to protect rebels against the strongman's wrath and being an

agent of American business interests. As Harry prepared to leave Havana, this hostile view hardened into dogma on the pro-Monocal American left. In his 1933 book, *The Crime of Cuba*, journalist Carleton Beals, who had been critical of the Guggenheims in Mexico as well, called Harry the real culprit in Cuba. In truth, he wrote, Machado had only been a "minor . . . executioner carrying out the mandates, transmitted by Ambassador Guggenheim, of an unholy trinity [*sic*] of American bank and utility companies."[66] The charge was unfair. Harry was solicitous of Cuban sovereignty. "Cuba," he wrote in 1934, "must work out her own salvation regardless of the mistakes that she may make. I am in complete agreement with the dictum that it is far better for Cuba to make her own mistakes than to have our government make mistakes for her."[67] Moreover, the ambassador was conscientiously carrying out the policies of his government. And those policies were not unsound. Compared with past Yankee interventionism, U.S. conduct toward Latin America under Hoover marked the beginning of an enlightened approach that would soon culminate in Franklin Roosevelt's Good Neighbor Policy. One result, as applied to Cuba, was the repeal of the Platt Amendment in 1934, a move that Harry strongly supported in his *Foreign Affairs* article and his book on Cuba, *The United States and Cuba: A Study In International Relations*, both published soon after he left Havana.

And yet Harry was not blameless by anticolonialist standards. He associated primarily with Cuba's ruling elite and apparently had little contact with the masses. According to Drew Pearson, then the Havana reporter for the *Baltimore Sun*, Harry was "most unpopular man in Cuba, next to Machado."[68]

Harry's private life in Havana was somewhat more satisfactory than his public life. He entertained frequently and took advantage of Havana's public amusements, especially the races at the Havana track. The ambassador and his wife threw elaborate birthday parties for their daughters; they hosted family and friends at their Vedado house. Daniel and Florence came for a visit in March 1930 and thoroughly enjoyed their stay. He would love to come again, Daniel wrote. "The only way to keep mother and I [*sic*] from making another visit to you in Havana is for

Carol and you to withhold any further invitations." While in Havana, he observed, he had heard "commendation and praise from all sides about the good work you are doing . . . and your popularity there."[69] Daniel obviously had not been introduced to many of the Cuban oppositionists.

The conspicuous flaw in the ambassador's personal life while in Havana was marital. His marriage to Carol was becoming increasingly contentious. Harry and she had always quarreled and the arguments became more heated in Cuba. She was a heavy drinker, and her bibulous habits apparently became an issue between them. To make matters worse, Carol came down with an intestinal disorder* and in the spring of 1932 had to return to New York for medical attention while Harry stayed on alone. It was probably a relief to both of them. Harry's ambassadorial career ended when Franklin Roosevelt defeated Hoover in November 1932. He resigned in March as the new administration took over in Washington and left Havana in April. Roosevelt replaced him with Sumner Welles, an ardent New Dealer. Encouraged by the new American representative, the Cuban opposition launched a general strike. Machado saw the inevitable and fled the country, going into exile in Miami where all good Cuban conservatives go. In the next five months five different men claimed the Cuban presidency. Finally a lowly army sergeant, Fulgencio Batista, took control, leaving the country no more democratic or politically honest than before. Batista, of course, survived for many years until overthrown by Fidel Castro in 1959.

DURING THE MID-1930S Harry's sense of public responsibility drew him into the campaign for crime control in New York. Back from Havana, with the work of the aeronautics fund completed, the Goddard project lagging, and his marriage foundering, he needed a high-octane cause to keep him happy. Crime prevention seemed likely to serve.

New York had a tradition of high-profile private anti-crime cam-

*The doctors described her ailment as an infection caused by "hemolytic streptococci" and "bacillus coli," but there is also the possibility, as her daughter Diana reported, that Carol was suffering a mental breakdown. See Dr. Foster Kennedy to Harry Guggenheim, New York, April 4, 1932, Box 54, Harry Frank Guggenheim Mss., Library of Congress. For Diana's view, see chapter 9.

paigners dating back to the 1890s when the Reverend Charles Parkhurst headed the Society for the Prevention of Crime and dramatically exposed the sordid connections between the Tammany Hall police and brothel keepers, illegal saloon owners, and professional gamblers. Parkhurst's revelations inspired the New York legislature's famous Lexow Committee investigation that led to the defeat of the Tammany Democratic machine in 1894 and election of a reform mayor.

Harry was less interested than his predecessor in demonstrating the corrupt linkage of politics and crime. In fact he was seeking to help, not hurt, two incumbent Republican politicians, the mayor of New York, Fiorello La Guardia, and the special anticrime prosecutor, Thomas E. Dewey, soon to become New York County district attorney. Both men had made organized crime, and especially "the rackets," into a major public issue. Dewey, of course, would eventually make his successful prosecution of mobsters the springboard to the governorship of New York and the Republican candidacy for president in 1944 and 1948.

In the spring of 1936 Dewey's grand jury foreman, appalled that racketeers and other criminals were escaping conviction by threatening witnesses, recommended the creation of a citizens' committee to mobilize businessmen and honest citizens to stand up to mob intimidation. La Guardia responded by creating the Citizens' Committee on the Control of Crime and appointing Harry, whom he probably had met in Italy during the war,* to head it. Other members included Sol Strook of the New York Bar Association, Lee Thompson Smith of the Grand Jury Association, and Philip Benson of the Dime Savings Bank. The operating head was a former assistant managing editor of the *New York World* named William Beazell. At a meeting in August at the summer city hall in Pelham Bay Park the mayor set out the committee's mission, along with the caveat that it must be "wholly dissociated from partisan politics."[70] The group would receive no public money. It would be organized as a private corporation with a board of directors and stockholders who

*During World War I Captain La Guardia, himself a pilot, had served in Foggia, Italy with the United States air mission in the Italian-Austrian war theater. Harry, while in the navy air arm, had been stationed too for a time in Italy.

were also financial contributors. Tired of mob extortion through the "protection" racket, many of the city's influential businessmen and professionals made contributions to the committee, usually in relatively small amounts.

One of the more prominent of the contributors was Harry's good friend Charles Lindbergh, who gave $250 in 1937. Slim's motives differed from those of the merchants, manufacturers, and bankers. Five years before, Charles and Anne Lindbergh had suffered the terrible tragedy of the kidnapping and murder of their first child by a German-born New York carpenter, and Lindbergh understandably considered crime one of America's greatest blights. On the occasion of his gift he wrote Harry that the problem of crime, especially in New York City, "must be solved before we can claim to have developed a satisfactory system of government."[71] Harry responded that his campaign to raise money was "sticking a little bit and . . . needed some impetus from somewhere." Lindbergh's well-publicized contribution, he noted, was a help.[72]

The committee's work, once under way, was primarily investigatory and educational. Its formal mandate was to "study and seek means of dealing with the problems that exist in connection with the prevention, suppression, and punishment of crime, and to educate the public with respect to such problems; and to assist in the maintenance of the activity and the efficiency of all the agencies of the City of New York . . . for the administration of criminal justice."[73] In fact its early efforts were directed to providing witness' families with the means to survive when "the husband . . . wasn't earning an honest living."[74] One of their clients was the family of Abe "Kid Twist" Reles, the notorious Brooklyn mobster who had become a stoolie and had agreed to testify against Murder Incorporated. They later investigated the lax enforcement of the law by the notoriously corrupt New York police who often avoided reporting nonviolent felonies to make their anticrime statistics look good.

Dewey hoped that the committee would spotlight criminal doings and so hold them in check. "No racket can develop and exist," he said, "if its every act is recorded, studied, and ultimately exposed as part of a complete picture."[75] The public must be made aware of how perniciously organized crime affected them personally and how much in their interest it

was to cooperate with the police and prosecutors. And in fact the committee functioned, as intended, primarily as a watchdog. Harry's staff devoted much of their attention to collecting yearly crime statistics and data, uncovering instances of corruption, suggesting ways to improve the court system, and proposing further areas of investigation by the police and the district attorneys. The "Little Flower" described its functions as a "daily watch over what the courts, the prosecutors, and the police do, and don't do, about crime."[76]

The committee's best publicized success was exposure of "grave irregularities" in law enforcement in Brooklyn.[77] Corrupt grand juries in Kings County selected jurors not on merit, but to provide patronage, to assure particular outcomes of investigations, and to leak information on their deliberations to interested parties. In addition the committee uncovered what it called the "complete demoralization" of the Kings County district attorney's office, and the scandalous inability of that office to secure convictions in criminal cases. Goaded by these disclosures, La Guardia launched a formal investigation of the borough DA's office, and Governor Herbert Lehman soon after appointed a special prosecutor to investigate its criminal justice agencies. This probe eventually led to the uncovering and prosecution by the new district attorney, William O'Dwyer, of a "National Crime Syndicate," better known as Murder Incorporated. Led by an alliance of Jewish and Italian hoodlums, the syndicate made assassinations, to enforce mob edicts, its chief business. Another report by the committee staff prompted creation of the Mayor's Committee for the Study of Sex Offenses, headed by Dr. Malcom Goodridge of the New York Academy of Medicine.

Harry found the crime committee job vexing at times. Raising money, especially, was uncongenial. "The last week or so," he wrote Lindbergh in May 1937, "I have been burdened with public addresses, radio talks, meetings, and other ballyhoo, all of which . . . I detest. Sometimes I wonder whether the game is worth the candle."[78] The committee's initial drive for funds had yielded more than $144,000, but with a budget of about $50,000 a year, it was constantly on short rations.

Did the Citizens Committee do valuable work? Harry certainly—and

predictably—thought so. In May 1940 he announced that since its formation "marked improvement has come in the administration of criminal justice in New York," though these gains "must be consolidated and held."[79] The mayor agreed. Writing Harry after three years of committee work, he noted that he often disagreed with the conclusions of the committee. Indeed, he admitted, "some of us become irritated about them." But "the fact remains," he conceded, "it has kept everybody on their toes and has helped me to keep departments on their toes."[80] Yet some observers were more skeptical of the purposes and achievements of the Citizens Crime Committee. A later New York citizen crime reformer, Spruille Braden, claimed that Harry had admitted to him that the committee was primarily a tool of Dewey's political ambition. Moreover, said Braden, it had "just dilly-dallied around and made motions and put out announcements and got nowhere."[81] Dewey himself in the end thought the committee had been more trouble than it was worth. Reminiscing about his earlier career, he remarked, "I was pretty young then and I didn't know that these things turn into public nuisances."[82]

In all likelihood, in choosing among these views, "all of the above" is the best evaluation. Harry was undoubtedly a Dewey partisan and hoped to advance the crusading attorney's political ambitions. And there *was* a dilettantish and amateurish quality about the committee's work. Yet both Harry and Fiorello were also right: the committee did call attention to hidden evils and goaded the authorities to action.

The committee lost momentum in the early 1940s. As the public's attention was drawn increasingly to ominous events in Europe and the Far East, Harry found it difficult to raise money. In early 1941 La Guardia and district attorney Dewey joined with the other city prosecutors in a fund-raising drive, but it flopped. In early 1941 the mayor wrote Harry noting the sparse contributions (a little over $14,000 from May 1940 to January 1941) and suggesting that the committee might consider returning the few checks it had received and closing up shop.

With Pearl Harbor the Citizens Committee inevitably curtailed its work. Harry went on active duty as a lieutenant commander in the navy air arm in 1942. One of the committee's directors, Charles Burlingham,

took his place. The committee apparently survived until late 1945, but with La Guardia himself now gone and Dewey immersed in national politics, it then shut down.

ANOTHER PHASE of Harry's public life was over. But still there remained the Guggenheims as a family, and to Harry its preservation and its reputation would assume overriding significance.

"High Priest of the Clan"

W RITING HER COUSIN HARRY in July 1966, Eleanor, Lady Castle Stewart, described her son Patrick's plans to visit the United States with his wife in early fall. Patrick apparently had not heard much about her family from his mother, but he had just read Milton Lomask's book *Seed Money*, on the Guggenheims and their benefactions. It had made a powerful impression. Patrick was now "mad keen on the Guggenheims!" Eleanor reported. He "longs to meet you as the High Priest of the Clan."[1] The phrase was exactly right. In the years after 1945 Harry took on the attitudes, manner, and burdens appropriate to the supreme pontiff of the Guggenheim family.

He himself had once challenged the family consensus, but in his later years Harry assumed the mantel of family leadership and reaffirmed the solidarity principle first pronounced by his grandfather. With each passing year he became more firmly convinced that he must hold the Guggenheims together, preserve their traditions, and pass along their heritage to the younger generation. It would become the guiding axiom of his life.

What set him on this course? In part he was following in his father's footsteps. Though himself the second son, Daniel had taken command of the family from the beginning and remained its helmsman for the rest

of his life. A benevolent parent who cherished and respected his second son, he gave little excuse for the rebellion so common in father-son relations. How could Harry fail to incorporate his father's values and seek to fulfill his hopes even after his death? Harry's military training also inclined him to respect forms and traditions. Though his stint in the navy air arm in both world wars was relatively brief, he associated his whole life with high-ranking military officers who valued discipline and deference. And there was Harry's inherent character, the structural underpinnings of his personality. He was what used to be called an inner-directed man. Particularly in his later years he was self-disciplined and authoritarian, a man convinced of his virtue and the rightness of his views and ways.

Harry struggled to lead and preserve the family in small ways as well as large. He made Falaise a family social center, bringing squads of cousins, nieces, nephews, in-laws, as well as his own siblings, children, and grandchildren to the North Shore mansion for evenings, weekends, and longer stays. Cain Hoy served a similar purpose. There was the annual Christmas gathering at the South Carolina lodge expressly for the family at which Harry dispensed generous sums of cash as presents. Unfortunately, he expected everyone to follow his directions at Cain Hoy, and at least one of the frequent guests, Nancy's second husband, Tom Williams, considered Christmas dinner at the South Carolina lodge an oppressively regimented affair, with Harry presiding as an autocrat and glaring at every infraction of rules. The family appreciated Cain Hoy more when they came at other times of the year. Edmund and Robert Guggenheim, and Gladys and Roger Straus visited often. Harry gave them the run of the lodge even when he was away. When the Strauses were preparing to visit in his absence in January 1945 he provided detailed descriptions of where the "turkey guns" were located and where they could find the cached cigars and cigarettes. Harry, as was his way, could not help micro-managing the visit of his sister and brother-in-law. "When you go turkey shooting early," he wrote Gladys on one occasion, "you can either have your full breakfast when you get up or have coffee and toast and then have a large breakfast when you return."[2]

Harry reinforced bonds with fellow Guggenheims in symbolic ways

as well. Like everyone else, he sent greeting cards to family members on special occasions. His cards, however, were often prints of the ubiquitous turn-of-the-century engraving of Meyer and the seven sons posed around the conference table in M. Guggenheim's Sons' lower Broadway offices. As he hoped, these were often effective energizers of family feeling. In April 1951 the elderly Leonie, Uncle Murry's widow, wrote to thank her nephew for the copy he had sent her. The picture, she wrote back in her imperfect Alsatian English, was "beautiful" and "preciouse." "On every occasion you never forget to remember your dear family. . . . You are really the one who never forget his own." His uncle Murry would be proud of Harry if he were alive, she concluded. "He loved you very much."[3]

Late in life, Harry deployed yet another propaganda device to reinforce family ties: copies of Milton Lomask's book *Seed Money*. An earlier dynastic history, Harvey O'Connor's *The Guggenheims: The Making of an American Dynasty*, published in 1937, criticized the family's business practices and resorted to fantastic recreations of speeches and even events in their lives. The family consensus was that it was dangerously radical as well as inaccurate. And by the 1960s it was also out-of-date. *Seed Money*, published in 1964 by Farrar, Straus and Company, the firm run by Roger Straus, Jr., Harry's nephew, opened with three good chapters of family history through the 1920s before turning to description of the family foundations. The book contained extensive interviews by Harry and provided documents that have since disappeared. Harry also subsidized its publication. When it came from the press, he sent volumes to every adult member of the family. Cousin Eleanor got her copy from Harry and, as we saw, it clearly achieved its intended result with her son Patrick.

Harry's devotion to family solidarity no doubt expressed his taste for dynastic vainglory. But he had nobler motives as well. He believed passionately that the Guggenheims had a public mission. "I have reached the time of life," he wrote his disaffected daughter Nancy in 1959, "when it is time to prepare for the future." He always hoped that his children and grandchildren "would carry on the best traditions of the family." Unfortunately, "I am," he noted, "the only one in my generation assum-

ing those responsibilities." Harry defined the "best traditions" to his forty-four-year-old daughter lest she had missed their nature. They included, he said, "developing some of the great natural resources of the world," and in the process "creating wealth for the use of mankind." This led inevitably and rightfully to "amassing fortunes" as a "reward in our free enterprise system." But this wealth had "been bequeathed in very large part to imaginative Foundations for the further benefit of mankind." "I have," he reminded his fault-finding daughter, "been the head of three Guggenheim Foundations, which have contributed, and will continue to contribute, to the benefit and progress of mankind."[4]

HARRY'S KINSHIP FEELINGS inspired his campaign to revive Guggenheim Brothers as a mining and resource exploitation firm. But first there was more public service for him to perform. By mid-1941, with World War II looming, Harry began to consider returning to active duty in the navy. In 1942, after Pearl Harbor, he reactivated his commission in the naval air arm. He worried about passing the physical but, as he noted, "got through without a flaw."[5] Harry served initially as assistant executive officer at Floyd Bennett Field in Queens and then was assigned as commandant at Mercer Field, an air base near Trenton where the navy tested and commissioned planes. It was useful work, but he chafed at his distance from combat, and in early 1945, at the ripe age of fifty-five, he got his high military buddies to arrange a transfer to the USS *Nehenta Bay*, a small auxiliary aircraft carrier operating in the Pacific. Once aboard, he talked the commanding officer into allowing him to fly with the ship's bomber pilots as observer and machine gunner. In the Ryukyus campaign in early 1945, Harry helped strafe Japanese installations from the air. Harry was the only navy pilot who saw actual combat in both world wars. He was mustered out in 1946 as a full captain, the equivalent of brigadier general. Ever after his grandchildren would delight in calling him "skipper"; business associates would often call him "Captain."*

*At 120 Broadway, the offices of Guggenheim Brothers, he was usually referred to as "Mr. Harry."

Harry returned to civilian life to find the fortunes of the family's resource businesses much diminished. After Uncle Simon's death in 1941, ASARCO had continued for a time under the lead of Francis Brownell, a longtime nonfamily Guggenheim associate. During World War II, like all firms in the mineral extraction industries, it made good money. In 1947 Harry's brother-in-law, Roger Straus, took over as ASARCO's chairman of the board and remained as head for the next ten years. At the end of Roger's decade the firm was the world's largest producer of lead, turned out 10 percent of the world's zinc, and was "easily the world's largest seller of silver."[6]

But ASARCO, Roger notwithstanding, was a public corporation, no longer controlled by the Guggenheims. The family collected ASARCO dividends, but they had sold off many of their shares. By the 1950s the Guggenheims were not the largest stockholders in ASARCO. In a word, the firm was no longer a central part of the Guggenheim empire.

Harry's dynastic hopes centered on the family partnership, Guggenheim Brothers, headed by the aging Solomon. Now mostly in nitrates, the firm had also made money during the war. But it soon lost its vigor. In late 1944 Medley Whelpley, long a managerial mainstay of the firm, retired. Solomon continued as chief executive, but he was ailing and died in November 1949. By the 1950s Guggenheim Brothers was a shadow of its former self, functioning primarily as a holding company with stocks of a dozen mining and refining firms in its modest portfolio, including shares in Anglo-Lautaro Nitrates, Pacific Tin Consolidated, Feldspar Corporation, Brazilian Mining and Dredging, and Kennecott Copper.

In 1951, determined to replicate the spectacular mining successes of his forebears, Harry created a new Guggenheim Brothers partnership, incorporating a new Guggenheim Exploration subsidiary, with himself as largest investor and senior partner. Other partners included Albert Thiele; Harry's son-in-law, Albert Van de Maele; his nephew, Oscar Straus; and John Peeples, one of a group long associated with Guggenheim enterprises. But Harry had no intention of allowing outsiders to run the revived company. His vision required that the family run the business as in the glory days. Initially he hoped that cousin

Edmond would help him manage and revitalize Guggenheim Brothers. Edmond would prove to be a frail reed.

It was natural for Harry to turn to Edmond for support, rather than to his own wayward brother Robert. Close in age, the two cousins had been allies since they committed mischief together at Grandpa's and Grandma's Upper West Side townhouse on Friday family nights early in the century. Harry and Edmond had also been the first of their generation to be admitted to full partnership in the firm. And, despite some differences, a warm personal relationship would continue to the end of their lives. During the post–World War II years they often visited each other at their various homes, exchanged birthday greetings and presents and, when they were not in the same place, wrote letters discussing family, boats, diets, the stock market, and politics. In the late forties and fifties Edmond spent his winters on his houseboat off St. Petersburg and liked to send Harry Florida oranges and grapefruit for his birthday. Harry in turn gave Edmond and his wife, Jeanne, embroidered dinner napkins and other small gifts.

After 1945 Edmond remained an active executive in Kennecott and when he was in town, still came to the firm's offices, shared with Guggenheim Brothers, on lower Broadway. He was also an administrator of his father's estate, composed mostly of securities in family-connected firms. Edmond seemed the logical partner in Harry's quest for a reinvigorated Guggenheim Brothers. But by the late 1940s, now sixty, Edmond was in semiretirement and was uninterested in cooperating in Harry's plans and visions.

This became clear in 1951 when the cousins clashed over the family's nitrate holdings. The occasion was a scheme by Harry to buy Lautaro Corporation first mortgage bonds as part of the Guggenheim Brothers reorganization. Harry wanted Edmond, as executor of the Murry Guggenheim Residuary Trust, to join him and the other investors. Edmond did not consider the transaction a good deal for him and refused. And he did so through his attorney without speaking to Harry directly. This response unleashed pent-up resentment in his cousin. "I cannot understand why you refuse to accept your share of this responsibility," Harry wrote Edmond, "and instead place your share of the bur-

den on all the rest of us." The hitch over the Lautaro bonds triggered complaints about other recent inconsiderate acts by Edmond that had violated Harry's sense of family solidarity. "Without so much as 'by your leave,'" Harry wrote, "you lifted your father's portrait from the wall of the Firm office, where it had hung with the portraits of all his brothers since his death." Edmond's claim that he had paid for the picture was not acceptable, Harry scolded. Each third-generation survivor had contributed a picture of *his* father and yet none had removed these portraits. And Edmond had also tried to walk off with the inscribed copper bar from the Chuquicamata mine displayed in the firm's offices. That bar had "become an important tradition for thirty years." "In view of all the above," Harry concluded, "I can only feel that you have been giving lip service to your expressions of a real desire to help me carry on our family enterprises and traditions."[7] In the end the cousins remained friends, but Harry came to recognize that he could expect little help from his own generation in sustaining the family's enterprises and maintaining family traditions.

But if the third generation would not do, perhaps the fourth would. Harry might have considered Albert Van de Maele, his daughter Joan's husband, who had served Solomon as financial secretary and was an active member of the new partnership. Harry would eventually be willing to go outside the circle of blood relatives for family leadership, but apparently he did not sufficiently respect Albert's abilities. And in any case he had not yet given up finding a real Guggenheim.

In the mid-fifties Harry began a campaign to test the potential of various relatives for dynastic advancement. In the summer of 1955 he dropped in on Aimee Guggenheim at her New York apartment to see her grandson, William Guggenheim III, on the occasion of his sixteenth birthday. William had met cousin Harry only once before and was startled when he left a hundred-dollar bill in his jacket pocket, then perhaps equal to a thousand dollars. Harry offered William a summer job at Cain Hoy working with the horses. William interpreted this to mean "shoveling manure." He much preferred to spend his summer going to baseball games and watching TV, he later recalled, and turned it down. Harry had not mentioned that "mucking out the stables" could lead to something

better. How could he know, William wryly asked a half century later, that Harry was shopping for a male heir?[8]

Even more tempting than remote cousins, however, were grandsons. In the spring of 1956 Harry sent Dana Draper, Nancy's son, only sixteen, to Chile to get acquainted with the Guggenheim nitrate business. Dana would be a summer intern in the chemical research division of Anglo-Lautaro. Harry obviously hoped that the experience would be Dana's entree into the family mining business. Lest he miss his grandfather's dynastic intent, Harry described his own ASARCO apprenticeship at Aguascalientes before World War I. In a letter to Dana that summer, he tried to make him aware how his seasoning in Chile connected him to four generations of the Guggenheim family. His own father— Dana's great-grandfather—had, Harry noted, been shipped off to Switzerland by family founder Meyer in the 1870s to "get [his] business education." Harry quoted remarks Daniel had made to him back in 1908 about this experience: "I was sent into a foreign land among strangers to take up my business career at about the same time that you are entering yours."[9]

Unfortunately, Dana's Chilean exposure did not take. During the summer apprenticeship he was more interested in watching the doctors in the clinic performing operations than observing the technicians in Anglo-Lautaro's chemical lab. But Dana was still very young and Harry could wait to see how he might develop in the future. Meanwhile, he continued to seek a family member who could duplicate the successes of the past, and turned next to the forty-five-year-old Oscar Straus II, his sister Gladys's older son. Years before, while Oscar was still a Princeton undergraduate, Harry had taken an interest in his career and helped him advance in the U.S. diplomatic service. Now, in a memo circulated among the partners in early 1959 acknowledging Guggenheim Brothers' difficulties, Harry announced his intention to appoint his nephew as chief operating officer. His explanation for this choice underscored again his dynastic faith. Oscar possessed "qualifications suitable for this task together with the highest personal standards," he noted. But besides, "his devotion to the family tradition is both in his training and generations of inheritance."[10] What he did not mention was how much

the choice would please Gladys, the family member of whom he was fondest.

Oscar had not been especially close to his uncle. Harry had been one of the relatives he encountered as a boy when Daniel's children and grandchildren visited the patriarch at Hempstead House. But as an adult his brother Roger had known Harry better than he. On the other hand, Harry and he shared experiences and interests. He had served as an officer in the coast guard under the navy's direction during World War II, and was a pilot of small planes. Oscar had worked under his father, Roger, as an official at ASARCO. When Roger retired as president, Oscar became chairman of the firm's finance committee, but found his way up blocked by his father's opponents. Harry had heard about his nephew's problems at ASARCO and knew he would be receptive to an offer at a revived Guggenheim Brothers. And he was right. Oscar jumped at his uncle's offer to head Guggenheim Brothers' exploration division.

His reign was not productive. In part the times were against him. The triumphs of Chucquicamata and Aguascalientes had relied on the favor of local governments. In the early 1950s, the firm had several successes in exploiting new mining properties. By the 1960s, however, the third world, where the Guggenheims had made their mark, was roiling with defiance against Western capitalism and struggling to purge itself of Western colonialism. In Latin America, Africa, and elsewhere governments were refusing new concessions to foreign investors or heavily taxing, or even expropriating, existing foreign-owned firms. In addition, there were the geological realities: all the most accessible ore deposits, it seemed, had already been discovered. At least as serious was the firm's undercapitalization compared to its rivals. Harry was unwilling or unable to invest heavily in the partnership, and the new firm simply did not have the means to outrace its competitors. While Phelps-Dodge and Kennecott had twenty to thirty million for exploration, Guggenheim Brothers had perhaps two million at most. Under Oscar's command the firm joined ASARCO, American Metal Climax, Reynolds Mining Company, and other companies in several joint ventures in Peru, Brazil, Canada, and elsewhere. None of these hit big, and in 1969 Harry dissolved Guggenheim Exploration, though Guggenheim Brothers sur-

vived as a peripheral player in world resource development. When Oscar sought to continue the exploration company under his own auspices, Harry refused to allow him to use the family name.

But personality clashes with Harry also limited Oscar's achievements. A bookish-looking man when in his forties, Oscar, some said, was willful and dogmatic. One of Guggenheim Brothers' attorneys described him as very much like Harry himself, "dictatorial and set in his ways."[11] Given Harry's own imperiousness, it is not surprising that uncle and nephew fought. John H. Davis, drawing probably on Harry's own personal descriptions, writes that after a time "the two men could not even remain in the same room together."[12] The situation became intolerable. Harry could scarcely speak to Oscar, communicating with him mostly through his younger brother, Roger.

As a kind of backup, when he hired Oscar, Harry also took on Peter Lawson-Johnston, his cousin Barbara's older son and Solomon's grandson, who had worked for some years in several Guggenheim business affiliates in the South and in Malaya. In late 1961 Harry made Peter a partner in Guggenheim Brothers with a modest 3 percent share of the business. Peter had little money of his own, and Harry subsidized his contribution as a partner. As we shall see, Peter would turn out to be the very man Harry had long sought. Harry balked, however, when his English nephew Patrick approached Peter in the late 1960s to join Guggenheim Brothers in some capacity. Peter feared that Patrick's British citizenship might cause legal problems and advised Harry against it.

HOWEVER SINCERE HIS DYNASTIC GOALS and however noble his sense of family mission, Harry's urges coincided with his innate disposition to control, to manage, to dominate. These irrepressible compulsions would lead to wounding clashes with his wives, children, and grandchildren, who came to resent his manipulations and his despotism.

Harry's domineering propensities were most damaging in his relations with his middle daughter, Nancy. Born in 1915, his second child with Helen, she was "dark as a gypsy," according to Dorothea Straus, sister Gladys's literary daughter-in-law.[13] Dorothea's husband, Roger, Nancy's cousin, recalled that she was very pretty as a girl with "almost an

Italian look about her." He remembered how on one occasion at his grandfather's house, she had been asked to perform some acrobatic dance for the uncles and aunts and "did it in great style."[14] After her parents' divorce, she had chosen to live with her father, while her sister lived with their mother. Her choice had deeply offended Helen, a vengeful woman, who refused to see Nancy and her children for many years. Dana, Nancy's older son, in fact, did not meet his grandmother until the 1960s, when he visited his aunt Joan in New York. Helen was also put off by Nancy's lifestyle and "strange ideas" and advised her that if she really wanted to live as a bohemian, she should not "live off us."[15]

As a teenager Nancy had accompanied her father to Havana and, though young, had served at times as his hostess. The close contact, unfortunately, did not lead to mutual understanding. His 1959 letter to Nancy, already noted, was a response to her angry refusal to meet him in Miami after they had clashed over the education of her two sons, Dana and George. Harry's claim that he was merely furthering the family's worthy mission seemed to Nancy a devious attempt to run her life. Denying Nancy's accusations that he was constantly meddling in her family affairs, Harry responded that he was merely offering advice or at most providing opportunities. He only wanted Dana and George to succeed, he protested, to have fulfilling lives.

In fact, as family high priest, Harry believed he had the obligation to prescribe his grandsons' education and careers. Both boys were the offspring of Nancy's marriage in 1939 to George Tuckerman Draper, a politically liberal New Yorker descended from Charles A. Dana, famed nineteenth-century editor-publisher of the *New York Sun*. Since then the Drapers as a family had turned to the arts and numbered a celebrated actress, successful dancers, and a world-class interior designer among their number. Nancy herself was interested in art and dance and was studying at Columbia and taking classes at Lincoln Kirstein's American School of Ballet when she met George Draper, himself a Columbia student. George soon went off to observe labor conditions among the Birmingham, Alabama, steelworkers and then served a stint as ambulance driver for the Loyalists in Spain. When he returned the romance took off.

After their nuptials in 1939 Nancy and George moved to northern California, to "get as far as we could from our families," George later said.[16] Here, in 1940, Dana was born. In 1941 George went off to war, but came back on leave to conceive a second son, George Tuckerman Jr. He returned to civilian life in 1945, divorcing Nancy shortly after, only to remarry her in 1951. This second turn lasted only a few months. One day he went out for a pack of cigarettes and never returned. Harry had been skeptical of the remarriage but had supported it, standing by his daughter when it failed.

In the 1950s Nancy and her sons lived in San Francisco. In 1955, when she married Tom Williams, a Bay Area lawyer, she was a teacher of dance and ballet, close to the ballet community of San Francisco. Her older son would describe her as "very kinesthetic."[17] In 1951 her book, *Ballet for Beginners*, a collaborative effort written for ten- and twelve-year-olds, was published by Knopf. It was so successful that Alfred Knopf prodded her to do a second ballet book.

Both boys were in their teens by the late fifties, and their grandfather, with two Cambridge University degrees of his own, was acutely concerned about the quality of their education.* For her part, Dana later said, his mother was more interested in his emotional health than his formal education. Harry acknowledged that the boys were "everything fine," as their mother believed they were, and had "excellent mental capacity."[18] But he was concerned that they were not getting good secondary educations in provincial California. And in fact Dana, he knew, was doing poorly at school in his junior year. His record, Harry feared, would keep him from getting into Stanford, the only California university Harry apparently respected. George too was not achieving sterling grades. Certain that "inferior schools" were the cause "of such failure as Dana and George have shown," Harry campaigned to get his grandsons into good eastern prep schools, where, needless to say, he would pay the tuition.

Harry's concerns over his grandsons' schooling had deeper roots than

*In fact, Harry was solicitous of the education of other young relatives as well. It was he, for example, who arranged for Alice Albright, his third wife's niece, to attend the prestigious Ethel Walker School in Connecticut.

the usual solicitude of a grandfather. Without a son, he planned for one or the other of them to assume family leadership. They must have elite educations. He was skeptical of their preferred teenage choices of profession—medicine for Dana and architecture for George—and where they expected to live—San Francisco. "There is certainly nothing unworthy in this," Harry wrote his daughter, "but it doesn't lead to family work." He denied once more that he intended to interfere with Nancy's "plans and ambitions," but he reproached her for failing to convey to the boys their family obligations. "I have always offered and made it possible for the boys to find out about the family opportunities and responsibilities," but "without enough response." He implicitly blamed his daughter for the boys' indifference to the family heritage. "Throughout recent years there has not been a single inquiry about the future," he complained, "not one expressed desire to take any part in the family affairs."[19]

Harry's desire to manage his grandsons' lives were undoubtedly rooted in spacious dynastic urges. But he could not help trying to fine-tune his grandsons' everyday habits. Harry himself, not surprisingly, was "regular" in his bowel movements and thought it important that his descendants be in theirs. Years later George remembered, while on visits with his grandfather, being greeted by Harry at breakfast with an embarrassing question: "Boys, have you done your duty today?"[20]

Though her father's overbearing assumptions infuriated Nancy, she solicited and accepted his largesse. Harry created trust funds for his three daughters in the early 1930s. In the 1960s these were in the form of *Newsday* shares. He gave additional funds to Nancy and to ex-wife Helen in 1946. He also gave Nancy the money to buy a house and paid the psychiatric bills for grandson George, who, at the age of thirteen, had developed a severe eating disorder. Moreover, he apparently sent Nancy money to pay day-to-day bills. It is not surprising that he who paid the piper expected to call the tune. It was a situation exquisitely contrived to breed resentments, and it achieved its inevitable result. "I know that you feel that I have an obligation to support you and your family because without any reference to you, I brought you into this world," Harry wrote in early 1959. But he questioned that commitment if Nancy

shirked her "obligations to me and your children and your responsibilities of inherited wealth." The boys were old enough to consider these matters, and he urged her to discuss them with Dana and George.[21] Nancy could ill afford to break with her father. Several months later she wrote him that she accepted his view of the boys' educational and professional futures. Harry was pleased and prepared to consult several experts to find out what the best prep schools for them might be. In June, however, after detecting insincerity in Nancy's acquiescence, Harry threatened to wash his hands of his daughter and her family. "Only at this late date you have expressed a change of mind. If you haven't a change of heart as well, I can't help you." While he was trying to get George into an eastern academy "where he might get some new ideas and inspiration," Nancy was still attempting to place him in a "school in the West where he would quite naturally gravitate by volition."[22]

Harry not only objected to Nancy's failure as a Guggenheim mother; he also found her way of life unattractive. By his lights it was chaotic and bohemian. Even her own mother, Helen, did not approve of it, according to Nancy's older sister, Joan. Equally bad, in Harry's eyes, Nancy was a political liberal, a Democrat. Harry periodically lectured her on the disorganized nature of her "aimless drifting and selfish living." In 1959 he quoted her favorite politician, Adlai Stevenson, on the dangers to the country of evading the "rigors and rewards of creative activity" and indulging in "the trivial and the mediocre." Yet however much he deplored Nancy's behavior, he regretted his estrangement from her. "I have a troubled heart about you and the boys," he wrote her while recuperating from an injured back. He did not know what had caused "distrust, antagonism, and indirection" in her relations to him. "At one time we had a very close and happy relationship," he lamented, and there was nothing that he "would not do for your and the boys' happiness and welfare." Yet while expressing his affection for his daughter and grandsons he threatened to disown them. He intended to "readjust the plans" he had formed for her and the children "to share fully in the family opportunities," he wrote. It was his "duty to see that the family's efforts for human progress" were "continued and not permitted to falter." If he

could not "succeed through the coming generation" he "must use other means to carry out" what he felt was "a sacred trust."[23] The letter angered Nancy. If her father was puzzled over why their relationship had deteriorated, he had only to review his own behavior, she replied. "All I can say to this is that you have repeatedly criticized me severely and unmercifully as to how I have conducted my life and raised my children. This at first hurt me deeply and over the years has caused me to feel antagonism as well as hurt."[24]

In the end Harry failed to impose his educational preferences on his grandsons. In 1959, after an abysmal year at Menlo Junior College Dana decided to duck the school issue by joining the army. That same year Harry succeeded in getting George accepted by the prestigious, all-male, South Kent School in Connecticut, but after a trip to the campus, George balked. The place was like a monastery and not for him, he decided. Nancy and her second husband, Tom Williams, visited South Kent soon after and agreed with him. When George, Nancy, and Tom assembled at Falaise after the campus inspections, Nancy told her father that George would not be attending the school. Harry blew up. While Nancy went off to her room in a huff, Harry dragged Tom out to the terrace. "Is she going through the change of life?" he demanded. "And who wears the pants in your family?" Harry brandished his ultimate weapon. "I'm going to see that you people don't inherit a goddamn nickel," he shouted. After a half hour of inveighing, he spat out: "You can pack up, the whole bunch of you, and get the goddamn hell out of here."[25] Nancy and Tom left for California that evening.

George settled for a boarding school in Scottsdale, Arizona. He later described the school as "a good fit for me,"[26] but Harry "thought [it] . . . was awful."[27] The ruckus over South Kent, apparently, totally disqualified George in Harry's mind for consideration as his successor.

George eventually attended the University of Oregon in Eugene, where he majored in a combination of architecture and sociology. After taking his degree he enlisted in the coast guard reserve to avoid service in Vietnam. In the early 1970s he settled in the Bay Area where he worked for a regional planning group. In the eighties he returned to school to

study filmmaking and photography and eventually established a business producing slide presentations and videos for environmental organizations. After the South Kent School fiasco George and his grandfather maintained a civil but cool relationship. "We tiptoed around . . . issues to avoid conflict," George later recalled.[28]

Harry never broke off relations with his daughter. The two continued to write each other and chat on the phone, often discussing politics, though Harry remained a conservative Republican and Nancy and her husband continued as liberal Democrats. Politics aside, Nancy tried to appease her father, sending him gifts and dispatching George on visits to his grandfather. But deep down, Harry obviously remained resentful and disappointed.

Life did not treat Nancy well. Her interest in dance waned, apparently, and she seemed to spend her later years without much focus. As she aged her autonomy became progressively impaired by cataracts. Her marriage to Tom Williams began to falter. In the late 1960s she contracted breast cancer and had a radical mastectomy. The medical mutilation was appalling to her. Depressed, in late 1972, at the age of fifty-seven, she committed suicide by taking an overdose of sleeping pills. Harry himself had died the year before.

HIS OLDEST DAUGHTER never caused Harry the heartache of Nancy. Born in 1913, Joan chose to stay with her mother when Harry and Helen got divorced. Perhaps it was a commentary on Harry's personality that, with reduced childhood contact, she got along better with her father as an adult than her sister. As a girl fair-haired and rosy-cheeked, though a little plump, Joan was married at twenty-one in June 1934 to Charles Murray at the Long Island summer home of her mother, now Mrs. Henry Matzinger. She had attended Friends Academy on Long Island and afterward spent three years at the School of Applied Arts in New York. As is often true of early marriages, Joan and Charles soon broke up, and in 1947 she married Belgium-born Albert Van de Maele, three years her junior. Harry made him a partner in Guggenheim Brothers. Joan and Albert lived in New York close to Harry and had a summer place, a gatehouse, on the grounds of Falaise.

Joan had no children, and that undoubtedly helped avert conflict with Harry. But besides, she was a dutiful daughter who seldom disagreed with her father and shared many of his interests. She loved racing and ran a stable of her own. One of her horses, Merry Hill, won the Frizette race for fillies at Belmont Park in 1958, earning a $56,000 purse. Joan often accompanied her father to Saratoga during the racing season. Like him, she also enjoyed quail and turkey shooting. Joan and Harry even went to war together in the 1940s, she as a captain in the Women's Army Corps in the Pacific while he served in the same theater in the navy. Joan would take over her father's care during his last illness. Writing just before Harry died in January 1971, Peter Lawson-Johnston, now Harry's heir apparent, complimented Joan for her loyalty to her father. "You . . . have taken on the responsibility of looking after your father during his illness with great ability, tact and devotion," he wrote. "I admire you greatly."[29] In a later era Joan might have become her father's successor in business and public service. For a brief time in the 1950s Harry toyed with the idea of bringing her into the business. But the weak impulse died when Joan herself objected, in part because she wanted to avoid competing with her husband.

Joan divorced Van de Maele in 1975. In her last years she lived in St. Croix in the U.S. Virgin Islands, where she helped found the local Boys Club. She died in Miami Beach in 2001 at the age of eighty-eight.

DIANE, CAROL'S ONLY CHILD with Harry, born in 1924, was much younger than her half sisters. She lived with her mother after Carol and Harry divorced and was apparently seriously disturbed by the breakup. Her adolescence was marked by more than the usual storm and stress, and she made life difficult for her mother, forcing Harry to intervene on his ex-wife's behalf. Diane fought her father's marriage to Alicia Patterson in 1939, though her two half sisters tried to convince her that Harry's new wife was a nice lady. In 1943, only eighteen, she married a young army officer, John Meredith Langstaff, who in peacetime was an aspiring concert singer. The wedding was held at Grace Episcopal Church on lower Broadway, with Harry giving away the bride. Undoubtedly Diane and Lieutenant Langstaff had been swept up by the

romantic frenzy that war brings, but the early marriage must have expressed as well Diane's desire to escape a troubled relationship with Carol.

Like many sudden wartime marriages, the union with Langstaff was soon over. When little Carol, her only child with Langstaff, was three, Diane secured a divorce in Reno charging "extreme mental cruelty."

In later years, not wishing to use either "Langstaff" or "Guggenheim," Diane adopted "Hamilton" as her last name, after an Irish folksong character, Mary Hamilton. Besides her daughter, Diane took from the marriage an interest in music and singing. In the 1950s she joined the spirited folk music–folklore scene emerging in America. She taught herself folk dances and learned to sing Appalachian ballads, accompanying herself on the stringed dulcimer. She became an avid collector of folksongs from around the world. But Diane had a particular fascination with Irish culture. According to daughter Carol, it derived from her Irish nanny who gave her the love her remote parents could not or would not.

One evening in August 1955 Diane and a friend, Catherine Wright, knocked on the front door of twenty-year-old Liam Clancy's house in Carrick, Ireland. Liam's two older brothers, Paddy and Tom, were in New York singing Irish songs in Greenwich Village clubs. Inspired by their performances, and already enamored of Irish culture, Diane and Catherine had decided to investigate the musical riches of the brothers' native land. They were in Carrick, they told Liam, to learn Irish songs from the Clancy family. Might they come in?

The visit turned into a "night," Liam later wrote. Diane, "narrow waisted, big bosomed, sallow, and soft-spoken," played and sang for the Clancys. Dressed in a "folksy plaid dress" and Capezio slippers, she performed a Morris dance for Liam and his family.[30] That evening the Americans recorded songs by Liam's mother on one of the clumsy tape recording devices of the day.

The next day Liam and the visitors drove to Kerry to meet Padraig O'Keefe, a legendary performer on the fiddle, and taped his performances. The three then spent several weeks touring Ireland visiting other performers and recording for their collection. On one of these for-

ays they met the talented Makem family in Keady. Tommy, the youngest son, was about Liam's age, and they became friends.

Diane, with her money and sophistication, was a marvel to Liam Clancy. A self-described "small-town boy, Catholic, parochial, puritanical," he was dazzled by "the great broadening vista [Diane's] conversations were opening up."[31] He did not find her attractive, however, and was put off by her brazen physical advances. Diane induced Liam to join them in Scotland where they recorded songs in the Hebrides and where she continued her siege of his virtue, though apparently without success. When she finally returned to New York in early December, Liam felt drained by Diane's constant "questioning, doubting, analyzing, teasing out, chewing on, quantum-leaping, U-turning, mood-changing."[32]

Diane's obsession with the young man, more than a decade her junior, continued unabated. In the next weeks she phoned Liam several times from New York, very upset, demanding that he acknowledge his love for her and threatening to come back to Carrick and commit suicide in front of the Clancy house. She did return to Ireland just after Christmas, but this time she was "full of the joys of spring" and bearing gifts for everyone. She induced Liam to accompany her to the Aran Islands, a place that held a special fascination for him. "I had no defenses against a woman of such wiles," Liam later wrote.[33]

In January Diane paid Liam's boat passage to New York, promising that he could take a course in film at NYU while devoting some of his time editing the tapes they had made. Once in New York, united with Tom and Paddy, Liam was introduced by Diane to the city's folksong community. Diane lived in the Village, and her apartment on West Tenth Street was always crowded with folksingers, folklorists, and members of the New York musical and theatrical worlds. She also brought Liam to Falaise to meet Harry, having first, to Liam's amazement, called her father to make an appointment. Harry's response to the visit from his bohemian daughter and her juvenile boyfriend could have easily been predicted. He seemed "none too pleased" to see them, Liam wrote.[34] Diane and her father at one point went into the library, where they engaged in a passionate muffled discussion that Liam assumed was about him. Later he and Diane wandered along the beach below the house, and

Diane told him how much she hated Falaise. She also admitted that her father had expressed dismay that she had taken up with him. Liam met Harry at least once more—at Cain Hoy. He did not like him either time. Harry seemed humorless and unfriendly on each occasion.

Some months later Diane formed a company to record and market the songs she had taped in Ireland as well as other folk and ethnic material. In 1956 Tradition Records opened an office in Greenwich Village, hired a staff, and began to issue albums of Irish songs and performances of Irish actors. One of these collections, *The Rising of the Moon*, featured Liam and his two brothers, joined by Tommy Makem, now in New York too, singing Irish rebel songs. The album was an immediate success and led to successful singing gigs for the Clancy Brothers around New York, additional recordings, and an appearance on the nationally televised Ed Sullivan show. During the 1960s, the "Clancy Brothers and Tommy Makem" became famous for their rousing recordings and concert appearances, singing of Ireland's woes and joys, while wearing their trademark Irish fisherman sweaters.

Diane remained a fixture of Liam's life for some years. She accompanied him on folksong quests in New England and the South. Along with Diane's young daughter, Carol Langstaff, they visited Cain Hoy while Harry was away. Sometime in the 1960s Diane bought a cottage near the Clancy home in Carrick and made it one of her major residences. She was always a disturbing presence in Liam's life. He was grateful to her for Tradition Records and opening up "a whole new world" for him.[35] But he lamented her mood swings and balked at her persistent romantic advances. At one point, he wrote, he had to literally push Diane, naked and needy, out of his bed when she crept under his covers. Diane eventually met an Italian singer named Mario Polidori and fell in love. She now abandoned her unrequited passion for Liam, much to his relief.

Diane's romance with Polidori did not last, and in 1963, after a brief marriage to the obscure Robert Guillard, she married William Meek, a graduate of Trinity College, Dublin. Born in County Down, Bill Meek was a talented journalist who wrote about the folk music scene for the *Irish Times* and authored several books. Diane and her husband made their home in Ireland though she occasionally came to visit her father in

America. Diane and Bill had two sons, Eoin and Colm, and adopted two baby daughters, whom they named Sorcha and Caitriona. These were Gaelic names, but actually Sorcha was English and Caitriona Korean. Harry marveled at the racial mosaic that his grandchildren represented. Responding to news of Eoin's birth, he observed that "this child has a wide mixture of races and cultures in his being." He hoped that the strains would "all blend to make him a happy . . . member of the . . . world into which he has been born."[36]

The union with Meek, four children notwithstanding, lasted only ten years. Diane then married John Darby Stolt, who dropped "Stolt" and combined "Darby" with "Hamilton," the name his wife had adopted, to make John Darby-Hamilton. In later years Diane continued to collect folksongs and in the 1980s recorded an album, *Green Autumn*, for a small Cambridge record company, featuring herself singing Irish, Scottish, and English songs, while accompanying herself on the dulcimer.

Diane's life was a restless quest for fulfilling experiences and relationships. Though she adored her father, she and Harry were too far apart on life's fundamentals to be intimate. Her daughter Caitriona reports that later in life she lost touch with her Guggenheim roots. And yet she came to New York from California with her children in 1984 to attend the Guggenheim family "reunion," and refresh her past at least briefly. Caitriona acknowledges that as a parent Diane was often distracted by her professional interests when she and her siblings were young. She was, nevertheless, she says, a good mother. Diane died in July 1991 at the age of sixty-seven.

HARRY'S MANIPULATIVE PROPENSITIES also made his married life with three different women stormy affairs. Helen, whom he wed in 1910 when he was twenty, was a nice Jewish girl whose Our Crowd background must have pleased his parents. The marriage was turbulent, however. Both were very young and found the realities of daily living together daunting. Helen, moreover, could not share Harry's nondomestic interests. But the breakup of Harry's marriage to Helen in 1923 was probably as much pull as push. Harry had met Caroline (Carol) Potter when he was in Mexico with ASARCO. She was the wife of

William C. Potter, the former banker who was then in charge of ASARCO's Mexican operations. Potter had helped mentor Harry and Edmond and been taken into Guggenheim Brothers as a partner, the one non-Guggenheim and non-Jew at that time.

Carol was everything that Helen was not. She was artistic, she was dreamy, she was gentile. Carol claimed at her divorce proceedings that William Potter's obsession with business had destroyed their marriage, but considering the timing, it is likely that she and Harry had started an affair before their marriages ended. Carol and Potter divorced in October 1922; Harry married Carol in February 1923. Carol already had two daughters when she married Harry—a teenager, Jean, and a younger girl, Charlotte. Diane would be their one child together. By marrying Carol, Harry ended up with three daughters, two stepdaughters, and no sons, a fate that affected the whole course of his life.

The marriage to Carol was no happier than the marriage to Helen. Carol was unstable; Harry was domineering. Difficulties had already appeared while they lived at the embassy in Cuba. As we saw, Carol had to leave Cuba early because she was ill, though perhaps she might have stuck it out if the marriage had been happier. When Harry's term as ambassador ended, they resumed living together in Manhattan and at Falaise, getting along no better than before. In 1937 they separated. Carol left with Diane, acquiring her own apartment in New York.

We cannot be certain why the marriage failed. Carol may have been sexually remote. Her granddaughter, Carol Langstaff, says that she had joined Frank Buchman's Moral Rearmament movement and adopted its principle of sexual abstinence. She recalls her mother describing Harry pounding on her bedroom door and not being admitted. But the evidence is confusing. Harry, for his part, may well have taken up with other women. Carol claimed that she had tried to make a go of the marriage, but Harry was uncooperative and was willing for "the thing to drag along as a marriage for me and freedom for you."[37] At another point she noted: "After all marriage is a fifty-fifty contract, not a harem."[38] And on still another occasion she accused him of "unwillingness to assume the essential obligations of marriage."[39] Harry in turn blamed her for "pursuing [her] life with complete independence" during the previous year and for

"departing with several millions of dollars" that had been intended "for the common purposes of our joint lives."[40] He also denied responsibility for their ceasing to sleep with one another. Every suggestion of a modus vivendi by her, he claimed, included the reservation that "under no circumstances" would she resume "the essential obligation of marriage."[41]

Carol may well have been mentally ill. There is some evidence that she became paranoid in old age. Diane later told Liam Clancy that her mother "was locked up for the last few years of her life."[42] She was confined in one of the upper floors at Falaise, according to Diane. But that seems unlikely. Diane herself was a fantasist and, as we have seen, emotionally volatile. Her story of her incarcerated mother calling down to her from the Falaise attic sounds too much like a nineteenth-century gothic novel. On the other hand, Carol Langstaff reports that late in her grandmother's life a male companion kept Carol totally isolated, perhaps to spare her contact with normal folk. This may have inspired the "crazy relative in the attic" story.

At all events, Harry and Carol were finally divorced in 1939. When Harry was later asked the reasons that his first two marriages failed, he blamed himself. "My first two wives were both wonderful women. The failure of both [marriages] . . . was entirely my fault."[43] It was a gallant gesture but not entirely true.

HARRY MARRIED for the last time in 1939. The union with beautiful, high-powered, headstrong Alicia Patterson transformed not only his personal life but set him, in his mature years, on a new and highly profitable road. Yet in the end, this marriage was just as tempestuous as the previous two, though it survived until Alicia's death in 1963.

Alicia was Harry's close match in wealth, interests, and intelligence. Her father, Joseph Medill Patterson, resembled Harry in many ways. Born into the rich and powerful Medill clan of Chicago, owners of the *Chicago Tribune*, Joe was a pilot, a World War I army officer in France, and a successful entrepreneur who founded the *New York Daily News* in 1919 and turned it into the most successful American tabloid of all time. As a girl in Chicago Alicia had been a hellion who was regularly thrown out of boarding schools in the United States and Europe for disobeying

rules. She grew up to be an auburn-haired beauty with a graceful figure and a lovely profile who had strong appeal to men. Hoping to tame her unruly spirits, in 1926 Patterson pushed her into marriage at twenty, to the son of a Marshall Field department store executive. The marriage lasted legally until 1930, though as a true relationship it was over in exactly a year. Once more single, Alicia went to work as a reporter for *Liberty* magazine, a joint venture run by her father and cousin Bertie McCormick of the *Chicago Tribune*. During this period Alicia and her father took flying lessons together, receiving their pilot's licenses at the same time. Joe was never a very good flier, but Alicia would set speed records for flights between major American cities. She also jaunted around the world reporting on hunting expeditions and exotic encounters for *Liberty*, *Vogue*, and other publications.

Alicia married again in 1931. Her new husband, Joseph Brooks, had been an All-American football player at Colgate and, like her father, an officer in the American Expeditionary Force in France. Fifteen years older than she, he was an outdoorsman and her mentor in fishing and hunting. Under his tutelage Alicia became a skilled shot and flycaster. Brooks was not a wealthy man so Alicia's father settled $25,000 a year on her and bought her a house on three acres at Sands Point on the North Shore. She and Brooks were also able to buy a hunting lodge in Kingsland, Georgia, near the Florida border, which became her favorite retreat, a place where she could boat, hunt, and fish. Alicia and Brooks lived a golden life for eight years. He was an insurance broker but preferred pleasure to hard work. While he gambled, drank, fished, flew, and partied with celebrities, his associates did the work of his office. Alicia generally joined her husband in his rounds of play, but she also worked at her father's *Daily News*, first in the advertising department and then as a book reviewer.

By the late 1930s the marriage was failing. Though Alicia was herself an earnest drinker, she began to feel that her life with Joe was aimless and dissipated. Moreover, her husband's debts were mounting, and she resented having to rescue him from his creditors. She also began to feel uncomfortable with her immersion in his hedonism. As a mutual friend

later remarked, "she felt she was winding up a drunken bum. . . . She was determined to get out of her marriage to Joe, much as she loved him."[44]

Alicia and Harry met sometime in 1938 when she was thirty-one and he sixteen years older. The Brookses' Sands Point home was close to Falaise, and they and Harry met at parties on the North Shore. Alicia also saw Harry at Saratoga, where the Brookses and he both went for several weeks each summer for the racing season. While Joe was off gambling in town, Harry escorted Alicia to the track to watch the horses run. Given Alicia's earlier, and future, romantic saga, it seems likely that the two began an affair sometime during the year. Harry appealed to her as the embodiment of all that a man should be. His history—pilot, sportsman, military officer—undoubtedly reminded her of her father. So, for that matter, did Joe Brooks. But Harry was also rich, stable, and sober. Most important, he seemed to respect her intellect. As one of Alicia's friends observed, "Where he got Alicia was he told her she was an intellectual, and that Joe didn't understand her great mind."[45] She apparently also considered Harry, at a trim forty-eight, a sexy man. For Harry's part, Alicia was beautiful, smart, and seductive. As a bonus, she enjoyed the things he did—flying, fishing, racing, and hunting. She was clearly no more compliant than Helen and Carol, but perhaps Harry really preferred a passionate, restless woman of spirit—at least as a wife, if not as a daughter.

Harry and Alicia were married in early July 1939 in Jacksonville, Florida, immediately after their Florida divorces from Carol and Joe. The ceremony was a small private affair at the home of Alicia's old Chicago friend, Dorothy "Dody" Michelson, daughter of physicist Albert Michelson, and performed by a local judge. Joe Patterson and Alicia's sister did not approve of Harry. Joe did not like Jews and, besides, undoubtedly saw Harry, whom he so much resembled, as a rival. Apparently no one from either family attended. The couple immediately set out on a flying honeymoon, heading their two-seater plane toward Roswell, New Mexico, where they intended to visit Professor Goddard and observe his progress on liquid fuel rockets.

* * *

ALICIA WAS UNABLE to have children owing to an ectopic pregnancy during her marriage to Brooks. Although she apparently wanted to adopt a child, Harry was adamantly opposed.* When Dody Michelson, acting as her agent, approached him with the idea, he was "stony about" it and advised Dody to "get out of his life."[46] Alicia acted like a parent to her nephew, Joe, and her niece, Alice, her sister Josephine's older children, but it was not the same as motherhood. Harry was not totally insensitive to Alicia's emotional needs. He realized that she must have something to occupy her mind and engage her energies if the marriage was to work. He suggested that she try running a newspaper and promised to buy a small publication for her. She agreed and he turned for help in finding a suitable property to one of Alicia's friends, Max Annenberg, circulation manager for her father's *Daily News*. Annenberg came through. While at the Goddards' New Mexico ranch the honeymoon couple received a telegram from him describing the availability of the *Nassau Daily Journal*, a small paper recently established by publisher S. I. Newhouse. Newhouse had shut it down after less than two weeks of publication rather than knuckle under to a union organizing drive. The paper's presses and other equipment had barely been used and the plant would be ready to roll quickly.

Harry was all for taking the offer. Alicia hesitated. Whatever her yearnings, the prospect of real responsibility frightened her. As Harry later explained, "she wanted at that moment to give up the whole idea. Until that time in her life she had undertaken stirring adventures but never had been faced with serious responsibilities." He wondered if she did "not foresee the utter devotion and . . . dedication to a newspaper that would embrace all of her future life."[47] In the end Alicia said yes. Harry asked William Mapel, a former journalism professor and newspaper editor, to make a survey of the potential market for a daily on western Long Island. His report in January concluded that by the end of its second year the paper would achieve a paid circulation of fifteen thousand copies daily in Nassau County. Impressed, Harry sent Mapel to speak to

*During World War II, however, Harry and Alicia provided a home for two small refugee children for the duration of the war.

Newhouse about buying the equipment of the defunct *Journal*. Mapel made an appointment to meet Newhouse at one of his papers, the *Newark Star-Ledger*, and encountered the publisher in the office hall. He introduced himself as Harry and Alicia's agent and asked what New-house wanted for the idle presses. "Make me an offer," the publisher replied. Mapel lowballed it: "$50,000." "You've got yourself a plant," responded Newhouse.[48] Harry would put up the money though he agreed to give Alicia as a gift a $4,000 capital stake in the enterprise. In exchange for her services as editor and publisher, he would give her half of all the profits if there should be any.

With the help of Annenberg, Alicia assembled a staff for the new pub-lication. They named it *Newsday*, a name ostensibly arrived at by a con-test open to the public.* Alicia chose Mapel as general manager and Harold Davis, a *Daily News* veteran, as managing editor. She hired other experienced people from her father's paper and took on a flock of young men and women with little or no journalism background as reporters, editors, and production people. What they lacked in knowhow, the young staff made up in verve. Rewrite man Norman Lobsenz, hired at age twenty-two straight out of Columbia's Pulitzer School of Journal-ism, said of these early days that it was "sort of like Judy Garland and Mickey Rooney sitting around and saying 'Hey kids, let's put on a show.'"[49] Alicia engaged a New York commercial designer to give the tabloid an original physical makeup that suited her vision that the paper would rely primarily on home delivery rather than newsstand sales. The first issue appeared September 3, the day after Labor Day, 1940, with the headline U.S. GIVES BRITISH 50 WARSHIPS. The lead story was about the destroyers-for-bases deal that marked another step in the progress toward American intervention in World War II. The press run was thirty thousand copies, with a third to subscribers and the rest for newsstand distribution. Only half the copies circulated were actually paid for.

In its early months the paper deserved no journalism awards. It was full of typos and its tone often seemed amateurish. Joe Patterson refused

*Actually the name was thought up by Mapel, but the paper found a contestant who came close to that and awarded him the $1,000 prize.

his daughter's request to run some of the popular *Daily News* comic strips, and her own original replacements were puerile. In part the tabloid's problems were physical. The rented plant, a renovated automobile showroom, was cramped; Alicia herself had to work in a tiny office. Many of the other difficulties were war-generated. No sooner did one of the young male journalists learn his job than he was likely to be drafted into military service. Yet the paper had its strengths, mostly owing to Alicia herself. Harry owned the paper and reserved the right to disagree with her editorially. But he generally allowed her to edit it freely.

Alicia was determined to publish a lively, antiestablishment paper like her father's but one geared to the rapidly growing suburban community of Long Island. *Newsday* would cover community news but would avoid the stuffy reticences and pieties of small-town journals. It would not protect local sacred cows. Its advertisements would provide vital information for young suburban parents in the throes of family formation. It would also deal with world events but emphasize their relevance to Long Island readers. In the mid-fifties Alicia described her journal as "a big-city paper that just happens to be published in the suburbs."[50]

Alicia's crusading zeal undoubtedly pumped up the paper's circulation. Unlike her father and her husband, she was a liberal who endorsed regional planning for Nassau County, supported women's rights, animal rights, and, less consistently, civil rights. She also made war on the Long Island political status quo. In the late forties the political leader of Suffolk County, Nassau's eastern neighbor, was W. Kingsland Macy, a rich patrician Republican of relatively liberal tendencies. Macy was an honest man; he did not need to steal. But he was a dictator who ruled with an iron hand. "He was an absolute czar," one *Newsday* reporter declared. "A sparrow couldn't fall and you couldn't have a job without his blessing."[51] Besides his domineering political ways, Macy, himself a Long Island newspaper publisher, treated the new boy on the block with contempt, seeking to discourage Suffolk advertisers from patronizing the paper and refusing to provide it with useful election information.

In 1949 Alicia decided to go after Macy. Under the aggressive leadership of Alan Hathway, Davis's successor as managing editor, *Newsday* launched a campaign to undermine Macy's power. Accusing him of con-

doning illegal gambling in Suffolk County, it goaded the Republican district attorney into an official investigation that ended without indictments but sullied the boss's reputation. In 1950 the paper challenged Macy when he ran for reelection as U.S. representative from Suffolk and part of Nassau. *Newsday* threw its support to Democrat Ernest Greenwood and dredged up information that Macy had sought underhandedly to manipulate his party's choices for governor and U.S. senator to his advantage. At the end of a very dirty, clamorous campaign, Greenwood unexpectedly defeated Macy, ending his reign as Long Island's political kingpin. The crusade against Macy was not a model of impartiality. Hathway was a brawler, and a drunken brawler at that, straight out of *Front Page*, the classic 1930s play about no-holds-barred tabloid journalism. But the campaign was a crowd pleaser that undoubtedly won the paper respect and readers.

Newsday's "causes" were often more worthy than the war against Macy. Alicia despised Senator Joe McCarthy and his brand of anticommunism. Though a dedicated anticommunist herself, she thought McCarthy "a punk," and valiantly attacked him and his "ism" in the paper.[52] On the local front *Newsday*'s most commendable campaign placed it on the side of creating Levittown, the iconic event of post–World War II American suburbia.

More than sixteen million Americans went off to war after December 7, 1941. Unlike Harry, most of them were young and single, and when they returned they married and began to procreate exuberantly. During the war the government had strictly limited new civilian home construction, and after VJ Day the veterans, in their leftover "Ike jackets" and navy peacoats, were forced to move in with relatives or start their housekeeping in surplus Quonset huts and abandoned army barracks.

Tradition-minded commercial builders rushed to fill the vacuum at the high end of the market. But that left millions of ordinary blue-collar and lower-middle-class veterans with no place to live. The crowded cities clearly would not do. There was little open space left in places like New York City, and former GIs were not about to return to the tenements of their parents. The potato fields and truck gardens of Nassau offered cheap, close-in land and seemed the ideal location for veterans' housing.

In early 1947 Arthur Levitt and Sons announced their plans to build two thousand houses on a tract of land at Island Trees in the town of Hempstead, in Nassau County. Using a single standard model, precut lumber, and their own concrete, and employing the assembly-line methods of Detroit, they would keep costs low. These Levitt homes would rent for $60 a month, with an option to buy for under $7,000. One way to contain costs was to forgo basements. The houses would be seated on concrete slabs that incorporated the needed plumbing and heating coils. Alerted to the impending housing crisis by a Port Washington neighbor, Alicia ran a series on postwar housing in *Newsweek* even before the war ended. Now, in May 1947, with its prediction of a major Long Island housing project vindicated, the paper ran the headline on page one: "2,000 $60 Rentals Due in L.I. Project."[53]

The Levitts had not reckoned with the local building codes. The town of Hempstead required basements in all new homes and threatened to block the project. To Hathway this seemed stupid. "We don't want any nonsense to hold up the Island Trees housing project," opined a *Newsday* editorial. "The project is a honey. . . . Maybe it was good enough for Grandpappy to live in a baroque chateau propped up over a hole in the ground, but it is not good enough for us."[54] (Could the chateau reference, if only unconsciously, been to Falaise or Hempstead House?) The paper fired more than one shot. Presumably with Alicia's support, Hathway banged away at the enemies of housing progress and marshaled the pro-Levitt forces for a hearing on changing the town ordinance. The meeting on May 27 was a walkover for the *Newsday* forces. After twenty minutes of testimony, the town council voted unanimously to repeal the restrictive rule. Levittown, and all it implied, could proceed.

In serving the shelter-hungry veterans *Newsday* had also helped itself. Levittown would be a source of much needed housing for the paper's employees. More important, the new community brought thousands of new subscribers to the paper. *Newsday*'s circulation managers practically followed the moving vans to the doorway to sell the new Levittowners subscriptions. *Newsday*'s liveliness obviously boosted its circulation. But the paper was also riding a demographic surge that Levittown was part of. In 1940 Nassau County had 406,000 people. By 1954 it had reached a

million and would soar to 1.3 million by 1960. Suffolk too had ballooned with thousands of new arrivals from the city. *Newsday*'s paid circulation, some sixteen thousand on its first day in September 1940, would reach four hundred thousand in 1964, the year following Alicia's death. In 1968 it had the nineteenth largest circulation in the United States; it was eighth among evening papers.

Favorable demographics do not alone explain the paper's success. *Newsday* was appreciated for its zeal to unmask corruption and nail white collar crooks milking the community. In 1953 the paper went after William C. DeKoning, Sr., a corrupt Long Island labor leader who ruled over the local construction industry and tightly controlled the harness-racing track, Roosevelt Raceway. In a series of articles under Hathway's sponsorship the paper revealed the misdeeds of DeKoning and his henchmen that led to his guilty plea to counts of extortion and grand larceny and sentencing to a year to eighteen months of jailtime. Journalists took note, and in the spring of 1954 the trustees of Columbia University announced that *Newsday* had been awarded the Pulitzer Prize for "meritorious public service." On September 13 Alicia's handsome face graced the cover of *Time* magazine. Inside was a four-page article "Alice in Wonderland," describing her family, her life, and her newspaper career. Harry, to his dismay, was barely mentioned. At a dinner party soon after the accolade, Harry was reported as "absolutely grim and . . . near purple."[55]

AT THE BEGINNING Harry was a silent partner in the running of *Newsday*. His name was listed on the masthead, but he knew little about how a newspaper operated and confined his role to the business side. That generally meant making good on deficits. But as Harry learned the ropes he began to assert himself and push his opinions. During the 1940 presidential race, he and Alicia wrote parallel editorials, he supporting Wendell Willkie and she FDR. In the escalating battle over intervention in the European war, Harry and Alicia agreed on the need for the United States to support Britain and Hitler's enemies. By taking the interventionist side Alicia broke with her father and with cousin Bertie at the *Chicago Tribune*. Harry for his part initially opposed American entrance

into war in Europe. But when "German victory seemed possible or even probable," fearing "enslavement by a German 'master race,'" he changed his mind.[56] He would soon find himself in the painful position of parting company with his good friends Charles and Anne Lindbergh.

LINDBERGH AND HIS WIFE were ardent antiinterventionists and charter members of America First, formed in September 1940 to prevent the United States from entanglement in the ongoing European war. They were also, at some level, anti-Semites. Isolationism by itself did not mandate anti-Semitism but, given Nazi Germany's ferociously anti-Jewish policies, some isolationists saw devious Jews behind the push to intervene on the Allied side. The Lindberghs, moreover, had established suspiciously friendly relations with the Nazi regime. They had visited Nazi Germany in 1936 to inspect recent German achievements in aviation and been courted by Hitler and his fellow Nazis. Lindbergh left Germany impressed by Nazi success in building an air force and convinced that Hitler's evil reputation in the democracies was the fault of "Jewish propaganda in the Jewish owned papers."[57] During a second German visit in 1938, he was awarded the Service Cross of the German Eagle from Hermann Göring, the Nazi air minister, for his contributions to aviation. Anne's enchantment with the Nazis took literary form. In 1940 she wrote a short book, *The Wave of the Future: A Confession of Faith*, condemning the tyranny of the European fascists but warning that there was "no fighting the wave of the future [that is, fascism] any more than as a child you could fight against the giant roller that loomed up ahead of you suddenly."[58] The work offended many opponents of Nazi ideology and triggered a fusillade of criticism.

Jews and alert anti-Nazis had no difficulty detecting the anti-Semitism barely beneath the surface of Charles's and Anne's pro-German views and acts. The two celebrities were widely denounced by Jewish groups and liberals, who demanded, unsuccessfully, that Lindbergh return the Nazi medal. But worse was to come when, in a foreign policy address in Des Moines on September 11, 1941, under the auspices of America First, Charles injected a malignant anti-Semitic note into the passionate isolationist-interventionist debate. Speaking

just three months before Pearl Harbor, Lindbergh blamed three groups for changing America's policy from "neutrality and independence" to "entanglement in European affairs": the British, the Roosevelt administration, and the Jews. He claimed he was speaking "only of war agitators," not of "sincere but misguided men and women." He also declared that he deplored the Nazi abuse of the Jews. "No person with a sense of the dignity of mankind can condone the persecution of the Jewish race in Germany. . . . But no person of honesty and vision," he continued disastrously, "can look on their pro-war policy here today without seeing the dangers involved in such a policy." At this point Lindbergh made a remark that could only be considered by Jews as a veiled threat to their comfort and safety in America. The policy that Jewish groups were defending would be bad both "for us and for them. Instead of agitating for war the Jewish groups in this country should be opposing it in every possible way for they will be the first to feel its consequences."[59]

Lindbergh's public display of anti-Jewish opinions is puzzling on the face of it. He was not an obsessed bigot like the American Nazis of the German-American Bund or the Silver Shirts. He would always deny he was an anti-Semite. At times he expressed admiration for Jews. But beyond this there was his close friendship with Harry and other members of the Guggenheim clan. Some of his "best friends" were indeed Jews. In 1936, well before the Des Moines speech, in a letter to Harry from England where he had gone to live after the tragedy of his baby son's kidnapping and murder, he denied that he favored Nazi racial policies. "There is no need for me to tell you," he wrote, "that I am not in accord with the Jewish situation in Germany." But at this time he professed to be ignorant of its details. He and Anne had not been in Germany long enough "to learn very much in this regard."[60] He excused Nazi anti-Semitism on the grounds that many German Jews were supporters of the communists, the Nazis' sworn enemies. His own remarks about American Jews, he insisted, were no more than the truth: influential Jews in the United States, especially in the media, were an important component of the interventionist bloc. And, of course, he was not entirely wrong. American Jews naturally despised the Nazis and hoped for their destruction. But the Jews were obviously not the only, or even

the most significant element, among the interventionists. Many of the most outspoken interventionists were members of the Anglophilic eastern cultural and business elite or southern bourbons who did not themselves admit Jews to their clubs.

Lindbergh must have understood that the attack on the Jews was reactivating the age-old bigotry he professed to dislike. Indeed, it was useful for the America First cause only if it actually ignited the tinder of anti-Semitism in the United States. Was that his intention? Perhaps he was influenced by his own family tradition. His father, a liberal member of Congress from Minnesota, had harbored the common populist suspicion of Jews as greedy financiers and was willing to express it publicly. In his relations with Harry, Lindbergh apparently avoided "cognitive dissonance" by making distinctions. In his own mind there were "good Jews," presumably like Harry, "along with the others."[61]

And what did Harry think of his friend's views? As we saw, unlike his brother-in-law Roger Straus, he was not an observant Jew with close ties to the Jewish community. He occasionally contributed to Jewish charities and defended Jews when they were disparaged, but Alicia thought him deficient in outrage when such attacks occurred within his own hearing. She was also a firmer supporter of Israel than her Jewish husband, who considered himself an anti-Zionist. As for his precise response to the Nazi attack on the Jews, we know little. Uncle Solomon supported the Jewish boycott of Nazi Germany during the 1930s and refused to travel to Berlin to shop for abstract paintings as he had often done in the past. But while we can assume that Harry felt dismay at the Nazi assault on the Jews, he never specifically spoke out against it.

He himself, his wealth and determined assimilationism notwithstanding, had paid a penalty for his ancestry. He had been kept off the Yale tennis team by an anti-Semitic coach, and that rebuff, as much as the charms of Helen, may have limited his stay in New Haven. He also paid a price through his children. In 1924, for example, he applied for admission of daughters Joan, eleven, and Nancy, nine, to the prestigious Brearley School for girls in New York. They were turned down on the grounds that "the definite quota of Jewish children . . . had been made up for the year."[62] Harry wrote his friend Dwight Morrow, asking if he

could intercede. Morrow tried, but to no avail. When Harry asked Morrow to help get the girls into the still fancier Chapin School, Morrow again obliged, but learned, he said, that "they have a rule against members of the Jewish religion." As he wrote Harry, "I, myself, am getting terribly impatient about these rules, but I am not sure that there is anything more that we can do in that quarter."[63] In the end the girls went to boarding schools, Nancy to the Santa Barbara Girls' School in California, where Harry had a summer home, and Joan to an academy on Long Island. Another parent might have been driven closer to his faith by this experience. Harry was not. Despite two Jewish parents, the girls were brought up as Christians.

All told then, he was probably not as offended by Lindbergh's attack as someone more closely identified with his religious origins. When his nephew Roger Straus asked him directly what he thought of Lindbergh's apparent pro-Nazi sympathies, Harry took refuge in the claim that Lindbergh and Anne were politically naive. He also, apparently, believed Lindbergh's denials that he harbored any anti-Jewish feelings. Roger concluded that Harry was anxious to deceive himself. His friendship with the Lindberghs was simply too important to him.

The clash over American neutrality created a hiatus in the Guggenheim-Lindbergh association during the war. But after wartime passions were past, Harry was eager to resume the relationship with Charles and Anne. In 1954 he proudly presented to Lindbergh the aviation medal sponsored by his father. By 1960 Harry was defending his friends' views as misconstrued. In an April 1960 memo to Alicia, he quoted a paragraph from Anne's *Wave of the Future* and noted that it had been taken out of context. It was the same "misunderstanding of statements that Lindbergh made that brought about his characterization as an anti-Semite."[64] The next day, in a letter to Anne herself, he praised the work as a "profound and philosophical book." It could properly be read now only as a "deep desire" to "not become involved in a devastating war."[65]

The friendship reestablished after World War II would remain firm and valuable. In fact Lindbergh and Harry would find new interests in common, and the two men in their later years would influence each other's thinking about peace and war and human nature.

* * *

HARRY WAS PROUD of his wife's success at *Newsday*. Yet the paper was also a source of friction between them. In the early years he usually restricted his role to monitoring the paper's finances. Here he served as a conservative check on Alicia's financial extravagances, or what he perceived as her extravagances. Alicia resented her dependence on Harry's fortune and when she inherited some money after her father died, she sought to change their financial arrangements for the paper. Her original stake in *Newsday* was a minimal $4,000 derived from Harry's outright gift. Now she wanted a substantial share of ownership. Harry agreed to sell her a share based on an assessment of the paper's market value for $80,000, but not more than 49 percent, a minority interest. He also insisted on deducting more than $3,500 from her existing stake to offset losses incurred in the lean years.

Alicia accepted the deal but did not like it one bit. According to Harry's nephew Oscar Straus, "the way Alicia saw it, she was actually running *Newsday*, and she deserved to have majority ownership as well."[66] Alicia wanted the extra 2 percent that would make her majority owner, and she constantly badgered Harry to give it to her. In at least one of his many wills Harry agreed that at his death she would receive the controlling 2 percent. But while she was alive he never yielded and, according to Dody Michelson, the frustration "just ate into her."[67]

Harry and Alicia also clashed over the paper's personnel. Harry disliked Mapel, the paper's first general manager, whom he considered a spendthrift. Despite Alicia's support, Mapel was forced out and succeeded by Henry Page and a succession of others, each of whom incurred Harry's wrath and became centers of personal storms between husband and wife. As one of the former managing editors ruefully told a colleague: "Don't ever let yourself be caught between a woman and a man in business."[68]

The business wrangles spilled over into Harry and Alicia's domestic life. Harry disliked the way Alicia managed her personal financial affairs and tried to rein in her household expenditures. She in turn sabotaged his personal comfort in small but telling ways. At Falaise she slept in a separate bedroom that she decorated in feminine pastels as if to protest

the mansion's somber medieval walnut and brown decor. After a fight with Harry over her 2 percent ownership deficit, Alicia decided to visit her sister in Wyoming just when Harry planned a big summer dinner party at Falaise. He was forced to muddle through the party without a hostess while trying to explain to his guests where his wife was, although he did not know himself. Alicia disliked the way Harry segregated guests by gender after dinner, leaving her with the ladies to chitchat. She retaliated by surrounding herself with female friends who ridiculed Harry, she enthusiastically joining in.

The most discordant note in the marriage, however, was the battle over politics. Harry was opposed to Franklin Roosevelt and the New Deal. He had enthusiastically supported Alfred Landon against FDR in 1936. In 1940, as noted, Alicia and Harry split between FDR and Willkie in the presidential race and wrote side-by-side editorial columns supporting their respective candidates. In 1948 Alicia endorsed the Republican, Tom Dewey, for president in his race against Harry Truman, whom Alicia despised. Harry had no reason to argue with her in this case. But then came the candidacy of Adlai Stevenson in 1952. This became a highly charged dispute, for Alicia and Adlai had started an affair in the fall of 1947 and remained lovers on and off until Alicia's death.

At first there had been a strong sexual attraction between Harry and Alicia. Leo Gottlieb, Harry's lawyer, told journalist Robert Keeler that the passion continued to the end. But there is evidence that it quickly ebbed. The marriage, it seems, was what a later generation would call "open." Dody Michelson believed that Alicia and Harry "had a very useful arrangement" and "did not question each other on what went on when they were not together."[69] We know that Harry had "girl friends."* Alicia, for her part, continued to see Brooks, her former husband, after she married, and took at least one lover, a newsman at another paper. According to Bill Moyers, who would become *Newsday*'s editor after Alicia's death, Harry always considered her more a business partner than a wife.

*One was a Miss "Sullivan," a WAVE whom Harry apparently met while he was commandant at Mercer Field during the war.

However frequent her other dalliances, Adlai was the love of her life. She and Stevenson both came from prominent Illinois families, meeting when they were scarcely older than teenagers. They had fallen in love during the 1920s, but both had married others and gone their separate ways. Just after World War II Stevenson, a lawyer, was appointed by Truman as adviser to the newly established United Nations and came to New York to live. In the winter of 1946–47, while he was still married to Ellen Borden, he and Alicia renewed their friendship and began a sexual relationship. Passionate at first, it became attenuated and occasional as the years passed and circumstances kept them apart geographically.

In 1948 Stevenson, soon to be a divorced man, was elected governor of Illinois. In 1952 he became, reluctantly he said, a front runner for the Democratic nomination for president. In the contest for the Republican nomination Alicia had supported Ike against Senator Robert Taft, leader of the party's conservative wing. When Ike edged out Taft, she felt honor-bound to endorse him for president even though her paramour, Adlai, in fact became the Democratic nominee. *Newsday* was strangely confused and inconsistent during the campaign. It criticized Stevenson for his attack on the Taft-Hartley Act and Ike for not dumping running mate Richard Nixon when he admitted taking money from California businessmen for personal expenses. Unlike Alicia, Harry had no trouble sorting out his preferences in 1952. In September Alicia hosted a dinner in Stevenson's honor for publishers and media magnates at the posh Manhattan River Club. Harry did not attend but he sent a telegram that Alicia mischievously read aloud to the guests. "Tell Adlai how sorry I am not to be able to dine with him. I would like to dine with him anywhere— even in the White House—if we are both guests of Ike."[70] In the end the paper endorsed Eisenhower but unrealistically advised that the winner appoint his defeated opponent to high office in his administration.

Alicia was in the hospital during part of the 1952 campaign, having her uterus and a portion of her cancerous colon removed. She feared dying and wrote Stevenson mournfully of her expected demise. She returned his "beautiful" letters to him, telling him she hoped he would give them to the Illinois Historical Society to be opened "a hundred years hence when all your family will have died."[71] Stevenson lost to Ike

that November. The Republican candidate carried both Nassau and Suffolk, but a divided *Newsday* could have had little to do with the result.

Did Alicia's affair with Stevenson threaten her marriage, "open" though it was? The affair with Stevenson was different from the others; Alicia truly loved him. The relationship obviously affected her willingness to remain with Harry. Several times she seriously considered divorcing him. Once, in 1957, while Alicia was off on safari in Africa with Adlai and a party of friends, lawyers from both sides were brought into play to see if they could settle the differences between them. Harry made it clear that if she did leave him, he would oust her from *Newsday*. There were other flaws in the relationship besides her love of another man, but surely that was a part of it. She told Adlai about her marital problems, perhaps expecting him to jump at the chance of marrying her since he himself was legally free. Stevenson reared back as if touched with a hot poker. "Certainly to seek divorce impetuously would be . . . a great mistake," he responded. "I should think it would be a last recourse." Three marriages were "quite a lot even for a brave free spirit!" he noted. "And then there's your child to think about—Newsday."[72]

Did Harry know of the affair? According to his nephew, Roger Straus, Jr., he probably did. Alicia's good friend Marietta Tree, the beautiful blue blood, who herself became Stevenson's lover, was also convinced he knew and certain that it was a source of friction between him and Alicia. When Alicia was on her deathbed in 1963, Harry refused to allow Stevenson to visit her in the hospital and then excluded him from the funeral when she died. Shortly after her death, moreover, he reportedly found one of Stevenson's letters to his wife in her desk and became very angry. Yet he did not break relations with Stevenson. In 1965 he asked Stevenson, now America's chief delegate to the United Nations, to write a column for *Newsday*. Stevenson declined, but in any case the matter soon became moot. Stevenson himself died of a heart attack just a few months later.

ALICIA PASSED AWAY in July 1963. Her 1952 surgery had averted a medical crisis, but by the spring of 1963 she began to feel intestinal distress again. A heavy drinker, whom Harry could not restrain, she had long

abused her gut. In late June she suddenly vomited blood and was hauled off to Doctors Hospital by her devoted secretary, Dorothy Holdsworth. She was diagnosed with a bleeding ulcer, and the doctors stabilized her condition by a combination of blood transfusions and intravenous feeding. Alicia was told she could hold the illness at bay either by drastic changes in her diet and drinking habits or by an operation. Never one to surrender fleshly delights, she opted for the operation. On July 1 the surgeons removed half her stomach and sewed her up. But the bleeding continued, and she was operated on a second time and then a third in a matter of a few hours. Nothing stopped the bleeding, and Alicia died near midnight on July 2.

However rocky the marriage, Harry, according to Dot Holdsworth, was "shattered" by Alicia's death. When she and Bill Woestendiek, a close associate of Alicia's at the paper, visited him just hours after her death, he "looked very pale." Josephine Patterson, Alicia's sister, remembered that Harry seemed unable to cope. Dana Draper came that same evening to Harry's townhouse to comfort his grandfather. He recalled Harry murmuring: "That wasn't supposed to happen. I was supposed to die first."[73] Letters of condolence poured in to Harry, conveying the senders' grief and dismay. One of the most touching was the note from Slim. Lindbergh had heard of Alicia's death from Harry's private secretary, George Fountaine, while he was in France. The news "came as a tremendous shock" to him and Anne, he wrote. "I have known you for so long and Alicia now for so many years, that it seems to me almost a loss in my own family. I wake at night thinking of you and her, and I cannot accustom myself to the fact that she is no longer here with us—at least in the sense of the past."[74]

Eight hundred people attended Alicia's obsequies at the Garden City Episcopal Cathedral. Besides family and *Newsday* associates, the mourners included distinguished journalists, editors, and publishers. President Kennedy sent a telegram of condolence, as did Governor Nelson Rockefeller and W. Averell Harriman. Adlai Stevenson also sent a message. There were many tears, especially after the organ pealed out the triumphant "Battle Hymn of the Republic." The day before the funeral, while on the terrace at Falaise, Harry read to Joe and Alice Albright a let-

ter from their aunt asking, if she predeceased him, to give them "a chance," presumably at *Newsday*. Alice politely declined to compete with her brother.[75] Some months later Alicia's ashes were buried under a live oak at her beloved Kingsland lodge in south Georgia.

With Alicia gone Harry faced the daunting prospect of running a daily newspaper by himself. He did not feel comfortable. In the words of Robert Keeler, "the rhythms and traditions of editing a newspaper were foreign . . . to him."[76] Harry was a literate man who had written many articles and several books, but he had none of the demotic flair that popular journalism required. Fortunately, as overall editor, he did not have to write very much. But he also lacked the feel for the good story that Alicia possessed in abundance. He knew his failings and quickly turned to others for help. Soon after Alicia's death he appointed her nephew, Joseph Medill Patterson Albright, a diffident young man with journalism in his genes, as his assistant. His first surrogate for Alicia as editor was an old Kentucky friend, Mark Ethridge, the editor and publisher of the prestigious *Louisville Courier-Journal* who in 1963 was sixty-seven and on the verge of retirement after a distinguished career in journalism and public service. Though he was a liberal Democrat who had served as adviser to both Roosevelt and Truman, he was of Harry's generation, and Harry considered him a man of parts and worthy of trust.

Ethridge was a stopgap for *Newsday*. His presence reassured the staff and provided a sense of stability. He also served as a restraint on Harry's impulses regarding editorial content and personnel and provided a useful bridge between the Alicia era and the time when Harry became more confident of his own journalistic prowess. Joe Albright later said that Ethridge "made an incredible difference in keeping Guggenheim from doing dumb things."[77] Ethridge also encouraged Albright to act more aggressively, to make a stronger play to succeed him as head of the paper. In May 1965 Ethridge quit as editor, retiring from active journalism to teach the subject at the University of North Carolina. Harry concluded that by observing his friend he had learned enough to take on the overall editorship of the paper himself.

As editor Harry, of course, was more conservative politically than Alicia. He had endorsed Nixon in 1960, and she favored Kennedy. In late

October they published opposing presidential endorsements in the paper. Like many Republican businessmen, Harry repudiated Goldwater in 1964 as an extremist, but he endorsed Nixon again in 1968. This time his liberal new editor Bill Moyers played Alicia's part of disagreeing in print with *Newsday*'s majority owner.

Harry also found himself out of step with many liberals, including colleagues at the paper, over Castro's Cuba. He knew Cuba firsthand and felt he had the right, indeed the responsibility, to judge the regime that had seized power from Fulgencio Batista, Machado's successor, in early 1959. It came as no surprise that he despised Castro. The bearded young rebel's image as a Robin Hood was a fraud, Harry insisted. In fact Fidel was an outright communist with the worst authoritarian inclinations of the far left. His takeover of Cuba was not a victory for the people but for radical ideologues and self-seekers. Though Cuba was potentially a rich country, Castro had "dissipated the wealth, accumulated over the centuries, of one of the most beautiful, rich and one-time peaceful and happy sunbaked lands in the world. . . . American reformers," he feared "will exult" in Castro's destruction of capitalism, but his regime would only bring the "degradation of human beings."[78]

Harry did not trust the Kennedy administration to deal effectively with Castro. Writing to his friend Gardner "Mike" Cowles, the midwestern press magnate, he denounced the "offenses of Castro against all human rights—as well as property rights." Unfortunately, "from the past record of this Administration," he had come to mistrust "the advice of his [Kennedy's] counselors. . . . In a world struggle in which we are pitted against the atheistic Sino-Russian Alliance, with its ruthless doctrine of strength, force, and guile, the President's advisers, I fear would resort to moral suasion and accept the Russian double standard interpretation of Colonialism."[79] The reference to "counselors" almost certainly included Adlai Stevenson, now serving Kennedy as U.S. ambassador to the United Nations.

Harry felt strongly enough about the Castro regime and the failings of American policy in Latin America generally to seek an interview with the president. Although the publisher had opposed his election in 1960, JFK agreed to meet with him in September 1963. Harry tried to make

the best of it. After some chitchat about the parlous condition of the president's paralyzed father, Joe Kennedy, JFK dutifully asked Harry about Latin America. Harry responded that he thought that the United States "had suffered in [its] diplomacy in Latin America from the practice of sentimentality and meddlesomeness." Kennedy objected to the accusation. They then discussed the views of economist Barbara Ward that rich governments would have to donate capital to poor nations if they were ever to rise out of poverty. Harry objected that the taxpayers in the rich nations would not stand for such sacrifices. He made his pitch for the way, as he saw it, the Guggenheims had helped make undeveloped countries richer: The only true way that poor nations could acquire capital was through private foreign investment.[80]

As the Vietnam War racheted up, Harry, still deeply respectful of the military, pushed the paper into supporting the Johnson administration's aggressive policies in Southeast Asia. In March 1965, soon after LBJ launched the Rolling Thunder bombing campaign against North Vietnam, he wrote an editorial for *Newsday* applauding the president's action. At one point he told a colleague, "if the president of the United States says we're going to win, we're going to win."[81] In 1965, as Vietnam became a contentious issue among the young following Johnson's order to bomb North Vietnam, Harry found himself entangled in a dialog with his own grandson over American policy in Southeast Asia. In May George Draper, Jr., now a senior at the University of Oregon, wrote "Skipper" that while it was difficult to get a clear picture about Vietnam, he felt that if the United States continued to bomb the North, the war would "escalate into a major war and perhaps a nuclear war." The United States should negotiate a peace. It should stop the bombing and embrace the 1954 Geneva Accords calling for free elections. The United States should accept "what ever government the people prefer."[82] Harry quickly responded. He was sure that the president would be "delighted" with George's solution if it were possible. As for negotiations, he repeated the formula that President Johnson had used during a personal meeting with Harry in the Oval Office just a few weeks before: there simply was no one with authority on the enemy side to negotiate with. But in any case, it was because the

other side had violated the Geneva agreements in the first place that "we are now in Vietnam."[83]

Yet Harry was no troglodyte. He tried to make sense of the turmoil and ferment of the late sixties but his social views were a jarring mixture of Tory and liberal. He worried about the sharp contrast between rich and poor in America and deplored the persistence of poverty-stricken ghettos "in the midst of our excessively rich nation." These "have existed far too long." He quickly reverted, however, to the standard views of successful older Americans faced with an insurgent generation. Youth in America were spoiled, he harrumphed. "The children have no chores to do at home and are not, as in the past, out to some useful work." Because of lack of indoctrination in "the everlasting verities," the "new generation" was falling "prey to the demogoguery of student agitators." Harry was certain the nation was experiencing a new reign of selfishness. People wanted benefits without having to pay for them. The average citizen demanded "all of the good things of life . . . , but at the minimum of sacrifice by the individual. . . . The spirit of sacrifice for the common good is absent."[84]

In his quest for answers, especially to the Vietnam puzzle, Harry began to question the origins of human conflict and ask why men resorted to violence and war to settle their differences. The issue would dominate his thoughts to the end of his life and leave a lasting residue in the shape of Harry's own "foundation."

HARRY WAS SEVENTY-FIVE when Ethridge quit. Though he tried to be his own editor-in-chief, he began to look ahead to when he would no longer be able to run *Newsday* editorially. At first he placed his hopes for a successor in Alicia's nephew, Joe Albright, the slight, baby-faced young man, married to a dark-haired young Czech-born Wellesley graduate named Madeleine Korbel.* Alicia had always regarded Joe as her surrogate son, taking him fishing and hunting with her at her Georgia estate. When he was only fourteen she would refer to him as her "heir apparent" at *Newsday*.[85] In 1961 she summoned Joe to Long Island to begin an

*They would be divorced in 1982.

apprenticeship with the paper. After a year's training Joe went to Washington to work in *Newsday*'s capital bureau. With Alicia's death Harry brought Joe back to Long Island, naming him "assistant to the publisher." But prospects that Joe was the right man as successor dimmed as Harry concluded that he was a mediocre journalist, deficient in judgment—over Castro, for example—and lacking decisiveness. Madeleine would later blame the absence of mentoring, in part, for Joe's failure. The rest was the difficult relationship with Harry. He "needed to impress uncle Harry but not irritate him," she later wrote. "It was, in the end, an impossible balance to maintain."[86] When Joe's mediocre performance became apparent, Harry shipped him out to remote Suffolk County as the local editor and turned to his grandson Dana Draper. Dana would, perhaps, still be able to fulfill Harry's dynastic yearnings.

For a time the plan seemed viable. Harry, of course, had been grooming his grandson for family leadership for some years. In the summers of 1954 and 1955 he found work for Dana at Cain Hoy as a cowpoke and general workabout. Dana liked the job but dismayed his grandfather when he turned up at a quail hunt with a camera instead of a shotgun. As we saw, the following year Harry sent him to Chile, where he had managed to avoid learning anything about Anglo-Lautaro's technical operations. Dana joined the army in 1959, to avoid being drafted, without attending a four-year college. Discharged in 1962, he came to New York and entered Columbia University's summer session. With George Fountaine closely monitoring his progress, he made good grades, and Harry got him admitted to full-time status at Columbia. Receiving partial credit from his junior college, he graduated in 1964 with a B.A. in anthropology. Dana's academic success restored Harry's faith in the young man. In June 1964 he established a trust fund for Dana that yielded about $30,000 a year and bought him a Porsche automobile. He also made him a trustee of the Daniel and Florence Guggenheim Foundation, the Solomon Guggenheim Foundation, and his own Harry Frank Guggenheim Foundation.

And yet Dana never became Harry's model young man. Doe-eyed, full-bearded, light brown hair brushing his shoulders, wearing jeans and a bandana around his neck, he was gentle and laid back, a proto-hippie

whose style and views his grandfather could not be expected to admire. For his part, Dana found his grandfather intimidating. As he told Robert Keeler, "Through all of this teaching I was getting when I was younger, his power and you know here he is God, the guy . . . he wants somebody to carry on and I'm the only male around that has possible potential and you think Jesus what are your grades like?"[87] Torn between his mother and his grandfather, he was not a focused, decisive young man.

In early 1965 Dana married a Barnard College student, Marilyn Kirschner. Born in Queens, daughter of a plumber, Marilyn was idealistic, liberal, and unconventional herself. George Fountaine considered her a socialist, and Harry feared that if she acquired any money through the family she would give it all away. Like many other Seven Sisters students in the mid-1960s she opposed the U.S. involvement in Vietnam and would argue with Harry over the issue. Neither of the two young people fit Harry's specifications, but he initially worked hard to keep on friendly terms with both. He invited the newlyweds often to Cain Hoy and Falaise, paid their expenses for a long European trip in 1966, and, as his own father had done for him, promised to build them a house at Falaise and furnish it for them. Having lived in apartments all her life, Marilyn's first response was "how nice."[88]

By this time Harry had clearly concluded that he might trust Dana to carry the family banner. In September 1965 he wrote his grandson laying before him the spacious destiny he envisioned for him. In his will and in memos to his executors and trustees he had made provision, he said, for Dana, "or some other member of the family" to "carry on the family tradition in the constructive use of funds available to them." He reviewed for Dana the family's long road from Lengnau, Switzerland, and the great contributions it had made to humanity: developing "the natural resources of the world," pioneering in "the air age and the rocket age," and, "through both their business activities and their philanthropies in education and art, [benefiting] the United States and the Western Hemisphere and mankind in general." Any person who succeeded to this legacy must have "character, integrity, a capacity for leadership, an urge to work and a determination to succeed." But for "such qualities to result in the greatest accomplishment" it was necessary for him "to have avail-

able adequate financial resources." He admitted that inherited wealth could "lead to a parasitic life," but it could "also be the means of constructive work on behalf of humanity and the greatest ultimate happiness to the legatee."

Harry went on to note that he had provided for all of his "immediate family" through his will or through trusts. None of his children "should ever be in want and should be able to live in luxury." As for Dana, he now believed that he "will prove to be intelligent and industrious and a worthy successor to the Guggenheims who are responsible for the family tradition." He went on to observe that he had already made his twenty-five-year-old grandson trustee of three family foundations. He noted approvingly that Dana had also begun "to show real interest" in the timber and cattle operations at Cain Hoy. But Harry at this point also expressed his uncertainties. "I cannot be sure at the present time that you will be interested in other matters such as Newsday and the mining ventures of Guggenheim Brothers." Nor was he sure that Dana would be willing to live in the New York area. And yet unless he did, "it would be impossible" for him to meet his obligations.[89]

Soon after, Harry wrote a memo to his "executors and trustees" making clear the contingency of his benevolence. He had arranged his affairs, he told them, so that "a substantial amount of income and very large amount of principal may be placed in the hands of my grandson." But this would be only "if he should develop interests and aptitudes and be so situated in his career and in his life generally that he would be in a position to carry on the Guggenheim family tradition in the business world and in the field of philanthropy."[90]

Harry continued to bombard his grandson with his own vision of his future family role. Later in 1966 he wrote Dana again on the subject. "I have had one great hope that the good Lord has granted me. I wanted to see you prepared by education and talents so that you could continue to build on the works that generations before you made for the progress of mankind, if you had the ambition and desire to do so." He had begun, he continued, to see in him and his "devoted wife . . . indications that with your education and talents and opportunities you will lead such a life."[91]

Harry was doomed to profound disappointment. Dana's personality

was artistic, not practical. He had already told his grandfather bluntly that he was not interested in Guggenheim Brothers and "the money-making business." But at the same time he acknowledged that he *was* attracted by *Newsday*.[92] This apparently was enough for Harry, and he sent Dana to William McIlwain, the paper's managing editor, for an interview. McIlwain gave Dana a literacy test, which he failed. McIlwain was not deterred. If he were a guy off the street he would be rejected, he told Dana. But he was a Guggenheim, "so you're in."[93] Dana began work at *Newsday* in October 1966. The campaign to make Dana the heir was a failure. Dana and Marilyn took up temporary residence at one of the gate-houses at Falaise, and Dana set to work under the tutelage of McIlwain, pursuing breaking stories and writing them up. Unfortunately, he felt overwhelmed by the job. He had no confidence, he later admitted, in his "communication skills."[94] None of his pieces was published. Dana was obviously unsuited for journalism, but perhaps, as George Fountaine believed, he was also being pushed too hard by the *Newsday* staff as a test. Dana's unhappy experience at *Newsday* was also colored by the question of where the couple would live. The Falaise grounds, they knew, could not be their permanent home; he and Marilyn would have to move from the city to Long Island if he expected to remain at *Newsday*. In November, after working for the paper for all of seven weeks, Dana told his grandfather that he was quitting. He left in mid-December.

Harry blew up when he heard his grandson's decision. "I have ever tried to convince you—but I failed," he wrote, "that all the preparation that I had attempted to give you was not in my interest, but in yours so that you would lead a full, fruitful and dedicated life to your fellow man in our family tradition." That tradition would be "carried on by those who consider it a privilege and a rare opportunity and not merely an obligation or for one's special benefit." He hoped "with greater matu-rity" Dana would "come to that conclusion and find some way to retrieve the opportunity" he had "discarded." Harry not only scolded Dana; he also retaliated. He intended to throw Dana off the foundations, he wrote him (though in fact he never did).[95] Harry's words—and deeds—were explicit: Dana had failed as his grandfather's successor. Strangely, Dana

later professed not to understand the significance of his rejection. "Looking back on it now," he later told Keeler in his fuzzy discourse, "what I realize is that he definitely had this interest [in my succeeding him] all along in a way I had no positive sense of it. Any creative sense of it."[96]

After leaving *Newsday* Dana took a stopgap job as a social worker in New York before settling into a career as a photographer and sculptor. Though he seldom saw his grandfather again face-to-face, he did not immediately sever relations with him. In December he wrote to thank Harry for giving him the opportunity to work at *Newsday*. After a year or so Dana began classes at the Art Students' League in Manhattan and then took a master's degree in art education. He joined a small group of artists interested in sculpture and the environment called SITE, helping with models and preparing grant proposals, while Marilyn worked for a publisher of children's books. During Harry's last year Dana sought to contact his grandfather to tell of his accomplishments with SITE. Harry apparently did not reply.

In the early 1970s, after his mother died and left him some money, Dana returned to California, where he and Marilyn settled in the Bay Area. Dana continued to practice his art—painting, drawing, sculpture— exploring various techniques and media and teaching art to teenagers at the YWCA. Marilyn and he were divorced in the mid-1970s after having a son, Brian. Ten years later Dana remarried. His second wife, Ingrid, is a graduate of the Rhode Island School of Design. Today they are partners in a business that designs handmade silk scarves and ties and markets them to museum shops and university libraries. Brian, thirty-one in 2004, is a bartender and a tournament backgammon player. Dana and his brother George both live in the San Francisco area and see each other frequently.

HARRY WAS NOW back at the starting line in his quest for a successor. It was a measure of his desperation that this time he went outside the family. The move would prove to be as unsuccessful and exasperating as the others.

Harry's improbable choice was Billy Don Moyers, Lyndon Johnson's

press secretary and adviser on domestic affairs. Raised in East Texas, an ordained Baptist minister, the idealistic young Moyers had linked up with Johnson during the tall Texas senator's abortive run in 1960 for the Democratic presidential nomination. He had helped in the ensuing Kennedy-Johnson campaign that year. Soon after the election, Vice President Johnson secured him a spot on the new Peace Corps under Sargent Shriver, Kennedy's brother-in-law. When JFK died in Dallas, Bill Moyers came to the White House to serve as aide to his successor. For the next few years the owlish, baby-faced Moyers worked closely with Johnson and his advisers to design and enact the Great Society, the greatest burst of liberal programs since the New Deal. Moyers had taken courses in journalism and worked on a Texas daily newspaper. In 1965 Johnson asked the thirty-one-year-old "Billy Don" to become his press secretary to succeed George Reedy.

The job was stressful. As the Vietnam entanglement transmogrified into full-scale war, Moyers found himself increasingly at odds with his chief. From the outset Johnson had feared a U.S. impasse in Vietnam, but his memories of Munich and World War II and his own internal demons dragged him inexorably into the mess. By late 1965 more than a hundred thousand American troops were fighting Vietcong guerrillas and North Vietnam regulars south of the DMZ. In public Moyers defended LBJ, as befitted a press secretary, but within the White House he tried to dampen the hawkish urges in the administration. He also fought for a tax increase to weaken the inflationary thrust of unbalanced war budgets. That too annoyed the president and created strains between him and his protégé.

By mid-1966 Moyers was ready to leave the Johnson administration and was shopping around for another career. Meanwhile, Harry too was shopping, in fact had been shopping even before Dana quit, for a successor. It may seem strange that this true-blue Republican should turn to a fervent liberal Democrat like Moyers. But we must remember that in 1964 Harry had supported Lyndon Johnson for president against Goldwater, and Moyers was part of LBJ's administration. Harry was also ignorant, apparently, of how deep Moyers's liberalism went. What he saw was a brilliant young man with broad journalistic experience who

had been immersed in national affairs at a critical moment of time. For his part, Moyers knew, from long practice, how to charm an older powerful man. He had, of course, done so successfully for years in Washington.

When, in the summer, at Washington's Metropolitan Club, Harry first approached Moyers to consider coming to *Newsday*, the White House press secretary had laughed incredulously at the proposal. "Captain," Moyers responded, "I know about your editorial policies, and I'm on the other side of the fence philosophically."[97] He said no to Harry's overtures. Besides his ideological doubts, Moyers was not yet ready to leave public service. But after his brother committed suicide in September 1966 he began to rethink Harry's offer. He had now become the chief support of James Moyers's family and could not manage the finances of two households on his government salary. He called Harry to say he had changed his mind, and the two had further discussions. Harry talked expansively about Moyers succeeding him but proposed for him now only the title of associate publisher. Moyers replied that he would be only "half a man in that role." It was full publisher or nothing.[98] Several days later Harry came back to him. *He* would be president and editor-in-chief, the man who would write the editorials. *Moyers* could be publisher under a five-year contract. In some large corner of his mind, surely, Harry was seeking more than a manager of his paper, however. He was also hunting once more for a surrogate son. Moyers did not share his blood but, for want of better, Harry was willing to consider Billy Don a substitute. As Dorothea Straus later put it, he hoped that Moyers would be "the son he never had, the anointed successor."[99]

The official announcement of Moyers's appointment came just as Dana left the paper in December. The former White House press secretary took over in mid-February 1967. By this time Harry had fired Hathway, whom he thought unsuited to work under Moyers. Moyers's appointment also pushed Joe Albright off the fast track of advancement, though Albright, as one of Alicia's heirs, remained a substantial part owner of the paper. As for Harry, he was initially well pleased with his protégé. He paid Moyers a generous salary, twice what he got at the

White House, and also allowed him to live rent-free in a Garden City house, newly purchased by *Newsday*.

Moyers had big plans for *Newsday*. He liked and respected the paper's veteran reporters and editors. They were able, full of juice, and enjoyed their work. But the paper was too parochial even in its vision of Long Island, he felt. He wanted to upgrade the Albany and Washington bureaus, add columns, put on new writers, and do a better job of covering Vietnam. He especially wanted to improve the paper's editorial page. He told Harry that he would have to spend a million dollars in three years to achieve these goals. Harry gave him the signal to proceed.

Generally speaking, Moyers inspired confidence in the staff. Many believed him capable, as he intended, of converting the paper from a regional voice into a respected national rostrum. But some senior editors saw him as an outsider who threatened to ignore the paper's traditions and customary practices. Particularly skeptical of Moyers was Al Marlens, the perfectionist, hard-driving managing editor. Marlens considered Moyers an opportunist who intended to use *Newsday* as a launching pad for a political career. Still, with the passing months, Moyers was able to imprint his policies and personality on the paper's character.

In his quest for national respect Moyers hired celebrities like Saul Bellow, Daniel Moynihan, Bayard Rustin, and Arthur Schlesinger, Jr., to write articles for the paper. Under Harry's aegis *Newsday* had already established a connection with Nobel Prize novelist John Steinbeck. Moyers tried, unsuccessfully, to get Steinbeck, now a conservative, to write a series of articles for the paper on the American scene. He hired Pete Hamill, a scrappy columnist for the *New York Post* in the tradition of Damon Runyon, to do a regular column from Washington.

Moyers, as we noted, was a dove on Vietnam, and many of *Newsday*'s reporters, columnists, and editors agreed with him. Eventually even Harry conceded that the war was a mistake, but he continued to support the American presence in Vietnam on the grounds, essentially frivolous, that it was a useful place to test American military hardware. The disagreement over what had become by the late 1960s the most powerful divisive issue in America roiled the waters at *Newsday* and eroded Harry's relationship with his protégé.

So did Richard Nixon. In the critical 1968 presidential contest Moyers supported Hubert Humphrey, the quintessential Democratic liberal. Harry knew and respected Nixon. In a memo to Harry, Moyers acknowledged that the paper's endorsement must be Harry's decision. But he warned that the Republican Party of Nixon was "philosophically and impulsively reactionary toward the crises we shall inevitably be enduring." Referring to his own role in helping to create the Great Society, he conceded that Nixon was experienced and intelligent. But his principles and Moyers's own were "so incompatible" that for him to support the Republican nominee "would be to negate those programs and ideas for which I have worked and in which I have believed."[100] In the end Harry endorsed Nixon in a signed editorial in October while the same issue carried a statement by Moyers that *he* endorsed Humphrey because "of his deep and sustained commitment to justice for the poor and the black [and] because he realizes that ending the war in Vietnam must be the first task of the new president."[101]

Though Harry was willing to tolerate such a divided voice between Alicia and himself, he was unhappy over the disagreements with Moyers. Worse was to come. In November, on the evening of the election itself, the paper's major editors gathered in Harry's office to listen to the returns as they came in. When it became clear that the Republican candidate had won, Harry, seeking to validate his pro-Nixon stand, observed enthusiastically that Nixon was now president of all Americans. At this an unidentified voice piped up: "He's not my President." For some reason Harry considered this remark more disloyal than Moyers's disagreements with him and the next day wrote a memo to his protégé. "I am sure you will find a way to free Newsday from the clutches of propagandists and polemicists who are so deeply prejudiced that they cannot see what is right for their country." Angry at this attempt to squelch free expression, Moyers responded with a threat. "[T]o be truly independent," *Newsday* must be "free to criticize as well as praise the new President." If Harry did not agree, he had "the right to obtain a publisher who put out the kind of paper" that suited him. But if he wanted "a paper that hews to an undeviating line on any President," he, Moyers, "shouldn't be running it."[102]

In the short run this blowup over Nixon seems not to have extinguished Harry's paternal feelings toward Moyers. Soon after, he revised his will giving Moyers a quarter share of Guggenheim Exploration Company, with other quarters going to John Peeples, a vice president at *Newsday* and a former associate in the Guggenheim Brothers firm; to daughter Joan and her husband; and to his cousin once removed, Peter Lawson-Johnston.* In December he formally selected Moyers as vice president of the *Newsday* company and designated him as the person who would assume his place on the paper if Harry died or became disabled.

But more tensions between publisher and owner were soon to come. One was over a parody of the current crop of raunchy best-selling novels by Jacqueline Susann and Harold Robbins, assembled by a group of *Newsday* editors and reporters. *Naked Came the Stranger*, each chapter written by a different anonymous journalist, appeared in the summer of 1969. To its creators' delight it became an instant best-seller. When the authors of the spoof became known, the straitlaced Harry was appalled. He considered the book a profanation of *Newsday*. It did not help that one of the zanier characters was a 104-year-old advertising executive obviously modeled on himself. Though the project began before Moyers arrived, and he had rejected an offer to write one of the chapters himself, Harry blamed his publisher for the book. The incident soon became another disagreement over free expression between the two. As Moyers later explained: "I wound up in a series of meetings defending [the authors'] right to do this, and therefore, becoming more in Harry's mind on the other side."[103]

The wedge penetrated still deeper when, in October 1969, Harry and Moyers clashed over *Newsday*'s favorable report of the massive antiwar, anti-Nixon demonstration called Moratorium Day, organized by student protesters. Harry believed the "left-wing city room" had accepted the demonstrators at their own worth as pure-of-heart young idealists. In fact they were cynical adults who were "trying to destroy our way of life."[104] He also believed that the paper was determined to nail Nixon

*This version was one of several, each changing the proportions to be received by the heirs in accordance with Harry's current estimate of their worthiness.

come what may. Moyers claimed that the paper was being evenhanded, but his boss refused to listen.

For the first two years of Moyers's reign, Harry had been a constant presence at the paper. After the 1968 election, Moyers would later note, he began to withdraw. He continued to keep in touch with the *Newsday* staff by phone, but he came to the editorial offices less often and seemed to lose interest. Moyers speculated that it was during the tumultuous year, marked by the assassinations of Martin Luther King, Jr., and Robert Kennedy, the New Left disruptions at Columbia University, and the riots in Chicago during the Democratic national convention, that Harry lost heart and became discouraged about America's future. But 1968 also marked the beginning of serious medical troubles for Harry. Both the health of the nation and his own undoubtedly combined to depress Harry and distance him from the paper.

NEWSDAY and the quest for a successor did not fully occupy Harry as he entered old age. Fortunately, he found a new diversion in the Harry Frank Guggenheim Foundation, a creation that continued the family eleemosynary tradition, stimulated Harry's restless mind and provided an outlet for some of his more diaphanous social theorizing.

Established with little fanfare in 1959 primarily as a tax avoidance device, the foundation served initially as an agency for Harry's minor charitable benefactions. During the early 1960s it dispensed small sums to the American Shakespeare Festival, the American Museum of Natural History, the Red Cross, the Children's Aid Society, the Community Chest of Charleston, the Henry Street Settlement, the Federation of Jewish Philanthropies, and other good cultural and charitable causes. But Harry had bigger plans for it. As realigned in the later 1960s, it would embody the social ideas that Harry had been discussing with Lindbergh and others for years.

World War II had set Harry to thinking about human conflict and ways to resolve it peaceably. Undoubtedly the Holocaust also triggered speculation, though it is not clear that he ever directly addressed the fate of European Jewry during World War II. Then, sometime in the late 1950s, he met Professor Paul Fitts, a psychologist at the University of

Michigan whose special field was "military psychology," a subject that naturally interested the "Captain." In the early 1960s Harry and Fitts began to talk about possible ways of improving "man's relationship to man." Lindbergh, once more close to Harry, joined in the discussions of human conflict, contributing his own Social Darwinist version of human relations that emphasized competition rather than cooperation. There was a "place for brotherhood and compassion," he wrote Harry, but it "must exist within the framework of competition."[105] Besides Slim, Anne Lindbergh and Harry's old friend James Doolittle joined meetings with Fitts to consider how to frame the foundation's purposes. Other discussants of the foundation's mission were Edward Pendray, head of the American Rocket Society and a Goddard enthusiast, and Robert Ardrey, the anthropology popularizer who had authored *Territorial Imperative*, a best-seller that sought to identify the basis for human aggressive impulses. Harry's nephew, publisher Roger Straus, Jr., remembered that Konrad Lorenz, the ethologist, also joined the discussions at Falaise. Harry wanted Lindbergh to become first director of the new foundation, but he refused. By the mid-sixties, Lindbergh was more interested in the emerging environmental movement and believed that it offered a better way to improve "human life" than a "direct attempt to improve man's relationship with man."[106]

In 1969 Harry summed up his thoughts about human relations, honed in the discussions with his friends, in an essay. Hinting at his own doubts, he asked if it was a "dangerous over-simplification" to conclude that "man's clash with his fellow man" derived from competition "for sustenance, sex, and domination," and that, in rich modern societies, the first two motives no longer counted. If so, the world was left with "man's instinctive or developed urge to dominate," and it was this urge that should be the focus of concern for the new foundation.[107] In conversations with Peter and others Harry simplified the formulation to: "Why are we able to put a man on the moon and yet cannot stop wars?"[108]

Influenced by Henry Allen Moe, who had long headed his uncle Simon's foundation, the reinvigorated Harry Frank Guggenheim Foundation followed the fellowship road. The foundation gave grants to

talented individuals and innovative groups whose work seemed relevant to its mission. It funded Jane Goodall's research into the lives of chimpanzees in Gombe, Tanzania; the Leakey family's quest for human origins in East Africa; studies of cooperation and conflict in Israeli kibbutzim; the role of dominance in children's cultures; the strain of violence in the student New Left; and many other studies of stressful social interactions. Many projects were undoubtedly worthy, advancing our collective knowledge of important subjects. None, that we can see, has made our world a less contentious and violent place to live.

It is startling that a Vietnam hawk who defended America's continued military presence in Southeast Asia as a test of American weaponry should worry about "man's inhumanity to man." But Harry apparently did not see Americans as aggressors in that conflict. It was the other party who was acting inhumanely and whose behavior therefore was puzzling. Harry did not perceive any dissonance between his foundation's goals and his support of military victory in Vietnam.

As THE SEVENTIES APPROACHED, Harry's health deteriorated. In 1968, when he was seventy-eight, he was diagnosed with prostate cancer, that slow-evolving malady that afflicts many older men. He spent some time in Doctor's Hospital for surgery, though it was publicly said to be for hepatitis. When, in January 1969, the board of the Solomon Guggenheim Museum feted his cousin Peggy at a black-tie dinner in New York to mark an exhibit of her art collection, Harry was too sick to attend. Peter presided instead. Harry went to Miami, where he had often visited for the races at Hialeah, to recuperate after the operation and was soon feeling better. But by this time the cancer had weakened him and he had to employ round-the-clock nurses. Then in the fall Harry had a moderately severe stroke followed by a smaller one the following January. As is often the case, the strokes affected Harry's personality. Never the most trusting or easygoing man, he became uncomfortably suspicious and cranky. It was at this time, apparently, that Harry concluded that Moyers was trying to find a purchaser for *Newsday*, in effect trying to sell the paper out from under him. Even worse, the prospective purchaser, he believed, would be the Time-Life firm, whose publisher,

Henry Luce, Harry detested. Face-to-face contact between Moyers and his boss now ceased. They communicated solely by written memos. Moyers believed that the relationship now finally snapped.

If Moyers felt free to search for a buyer, as charged, it was because he had learned that Harry himself intended to wind up his affairs. As his health worsened, Harry began to consider two momentous moves: selling the newspaper to the Chandlers, the family that owned the prosperous *Los Angeles Times*, and transferring his capital and responsibilities to his distant cousin Peter Lawson-Johnston.

Fortunately for Harry's purposes, Otis Chandler, the man who had rescued the *Times* from mediocrity and right-wing reaction, wanted to expand his Times-Mirror publishing conglomerate to the East Coast. He had known Harry and Alicia socially for years and admired *Newsday*. Harry also knew Norman Chandler, Otis's father, a far more conservative man who had long run the Los Angeles paper. Harry, it seems, failed to understand that within the Times-Mirror company the more liberal junior was now in charge, and he believed a Chandler takeover would assure that his paper remained a bulwark of Republicanism. *Newsday* itself was in fine shape. Its circulation had reached 450,000, making it the seventh-largest evening paper in the country. It was a tempting property for the Chandlers.

In February 1970, while recuperating in Florida, Harry phoned Norman Chandler. He wanted to sell the paper, he told him. Chandler was interested. To negotiate the deal Harry turned to Peter Lawson-Johnston and to an old friend and fellow horse racing enthusiast, John Hanes. A highly successful business executive, Hanes had collaborated with Harry in creation of the New York Racing Association, the body that ran New York State's racetracks. The two together would manage the sale arrangements. Harry wished to make it a simple, direct sale, without the intermediaries of brokers and banks, and told his agents he did not want to haggle over price. In the ensuing negotiations Peter was the "legman," gathering data to determine the value of the paper's assets to establish a valid price for its shares. Hanes was "the brains," Peter admitted, dealing with the negotiators on the other side.[109] There was one major complication. Harry did not want Moyers to know anything

about the negotiations, and Peter and Hanes, the former later admitted, had to be "deceptive" to keep Moyers from finding out what was afoot and seeking a more liberal buyer than the Chandlers.[110] Harry's personal attorney, Leo Gottlieb, was also cut out, ending up supervising only the technical details of final terms. Otis Chandler grasped Harry's ignorance of the liberal shift at the *Los Angeles Times*, but failed to enlighten him.

With the deal virtually clinched, Harry called Moyers, vacationing with his family in the Caribbean. Would Moyers please stop off in Florida, where Harry was staying, so they could talk? When they met, Harry told him about the proposed sale. Harry seemed very sick. He looked like an "unwrapped mummy," Moyers later said. "Death was on his face," and he was not arguing rationally.[111]

Believing that he was to blame in part for Harry's desire to sell out, Moyers generously offered to resign. But when Harry resolved to proceed, Moyers tried to rally enough backing to buy the paper himself and offered to pay $10 million more than the Chandler deal. When this attempt fell through, Moyers sought to convince Harry that Otis Chandler was not a reliable conservative; his editorial positions in fact were close to *Newsday*'s own under the Moyers reign. This tack did not succeed either and the negotiations moved ahead. On March 12 a front-page article in the *New York Times* announced that the Chandlers had offered the stockholders of *Newsday*, minority and majority, a total of $75 million in Times-Mirror stock. It was not known, the report continued, if the minority stockholders had also agreed to sell.

In fact they were miffed. Harry had not consulted Alicia's heirs—Joe Albright; his sister Alice Albright Hoge; and two younger siblings, Adam and Belinda—and news of the proposed sale came to them as an unpleasant surprise. "[W]e had no idea he was thinking about this. We thought he would leave us the extra two percent to [give us] control," Joe later said.[112] He and his fellow heirs claimed the Times-Mirror people lacked the high journalistic standards that *Newsday* practiced. They also fretted that the minority owners' financial interests would be damaged. The Albrights' misgivings about standards matched the feelings of most of the paper's editors and reporters. The news of the impending sale,

Moyers wrote Harry, "broke here like a bomb shell, and people . . . were weeping in the city room. Those people love Newsday."[113] Believing the transfer to the Chandlers was certain to end the paper's "most vital asset," its "independence,"[114] they petitioned the minority shareholders to block the sale. Joe Albright responded favorably to the staff's feelings and hired an attorney to consider legal action against Harry. His mother, Josephine, Alicia's sister, also weighed in. "Give us a break here," Josephine implored Harry, "Alicia would have wanted it." Would Harry please hold off so that her children could raise the cash to buy the paper? Harry responded rancorously. Her offspring were all New Lefties, and he disapproved of them. No, he had made up his mind.[115]

The sale of Harry's 51 percent was concluded at the end of April. He had not bargained hard. The $31.6 million in Times-Mirror stock and notes was a steal according to other publishers. Still, considering Harry's original investment of under a hundred thousand dollars, with another $700,000 or so added over time, it was a bonanza that would have made old Meyer Guggenheim proud. In the end the Albrights sold their shares too. Having concluded, Joe later said, that the Times-Mirror people were not shoddy journalists after all, in October they handed over their 49 percent to the Chandlers for $37.5 million. Having held out longer than Harry, they got $6 million more. Joe Albright soon after severed his remaining professional connection to Newsday.

When Otis Chandler visited the Newsday offices for the first time in early May, he had been greeted with something less than delight. But he could feel more confident than ever that he had made a good deal. That very day, Columbia University announced that for its exposé of a series of corrupt zoning scandals in Suffolk County, Newsday had been awarded its second Pulitzer Prize. Bob Green and his associates working under Moyers had dug up the dirt, but the award did not help Moyers's status. In the past, Harry had unceremoniously dumped people who had disappointed him. He now resolved that Moyers would have to leave before the Chandlers took charge. Harry bought out the two years left on Moyers's contract, paying him a total of $300,000 in three installments and allowing him to remain for two months rent-free in his Garden City home. This was a generous response, but Harry also managed to be vin-

dictive. If Moyers had been successful as publisher at *Newsday*, he had proven, in Harry's eyes, deficient as a potential leader of the family dynasty, and Harry felt deeply disappointed. Harry had provided a bequest to Moyers of $100,000 in his March 1970 will as well as a significant chunk of Guggenheim Brothers shares. Now, in May 1970, he wrote a codicil canceling Moyers's holdings in the partnership and eliminating the cash bequest. He also threw Moyers off the Harry Frank Guggenheim Foundation.

WITH THE PAPER safely disposed of, Harry's final business in life was how to pass on the family heritage and the family wealth in the face of so many bitter defeats. Nephew Oscar Straus and grandson Dana had failed him; neither Joe Albright nor Billy Don Moyers had worked out. Harry took a flyer on his first cousin, once removed, Peter Lawson-Johnston.

Son of Solomon's daughter Barbara by her first marriage, Peter had inherited breeding but little money. A slender, elegant young man, he had gone to Lawrenceville Academy and served in the army as an NCO at the end of World War II. He graduated from the University of Virginia in 1951 and worked for a while as a reporter and editor at the *Baltimore Sun*. He then moved into public relations, where, he said, the money was good but the personal rewards disappointing. At this point someone in the family offered him a job at Anglo-Lautaro but Peter's wife, Dorothy, refused to live in Chile, and he turned it down. Peter was not out of the Guggenheim business picture, however. He accepted a job with a Guggenheim Brothers division offered by one of the nonfamily partners, Albert Thiele, Uncle Solomon's right-hand man, and made a go of it.

Peter later remembered that he really did not know Harry very well at this point. His mother had been closer to Robert, Harry's scapegrace brother. But he had constantly been quizzed about the Guggenheim Museum by people who knew of his family affiliations, and embarrassed by his ignorance, he asked Harry to put him on the institution's mailing list. This established direct contact with his cousin, and in 1961, as we noted, the clan head made him a Guggenheim Brothers partner. In 1964 Harry appointed him a member of the Guggenheim Museum board and

the next year got him elected to the board of Kennecott Copper. Harry soon made Peter president of the museum's board, jumping him over Albert Thiele, who resigned in a huff.

By the mid-sixties it was obvious that Peter had bought into Harry's vision of the family and was being groomed as his heir. In December 1966 Harry wrote his new protégé: "Your interest in the family's tradition, and your willingness at all times to contribute to the family's enterprises and the family's benefactions, have impressed me very much."[116] Harry followed up his note with a substantial check to Peter and his wife. Peter was grateful for Harry's patronage. "You have rescued me from an existence of limited dimensions" he wrote his benefactor, "and provided me with opportunities to demonstrate my desire to help carry on the tradition."[117]

From this point on Peter's rise was meteoric. In 1967 Harry began to consider seriously making him his formal heir now that Dana had left the scene and his ideological differences with Moyers had become more galling. Harry may have briefly entertained the idea that his son-in-law Albert Van de Maele might succeed him, but Albert seems not to have been a very imposing or able man. So who else was there for Harry to turn to? Besides, Peter was hard to resist personally. Everyone, including family members who had reason to resent his rise, agreed that he was a very nice man.

Harry's growing ill health accelerated his reliance on Peter. In August 1970, while in Saratoga with Joan, Harry had a devastating third stroke that rendered him physically helpless and unable to speak. He was brought back to New York by ambulance and eventually removed to Falaise to be taken care of. Harry was now in parlous state. Joan later said she "couldn't tell what was going on [in his mind] except by looking in his eyes. . . . It was awful."[118] Though he had difficulty speaking, his intellect was not affected, and he understood when others spoke to him. During his final months Harry rested at Falaise in the accessible downstairs book room, rather than his usual bedroom, attended by two professional nurses around the clock. Joan stayed with her father and managed his care through his final days. He had few visitors. Peter came to see him. Daughter Diane came occasionally, as did nephew Roger

Straus, Jr., but the most devoted visitor was Slim. Lindbergh dropped in all the time and was willing to talk to the nearly mute old man, who seemed to understand though he could not reply. Thomas Messer, director of the Solomon Guggenheim Museum, showed up unannounced one day at Falaise. Fully dressed, Harry was alone except for two servants, a maid and a waiter whom Messer recognized from dinners he and his wife had partaken at the mansion. It seemed to Messer, who had known Harry for years, a sad case for one so vibrant and powerful "to be at the mercy of servants."[119]

With the advice and guidance of Hanes, Harry rewrote his wills. In late 1970 he signed a power of attorney in favor of Peter. Harry had to be helped with his signature. Peter was now in charge of all Harry's financial and business affairs. Harry's daughter Joan, who might have resented Peter's rise to favor, was pleased with the role he was playing. In late December she wrote to praise him for having saved the family from "a very bad situation financially." He had been "so cheerful and helpful in every way, and wise." Astutely recognizing her father's inner motives, she noted that he had been a "real comfort" to Harry, "like the son he always wanted."[120]

As Harry's health deteriorated, Peter officiated at the sale of many of his remaining assets. As early as 1968, pleading inability to give the Cain Hoy Stables the attention it deserved, Harry had decided to get out of Thoroughbred racing. At the end of the year he put his horses up for sale. Auctioned at the Belmont race track, the thirty yearlings and twenty-seven racing horses brought $1.8 million. Additional horses were sold in the years to follow. In 1970 he sold off his Cain Hoy cattle, more than five hundred calves and eight hundred cows and bulls, for $280,000.

HARRY DIED on January 22, 1971, at Falaise, six months past his eightieth birthday. The funeral was held at Temple Emanu-El where Rabbi Nathan Perilman conducted the service, assisted by Rabbi Barry Greene of Congregation B'nai Jeshrun of Short Hills, New Jersey, a U.S. navy reserve chaplain. Dorothea Straus thought the service must have seemed strange to Harry's three daughters, none of whom had been raised in the family faith. Neither rabbi, apparently, had ever met the deceased, and

Dorothea was put off by the "ersatz connection" they tried to establish with him. Dana, she noted, was "conspicuous by his absence."[121]

After the temple obsequies, the funeral party drove to Salem Fields on Long Island, not far from Falaise. The rabbis delivered the final traditional prayers over the flag-draped coffin inside a tent next to the Guggenheim mausoleum. There was a multigun salute, the number of volleys appropriate to a navy captain, and afterward a navy honor guard meticulously folded the American flag in the prescribed way to present to the family. Then the coffin was placed in the tomb and the massive doors closed. The odd mixture of themes—secular, military, and, finally, even Jewish—summed up the spirit and essence of Harry Guggenheim.

Undoubtedly many in the funeral party mourned Harry. But some were also agog at the terms of the will. The total estate added up to about $50 million. Control and distribution of this sum was placed in the hands of trustees to include representatives of the Morgan Guaranty Trust Company and, significantly, Peter Lawson-Johnston. The trust was to terminate at the death of Peter and the remaining assets turned over to the Harry Frank Guggenheim Foundation.

Though John Hanes's was the guiding hand behind the will as finalized, it was consistent with Harry's wishes. It left nothing to his grandsons, Dana and George.* Harry clearly had never forgiven them for their transgressions. Some friends and family members also said it was ungenerous to his granddaughter, Carol Langstaff. At one time she had been a favorite grandchild but supposedly had offended him by falling in with a raffish theatrical crowd. In fact Carol denies that she felt snubbed. Harry, she points out, forgave the loan she used to buy her place in Vermont and gave her title to his East 57th Street New York coop apartment and all the furniture and art in it, as well as $2,500 a year for a period of five years. With her grandmother's trust fund besides she felt well fixed.

Though the trustees were given considerable discretion, Harry stipulated many specific bequests. Having previously established generous

*Neither was left impoverished, however. Each inherited a half million dollars from their mother. In addition Dana had access to a trust fund Harry had established for him when he went to Columbia.

trusts for his daughters, he explained, he left them only $250,000 apiece. He also gave them his clothing and the jewelry located at Falaise and at his New York townhouse, as well as the contents of his mother's Long Island home, Mille Fleurs, including its art, and all his "wines and spirits." Joan, his favorite daughter, received an apartment in a second townhouse Harry owned in New York as well as the main gatehouse and some adjacent property at the Falaise property in Sands Point. He gave $100,000 to his son-in-law Albert Van de Maele and other moderate sums to his secretary George Fountaine, to his attorney Leo Gottlieb, to Henry Moe of the John Simon and Harry Frank Guggenheim Foundations, and to assorted friends. He provided small bequests to loyal servants and employees at Falaise, Cain Hoy, and at his other homes. He left sums of $100,000 to North Shore Hospital on Long Island, to the Sloan-Kettering Cancer Institute in Manhattan, and to Pembroke College at Cambridge, his alma mater. Harry's favorite home, Falaise, did not go to the family. Instead it was bequeathed, with most of its furnishings and contents intact, to Nassau County to be maintained as a museum.*

Harry's chief beneficiaries were the family foundations, with his own, the Harry Frank Guggenheim, far in the lead. The trustees of the estate were directed to distribute income from the multimillion dollar proceeds from the sale of *Newsday* to the family foundations, especially Harry's own, and from time to time chunks of the principal as well. The Harry Frank Guggenheim Foundation was also to receive directly the valuable Daniel Island, adjacent to Cain Hoy.

Peter Lawson-Johnston was the chief individual beneficiary of Harry's will. Harry gave him outright his Seventy-fourth Street townhouse and some waterfront property at Falaise. He was also bequeathed 40 percent of the stock of the surviving Guggenheim resources businesses, along with lesser portions for Joan; her husband, Albert; and John Peeples. Bill Moyers was to receive 20 percent too, but this provision, like the cash bequest, was eliminated in the later codicil. Peter was

*It remains to this day a part of the county museum system and is open much of the year to visitors.

also designated as chief trustee of the will and of the Harry Frank Guggenheim Foundation. Using many of the same words he had written to Dana five years before, Harry specifically transferred to Peter all the financial benefits promised to his grandson if he had conformed to his desires. Peter was to receive for life quarterly income installments equal to 5 percent of the fair-market value of the trust's assets. The trustees were authorized, as well, to distribute to Peter portions of the trust principal "to enable him to use his human and financial resources for the progress of man in the best traditions of the Guggenheim family." Harry had originally envisioned a collaboration between Moyers and Peter in running the paper and the Guggenheim business enterprises. With Moyers out of favor, and the paper sold by 1970, Peter alone would be in charge of the remaining mining and refining businesses and of the foundation. Harry obviously recognized that he would be accused of gross favoritism for his decisions and he sought to blunt the charge's edge by echoing words he had earlier addressed to Dana. "If I were to provide for all of my family equally," he wrote, "none of them, in my opinion, would be in a position to carry on the family tradition effectively. All of my descendants have been provided for by me either in my will or in other ways, so that none of them should ever be in want and, in fact, all of them will be able to live in luxury." He had, he continued, from long and careful observations of Peter's "potentialities" decided that he would carry on successfully the family's traditions. He apologized for any discrepancies among his daughters in their benefits. He loved his daughters and hoped each would have the material means to find satisfaction and happiness. Any difference between their portions, he believed, reflected only the differences "in the overall economic position of each" as he understood it. It is not clear what Harry meant here; Joan clearly came out ahead in the will, especially if one adds in the bequests to her husband. But Harry perhaps was including in his calculations past gifts and loans to his daughters that he agreed to forgive.[122]

Did Harry's daughters resent the will? Harry had tried to avoid a contest by specifying that anyone who challenged the will would be automatically cut out of it. Joan, it seems, was satisfied. When asked many years later whether she was angry that Peter got control of most of

the estate, she said it did not bother her. She had been provided for, and in any case her father gave Peter so much because he knew how to handle money. "I'm sure that's the reason."[123] Joan and her father were close and she was not likely to question his choices. But what about Nancy? She was not as happy. At her behest, her husband, Tom, a lawyer, came East to look into the possibility of contesting the will. He quickly discovered that no New York law firm would touch the case. And Joan, who had not done much better than her sister, refused to join a suit. "Father has a right to do what he wanted with his money," she told her brother-in-law.[124] At this point Nancy gave up. She committed suicide shortly after but, as we saw, her despair had little relationship to her treatment by her father.

As for Peter, it was difficult for the other heirs to resent Peter. For one thing, he seemed an unusually kind and pleasant man. He would receive a very generous income during his life—perhaps a half-million dollars a year—and would be in charge of a large fortune. But on the other hand, as he noted, it would all revert to the foundation at his death. Dorothea Straus was right, "the foundation had triumphed," not Peter.[125]

WHEN MOYERS SUBMITTED his formal resignation in May 1970 Harry had complimented him on the way he and his wife Judith were raising their children. Moyers did not consider the remark flattering; he did not believe their parenting skills particularly noteworthy. The remark was a judgment, he felt, on Harry's own failure as a father. At the end of his life, Moyers concluded, Harry "was a sad, sad man."[126]

And he had reason to be sad, given his expectations. The energy and drive that had raised the Guggenheims to wealth and power could not be sustained. It inevitably dissipated with each succeeding generation. Harry was fighting entropy, and like all men who seek to defy fundamental laws of nature, he failed. But if he had reasons for despair over his dynastic defeats, he had reason for joy over the rest of his stay on earth. He had lived a rich and useful life. Entrepreneur, publisher, aviation prophet, war hero, public servant, public benefactor, he had contributed to society more than most men, even those in his privileged position.

We have said little of Harry Guggenheim's influence in the arts.

During the post–World War II era he would play a role here too, yet in truth Harry's part was a minor one. He appreciated conventional painting, sculpture and architecture, but could never fully penetrate the cacophony of modernism. But two other Guggenheims, Uncle Solomon and cousin Peggy, would take up the slack and significantly channel and shape the early twentieth-century revolution in the visual arts.

"The Grand Old Man"

The Guggenheims were always beguiled by the arts. During the early years in Philadelphia, the patriarch, Meyer, had struggled, if unsuccessfully, to instill a love of music in his sons. Murry and Daniel would sponsor free band music for the New York City masses for decades. Other Guggenheims would pursue musical careers either as performers or as promoters. Diane, Harry's youngest daughter, became a folksinger and a collector and recorder of folksongs. Diane's daughter, Carol Langstaff, in collaboration with her singer father, would create a new music-performance genre. The other arts attracted Guggenheim descendants too. Harry's middle daughter, Nancy, was a dancer as well as a writer on ballet. Hazel, Ben's youngest daughter, was a painter, as was her niece, Pegeen, Peggy's daughter. Dana Draper, Harry's grandson, became a sculptor and painter. Roger Straus III is a professional photographer.

But Meyer Guggenheim's posterity were above all *patrons* of the arts. Daniel collected old masters and contributed paintings to the Metropolitan Museum of Art. Florence, his wife, was a generous donor to the Metropolitan and other museums. In the 1930s Olga, Simon's wife, served as a trustee of the Museum of Modern Art in New York and contributed twenty-four major pieces, including Picassos, Modiglianis,

Matisses, and Legers to its permanent collection. But no Guggenheim, including Peggy, became such a generous Maecenas of visual art, and such a force in the evolution of public taste and appreciation of modern painting and sculpture, as Solomon Guggenheim, the dapper, amiable last male survivor of Meyer and Barbara.

SOLOMON AND IRENE, like other Guggenheims of their generation, lived opulently. At their Sands Point mansion servants wore livery, and at dinner one stood behind each guest's chair to whisk away empty plates. Olgivanna, architect Frank Lloyd Wright's wife, visiting Trillora Court in 1945, remembered how her host, having noted her discomfort at the servant's swift moves, whispered to her: "Victor can be very quick, Mrs. Wright, but if you keep your thumb on the plate he will not touch it."[1] Art was a significant part of Solomon and Irene's lives. From the outset of their marriage the walls at Trillora Court and at their Plaza Hotel suite on Central Park South were covered with Watteaus and works of the Italian and Flemish Renaissance and Dutch, German, and Italian primitives. The initial collection was more than decoration, but it was clearly not equal in quality to J. P. Morgan's or Henry Clay Frick's. When disposed of by auction in the late 1930s it brought only about $340,000. Yet Solomon's tastes, if not Irene's, were soon to be jolted into a phase change.

The transforming agent was Hilla Rebay, born Baroness Hildegard Anna Augusta Elisabeth von Ehrenwiesen in 1890 in Strasbourg, then a city of the German empire. The blond second child of an officer in the kaiser's army, the young Hilla, like all children of professional military families, moved frequently—to Freiburg, Cologne, Hagenau, and other cities. Along the way she became an accomplished painter and a disciple of Rudolf Steiner, a founder of the theosophist movement that sought to disseminate the spiritual aspect of Eastern religions. In 1909–10 she came to Paris as an art student at the Académie Julian. There she studied portraiture, winning first prize for a student set piece, the *Dance of Salomé*. She soon committed herself to "living exclusively for art."[2]

Hilla began her painting career at the beginning of a revolution in Western visual art. The years straddling World War I brought a trans-

formation of artistic sensibility throughout Europe. It was in this unsettled period that an avant-garde of artists, and the men and women who appreciated and patronized them, began to visualize the world around them in new ways and record it with techniques that were given the names Cubism, abstractionism, and Dada.

Each of these aesthetic approaches in its way challenged an ordered, formalistic worldview already undermined by the scientific, political, and psychological uncertainties of the new twentieth century. In each case they rejected mimesis, figurative representation, that employed traditional perspective developed over the centuries in the West. They often borrowed from the "primitivism" of African sculpture and Eastern painting that eschewed naturalism. To the uninitiated and untutored their results would often seem coarse, ugly, suffocating, and incomprehensible. To cognoscenti and cultural rebels the new currents seemed fresh, exciting, and defiant.

In many cases a single magnetic individual, or a small number, set in motion the process of altered artistic sensibility. Cubism emerged from the experiments in perspective and surfaces of a Spanish artist living in Paris named Pablo Picasso, and his friend, a Frenchman named Georges Braque. The Cubists abandoned traditional perspective; their paintings were often assembled out of scattered and interlaced flat planes. Objects were depicted not as the eye usually sees them, but as they register on the mind, all sides simultaneously. In Picasso's epochal 1907 *Les Demoiselles d'Avignon* five nude, angular females crowd the jagged canvas. Several of the faces are shown full-faced but noses are viewed sideways. Perspective is gone; the plane is flat. Several of the women's faces resemble West African masks.

In later Cubism, forms become increasingly dissociated from recognizable objects, but true abstract, or nonobjective art, emanated primarily from the mind of a Russian genius domiciled in Munich. Wassily Kandinsky, the most articulate of the early twentieth-century aesthetic pioneers, ascribed his new vision to his sense that the scientific certitudes of the past were no longer valid. Writing about the year 1909, Kandinsky noted that "the disintegration of the atom was to me like the disintegration of the whole world." With the unity of reality gone, nature and its

representation seemed no longer interesting. In that seminal period Kandinsky had a vision of painting's future. One day, at twilight, he came into his studio, he wrote, and suddenly saw "an indescribably beautiful painting permeated by an inner glow." The painting was nothing but forms; it had no identifiable subject matter at all. "Now I knew with certainty that the object harms my paintings. . . . The ends (and hence also the means) of nature and art," he concluded, "differ essentially, organically and by virtue of universal law."[3]

It took a few years for Kandinsky to slide from neo-impressionist into the new abstraction. In 1911 he returned to Munich from several roving years in Paris, Switzerland, and Italy and soon after formed the group known as the Blaue Reiter (blue rider). In 1912 they announced as its "great revolution . . . an intensive turn to inner nature, and . . . a refusal to embellish outer nature." Kandinsky later illuminated—or obscured—this description with oracular phrases: "Nature creates her forms for her own purposes. Art creates its forms for its own purposes. . . . Our devoutest wish is to arouse joy through giving examples of the inexhaustible wealth of forms, which the world of art creates indefatigably, in accordance with its laws."[4]

Dada, and its offspring, surrealism, was the response of a group of exiles in neutral Switzerland to the horrors of World War I. That barbarous, seemingly senseless conflagration called into question all of bourgeois civilization with its circumspection, its rationality, its prudence, its good taste.

The seminal surrealist figure in Zurich was Tristan Tzara, a small, foppish young Romanian poet who made a religion of nihilism. Tzara and his friends, most prominently Jean Arp, ferociously attacked and mocked contemporary aesthetic values and indeed all the symbols and icons of respectable life. As was famously said, they "spat in the eye of the world," replacing logic and sense with absurdity and defiance.[5] Jimmy Ernst, son of pioneer surrealist Max Ernst, said the Dadaists believed that "sacrilege was the only potent answer to sanctimony."[6]

In 1920 Tzara and friends came to Paris at the behest of André Breton, a young French intellectual, and set the city's artists and thinkers aflame with a multimedia performance of posters, poetry, and theater

designed to offend and outrage. They succeeded. The conventional press and critics denounced them as dangerous and mad, yet the city was soon reveling in Dada skits, demonstrations, and assorted happenings. By the mid-1920s, having fulfilled its purpose as a purgative, Dada subsided. Soon after, under the leadership of Ernst and Breton, it ingested the subconscious as discovered by Freud to create surrealism. "If Dada had been the debris-cleansing storm," wrote Jimmy Ernst, "Surrealism lit up the sky as a fireworks of the mind. Fed by the essence of its short-lived forerunner, it was to reveal the marvelous and the magic that had lain hidden in the recesses of human consciousness."[7] Surrealist artists painted dreamworlds of mysterious, distorted objects, some with an impressionistic touch, others with the limpid clarity of verism. As surrealist writer Louis Aragon poetically described the new movement in the early 1920s: "a new vice has just been born, one madness more has been given to man: *surrealism*, son of frenzy and darkness."[8]

Hilla Rebay absorbed the exhilarating new ideas from Jean Arp, an Alsatian-born painter and sculptor whom she met in Zurich in 1915. Arp introduced her personally to the Dadaists in Switzerland and to a group of avant-garde artists, including Kandinsky's Blaue Reiter circle, who foregathered in Berlin under the name Der Sturm. Besides Kandinsky, these included Paul Klee, Marc Chagall, and, most portentously for her, Rudolph Bauer, a disciple of Kandinsky whose geometric shapes unfortunately lacked the Russian's inner spirit. While retaining her skills as a conventional portraitist, Rebay became a practitioner of the new experimental styles and exhibited with the Der Sturm group.

As the war wound down Hilla and Bauer began an intermittent love affair that would last for many years and alter the course of both their lives. In 1925 Hilla went to Italy to paint and restore her fragile health. But the Italians had little interest in her nonobjective art, and she soon realized that she would not be able to support herself in Italy. In 1926 she decided to move to the United States, the supposed mecca of "the modern," where, she believed, everyone would appreciate her art. She arrived in New York in January 1927.

Hilla was a handsome woman. In her twenties she had "unusually beautiful hair," and "a new and exotic way of speaking which discon-

certed and fascinated."[9] At age thirty-seven, when she moved to the United States, she was still attractive, with pleasant, even features and a helmet of short bobbed hair. Her good looks would boost her career in art, but at first America proved disappointing. The New York art world of painters, critics, and interested public, it turned out, was primitive by the standards of Paris or Berlin and did not understand her work. It was also a disadvantage being German so soon after the armistice. For months she could only support herself by drawing commercial posters or designing window displays. On the other hand, she immediately appreciated the freedom allowed individuals in America to mold their own lives.

By the fall of her first year in the United States her looks and her title began to make an impression and Rebay began to prosper. She was invited to show her work at the art museum in Worcester, Massachusetts, and at the Marie Sterner galleries on East Fifty-seventh Street in New York. Her pieces were collages, nonobjective works made of forms pasted on sheets of rice paper, a style still unfamiliar to Americans. The New York show brought Rebay to the attention of Gertrude Whitney, a Vanderbilt heiress, who was also an art patron and a sculptor herself. Whitney bought several of her collages. Other buyers included Irene Guggenheim, Solomon's wife. One suspects that Hilla's patrician pedigree helps explain her quick, warm reception by these upper-class women.

Rebay had arrived in America with letters of introduction to the Guggenheims. She actually met them at the home of James Speyer, a rich banker with close ties to the New York German-Jewish community. Irene took an instant liking to Hilla and the two women were soon attending the opera together. When in May 1928 Hilla returned to Europe for a brief vacation, Irene sent her a bon voyage telegram. Back in New York in the fall, Hilla was enlisted as the Guggenheim family portraitist to capture, with her somewhat rusty early skills, the likenesses of Irene, Solomon, and assorted Guggenheim relatives. The important commission, however, was the portrait of Solomon. Completed in the fall of 1928, after many weekend sittings at Trillora Court, it showed a

slightly rumpled old gentleman with skinny ankles, wearing plus-fours as if about to play a round of golf. It was a good likeness of Solomon and reputedly cost him $9,000.*

Hilla used the sittings as occasions to propagandize for nonobjective painting. As she applied her brush to canvas she massaged Solomon's sense of adventure. The new art, she told him, was unexplored country like Mexico or Chile. There he could be a pioneer. Solomon must also have understood that he could not expect to achieve distinction as a collector of old masters; their prices, boosted by the collecting frenzy of men like J.P. Morgan, were already becoming exorbitant even for a Guggenheim.† Rebay deployed more than words in her campaign. She had brought with her from Europe her own collection of nonobjective paintings and added more after she arrived through purchases by Bauer in Berlin. She proudly displayed these to the Guggenheims and other potential patrons at a small studio she rented at the Carnegie Hall annex on Fifty-seventh Street.

Solomon soon succumbed to Rebay's persuasion. His conversion seemed mystifying to friends and business colleagues. Harry's attorney, Leo Gottlieb, remarked at one point that Sol was the "last person in the world you would expect to be associated with art." Another business acquaintance noted that Sol's artistic interests seemed a "strange quirk."[10] But they were neither "strange" nor a "quirk." As Hilla had shrewdly perceived, they were eminently compatible with the Guggenheim business tradition. Not that profit entered the picture. With the exception of Picasso, modern painters and sculptors did not sell in the 1920s and 1930s. Yet Sol's new interest was indeed in some measure an extension of the Guggenheim entrepreneurial spirit. As Hilla wrote Bauer in 1930, Sol was looking for a new world to conquer. He did "not

*After Solomon's death and the subsequent rupture between Harry and Rebay, the picture apparently was destroyed.

†In 1911 a middling Rembrandt already cost a half-million dollars. Ten years later Henry Huntington paid $620,000 for Gainsborough's celebrated *Blue Boy*. Twentieth-century paintings were far cheaper. In 1932, for example, Solomon would buy two Kandinskys for a total of $1,200.

know what he would do. But he wants to do something great and what greater thing could he find?"[11] By buying and promoting twentieth-century art Solomon was discovering and exploiting a mother lode, this one cultural, as he had in Latin America and the American West. Sol himself admitted to less imperial motives as well. Years later he noted how welcome an amusement collecting and promoting modern art had been for him. In a letter of 1944 he thanked Rebay for providing so much pleasure. "What relaxation you have given me in the way of Non-Objective Art, which has proven such a diversion for me from many business matters."[12]

And then there was the power of an old man's libido. Whether Rebay's aesthetic conquest of Solomon was abetted by actual physical intimacy is unclear. Hilla herself always denied that she and Sol ever had an affair. He was too old, she said; he was like a father to her, not a lover. In letters to Bauer and others she called him "the grand old man." Reinforcing the claim of innocence, Rebay's biographer notes that in the many letters between them there is no hint of personal romance. But Joan Lukach also admits that most of the letters were dictated to secretaries and so had to be discreet. On the other hand, Solomon was a lusty man. According to his niece Gladys Straus, his string of mistresses included some of the most beautiful women she had ever met. In 1927 he was still only sixty-six and at an age when even a man of the world might become captivated by a beautiful woman *d'une certain age*. There is no question that Hilla intrigued and excited Solomon. Gladys later told John H. Davis that "Sol was getting old and tired without purpose in life. Aunt Irene was so stodgy. Hilla gave uncle Sol a whole new existence and it was so *good* for him. All of us saw how much he perked up after Hilla came on the scene."[13] Thomas Messer, the director of the Solomon Guggenheim Museum in the 1970s and 1980s, also ascribed Solomon's conversion to deep feelings, although he was more circumspect about the carnal specifics. Referring to the modern art collecting bug, he noted that "Hilla brought passion to it" for Sol.[14] In the end we must conclude that, while libidinous, the relationship may well have sidestepped actual intercourse.

Whether Hilla's hold was sexual or not, family opinion, with Gladys

excepted, would in the end paint her as a villainess. Peggy, Sol's niece, claimed she had "poisoned" Aunt Irene's life. "My aunt hated her," she recalled.[15] Peter Lawson-Johnston, Sol's grandson, remembered that when he was growing up his mother and grandmother would refer to Hilla as "the B." He assumed they were referring to the "baroness." He later learned that the "B" referred to another of Hilla's attributes.[16] One of the family's complaints was that Hilla was a "gold digger," in the vocabulary of the mid-twentieth century. Solomon's youngest daughter, Barbara, Peter Lawson-Johnston's mother, at one point exclaimed: "Well, she came over here to find a rich American, *and she found one!*"[17]

Rebay's friendship with the Guggenheims transformed her life as well as theirs. In 1929 she cemented her relations with Irene and Solomon on a trip to Europe where the baroness introduced them to Bauer and Kandinsky. Solomon agreed at this time to give Hilla money to buy paintings for his collection and to subsidize portfolios of works by her and by Bauer. Solomon also agreed, at Hilla's urging, to provide a monthly stipend to Bauer so he could paint without the distraction of having to earn a living. The money would be a lien on the work Bauer produced. Hilla herself had extracted a promise from her patrons that they would systematically build a nonobjective art collection with herself as their primary guide. When she returned to New York in August she could not help exulting: "Success is simply great and wonderful. . . . My life must be easier from now on."[18] But there remained a real concern. Irene Guggenheim continued to be taken with her and her art, but Irene's friends were becoming hostile. They were "working against" her, Hilla wrote Bauer on Christmas Day, 1929. They "say this isn't art, it won't last, it is geometry, it is worthless and comes from tasteless Germany, that everything good comes from France."[19] Before very long Irene would share her friends' doubts of the new art and especially their skepticism of Bauer.

It was about this time that Solomon began to consider establishing a museum to showcase the paintings he was accumulating. His first thought was that he would eventually leave his collection to the Metropolitan. But when the Rockefellers opened their Museum of Modern Art and Gertrude Whitney announced *her* museum of contem-

porary American painting and sculpture, he decided to create his own museum. Rebay was thrilled with Solomon's plans. She knew she would be at the center of its design and began to concoct grandiose schemes for what she called the "Temple of Non-objectivity." The new museum "must be built in a fabulous style" with a large library and a room for music and lectures, she reflected. It should be a school for educating young people. The "first room must have blue ceiling lights like Napoleon's Tomb in Paris, a room for composure, warmth, and rest, where one can get away from the noise of the streets before entering the temple of art." The establishment "must become the standard for greatness for all nations, truly the Temple of Peace in the universe."[20]

In the spring of 1930 Rebay set off for Europe to display her own work at the Bernheim-Jeune gallery in Paris and to line up artists for Sol and Irene to visit when they followed her later that summer. Before her benefactors arrived, Hilla consulted some of the most esteemed of living modern painters—Piet Mondrian, László Moholy-Nagy, Fernand Léger, Sonia and Robert Delaunay, and Marc Chagall—to ask their advice about paintings to be acquired for the growing Guggenheim collection. She also bought paintings on the Guggenheim account from each. When Sol and Irene arrived in Europe Rebay took them on the rounds of the Paris artists, followed by an auto tour of Belgium, Holland, and Germany. In July the party stayed a week with Hilla's parents in Teningen in the Black Forest. General von Rebay, long retired, was impressed by his visitors' opulent equipage. "Hilla and her friends were here this summer," he later wrote his brother. "[H]e is one of the richest men in America. They arrived in their own car accompanied by a secretary, a servant for him and one for Mrs. Guggenheim."[21]

In July the Guggenheim party reached Berlin. There they finally met Bauer, Hilla's paramour and agent. Solomon liked the man and his work despite his braggadocio and posturing, but Irene, already negatively primed, felt repelled by both. The Guggenheims spent an evening with the modern architect Walter Gropius, recently retired as head of the famous Bauhaus school of art in Dessau. At dinner at the Gropius house, furnished with their spare Bauhaus furniture, Solomon told his host that his openness to modern painting was inspired by his experi-

ence in defying convention and using new methods to extract copper from the ground. Gropius noted that Irene had turned up in full evening regalia and probably felt embarrassed by its inappropriateness in their austere home.

BY THE TIME SOLOMON and Irene returned to New York they had gathered an impressive collection of modern paintings. Where to place them? Solomon decided to sweep out the traditional old masters at their Plaza suite to make room for the new paintings. To create an appropriate setting for the collection, he redecorated three large rooms in handsome modern style, but the collection spilled over into other rooms and into the halls as well. Solomon did not intend to keep the paintings for his exclusive enjoyment. Once a week, usually Thursday afternoons, the Guggenheims opened the collection to viewers who had applied for admission. Sometimes as many as eight hundred art lovers jammed the suite at one time. As the collection outgrew the space in the suite, pictures were rotated in and out of storage.

Clearly the collection needed a better space, and a permanent one, to display its riches to the public. But Sol was not yet ready to move ahead on constructing a museum home. For a time in 1933 he considered renting rooms for the collection in a cluster of buildings going up near the new Rockefeller Center. But this was the depths of the Depression, and like many other ambitious projects this scheme quickly crashed to earth. As the economy reached bottom even Solomon was forced, at least briefly, to curtail his purchases of paintings, though many fine works could have been snapped up at rock-bottom prices.

Solomon found other venues for his collection during these early years. Some paintings were lent for viewing to the Toledo art museum and to the Baltimore Museum of Art. For several years the collection as a whole went on exhibit in museums elsewhere around the country. The Guggenheims had an elegant home in Charleston on the famous Battery where Rebay visited him several times. Robert Whitelaw, the director of the Gibbes Memorial Art Gallery, the local Charleston art museum, knew of Solomon's growing collection and in 1933 approached Sol to lend some of his paintings for display. Sol turned him down but Rebay

managed to wangle an invitation to show her own work at the Gibbes two years later. In the spring of 1936, after the trustees had spent several thousand dollars to improve the gallery's interior layout and lighting, Solomon shipped to the Gibbes his entire modern collection supplemented by new paintings by Rebay. Rebay wrote the catalog for the exhibition. Many of the works were Bauer's geometric abstractions. Bauer himself, never before in the United States, visited the museum in April and that May came to Chicago to view a one-man show of his own work.

The Gibbes exhibition, the first full public display of what Sol had gathered, was followed by another show at the Philadelphia Art Alliance early in 1937. Some 138 abstractions, heavily weighted with Bauers and Kandinskys, were hung along with sixty "near abstractionists" including Picasso, Modigliani, Chagall, and the impressionist Seurat. Hilla again prepared the catalog and used the occasion to purvey her mystical, fuzzy, and often incoherent vision of nonobjective art conquering all. "Nonobjectivity," she wrote, "will be the religion of the future. Very soon the nations on earth will turn to it in thought and feeling and develop such intuitive powers which will lead them to harmony."[22]

The success of the two exhibits only buttressed the need to find a suitable permanent home for Solomon's collection. Meanwhile, he and Rebay were once more able to add to it at bargain prices. Many of Europe's greatest modern artists had been devastated by the Depression and were desperate for buyers and patrons. Marc Chagall, for one, sought Hilla's help. Writing from Paris in 1935, he explained the financial problems he was experiencing with his projected illustrated Bible. He had completed forty engravings for Genesis and Exodus and now wanted to illuminate Kings and the Song of Songs. But he needed support. Would "Mr. Guggenheim be interested in doing this book?" he asked Hilla His "hands burn[ed] with desire to work."[23] Sol was unwilling to underwrite the illustrated Bible, but the next year, on a visit to Paris, he bought five of Chagall's paintings. In 1941, with France defeated and occupied by the Nazis, he would provide affidavits of financial support so the Chagall family could obtain visas to the United States.

And despite hard times Bauer continued to receive Sol's help. Sol's Jewishness was not a prominent part of his life; still he refused to travel to

Germany, the land he had visited so often in the past, now that the Nazis had taken over and unleashed their brutal campaign against the Jews. Unable to visit Germany himself, in 1936 Sol came to rely completely on Bauer as his resident purchasing agent in Berlin.

About this time Irene finally broke entirely from Bauer. She now considered his paintings "crazy pictures" and a waste of money.[24] Before long Irene had grown "cold" to Rebay as well. The blandest explanation for the breach between the two women is that Irene's distaste for Bauer came between them. But there is a psychologically truer answer: Irene was probably jealous of the younger, prettier woman. Latent at first, her feelings finally broke through the surface. Whether Hilla and Sol were lovers or not, she assuredly stirred his emotions, something that Irene could no longer do, if indeed she ever had. The baroness, as we saw, denied the relationship, but admitted that "evil minded gossips" had "whispered terrible things."[25]

In 1937 Solomon decided to institutionalize his venture into modern art. That year he established the Solomon R. Guggenheim Foundation "for the promotion and encouragement of art and education in art and the enlightenment of the public especially in the field of art."

Solomon would be president of the new foundation and the board of trustees would consist of family members and prominent businessmen associated with Guggenheim enterprises. The formal announcement in late June mentioned no specific sum of money for the new foundation. Nor were its precise objectives made clear. Reporters, however, correctly interpreted the coy statement that the trustees would "further such movements in the world of art as [they] may believe merit support," to mean the promotion of abstract art. They also speculated that the foundation would seek to build a new museum, presumably located in New York.[26] At the trustees' first meeting the next day, Rebay was designated the director of Solomon's collection and the collection itself was formally transferred to the foundation. The trustees also created a committee to investigate where a public gallery or galleries might be located.

The art world hailed the foundation's advent as an important event, but nonobjective painting was still controversial, and several critics were skeptical about the art it was designed to promote. Edward Alden Jewell

of the *New York Times* noted that a promised public exhibition of the collection during the fall was certain to create "fireworks" and raised questions about the heavy emphasis on two artists, Kandinsky and Bauer.[27]

During the next two years, with Rebay in the driver's seat, the foundation continued to augment the collection. Rebay made several trips to Europe, buying likely paintings, including Bonnards, Gauguins, Delacroixes, and Rousseaus—"precursors" whose work presumably foreshadowed the abstract painters. In July 1938 she reported from Paris that she had bought sixty-three paintings on her recent trip. Meanwhile, in Berlin, Bauer too lined up works he deemed worthy for the collection. As was his way, he could not forgo self-aggrandizement. He had the invoices sent to himself and then often billed the foundation for an amount greater than the actual purchase price.

Among Rebay's purchases in these months were several paintings from the Munich exhibition of "degenerate art" staged by the Nazis in 1937. The National Socialist regime despised modern art as an excrescence on civilization and rigged the exhibit to display Kandinsky, Klee, Ernst, Moholy-Nagy, and other moderns, alongside the daubs of children, criminals, and mental patients. Whatever they personally thought of these pictures, however, the German authorities were happy to rake in dollars, pounds, and francs, after the exhibition closed, by selling them at auction to foreigners in Switzerland. Buying the pictures was morally dubious. Any purchase rescued a brilliant painting from probable destruction. But it also stoked the Nazi regime by providing it with precious foreign exchange. In the end Rebay, undeterred, bought a Delaunay and six Kandinskys for the foundation.

In 1938, at the urging of Rebay and her European friends, Solomon invested several thousand more dollars to create a Centre Guggenheim in Paris to encourage the "study and diffusion of non-objective painting."[28] The foundation's representative in Paris, art critic and editor Yvanhoé Rambosson, quickly set up a publicity agency, a library, a "Friends of the Solomon Guggenheim Centre" group, and announced a 5,000-franc prize for the best article in French on nonobjective painting.

Rambosson and Rebay soon faced a potential danger in the shape of another Guggenheim: Solomon's niece Peggy. At loose ends in early

1938 following the death of her lover, Peggy had created Guggenheim Jeune, a successful gallery of modern art in London. Shortly before a showing of Kandinsky paintings, she wrote her aunt and uncle in New York asking if they might be interested in buying one of the needy Russian artist's pictures. Solomon referred the letter to Rebay, who answered Peggy with a blast. Hilla resented and feared any other Guggenheim intruding onto the Grand Old Man's turf, and her response was both harshly dismissive and supercilious. "First of all we do not ever buy from a dealer, as long as great artists offer their work for sale themselves," she wrote. And "secondly," she continued in her Germano-English, "will be your gallery the last one for our foundation to use, if ever the need to get a historically important picture should force us to use a sales gallery." Hilla then went on to lecture Peggy on the difference between the lofty mission of her uncle's foundation and the art business. "It is extremely distasteful at this moment, when the name of Guggenheim stands for an ideal in art, to see it used for commerce so as to give the wrong impression, as if this great philanthropic work was intended to be a useful boost to some small shop." Hilla could not refrain from concluding with a boast and another putdown. "Due to the foresight of an important man since many years collecting and protecting real art, through my work and experience, the name of Guggenheim became known for great art and it is in very poor taste indeed to make use of it, our work and fame, to cheapen it to a profit."[29] Peggy reported Rebay's "insolent" letter to Solomon. She also fired back. "I was very amused by your letter," she replied to Rebay. Her good friend, the English art critic Herbert Read, had suggested that she "frame it and hang it in my Gallery." Peggy denied that her Guggenheim Jeune had a commercial focus. "[A]s I do not belong to the first but the third generation of Guggenheims, I do not seek to make money but to help artists." She too could not forbear getting off a cheap shot at the end. "I also have a good and growing collection of paintings. However it does not and never will include second-rate painters like Bauer."[30]

This exchange was in the past, but now in Paris, Peggy reemerged as a threat. In fact, Peggy had come to Paris not to bedevil Hilla but to find richer soil for modern art. Despite its critical success, Guggenheim

Jeune had lost money. London was not sufficiently congenial to modern painting, and Peggy had decided to try again across the channel. But whatever the motives for Peggy's Paris move, the prospect sent a chill through Rambosson, who wrote Solomon in awkward English, that Peggy "would gather up here the whole result of our efforts and our activities." Moreover, Peggy's primary interest in Dada and surrealism, rather than abstraction, was a matter of concern for she would "deviate the movement on a wrong way."[31] In the end, the outbreak of World War II in the fall of 1939, and the German invasion of France the following June, terminated both Guggenheim Paris ventures, Peggy's and Solomon's. The clash between Rebay and Peggy, however, would trigger a feud that would be transplanted to New York during the 1940s and create distrust and lasting ill-will between Peggy and her uncle's partisans and successors.

IT WAS NOT UNTIL April 1939 that the projected Guggenheim Museum of Non-Objective Painting finally opened in New York on several floors of a former automobile showroom at 24 East Fifty-fourth Street in Manhattan. There it remained for almost a decade and then moved several times before settling permanently into its new Frank Lloyd Wright building in 1959, long after Solomon's death.

The new midtown museum, though improvised, was a pleasant space, with thick-carpeted floors and white painted walls covered in part with gray velour. The lighting was soft and fluorescent, a new technology, and Bach and Chopin were piped into the rooms through a top-of-the-line sound system. Visitors were able to rest their feet while sitting on velvet-covered benches. The paintings were actually displayed close to the floor to accommodate Hilla's opinion that they were best viewed while sitting.

The new museum was well patronized, but the collection itself earned mixed reviews. The first public showing, called the "Art of Tomorrow," opened on June 1 with more than four hundred items from Solomon's collection. The critics praised the Légers and Kandinskys but almost uniformly decried the Bauers. Hilla's catalog, however, as if anticipating the attack, defended the German abstractionist as "the greatest of all painters, spiritually the most advanced artist."[32]

Bauer would continue to be Hilla's cross. The critics dismissed him with contempt. Emily Genauer remarked that his paintings were "completely sterile, antiseptic creations."[33] Edward Jewell reluctantly conceded that he was "an artist," but was inferior to Kandinsky and deserved to be considered "academic."[34] When Bauer in person finally reached New York in 1941 after fleeing German-occupied France, Max Ernst, a major surrealist painter, soon to be Peggy's second husband, ridiculed the Museum of Non-Objective Painting as "the Bauer House."[35] The leading members of the art world would also object to Rebay's gassy spiritualism and her egotistic claims to abstract art's chief-prophet status. In later months they also questioned the absence under her regime of American artists.

Rebay's fixation on Bauer undoubtedly undermined her reputation. But she was unable to shake free from the connection for several more years. Hilla had been urging Bauer to leave Berlin for many months. He resisted. Stuffed with Guggenheim dollars, he had been living in high style with servants and a chauffeur. Bauer even had foolish hopes, though he was himself one of the Nazis' "degenerate artists," that he might find favor with the regime and even be appointed minister of culture. He finally awoke to reality when the Berlin authorities threw him in jail for illegal currency speculation. Rebay and Solomon came to his rescue. Fortunately, Hilla's brother was an official of the Nazi Ministry of the Interior. On his advice, Guggenheim money was passed and Bauer freed. He arrived in New York in early August 1939, a month before the war broke out, bringing with him his car and most of his personal possessions.

Once in America, he continued to receive Sol's largesse. The Grand Old Man reinstated his subsidy, in exchange for Bauer's new paintings, and bought him several luxury cars and a palatial home in Deal on the Jersey shore. There Bauer lived in splendor while Hilla made joyful weekend visits. This idyll did not last long. Accompanying the Deal house was a housekeeper, an attractive woman from upstate New York. She and Bauer soon began an affair. When Hilla discovered it she became livid and urged Sol to cut his subsidies to her former lover. But then, when the United States joined the worldwide war in December

1941, Hilla's own status became shaky. She had applied for American citizenship in 1938 but was still a German national when the Japanese attacked Pearl Harbor. She now became an enemy alien. For two months in the fall of 1942 Rebay was held in custody in Boston while charges against her of hoarding food at her house in Connecticut were investigated. She was finally exonerated, but rumors, probably spread by Bauer, soon collected around her that she had Nazi sympathies and despised Catholics, Jews, and blacks. She denied them all, pointing out that she could not possibly have been on such good terms with the Guggenheims if she had been an anti-Semite. Most damaging to her, however, she was not allowed to travel freely from her Connecticut home to the museum in New York, and during these months Sol allowed Bauer to move into the vacuum of managing the museum.

Bauer's reign as Rebay's substitute was a monumental flop. The role of acting director inflated his natural grandiosity, and he proposed that the museum undertake enormous new expenditures for paintings. Sol rebuked him. Bauer should be "made to appreciate fully that our means are *not* unlimited," he wrote Hilla.[36] A year later, the architect Frank Lloyd Wright, now working with the foundation on plans for a new museum, remarked on Bauer's puffed-up ego. "Bauer has been so inflated by the Solomon R. Guggenheim Foundation . . . that he doubtless imagines *he* is the Foundation and without him it could not go on." It was "a sad state of affairs for the 'freedom of the Art of Painting' if it is true."[37] To Hilla, Bauer's marriage to the housekeeper in 1944 was the final betrayal. She could not help bitterly denouncing the new Mrs. Bauer as a tramp, a prostitute. The Bauers sued, and Sol had to pay a lawyer to defend her against charges of slander and defamation of character. The case went to trial in 1945, and Hilla was acquitted. By now Sol too had seen the light and terminated Bauer's subsidy and role at the museum. Bauer later moved to upstate New York, where his wife left him. He died of lung cancer in 1953.

AS THE WAR DREW TO A CLOSE, disappointments and struggles magnified Hilla's eccentricities and turned her into an erratic, irrational virago. Already in Irene's bad graces, she was scorned by the rest of the

family and ridiculed by the art critics. She continued to hold the strings of a very large purse, however, and many artists and gallery owners remained friendly. Most important, she retained the favor of Sol, the one Guggenheim who counted.

Though drained by her gyrations and unruly passions, he continued to rely on Hilla for the remainder of his life. His need was intellectual as well as emotional. "I miss very much talking to you about our future in art in which we are so much interested," he wrote her from Charleston during the spring of 1944. "I always look forward to Sundays and Wednesdays," he wrote again at the end of the year, "because they give me the opportunity to chat with you over the phone and learn that you are well and that everything is running smoothly with the Foundation." He praised her for advancing the cause of "Non-objectivity" and for "the relaxation" she had provided for him. It had "proven such a diversion for me from my many business matters."[38]

When Sol and the foundation finally got around to erecting a permanent building for the collection, Hilla was the impresaria. Ever since 1930 she had been urging Sol to consider erecting a new museum structure fully worthy of the collection. The onset of the Depression had aborted the first proposal, the outbreak of war a second. In 1943, the war notwithstanding, action seemed urgent. Sol was over eighty, and Hilla knew that doubts about the foundation and about her position loomed after his death. But who would design the edifice? She rejected the suggestion of her European friends that the foundation choose an architect from the roster of Central European modernist stars. She had been attacked for her neglect of American painters in the nonobjective museum's shows and wanted to avoid further reproach. That wartime June she wrote a letter to Frank Lloyd Wright at his studio, Taliesin, in Wisconsin, asking if he would come to New York to discuss designing a building to house the Solomon Guggenheim collection. "I need a fighter, a lover, an originator, a tester, and a wise man," she wrote, to construct the appropriate physical setting for the collection.[39]

In June 1943 Wright, though already world famous for his terrain-hugging "prairie" homes and for innovative commercial buildings in Chicago, Buffalo, and Racine, was in a fallow time. The war had dried

up private building commissions, and many of Wright's male apprentices and employees had been drafted. Hilla's letter was immensely welcome, and the white-haired, seventy-six-year-old architect wrote back within the week. Wright knew little of the Guggenheim Foundation and nothing of Rebay. Her first name was unfamiliar, and assuming she was a man, he invited Rebay to come to Taliesin with "his" wife. Hilla responded urging Wright to visit New York instead. As an enemy alien she could not travel, and besides, Solomon would be in town only for a few more weeks. He was already eighty-two, she noted, "and we have no time to lose. . . . On him depends a good deal and he is a great man, full of vision, courage and understanding, loving non-objectivity."[40] Soon after, Wright came to New York, and the parties concluded an agreement for Wright to prepare plans for the structure after a suitable site had been acquired. By the terms of the agreement the building would include space for the gallery, a small auditorium, a penthouse area, small study rooms, and studios for guest artists—"all according to the requirements of . . . Curator Hilla Rebay." Exclusive of the site, the structure should cost a total of $750,000. Wright would receive various sums for preliminary studies and for plans and specifications, the final fee, upon completion and acceptance of the building, to be ten percent of the total cost. Actual construction, it was understood, would be delayed until after the war.[41]

The next months were devoted to finding a suitable site in New York. During a quick visit to the city, Wright contacted his good friend Robert Moses, the New York parks commissioner, and the two tramped about viewing possible locations. They considered Riverdale in the Bronx with a view of the Hudson River palisades. Another location near the Museum of Modern Art in midtown seemed possible, as did several spots on Park Avenue. Wright wrote Solomon, vacationing in New Hampshire's White Mountains, about his reconnaissance with Moses. He was leaving the quest in Hilla's hands, Sol replied, though he would like to see copies of their correspondence on the subject. The site hunt continued for many months and was not concluded until a choice lot on Fifth Avenue and Eighty-ninth Street, opposite Central Park, came on the market in March 1944. The location was far uptown but it appealed to

Wright because of its distance from midtown congestion and its proximity to the park. The deal was quickly concluded. Meanwhile, even before the purchase, Wright had made some preliminary sketches of how the museum should look. There would be many changes thereafter, but the 1944 sketches bear a close resemblance to the final museum when it opened a decade and a half later. The chief feature then, as later, would be the poured concrete main exhibit hall in the shape of a squat, inverted cone. Inside this would be one soaring space. There would be no individual rooms for the art. Paintings would be hung along the inside wall, a wall that sloped outward from the bottom, and patrons would view them as they descended by the spiral ramp from the top.

The model was radical in concept and made even Hilla uneasy. For months she and Wright argued over color schemes, over where to put different schools of painting, over placement of a restaurant and a roof garden, and over how to mount individual works. Some of these had been resolved by the time Wright prepared a model of the museum, but other, more serious ones, remained. Wright's design was truly original, but many critics and artists had doubts about its value as a setting for paintings. The architect had no feel for painting, the skeptics insisted. And Wright did indeed feel that architecture was "the Mother-art of which Painting is but as a daughter."[42] The naysayers urged Hilla to get a second opinion on the building; perhaps consult the architect Mies van der Rohe. When Wright got wind of Hilla's doubts he blew up. "[Y]our fickle fears and suspicions," he charged, "are dangerous—not only to yourself but even more so to the great work we have undertaken together." He feared her misgivings were undermining "this great undertaking of ours." If she persisted, "its great integrity is never going to be realized."[43] Yet these initial difficulties were resolved, and in September 1945, a month after the war ended, a model of the new museum was unveiled to the public with some fanfare with a photo of Wright, Rebay, and Solomon standing together by the large gleaming model. On the occasion Wright told reporters that unlike the museums of the past, the new structure should "serve as an inspiring place where great art should be seen to good advantage in human scale."[44]

Actual construction of the building did not begin until 1952. The structure was innovative not only in its design but also in its engineering.

Many of its structural principles were new and not condoned by existing New York building codes. The objections of the experts would have to be addressed and overcome. Though Solomon seemingly had signed on to the Wright design, he delayed giving the signal to begin digging. Like others, he continued to worry that Wright was placing the physical structure before the art. The paintings, he cautioned Wright in August 1946, "should be in no danger of being overwhelmed by the building. . . . It is to be a building for exhibition of paintings, and . . . to my mind . . . its main object . . . must be emphasized; the paintings must not be subjugated to the building."[45] Sol also worried that rising prices for labor and materials would push costs far over budget. And in fact his fears in this case were justified. In 1946 Wright warned his patron that the final cost of the structure would probably be $1.5 million, twice the original estimate. Two years later he upped the cost to $3 million. Hilla worried that Sol had not provided enough money to build the museum and prevailed on him to alter his will from the $3 million he had originally bequeathed to the foundation to $10 million to the foundation directly, with $2 million earmarked for construction of the Wright building itself.

There were good reasons for both Wright and Hilla to worry in these immediate postwar years. Sol was becoming infirm. In 1943, while at one of his western ranches, he came down with severe stomach pains and in Salt Lake City had an emergency operation for what was described as a hernia from horseback riding. For a time after the procedure his health improved. But by 1948, now eighty-seven, he was clearly very ill. Harry visited Sol in April and reported to cousin Edmond that he "was rather shocked at his physical appearance," though his mind seemed "as clear and active as it has ever been."[46]

Sol faced the prospect of death calmly, and quietly put his house in order. In March 1949 he composed a letter to the foundation trustees that described his early enchantment with nonobjective art and his pleasure that young people had become so enthusiastic about it. He expressed pride in having been able to acquire for the foundation "the finest collection of non-objective paintings in the world." He enjoined the foundation trustees to continue to promote nonobjective art. Sol

took pains to bolster Hilla's status at the foundation. It was through her "self-sacrificing devotion" that the foundation had been able to achieve its present position. No one else could "have accomplished what she accomplished" in the short time the foundation had existed. It was therefore his wish "that in furthering the aims of the foundation, she be provided with every possible help and that her experience be availed of and her advice used even if she should not be able to do all the work she is now doing." During her lifetime, he advised, her approval should be required for any foundation acquisitions, whether by gift or purchase. He also proposed that the foundation provide her with the assistance she needed to continue to paint.[47] The letter might have been written by Rebay herself, except that Sol, his practical sense reasserting itself, noted that his suggestions were nonbinding. That clause would enable the trustees to change the regime at the foundation when the opportunity came.

Sol and Irene spent the summer of 1949 in the White Mountains. They returned to New York in September. Sol was well enough to go to his Manhattan office for a time, but then toward the end of October, his strength drained away. He died at Trillora Court on November 3, 1949, with Irene and daughter Barbara at his bedside.

Six hundred mourners attended the funeral at Temple Emanu-El. Many of the Guggenheims' longtime business associates were present, including Bernard Baruch, George Whitney of J.P. Morgan and Company, Carl Ulrich of Kennecott Copper, and Horace Graham of Anglo-American Nitrates. The family, of course, was there in force, including Eleanor and Arthur, the seventh earl, who flew in from England. Frank Lloyd Wright and his wife, Olgivanna, came from Taliesin; Hilla from her estate in Connecticut. Sol was buried at the family mausoleum in Salem Fields.

Sol left some $20 million, the bulk of his estate, to Irene, his daughters, and his four grandchildren—Eleanor's two sons, Arthur Patrick and Simon Walter, and Barbara's sons, Peter and his half brother, Michael Wettach. As Hilla had hoped, the foundation got $10 million. Two million of that sum was to be allotted to construction of the museum building and the rest to serve as an endowment to maintain the museum and collection and promote art education. The will also formally conveyed

the part of Sol's art collection not already at the museum of Non-Objective Art to the Solomon R. Guggenheim Foundation. Hilla received stock worth about a million dollars in several blue-chip companies. The will said nothing about the paintings in Hilla's possession, bought with Sol's money over the years and never accessed by the museum.

DESPITE SOL'S EFFORTS, Hilla's hold on the museum and the foundation quickly slipped from her grasp. She had worried that Sol's death would end her influence, alter the foundation's direction, and sabotage the Wright museum. And except for the last, it did. The first sign of change came when, shortly after the funeral, the trustees changed the name of the museum from Hilla's choice, the Museum of Non-objective Painting, to the Solomon R. Guggenheim Museum, the preference of the family and the trustees. More defeats were soon to come, and Hilla herself was to blame for most of them.

Solomon's final demise virtually unhinged her. Her anxieties translated into lengthy, almost incoherent letters to Eleanor, Harry, and others, imploring them to hold fast to Sol's purposes and vision. She was right to be anxious, but at first she retained her status. Arthur Castle Stewart, Solomon's titled English son-in-law, became chief foundation trustee after Sol's death. He and Eleanor knew and liked Hilla. She had stayed at their place in Sussex, and they appreciated her sincerity and her role in creating the collection. Not so Harry Guggenheim, who shared the family's dislike of Hilla for her hold on Sol and for her erratic behavior. Unfortunately for Hilla, the Castle Stewarts' distance from the scene limited their effectiveness, and after a year or so Harry took their place as head of the board. The board of trustees was small in these years, consisting, as we saw, of family members and a few long-time Guggenheim business associates such as Albert Thiele, who served as secretary. "It was a very cozy board," Thomas Messer, museum director in the 1960s and 1970s, would later say.[48] Harry had no trouble running it like his fief.

As of 1950, not a single shovelful of earth had been turned at the plot at Eighty-ninth Street, and it looked for a time that none would ever be. In a destructive mood, Hilla told Wright that Harry and the trustees had

heard that he could never finish a project at the agreed-upon price and feared that the $2 million set aside for the museum would prove to be insufficient. That explained, she said, their failure thus far to provide funds. Discouraged, Wright considered walking away from the commission. But he could not bring himself to do so. For Wright, the Solomon R. Guggenheim Museum was a precious prize. All his body of work had been in the heartland; not a single structure in the nation's largest city bore his stamp, and he fought to prevent the commission slipping from his grasp. He wrote Thiele to condemn an unnamed "museum official's" fraudulent claims. Sol's old associate emphatically denied the charge of trustee delays.[49] Wright now turned on Hilla as a meddlesome old fool. At one point he wrote Arthur Holden, his architectural consultant in New York, calling Hilla an "ambitious ignorant woman." If he ever succeeded in "building the thoroughbred building" he "planned for SRG," it would not be "because of her, but rather in spite of her."[50] Wright soon wrote Hilla a choleric and abusive letter. "Your allegations are beneath contempt. The psychopathetic [sic] ward is where such conduct invariably ends and no warning ever saved the patient."[51]

The letter might have ended the relations between the two, but Wright retained some affection for her. It was Rebay, after all, who had recruited him for the great New York enterprise, and he continued to inform her of the latest developments. Yet he could see that the trustees were determined to dump her, and he soon shifted his serious negotiations to Harry and Arthur in England. On a visit to the Castle Stewarts at Old Lodge, Kent, Wright received reassurance that the trustees intended to proceed with the project. Wright urged Lord Arthur to authorize purchase of a small parcel on the north side of the Eighty-ninth Street site to round out the plot, and he agreed to do so. Wright now revised the plan to allow for a new entrance to the museum. He wrote Hilla urging her not to obstruct the changes, which included eliminating a house originally planned for her on the site.

In 1952 Arthur and Eleanor turned over full control of the foundation and the museum construction project to Harry. Harry and Alicia were soon trading visits at Taliesin and Falaise with Wright and his wife. Meanwhile, relations between Harry and Hilla were deteriorating into a

bitter mud-slinging contest. Hilla's health had worsened, and her pain and discomfort made her particularly waspish and suspicious. At times she seemed unbalanced. She had also become more vulnerable professionally. In April 1951 the well-known art editor and critic Aline Bernstein Saarinen blasted Hilla's administration of the collection in an article in the *New York Times*. For the sake of nonobjective purity, Saarinen asserted, Rebay had neglected to display important nonabstract modern paintings from Solomon's collection. Any painting that contained an "object" was "pedantically" excluded, she wrote. Too many of the works on exhibit, moreover, were Rebay's own or Bauer's, though it was the opinion of most critics that no other museum would give these two the same attention. Rebay had also alienated many painters by the "mystic doubletalk" of her catalogs and by tinkering with paintings accepted for display. Saarinen concluded with the harsh proposal that the trustees transfer the whole collection and the foundation's funds to one of the other museums of modern art in the city.[52]

With little patience for histrionic temperaments like Hilla's, Harry went on the attack. He accused her of disparaging him and all the trustees in "insulting and scurrilous terms." Hilla replied that it was he who had started the attacks and that his behavior was more reprehensible than hers because she was a lady. Claiming that he only wished to spare her further "unhappiness," Harry next proposed that she "discontinue" her "duties and responsibilities."[53] In March he forced her to resign as director, though permitting her to retain emeritus status. But Hilla did not go quietly. She continued to attack and even spewed some distasteful anti-Semitic invective at Harry. When she refused to stop, he barred her from trustee meetings, had her allowance for secretarial services terminated, and took away her emeritus status. Hilla responded to her banishment with a mixture of self-pity, self-justification, and incoherent paranoia. "I was almost unprotectedly exposed when the foundation was forced onto me and with enemies of the foundation's work encouraged secretly in our own ranks until my lungs and heart condition in the summer of 1951 were so choking due to over work, so as to be hopelessly ill and considered by five surgeons and specialists to have only two to four weeks to live and now I marvel at how I was able to overcome death due

to Tibetan training. But I am still not rid of the burdens of the responsibility due to international renown and obligation to my late great co-worker, S.R.G."[54]

In October 1952 Harry announced the appointment of James Johnson Sweeney to succeed Hilla as director of the Guggenheim museum. A one-time poet, Sweeney had been a curator at the Museum of Modern Art, where he had championed the most innovative American artists, and had authored books on Alexander Calder and Stuart Davis. He brought a new regime to the Guggenheim collection. After the museum moved to new temporary quarters near the Eighty-ninth Street site, he put many of Hilla's and Bauer's works into storage. Simultaneously he brought in for display Sol's hidden Chagalls, Klees, Légers, and Picassos, and added other celebrated modern painters to the collection. He abandoned Hilla's all-European bias and opened an exhibit of young American painters. Hilla had disavowed sculpture for its "corporeality"; Sweeney acquired sculpture for the collection. The new leadership was widely hailed in the art world. The public had formerly seen the museum, wrote Aline Saarinen in 1954, as "an esoteric, occult place in which a mystic language was spoken." It was now a "lively gallery for living art."[55] Harry would later say that Sweeney was "of major importance in helping me save the museum from the fantastic antics of the past. The museum had become ridiculous, and Jim came just in time to reverse that conclusion in the art world."[56]

Hilla was able to exact posthumous compensation for her humiliation and loss of power. Over the years she had bought many paintings with Sol's money, with the understanding that these would be devised to the museum at her death. When she died in September 1967, however, she gave the works to her own foundation located on her Connecticut estate, Franton Court. The Guggenheim trustees asked that they be transferred to the foundation instead. Her lawyers initially balked but in the end agreed to allow Thomas Messer, Sweeney's successor, to select half the paintings for the Guggenheim. In effect she walked off with half of the works bought with Sol's money. Eventually, the remainder of Hilla's collection was transferred to the Guggenheim as a long-term loan.

* * *

HILLA'S EXILE IN 1952 had left the giant problem of how, or even whether, to proceed with the Wright museum. Ever since publication of the early plans, and especially after the unveiling of the scale model in August 1945, the structure had become a cultural lightning rod drawing some public praise but mostly hostility and ridicule. The Wright building defied traditional canons of taste and seemed to be particularly jarring against the background of the bland red-brick façades of upper Manhattan. The public could not resist making fun of its appearance. Its main exhibit hall looked from the outside to many like a "cupcake" or "a concrete ice cream cone," or an "old fashioned washing machine," or "a fat woman wearing a chemise" or an "oversized and indigestible hot cross bun."[57] Parks Commissioner Robert Moses called it "an inverted cup and saucer with a silo added for good luck."[58] Many artists also disliked it, primarily for the interior arrangements imposed by Wright's plan. In December 1956, after construction had actually begun, twenty-one prominent painters, including Willem de Kooning and Robert Motherwell, signed a manifesto of protest. Given the outward slope of the inside wall, they claimed, the paintings would have to be placed askew. For a painting to be properly mounted "a rectangular wall and level floor" were "terribly important."[59] It was well known, the critics complained, that Wright was no respecter of modern painting, and his museum plan confirmed that conclusion. The museum was a monument to Wright's ego rather than a proper showcase for modern art.

Sweeney himself did not like the spiral ramp and the sloping walls. He disagreed with Wright's scheme to paint the walls beige; he wanted white. Wright preferred natural light; Sweeney believed artificial light necessary. Sweeney, like others, considered the museum an expression of Wright's narcissism. After he left the directorship, he would derisively charge that the plan was a leftover from one of Wright's failed commissions. It was designed originally as "a jam factory or something," he later said, and when that project fell through Wright resubmitted it as a museum "so he wouldn't have to go to the trouble of constructing a new model."[60]

Wright and Sweeney fought out their differences before Harry and the trustees, Sweeney in person and Wright with a barrage of letters

addressed affectionately to "Meine Liebe Harry" and "Lieber Harry, the Guggenheim," but also with visits back and forth, between Taliesin and Falaise. Wright understood Harry's reverence for his family. One bell the architect constantly rang was the obligation to fulfill Sol's lofty vision. He professed to remember Solomon's exact words on the sort of museum structure he wanted and who he wanted to create it. "I want a building to match the advanced painting I want to put in it," he quoted the Grand Old Man as saying. "I believe you can do that building. I trust you."[61] "You, Harry and you, Alicia," the architect wrote in April 1954, "have the background necessary to see the unusual museum the donor wanted and was aware of in every little detail." Perhaps, he added, Sweeney could "be made to see it too, I don't know. He has the conventional museum background which can be useful or destructive as the case may be." But he was hopeful that Harry and Alicia, as well as Lady Eleanor, had "the fate of the Solomon R. Guggenheim bequest in your hearts and consciences—as he saw it and wanted it."[62] The cordial relationship between Harry and Wright assured the museum would survive with its basic design elements intact. Wright won on the spiral ramp and the sloping walls, but Sweeney got his artificial light and the white wall paint.

A more formidable opponent of the Wright building than the New York public, the modern painters, and director Sweeney was the New York City Department of Building and Housing, seemingly allied with the powerful Robert Moses. For a time the Napoleon of New York's parks, bridges, beaches, and highways loomed as a dangerous enemy of the museum. Notoriously, Moses despised modern art and architecture. He admitted to Harry at one point that he did not "personally like either the museum or what's going into it."[63] There was also the matter of an extended feud with Solomon in the early 1930s over rights to a five-hundred-acre stretch of beachfront on Long Island's South Shore. Sol and his friend William Loeb, Jr., had leased the property from Oyster Bay and used it as a duck-shooting preserve. Moses wanted to push a boulevard through the property as part of his development plans for Jones Beach and identified Sol and Loeb as "selfish people of large wealth" who were seeking to "interrupt the park program."[64]

Moses won that battle, but did he hold a grudge and would he fight the application?

In April 1952, after the official transfer of the designated $8 million from the estate to the foundation, Wright and the trustees formally requested a building permit from the city. It was turned down on the grounds that the plan violated the city's building codes on thirty-two different counts. After Wright modified the design over the summer to meet objections, the foundation appealed in the fall to a higher authority, the Board of Standards and Appeals. The board held hearings lasting many months while Wright fumed. He was used to obstructionist bureaucrats, but New York's seemed particularly obtuse. Wright's anger boiled over at the city itself. New York was "fit only for cockroaches," he announced. "Indeed, [it] is inhabited only by cockroaches."[65] In the end Moses, who knew both Harry and Wright and was distantly related to Wright, helped rather than hurt, making calls and writing letters to strategically located politicos and bureaucrats. Finally, in March 1956, the essential permit was granted and construction, it seemed, could begin.

But the problems did not end. Abruptly the Wright-Sweeney war flared up again. Sweeney now demanded that the plans be revised once more to provide additional workspace for the director and the staff. Wright saw this as a move to scuttle the building entirely and wrote Sweeney a scathing letter. He had already accommodated Sweeney's demands at the cost of hundreds of thousands of dollars. "Now, at the final moment, without warning you go back on the whole thing and show by your demands that you have never really taken in the idea of the museum as planned." Either he was acting out of ignorance of the building's overall concept "or, as gossip has had it, you intend to prevent its erection." If Sweeney got his way, Wright would take his name off the plans and would "be ashamed to see the name Guggenheim go up on the building."[66] Wright also wrote Harry to condemn Sweeney and again defend his vision of the museum. The frustrated architect now included Laura, Mrs. Sweeney, among the obstructionists. She was "poison to the house of Guggenheim," he asserted, and even more active than her hus-

band in opposition to the Wright edifce.[67] Fortunately, Harry and the trustees ignored the latest Sweeney attack, and construction could finally proceed.

Wright came to New York for the groundbreaking ceremony on August 16. He and Olgivanna had been renting a suite at the Plaza Hotel for almost two years to keep an eye on the progress of the museum. Now it would serve as a well-used pied à terre while the eighty-seven-year-old architect, in all weathers, visited the building site and clambered over the scaffolding of the emerging structure to supervise, correct, and admonish. It was hard on his aging body, but he could not stay away from his masterpiece, that "great gift to humanity."[68]

But still the struggle over the structure did not cease. Wright felt compelled to the very end to defend his concept and fight off Sweeney and his supporters. Harry found himself uncomfortably caught between the two men. He tried to get out of the line of fire by refusing to head the foundation's construction committee. Yet he could not avoid making decisions about construction or picture-display details, and many of them went Wright's way. Even during the last year of construction the Sweeney-Wright battle continued without letup. In May 1958, citing information that Wright would have his way on the lighting and how the pictures would be hung, Sweeney submitted his resignation. He had obviously lost the confidence of Harry and the trustees, he stated. Anticipating a scandal if the museum's director were to quit with the building so close to completion, Harry sought to soothe Sweeney's feelings. Yet at the same time he chided Sweeney for his apparent insistence that the trustees had no right to consider matters such as how to present the collection. If that was Sweeney's view, he would, "with deep regret," have to accept his resignation.[69] Chastened by Harry's reproof, Sweeney backed down and withdrew his resignation.

Yet Harry was losing patience with Wright too, especially his constant invocation of Solomon's supposed wishes regarding the museum. "Now, finally, let me lay once and for all, my uncle's ghost that you exorcize [sic] when all else fails," Harry wrote in July. He had examined Solomon's correspondence about the museum and there was "not one

shred of evidence to support" Wright's "reiterated appeal to the memory of, to paraphrase you, that 'good man our benefactor who must not be betrayed.'" Indeed, he said, from the archival evidence it was clear that Uncle Solomon was worried that the planned museum would not properly display his beloved collection. Harry censured Wright for failing to ever answer Sol's doubts, and asked him to cease his "diabolical maneuvers." But he conceded that the Wright building was "for the angels." "Let us finish this job," he pleaded, and "help us dedicate in harmony your beautiful and ingenious pile to an eager world."[70] In the struggle over the museum Alicia often sided with Wright against Sweeney. On the other hand, Olgivanna hurt the cause by openly disparaging Harry, forcing Wright to deny he had had anything to do with her remarks.

As the structure neared completion, Wright saluted Harry for his support. Despite his occasional wavering, Harry had made the building possible. "I am fully aware," Wright wrote in late November 1958, "that but for you the Museum would never have been built."[71] In January Wright visited the site for the last time. The building was almost finished. The wooden forms for the poured concrete were down and the structure fully revealed, either in all its glory or in all its infamy, depending on the observer's point of view. The public came to gawk and carp or to wonder and admire.

Wright did not live to see his museum completed. While visiting Taliesin West, his western branch studio and school near Scottsdale, Arizona, he was rushed to the hospital with an intestinal blockage. He died on April 10, 1959, just before his ninetieth birthday.

The opening of the museum was marked with a series of gala celebrations starting with a preview for the media and art critics on October 19. The next evening there was a viewing by friends of the trustees and of the family, as well as by prominent collectors, curators, and gallery owners. One guest was Harry's cousin Peggy, visiting from Venice. Peggy had not been in New York since 1947 and had not seen her cousin for thirty-five years. The occasion revived an arrested relationship. The formal opening came on the morning of the twenty-first with a ribbon-cutting ceremony and speeches by HEW Secretary Arthur Flemming, UN Ambassador Henry Cabot Lodge, New York's Mayor Robert Wagner,

and Robert Moses. Excluded from the speakers' list were Olgivanna
Wright and James Sweeney. Harry later told author Milton Lomask that
he feared that if they spoke they would "present their extreme views" and
"hold the museum up to ridicule."[72] Olgivanna managed to stir things up
anyway by telling reporters that had her husband lived, he would proba-
bly have stayed away rather than swallow Sweeney's last-minute changes.
Hilla Rebay remained at her Connecticut estate. She disapproved of the
inaugural exhibition for including too many representational paintings,
and came to none of the ceremonies.

That afternoon the public, lined up for four blocks on Fifth Avenue,
was finally admitted to the building. However maligned during con-
struction, once completed the building was an enormous success with
New Yorkers and other visitors. Within six months of its opening half a
million people had paid 50 cents apiece to pass through its glass doors.
Yet it is possible that many visitors were drawn more by a kind of pruri-
ent curiosity to see so notorious an edifice than by a sincere appreciation
of the building or of modern art. As for the critics, they remained
divided. At the *New Yorker* Robert Coates called the structure a "daring
and adventurous building," but insisted that it suffered from "serious
drawbacks as a museum." The *New York Herald-Tribune*'s art critic
judged the Wright edifice "the most beautiful building in America" and
also wonderful as a museum.[73] Everybody joined the critics' chorus,
including sports writers and women's page editors. Architecture critic
Ada Louise Huxtable summed up the response. The museum building,
she wrote, "has been hailed as a masterpiece, attacked as an atrocity,
called the finest museum of all time and denounced as no museum at
all."[74] To this day, opinion is as divided as it was half a century ago.

SCARCELY HAD THE dedication ceremonies concluded than Sweeney
abruptly left. Officially he resigned, but it is clear that he was actually
fired. In his resignation letter he claimed he was leaving because of the
differences between the trustees' "ideals" and his own "with reference to
the aim and uses of the museum." Harry's response sought to clarify what
the differences were. He was defensive. After a pro forma acknowledg-
ment of the director's splendid job, his brief letter to the press empha-

sized the success of the museum as a public attraction. Some 750,000 people "from all walks of life" had visited the museum, he noted, and he concluded from this fact that it was now time to focus on making the museum into a tool of public education. Programs should be developed that would be "interesting, informative, and educational to an ever widening number of art lovers."[75] Presumably Sweeney did not agree and so had been let go.

It is easy to see the confrontation between Sweeney and Harry as an example of the eternal tension between popularity and purity in the arts. Though Sweeney was not indifferent to the museum's role as an agent of public enlightenment, he feared the vulgarization of its mission. He was, in many ways, an unabashed highbrow who once wrote that "the highest experiences of art are only for the elite."[76] Harry, on the other hand, though scarcely a democrat, was a businessman concerned about box office "take" and paying the museum's bills. At 50 cents a person, the "gate" was not irrelevant. But was this all? Sweeney continued to dislike Wright's setting for paintings and sculpture. Harry and the trustees, whatever their previous doubts, believed it had proved itself and found the director's complaints grating.

After a brief interregnum in 1961, Thomas Messer took over as third director of the museum. Czech-born, American-educated, a suave diplomatic man with a slight *Mittel European* accent, Messer had headed the Institute of Contemporary Art in Boston. He had been recommended by a former director of the Art Institute of Chicago, and Harry accepted his advice. After his experience with Hilla and Sweeney, Harry was suspicious of the directorship function, however, and induced the trustees to divide his authority. There would be an administrator who would attend primarily to business affairs, while the director's role would be confined to the pure "art" side.

Under Messer the museum became one of the world's major showcases for modern painting and sculpture. Like Sweeney, he refused to abide by Rebay's formula that anything figurative was verboten. Messer added to the collection works by Francis Bacon, Klee, Miró, Calder, Schiele, and Dubuffet. He tried to avoid trendiness, but when pop art came along, he felt compelled to join the flow. In 1969 he gave a one-

man show to pop artist Roy Lichtenstein, he of the comic strip characters. Harry and most of the board members profoundly disliked the show, and Harry made his feelings known, but he did not veto it. Harry also disdained the "minimalist" exhibitions in the late sixties.

Sweeney had run the museum as a one-man operation. Messer added a flock of curators to help him administer and develop special collections. As Harry came to trust his director, he eased out the business manager and transferred his authority to Messer. Yet for his first decade at the museum, the director had to share his power with Harry. When it came to the "High Priest of the Clan," Messer had no illusions. "Harry Guggenheim was certainly the last word on everything," he told an interviewer in the mid-1990s. "We were all scared out of our wits. Harry was an overwhelming personality."[77] Harry "called the shots," he told Robert Keeler.[78] The board of trustees was merely a rubber stamp. It met infrequently, and when it did, Harry ran through the short agenda in brisk tempo. Nobody on the board "as much as cleared their throats," Messer remembered.[79]

Unfortunately, Harry was not an expert in modern art or art in general. In Messer's view, none of the Guggenheims, with the exception of Peggy, "had a personal relationship of any intensity with art." As they conceived it, he said, art was an elevated enterprise, a reverent endeavor, a testament to civilization. This attitude, of course, was the very antithesis of defiant modern art movements. The Guggenheims, Messer believed, were interested in the museum primarily "as a monument to the family." In fact, Harry considered the museum "an extension of his home."[80]

But Harry was educable and in fact eagerly pumped his director for advice and knowledge. Messer took Harry to gallery showings on Saturdays and had long conversations with him about art and artists. He used these occasions to get Harry's approval for purchases he wished to make. If Harry said "OK," the acquisitions committee would automatically approve it.

During the decade that Harry headed the board, the museum lived primarily on the income from its endowment, supplemented by patron admissions. At one point it also sold off fifty lesser Kandinskys from its

collection, prompting an outcry from critics who considered it some sort of betrayal. At most other nonprofit institutions—museums, universities, foundations—trustees were major financial contributors. In fact they were usually appointed to the boards in expectation of large donations. But at the Guggenheim neither Harry nor the other trustees contributed more than token amounts either to the museum's operating expenses or to purchase new art. The one exception was Harry's substantial donation in 1963 for a ceramic tile mural by Joan Miró in honor of Alicia.* Unlike Sweeney, Messer was not too inhibited to solicit outside gifts, but he was never very enthusiastic or successful. Fortunately, in the 1960s, the museum's annual budget was low, about a million dollars a year.

Even after Harry's death in 1971 the family continued to play an important role in the museum's affairs. For a time, as under Harry, the board of trustees remained a family affair, essentially a small circle of Guggenheims and their long-time satellites. But Peter Lawson-Johnston, Harry's successor as board president, was less authoritarian and less intrusive than his cousin. His relationship with Messer was more that of a friend than boss-employee. Peter shared Harry's sense that the Guggenheims owed an obligation to art but was less interested in understanding it and discontinued his cousin's gallery visits and informal seminars with Messer. On the other hand, Messer found him easier to get along with than his cousin.

Peter and Messer together presided over a steady growth of the museum. Peter guided the construction of a four-story annex in the 1960s and then, twenty-five years later, of an addition that increased its height six additional floors. The collection too was augmented and enriched. In 1963 the museum acquired on permanent loan the important Thannhauser collection of Degas, Manets, Picassos, and others. In 1976, on Thannhauser's death, these treasures were bequeathed to the museum permanently. A highlight of Messer's administration was the

*Nineteen feet long and eight feet high, this abstract work was hidden from view from the 1990s on because it was believed to distract attention from other exhibits. It was temporarily uncovered in the summer of 2003 when the museum displayed its permanent collection.

museum's acquisition in 1974, after years of negotiation, of Peggy Guggenheim's $40 million collection of modern art, a subject to which we will return.

As the museum expanded, it outran its original resources. Peter responded by appointing corporate executives to the board. In 1993 he retired and turned the running of the museum over to Peter B. Lewis, a rich auto insurance company executive. Two years later Revlon CEO and corporate raider Ronald Perelman became the foundation's president. In 1998 Lewis gave the museum a cash gift of $50 million. But even when the new members did not themselves contribute money, they opened doors to others who did. Yet more was needed, and director Messer began to solicit in earnest grants and gifts from individuals, foundations, and government agencies. The museum also began to copy the practice of its peers of selling "memberships" that entitled prosperous friends of the museum to various privileges. The new approaches were effective. By the late 1980s the museum's budget had expanded ten times to $10 million annually. And yet Messer felt the museum was always underfinanced.

Messer retired in 1988. During his quarter century as director the museum attained world renown. In part its success flowed from the quality of its permanent collections; in part from the brilliant exhibitions that Messer mounted of borrowed works. But perhaps it was the Wright building that kept the name Guggenheim before the wider public. Did the aesthetic controversy that swirled around the structure at its birth ever settle into a consensus? Was the building an effective showcase for great art?

The aesthetic conundrum cannot be solved since in matters of taste there is no final authority. There are those who bow low before the building's architectural glory. After its restoration in the early 1990s, art critic John Richardson called it "perhaps the greatest building by perhaps the greatest modern architect in America."[81] Others continue to call it a "cupcake" or worse. Overall, today, after more than forty years, the building's deficiencies and aesthetic absurdities have been softened by familiarity. To many critics it has attained an endearing ugly-duckling quality. As for its practicality, that still remains in serious doubt. One problem with Wright's chef d'oeuvre was insufficient room. This deficit

was partly rectified in the early 1990s by construction, as we saw, of an attached ten-story tower for additional office, gallery, and storage space. More daunting were the awkward angles and surfaces of the main hall. According to Richardson, in the Wright building paintings had "a way of looking like posters or pimples," sculptures "like unclaimed luggage."[82]

MESSER'S SUCCESSOR was Thomas Krens. Peter endorsed Krens and supported his administration of the museum, but there is reason to believe that Krens also reflected the entrepreneurial spirit that the new business leaders brought to the board.

Appointed in 1988, Krens was a tall, balding, former basketball player of forty-one, previously director of the small but prestigious art museum of Williams College. In 1986 he had helped create the Massachusetts Museum of Contemporary Art (Mass MoCA) in North Adams in the Berkshires, a twenty-six-building arts complex assembled out of the abandoned factory buildings of the Sprague Electric Company. Chosen for the Guggenheim museum by Peter Lawson-Johnston, primarily for his enterprise, he did not disappoint his sponsor. Krens considered works of art "assets that have to be maximized." The museum's collection, he said, represented "$3 billion worth of stock."[83] To solve the eternal problem of money he resorted to what has been called "McDonaldization." Modern art, he seemed to believe, was a brand-name consumer product, and the Solomon Guggenheim Museum was the home office for a marketable commodity that could be franchised. The first actual Guggenheim branch, established in 1992, was in Manhattan's SoHo district, a neighborhood created in the 1970s to replace high-priced Greenwich Village as a suitable locale for artists, galleries, boutiques, and chic restaurants. Like all successful franchise entrepreneurs, Krens soon expanded overseas. In 1997 the Guggenheim dedicated a striking new museum designed by Frank Gehry in Bilbao, Spain. This branch helped the museum's bottom line considerably. Besides agreeing to invest $10 million for constructing the building itself and raising another $50 million to stock it with art, the Spanish promoters promised $20 million to the Guggenheim's endowment.

Another branch, the Deutsche Guggenheim, opened in Berlin the same year as Bilbao. Dissatisfied with the space on upper Fifth Avenue, Krens launched a campaign to build another Gehry-designed structure in lower Manhattan, estimated to cost $900 million. In October 2001 he opened a branch in fast-growing Las Vegas. Much of the expansion funding, as in the cast of Bilbao, came from arrangements with other museums and civic groups anxious to secure a cultural franchise, much like a major sports team. Some of it, however, came from selling off parts of the permanent collection in New York. The *Wall Street Journal* estimated that Krens had netted more than $10 million from sales in 1999.

Few in the art world approved of Krens's grandiosity. Several praised his imagination, but many critics considered his campaign mercenary and culturally shoddy. In early 2002 Jerry Saltz of the *Village Voice* called his "vision" a "ruse masquerading as a wow." Krens was creating "glitzy palaces and high-concept productions dependent on onetime out-of-town visitors." He had turned the Guggenheim into "a rogue institution, broken faith with art, and stripped it of the reputation won for it by generations of artists and curators."[84] The famous art critic Hilton Kramer in late 2002 was asking why Krens had not been fired. In his fourteen-year tenure the Guggenheim had "virtually ceased to make a significant contribution to the art life of New York."[85] On the other hand, the Krens administration has its partisans. Within the family itself Peter Lawson-Johnston defends his choice of successor to Messer as a wise one. Dana Draper, Harry's grandson, also endorses the Krens regime. Now in his mid-sixties, Dana is an artist and craftsperson in California, but remains on the Guggenheim museum's board. Weary of the conventional conduct of museum affairs, he is intrigued by the director's bold innovations, which he sees as populistic.

Krens's cultural franchise system was a by-product of the 1990s "bubble" years when the American economy seemed invincible. Reality intruded with the new millennium and the collapse of the "irrational exuberance" that marked it. Attendance at the flagship New York museum fell by 25 percent, and corporate funding plummeted. The

museum cut its hours. In late 2002 museum chairman Peter B. Lewis announced that radical retrenchment in staff, programs, and exhibitions would be necessary and hinted that the museum's very survival was in jeopardy. With the mother museum in trouble, the branch in Las Vegas, while retaining a toehold in the city, virtually closed its doors in January 2003, just fifteen months after it opened. In 2002 the ambitious spinoff planned in lower Manhattan was abandoned.

Krens was criticized not only for his entrepreneurial approach to modern art but also for his curatorial judgment. During the last decades of the twentieth century the abstract art that formed the original core of the Guggenheim's collection fell from critical grace. Once seen as the vehicle of cultural emancipation and an instrument of antibourgeois rebellion, by the 1970s it had come under a withering barrage from critics of the left as elitist, as an expression of philosophically reactionary "idealism," and as an American cold war cultural weapon. In 1996, to counter the new antagonism, the museum mounted an exhibition, "Abstraction in the Twentieth Century," organized by curator Mark Rosenthal.

The showing was not a complete critical success. The "progressive" critics of "high art" and post–World War II American cultural "hegemony" predictably disparaged it. But even Hilton Kramer, a political conservative, considered it disappointing. The exhibition, he held, did not do justice to the art it was intended to defend. It did not display a truly representative sample of the abstract school and failed to defend it vigorously enough. In the last pages of Rosenthal's catalog, Kramer declared, he all but "surrenders to the enemies of abstract art in a feckless attempt to appease and accommodate their assault upon it."[86]

Whatever his failings, Krens has undoubtedly perpetuated the renown of the Guggenheims. Few people know anything about the family's achievements in metallurgy, aviation, or journalism. But it would be hard to find a literate American who is not familiar with the Solomon R. Guggenheim Museum. One component of its fame, of course, is the odd, nonconforming building on upper Fifth Avenue that

so narrowly escaped oblivion. Along with the grant-conferring institution created by Solomon's younger brother Simon, it is one of the pillars that elevates the Guggenheims above the undifferentiated jumble of mid-rank early-twentieth-century business tycoons. Krens, at whatever cost, has reinforced a flagging fame by his controversial ambition and overreach.

CHAPTER ELEVEN

A Fool for Love

PEGGY GUGGENHEIM was driven all her life by her quest for love. Perhaps we all are. But seldom is motive so transparent as in her case. Not usually self-aware, she understood her deepest emotional needs. "Love is the best thing," she told a friend, "even if it is the most painful."[1]

Love was so precious for her because it was so meager. Her mother, Florette, was an emotionally impaired woman incapable of showing affection, at least to her children. Her father, Benjamin, seems to have loved his daughters, but he withdrew from his wife and children when Peggy was young to live abroad and then disappeared abruptly from her life when the *Titanic* went down in 1912. Peggy had two husbands and many sexual partners, but they did not love her—at least she did not believe so. They seemed to cherish her money more than her person. Her sisters might have filled her hollow heart. But Benita died young and Hazel was her rival. Friends and children? Peggy's two offspring, Pegeen and Sindbad, both had stormy relationships with their mother. She loved them in her way, but her devotion was not fully returned. Both fought constantly with her even during the usually calm years of childhood before raging hormones well up. Peggy had scores of friends, but with the exception of Peggy David, an old New York chum, few of

them were loyal or trustworthy. In later years many would disparage her cruelly.

Peggy's human contacts were tainted by money. She was never rich by the standards of her Guggenheim relatives: in her own mind she was "the poor Guggenheim." But after her mother died her trust funds totaled about a million dollars, and through World War II they yielded perhaps $80,000 a year. Though modest by Guggenheim family standards, that amount went far in the first half of the twentieth century and gave her exalted status, and impressive weight, among the struggling artists she cultivated.

Peggy's relationship with money was confused. Like her mother, she could be astoundingly cheap. The stories are innumerable. Laurence Vail complained that during most of their married years they "lived in a house with orange crates." "We had no furniture," he declared.[2] On one occasion she insisted on collecting $3 from her aunt Irene for the catalog to the Art of This Century gallery though she hadn't seen her for years. Her parties in New York during the 1940s attracted the elite of the international art community, but she served little more than whiskey and potato chips as comestibles. During her years in Venice she would traverse the entire city to buy toilet paper at a bargain price and paid her servants so little that they would not stay. Yet she was capable of spontaneous generous acts. For many years she sent money to her old Jacoby School teacher Lucille Kohn so she could devote her time to liberal causes. She gave freelance photographer Bernice Abbott 5,000 francs to buy a good camera to do her work. She donated $10,000 from her grandfather James Seligman's bequest to the support fund for British miners during the militant 1926 general strike. During the winter of 1943 she gave her stepson Jimmy Ernst the money to buy an overcoat when she noticed he was shivering in the cold.

She used her wealth to buy love but it often had the opposite effect from her intentions. She supported Pegeen and Sindbad to the tune of $12,000 a year. But as Sindbad carped, "She didn't teach us how to make our own."[3] She subsidized her first husband, Laurence Vail, even after they were divorced, but that did not keep him from betraying her constantly with other women. For many years she sent checks to novelist Djuna Barnes so she could devote herself to her writing, but Barnes

deeply resented her benefactress. At one point she taunted Peggy: "You've got the money, but I've got the brains."[4] The painter Jackson Pollock and his wife, Lee Krasner, would at times have gone hungry if not for Peggy's stipends. They ended up detesting her.

Peggy's lifelong pursuit of love was undoubtedly spurred by her impaired physical self-image. She had been a pretty little girl, and even adolescence did not completely overwhelm her charms. She had blue eyes, an oval face, and a winning smile. She remained slender until she was in her sixties. According to a friend who knew her as a young woman in Paris, "she had an elegant figure and had the money to dress well."[5] She was always proud of her slim ankles, though they gave her trouble most of her life and seem downright skinny to modern tastes. Her great physical flaw, nullifying all her other graces, was her nose, the feature she tried to revise back in 1920 and had undoubtedly made worse. Seen full-face it was not unsightly. Viewed in profile it was a clown's nose with a large bulbous tip. Her sister Hazel called it a "terrible nose, like a potato."[6] The painter Theodore Stamos, even more cruelly, compared it to an "eggplant."[7] Peggy tried to avoid being photographed in profile, but in some of her surviving pictures her nose, seen from the side, seems almost grotesque. Her nose seldom went unremarked and undoubtedly damaged her self-esteem.

PEGGY NEVER LIKED her own country. She and her sisters had been taken by their parents to Europe at an early age, and she enjoyed the visits. Her cosmopolitan upbringing kept her from ever putting down roots in America. In 1920, after six months at Sunwise Turn, the New York book store, Peggy, now twenty-two and finally in possession of the half-million dollars her father had left her, decided to follow her cousin Harold to Europe. That she expected to make Europe her permanent home is unlikely. She was probably drawn by the same fascination that was beginning to pull thousands of young Americans to Paris as peace returned and the Great War's echoes subsided. On this first postwar trip Peggy was accompanied by Florette and a cousin, Valerie Dreyfus. The trio traveled not as pilgrims to the Left Bank but as rich ladies wrapped in furs who stayed at the best hotels. They started with Britain, visiting

the Lake District and Scotland and then crossing the channel to tour Belgium and Holland and the French chateau country, ending with Paris, where they put up at the elegant Hotel Crillon.

Like many prosperous Americans in these years, they treated western Europe as one giant museum. Peggy later remarked of this trip that "I soon knew where every painting in Europe could be found, and managed to get there, even if I had to spend hours going to a little country town to see only one."[8] She not only viewed art; she read about it. On the advice of a new acquaintance, Armand Loewengard, she read the major works of art critic and historian Bernard Berenson, absorbing his first principles for properly assessing a painting and learning about the old masters and their times. The self-instruction undoubtedly sharpened her artistic perceptions, but scarcely prepared her to appreciate the new art currents of the twentieth century.

During these first months in Paris Peggy collected beaus and frocks along with cultural knowledge. Parisian couturiers had discovered the flapper and were designing slinky dresses with short skirts, accessorized with satin shoes, feathered headdresses, and headbands. Peggy was quick to adopt the new style along with the other complements of the flapper dress uniform: short, pomaded hair, painted-on eyebrows, and small, brightly lipsticked mouth. It remained her uniform well into her middle years.

In early June 1921 Peggy and Florette came back to New York for Hazel's wedding to Sigmund Kempner. They returned to Paris soon after with two friends in tow from Peggy's months with Sunwise Turn, Helen and Leon Fleischman. Mother and daughter put up at another luxury hotel, the Plaza-Athénée.

By this time Paris was well launched as refuge-of-choice for oddball, creative, rebellious, dissolute, and adventurous young Americans anxious to escape what they considered the stifling conformity and materialism of their native land. For expatriate Americans Paris became the capital of freedom, the place where they could express their every hidden, repressed urge and unleash their buried talent. Peggy soon detached herself from her mother's world and joined the fun.

The catalyst for her breakout was Laurence Vail, whom she had met

briefly in New York when she worked at Sunwise Turn. Vail had recently become the lover of Helen Fleischman, who lived in an "open" marriage with Leon and had wasted no time, once in Paris, to put her marital principles into practice. One evening the Fleischmans invited Peggy and Laurence to join them for dinner. Vail was thirty and not self-supporting. He lived with his mother and his adored sister Clotilde in an apartment near the Bois de Boulogne and spent his days and nights in the cafés of Montparnasse. He loved parties and wrote plays and verse, some of which made it into avant-garde magazines. Vail was taken with Peggy. She was seven years his junior, naive and shy, yet stylish and still bursting with the juices of youth. She was also an heiress. The combination was appealing, and after dinner Vail invited Peggy to take a walk with him up the Champs Élysées and along the Seine. It was the beginning of a new life for Peggy.

Vail was the quintessence of the twenties cultural rebel. Peggy called him "the King of Bohemia."[9] Though he was born and raised in France and Britain, his parents were American. His mother, Gertrude, an avid mountain climber, could trace her ancestry back to prominent seventeenth-century New England clergymen. His father, Eugene, was the son of a New Yorker and a Breton woman. Though a double-dipped neurotic, Eugene was a moderately successful landscape painter who had won a gold medal for his work at the 1889 Universal Exposition. Both Gertrude and Eugene were indifferent parents, and Laurence and Clotilde clung tightly to each other to protect themselves from a heedless world.

When Peggy met him Vail was an attractive, charming man. Of middle height, he had streaky blond hair that he wore longer than conventional American men. He had an aquiline nose and a somewhat weak chin but he was considered handsome. He dressed bizarrely: red or pink shirts made of material for curtains and bedsheets, blue sailcloth trousers, terra-cotta or azure overcoats. These he had made up by London tailors from material he supplied. He had attended Oxford and was well educated, especially in the arts. He seemed to know everyone who counted in the Paris cultural world. Peggy saw him as everything the people she knew were not: bold, experimental, original, passionate—

and gentile. He was "from another world," she later wrote. He was like "a wild creature. He never seemed to care what people thought."[10]

Peggy at twenty-three was still a virgin, no matter how flirtatiously she behaved. But she was intensely curious about sex and had studied closely the famous Roman frescoes from the excavated Pompeian brothel that illustrated many exotic varieties of sexual embrace. Early in their relationship she resolved to use Laurence to advance her education. One day, while Florette was away, he came to Peggy's hotel room and started to make love to her. Peggy responded, but noted that her mother would be returning soon and insisted that they transfer their activities to another venue. They went to a hotel, where Peggy demanded that Laurence perform the sex act in every way the frescoes depicted. He apparently did, though even he was amazed at the variety of positions demanded. As Peggy later conceded, "I think Laurence had a pretty tough time."[11]

Helen Fleischman surrendered her lover without a murmur when she heard of Peggy's affair with Laurence. From then on he devoted all his attention to Peggy, who must have struck him as a real find: a sexual prodigy as well as a rich American. One day, while surveying Paris from the top of the Eiffel Tower, Laurence proposed marriage. Peggy immediately accepted but then Laurence had second thoughts. Both families opposed the match. Gertrude Vail sought to break it up by pushing one of her son's old flames back into his life. Florette, when told of the engagement, was dubious and insisted on checking out Vail's credentials. Despite the skepticism on both sides, the marriage came off on March 10, 1922 at the *mairie*, the local registry office, of the Sixteenth Arrondissement. The later Plaza-Athénée reception was a microcosm of the people in the married couple's lives. Gertrude Vail brought much of the American colony in Paris. Florette rounded up her French Seligman cousins. Laurence brought all his bohemian acquaintances, but including, apparently, tramps and prostitutes, gathered off the street. The reception was suitably festive. Supplied with endless champagne by Florette, the celebration went on for hours with lots of jollity. The married couple then went off to bed at a separate hotel. The next day at lunch, the prurient Florette questioned her daughter about her bridal experiences the night before, much to Peggy's disgust.

A few days later Peggy and Laurence traveled to Rome to begin their honeymoon. They dropped in on cousin Harold, who was busy publishing *Broom*. Though himself a rebel against bourgeois conformity, Harold was surprised at Laurence's dress, especially his bare feet in sandals. At Harold's request Laurence dashed off a short poem for *Broom*, "Little Birds and Old Men." As we saw, it triggered a crisis between Harold and his uncles when it appeared in the September 1922 issue. The wedding party next moved on to Capri, where they expected to spend most of the summer.

In 1922 the island in the Bay of Naples was still an unspoiled Lotus Land, a place of beautiful flora, magnificent headland vistas, exquisite climate, and sybaritic indulgence. Peggy and Laurence had rented a villa, and she expected they would walk and swim and mingle with the exotic folk who made the island their refuge. But Peggy's time was spoiled by the appearance of Clotilde, who won Laurence's attention more than his wife. "She did not relinquish one inch of him to me," Peggy would complain.[12] Clotilde was more promiscuous than Peggy at this point, and her many Capri lovers made Laurence insanely jealous. She also tried to run Peggy's household, and to top it all, she was prettier than her sister-in-law.

Toward the end of the summer the trio left Capri and drove through Italy, ending up at San Moritz in Switzerland, where they were joined by Gertrude Vail and some friends. Soon after, Peggy sailed to America to visit Benita while Laurence went off with Clotilde to the Basque country of Spain. In America Peggy began to feel unwell and returned to Europe with her aunt Irene, bunking in her stateroom aboard ship. She soon realized that she was pregnant and radioed the news to Laurence, who met the ship at Southampton. Neither parent wanted the child to be born in France, fearing that if a boy, he would be subject to French military service. They decided they would return to France, but in May Peggy would come to London to have the baby under the supervision of cousin Eleanor's obstetrician.

Back in Paris Laurence and Peggy began what would become the pattern of their married life. Laurence loved big parties, and now well supplied with money, he threw many for his friends and for strangers who

promised to liven up the proceedings. They also had a taste for the bucolic and spent part of the winter in the south of France.

Laurence was a violent man who made nasty scenes, especially when drunk. On one occasion, early in his relationship with Peggy, he got into a fight at the theater with other patrons over a play that he liked and they despised. The police had to be called to rescue him from his enraged opponents. Another time, during the months of Peggy's pregnancy, while staying at the Hôtel Lutétia, Peggy told him she was in love with her Russian lessons teacher. Laurence grabbed an inkwell and threw it against the wall. It had to be repapered. The most spectacular outburst, however, came later while Peggy, Laurence, Clotilde, and some friends were having dinner at Pirelli's on the Left Bank. In another corner of the dining room five animated Frenchmen, all army officers, were eating as well. Laurence, as usual well along in drink, thought they were making fun of him and his friends. Walking over to the bar, he seized some bottles from the shelf and hurled them at the laughing Frenchmen. One of the bottles almost brained one of his targets. The officers called the police, who arrested Laurence and hauled him off to jail. Distraught, Peggy spent the night walking the Paris streets accompanied by a sympathetic recent acquaintance, the painter Marcel Duchamp. Fortunately Laurence received a six-month suspended sentence and Peggy was able to gather him up the next day and take him home. As on this occasion, in his rages Laurence often threw bottles. Alluding to his later foray into crafts, he admitted that he was "an emptier, thrower, and decorator of wine bottles."[13]

In late April, as planned, Peggy and Laurence went to London for the birth of their baby. Benita, visiting from New York, joined them to help out. Florette, a fussbudget, had not been told till the last minute to keep her from getting in everyone's hair. When finally informed, she too came to be present at the great event, staying with Benita at the Ritz. The baby, a boy, black-haired and healthy, arrived on May 15. He was named Michael Cedric Sindbad, but was always known as Sindbad, after the Arabian Nights character whom Laurence admired. While in London Peggy needed more help with the baby than her family could provide. She nursed him for a month, then ran out of milk. Eleanor's doctor for

some reason made her stay in bed for three weeks. Her old friend from New York, Peggy David, an intelligent woman who slipped in and out of her life* and now lived in London, offered help. Peggy David had "the logical brain of a man," her best friend believed, and could always be counted on to provide practical help and wise advice.[14]

Peggy, Sindbad, and Laurence returned to Paris in time for Bastille Day, bringing a young nurse recommended by Eleanor to care for the baby. In the months that followed they went off again with Clotilde and Peggy David to Capri, where Laurence was arrested and jailed for assaulting one of Clotilde's new lovers who, she claimed, had insulted her. At the trial he pleaded that he was drunk and intended no harm. He was acquitted. After the trial the party traveled to Amalfi, and without Clotilde and Peggy David, Peggy and Laurence moved on to Egypt. Here they immersed themselves in the local culture, drinking sweet Turkish coffee, eating roasted lamb at Arab restaurants, and shopping at souks for trinkets, local textiles, and earrings. In the Arab quarter one day Peggy inexplicably gave Laurence "an evening off" to sleep with a beautiful Nubian belly dancer.[15] To Peggy's horror he returned to her the next day with a case of crabs.

Leaving Sindbad and his nurse in a Cairo hotel, Peggy and Laurence took a side trip to Jerusalem. The Zionist experiment with "a Jewish national home" was already well under way, but in Peggy's view it was not working very well. She appreciated neither the kibbutzniks, the idealistic young Zionists who had established cooperative agricultural colonies, nor the older community of religious Jews in traditional dress who spent their days praying at what then was called the Wailing Wall. In contact for the first time with her medieval forebears, Peggy felt the disgust of an assimilated German Jew. "It mortified me to belong to my people. The nauseating sight of my compatriots publicly groaning and moaning and going into physical contortions was more than I could bear and I was glad to leave the Jews again."[16]

Back in Paris that fall the Vails rented an apartment for six months

*Peggy David was married to Edwin Loeb, Peggy's cousin, in 1916. The marriage was brief, and in 1934 she would marry Milton Waldman, Hazel's former husband.

on the Boulevard Saint-Germain. There they gave many raucous parties usually on Sunday evenings. With so many oddball strangers, artists, and Left Bank eccentrics as guests, Peggy worried about the silver count and about the state of her sheets and floors. She sprayed the beds with Lysol to prevent venereal disease and assigned one of her cousins to keep guard over the forks and spoons. Peggy presided over her parties dressed like a slender, exotic bird, in a long dress of gold lamé, covered in glass beads, designed by Paul Poiret, who created costumes for Diaghilev's Ballets Russes. On her head she wore a gold turban designed by composer Igor Stravinsky's fiancée. Man Ray, the photographer and painter, took her picture in this outfit, and it became her favorite portrait.

Florette enjoyed the parties and was titillated by the wild bohemian characters her daughter cultivated. But she scolded Peggy constantly for her dissolute ways. She called her daughter's poor friends "beggars" and labeled her woman friends who consorted with lovers "N.G.," meaning "no good." Although she would have preferred Peggy to marry a rich Jewish businessman, she personally liked Laurence, who—insincerely—flirted with her. In fact Laurence despised his mother-in-law. In his 1931 autobiographical novel *Murder! Murder!* he makes fun of Florette's habit of tripling words and phrases. He deplores her stinginess, a quality he believed she had passed on to her daughter. He ridicules her appearance. She had a "large, flabby face. . . . All the woes of Israel seem to be assembled on her dark face."[17] Florette herself entertained during her months in Paris, but her parties in her Ritz hotel suite seemed tedious to Peggy and Laurence.

Among the regular guests at the Vails' Saint-Germain carouses were two young women who would become Peggy's fast friends. Both were handsome and former lovers of Laurence. Mary Reynolds was a rich American war widow from Minneapolis who had drifted to Paris to find independence from her conventional family. After her brief fling with Laurence she became the mistress of Marcel Duchamp, the French painter whose *Nude Descending a Staircase No. 2* was the sensation of the famous 1913 Armory Show in New York. During her later years she was a bridge between Peggy and Duchamp and through him the wider circle

of creative modern painters and sculptors. Mary herself had artistic talent that she displayed as a binder of expensive books.

Djuna Barnes, another beauty envied by Peggy, was more dependent on Peggy's largesse than Mary. Born in upstate New York, she was the child of unconventional, free-spirited parents who neglected her formal education but encouraged her to find her artistic way. Djuna attended Pratt Institute in Brooklyn, then switched to journalism and joined the prewar bohemian community emerging in Greenwich Village. There she met Laurence almost at the same time as Peggy and briefly became his lover. Barnes, in fact, was a lesbian but did not reject men entirely. She had the useful quality of attracting patronage. In 1920, on the advice of Leon Fleischman, Peggy sent Barnes money so she could come to Paris, and then continued her largesse once she arrived. It initially took the strange form of a clean but worn set of Peggy's undergarments. Peggy soon became more generous and conventional, however, sending Barnes a monthly check of $100. These continued well into the 1970s, by which time cost-of-living increases had pushed up the amount to $300 a month.

Peggy's subsidy enabled Barnes to turn out several books of plays, poems, and short stories. In 1936 she published *Nightwood*, a strange, difficult novel about star-crossed sexual relationships told in stream-of-consciousness dialogs. Its frank description of lesbian love shocked conventional readers and reviewers but was hailed by the liberated public as original, honest, and courageous. Barnes dedicated it to Peggy and Peggy's then lover, John Holms.

Besides Laurence's two former lovers, during these Paris years Peggy befriended Mina Loy, another young expatriate woman with artistic ambitions. English and an old friend of Laurence, Mina was a dress designer and a craftsperson, as well as a poet and painter. Her metier, however, was creating "arrangements"—lamps and lampshades out of flea market bric-a-brac, colored paper, bottles, and old maps and prints. Laurence himself was intrigued by the recycling of discards into decorative items—in his case used wine bottles—and prevailed on Peggy to sponsor Mina. He cruelly told Peggy, she later reported, that "I was fortunate to be accepted into Bohemia" and that since "all I had to offer was

my money I should lend it to the brilliant people I met and whom I was allowed to frequent."[18] Peggy advanced Mina money to open a shop near the Champs Élysées to sell her creations, taking it on herself to find American customers for Mina's lamps and lampshades when she and Laurence visited Benita in New York in the spring of 1925.

By then Peggy was pregnant again, and to avoid the French draft once more, the Vails considered staying in New York for the birth of the baby. Neither liked the United States, however, and they decided to return to Europe, settling in Switzerland in July. The birth on August 18 was supposedly precipitated by Laurence, in a rage, spilling a hot plate of cooked beans into Peggy's lap. The baby was a girl whom they named Pegeen Jezebel. As Laurence explained it, the first name "was for fertility," the "second for use."[19] He was right on both counts: Pegeen Jezebel Vail would have four children and be notoriously promiscuous.

Early in 1925, before visiting America, Peggy and Laurence had decided to leave their wayward hotel life in Paris and buy a home in the south of France. They chose a remote community along the Mediterranean, near Saint-Tropez in the hamlet of Pramousquier, which they had stumbled on while motoring back one week from Rapallo to Paris. The house, a former hotel, was on the beach but lacked electricity and a telephone. It was also distant from services and conveniences. In the fall, after renovations, they moved in. They eventually added on two studios, a guest cottage, and a library. They hired a staff, including a nurse for Sindbad and Pegeen. Peggy learned to keep household accounts and in fact drove Laurence crazy by her insistence on recording every sou disbursed for salaries, food, liquor, and services. However chaotic her private life, by keeping meticulous accounts of her finances, she established some sense of order. They solved the problem of rudimentary local public transportation by buying a small car. Peggy learned to drive so that they could buy groceries and milk for the children.

For the next three years the Vails spent their springs and summers at Pramousquier. They had frequent guests, including Florette, who mispronounced Pramousquier as "promiscuous," not a bad description of the activities that sometimes took place there. More often they lived quietly, Peggy sunbathing and reading and Laurence working on his novel.

Winters at the isolated house were dreary, however, and they escaped to Paris or went skiing in Switzerland. In the winter of 1926–27 they returned to the United States to visit Benita, who was pregnant again after five miscarriages. The Vails were at Pramousquier when Peggy learned that her beloved older sister had died in childbirth.

The following winter Peggy and Laurence met the notorious anarchists Emma Goldman and her lover Alexander Berkman. Living in Paris after virtual exile from America, the two were battling poverty and isolation, and Emma, middle-aged, squat, red-haired, masculine-looking, was trying to write her memoirs. She reminded Peggy of her socialist friend Lucile Kohn, and Peggy took an immediate liking to her. Playing lady bountiful, she bought Emma and "Sacha" a house in Saint-Tropez where Emma could write and established a fund to support her and Berkman during the process. Peggy also found Emma a secretary, Emily Coleman, who served virtually as a ghostwriter.

Emily was an attractive American woman of twenty-nine. Married, with a small son, she had fallen in love with a thirty-year-old Englishman, John Holms, who lived in Saint-Tropez with his long-term companion, Dorothy. Dorothy had taken his name and considered herself his wife. Emily introduced Peggy to the tall, loose-jointed, decorated former officer in the Highland Light Infantry, and Peggy was instantly smitten. Holms was irresistible to Peggy. He was handsome, articulate, and came from the British upper class, though his income was meager and spotty. Unfortunately, he drank too much and lacked will and focus, qualities that Peggy did not detect at first. During the summer of 1928 the Vails invited John and Dorothy to Pramousquier for a brief visit. Peggy and John found the time to make love on the beach while their spouses were away.

BY THIS TIME Peggy was seeking ways to end her marriage. The scenes with Laurence, she explained, "were becoming more horrible."[20] One evening in a Saint-Tropez bistro, roiled by Clotilde's exhibitionist dancing and jealous of John Holms, Laurence slapped his wife's face hard and tried to rip off all her clothes. Some months before he had thrown her down the stairs of his Pramousquier studio and stomped on her stomach.

At first Peggy considered Holms primarily a means to escape her marriage to Laurence. One evening she connived to have Laurence find her and Holms in flagrante. Enraged, he attacked Holms with a heavy pewter candlestick, but the Englishman was bigger and stronger and managed to sit on his rival until the gardener came and separated them. The next morning, Peggy asked Laurence if he would mind if she went to London to visit her friend Peggy David. He demurred, but when he went off to cash a check in town, she took the train to Avignon, leaving behind a note: "Don't know if I'll come back. Life too hellish."[21]

Soon after, Peggy and Laurence found themselves back in Paris in the throes of a divorce action. The chief issue was child custody, and in the end the terms were relatively simple: Pegeen would live with her mother, Sindbad with his father, and Sindbad could visit his mother and sister sixty days a year. Since Laurence had little income of his own, Peggy agreed to pay him $300 a month. It would take a full two years before the divorce became final. Meanwhile, disregarding three-year-old Pegeen's fear of abandonment, Peggy left her with a nurse at Pramousquier and went off with Holms on a sort of honeymoon to Vienna.

Peggy and John Holms never did get married. Besides the necessary two-year wait for Peggy's divorce papers to come through, there was the impediment of Dorothy, who insisted, perversely, that John marry her first, before getting a proper divorce. That way she would not have to tell her conventional parents that she and Holms had never been married! Peggy and Holms spent part of the next year wandering through Europe by car—Scandinavia and Germany, mostly. John Holms did not like Pramousquier, and Peggy sold it. The couple went to live in Paris, where Peggy resumed her rounds of parties and café crawls. By now the Wall Street crash and the Depression had sent many of her old friends fleeing Europe. Peggy's own investments fared well, however, and she stayed on, with new friends substituting for the old. Among them was James Joyce, whose son, Giorgio, had become the lover of Helen Fleischman. Florette continued to visit her daughter, but having come to accept Laurence, no matter how reluctantly, she found John Holms hard to swallow, especially since he and her daughter were not even married.

As for Laurence, he had taken up with Kay Boyle, a young writer from Minnesota, who for a time had lived with her young daughter in the utopian colony near Paris run by Raymond Duncan, the eccentric, creative brother of dancer Isadora Duncan. Kay soon had enough of precious arts and crafts, utopian social philosophy, and goat cheese meals, and left the Duncan center to live with Laurence. More stable than Peggy, she proved to be a good wife to Laurence and a good stepmother for Sindbad. In December 1929 she bore Laurence a daughter, Apple, who became for him a substitute for the lost Pegeen. Together the two adults and three children, later joined by another daughter, Clover, formed a more substantial family than Peggy and Laurence together could ever have created. Kay and Laurence finally got married in the spring of 1932, with Peggy present at the ceremony as a result, she said, of a trick played by Laurence.

Though a good mother and wife, Kay was not an agreeable woman. Acquaintances considered her a troublemaker, both bitchy and devious. Despite Peggy's continuing subsidy of $300 a month, Kay managed to keep Laurence's resentments of Peggy alive. She also tortured Peggy by threatening to limit her contact with her son. The two women detested each other. "I loathed her and she loathed me," Peggy exclaimed at one point.[22]

Peggy's romance with Holms was another failed love relationship. Socially and physically, he was everything she admired. Their physical passion was intense. He also broadened her knowledge of literature and music. But he was another weak man who could not resist the comfort and luxury she provided. A brilliant talker and a savant, like his predecessor he was unable to yoke his intelligence and talent to serious work. He yearned to write fiction and criticism, but could neither begin nor finish very much. Instead he drank—remorselessly. As Laurence's mother Gertrude remarked, "that redheaded Englishman—I saw him at St. Tropez drinking like a fish."[23] Holms typically drank all night and then stayed in bed until early evening, when it was time to begin another round of drinking.

During the summer of 1933, while he was riding at their rented English house, Hayford Hall, John's horse stumbled and threw him, break-

ing his wrist. It was set by a local doctor, and he was able to use it in a few weeks when it healed. But it continued to give him pain, and in January he decided to have it therapeutically broken and reset in London. Having been drinking heavily the night before the operation, he died under the general anesthesia the surgeons administered. He was thirty-seven.

Peggy mourned John Holms deeply. For weeks she surrendered to despair, weeping constantly. Though they had never married, she regarded herself as his spiritual wife. For years she tried to get his letters published as a contribution to literature. Yet Peggy already had someone in the wings. While Holms was still alive, she had met Douglas Garman. An editor and publisher, he was five years younger than she and good-looking, with dark brown hair, a strong chin, and a classic profile. Son of a country doctor, he had flattered Peggy while visiting Hayford Hall. He sent her a warm condolence letter when John died, and they soon started a romantic relationship.

In the summer of 1935 Peggy went off to Yew Tree Cottage, an ivied structure of brick and stucco in Sussex, to be with her new lover. Pegeen lived with them, along with Garman's daughter Debbie. The two girls attended the local "dame school," run by a local schoolmistress, and then moved on together to the newly founded progressive Beltrane's boarding school. This was a happy and relatively stable period for Pegeen. She loved Debbie and got along well with Garman. Peggy herself found her sexual relationship with the handsome publisher deeply satisfying, though their age difference made her feel insecure. More damaging, however, was his obsession with left-wing politics.

Garman worked as editor for the leftist publisher Ernest Wishart. Like many Cambridge intellectuals of the mid-1930s, he himself was a "progressive." With the rise of Hitler and fascism he joined the international confrontation of left and right that marked the decade. Peggy was herself sympathetic to the left. At one point she actually joined the British Communist Party, which welcomed her, as a rich American, with open arms. But she refused to buy into the party's uncritical Stalinist line. Not so Garman. As the world clash between left and right escalated he became an ardent party loyalist who studied and lectured on Marxism and became a member of the British Communist Party's Central

Committee. As his devotion to the Soviet line intensified, it came to dominate his relationships. Fewer and fewer amusing artists and intellectuals came to Yew Tree Cottage for visits; more and more of the guests were hard-nosed communist functionaries. By the spring of 1937 Garman had encountered a woman of the people and decided that she was more appropriate for a communist than an American heiress. Soon after, he and Peggy decided to separate.

Meanwhile, Florette was dying. She continued to visit Peggy and her children in Europe almost to the very end, however, and though Sindbad and Pegeen might be skeptical of their grandmother, she delighted in them. In London she took the children to tea at the Ritz. She visited them at Yew Tree Cottage, which Peggy generously left in Garman's possession after their rupture, but for a time rented from him to provide him with some income. As we saw, neither surviving daughter was present when Florette died in New York in November 1937. Both benefited financially from her death. Their mother left Peggy and Hazel a half-million dollars each in the form of trust funds. Peggy now had twice as much income as before to indulge her whims and her interests. One of these was twentieth-century art. Peggy was about to embark on the journey that would occupy the rest of her life.

DURING THE SUMMER and fall of 1937, her relationship with Garman over, Peggy was at loose ends. She had not ceased her quest for true love; she never would. There would be scores, maybe hundreds, of future one-night stands, many affairs, and even one more marriage. But she would never find her soul mate. Meanwhile, she hunted for some occupation that would engage her mind and energies in a worthy way. If it also expanded her circle of eligible lovers, so much the better.

The suggestion that she start either an art gallery or a publishing house in London came from Peggy David, now married to Milton Waldman, sister Hazel's former husband. Peggy David urged her to find something serious to do with her life, "anything that would be engrossing yet impersonal."[24] Peggy G. rejected the publishing venture as too expensive but found the gallery proposal intriguing. Some of her critics have described her as artistically illiterate when she first began her career

as an art dealer and patroness. Her own granddaughter claims that at this point Peggy "knew virtually nothing about Modern art."[25] That is incorrect. She knew more about old masters than twentieth-century art, it is true, but she was not ignorant of the new currents in European and American painting and sculpture. She had first encountered modern art while clerking at Sunwise Turn in New York. Her education continued with Laurence in Paris during the 1920s. Many of their fellow roisterers at La Coupole and le Dôme were artists whose merits were finally beginning to impress the critics and the lay cognoscenti. Peggy was capable of absorbing the judgments and insights of the Left Bank. And yet Peggy always preferred the impressionists to the newer schools. Her granddaughter Karole Vail recalled that in 1974, when Peggy was in Paris for a showing of her own collection at the Orangerie, she went each day to the gallery's basement to view Monet's *Lilies*. She would have chosen to collect the impressionists rather than their successors, she said, but like her uncle Solomon, she "wasn't able to afford them."[26]

For help in practical matters and to make up for her deficient knowledge Peggy turned to a young surrealist English painter, Humphrey Jennings, a friend of Emily Coleman. Jennings, Peggy later said, "was a sort of genius," though he "looked like Donald Duck,"[27] He helped her find space for a gallery and she in turn took him to bed. He introduced her to surrealists André Breton and Yves Tanguy. Yet it took many weeks before Peggy finally found a location—30 Cork Street, in London's West End—for her gallery of twentieth-century art. By this time Duchamp had superseded Jennings as her mentor.

Peggy, as we saw, had met Duchamp in the 1920s when he was the lover of Mary Reynolds. Duchamp was a strong presence in the world of twentieth-century art. He had experimented with a number of new painting styles early in the century and eventually joined the surrealist camp. After his unfinished 1923 masterpiece, *The Bride Stripped Bare by Her Bachelors, Even*, he abandoned painting for chess, but became a sort of elder statesman of the modernist movement in Paris, respected for his judgment of artists and styles. To Peggy his strong masculine features made him look like "a crusader."[28] Every woman in Paris wanted to sleep with him, she declared, but he was addicted to ugly mistresses. Whether

she excluded herself from the mistress list to avoid being labeled, in the end she and Duchamp had only the briefest fling.

Though not a complete neophyte, Peggy needed a mentor, and Duchamp was her guide to the mysteries of modern art. "I don't know what I would have done without him," she later wrote. He taught her the difference between abstract and surrealistic art, planned shows for her gallery, and gave her "lots of advice." "I have him to thank," she later acknowledged, "for my introduction to the modern art world."[29] Through Duchamp Peggy met leading figures in the circle she was seeking to enter: sculptors Jean Arp and Constantin Brancusi, and surrealist poet Jean Cocteau, among others.

While in Paris, under Duchamp's tutelage, Peggy also met a friend of James Joyce, a tall, introverted Irish writer named Samuel Beckett, a young man with smooth, combed-back hair and piercing blue-green eyes. She had encountered the brooding, eccentric Beckett before but had scarcely made contact. This time, after an evening with the Joyces at a restaurant, Beckett escorted her to her borrowed Paris apartment and, loosened by champagne, the two made marathon love. Peggy did not see Beckett again for some time and then met him accidentally on the Boulevard Montparnasse. They went off again to the apartment and spent the next twelve days talking, drinking, and coupling. Peggy confessed to her lover that she still preferred old masters to modern art. He urged her to shift her allegiance completely. Modern art was "a living thing," he told her; the old masters were dead.[30] The affair with Beckett, who eventually won a Nobel Prize for literature, ended in bitter disappointment for Peggy. Clearly he never loved her, and in January 1939 she discovered that she no longer loved him.

Peggy's London gallery was named Guggenheim Jeune on the suggestion of her new secretary, the efficient Wyn Henderson, a redheaded former typographer. It opened on January 24, 1938, with an exhibit of furniture and drawings, mostly of hands and fingers, by Cocteau, and was a great success. Peggy stood out at the opening night party, wearing an exotic dress and long, dangling earrings, made of tiny mobiles designed by Alexander Calder. The gallery's later shows, exhibiting the works of sculptors Constantin Brancusi, Jean Arp, Calder, and Henry

Moore, as well as paintings by Kandinsky, and Ernst, were also critically successful. Sales, however, were less than scintillating. Many of these artists, world famous later, were still relatively unknown by the general public in the late 1930s, and few paintings found buyers. The exception was the works of Yves Tanguy, a young French surrealist, whom Guggenheim Jeune exhibited during its second year. Tanguy's pretty fantasy landscapes sold well, and for the first time in his life the genial-looking Frenchman had money to spend and waste. Peggy herself bought several Tanguys. In fact, to bolster their morale, she made it a practice to buy at least one work from each of the artists she displayed even when they found no other buyers. This unsystematic practice was the beginning of her private collection.

Peggy also enlisted Tanguy into her corps of lovers. She considered the thirty-nine-year-old Tanguy "a lovely personality, modest and shy and as adorable as a child."[31] Indeed, with his near-bald head and chubby cheeks, he looked like a small child. Tanguy was married, but this did not deter Peggy, who began their affair while he and his wife were in London for his Guggenheim Jeune show. Peggy and Ives conducted their romance for months on both sides of the channel, narrowly avoiding discovery by Mrs. Tanguy. Tanguy painted a pair of earrings for Peggy to wear and designed a cigarette lighter with a phallic motif for her, which she later lost in a taxi.

The lovers broke up in early 1939 when Peggy took up with an English sculptor-painter whom she called "Llewelyn."* He was a married man who in a moment of despair at his wife's illness had succumbed to Peggy's advances. Whether the liaison meant much to Peggy is unclear. She was in constant heat during these years and put out sexual feelers to every eligible man and even some ineligible by virtue of homosexual preferences. She probably experimented with lesbian relationships too. Peggy was indifferent to, almost contemptuous of, the marriage bond. Thomas Schippers, the handsome young conductor, once asked her how many husbands she had had. She replied: "My own or other people's?"[32]

*When Peggy reissued her autobiography in 1979 she allowed the pseudonyms she had originally used to be replaced by real names for the deceased. Most of the living gave permission to have their true names revealed, but "Llewelyn" objected to Peggy's dismissive attitude toward his painting and refused to be identified.

As more than one observer has noted, she often puffed up sexual connections into "affairs," but many were brief, single couplings, apparently without either much foreplay or postplay.

Peggy's sexual life has puzzled biographers and observers. Her romantic career resembles that of Lord Byron, the early nineteenth-century English poetic genius whose carnal history established the romantic-era prototype for the artist-libertine. Peggy was one of the few women to follow in his tracks. Some have said that she was moved primarily by a desire to scandalize. If so, she succeeded even in her circle of sexually liberated bohemians. In any event, the brief liaison with "Llewelyn" ended badly, with Peggy, at the age of forty-one, pregnant. She had an abortion, one of possibly seven in her lifetime.

The end of the pregnancy corresponded with the end of Guggenheim Jeune. Peggy had been losing money on the gallery. Tanguy's success aside, few of her artists had sold any works, and, in the absence of commissions, the gallery lost £600 in its first year. This was not a devastating drain, but it was discouraging. Yet Peggy wanted to retain her connections with the art world. In just a few years she had become a personage in that world, and the role was exhilarating. There were already in existence several museums dedicated to the display and advancement of twentieth-century art. The Museum of Modern Art had been around for a decade; Solomon's Museum of Non-Objective Painting was about to open. Both were in New York, and there was no equivalent in Europe, certainly not in London. Peggy would start one.

But even with the experience of Guggenheim Jeune under her belt, Peggy felt insecure in the field and turned for help to Herbert Read, a prominent English art historian, offering him a five-year contract to be the museum's director as well as her adviser. Read accepted and was soon puffing the proposed institution to the press. He described the mission of the new museum to a reporter for the *Sunday Times* as "educational in the widest sense of the word." It would conduct a regular program of lectures, recitals, and concerts, and would not define modern art narrowly.[33] Peggy's personal collection was still small, and Read drew up a list of potential acquisitions for the museum, either by purchase or by loan. The list covered all the important movements in Western art since

about 1910: Cubism, surrealism, constructivism, futurism, abstraction-ism, and others. In August 1939 Peggy and a new friend, Nellie van Doesburg, widow of painter and art critic Theo van Doesburg, set off for France to consult with leading artists and make additional plans for opening the London museum later in the year. With Sindbad in the backseat of Peggy's Talbot car they headed for Paris, where the sixteen-year-old went off to join his father in Mégève, in the French Alps. Soon after, Peggy and Nellie visited Mégève themselves and stayed a week with Laurence and Kay and their large menage, which included Pegeen and her half sisters, Apple and Clover, and stepsister Kathe. Peggy and Laurence got along now but Peggy found she still disliked Kay. The two visitors soon left for the Riviera for the sun and the swimming.

On September 1 the German army invaded Poland. Two days later, fulfilling their guarantees to Poland, Britain and France declared war on Germany. Peggy had thought little of the worsening international crisis but was forced to confront reality as she watched mobilized French military recruits marching off to their assigned postings. Part of that reality—much trumpeted during the diplomatic crises leading up to war—was the likelihood of devastating air attacks on London. The museum must be postponed, she concluded. Peggy paid Read off for his time and effort and decided to stay in France. Paris, she assumed, would be safer than London in the months to come. She arranged to have her London collection, to be the core of the new museum, shipped to France.

PEGGY SPENT THE "PHONY WAR" in France. During the months fol-lowing the collapse of Polish resistance in late September 1939, only light sparring went on between the Germans and their enemies while Hitler regrouped for a major attack on the Western allies. The wags soon coined the word "sitzkrieg" to describe the calm after the "blitzkrieg" that had overwhelmed Poland. During the period, a mood of complacency settled over England and France though many people remained uncertain and apprehensive.

Peggy used this unsettled time to great advantage. There is little evi-dence that she felt deeply about the issues of the war. The artists and

intellectuals around her were almost all fiery antifascists, whether as left-ists or because the Nazis had declared war on artistic modernism. She shared their views and, indeed, could not help but do so if she wished to be part of their world. But she was not a passionate antifascist ideologue. Nor was she markedly upset by Nazi-sponsored anti-Semitism. Admittedly this was before the Holocaust had made clear the full mur-derous intent of Hitler and his minions toward the Jews. And she did understand that as a Jew she might be in jeopardy if she ever fell into the Nazis' hands. But she seemed to have no special sympathy for her fellow Jews' plight under Nazi domination. All told, during the next eight months she enjoyed the parties and the dinners, and the romances that phony war Paris afforded.

Her chief goal during this period was to buy pictures and sculpture at the lowest prices she could get. For a time, lulled by the military calm, she considered establishing her museum in Paris. It was this brief urge that had enraged Hilla Rebay and her Paris representative when they got wind of it. In the end the plan went nowhere. But in any event, Peggy intended to establish her museum somewhere when normal times returned, but with a much larger core of her own paintings.

It was not difficult to achieve her buying ends. Many of the painters and sculptors who would later become famous and whose works would sell for many thousands of dollars were still barely known to even the educated public. But the general nervousness also played into her hands. Virtually no one else was buying. At the same time, many refugee artists fleeing Nazi repression sought desperately to get their hands on cash so that if the worst were to happen, they could leave with money to ease their way.

Armed with her list from Read and with the eager help of Nellie and rotund, pink-faced Howard Putzel, a California art critic and gallery owner, she set about buying up as many modern works of art as she could. As she told American art critic John Richardson, her goal was a "picture a day." (When Richardson proposed that a man a day was also on her shopping list, Peggy told him "pictures were easier to obtain.")[34] Putzel fatefully introduced her to Max Ernst, the surrealist painter, then living near Avignon with his beautiful English mistress, Leonora

Carrington,* while maintaining a studio in Paris. Peggy was not able to acquire any of his paintings at this time but she took note of his virile good looks. She never actually attained the one-a-day rate she aimed at, but she was able to acquire scores of vibrant works by some of the outstanding artists of the day at fire-sale figures. A Picabia went for $330, a Delaunay for $450, a Masson for $125, a picture by the young French artist Jean Hélion for $225, a Bracque for $1,500, a Léger for a thousand, and others at similar bargain prices. Only Brancusi, the eccentric, bearded, faux peasant Romanian sculptor, was able to hold out for more. Peggy craved Brancusi's *Bird in Space*, a slender, polished gold-surfaced bronze column mounted on a wooden base. But Brancusi wanted $4,000 and Peggy refused to pay it. The two wrangled, but in the end she had to settle for a different polished Brancusi bird, his less graceful *Maiastra*, which she bought from a third party for a thousand dollars. Peggy tried to add some Picassos to her collection, but the Spanish painter, contemptuous of rich American ladies, considered her a huckster, and when she visited his studio one day with her list, he at first ignored her. After a time he sidled over and, with curling lip, said: "lingerie is on the next floor." All told Peggy probably spent about $40,000 on these wartime acquisitions. They would eventually be worth many millions.†

The phony war ended with the Nazi invasion of Denmark and Norway in early April 1940. A month later the German army smashed into the Low Countries and swept into northern France. British-French resistance quickly crumbled under the assault of the Wehrmacht's panzers and the Luftwaffe's stuka dive bombers. By the thousands, desperate, distraught refugees from the north were soon streaming into Paris before the advancing German tanks and troops. Peggy seems to have

*Leonora was a talented surrealist painter. She should not be confused with Dora Carrington, another English painter who was a member of the famous Bloomsbury literary-artistic group of early twentieth-century London.

†Another estimate of Peggy's purchase costs as of December 1942 is about $75,000. See Virginia Dortch (ed.), *Peggy Guggenheim and Her Friends* (Milan: Berenice Art Books, 1994), p. 93. Anton Gill, writing at the beginning of the twenty-first century, estimates the market value of Peggy's collection at $350 million. See Anton Gill, *Art Lover: A Biography of Peggy Guggenheim* (New York: HarperCollins, 2002), p. 419.

scarcely noticed. She was in the throes of an affair with Bill Whidney, a married man, and the two sat calmly in the Paris cafés drinking champagne as people around them trembled with fear of capture and death and pondered how to escape. Peggy would later deplore her own narcissistic behavior. "It is really incomprehensible now to think of our idiotic life when there was so much misery surrounding us. Trains kept pouring into Paris with refugees in the direst misery and with bodies that had been machine-gunned en route. I can't imagine why I didn't go to the aid of all those unfortunate people."[35]

But eventually even Peggy realized that it was not smart to stay. The United States was still neutral, and as an American citizen Peggy would have to be treated "correctly." But she was also a Jew and did not relish being exposed to Nazi anti-Semitic policies. On June 12, two days before the Germans arrived, she and Nellie left Paris for Megève in Peggy's car. There, in Laurence's home, Peggy was reunited with Sindbad and Pegeen, who had been staying with their father. Before leaving Paris she had tried to induce the Louvre to store her paintings for the duration. But they considered her art unworthy of their concern and refused. Fortunately, one of Peggy's friends agreed to hide the pictures in a barn near Vichy.

The French sued for peace on June 17, and the government of Henri-Philippe Pétain signed an armistice with Hitler five days later. The agreement divided France into an "occupied zone," including Paris and France's northern and western coastal regions, where German rule would be unchallenged, and an unoccupied zone to the south and east with its capital in Vichy, where the collaborationist, semifascist Pétain regime would exercise authority. Fortunately Peggy, her children, her paintings, and the Vails found themselves in the unoccupied Vichy zone, relatively safe.

But the arrangement could not last. Bit by bit the Germans chipped away at Vichy's remaining autonomy. Total occupation seemed just down the road. At the same time the British blockade of the continent began to make food and other necessities hard to get, and the Vichy authorities established a painfully strict rationing system. Looking ahead, it appeared that the United States was drifting into the war. When and if it became a belligerent, Peggy and her family would become enemy aliens,

cut off from Peggy's source of funds and exposed to the naked edge of Nazi oppression. Laurence urged them all to leave for America, and so did the American consul in Vichy. One of Peggy's chief concerns was the safety of her collection if she left. It must come with her. Fortunately, she learned, the paintings and sculpture could still be shipped to America if some household goods were sent along with them. After several weeks of effort the art was packed into five large crates cradled with bedsheets and blankets, ready to be dispatched.

Peggy now faced the question of who should leave with her besides her children and Laurence and his family. The unoccupied zone was crowded with refugees from the Nazis—leftists, antifascists, artists, writers, journalists, and intellectuals, many of them Jewish. The armistice of June 1940 required the Vichy government to surrender to the Germans anyone whom they wanted to take into custody, and needless to say the level of anxiety among the stateless refugees was excruciating. Many crowded into Marseilles seeking visas to any nation that would take them. It would be pleasing to say that the United States opened its arms to the exiles. It did not. Tight immigration quotas and requirements of sponsorship to prevent dependency on American social services, combined with scarcely disguised anti-Semitism, made the United States an unattainable goal for many of the refugees in southern France. Recognizing the plight of many talented Europeans caught in Nazi-occupied Europe, a group of American liberals, artists, and intellectuals founded the Emergency Rescue Committee, which sent a young Harvard scholar, Varian Fry, armed with $3,000 in cash and a clutch of visas, to France to help extricate artists, writers, and scientists.

Fry arrived in Marseilles in the spring of 1940 and quickly discovered that he had too few visas and too little money to do the job. He asked Peggy for help. Afraid to offend the Vichy authorities, she asked the American consul for advice, and he told her to avoid the Emergency Rescue Committee. Though fearful, Peggy gave Fry some money and then left Marseilles, returning to Grenoble where she was staying. But if Peggy proved timid in the case of Fry, she responded better to a cable from Kay Sage, Yves Tanguy's rich new American wife, asking her to pay the fares and expenses of five people, including André Breton, his wife

and daughter, Max Ernst, and a friend of Breton's. Though she rejected the friend, Peggy agreed to sponsor the others. Back in Marseilles, she contacted Fry and helped get the Bretons aboard a ship for Martinique in the Caribbean, from which they could easily cross to the United States. She also agreed to pay for Max Ernst's passage, though, since he was a German national, the process for him promised to be more difficult.

Ernst's position was very precarious. He had been living in France for years but had never become a citizen. With the war, the French had interned him then released him and then interned him again. He had been married twice before and had had many mistresses. In the spring of 1941 he was still in love with the beautiful but erratic Leonora, though they had parted and Leonora had taken up with a Mexican journalist. Peggy did not know Ernst very well. He had been living with the Bretons in Marseilles where he and André had been leaders of a sort of surrealist court. With Breton's departure for America the circle dissolved, and Ernst was desperately seeking to escape wartime Europe.

Ernst was fifty in the spring of 1941. A native of Cologne, son of a Catholic education bureaucrat, he exuded charm and was immensely attractive to women. Peggy considered him "exquisitely made," though in his surviving photographs, with his shock of white hair, delicate frame, and sharp beak of a nose, he looks more like a small bird, perhaps a parakeet, than an Apollo.[36] Peggy took advantage of Ernst's penury to buy most of his extant paintings for $2,000. She also began an affair with him and in their first time together, he managed to make love to her three times in quick succession. His performance was obviously flattering. In the next weeks their affair shuffled along though Max resented Peggy's hard bargaining and continued to ogle attractive woman compulsively.

The remainder of the spring was a tense time for Peggy. Her own visa had expired as had Laurence's, promising to cause trouble with the Vichy officials. Ernst needed an exit visa to leave France as well as an American visa to enter the United States. Fry's rescue committee got him the latter, but it expired before the exit visa was issued. Desperate, he decided to leave without his French documents, and packing his rolled-up canvases in his suitcases, he left Marseilles by train for the Spanish frontier, heading for Lisbon. At the crossing into neutral Spain he was intercepted by

French officials who, discovering he was an artist, generously allowed him to leave the country. He arrived safely in Lisbon to await the arrival of Peggy and her party. Laurence and Kay with the children left France separately, and Peggy soon followed, bringing with her Jacqueline Ventadour, Pegeen's fifteen-year-old friend who was leaving France for New Orleans. The whole party was in Lisbon by early June.

Now came the wait until seats became available on the "Clipper," one of the four-engine Pan American "flying boats" that had pioneered the transatlantic commercial air route and were then the only aircraft regularly flying between Europe and America. Kay Vail had reserved ten tickets aboard the plane for the party, but it was Peggy who agreed to pay for them.

The wait in Lisbon lasted five weeks. It was a period of boredom and anxiety for Peggy, made worse when Max told her the moment she stepped off the train in Portugal that he had found his true love, Leonora, in Lisbon. "I felt a dagger go through my heart," Peggy later remarked.[37] For a time, believing the seaside was better for the children than hot, dirty Lisbon, Peggy, the Vails, and all the children went off to Monte Estoril, a hotel on the coast. Though he was now seeing Leonora, Max joined them, and he and Peggy resumed their affair. Everyone ate together at one big table at the hotel, with Peggy at the head, Laurence and Max at either hand, and the children along both sides.

Departure for America finally came on July 13. Eleven in Peggy's party made the trip—in her words, "one husband, two ex-wives, one future husband, and seven children."[38] The flight lasted more than thirty-six hours and included stopovers for refueling in the Azores, where Peggy bought herself an enormous straw hat, and in Bermuda, where the British authorities closely examined everyone's luggage and papers. Late on the fourteenth the plane passed over Long Island, and they glimpsed the Manhattan skyline. A party of friends, and at least one reporter, awaited them when they landed at the Marine Air Terminal at La Guardia Airport.

One greeter was a relative. Max had had a son, Hans-Ulrich, by his first wife, Lou Straus, who had changed his name to Jimmy when he came to America alone in 1938 at the age of eighteen. Max had left Lou

for another woman when Jimmy was a small child, and he scarcely knew his father. With few skills and little education, he had worked at odd jobs since coming to the United States and was a mail clerk at the Museum of Modern Art when he arrived at La Guardia Airport that July day to welcome his father and his friends.

Jimmy got his first glimpse of Peggy Guggenheim as he strained to distinguish the passengers deplaning. "Her legs seemed absurdly thin even for her fragile, angular figure," he later wrote. "Her face was strangely childlike, but it expressed something the ugly duckling must have felt the first time it saw its reflection in the water. All the features of that face seemed to be intent on wanting to draw attention away from an unnaturally bulbous nose. The anxiety-ridden eyes were warm and almost pleading, and the bony hands, at a loss where to go, moved like ends of broken windmills around an undisciplined coiffeur of dark hair." "You must be Jimmy," she exclaimed, when she saw him. "I am Peggy Guggenheim."[39] Max had been impatient to see his son all the way over on the plane, but at the moment, she informed Jimmy, he was detained by U.S. inspectors who were examining his passport and other documents to see if he could be allowed into the country or would be sent back to Europe.

Jimmy found his frightened father in the airport immigration room being questioned by reporters while the American officials appraised his papers, puzzled that he had a German passport, though he had lived so many years in France. When he saw his son, Max embraced him and managed to blurt out in English: "Hello, Jimmy, how are you."[40] After some hours the inspectors at La Guardia decided to send Max to Ellis Island for further consideration. Since the last ferry to the island had already completed its run, he was placed in the custody of a Pan Am detective and put up at the Belmont-Plaza Hotel in Manhattan. The next day he was hauled off to Ellis Island while officials pondered his case.

In the next few days Peggy, the New York art world, and assorted Guggenheims rallied to Ernst's defense. Nelson Rockefeller and John Hay Whitney, prominent trustees of the Museum of Modern Art, pulled wires. Alfred Barr, Jr., director of MOMA, sent a letter describing Ernst's prominence as a modern painter. Peggy paid for lawyers and managed to

corral officials of ASARCO, still a family firm, to attend the hearings and speak for Ernst. The pressure from leading Americans undoubtedly influenced the judges, but ironically they based their decision that he could stay on the willingness of Jimmy, on his $15-a-week salary, to guarantee that his father would not become a charge on the community.

Max was released in the custody of his son. The jubilant party went off to the hotel where a crowd of well-wishers, including the growing community of refugee European artists, congratulated Peggy and Max. Peggy now learned from Howard Putzel that her collection had arrived safely by ship but would have to clear customs. As he left the celebration, Peggy asked Jimmy if he would become her secretary. If he helped her organize her collection, she would pay him a generous $25 a week. The next evening Jimmy accepted the offer while dining on Lindy's restaurant's famous matzo ball soup and cheese blintzes, with Peggy, his father, and Julien Levy, a prominent New York art gallery owner.

DURING THE FIRST WEEKS in New York Peggy and Max explored the city, especially its art resources, reestablishing contact with the art refugees who, like themselves, had escaped the Nazis. They visited Alfred Barr at MOMA and went to Solomon's Museum of Non-Objective Art where they clucked their tongues over the excessive number of Bauers on display. Max was delighted with the Museum of Natural History and fascinated with the Museum of the American Indian. The latter's totem poles, kachina dolls, and ceremonial masks opened his European eyes to intriguing new visual forms. Peggy went to see André Breton, and they talked about his narrow escape from Vichy officials in Martinique who had threatened to throw him into a detention camp. Peggy agreed to give him $200 a month for a year so he could get on his feet. Eventually, when they became settled in New York, Peggy and Max linked up with the wide circle of exiled painters and sculptors who were living in the city or its suburbs by 1942. These included Piet Mondrian, Tanguy, Léger, Salvador Dali, Joseph Albers, Jacques Lipchitz, Chagall, and Pavel Tchelitchew. For the next four years these creative men would make New York the capital of the avant-garde's government-in-exile.

By now Peggy was determined to marry Max come what may. But

Jimmy had learned that Leonora Carrington had arrived in New York. Max was soon pining for his lost love, and Peggy became nervous. At this moment Hazel asked her sister to visit her and her new husband, Charles McKinley, in Southern California. Peggy seized on the invitation as a way of separating Max from Leonora. At the same time she would get to see a new part of the country herself while exploring for a possibly better location than New York for her collection. At the last minute Hazel ask them to delay their arrival; she had had cosmetic surgery and was still recovering. Rather than put off the trip Peggy and her party flew to San Francisco. After spending time exploring the scenic city, they rented a car and drove south to Hazel's house in Santa Monica.

We have already described the visit with Hazel and need not repeat it. On the way back east in the gray Buick Peggy bought in Los Angeles, they stopped in Santa Fe, where Max bought kachina dolls and Indian blankets. He fell in love with the desert Southwest, which eerily resembled surrealist landscapes he had painted long before he ever saw New Mexico or Arizona. The trip left a permanent mark in Max's consciousness, and he would spend some of his later years living in Arizona. The quest for an alternative to New York for Peggy's collection did not pan out. The West Coast art scene seemed isolated and provincial. New York would have to do. Her campaign to get Max to marry her also failed. Peggy sent Jimmy to inquire into the marriage laws of almost every state they passed through on the way back to New York. Each attempt seemed only to make Max more resistant.

When they returned in September, Max and Peggy took a two-room suite at the Great Northern Hotel near Carnegie Hall. Pegeen was registered as a boarder at a Manhattan prep school and Sindbad enrolled at Columbia College. Laurence was now in Connecticut with his children by Kay. For a time Peggy considered moving near him but in the end found a spacious, three-story house to rent on the East River at Fifty-first Street and Beekman Place. It was called Hale House after the American patriot Nathan Hale, who had been hanged near the site by the British during the Revolutionary War. It was large enough for two whole floors of bedrooms as well as a large kitchen and maids' room.

Max had a studio on the third floor, where Clifford Odets, the playwright, for a time had rented an apartment. The city refused to allow Peggy to make Hale House into a museum but she was able to install her paintings at the triplex as personal effects. Max distributed his now-treasured Indian artifacts through the rooms and halls. He supplemented the pieces bought in the Southwest by rummaging through antiquarian and antique shops, buying items with money advanced by Peggy or raised by an occasional sale of one of his paintings. In one of the lower Manhattan antique stores he found a flamboyant thronelike upholstered chair with a high back that had probably once served as a stage prop. It became his favorite seating place, and he loved to be photographed nestled deep in its arms.

Peggy soon converted Hale House into Paris West, where the European exile art community could gather to drink, talk, argue, denounce, and complain. She and Max threw raucous parties where the women paraded around in gaudy costumes or almost no costumes at all. Peggy herself wore eccentric, revealing clothes with strategically placed transparent panels or long tears. Guests were mostly from the art community, but intellectuals, theater celebrities, writers, and musicians, and even some Seligman and Guggenheim relatives, also turned up. Among the carousers were musicians John Cage and Virgil Thompson, writers William Saroyan and Paul and Jane Bowles, actor Zachary Scott, and, oddly, the stripteaser Gypsy Rose Lee, who was a part-time painter. Peggy had a talent for collecting interesting people. "She was a fantastic collector. She knew how to find people," André Breton's wife exclaimed.[41] Peggy once more showed her cheap streak by serving only potato chips and inexpensive blended whiskey. But no one seemed to mind. And sometimes she made her favorite Mexican chicken with chocolate sauce, or Max made a curry.

Peggy never relented in her campaign to tie Max to her by marriage. He resisted with all his strength. He still loved Leonora, though she was now married. But he was also an incorrigible skirt chaser. Interspersed with his scouting expeditions for Indian artifacts were his "treasure hunts," as he called his forays to pick up women, invariably young and

pretty ones. Despite his age he was often successful. Deploying the old seducer's trick, he invited the girls back to Hale House to see his paintings when Peggy was away.

After America's entrance into the war in December 1941, Max's status in the United States became less secure. He trembled that he might now, as in France, be interned as an enemy alien. Peggy played on his fears: as the husband of a citizen he would be safe from harassment, she told him. He finally yielded. New York required a blood test followed by a waiting period for a marriage license. Besides, the alert local press was likely to publicize the event. So Peggy and Max decided to visit cousin Harold Loeb, then living in Washington, D.C., and have the ceremony performed in neighboring Maryland. No one but Peggy considered the marriage a good idea, including the intended groom. Sindbad later claimed that he knew that no good would come of the marriage. Pegeen, observing Max's reluctance, scolded her mother: "Mama, how can you force the poor thing to marry you? Look how miserable he is."[42]

A hitch developed in Maryland. Their divorce papers were in French and the local bureaucrats could not read them. Harold suggested they try Virginia, where, though a blood test was required, there was no wait. With Harold and his wife Vera as witnesses, on December 30, 1941, Peggy and Max were finally married by a justice of the peace in Fairfax County.

PEGGY'S NEXT CONCERN after making Max her husband was her collection. Frustrated in Europe by the war, she was determined to open a gallery-museum in New York. It would show her judgment as a collector, help raise the artistic consciousness of the American public, and provide a showcase for new talent. Early in 1942, despite Hilla Rebay's attempt once again to stop her, Peggy found a set of rooms on the second floor of a building on West Fifty-seventh Street near Fifth Avenue that would serve her purposes. The location, not far from the Museum of Modern Art, was good, but the space, formerly home to two tailor shops, would have to be drastically redone. On the advice of Putzel, she contacted Frederick Kiesler, a heavyset, very short, Austrian-born architect and scenic designer who taught at Columbia. Kiesler had strong aesthetic

views and an original mind and had been experimenting for some years with an art museum approach that he called "continuity of architectural space"—eliminating the paintings' frames so that the pictures merged with the space itself.[43] Feeling that abstract, Cubist, and surrealist art deserved a distinctive setting, Peggy embraced Kiesler's vision. While Peggy and Kiesler wrangled over the costs and details of the new museum space, she continued to add to her collection by buying Kandinskys, a rare Duchamp, a Chirico, an Ozenfant, Klees, Mirós, and several Picassos.

The museum opened on October 1, 1942, with a roar of publicity. Despite the constant battle with Peggy over expenses, Kiesler had created a beautiful and unique frame for her collection. The conventional rectangular rooms of the loft had been transformed into four separate galleries arranged, when seen from above, in an upside-down U: a surrealist gallery, an abstract gallery, an "automatic" display gallery, and a "daylight" gallery. The first was the most innovative. Foot-long wooden arms—sawed-off baseball bats—extended from concave, curved walls, and the frameless paintings were attached to these at various angles. To the viewer the paintings seemed to hover in space. The room was lighted entirely by adjustable fixtures suspended from a strip running down the center of the ceiling. In the abstract, or Cubist gallery, the walls were made of ultramarine canvas and were portable. Here the paintings—and sculptures—were suspended on ropes. This room was bathed in an intense and uniform fluorescent light. It also held Peggy's desk, where she greeted visitors and could keep an ever-wary eye on the doings of her enterprise. The third room was referred to by the critics as the "Coney Island" division. Here works by Klee, Duchamp, Breton, and others were attached to a sort of lazy Susan and could be seen one at a time for ten seconds through a peephole as it revolved. The wheel was set in motion by viewers when they broke a beam of light that activated an electric eye. This room also had several small works hidden within boxes and accessible through a peep-show arrangement. The last of the galleries was the most conventional. With white walls, it was illuminated by natural light that came through windows opening on Fifty-seventh Street. It was intended mostly for temporary exhibitions.

Art of This Century was uniquely furnished. Kiesler sought to spare the visitor the usual gallery-trodding fatigue. Scattered throughout were specially designed lightweight folding chairs that viewers could carry from room to room to sit on when they became foot-sore. He also designed sculpturelike oak platforms covered with linoleum that could be used either as seats or, turned over or fitted together, serve as display bases for artworks.

In advance of opening, Peggy issued a press release expressing her goals for the gallery. If actually driven by ego and restlessness, she professed higher motives. She hoped that Art of This Century would "become a center where artists will be welcome and where they can feel that they are cooperating in establishing a research laboratory for new ideas." The manifesto resembled Alfred Stieglitz's for his pathbreaking 291 Gallery back during the Great War when Peggy was more interested in beaux than art.

Opening night was a major social as well as artistic event. Many invitations had been mailed and hundreds of soigné guests attended, including a flock of Guggenheim cousins, uncles, and aunts. Peggy greeted them all wearing a white dress and contrasting earrings, one a tiny surreal landscape by Tanguy, the other a miniature mobile by Calder. Each visitor had paid a dollar admission, the proceeds from which were assigned to the wartime Red Cross.

The opening was treated by the media as a major public event. *Time* and *Newsweek* reviewed it. The New York daily press, of course, gave it extensive coverage. The whole New York art community, native and transplanted, turned out in force. Most of the critics were delighted by what Kiesler had wrought. He had "built the museum in a truly miraculous way and with such inventive thoroughness that if anything has been overlooked it won't be missed," Edward Alden Jewell of the *Times* pronounced.[44] The knowledgeable considered the collection itself old hat. Emily Genauer, of the *New York World-Telegram*, reviewing both Peggy's opening and Marcel Duchamp's recent show at the Whitelaw-Reid mansion, declared that the pictures were "practically all either very familiar or very typical." It was "the installation . . . which is the big news," she noted.[45] This conclusion was unfair. Though it was undoubtedly the

quirky, entertaining Kiesler setting that brought the crowds, many viewers for the first time found themselves giving serious attention to abstract, surrealist, and Cubist art.

The opening show was followed by many others. Art historian Melvin Lader lists fifty-five different ones over the almost five years the gallery survived. Some were thematic, such as "The Women" of June–July 1945 or "Collage" of April–May 1943; others were one-man shows. One of these was devoted to Pegeen's paintings, another to Laurence Vail's decorated bottles. The exciting young innovator Jackson Pollock received all of four one-man shows. Besides painting and sculpture, Peggy also occasionally featured music, including a concert by Paul Bowles. The gallery became a popular attraction in the city. Everyone in the art world visited. Rudolph Bauer came one day, and brandishing a roll of hundred-dollar bills, bought a copy of every art magazine on sale. Curiosity even drove some Guggenheim relatives to come to the rooms on Fifty-seventh Street for second viewings. When Harry turned up one afternoon, Peggy, assuming that he disliked modern art, asked him which painting of her collection he considered the least offensive. He would be happy to accept a Mondrian, if offered, he replied. As she remarked, "Needless to say, I did not give him one."[46]

The early Art of This Century shows focused on the surrealists, especially the group that had escaped to America just before the war—Ernst, Tanguy, Duchamp, Breton. These were Peggy's good friends, and it was natural that she should think of them first. After 1943, however, under the influence of Putzel, she provided space for more and more Americans. In the two years following November 1943 she gave one-man shows to a flock of young home-grown painters who were experimenting with a new form of abstract painting. These included William Baziotes, David Hare, Mark Rothko, Robert Motherwell, and Jackson Pollock. The series had been launched by Pollock, whom Putzel considered "an American genius."[47]

Peggy acknowledged Putzel's influence on her gallery's changing emphasis. But the shift also echoed the collapse of her marriage. It had never been solid. Ernst had been coerced into matrimony and induced to

stay by his insecurities and his taste for good living. He had not been faithful, but his sex partners were usually casual. Then he found Dorothea Tanning, a beautiful young painter originally from Illinois, now married to a U.S. naval officer on active sea duty. Tanning's advent, ironically, was Peggy's own fault. At the end of the first year of Art of This Century, she decided that she ought to present an all-woman show and induced Max, along with Putzel, Breton, Jimmy Ernst, and others, to form a jury to decide whom to include. The judges chose Frida Kahlo, Louise Nevelson, Buffie Johnson, and other serious artists, as well as Peggy's sister Hazel, Gypsy Rose Lee, and Djuna Barnes. Max had met Dorothea the year before and been taken by her and by her work. He selected two of her paintings to be shown at the exhibit, called "31 Women."

Peggy later joked that she should have limited the number to thirty, for the meeting with Tanning meant the end of her marriage. Max fell hard and was soon spending days with Dorothea at her apartment and not coming home. Hale House became only a place to paint. Feeling used, Peggy took away his keys but that only threw him into Dorothea's arms all the more. She retaliated in other ways too, abusing Max verbally and resuming her own promiscuous affairs. According to Hazel, "she did everything she could to humiliate him."[48] Max's infidelity was excruciating to Peggy. She was now forty-five and more insecure than ever about her physical charms. She could not sleep and cried a lot. "Her eyes were always red, her nose all swollen," recalled Ethel Baziotes, wife of the painter.[49] She threatened to commit suicide if Max did not come back to her. Peggy appealed for help to Putzel and Duchamp, who could do little except sound sympathetic.

In fact much of the art community sympathized with Peggy. However unconventional and socially tolerant, the artists did not approve of a romance in wartime between a woman married to a naval officer on active service and a German national. Particularly after publication of Peggy's autobiography in 1946 with its scathing account of their affair, Max and Dorothea found themselves shunned by many of their former friends. That year they left New York for Sedona, Arizona, in part to escape their moral censurers, in part to improve Dorothea's

health. Scandal followed them. Max continued to do good work during his years in Oak Creek Canyon, but the critics and the public ignored it. In 1953 he returned with Dorothea to France, where he died in 1976. Dorothea was an impressive survivor. She lived into her nineties, basking in a reputation as a pioneer surrealist and enjoying a second incarnation as a poet.

After Max left Hale House, Peggy took up with Kenneth Macpherson, an English homosexual who had married the wealthy lesbian poet Winifred Ellerman, better known by her nom de plume, Bryher. He was in New York, using her money to publish a film magazine, when Peggy met him at a performance at the Met of *Don Giovanni*. Though Macpherson would not, or could not, make love to her, she was smitten by his good looks, his impeccable tailoring, and his haughty English charm. She did not mind that he also wore makeup and dyed his hair blond. Macpherson tried to teach Peggy how to dress and how to groom, but she seemed incapable of taking instruction.

In the fall of 1943, having left Hale House, Peggy moved with Macpherson into a duplex apartment with many small rooms in a double-width East Sixty-first Street brownstone. They soon got to work renovating and decorating it to suit their different living styles. Kenneth would have the second floor, she the first, where she could hang her paintings not on display at the gallery. As part of the redecorating, in July Peggy commissioned the promising Jackson Pollock, a balding, chunky young painter, to do a large mural for the entrance hall to be ready for a big party planned for January. By the following December he had not even begun to paint, and Peggy began to prod him. Just a week before the event, he completed the whole nine-foot-long canvas in a fifteen-hour spasm. When it dried he rolled it up and carried it to Peggy's for mounting on her foyer wall the day of the party. It was too big! Pollock panicked and phoned Peggy repeatedly at the gallery to ask what to do. She summoned Duchamp, who devised a Solomonic solution. Since the painting was abstract, he said, it really had no beginning or end. Just cut off eight inches, he advised. Pollock agreed, but the whole affair had so unnerved him that he got drunk at the party and, unzipping his fly in full view of the guests, peed into the fireplace.

For Peggy, Pollock was both a trial and a triumph. She had first met him when, on the suggestion of the Chilean-American surrealist Roberto Matta, she included his work in her 1943 Spring Salon of young American artists. The critics liked the exhibit, and Pollock's *Stenographic Painting* received special praise. Sophisticates detected a great new talent. Peggy's old friend Piet Mondrian, the Dutch abstractionist, one of the salon's jurors, told Peggy that Pollock deserved to be closely watched. In *The Nation* Clement Greenberg, soon to become Pollock's biggest champion, said his work had left the jurors "starry-eyed."[50] Impressed by the acclaim, Peggy made an appointment to visit Pollock's studio in the Village to see more of his paintings. Pollock and Lee Krasner, his live-in companion, were late returning from an outing and intercepted Peggy in the street leaving their East Eighth Street apartment in high dudgeon. Despite this shaky beginning, Peggy decided to give Pollock a one-man show.

Until now Pollock had been living hand-to-mouth. Born in Wyoming and raised in the West, he had come to New York in 1930 to study at the famous Art Students' League. During the Depression he had worked for the Federal Arts Project, a New Deal agency established to keep artists from starving, and by mid-decade was beginning to develop a distinctive abstract style. When his job with the federal arts program ended, he came to work for Hilla Rebay at starvation wages as a custodian of paintings for Solomon's museum. Pollock clearly needed help, and urged on by Putzel, Peggy offered him a contract: He would assign to her virtually all his painting output for sale in exchange for $150 a month, with the possibility of more if the gallery sold more than $2,700 of his work in a given year. Pollock quickly signed. In light of Pollock's later fame this deal may seem tight-fisted. Pollock and Krasner were themselves ambivalent about the contract. Happy that he could now do his work uninterruptedly, they were dismayed by the limitations imposed. As Pollock wrote his brother, "I am getting $150 a month from the gallery, which just about doesn't meet the bills. I will have to sell a lot of work thru the year to get it above $150."[51] On the other hand, Peggy was not too happy herself with the arrangement. She later claimed that she never sold a Pollock for more than $1,000 and that she devoted so

much attention to peddling his works that she neglected her other painters and so lost many of them to other gallery owners. Both sides had a point. Yet the arrangement freed Pollock to devote himself to his painting and experiment with the techniques that became his hallmark.

And Peggy continued to help Pollock beyond the initial deal. Despite his limited commercial success, she renewed his contract several times, raising the monthly stipend in 1946 to $300. In 1945 she lent him and Lee $2,000 so that they could buy a house on Long Island, where Lee thought Jackson might be weaned away from his drinking binges. The one-man show in November 1943 was another helpful and generous act. Pollock's work still retained some elements of surrealism; he had not yet developed his famous splatter and drip technique, using commercial enamels and automobile paint. But the critics were deeply impressed, and the exhibit was an enormous break for Pollock. Even the skeptical Lee Krasner acknowledged that Peggy had given a huge fillip to her lover's career.

Whether Peggy was a patron or an exploiter, neither she nor the Pollocks liked each other. Pollock considered Peggy physically unattractive and fended off her occasional sexual advances, perhaps succumbing once while drunk. He is supposed to have brutally said: "to fuck Peggy, you'd have to put a towel over her head first."[52] To Lee Krasner Peggy was a sick tightwad. Recruited to stuff and address the catalogs for Pollock's one-man show, she accidentally ruined three envelopes. Peggy "bawled the hell" out of her, she said, for the 9 cents wasted.[53] Peggy also struck her as polymorphously bizarre. She later recalled how Pollock's patroness, moved by a call of nature while in a New York taxi, leaped out into the street, spread her skirt, and peed down a manhole cover. Peggy felt equally hostile. She did not like Pollock personally. His rural western background seemed alien to someone born to wealth in New York and for years an expatriate in Paris. She feared his angry alcoholic sprees and his volatility; she found his taciturnity impenetrable. Besides, despite the praise of Putzel, Greenberg, and Mondrian, she really did not respect his work. Before his reputation took off, she gave away many of his paintings, including the nine-foot mural he had done for her duplex. Jackson Pollocks donated by Peggy ended up at the Art Museum of Omaha, the Tel Aviv Museum, and the National Gallery in Rome.

Part of Peggy's reservations about the Pollocks was undoubtedly chagrin at her failure to capitalize on his emerging fame. Peggy later claimed that her support of Pollock was one of her major accomplishments as a patron of twentieth-century art. It can be argued that, through Pollock, she helped launch the New York School of "abstract expressionism" and expedited the transfer of the world's art capital from Paris to New York. Yet at the same time she failed to detect the value that the art world would place on Pollock and dumped his paintings. By contrast Lee Krasner—who finally married her unstable companion in 1945—kept her Pollocks and after he died in an automobile crash in 1956, reaped the harvest. Peggy deeply envied Krasner her cache of paintings, many now worth a million dollars or more. In 1961 Peggy sued Krasner, insisting that under her last agreement with Pollock many of the works now in Krasner's possession rightly belonged to her. Krasner called Peggy a total hypocrite. "Her behavior sickened me," she later told Jacqueline Weld, Peggy's biographer. "She was such a champion of Pollock that she never bought three cents' worth after she had left [New York]."[54] Peggy returned the sentiment. She admitted that suing Krasner had not been very nice, but Mrs. Pollock had retained many paintings from 1947, when the contract still applied. "I hate Lee, if you can hate a crook," she exclaimed.[55] When Krasner said hello to her at the 1969 showing of her collection at Uncle Solomon's museum, Peggy turned to someone else and asked, "Who is that woman?"[56] The suit dragged on for four years and was then settled out of court. Peggy had undermined her case by saying in her autobiography that she received all the Pollock paintings she was legally entitled to. In the end she was awarded two minor items worth scarcely $400.

Peggy's life with Macpherson in the duplex was even more dissolute than before. Peggy and Macpherson both threw big, riotous parties, his mostly populated with his gay friends and acquaintances, hers predominantly with members of the art world. But they frequently intermixed. Gay men are often attracted to flamboyant older women, and many of Macpherson's friends enjoyed Peggy's company. She in turn experimented with several lesbian relations. But she remained loyal to men.

Speaking of this time, "Peggy went to bed with everyone," remarked Dorothy Miller, Alfred Barr's assistant at the Museum of Modern Art.[57] "She went after every male that was there," remembered Lee Krasner.[58] Peggy later told Jacqueline Weld, "I used to have so many people when I lived in that flat with Kenneth, I can't even remember their names now." She denied to her biographer that she was a "nymphomaniac," a term which then had more medical authority behind it than today. Sindbad, she said, agreed: she was just "oversexed."[59] In fact her behavior at this point, as in the past, can be seen as another desperate feint to fill her life-long emotional emptiness.

Art of This Century made Peggy a celebrity and her name a marketable commodity. In 1944, prodded by Clement Greenberg, Dial Press approached her for her autobiography, and Peggy, who always craved a literary career, agreed to write it. At the gallery and while sunning herself at Fire Island that summer, she pounded out 175,000 words on her portable typewriter. At Laurence's suggestion, and to echo her gallery's name, she called her book *Out of This Century*. Edited by Greenberg at Dial and revised with the help of Laurence, Mary McCarthy, and Lee Krasner, the book came out in March 1946. Its striking jacket had been designed by Pollock, not yet in Peggy's bad graces.

The book's reception was mixed. Peggy made a stab at disguising the names of her characters, but most were easily deciphered. Many of her cast objected to her description of their personalities, their work, and their doings. Peggy pulled few punches. Her own romantic affairs were laid out in graphic detail. People were revealed as adulterers, as libertines, as homosexuals, as frauds. Her judgments of artists' work was often harsh. Critic Harry Hansen of the *New York World-Telegram* commented that "a lot of men mentioned in it will wish they were disguised as non-objective art."[60] Peggy wrote tartly of her childhood and youth as well as of her adult years in the art world, but she was less harsh with her relatives than with her later friends and lovers. The Guggenheims came out better than her mother's family, the eccentric Seligmans, yet a false rumor had it that Uncle Solomon tried to buy up all the copies in stores to keep the book from circulating. Another story, more believable, is that among themselves the Guggenheims renamed the book "Out of Her Mind."

The critics generally lambasted *Out of This Century*. Elizabeth Hardwick called it "an unconsciously comic imitation of a first grade reader."[61] The reviewer in *Time* said it was as "flat and witless as a harmonica rendition of *Liebestod*."[62] In truth the book is neither Rousseau's *Confessions* nor Franklin's *Autobiography*. It is written in a naive idiom that may have been imposed by the author's literary limitations. But even if unintentional, the style is suited to Peggy's purposes. Though the book describes events that are often immoral, it is seldom apologetic or self-serving. It seems like the avowals of a child unable to understand why anyone should be repelled by things she did and observed. The book lacks insight, yet Peggy's frankness is hard to resist; indeed, there is something endearing about it. Even if the book was not the great commercial success that Peggy hoped, it added to her fame or, rather, her notoriety. And perhaps that had been one of her chief goals after all. Dial printed six thousand copies, and though it sold well among members of the art world, the publisher did not choose to reprint it.

THE WAR IN EUROPE ended in early May 1945 with Hitler's suicide in Berlin and the surrender of the Nazi government and the German armies a few days later. Europe was left devastated, its cities wrecked, its factories and railroads crippled, its people uprooted and exhausted, its governments repudiated. Forty million Europeans had died in the five and a half years of combat. The United States by contrast had been physically and demographically almost untouched. The country was prosperous in 1945 as it had not been since the 1920s. Peggy had good reasons to stay in New York. She and her gallery had helped midwife the Abstract Expressionist revolution and paved the way for transfer of leadership in the Western art world to New York. Perhaps the transit was not fully apparent in the months following VE Day. Clement Greenberg, one of her partisans, noted that "not until considerably later [were] the artists Peggy showcased . . . appreciated."[63] Yet it was already clear that Europe had become an artistic backwater. The vigor of Cubism, surrealism, and nonobjective painting was depleted and the genres were being superseded. Late in life Peggy would admit that "the most interesting years" were "in New York during World War II."[64] Yet Europe beckoned irre-

sistibly. Aside from the brief span 1941–46, she had never liked her native land. She was enamored of Europe, and had no intention of staying in the United States. Still, for Peggy to return to the old continent was to surrender the future for the past.

But Peggy was following the crowd, her crowd. Many people close to her were leaving or had already left. Sindbad, who had served during the war in the U.S. Army, was in France as a military interpreter. Now married to Jean Hélion, a young French painter and war hero, Pegeen was back in France too. In June Laurence Vail and his newest wife, Jean Connolly, went to live in France. And many of Peggy's artist friends were also returning to Europe. Besides, she was tired of the gallery. Keeping it going had worn her out, and she yearned to be free of it. But she was conflicted. "I hate America so much," she wrote Herbert Read in February 1946, "but I am scared to come back to Europe for the moment."[65] That summer Peggy went on a reconnaissance trip to Paris and found it deprived and dispirited. The people in the cafés were strangers; Sartre and existentialism, not surrealism, were now all the rage.

Mary McCarthy and her husband, Bowden Broadwater, encountered Peggy in Paris as she was about to leave for London to take care of unfinished family business. They persuaded her to accompany them to Venice instead. McCarthy later wrote about the meeting in a short story, "The Cicerone," included in *Cast a Cold Eye*, published in 1950. In the story Peggy is disguised as Polly Herkimer Grabbe, a "flower-bulb heiress," but the events, as described, are true. It was on the train from Paris, according to McCarthy, that Peggy first thought of moving herself and her collection permanently to Venice. Unfortunately, McCarthy contracted mononucleosis while on the train and stayed over in Lausanne. Peggy went on alone to Venice and was waiting in a gondola to greet McCarthy and Broadwater when they finally arrived in the Adriatic city.

McCarthy's portrait of "Miss Grabbe" was not flattering. The lady wore a "snood and sandals" along with "bright glass-bead jewelry" an "angora sweater, and shoulder-strap leather handbag." Her "brown face had a weather-beaten look, as though it had been exposed to the glare of many merciless suns; and her eyes blazed out of the sun-tan powder around them with the bright blue stare of a scout; only her pretty, tanned

legs suggested a life less hardy—they might have been going to the beach."[66] But the physical descriptions were not the most uncharitable remarks. McCarthy depicted Peggy as a sexual glutton. "Sexual intercourse, someone had taught her, was a quick transaction with the beautiful, and she proceeded to make love, whenever she traveled, as ingenuously as she trotted into a cathedral." Peggy-Polly "made love in Europe because it was the thing to do, because European lovers were superior to American lovers, . . . because she believed it was good for her especially in hot climates, and because one was said to learn languages a good deal more readily in bed."[67]

Peggy returned to New York in the fall prepared to close the gallery and arrange her final departure as soon as she could. Many of her friends and colleagues considered Venice culturally provincial, but she was determined to make it her permanent home. Peggy tried to find an alternate patron for Pollock. None of the gallery owners wanted to deal with a wild man, however. In the end she agreed to continue her subsidy to him until early 1948. Meanwhile, she gave Pollock his fourth one-man show. It was here that he first displayed paintings in his mature style created by dripping paint on canvas laid on the floor of his Long Island barn.

Art of This Century closed its doors on May 31, 1947. Peggy sold off the furniture, the curved walls, the peep shows. She also discarded some of the lesser paintings. Many of the pictures by Jimmy Ernst, for example, were merely dumped. An era in her life had ended.

Peggy arrived in Venice in the fall, only to be sidetracked to Capri for several months by Laurence and Jean, his third wife. She quickly resumed the promiscuous life she had enjoyed there years before when she had visited with Laurence and Clotilde, who had died in 1935. In November Peggy wrote Greenberg about life in Capri: "People do mad things and no one can be held responsible for their actions . . . There is an intense social life in Capri. One need never be alone for five minutes."[68]

In the spring she was back in Venice looking for a home for herself and her collection. Peggy knew few people in Venice. And in fact for many years she would be held at arm's length by the city's elite. At first her best friends were members of the city's gay community. As she

reconnoitered, the city's isolated artists looked forward eagerly to her patronage and the increased artistic prominence that her collection promised to bring to the city. One of the local painters called her appearance like a "meteorite from outer space."[69]

Before she could find a permanent location for herself and her art, the secretary-general of the Venice Biennale, a venerable international art fair held every two years, invited her to display her collection at the fair's twenty-fourth show in 1948. The Biennale would arrange to transport her paintings and sculptures from the United States and cover all costs. Peggy would be assigned the pavilion usually reserved for Greece but unused while the Greeks were in the throes of a civil war. Peggy leaped at the chance.

The Biennale was a triumph for Peggy. Not everyone approved of her display. Bernard Berenson, the pundit of pundits, Peggy's onetime idol, asked her dismissively as he shuffled through her pavilion: "why do you go in for this?"[70] Most of the Venetian public also turned up their noses at her collection. But many of the local critics, long cut off from modern art and unfamiliar with recent American art, were delighted by it. By contrast the other pavilions seemed hidebound and academic. Toward the end of the Biennale Peggy was invited to show her collection in Florence and then in Milan. Amid this pleasing prospect there was one problem. The Biennale officials had paid to bring her collection from New York for display at the art fair. But she could not keep it in Italy permanently without paying an exorbitant duty. Many months were to elapse before the difficulty was resolved by subterfuge: sending the collection to Amsterdam and Zurich and then slipping it by the ignorant customs inspectors at minimum valuation.

Meanwhile Peggy had found a perfect location for her collection and for herself. The Palazzo Venier dei Leoni adjoined the Grand Canal near Venice's city hall. Its construction had been begun in 1748 by a prominent local family, the Veniers, who reputedly had kept pet lions on the premises. Though it was intended as a two-story structure, only the basement and first floor had been completed. It was low and long and had six black marble bathrooms. Peggy bought it for $60,000 and set about renovating it as her home and her museum. She repainted the

exterior white, added modern plumbing, repaired the flat roof, and restored the garden. She installed the paintings and other art the Italian government allowed for her personal use while the bulk of her collection remained in storage pending resolution of the duty question. The palazzo had its own *pali*, a pole to which gondolas were tied. She painted hers turquoise and white as she did her own private gondola when she acquired one. For years she would get around the city by gondola and often took visitors on canal trips. She would be the last person in Venice to have her own private gondola.

Peggy moved into the palazzo in early 1949. In 1951, with her collection finally in hand, she was able to open her museum. The palazzo soon became a magnet for locals and visitors alike. The Venetian public believed Peggy far richer than she was and called her La Dogeressa, the lady doge, the title of the Venetian republic's ruler. Many Venetians deplored her "degenerate" art, and students from the local university sometimes threw dead kittens into her garden. Visitors, of course, were friendlier. Scores of people—family, friends, and celebrities—came to see Peggy at her palazzo. The collection soon became a must stop on every Italian tour, and Peggy herself became a Venetian tourist attraction. Peggy threw her usual raucous parties at the palazzo. Many who stayed with her were appalled by her pack of exotic, undisciplined Lhasa Apso dogs which made messes on the floor and seemed in constant heat. All told, fifty-seven puppies were born in the palazzo. Peggy gave most of them away but retained as many as seven or eight at one time. Despite her open hospitality, she often said she preferred her dogs to people.

The palazzo's role as a museum as well as a residence was an awkward compromise. Quarters were cramped. The basement, where the overflow from the collection had to be stored, was damp, and some paintings were hung in the bathrooms, next to Peggy's wet stockings. Viewers could see the collection on Mondays, Wednesdays, and Fridays from 3 to 5 p.m. during the summer season. Initially Peggy allowed visitors access to the private rooms, but when they poked their noses into her guests' bedrooms and into her own apartment, she locked off the residential parts of the palazzo. During museum viewing hours Peggy herself usually went to the palazzo roof, where she often sunbathed in the nude to

the scandal of local Venetians. Having been criticized for charging a fee at Art of This Century, Peggy allowed viewers free admission to her Venice museum. She did recoup some of her costs, however, by selling catalogs to visitors. The museum did not have trained guides; her household servants doubled as guides. In the process, she noted, they learned much about modern art.

In Venice Peggy resumed her quest for love. Her looks, now further diminished by age, undoubtedly deterred lovers. Truman Capote, in his unfinished roman á clef *Answered Prayers*, noted how, when he stayed with her at the palazzo for six weeks in the late fifties, she would unpleasantly rattle her false teeth. She looked, he unkindly said, "like a long-haired Bert Lahr."[71] Peggy denied that she was still on the prowl. "I don't even think about love any more," she told a reporter from *Time* in 1957 when she was sixty. "My only love is art and my collection."[72] Yet her sexual liaisons continued, though at a slower pace. In 1951 Peggy met Raoul Gregorich, a muscular Italian garage mechanic and sportscar enthusiast, twenty-three years younger than she. He was not interested in art and could speak no other language than Italian. He was, said one of Peggy's friends, simply "a gorgeous Italian stud."[73] He became the last of her serious lovers.

By most measures Raoul was a gigolo. She paid his bills and generally "kept" him. When he decided to open a car renting business, she bought him three automobiles to get started. He may have admired her for her style, sophistication, and wealth, but she idolized him. "I was madly in love with him," she said. "It was ridiculous."[74] In September 1954 Raoul died in a crash when he swerved his baby-blue convertible to avoid hitting a motorbike. He was thirty-three, and they had been together for three years. Peggy was devastated. "I don't think I'll ever love anyone again," she wrote Djuna Barnes. "I hope and pray not."[75] And she probably did not. Her few liaisons after Raoul were brief encounters that left no serious residue.

At least one of her friends believed that after Gregorich Peggy "changed drastically." Art historian Fred Licht wrote that with his death "she discovered inner resources." "Without impairing her sense of fun, a new and happy self-sufficiency became part of her day to day existence."

In a word, she lost much of her wild streak. She was quite happy to be by herself, Licht says. The raucous parties and flamboyant behavior no longer appealed.[76] In fact, whether it was grief or simply the onset of age is unclear. But Peggy's life did become more serene and more conventional after the mid-1950s.

PEGGY'S RELATIONS WITH HER CHILDREN continued to be problematic after she returned to Europe. In 1943 Pegeen, now a beautiful blond nymph who had escaped the Guggenheim rhinologic curse, had married the French painter Jean Hélion. She was eighteen and he twenty years older. The marriage was something of a rescue operation. Pegeen had had a troubled adolescence, marked by constant battling with her mother. At seventeen she traveled alone to Mexico and spent time aboard the Acapulco-anchored yacht of actor Errol Flynn, a notorious seducer of young girls. When she left Flynn, she moved in with the peasant family of a young Mexican who dove from the Acapulco cliffs for coins from the tourists. When Pegeen refused to come home, her father charged off to Mexico and dragged her back. She had contracted a venereal disease.

It was not surprising that Pegeen's dealings with men were problematic. Laurence Vail was a roué who took lovers wherever he could find them. Still more inciting were her relations with Peggy. Peggy's unbridled libertinism did not spare her daughter. She was constantly talking about sex with Pegeen. In New York, while they were living together in the duplex, she also encouraged her daughter, a high school girl, to engage in sexual escapades.

Once back in New York after her Mexican misadventure. Pegeen continued to fight with her mother, and to keep them apart Peggy set her up in a small Greenwich Village apartment. Laurence introduced his daughter to Hélion and urged him to marry her. Attracted to the sexy young blond and not indifferent to Peggy's money, Hélion divorced his American wife and married Pegeen in a simple civil ceremony.

The marriage was successful for a while. The couple moved to Paris after the war, where both pursued artistic careers. Hélion's painting style during this period shifted from nonobjective to figurative. For her part,

Pegeen painted doll-like young blond girls. They had two sons, Fabrice and David, and gave lavish dinner parties in their Paris apartment.

Even during this stable period of her life Pegeen had affairs. On visits to Peggy in Venice she slept with other men with her mother's full approval. In 1951 she took up with a Milanese antiques dealer. Her son Nicolas, rumor had it, was the dealer's child, not Jean's. Somewhat later she had an affair with a desperately poor Italian painter named Tancredi Parmeggiani whom Peggy was subsidizing. The gossips in Venice claimed that both mother and daughter were sleeping with Tancredi, though Peggy vehemently denied it.

By the later fifties Pegeen's marriage was on the rocks. Besides the other problems, She was a depressive who had tried to commit suicide several times. In 1957 Hélion and Pegeen separated, and Pegeen came to Venice with Nicolas to live with her mother for a year. On a visit to England with Peggy she met painter Ralph Rumney, the sharp-featured son of a Church of England clergyman. Rumney was nine years younger than Pegeen but they began an affair. In June 1958 Pegeen bore Rumney a son, Sandro. Shortly after, her marriage to Hélion officially ended in divorce.

Pegeen and Rumney soon married and went to live in Paris with Sandro and Nicolas. Peggy was forced to support them, for neither was able to earn a living from painting. Despite Peggy's largesse, she and her son-in-law did not get along. Rumney was actually an English version of Laurence Vail. Like Peggy's first husband, he was the complete nonconformist. A mediocre painter, he was a significant intellectual figure who helped found the Situationists, a movement that mixed hedonism, surrealism, and Marxism, and was one philosophical source of the 1968 student uprising in Paris. Peggy considered Rumney a bad-tempered boor. He was "an awful creature" whom she "absolutely loathed."[77] She was jealous of him as she had not been of Hélion and refused to have him at her home. Pegeen was forced to rent an apartment in Venice where she and Ralph could stay when she wanted to visit her mother. Peggy's good friend Jean Cocteau warned her that she must avoid alienating her daughter by her hostility toward Rumney. "You are damaging yourself and hurting her," he wrote.[78] But Peggy could not desist from attacking her son-in-law.

By the mid-1960s Pegeen's latest marriage was falling apart too. In late 1966 she returned to Paris, leaving Rumney in Venice. In February he joined her seeking a reconciliation, but Pegeen was drinking heavily and downing mouthfuls of pills, mostly tranquilizers and sleeping pills. They produced paranoid responses preventing the two from discussing their marital problems without shouting and recriminations. On the night of March 1, 1967, Ralph and Pegeen went to bed in separate rooms at their Isle St. Louis townhouse apartment. Pegeen asked him to take the children to school and feed the cats the next morning; she would probably sleep late. When morning came he tried to enter her room but found it locked. When he managed to break in he found Pegeen's lifeless body on the floor. She had apparently choked on her own vomit while comatose from barbiturates and alcohol.

Peggy was in Mexico when her daughter died and struggled to get to Paris in good time. The French police ruled Pegeen's death a suicide. It is just as likely that it was an accident. Peggy at first made the preposterous claim that Rumney had murdered her. Hélion thought that if anyone had killed Pegeen it was Peggy by her constant attacks and recriminations. Laurence believed that in some ultimate sense both Ralph and Peggy were to blame. "Ralph finished off Pegeen," he wrote Djuna Barnes, "but also Peggy is responsible. She loved Pegeen, but jealously, possessively." For over twenty years Peggy had done "all she could to break up Pegeen's relationship with whomever she was living with, husband or lover." Pegeen had led a miserable life, torn between her mother and whatever man she was living with.[79]

Eventually Peggy conceded that her daughter had probably taken her own life. She also acknowledged that perhaps she had contributed to her daughter's unhappy end. But that did not stop her from continuing to revile Rumney and fighting to keep him from getting a sou of his wife's money. Rumney's presence kept Peggy from her daughter's funeral, though Sindbad pleaded with her to come. Pegeen was cremated and her ashes buried in a Paris cemetery. Her rancor against Rumney did not dilute Peggy's grief for her daughter. In her revised memoirs of 1979 she called her "my darling Pegeen, who was not only a

daughter, but also a mother, a friend, and a sister to me. . . .There is no one in the world I loved so much. I felt all the life had gone out of my life."[80] Peggy set aside a room in the palazzo for displaying Pegeen's paintings. To one of Pegeen's sons it seemed as if the shrinelike space was intended by his grandmother to make amends for her bad behavior toward her daughter.

Laurence Vail survived his oldest daughter by only a year. He had long suffered from ulcers but despite his many excesses and dissipations managed to reach seventy-seven. Shortly after Pegeen's death he came to the United States to see his daughter Apple, now living in Miami, and to visit his old friend Djuna Barnes in Greenwich Village. Djuna thought he looked haggard. He was already sick with cancer and died in April 1968.

Sindbad was not as close to his mother as Pegeen. As a child he had lived mostly with Laurence, seeing Peggy on relatively brief visits. She did not know how to deal with a boy, and their contacts were often awkward. Sindbad later said that Peggy had been "a lousy mother."[81] Their alienation continued into his adulthood. Unlike his sister he was not interested in painting. That opened a wide gap between him and Peggy. "I have nothing to say to him," Peggy remarked at one point.[82] Just after the war Sindbad married Jacqueline Ventadour, the girl, then fifteen, whom Peggy had brought with her on the 1941 clipper escape flight from Europe. Sindbad and Jacqueline moved to Paris and had two sons, Clovis and Marc. Perhaps to prove to his mother that he aspired to higher things, Sindbad began a literary magazine in 1949 called *Points* that showcased younger writers in French and English. He also began to drink. In 1955 his marriage broke up. In a surprising switch, Jacqueline fell in love with Hélion, now divorced from Pegeen, and married him in 1963. Meanwhile, Sindbad fell into a depression and gave up the magazine. He had neglected it, and in any event, it had not been a critical success.

In 1957 he remarried. His new wife, Peggy Angela Yeomans, was an attractive, dark-haired Englishwoman, twelve years younger than he, with whom he had two daughters, Karole and Julia. Contemptuous of Peggy Angela's humble origins, jealous of another woman in Sindbad's life, and irrational enough to resent sharing a name with her daughter-

in-law, Peggy hated Sindbad's new wife. "She tried everything to break up the marriage," Peggy Angela later said.[83] She encouraged both her son and her daughter-in-law to have affairs and even tempted Sindbad with attractive boys. She eventually came to like her daughter-in-law, but for two decades she conducted a guerrilla war against her.

Sindbad never could please his mother. Though he spoke like her and had the same unlovely nose, he was too conventional, too bourgeois, for her and her circle. He and Peggy Angela lived in a dreary Paris suburb, not the Left Bank or one of the stylish arrondissements north of the Seine. After his magazine failed he worked as a real estate agent and then as an insurance broker. But his first interest was cricket; he founded the English cricket club in Paris. For his part Sindbad resented his mother's tightfistedness. He was constantly nagging her for money, which she gave, when she did, only reluctantly and with ill-grace. Undoubtedly, it would have been better if Sindbad had been able to support himself and his family on his own. But even when he could justifiably turn to her for help, as when he was battling cancer in the mid-1970s, she refused to come through. Still, Sindbad never broke with his mother. He visited her in Venice with his family and inscribed in her guest book at the palazzo: "Sindbad Vail with all my love to Moma [sic]."[84] She in turn, when her collection came to Paris for exhibit at the Orangerie in 1975, spent time with him. Mary McCarthy, who observed them together on this visit, considered the connection a "rueful relationship."[85]

As PEGGY REACHED her later years she began to brood over the fate of her collection. It did not have an endowment, and she feared it would be broken up after her death. Many institutions expressed interest in acquiring it at her demise, but none followed up when they learned they would have to provide the financial resources to maintain it. Except one: the Solomon Guggenheim Museum run by cousin Harry.

Peggy's relationship with Harry and the foundation he headed was relatively cordial. As we saw, she and Hilla Rebay had detested each other, but after her old friend James Sweeney took over as museum director, the relationship with Harry improved. In 1959 when she passed through New York on the way back to Venice from Mexico, Harry

treated her to a tour of the still unfinished Wright building. The spiral ramp, she said, made her dizzy. The eventual fate of Peggy's collection was already on Harry's mind, and soon after this visit he wrote that it would probably be best if she bequeathed it to the Italian state. He soon shifted ground. Sometime around 1965 Harry dispatched Thomas Messer, Sweeney's successor, to Venice to explore establishing a closer relationship between the two museums. Messer arrived as Peggy was in the midst of dickering with the Tate Gallery in London to take over the collection. In 1965 the prestigious British museum had honored her with a five-week exhibition of her collection. When she visited London, the English art world and the media had lionized her. Understandably, when the Tate made an offer to acquire her art, she was impressed. But this proposal foundered on the problem of estate taxes and the Tate's reluctance to absorb the Venice works without a substantial subsidy from Peggy. Another suitor was the University of California, whose president, Clark Kerr, visited Peggy in Venice in 1966 and began negotiations for the university to acquire her collection. This overture collapsed when Governor Ronald Reagan fired Kerr for his permissive attitude toward the student insurgency in Berkeley.

From 1965 on Messer conducted a spirited campaign to induce Peggy to bequeath to the Guggenheim what he believed was "probably . . . the most important collection of modern art still in private hands."[86] The campaign was like a romantic courtship. Once or even twice a year he visited Peggy in Venice to charm and flatter her. He would appear at the palazzo with a giant bouquet of flowers in hand and call out *"Fiori"* when the gatehouse intercom asked who was there. Peggy was amused and touched when she learned about his approach. But she remained suspicious of Messer as Uncle Solomon's emissary. She did not want to be "swallowed up" by Harry's "much more important Foundation," she explained.[87] And yet, according to her friend, John Richardson, she understood that she was "in no position to refuse."[88]

The breakthrough came in 1969 when, after months of negotiations and a delay caused by Pegeen's death, Peggy agreed to ship 125 of her best pieces to New York for display at the Solomon Guggenheim Museum. Peggy came to the opening in January, staying in New York for

the first time in almost a decade. The festivities began with a small black-tie dinner to honor Peggy, hosted by Peter Lawson-Johnston in the absence of the ailing Harry. The guests included Peter's mother, Barbara; Roger Straus, Jr., and his brother Oscar; Harry's daughter Joan; and Michael Wettach, Peter's half brother; as well as a group of close friends and museum benefactors. Peggy was impressed with the family's prosperity and Peter's good looks. Just before the dinner Messer showed Peggy how he had installed her paintings at the museum. She thought they looked a bit like postage stamps on the walls, but added with some glee, reflecting on the rivalry with the "rich Guggenheims": "If my uncle Solomon can now see me he is surely turning in his grave."[89]

After the family dinner, the doors to the main exhibition hall were thrown open and another thousand guests—celebrities, critics, artists, media folk—swept in to eat and drink, view the paintings and sculpture, and gawk at the sensational costumes of fellow guests. Some of the critics claimed the collection focused too much on the surrealists and criticized the quality of the abstract expressionists. But most agreed that Peggy had done a remarkable job as a collector and patron of art. Alfred Barr, admittedly one of her oldest friends, said she had "created a collection which is unique in its span, variety and consistent top quality. There's no one like her around now and probably won't be for some time."[90]

The exhibit was the turning point in the Guggenheim-Guggenheim negotiations. Before leaving America Peggy visited Boston and Santa Fe. When she returned to New York, she and the trustees drew up an agreement leaving her collection to the Solomon Guggenheim Museum. Harry was seriously ill, but supposedly followed the negotiations closely and approved the terms concluded. Under the agreement, the palazzo and Peggy's collection would pass to the Solomon Guggenheim Foundation, but the collection would remain intact and stay in Venice. Meanwhile, during her lifetime Peggy could live in the palazzo and administer it. The New York people, however, agreed to provide much needed restoration and custodial services for the paintings and sculpture and for the decaying palazzo itself. The 1969 agreement did not amount to outright legal transfer of the art. The Guggenheim Foundation

trustees had not ratified the transfer, and dismayed by the physical dete-
rioration of the palazzo, delayed until 1974. Not until 1975 was her own
Peggy Guggenheim Foundation replaced by her uncle's foundation. Yet
it essentially settled the issue of the final disposition of Peggy's collec-
tion. "I'm very happy about it," Peggy declared. "I think it's a solution
to all my problems. I've been worrying about it for years and now it's all
settled."[91]

PEGGY LIVED FOR another ten years after she transferred her paintings
and sculpture to the Guggenheim Foundation. They were inevitably
years of decline. She stopped buying additional works after 1973. When
art dealer Sidney Janis saw her in Venice in the later 1970s, she told him
that she "abhorred the work of recent generations."[92] She ceased acquir-
ing new dogs as the others died. Like many older people in a period of
rising prices, she came to perceive everything as horribly expensive and
sought to economize even more compulsively than before. She sold her
car and her motorboat. She retained her personal gondola, but fired one
of her two gondoliers. She no longer employed live-in help and had dif-
ficulties keeping day servants because she paid so little. At times her par-
simony was comical. She maintained two larders: a relatively expensive
one for her dinner guests, and a barebones one for the servants. At din-
ner parties she urged her guests to eat everything on their plates; other-
wise the kitchen help would get the pricey leftovers. But even guests
were shortchanged. Her favorite form of entertainment was the cock-
tail party. At these she could avoid providing food almost entirely. To
accompany the drinks, guests had to be content with the likes of sardines
on crackers. In this matter, she had not changed much since her New
York gallery days!

Yet even the last years had their victories. Now that Peggy was an
international celebrity, it became mandatory for every visitor to Venice
to drop in at the Peggy Guggenheim collection and, if possible, get a
glimpse of the notorious lady as she stepped into her gondola. Peggy's
fame induced London publisher André Deutsch in 1979 to reissue her
1946 memoir in a revised, updated edition with a foreword by one of
her friends, the novelist Gore Vidal. In the new version real names

were used and the story was sketchily extended to the 1970s. When first approached by editor Louis Barron of Universe Books, she had vetoed the scheme. She had had "enough of the scandal the book had caused," she told him. Then she relented, allowing Barron to visit her in Venice while she helped him replace the original pseudonyms with real names. Peggy was "very frail," Barron reported, but had "almost total recall of the past."[93] The reviews this time were relatively favorable and the book sold well.

A particular high point in these last years was the exhibit of her collection by the Louvre. The venerated art museum had loftily refused to protect her works in 1940 when the Germans were marching on Paris. Now, in the winter of 1974–75, they were happy to provide space for them at the l'Orangerie for three full months. The show was a great critical and popular success. Peggy was able to visit with Sindbad and his family in Paris and glory in the many media interviews. In 1976 another exhibition in Turin was also well received.

Peggy let her hair go white in the early 1960s. She had been dyeing it jet black for many years and it had come to seem increasingly artificial. The change actually made her look younger. Yet from the mid-seventies on her health began to fail. She suffered from high blood pressure and poor circulation. Her arthritis gave her great pain. In 1976 she fell and broke eight ribs. Thereafter she had trouble getting about. Two years later she had a heart attack. In 1973 Peggy had met John Hohnsbeen, a blond, gay art dealer with a wicked tongue. She invited him to stay with her to help her with the collection. In effect, he became her informal curator. He was with her when she had her heart attack, and sobbing by her bedside, he was certain that she would not survive it. But she did. In late August her friends and family gave her an eightieth birthday party, held at the Gritti Palace Hotel. Sindbad gave a speech, and the famous film director Joseph Losey served as toastmaster. Losey maladroitly referred to Peggy as a *jolie-laide*, to her displeasure. But perhaps her chagrin was offset by a banner stretched across the hotel entrance wishing happy birthday to "l'Ultima Dogeressa."

Guests continued to visit her at the palazzo. In May 1979 Gore Vidal came again, bringing with him the actor Paul Newman and his wife,

Joanne Woodward. Jimmy Ernst visited in October. It was no time for resentments, and he wrote in her guest book: "My love for you stretches from the East River to the Grand Canal. It will last as long as both bodies of water exist."[94]

In the fall she slipped as she leaped from her gondola and broke a bone in her foot. When it refused to heal she was taken to a hospital in Padua for an operation. There, while she and the doctors debated the wisdom of proceeding, she suffered a stroke that paralyzed one side of her body. Sindbad was called in Paris and came with Peggy Angela to see her. "Her face was contorted," Peggy Angela later told Jacqueline Weld. "It seemed as if her soul was trapped in this body that didn't function any more." She was, however, able to say to Sindbad: "Please, kiss me."[95]

Peggy slipped in and out of a coma for a week. On Sunday, December 23, the hospital called the palazzo with the message that she was failing. A second phone call soon after told Sindbad that his mother had died. Peggy was cremated and her ashes buried in the garden of her palazzo next to her beloved dogs.

THOMAS MESSER, informed that she was on her deathbed, was at the palazzo in a matter of hours after she passed away to assure the smooth transfer of the premises and its contents to the Solomon Guggenheim Foundation. Peggy had given him a key to open the garden gate and the palazzo's main door. Messer selected Philip Rylands, a young art historian whom Peggy knew and liked, as curator at the collection to replace Hohnsbeen. It was Rylands's job to complete the physical restoration of the palazzo and the art preservation work Messer had begun, and ready the collection for reopening to the public.

The museum officially reopened on April 6, 1980. Peter Lawson-Johnston, Sindbad and his family, three of Pegeen's sons, and others from the art community, as well as friends, were present for the occasion. Those familiar with the palazzo while Peggy was alive were startled to find that virtually all traces of her presence had been removed. Her bedroom alone was preserved as during her life. The palazzo was now exclusively a museum. Peter gave a little speech recalling Peggy's candor.

Sindbad was not called on and felt resentful. That evening there was a black-tie dinner to raise money for the collection.

If Sindbad resented his treatment at the reopening ceremony, he was even more annoyed at the disposition of her estate. Peggy left most of her money to the family. Sindbad, appointed her executor, was the chief legatee. She also left various trust funds to her eight grandchildren. Sindbad inherited perhaps a million and a half in cash on which heavy taxes would be levied. This was far less money than he had expected, but he and Peggy's grandchildren were more displeased by the fact that they received not a single picture from the collection. According to Sindbad's older daughter, Karole, he was angry at his mother for not sharing at least some of her collection with him and the family and for excluding him from any say in the museum in favor of Peter Lawson-Johnston. Cousin Roger Straus, Jr., agreed that Peggy had been unfair. Peggy's children and grandchildren, he told Robert Keeler, "had been left with an outrageously small amount of money" considering that all Peggy had to do was take a couple of pictures off the Venice museum's wall and give it to them.[96] To the end, then, Peggy had managed to rile and antagonize those whose love she craved.

Sindbad's last years were not happy. He drank to excess and often could not work at his real estate and insurance jobs. He died in 1986 of throat and lung cancer. Peggy Yeomans died two years later.

WAS PEGGY GUGGENHEIM'S life important to the development of twentieth-century art? The answer cannot be categorical.

The critics agree that over her lifetime Peggy assembled an excellent cross-section of Western art during the first half of the twentieth century. James Soby, influential collector and art writer, called her wartime New York gallery "a landmark in the best sense of the word. . . . Her sense of quality seldom failed."[97] Even when she disliked a painter, as she did Dali, she felt she must include some of his work in her collection. One reason Messer was so eager to acquire the Venice collection was that he felt it was more representative of the great era of early twentieth-century Western art than the Solomon Guggenheim's own holdings in New York.

Was Peggy herself responsible for the collection's excellence? Some critics believe that she actually knew little about art, that she merely had good advisers. Anton Gill, her latest biographer, is particularly harsh. She was, he says, "unsure of her taste."[98] As he sees it, she collected primarily artists who were already acclaimed by the cognoscenti. Jackson Pollock and the abstract expressionists were the exceptions, but their cause, he says, "was a party Peggy joined late and left early."[99] On the question of originality even Messer agreed. The European paintings she bought, he said, "were already history."[100] One of Peggy's friends, the musician Arthur Gold, noted that "her taste was always other people's taste."[101] When she became detached from Breton, Ernst, and Duchamp, after she came to Venice, all agree that her selections of new paintings and sculpture declined in quality. But there are other voices. Jacqueline Weld, another of Peggy's biographers, gives her more credit than Gill for discernment. Also emphasizing the artists exhibiting at Art of This Century, Weld notes that her "judgments . . . were often founded on her uncanny intuition for talent. . . . Peggy had an eye for quality in people and paintings."[102]

When critics and scholars argue like this, the truth generally lies somewhere in the middle. There can be no question that Peggy helped midwife abstract expressionism, though admittedly, soon after its birth she abandoned it. Her foray into the American art scene during World War II was adventitious, not calculated. But it served nonetheless as a national tutorial that left a lasting mark on American taste. And even if her judgment in strictly artistic matters was sometimes clouded, her life had significant effects on the course of public taste and interests. Peggy's extravagance, her profligacy, her candor made modern art—already redolent of the scandalous and forbidden—still more glamourously wicked. Undoubtedly the notoriety repelled conventional Americans, but it just as certainly allured the young and the adventurous who saw it as an expression of a brave spirit, possessed by passion. Though no artist herself, Peggy's quest for love had, as Freud supposed, been sublimated into art after all.

Unraveling

O N SATURDAY, NOVEMBER 17, 1984, descendants of Meyer and Barbara Guggenheim assembled at the Solomon Guggenheim Museum on upper Fifth Avenue for a reaffirmation. The gathering was arranged by Peter Lawson-Johnston, chief guardian of the family flame in the absence of High Priest Harry himself. Peter and his oldest daughter, Wendy McNeill, had contacted every member of Meyer and Barbara's lineage whose addresses they could find, and invited them to New York to renew a sense of family identity. Wendy, Peter later said, "did a lot of the heavy work."[1] The event resembled a high school reunion, though, unlike that cherished American ritual, it brought together a mixture of backgrounds, generations, and nationalities.

We have a roster of participants' names.* Almost a hundred people attended, direct "blood" descendants as well as spouses and a few "guests" of the principals. Dana and George Draper came from California. Carol Langstaff, their cousin, arrived from Vermont with her husband, Peter Duveneck. Diane Langstaff, Carol's mother, also made the trip from California, with fourth husband John Darby-Hamilton and

*Courtesy of Peter Lawson-Johnston and Mary Donat of his staff at the Harry Frank Guggenheim Foundation.

her four Meek children, now in their mid- or late teens. Sindbad Vail, his wife, Peggy, and two of their children came from France, as did Pegeen's sons, David, Fabrice, and Nicolas Hélion and Sandro Rumney. Jean Hélion, Pegeen's first husband, was invited but sent his regrets. The Loeb brothers, Harold, Willard, and Edwin, were all deceased, but Loeb widows, grandchildren, and grand nieces and nephews attended. Audrey Love and her two daughters, Noel and Iris, were there. So was Joan Van de Maele, Harry's, oldest daughter, and, though no blood relation. Albert Van de Maele, Joan's former husband, with his new wife. The event drew a Rothschild descendant of Cora, one of Meyer and Barbara's elusive three daughters. Countess Eleanor, now eighty-eight, sent her regrets, but Arthur Patrick Avondale Stuart, eighth earl of Castle Stewart, and his wife attended, as did their son, Viscount Andrew, and his wife. Peggy's sister Hazel, also in her eighties and living in New Orleans, sent her regrets. Six Guggenheim descendants who actually bore the family name were at the reunion: M. Robert Guggenheim II, son of Harry's brother, from Southern California, with his fourth wife, Shirlee, as well as his son, Daniel, and Daniel's wife; and William Guggenheim III with three of his teenage children from Florida. Publisher Roger Straus, Jr., was there with wife, Dorothea, and son, Roger Straus III. So was his brother, Oscar Straus II, and Oscar's son. And of course Peter and his family all attended. Many of the names on the roster do not appear in our story. They carried the genes of Meyer and Barbara, but however estimable their lives, they contributed little to the family saga. And, of course, many descendants of Meyer and Barbara did not come to the celebration on upper Fifth Avenue, either because they could not be located, or were too young, or chose to stay away.

The guests were taken to the Island by tour buses to visit Solomon's Trillora Court and nearby Falaise—the family "mansions," a word that Roger Straus, imprinted with the egalitarian reticences of the day, told the *Times* reporter that he found "revolting."[2] Back at the museum, they inscribed their names on a large family tree, listened to an a cappella group sing a cantata composed especially for the occasion, and had their collective picture taken standing on the spiral ramp of the Wright building. The centerpiece of the gathering was dinner in one of the galleries

of the museum. The descendants were seated at tables by family affilia-
tion, recalled William Guggenheim III. He found himself and his chil-
dren placed next to the Daniel M. Guggenheims from California, whom,
though they bore the same last name, he had never met before. The
guests were almost uniformly impressed with the event. "Peter,"
William later said, "put on a show" that was "flawless, first class,
deluxe . . . beautiful."[3] Dana Draper, now a man of forty-four, called it,
in his laid-back, California way, a "kind of fun thing to do."[4]

The affair was also a last hurrah. Roger Straus, Jr., told the *Times* that
it was "the kind of thing that you do just once."[5] Peter later said that he
never intended to repeat it. There would be a number of small family
gatherings, usually to celebrate exhibition openings at the museum, but
in fact no reunion was ever held again. And probably for good reason.
For a few guests the occasion had been revelation. William Guggenheim
III, though he bore the family name, had always considered the
Guggenheims remote and rather mythic, an Olympian American busi-
ness dynasty—like the Rockefellers, Du Ponts, or Astors. The reunion
had "made it personal," he later remarked.[6] Yet he acknowledged that he
had made just one new contact—Daniel M. Guggenheim, the only other
adult male who still bore the family name. Peter himself joked in late
2003 that the reunion's only effect was that he was now receiving
Christmas cards from people he had never met before.

After the mid-1980s the Guggenheims as a family unraveled still fur-
ther. By the twenty-first century hundreds of individuals could claim
descent from Meyer and Barbara. A few cherished their Guggenheim
heritage, but collectively there remained little sense of family or even
accurate knowledge of family history. If anything created a bond among
the scattered and diverse clan members it was the foundations and muse-
ums. These remained living testaments to the family's accomplishments
and sustained a sense of family pride among some Guggenheims. For a
select few, they also provided employment as trustees, vice presidents,
advisers, and curators. It was the civic obligations and cultural infatua-
tions of Daniel, Simon, Solomon, Peggy, and Harry—the foundation
makers—that had, unintentionally, provided cement for whatever cohe-
sion the Guggenheim family retained.

* * *

IF NOTHING ELSE, the reunion reaffirmed Peter Lawson-Johnston's role as designated preserver of family solidarity and reputation. That, of course, had been one of Harry's hopes when he made him his successor. Peter understood his obligation well. "Harry sort of left me with the responsibility" of guarding the family's heritage, "and I took it seriously," he later said.[7]

On the business side of his mandate from Harry, Peter's success was modest, however. Though a member of Kennecott Copper's board of directors, he refused the offer to become its CEO in 1978 "because of family business."[8] In the 1980s Peter spoke optimistically about Guggenheim Brothers' investments in geothermal power in California. But apparently the returns proved limited. He remained chairman of the Zemex Corporation, a successor of the family's Yukon Gold Company. Zemex was a profitable producer of feldspar, kaolin, mica, talc, and other basic construction materials, as well as metal powders and tin. But the Zemex profits were also moderate and in any event the family retained less than 50 percent of the firm's ownership. We know of another family firm, Elgerbar Corporation. Founded by Solomon years before, its title assembled from the first syllable of his three daughters' names (Eleanor, Gertrude, Barbara) it manages timberlands in South Carolina and serves as a holding company for family securities. All told, the remaining family enterprises consist of a few mid-sized firms with unspectacular profits. Clearly, Peter was not destined to revive the family's past industrial glories.

The most interesting economic success under Peter's watch was the development of the forty-five-hundred-acre Daniel Island, the part of Cain Hoy plantation that Harry had bequeathed to his foundation.

For years after Harry's death the "island"—actually a stubby, thumb-shaped peninsula of the mainland—was left undeveloped. That could not continue for long. Located adjacent to Charleston, the property soared in value as the city grew and became a major tourist magnet. Harry had foreseen the island's inflation in value and had advised Peter to "just sit on it for a while."[9] Peter and his advisers did just that, but by the late 1980s the time seemed ripe for the asset's development. The

foundation created a master plan for the site and, working through a private firm, the Daniel Island Development Company began to promote the property as a residential community. In 1991 the city incorporated the island into its official municipal limits, thereby making available city services and conveniences. Development really took off, however, with the opening of the Mark Clark Expressway, linking the island directly to the city. By 2002 Daniel Island had become a thriving community of homes, golf courses and tennis courts, community centers, and small businesses, with a population of two thousand. Unable under the law to serve as a profit-making real estate developer, in 1998 the foundation sold the tract to the development company for some $12 million. These funds were added to the foundation's existing endowment assets, raising them to about $50 million in total worth.

But in truth, Peter Lawson-Johnston was more interested in the family's cultural holdings than its business affairs. Peter remained chairman of the Harry Frank Guggenheim Foundation and, as "president" of the Solomon R. Guggenheim Museum, remained the ultimate authority for many years in that institution's governance. He held the title at the museum for twenty years and in 1984, as part of his campaign to recruit rich benefactors, surrendered it to Ronald Perelman, the head of Revlon cosmetics, retaining the office of chairman of the board of trustees. Eight years later he turned over the "chairmanship" to financier Peter B. Lewis, another business mogul. Lawson-Johnston joked about the migrating museum titles. "You know, I'm happy to do this and it's a great for the institution, but there's only one problem here: I'm running out of titles."[10]

Though willing to hand out honorifics, Peter had no intention of divesting the family of its cultural influence. Peter Sr. and his wife, Dede, have four children, one son and three daughters. All are closely involved in the running of the larger Guggenheim Foundations. Peter II is a trustee of both the Solomon Guggenheim Foundation and the Harry Frank Guggenheim Foundation and heads their investment committees. His sisters, Wendy, Tania, and Mimi, are all officers of the family foundations. Wendy is a vice president and trustee of the Solomon Guggenheim Foundation; Tania is director of the Harry Frank

Guggenheim Foundation, and Mimi is a member of the Peggy Guggenheim Advisory Board.

If Peter Sr. himself found art and scholarship more suited to his interests than business, Peter II was more in the entrepreneurial mold of his Guggenheim ancestors. In many ways he, rather than his father, carries on the family business tradition.

Peter II, like so many Guggenheims, started out as a humble worker in a family enterprise—as an oil field roustabout on Alaska's North Slope. After graduating from Trinity College in Hartford, he decided to go into real estate and then into financial management. Peter *père* is proud of his son's success as a money manager. In 1999 Peter II and a group of associates founded Guggenheim Capital, as a "diversified financial services firm." Its clients included "ultra high net worth individuals" as well as foundations, insurance companies, endowments, and pension funds. In 2004 it supervised more than $90 billion of assets and employed more than 375 men and women working out of offices in New York, Chicago, Miami, Los Angeles, and other American cities, as well as Geneva, Hong Kong, and London. Structurally the company consists of two parts: Guggenheim Capital Markets and Guggenheim Partners. The first focuses on structured finance, sales and trading, corporate funding and merchant banking; the second on wealth and investment. Peter II acknowledges that the firms' names reflect his desire for continuity with his Guggenheim forebears. He ascribes the success of the company to its offer of a "true partnership approach" to its clients and the fact that "we are opportunistic and nimble."[11] Even during the financial doldrums of 2000 to 2004, his father notes with pleasure, the firms were able to make a large contribution to the Solomon Guggenheim Foundation.

Whatever may be true of the Guggenheims as a whole, Peter Sr.'s own family is a tight-knit group. All three of his daughters live in New Jersey, not far from their parents' home in Princeton. They spend much of their time attending to the business of the foundations. But Wendy McNeil is also on the advisory board of Sun National Bank and a fundraiser for the Mercer County chapter of the American Red Cross. Tania McCleery has a bookkeeping business and works for the surviving

Guggenheim Brothers firm. She is on the board of the family company, Elgerbar Corporation, and is a member of the board of the Planned Parenthood Association of Mercer County. Mimi Howe is also on the board of the Elgerbar Corporation. She has small children but manages to enjoy tennis and arts and crafts. Peter II lives in posh Greenwich, Connecticut, with his wife, the former Karen Gallagher, and their sons, Peter, Henry, and Sam. All three are just on the verge of adolescence.

AT THE OPENING of the twentieth-first century Peter Lawson-Johnston, Sr., remains the family patriarch, if that term has any meaning today. But of this fourth generation of Guggenheims the educated public probably best knows Roger W. Straus, Jr., second son of Gladys and Roger W. Straus I, grandson of Daniel, the family leader in the early twentieth century.

Roger was born in 1917 just before his father went off to war. As a child he frequently saw his aunts and uncles and played with his cousins on visits to grandfather Daniel's Hempstead House mansion. One difference between them and him was that, like his grandparents, he and his siblings, Oscar and Florence, were being raised as Jews. Neither Roger nor Oscar had bar mitzvahs, the traditional ceremony admitting male Jews into the covenant at the age of thirteen; Reform synagogues of that era did not perform such ceremonies. But they each underwent its equivalent, a "confirmation" ceremony.

Roger was more interested in sports than in books. His father wanted him to go to top-ranked St. Paul's, but with his mediocre grades he had to settle for lesser St. George's School in Rhode Island. Roger was the only Jewish boy at St. George's, but that suited his father, who was determined to prove to "those non-Jews out there that there was very little difference" between Jews and gentiles.[12] Roger, in effect, was his father's guinea pig, and the experiment was a failure. His athletic prowess blunted his schoolmates' hostility somewhat, he remembered, but he became the butt of some nasty anti-Semitism nevertheless. He never finished at St. George. At fifteen, after a summer as copy boy on the *White Plains Daily Reporter*, he quit school to become a junior reporter for the paper.

Roger soon had second thoughts about his aborted education. Though he had no high school diploma, he applied to Hamilton College in upstate New York. Backed by influential family friends, he was admitted in 1935. The pull of journalism again proved irresistible, however, and after two years, and without his degree, he switched from Hamilton to the well-regarded journalism school at the University of Missouri. In 1938, while still at "J school," he married Dorothea Liebmann, a dark-haired senior at Sarah Lawrence whose father owned Rheingold Brewery in Brooklyn. After graduation in 1939 he returned to the White Plains paper as a labor reporter.

Journalism, at least in its lesser reaches, was apparently less satisfying than Roger had expected. However unstudious as a youth, he was heir to a literate family tradition, and in 1940 he began to edge into book publishing. In 1941, the year of Pearl Harbor, he founded a book-packaging firm, Book Ideas Inc. Soon after, suffering from a spinal infection and unable to pass the armed services physical examination, he became a civilian public relations adviser for the navy. When his health improved he enlisted in the V-12 program and spent six weeks at Cornell University in a training course for navy officers, emerging with an ensign's commission. After graduation he was shipped off to Washington and then reassigned to New York to write propaganda for the navy.

After VJ Day Roger resolved to become a publisher. Without experience, he needed a mentor and was directed to John Farrar, a respected older man, formerly a senior partner in Farrar and Rinehart, a small New York publishing house. A civilian at the Office of War Information during the war, Farrar had been forced out of his own firm by novelist Mary Roberts Rinehart, the jealous mother of the two other partners. After 1945 he found himself at loose ends, holed up in a gloomy one-room office in the Chelsea neighborhood of Manhattan, dabbling in marginal publishing ventures. Brought together by friends, the two men started discussions at lunch at the old Murray Hill Hotel and soon worked out a partnership agreement. Farrar would supply the experience, Roger the capital, to be provided by his parents and rich friends. In early January 1946 *Publishers Weekly*, the industry's trade organ, announced formation of Farrar, Straus and Company, with Farrar as chairman of the board of

directors and Roger as president and largest stockholder. The new firm, the *PW* news item noted, would start with a small number of titles in the spring, followed by a longer list in the summer and fall. It would publish both fiction and nonfiction and target the "new writer and the young writer, and the work of men and women who have returned from war service."[13] Six weeks later John Hutchens of the *New York Times* Sunday book section reported that the "F. & S. shop" was a "busy place these days," with several books ready for press, including a new novel by veteran author James Branch Cabell, and "Yank, the GI Story of the War."[14]

Despite the upbeat puffery, the early years proved difficult. Not until 1950 when the firm signed up Gayelord Hauser, a prominent dietitian and writer of self-help nonfiction, did it find its financial footing. Hauser's *Look Younger, Live Longer* sold three hundred thousand copies during its first year, and sustained the firm during its hazardous infancy. Though now a book publisher, Roger did not forget his professional origins. That May the firm announced, in cooperation with Twentieth Century–Fox Films, creation of a fellowship program to pay advances of $13,500 each for novels written by working newspaper and magazine writers. In 1950 the firm became Farrar, Straus and Young after taking on as partner Stanley F. Young, its managing editor. In 1953 it absorbed Pelligrini and Cudahy, another firm founded at the end of the war, and added "Cudahy" to its title. Eventually it dropped Young from the firm name and in 1955 added Robert Giroux, who came from Harcourt, Brace, bringing with him a dozen prominent writers, including Bernard Malamud and Flannery O'Connor.

Farrar, Straus & Giroux would evolve into one of the two or three most prestigious publishing houses in America. After Farrar died in 1974, the firm continued, with the scholarly Giroux serving as general editor while Roger remained the "mover and shaker."[15] His guiding principle, Roger proclaimed, was that the firm must be "editorially driven," by which he meant its "first and most important responsibility" was "toward the authors" it represented rather than its balance sheet.[16] His appraisal of writers, once past the firm's baby steps, was unerring. Roger was as perceptive a judge of authors as his uncle Harry was of horseflesh. He wooed literary men and women with great panache and

assured them that their works would remain in print for many years. He foraged widely for writing talent in Europe. On an early postwar trip to Italy he discovered Carlo Levi and in 1947 published *Christ Stopped at Eboli*. It would go through more than thirty printings. By the 1980s Farrar, Straus's list of authors included Isaac Bashevis Singer, Tom Wolfe, Susan Sontag, Pablo Neruda, Nadine Gordimer, Margarite Yourcenar, Philip Roth, Bernard Malamud, Czeslaw Milosz, Elias Canetti, Alexandr Solzhenitsyn, T.S. Eliot, and Mario Vargas Llosa. More than a dozen of its authors would win Nobel Prizes; an equal number National Book Awards. One of Roger's colleagues in publishing, Richard Seaver, then of Henry Holt, remarked in the late 1980s: "You judge a publisher by his or her list and the Farrar, Straus list is simply superb."[17]

With passing time the firm absorbed a number of specialty houses as subsidiaries—Noonday Press, Octagon Books, L.C. Page, McMullen Books, and Hill and Wang—but itself avoided incorporation into any of the sprawling publishing empires that began to emerge in the 1970s and would become dominant in our own day. This independence was not accidental; it was made possible by the firm's commercial success. Roger denied the charge that he had been forced at times to draw on his private fortune to meet deficits. In a 1977 interview he insisted that in the previous decade the firm had been in the red only twice. Roger in fact made the chancy publishing game, with narrow profit margins, into a financially successful enterprise. He had no need to sell out.

Principle as well as profits assured Roger's independence. The conglomerates, he was certain, were driven exclusively by their balance sheets, and that was toxic to literature. He could see no good in publishing houses "being run by accountants, businessmen, and lawyers who have little concern for books." "They could just as well," he said, "be selling string, spaghetti, or rugs."[18] Though he had been saved from early ruin himself by a bestseller, he despised bestseller lists, believing they fostered potboilers. He denounced the large chain bookstores. These dreary places encouraged the trashy, gimmicky books that had come to dominate the publishing enterprise in America. His views were elitist,

critics claimed. Roger did not deny it. If they meant that publishing qual-
ity books was elitist, he was guilty as charged.

Straus's publishing philosophy was not universally admired. Robert
Snyder of Simon and Schuster, considered the anti-Roger, acknowl-
edged that Farrar, Straus had published works of great merit, but ques-
tioned Roger's ability to market these successfully. He "almost thinks
that if books sell," he told an interviewer, "that's commercial and there-
fore bad."[19] Snyder believed that Straus made these claims of publishing
purity to attract authors who seemed particularly susceptible to the "art-
for-art's-sake" appeal. They were often disappointed, he said, when their
books failed at the bookstores. Other dissenters included some of
Roger's underpaid employees. Their boss, one said, had the notion that
the young people who worked for him were being subsidized by their
rich parents and paid them accordingly. Still, many remembered their
years with Farrar, Straus with affection as an exciting, creative time.

And despite his claims, Roger had his share of commercial bonanzas.
In 1987 the firm published two blockbusters, Tom Wolfe's *Bonfire of the
Vanities* and Scott Turow's *Presumed Innocent*, both well written, assuredly,
but not likely to put their authors into Nobel Prize contention. The suc-
cess of the two 1987 novels illustrated the downside of getting what one
wishes for. The flood of revenues they produced inspired a wave of costly
expansion and zealous first printings based on exaggerated expectations.
Over the next few years the firm repented at leisure. "We had a lot of
hopes and expectations that didn't materialize," Roger later admitted.[20]
In 1992 Farrar, Straus laid off 15 percent of its staff and cut other costs as
well. The firm recovered, of course, and during the first decade of the
twenty-first century scored some important publishing successes with
Jonathan Franzen's *The Corrections* and Jeffrey Eugenides' *Middlesex*.

Craggy-faced, with wavy, combed-back hair, white in later years,
Roger had the personality of a steam locomotive—all whistles, pumping
pistons, turning wheels. He vibrated with energy and talk, much of it
slangy and contrivedly vulgar. Tom Wolfe recalled that when he came to
New York in the early sixties he expected that everyone "was going to
have great electricity and 150-watt eyeballs, and be full of life."[21] Only
Roger Straus among the publishing celebrities did not disappoint him.

Roger did not bear the Guggenheim name, but he had absorbed the Guggenheim mythos—though perhaps not in the pure form professed by Uncle Harry. Roger was close to his uncle. He had his own country home, Sarosca Farm in Westchester, inherited from his Straus grandfather, but he and Dorothea visited frequently at Cain Hoy and Falaise. Dorothea had matured into a dark, slender, interesting-looking woman, with an intense temperament and sensitive perceptions of people and places, who dressed in dramatic Edwardian style. She shared her husband's enthusiasm for literature and was a writer herself. One piece in her memoir, *Showcases*, was a brilliant, high-contrast portrait of Harry and the dramatis personae of Harry's somber later years. Roger sent Harry and Alicia many of Farrar, Straus's latest books when they appeared. He shared Harry's interests, including his sense of family distinction. In 1955 when Harry was exploring the possibility of a family history, he turned to Roger for advice about its scope and possible author. The outcome was Lomask's *Seed Money*, published by Farrar, Straus in 1964. Roger participated in several of the Guggenheim family foundations. In the 1980s he was on the boards of the Harry Frank Guggenheim and the John Simon Guggenheim foundations. He and Harry were both attracted to Latin American culture and politics. In the 1970s Roger was a trustee of the Center for Inter-American Relations.

One interest that uncle and nephew did not share was the ancestral religion. Harry barely acknowledged his Jewish roots. Roger Jr. was not as active in Jewish affairs as his father, but he remained a practicing Jew. He attended high holiday services and was a member of the Union of American Hebrew Congregations, the umbrella organization for Reform Judaism, serving on its publications committee for a decade from 1955 on.

In later life Dorothea Straus moved closer to Judaism. Jewish by origin, her parents and grandparents had either aggressively rejected their religion or allowed it to slip away. By Dorothea's generation the family connection to Judaism had attenuated to the point of invisibility. The Liebmanns never mentioned being Jewish, though they felt its presence like a hidden malady, and celebrated Christmas with all the enthusiasm and opulence of high Episcopalians. As Dorothea later wrote, "we never

wanted to be Jews, and we had hoped to merge with those less endangered than ourselves."[22] Dorothea's world changed when she became a good friend of Isaac Bashevis Singer, the Yiddish writer, a Farrar, Straus author, and helped him translate some of his work into English. When Singer flew off to Stockholm in 1978 to receive the Nobel Prize for literature, Dorothea and Roger were part of his entourage. Her friendship with Singer led her to rediscover her heritage. At his Nobel address in Stockholm, she later wrote, as the audience rushed to congratulate the aged laureate, she suddenly realized, "I had outgrown the pronoun *them* in my thinking about Jews."[23] Dorothea carried her insight into practice. In recent years, often accompanied by her husband, she attended services on major holidays at Temple Emanu-El.

Roger was eventually forced to compromise his independent publishing principles. In the early 1970s, when American interest rates peaked close to 20 percent, he faced a daunting situation. Publishers work on borrowed money, and these rates threatened to cripple the firm. Since German interest rates had remained much lower, Roger contacted Verlagsgruppe Georg von Holtzbrinck in Frankfurt to arrange financing in exchange for a partial stock sale. The deal fell through when Roger realized that von Holtzbrinck sought complete ownership. By 1995 circumstances had once more changed, and the German publishing conglomerate and Farrar, Straus reached an acquisitions agreement. Von Holtzbrinck promised to "preserve the integrity and uniqueness" of Farrar, Straus.[24] And it has. Jonathan Galassi serves as president and publisher of Farrar, Straus & Giroux, but Roger continued to make major editorial decisions at his beloved firm until his death in mid-2004.

ROGER STRAUS'S UNEXPECTED SALE of Farrar, Straus in the mid-1990s echos Uncle Harry's sale of *Newsday* twenty-five years before. In both cases an aging magnate who has created a successful company finds himself without an anticipated successor and surrenders his cherished life's creation.

Roger and Dorothea had one son, Roger W. Straus III. Born in 1944, he attended the prestigious Choate School and Columbia College, and in 1965, when he was twenty-one, married Nina Pelikan, granddaughter

of a Lutheran minister. The ceremony was performed by the bride's uncle, the Reverend Jaroslav Pelikan, a prominent Lutheran theologian. Undoubtedly the groom's parents had come to accept the reality of intermarriage in mid-twentieth century America, but we do not know what Dorothea and Roger felt as they accompanied their son down the aisle of the Pelikan home during the ceremony.

As a child Roger III was close to his father. He often came down Saturdays to the Farrar, Straus office on Union Square to open John Farrar's mail. Afterward his father would take him to a baseball game or some other amusement. "[I]t was . . . a terrific way to be friends with your father," he told an interviewer years later.[25] The relationship fostered a passion for publishing. "I loved the game, I loved the serious aspect. It turned me on. I could see what my father loved about it and I shared his passion. I never thought about doing anything else."[26] To prepare for his future career, Roger III majored in English and art history at Columbia and took courses in publishing. For a time he was also caught up in the sixties student insurgency and adopted the facial hair and casual dress of the generation of undergraduate protesters. At a towering six-foot five, he must have seemed a formidable foe of the establishment. The sixties experience implanted a trace of rebellion and nonconformity in Roger that would emerge in later years.

After college he joined the family firm. Starting as a junior editor, he became a jack-of-all-trades, learning the publishing business in all its aspects—editing, marketing, advertising. Roger claimed that his father was easy to work for, but also that he was emotionally inaccessible. "We talked best and most fluently and articulately about business. . . . We haven't had a lot of personal, deeply intimate conversations."[27] Reinforced, perhaps, by a persistent flaw in the father-son relationship, after a decade with Farrar, Straus the powerful urge for separate identity won out over filial ties. As Roger III explained in 1979, he realized that as long as he remained at Farrar, Straus he would always be regarded "as my father's son." That had two sides. It was "an asset because I love, admire and respect him and being his son is a source of pride; a liability because you are never quite looked upon as being yourself; you're always part of something else."[28] Over the years Roger had been tempted by offers of

other publishers but he did not make the break until 1975 when Harper and Row offered him an important job in their marketing division. His father was sorry but told his son that he must choose his own path.

Roger III did not remain at Harper's. In 1985 he returned to the family firm as managing director. Again he did not stay. Working for a large firm like Harper's, he had acquired their publishing modus operandi—sign up bestsellers—and back at Farrar, Straus he wanted to build on Turow's *Presumed Innocent*. His father continued to favor the quest for exceptional talent, however marketable. "Roger wanted to move faster than I felt we should," was how Roger Sr. expressed it.[29] The clash of goals was publicly displayed at company editorial meetings, with the father at times publicly sabotaging his son and overruling him. "Ultimately there was only one vote," Roger III later explained. There had always been only one vote that counted and always would be. As long as he was "comfortable with that it was fine, and to the degree that I wasn't, there was going to be a problem."[30] In 1993 Roger III quit Farrar, Straus for the second and last time. His father clearly felt bruised by the move. "I was sad," he told Ian Parker. "Because I like the idea of being able to hand the company over to him. My wife and I used to talk about that."[31] Two years later, his dynastic hopes dashed, Roger II, as we saw, sold the controlling interest in the firm to von Holtzbrinck.

Forty-nine when he left his father's firm, Roger III did not abandon the book business; it was, after all, part of his DNA. After leaving Farrar, Straus, he expanded his professional range. Long interested in photography, in 1991 he had collaborated with *New York Times* writer Andrew Malcolm on a photographs-cum-text panoramic description of U.S. 1, the historic north-south federal highway connecting Maine to Florida. It was the second volume of a projected "road" series by St. Martin's Press that had opened with *Route 66: The Mother Road*. In 1996 he joined Malcolm again on a volume of text and photographs exploring the past and present of the Mississippi River, called *Mississippi Currents: Journeys Through Time and a Valley*. Later he did the photography for *Modernism Reborn: Mid-Century Houses*.

Roger III and Nina had three daughters—Laura, Rachel, and Tamara—but they were divorced in the mid-seventies. In 1977 Nina

took a Ph.D. in literature at NYU and in 1980 joined the faculty of State University of New York at Purchase where she taught courses on Tolstoy, Dostoevsky, and the modern novel.

Roger soon married Marian Young, an advertising manager for a publishing house. That relationship did not last, and he then took a third wife, Doris Borowsky, eleven years his junior. Doris had worked in publishing herself but quit to pursue her love of horticulture as a staff member of the New York Botanical Garden. The Strauses bought a house on City Island, a picturesque waterfront community on Long Island Sound, within New York's city limits that resembles a New England fishing village. There Doris could express her interest in creative gardening and Roger could plan his next book of architectural photographs. He is currently working on two books, one on the homes of prominent southern writers, the other on those of the Founding Fathers.

Besides their two sons, Roger I and Gladys had a daughter, Florence. Born in 1922, she attended Brearley, the girls' private school in New York that had excluded her two older cousins, Joan and Nancy, in the mid-1920s. She had graduated from Sarah Lawrence and was at the Columbia School of Social Work when she married Lieutenant Max Hart in June 1945 at the Straus family's country home in Purchase. The marriage joined two members of the German-Jewish elite. Max, about to be discharged from the army, was the son of a founder of Hart, Schaffner and Marx, the flourishing men's clothing manufacturer located in Chicago. Governor Thomas Dewey and his wife were among the honored guests.

Florence Hart has a daughter and a son and lives in Chicago. She is active in a large number of volunteer social service groups and has immersed herself in many local civic activities.

OSCAR STRAUS II'S public career proved to be less newsworthy than his younger brother's. Yet in their early years this could not have been foreseen. Oscar was his father's favorite. The firstborn, as a child he was academically more talented and more attuned to his father's values and aspirations than Roger. Oscar's grades got him into the prestigious St.

Paul's School, a bastion of high Episcopalianism, and then Princeton, his father's alma mater.

After his B.A. in 1936 Oscar joined the U.S. Foreign Service, hoping to become a career diplomat. But he miscalculated by marrying a Canadian woman, Marion Miller, while vice consul in Montreal, and under existing State Department rules, he was disqualified for further employment as an American foreign service officer. For a time after leaving the foreign service he worked with New Dealer Adolph Berle at the State Department. During World War II, excluded from the navy by his bad eyes, Oscar enlisted in the coast guard, and when he was mustered out in 1945 turned to family enterprises for his livelihood. In 1945 he joined ASARCO, where his father was president, and rose to become chairman of its finance committee. When Roger Sr. left ASARCO in 1957, Oscar, finding his way up blocked, was happy to accept his uncle's invitation to come to the revived Guggenheim Brothers.

Oscar has been described by his second wife, Joan, "as the most stable person I know," but, as we saw, his tenure as his uncle's right-hand man and potential successor proved to be acrimonious and short-lived.[32] Still committed to mineral development, after he left Guggenheim Brothers Oscar founded Straus Explorations, named so by default after Harry vindictively refused him the right to use the Guggenheim name for the new firm. Straus Explorations sought out gold, diamonds, and copper in Brazil, Mexico, and Canada, but with all the richest accessible ore bodies already exploited, it did not achieve major discoveries.

In 1974 Oscar transferred his energies to the Daniel and Florence Guggenheim Foundation. Gladys, his mother, had already presided over the foundation's shift of emphasis to criminal justice system reform, but the process accelerated under Oscar's long presidency. In the words of Oscar Straus Schafer, a Straus cousin and recent head of the foundation, its revised goal was to "reduce the level of crime in American society, increase fairness in the criminal justice system, add to our knowledge about the causes of crime and its effects on society, and provide training in problem solving and administration."[33] The foundation has sponsored academic criminal justice programs at Princeton, Yale, Harvard, and Berkeley. These aimed to change the perception and administration

of criminal justice in the United States and encourage more talented young people to choose careers as defense attorneys and law enforcement administrators. A particular recent focus of the foundation is easing the plight of imprisoned women, many of whom have been herded off to jails for violating the punitive drug laws. The foundation has also shifted its geographical range. Once claiming a national reach, since the 1990s it has limited its benefactions to projects and organizations close to the New York region.

Oscar, even more than his brother, observes the family faith. His first wife was not Jewish. When he married a second time in 1982, though his bride, *Toronto Star* columnist Joan Sutton, was not Jewish either, the ceremony was performed by Rabbi Ronald Sobel in his study at Temple Emanu-El. Joan converted to Judaism. During the 1950s Oscar was a member of the board of trustees of Temple Emanu-El. In the 1990s he served as president of the Emanu-El congregation.

At the age of ninety Oscar found himself immersed unexpectedly in an event that reverberated with echoes of the family past. In 1929 grandfather Daniel had given the Chilean Republic a half-million dollars to establish an aeronautical club and an aviation school, a gift that combined the family's interest in both Chile and aviation. In the opening years of the twenty-first century the Chilean government decided to convert the property into a housing and office complex. Oscar and Joan flew to Santiago—no mean trip for a ninety-year-old—to see if they could not preserve the family bequest for some better purpose than that contemplated by the Chilean government. The trip was a success. To compensate the family for surrender of the property, the Chilean government agreed to invest $5 million in a criminal justice program of the kind favored by the Daniel and Florence Guggenheim Foundation in the United States.

OSCAR'S ONLY CHILD, Oscar Straus III, born in 1942, is a graduate of the University of Arizona. His first wife was Geraldine "Missy" Coors of the famous Colorado brewery family. Missy attended Miss Porter's School in Connecticut and then went to Connecticut College for Women. Oscar, then at Princeton, was dazzled by the beautiful blond

girl of the golden west, and they were married in June 1961 when they were both under twenty. Bill Coors, her father, a sponsor of far right causes, could not have relished his oldest daughter's marriage to the son of an observant Jew. Nor could Oscar II have appreciated his son's new ties to a family that provided major financial support to the John Birch Society. Apparently the two families had little contact with each other in future years. Oscar transferred to the University of Arizona to complete his education, and the newlyweds went to live in Tucson. Missy and Oscar soon started a family. William was born in 1962 and David in 1967.

Even as a girl Missy was "emotionally delicate."[34] And no wonder. Her mother, Geraldine, was an alcoholic; her father was too busy at the brewery to give her any attention. As a four-year-old she had watched in horror as her little brother, William, choked to death on a chicken bone. What effect these experiences had on the little girl we can only imagine, but we know that in later years she manifested classic symptoms of bipolar disorder and took lithium to control it.

Oscar and Missy lived abroad for a time while he worked in Malaysia with Pacific Tin, one of the Guggenheim family firms. When they returned to the United States he took a job with Guggenheim Brothers and the couple lived on East End Avenue in New York. Despite the lithium Missy's behavior was unpredictable. By the 1980s she and Oscar were estranged. In early afternoon on August 6, 1983, startled passersby in the affluent Gramercy Park neighborhood of Manhattan saw a naked woman sitting on an apartment ledge twelve stories above the street. Several were shouting "Don't jump!" and "Go back! Don't jump!" when she hurled herself from her perch and fell screaming to the pavement below.[35] Missy was pronounced dead at the hospital. She was forty years old. Oscar rushed to the hospital when she was brought in, but William, now twenty-one, and David, sixteen, were in Maine for the summer and flew back to join the family gathered to sort out their mother's tragic death.

Missy was not Jewish, and while she and Oscar were married, he ignored his family's religious heritage. Even before Missy's death, while in his forties, Oscar decided to became a lawyer. He went to Brooklyn Law School, an independent school often attended by older and part-

time students, where he met Sarah Barish, from an observant Long Island Jewish family of middle-class background. They married in 1985 in their final year. Through his second wife's influence he converted to Judaism. Oscar II says with amusement that his son is now more religious than he.

Oscar III specializes in senior citizens' legal issues. For a time he was manager of the Brooklyn Law School Senior Citizens Law Office. He later became director of the Elderly Project of Volunteers of Legal Service, Inc, a group created in the mid-1980s to increase the availability of pro bono legal services for New York's poor. Oscar III took over as president of the family foundation in the late 1990s, after Oscar III retired. To his father's regret, he decided after two years that he was not interested in the work. He now lives in New York City, but spends much time at his second home in Red Hook, New York, a Dutchess County community on the Hudson. Besides his two older boys, he has two sons by Sarah: Daniel, born in 1990, and Adam, born in 1993. Daniel was bar mitzvahed at the appropriate age and Adam is now preparing for his confirmation. His grandfather says he is looking forward to attending it.

FEMALES HAVE BEEN BLAMED for the decline of Guggenheim wealth and influence: the family supposedly produced too many daughters. Meyer's seven sons had created the family empire and raised it to giddy heights; the decline that followed, it was said, derived from the virtual disappearance of male heirs.

Though plausible, the claim is shaky. The third Guggenheim generation certainly produced enough boys to continue, or even expand, the family business empire. Harry, Robert, Edmond, William Jr., and the Loeb boys—Harold, Edwin, and Willard—were the seven male third-generation members, a number equal to their parents' own exemplary cohort. Yet only Harry and, to a lesser extent Edmond, showed business interest and business acumen. The others rejected "trade" and preferred to drift through life on the success of their sires or divert their energies to the arts or to the social sciences. A still more telling refutation of the "daughtering-out" claim is the achievements of several female descendants of Meyer and Barbara. No single Guggenheim is as famous as

Peggy. Mention "Guggenheim" in almost any cultivated company, and the name—probably the only name—that will come to mind is Peggy, the flamboyant, outrageous collector of art and lovers. Other third-generation female descendants of Meyer and Barbara struggled to accomplish worthy objects beyond the domestic sphere—Nancy, Diane, Carol Langstaff—but all except Peggy failed to achieve broad recognition.

The fourth generation of Guggenheim women arrived on stage during the last decades of the twentieth century, when women had greater opportunity for individual distinction. But none achieved as much as Iris Cornelia Love, great granddaughter of Isaac Guggenheim.

In 1928 Iris's mother, Audrey Josephthal, daughter of Edyth Guggenheim and Louis Josephthal, a rich stockbroker and reserve rear admiral, married Cornelius Ruxton Love, Jr., Yale-educated son of a Brooklyn doctor. They had met two years before while Audrey and her mother, Isaac's middle daughter, were traveling by boat from China to India. Ruxton was then in the American diplomatic service, posted to China. The couple had two daughters, Noel, born in 1929, and Iris, born four years later.

Iris's grandmother Edyth, "an incredibly domineering person" and "a woman of frightening energy," was a rich heiress, but Ruxton, a Wall Street broker, though prosperous, was not among New York's super rich.[36] Iris's parents were distant emotionally; she saw them briefly in the evenings when they dressed to go out. The two girls were raised primarily by an English governess in a Park Avenue apartment surrounded by classical objets d'art. However aloof, the Loves were cultivated people, and some of their closest friends were connected to the nearby Metropolitan Museum of Art. In her last years Audrey would move to Key Biscayne, Florida, where she helped found an art museum and contributed to the Florida Philharmonic and the Florida Grand Opera. Ruxton died in 1973, but Audrey lived to one hundred, dying of a heart attack in November 2003 while attending a performance of Verdi's *La Traviata* the night before her birthday.

Iris and Noel were raised as Episcopalians. Iris remembered as a girl singing in the choir of St. James Episcopal Church on Madison Avenue

and attending services there three times a week. No one told her of her Jewish roots, and she only learned of them as a teenager while a student at the exclusive Madeira School in Virginia. One day, returning from New York after Thanksgiving recess, she was greeted in her room by a small delegation of Madeira classmates who demanded to know her religion. Flabbergasted, she asked what they meant. "You're Jewish," they flung at her and then left. Iris later asked her governess if she was in fact Jewish and was told, "Of course not. Whatever gave you that idea?" Sister Noel, older and wiser, told her the truth, but her father's response to the same question was: "Don't ever ask me such a thing again." When Iris quizzed her Guggenheim grandmother, the old lady replied: "So, you found out."[37]

After Madeira, Iris went to Smith College, her mother's alma mater. There she learned that her "destiny was classical art and archeology."[38] She spent her junior year at the University of Florence immersed in Renaissance and ancient classical treasures and artifacts and returned to finish her schooling in Northampton. After her B.A. Iris entered New York University's prestigious Institute of Fine Arts and completed the coursework for her Ph.D. but never wrote her dissertation. Her lack of a doctorate would later weaken her credibility in academic circles.

From an early age Iris was an iconoclast. As a child she had noticed that the famous terra cotta Etruscan warrior statues at the Metropolitan Museum seemed to be unique; there were no others like them. Iris concluded they were probably fake and told her classics professor at Smith of her suspicions. He advised her to make the statues the subject of her senior thesis. The essay, when completed, demonstrated convincingly that at least two of the three figures were forgeries. Some years later, when she was about to publish her results in an art history journal, she told the director of the Metropolitan, James Rorimer, an old family friend, of her conclusions. The Met experts, apparently, had come to a similar finding independently, and in early 1964, just before Love's piece appeared, the museum announced the sensational news in the *Times* with no mention of Iris. When she called up Rorimer to protest, he admitted, she later said, that "he'd treated me rather shabbily."[39] Iris may have resolved then and there not to be scooped again.

In 1955, while still at NYU, Love joined the university's archaeological expedition on the island of Samothrace in the Aegean and spent nine summers at the dig learning to be a field archaeologist. During the winters, meanwhile, she taught part-time at Cooper Union, Smith, and C. W. Post College on Long Island. In 1967 she became research assistant professor of art history at Long Island University and, with the help of friends, assembled an expedition to Knidos (or Cnidus), the site of an ancient Greek port on the Aegean in what is now the Turkish Republic.

Though not world famous like Athens, Sparta, Corinth, and other political and cultural centers of classical mainland Greece, the small Ionian city had been a commercial and religious hub with a medical school and a fine, man-made harbor. In the fourth century BC, however, it was most renowned for its temple of Aphrodite Euplola, the protectress of sailors. The circular temple featured a larger-than-life nude statue of Aphrodite by Praxiteles, the most famous sculptor of the classical world. The statue, considered the master's finest piece, drew admirers from all over the ancient Mediterranean, and rich Greek and Roman art collectors eagerly bought the many marble and terra-cotta copies made to supply the market. Knidos's period of prosperity ended about AD 600. The city was eventually abandoned and the temple and other ancient structures buried under the debris of centuries. The original statue disappeared, presumably a victim of Christian intolerance of pagan religious symbols.

Knidos was clearly worthy of investigation. But perhaps Iris's interest was fortified by personal identification. Is it farfetched to link "Love" with Aphrodite? And there would certainly be, especially later in the successive annual digs, a strong feminist cast to the enterprise. Most of the volunteers who worked at barren Knidos each summer were young women who admired Iris and her work. One dismissive Greek archaeologist described Iris's summer crews as her "amazons": another male archaeologist belittled the Knidos dig as "beautiful girls in bikinis."[40]

However deserving the project, it met opposition when first proposed. At LIU, according to Love, the jealous members of the art department tried to sabotage it. So did her "own flesh and blood."[41] When the rich trustee of LIU, construction magnate William

Zeckendorf, offered her $35,000 of the $50,000 she needed for the first year, her father told Zeckendorf he would supply the remainder. When Iris phoned to thank him, Ruxton denied that he had ever made such a promise. As follow-up, he wrote the university chancellor that he "had no confidence in any project with which Miss Love was connected." He went on to describe himself and his wife as "rich," but Iris as poor and presumably unable to support the project by herself.[42] This betrayal, so seemingly gratuitous, reveals a rift between daughter and father incomprehensibly deep, or a serious flaw in Ruxton's paternal instincts, or probably both.

Fortunately Iris was able, this first summer and subsequent ones, to raise enough money from foundations and individuals to support the excavations. Finds during the first few seasons included a Doric portico, a Roman temple, a necropolis, wall paintings, and a goddess's head. Then, in late July 1969, just as the first human set foot on the moon, Iris discovered the ruins of the Temple of Aphrodite itself on the crest of a hill where ancient descriptions said it had been sited. When she announced the discovery later that year at a meeting of the Archeological Institute of America, it made headlines around the world.

Love became a celebrity overnight. Though she was tall and slender with lustrous black hair, her square jaw and wide mouth kept her from being beautiful. Yet she added feminine glamour to a profession hitherto dominated by professorial old men with beards. Reporters and TV crews flocked to interview and film her, and when she spoke at professional meetings the seats were all filled. Then the year following the temple discovery she stirred up a controversy that augmented her celebrity but tarnished her reputation among her professional peers. One day in November 1970, while Iris and her cousin Margot Love Marshall, following a lead from a catalog entry, were sifting through the vast storage holdings of the British Museum in London, they found a chinless, jawless, coifless head that they identified as a surviving fragment of the original Praxiteles Aphrodite statue. According to Iris, the piece was hidden in a basement covered with a cloth and "the dust of ages." "I pulled it out, looked at it, and screamed 'It's here! It's here!'" she later reported.[43] Museum officials denied the details of the discovery. Miss Love had not

found the piece in the cobwebby basement; she had requested it and it had been brought to her in the students' room. Besides, the head was not unknown. It had been examined by experts several times previously and photographed. And, most important, it was definitely not from the long-lost statue by Praxiteles, but rather, probably, a head of Persephone by a lesser contemporary of the great sculptor.

Iris defended her attribution passionately. The museum's response must have seemed yet another attempt, like the Met's years before, to deny her discovery rights. The head could not be that of Persephone, she insisted. That goddess was generally depicted with a tall-crowned hat and was usually accompanied by a poppy or a sheaf of grain. The modeling and surfaces of the museum head also had extraordinary qualities that only a genius like Praxiteles could achieve.

The controversy was never settled definitively. The museum refused to relinquish their view that "Miss Love" was deluded and a publicity hound to boot. Iris, for her part, did not budge. The archaeological establishment accepted the British Museum's position and, additionally, denounced her use of dynamite to remove a rock at the site of the temple to uncover its base. Proper archaeological technique required delicate methods: hand trowels and fine brushes; dynamite was outrageous. Iris smarted under the criticism, but at least, she always noted, no one could deny her discovery of the famous temple.

During the later 1970s Iris continued her work at Knidos and expanded her investigations to include Knidian colonies in southern Italy and Sicily. In 1982 she rediscovered another temple to Aphrodite at Ancona on the Italian peninsula. Though denied full acceptance by her peers she gathered honorary degrees from colleges and universities and foreign archaeological bodies conferred membership on her. Yet by the time she reached her late fifties Iris's passion for Knidos had waned. Perhaps those austere, exhausting, sweaty, mosquito-ridden summers in the eastern Mediterranean finally became unsustainable. She took up photography and traveled the lecture circuit. She attended fashionable parties where her scientific credentials gave her prominence. Gossip columnist Liz Smith wrote that "she never missed a party, an opening,

any occasion. She loved celebrations, putting on costumes, noting birthdays and dancing to almost anyone's tune."[44] She became a celebrity archaeologist who guided the likes of Barbra Streisand and Faye Dunaway on tours of the Aegean. During the late 1970s, between frequent trips, Iris lived comfortably with her Love relatives in Brooklyn on the proceeds of several trust funds established for her by her grandmother. She "came out" as gay when Liz Smith described how, after meeting Iris often at parties, she encouraged Iris to sleep over at her Manhattan apartment cum office when she was in New York. "Finally," writes Smith, "deep friendship and romance won out over common sense and I invited her to move in and stay."[45]

The friendship with Smith continued into the 1990s. The columnist describes a Florida trip in 1990 with Iris and her sister, Noel, and Noel's husband, Nelson Gross. On the plane back they met Katharine Hepburn, then in her nineties and a well-known recluse. She and Liz became Hepburn's friends and often visited the legendary star at her home in Manhattan and attended the theater with her.

Today Iris's name is more closely linked with dogs than ancient artifacts. A breeder of championship dachshunds at her home in Vermont, she is active in the American Kennel Club and is a member of its art committee. In February 2004, just days before the opening of the Westminster Club's annual dog show in New York, Iris was in the news for her yearly party at Tavern on the Green for "dachshunds, show dogs and dogs in general"—and, presumably, their owners.[46] Iris does not share the preoccupation with the Guggenheim dynasty of her distant cousin Harry. But she was proud of the family heritage nonetheless. When, in 2001, a French company, Trans Europe Film, did a seventy-five minute documentary film on the Guggenheims, *Guggenheim: Un Rêve Américain*, Iris was happy to participate. In the film she contributed her slightly shaky version of the family history and linked her discovery of the Temple of Aphrodite to Harry's Goddard rocket project through the coincidence in timing of the first moon landing and her Knidian find. Iris's are the final words in the film: "My last name is Love, but I am very proud to be a Guggenheim."[47]

* * *

NOEL LOVE, Iris's older sister, was almost her antithesis. Blond and pretty, traditional in her sexual focus, conservative in her civic interests, in 1960, after graduation from Sarah Lawrence, Noel married Nelson Gross, a young New Jersey lawyer, in a Methodist ceremony. Noel and her husband lived in tony Saddle River and were active in Republican politics, he as chairman of the State Republican Committee. New Jersey's Republicans were usually moderates, but Noel was a self-confessed conservative and an early supporter of Ronald Reagan's bid for the Republican presidential nomination. In 1969 Nelson successfully managed the gubernatorial campaign of William T. Cahill. The next year he was himself the Republican candidate for the U.S. Senate, but failed to unseat incumbent Harrison Williams. Gross's political career collapsed abruptly in 1974 when he was indicted, tried, and convicted of tax fraud and perjury in his capacity as chairman of Cahill's campaign, and sentenced to two years in federal prison. Despite this family setback, Noel was elected national Republican committeewoman from her home state.

After release from prison Gross became a successful restaurateur, caterer, and real estate developer in Edgewater, across the Hudson from Manhattan. Noel herself was chosen New Jersey racing commissioner. In September 1997, when he was sixty-five, Nelson became the chief character in another crime story when he suddenly disappeared after withdrawing $20,000 from his bank in the company of two unidentified men. Neil Gross, his son, according to Noel, had called his father on a cell phone when he saw Nelson suspiciously sitting in a car with the men. Nelson had replied to Neill's worried call that he was all right. "It's business. It's just business," he told his son and hung up.[48] The family assumed that Nelson was the victim of a kidnapping and offered a $100,000 reward for his safe return. The FBI entered the case under the federal antikidnapping laws. Days later Gross's car was found abandoned on Riverside Drive in Manhattan's Washington Heights. The FBI pried open the BMW's trunk but it was empty.

Apparent inconsistencies in his story led the police for a time to suspect that Neil, whose past relations with his father had often been

stormy, had participated in his father's disappearance. He voluntarily took a lie detector test and failed it. But Neil was innocent. On September 25, after a week-long hunt, an informer's tip directed the police to an embankment between the Henry Hudson Parkway and the river in upper Manhattan where they found Nelson Gross's body. He had been bludgeoned with a rock and repeatedly stabbed. The New York police quickly arrested three young Hispanic men. Apparently, after forcing him to make the $20,000 bank withdrawal, they had planned to free Nelson until they realized that he might recognize one of them, seventeen-year-old Christian Velez, who had worked as a busboy at Nelson's Edgewater eatery. Gross could not be allowed to testify against them. All three confessed to the murder. Two, directly implicated in the killing, including Velez, were sentenced to thirty years in prison. A third, who agreed to testify against the others, received a seventeen-year sentence.

Noel was now in her late sixties. Her husband's murder was the culmination of difficult and tragic events. Her charmed early life had turned into a sad reality.

AMONG HARRY GUGGENHEIM'S grandchildren Carol Langstaff, like Dana, chose the road of art for her life's journey. Her father, John Langstaff, Diane Guggenheim's first husband, was a professional singer. John came from a musical family and after a modest concert career branched out into music education and writing prize-winning children's books. A creative man, in 1957 he invented a new theatrical form, the "Revels." This combination of music, dance, and drama resembled early seventeenth-century English "masques." But unlike this older genre, the Revels incorporated audience participation and ritualistic medieval and folkish elements. Langstaff believed that the Revels introduced a much-needed communitarian component into modern theater. An occasional happening in the 1950s and 1960s, the Revels performances later became regular yearly events at both Christmas and the spring solstice in various locations.

Carol was an experimenter with life as well as art. As a preadolescent she was "a tall, lovely girl."[49] She lived part of the year with Diane, the

passionate seeker, and part with her focused father. Neither, it seems, was a caring parent. To some extent, her grandfather filled the gap. Harry was indifferent to her when she was a child, she reports, but he discovered her when she reached seventeen and was living in Cambridge, Massachusetts attending music school. He invited her to come to an opening at the Guggenheim Museum and, to make sure she was presentable bought her a dress and shoes for the occasion. Thereafter Harry and she forged a warm relationship. They spent time together at the races in Saratoga. She also lived with him for several periods at Falaise where they took walks and enjoyed nature, often in silent communion. He worried about her health (she was too skinny), and about her finances. He gave her money for warm clothes, and paid her medical bills. When she was 21 he lent her the cash to buy her house in Vermont and soon after unbent enough to visit her at her rustic new home, arriving from Saratoga by chauffeured limousine. The Master of Falaise slept upstairs in a small, sunny room and used the outhouse.

But however warm the relationship, Harry was not entirely happy with her bohemian life and her artsy friends whose ways, he believed, were leading her astray. He once wrote her a letter, she says, expressing his hope that she would move to Washington, D.C., and marry a diplomat.

It took Carol a number of years to find her way professionally. She performed in her father's first Revels at New York's Town Hall in 1957, but did not make the form her vocation for some years. In the mid-sixties she proposed starting, in collaboration with poet Aram Saroyan, son of novelist William Saroyan, a combination bookshop and gallery for "concrete poetry"—described as a "material expression" of verse. Harry advised her against the venture and it is not clear that the project ever got off the ground. In the 1970s Carol joined her father as producer of Revels events, taking Cambridge, Massachusetts, where she then lived, as her initial venue and then moving the Christmas performances to the Dartmouth campus in Hanover, New Hampshire, and the summer Revels to Strafford, Vermont. Eventually Carol got tired of the Revels and started her own dance company, Flock Dance Troupe. It performed in the open air in Sharon, Vermont, using a mixture of professional and amateur dancers. The dances are often narrative; they frequently have

"social content." Several are based on Guggenheim themes. One piece told the story—probably untrue—of how Guggenheim copper miners were forced by their bosses to go down into the pits at the point of a gun. Another was staged on the pretend tailings of a copper mine.

Carol married twice. With building contractor Peter Duveneck, her first husband, she had three children, Sarah, Matthew, and Sonja. Her second husband was Jim Rooney, a record producer, singer, songwriter, and guitarist. He and Carol lived—and performed—half the year in Vermont and half in Ireland, the land both she and her mother had come to love.

THREE OF CAROL'S HALF SIBLINGS—Colm, Sorcha, and Catriona—were taken by Diane to Southern California in 1980 after she married John Darby. Eoin, the other child of Diane and William Meek, remained in Ireland, joining his siblings in California a few years later.

The Meek children, though of mixed origins, retain strong Irish loyalties. Eoin, the oldest, lives in Ireland with Helen, his wife, and their three children, Fiachra, Laoise, and Caoilinn. He restores antique furniture and plays traditional Irish music on the Uillean pipes. Colm, his younger brother, and Sorcha, his older sister, lived for years in Ireland although they eventually returned to the United States. Catriona, the youngest Meek child, visited Ireland often.

Caitriona married Thomas Nelson in 1993. The Nelsons live in Ojai, California, but have given their three sons Irish names: Conan, Tiaman, and Ciaran. She describes her life during the past ten years, without apologies, as "dealing with sleepless nights, stomach flus, diapers, emergency rooms, complaints, fights, extracurricular activities, tournaments, and so forth." It has been "rewarding in its own right."[50] Sorcha makes her home in Hood River, Oregon, and is a professional working artist who exhibits in many galleries. She is married to Barry Paul, a software engineer who runs his own firm. She has two daughters, Lilly and Leia Paul.

The Meek children, as grandfather Harry noted of Eoin back in the mid-1960s, represented a "wide mixture of races and cultures," but they seem, as he hoped, to "blend to make . . . happy . . . member[s] of the . . . world into which" they "had been born."

* * *

AS WE HAVE SEEN, Daniel's older son, M. Robert Guggenheim, was a disappointment to his parents and to his younger brother. He married four times but had children only by his first wife, Grace Bernheimer: Daniel Guggenheim II, born in 1906, and M. Robert Jr., born four years later. Daniel died in 1925 at age eighteen of a heart attack while attending Phillips Exeter Academy.

His parents' divorce in 1915, when he was five, and the tragic death of his older brother ten years later, were severe emotional blows to the young Robert. The divorce was more disturbing than it need have been. Robert found himself shunted back and forth between his mother, now living in Philadelphia with her second husband, a department store magnate, and his father, who lived in Washington, D.C., and South Carolina. Though his grandfather Daniel, sought to restrain the mischievous streak he shared with his father, at times, while a teenager, Robert was forced to apologize to Daniel for practical jokes. John H. Davis believes that the instability of his early years left him with a sense that life was fragile and capricious.

Robert attended Dartmouth and graduated in 1933. His formal major was English, but he was really interested in theater and in his CV listed his major as "Public Speaking."[51] Prodded by his father, Robert joined ASARCO immediately after Dartmouth, spending 1934–35 as assistant ore buyer in Mexico and then transferring to an executive job at the Garfield smelter near Salt Lake City for the next two years. In June 1934 he married Helen Allyn of Montreal in a Protestant ceremony. They would have two children, Grace Anne, born in 1935, and Daniel M. Guggenheim, another namesake of his grandfather, born in 1938. Robert Jr.'s marital record was typical of Guggenheim males. In 1950 he divorced Helen and then soon after married his secretary. This marriage was brief, and over the next decades, he married twice more, the last time in 1970. At twenty Grace Anne was "introduced" to Washington society, at the home of her grandparents, Polly and the former ambassador.

Robert disliked the smelting business and made his life bearable by joining the Salt Lake Little Theater, an amateur drama group. The experience only whetted his appetite for the entertainment business. In 1936

he took a job in Hollywood with David O. Selznick, the movie mogul. "I'm starting at the bottom," he told a newspaper reporter who found the transition from metals to movies an interesting story. "My first job will be third assistant director for one of United Artists Independent producers— a sort of 'call boy.'"[52] Robert claimed that his father approved of the film venture, but in fact M. Robert Sr. was appalled at his son's defection and flew out to Los Angeles to deter him from hitching his star to Hollywood. The effort failed.

Robert had a hand in several successful Selznick movies including *A Prisoner of Zenda*, and *A Star Is Born*. He soon clashed with several Selznick directors, however, and was fired. In 1937 he moved to Twentieth Century–Fox as assistant producer under Daryl Zanuck, but that job lasted only until 1940. During these movie years, according to his son, the family lived luxuriously in Beverly Hills. Yet Robert's movie career did not last long. Professing not to like Hollywood people very much, he became a producer at KNX, the Los Angeles radio affiliate for CBS. He remained at the station until 1942 when he joined the navy as an intelligence officer, serving both ashore and at sea in the Pacific the- ater until December 1945.

Robert later regretted that he did not return to ASARCO after the war. He had made "a big mistake not staying with the company," he told his son.[53] Instead, he moved in and out of various jobs and businesses the rest of his working life. He tried a flock of "wild schemes," including investments in ice cream parlors, a jewelry store, and the manufacture of "novelties."[54] He sought to make a go of public relations and market research under the firm name Guggenheim Enterprises. He later worked for a advertising agency where he managed the West Coast accounts of Revlon and Cadillac. In the 1950s he took a job with televi- sion station KNBH, the NBC affiliate in Los Angeles. There he remained for several years, in charge of their films division.

At times Robert made good money, but there were periods when he was seriously strapped and forced to live on unemployment insurance and the proceeds of a small family legacy. When Harry revived Guggenheim Brothers in the early 1950s, Robert eagerly offered to head a West Coast division if one was created. He was disappointed when

Harry denied any interest in starting such an office. Daniel believes that despite some success in advertising and the movies, his father remained sensitive about his modest financial achievements, especially during this period of his life.

Robert got through these difficult years in part on hope. He was his father's only surviving child, and Robert Sr. was a rich man. His mother, Helen, believed that her first husband had diminished his own life by counting too much on his inheritance, and she warned her son to avoid that same pitfall. But Robert had guessed right. When his father died in 1959, Polly, his widow, got their large Washington, D.C., estate, but Robert Jr. received several million dollars as a life trust. He also inherited money from his stepfather, Morton Snellenberg, the Philadelphia department store executive. Robert quickly moved out of middle-class West Los Angeles and bought a large home in posh Newport Beach in Orange County. According to Daniel, after 1959 his father "never had to work again."[55]

Though he lived in California to the end of his life, Robert did not sever his family ties back east. He visited the East Coast often, stopping in Washington to visit his father, in Philadelphia to see his mother, and in New York to spend time with Uncle Harry. He and his then current wife more than once joined Harry's family Christmas gatherings and turkey shoots at Cain Hoy. In his letter to his uncle exploring the possibility of becoming West Coast representative of Guggenheim Brothers, he noted how much he "would welcome identification with the Guggenheim heritage."[56] Given his attachment to the family, why did Harry never consider Robert as his successor? He was a closer blood relation than Peter, after all. But apparently Harry was certain that his nephew would never leave California. More important, according to Daniel, Harry's attitude toward his nephew echoed his skepticism toward his own playboy, womanizing older brother. Though Daniel believes his father was a talented and reliable man, it would not be surprising that to Harry, Robert Jr. seemed unstable and untrustworthy.

Robert wed his fourth wife, Shirlee McMullen, in 1970. They lived in a nine thousand-square-foot home that also housed his extensive, if minor, art collection. Soon after their wedding, Shirlee discovered that

she had multiple sclerosis. Sometime before this Robert had conducted a telethon to raise money for MS and knew the symptoms well. It was he, even before the doctors, who diagnosed his wife's illness. Thereafter he and Shirlee became major fund-raisers for the MS Foundation and other charities. Robert was also a benefactor of Chapman College, a small liberal arts school in Orange County, to which he bequeathed his paintings, prints, and sculptures. In his later years Robert led the local Big Brothers/Big Sisters of Orange County, an international mentoring organization for children and youths. His son feels that in his last decades Robert worked hard to make a worthy life for himself to compensate for his wastrel of a father and his own less than spectacular success as a businessman. Yet he never felt that he had won the respect of the family and was sensitive to apparent slights. He deeply resented, for example, his dismissal with just a bare mention in Lomask's 1964 book on the Guggenheims. He blamed the omission on Harry and conveyed his chagrin to his son, who wrote Harry an angry letter that he later came to regret.

Robert died of cancer in 1991, at the age of eighty. Services were held at St. Marks Presbyterian Church. Shirlee received most of his money as a life trust, to be transferred to Daniel and his sister at her death.

IN THE CASE OF Daniel, the family mystique survived into the fifth generation. In the early 1950s, while still a high school student, Daniel wrote great uncle Harry asking whether he could work for Guggenheim Brothers after completing college. He also asked him for advice on which college to attend if, as he expected, he chose engineering as his profession. Harry prescribed his usual formula for young male Guggenheims aspiring to join the family business. Before attending college Daniel should go to Anglo-Lautaro Nitrates in Chile for three years to get "an understanding of the nitrate business and the Chilean people [and] also a thorough knowledge of Spanish."[57]

In fact Daniel was more interested in the stock market than in mining and smelting. Yet to oblige his father he applied for admission to the highly competitive Berkeley engineering program. He did not "make the cut," and was happy to shift his major to economics and business.[58] In

1962, after a stint in the navy, he became a stockbroker. This was a commission business where income depended on churning the client's portfolio, a practice he found offensive. He left this job in 1970, joining a friend in the investment management business, where his income came from straight fees. Unfortunately, the partners had the bad luck to encounter a bear market just as they started out. After three years of painful losses, Daniel turned to real estate, joining Coldwell Banker to learn the ins and outs of the commercial property market. He remained at Coldwell Banker until 1983 and then joined two friends as a developer and renovator of apartment complexes. In the 1980s he established a real estate development firm, Guggenheim Company, which planned apartment developments in both northern and southern California. The firm was very successful. Daniel later said that he had made through his own efforts in real estate five times the money he had received from all his inheritances.

Daniel married twice and had four daughters. With Carol Foulds he fathered Kerry and Kristin; Sara and Beth were his daughters with Susan Winchester, an English model he met in California. He too had "daughtered-out," but Daniel is proud of his children. Kerry Brewer lives in northern California and works for a company that markets "open" MRI machines. Kristin lives in Sun Valley, Idaho. Her father proudly describes her as a "go-getter."[59] She is married to a money manager and despite three children of her own has opened a successful Montessori school in Ketchum, Idaho. Sara too is an educational entrepreneur. She graduated from Long Beach State College and, with the financial help of her parents, opened a preschool that in 2004 had 320 students and a long waiting list for admission. Daniel claims that fathers come straight from the delivery room to register their newborns in Sara's school. The youngest, Beth, is a housewife.

Although his own business interests were remote from the family's traditional metals industries, Daniel continued to be intrigued by the Guggenheim mystique. He joined the board of the Daniel and Florence Guggenheim Foundation and took his work as a board member seriously. He remained an active board member until 2003 when the foundation's shift of emphasis to programs and projects primarily in the New

York area made him feel, as a Californian, that he no longer had much to offer. In 1996, when the Guggenheim school of engineering at Georgia Tech rededicated the aeronautical engineering building that his great grandfather had donated, he was asked to speak for the family. It was a moving occasion for him, one that reinforced his family pride.

PEGGY'S GRANDCHILDREN, the sons and daughters of Pegeen and Sindbad, remained busy, creative people through the remainder of the old century and into the new. All told they numbered eight, four the children of Sindbad by two wives—Jacqueline Ventadour and Peggy Angela Yeomans—and four of Pegeen's by husbands Jean Hélion and Ralph Rumney. Proud of their grandmother and the Guggenheim connection, several sought to rescue Peggy's reputation from the critics who belittled her artistic taste and considered her little more than an "oversexed lightweight."[60] At times their concern for their grandmother's reputation pitted them against Peter Lawson-Johnston and the Guggenheim Foundation trustees. In 1991 Nicolas and David Hélion and Sandro Rumney, Pegeen's sons, threatened to sue the foundation for mismanaging their grandmother's palazzo museum in Venice. The New York people, they charged in an interview with a *Times* reporter, had eliminated all vestiges of Peggy's life at the Palazzo Venier dei Leoni. "The only purpose is to show her life and personality," asserted Sandro, an art dealer and later art publisher in Paris. Now, after the Solomon Guggenheim people had removed virtually all traces of her personal presence and many of her art pieces, the palazzo had "lost all its originality and personality. . . . Its spirit has gone." One of the threesome's complaints was that the room Peggy had set aside as a memorial to Pegeen, displaying her paintings, sculptures, and personal objects, had been eliminated. They were, they said, "deeply shocked" by that action.[61]

Peggy's other grandchildren refused to join the attack. Karole Vail, an art historian herself, was notable by her absence. Yet the indictment by David, Nicolas, and Sandro was dismaying to the Guggenheim trustees. Museum director Thomas Krens refused to respond to the charges, but his deputy, Michael Govan, answered vigorously on his behalf. Peggy, he insisted, had clearly meant the palazzo to be a museum after her death,

not a private dwelling. It was never intended that it be preserved as a monument to Peggy. The next day Peter Lawson-Johnston, the foundation president, wrote to the editor of the *Times* seconding Govan. Even if the foundation had wished to do so, he said, it was not possible to keep the palazzo as a restored home. For one thing, Peggy's gift had not included her personal effects. There had been some physical changes in the arrangements within the building, he admitted. But the need to preserve the collection and to provide public access required that some of the paintings she had placed in the entrance hall be shifted elsewhere. As for claims that the New York directors had subordinated the Venice museum to their own ambitions, the foundation in fact had fully restored the palazzo and completed a massive scholarly catalog of the collection.

However dismissive of the charges, the Guggenheim trustees sought to appease the grandsons. In 1993 they thoroughly renovated the palazzo and its neglected garden and restored the room dedicated to Pegeen. Despite their effort, the suit, entered in Paris, moved forward, with the plaintiffs arguing that the collection had not been displayed the way Peggy would have approved. In December 1994 the Tribunal de Grande Instance de Paris dismissed the suit and ordered the plaintiffs to pay legal costs of 30,000 francs. Though a moral vindication for the Guggenheim Foundation, the expenses of preparing its defense had been considerable.

The effort by family members to rehabilitate Peggy's memory continued, however. At her husband Sandro's urging, French journalist Laurence Tacou-Rumney wrote a short affectionate biography in French of Peggy that filtered out most of the sexual scandal and misbehavior. Its strong point was its illustrations, many of them unique personal photographs from the family's private cache. Laurence was thoroughly French and the translated 160-page essay, though a readable review of Peggy's life, contained the sort of factual and interpretive errors difficult for a non-American to avoid.

Karole Vail—Sindbad and Peggy Angela's older daughter—though she did not join her cousins in their suit, took up the cause of repairing her grandmother's besieged reputation soon after. Born in 1958, Karole had not enjoyed Peggy's company while she was a child. She had dreaded

her periodic Easter visits to Venice with her sister, Julia. Alluding to Peggy's Lhasa Apsos canines, she remarked, "We used to call her Grandma-the-dogs to distinguish her from our other grandmother." On each occasion, for two weeks before the girls left their home in Paris, Julia recalled, her sister would be sick. Karole herself remembers Peggy as "very domineering," a grand inquisitor who would ask her, when she was twelve years old, about her boyfriends and if she was a virgin.[62]

Born in England, but raised in France, Karole turned into a beautiful, chic Parisienne with chiseled features, black hair, and a slender figure. During her twenties she lived in Italy, predominantly in Florence, where she worked in publishing and as a curator, organizing exhibitions. When she was thirty she began to understand her grandmother, she later declared. Her father, she concluded, was wrong to resent his mother's refusal to bequeath any part of her collection to her children. It would have been "a terrible pity to divide her unique collection among so many grandchildren and, in effect, ruin her life's work."[63] Karole also came to believe that Peggy had been underappreciated. But her own way of repairing the damage was cooperation and celebration rather than confrontation.

In the mid-1990s Karole came to New York to work for the Guggenheim Museum as a curator of modern art. At the end of that decade she persuaded director Thomas Krens to mount a "Centennial Celebration" of her grandmother and her collection and served as the exhibit's "project curatorial assistant." Karole felt that Peggy's collection "was her only true and honest commitment in her life," and the exhibition was a tribute to Peggy's artistic sagacity and seriousness of purpose.[64] On the part of the Guggenheim Museum leadership the show was another concession. In the essay he wrote for the elegant volume that Karole composed for the exhibit, Krens's opening sentence is almost an act of atonement: "Peggy Guggenheim was among the most important and original figures to play a role in the art of this century."[65]

The show itself opened in June 1998 at the Frank Lloyd Wright building. The accompanying volume, besides Krens's foreword, contained a twenty-five page essay by Thomas Messer, the former director of the museum, describing his extended negotiations with Peggy over transferring her collection to the New York institution. The bulk of the

gorgeously illustrated volume was Karole's one-hundred-page homage to her grandmother. The critic of the *New York Times* was dismissive of the exhibition, but most of the art world praised it generously.

Karole is currently working in the Guggenheim Museum's lower Broadway curatorial office planning an exhibition of the Italian painter Umberto Boccioni. She lives in New York and is married to a painter whose background is as cosmopolitan as her own. Karole loves New York. It is still the most creative place for a artist to be, she says, certainly more exciting these days than Paris. And yet she is thinking seriously of returning to Europe. She is still a European, she notes, who dislikes America's cultural homogeneity. She prefers the old continent's individualistic and idiosyncratic ways; she is also displeased by the recent political climate of the United States.

Karole's sister, Julia, lives with her husband and two children in Australia's Queensland outback, where she is an acupuncturist. Karole never sees her half brothers Marc and Clovis, the sons of Jacqueline Ventadour. She is close, however, to her cousins Nicolas Hélion and Sandro Rumney, who themselves remain involved in the workings and doings of their grandmother's museum in Venice.

IT IS IRONIC that the largest contingent of Meyer and Barbara's descendants who retain "Guggenheim" as their patronymic in the twenty-first century are the grandchildren and great grandchildren of William, the last, and in some ways the least, of their seven sons.*

William II, the black sheep's only child, died young. He in turn had a son, also named William, born in 1939. William III's grandmother Aimee, long divorced from her husband, considered his birth a triumph over her brothers-in-law, whose lines threatened to "daughter-out" in the near future. As we saw, Aimee had been badly treated by her husband, yet she managed to rescue some of the money William I had acquired and was exuberantly squandering on his chorus girls. Some of

*Daniel M. Guggenheim, as we saw, has had four daughters and no sons. The family name, accordingly, will not continue in his line beyond his own life span—unless his daughters retain after marriage what used to be called their "maiden" names or in some other way are able to pass it on.

this wealth apparently trickled down to her grandson. With an annual income of more than $50,000 a year, William III, accordingly, was not a penniless young man. Raised as an Episcopalian, ignorant of his Jewish ancestry until he was sixteen, he attended the Browning School in New York and went on to Yale, but dropped out before his junior year. For several years after, as a young man with money, he became a life-explorer, trying out the media professions, photography, banking and stockbrokering. In 1962 he married Grace Embury Ley, a graduate of the fancy Miss Hewitt's Classes. They had two daughters, born in 1962 and 1963, with the interestingly spelled names Maire and Jaenet.

Dark-haired, slender, and debonair, during the brash sixties William was attracted to the "mod," the popular dress and personal style introduced by English Carnaby Street designers. In 1967 he invested $40,000 in an Upper East Side Manhattan boutique, Dispensable Disposables, which sold paper dresses and other paper garments, a faddish concept for a brief time in the swinging decade. In 1973, after the paper dress store folded, he published *The Love Game*, a sex manual intended to free people from their repressions. William now considers the book a youthful indiscretion, though he denies it was pornographic. It was "worded so gently that no one could complain."[66] William's marriage to Grace lasted only a few years, and in 1967 he remarried. His bride, Judith Arnold, was a pretty airline stewardess from New Jersey. This second marriage produced three sons, William Douglas, born in 1970; Christopher Mark, born in 1976; and Jonathan Paul, born in 1978.

It was in the same decade as his sons' births that William III abandoned his quest for material success and dedicated his life to expressive and spiritual matters. For a while after the sex book appeared he experimented with various occupations, including volunteer work at a school for the mentally retarded and as a full-time, nonpaid fireman in New Jersey.

An only child whose father died when he was eight, William was able to suppress his feelings about death, which he had always found "morbid and distasteful."[67] Then, in 1974, he began to receive strange messages from "the other side." These communications were not precise words, apparently, but "thoughts" that took many forms, including stories,

parables, poems, and philosophical musings. He copied these down himself or dictated them to his wife, Judy. Receipt of these messages, he told John H. Davis, was not only his "psychic beginnings" but also his "spiritual awakening."[68] For a while he and Judy "tried different life styles," including, he admitted, "phony holy." They soon refined their response into "mystical Christianity," a faith described by an outsider as "short on ritual and long on brotherhood."[69]

In the late 1970s William and Judy moved to Longwood, Florida, and created a new age after-death enterprise. The After-Death Communications Project (ADC) was inspired by the work of Dr. Elisabeth Kübler-Ross, a Swiss-born and -trained psychiatrist. Kübler-Ross had invented the field of "thanatology," the study of death and dying, and it was she who first described the emotional stages the terminally ill pass through when they discover their unavoidable fate. The Guggenheims met Kübler-Ross in 1977 when they attended the workshops she gave in North Palm Beach to help recently bereaved people cope with their losses. In the course of these sessions William was startled when several participants claimed to see vivid images of departed relatives and described communicating with them. He soon learned that the revered doctor herself had had similar experiences. Inspired by the workshops, William and Judy began to read everything they could find on contact between the living and the dead. They soon affiliated with the International Association for Near Death Studies organized by John Audette. In 1984, after seventeen years of marriage, William and Judy were divorced but remained friends and continued as associates in their shared interest while living apart.

In 1988 they launched the ADC Project in Orlando to investigate the subject of communication across the great divide. During the years that followed they collected more than three thousand firsthand accounts of after-death contacts from people all over North America. Their work received wide publicity and they were invited to give talks and workshops and to appear on radio and TV in the United States and Canada. William and Judy considered the ADC Project primarily a quest for the truth about after-death experiences, but they concluded that their investigations also had therapeutic value. This view evolved into what

William considered a "ministry" revolving around informal gatherings of small groups of enlightenment seekers who came to his home to listen to tapes of spiritual leaders and gurus. These meetings eschewed "seances," the efforts to communicate with the dead through mediums. Rather, they resembled group therapy sessions and like these provided grieving participants with emotional comfort. The Guggenheims did not charge for the sessions as did traditional therapists. As William explained, the money inherited from his mother enabled him to finance the work himself.

In 1995, after seven years of research and writing, William and Judy summed up their conclusions in a four hundred-page volume, *Hello from Heaven!* The book sold an amazing 250,000 copies worldwide, but did not pay them large royalties. As William explains, the publisher paid a large advance that even excellent sales did not cover. William ascribes the shortfall to the competition of "mediums" whose promises of direct contact with deceased relatives and loved ones had captured the public's imagination at the time their book appeared.

William and Judith continue their work today. They give many work-shops for bereaved parents. They are currently writing a book on children and the after-death experience. William married again in 1993, but he and Stephanie Maddox were divorced four years later. Though all are now adults, only one of William's five children, William Douglas, is married. He lives outside Pittsburgh and is a self-taught computer software expert who designs Web sites. William's older daughter, Maire, teaches horseback riding as therapy to emotionally and physically handicapped children. Jaenet lives in Santa Fe and works with her mother as a publisher. Christopher, a graduate of the University of Florida, is in real estate, and Jonathan, described by his father as "the artistic one," is working in computer animation.[70]

William's trio of male offspring guarantees that the family name will survive for years to come. But not necessarily consciousness of the family heritage. Back in the 1970s William was so isolated from the rest of the family that when Christopher was born he could not inform the family through the usual mailed birth announcements: He had no addresses, he said, except Peter's.[71]

William III was interested enough in the Guggenheim clan, however, to attend the 1984 reunion with his two daughters and his oldest son. He has thought a good deal about the Guggenheims and his own place in the flow of family history. He told Davis that he considered the Guggenheims a "uniquely *creative* family." Peggy and Harry were the great achievers, he acknowledged, but he too was in the creative group, "though in a far more limited way." William ascribed the family's achievements to a sort of pre-birth pact of a "group of souls" to "carry out some special plan or project." That plan was to establish the foundations for the benefit of human-kind.[72]

IT IS IMPOSSIBLE to trace the lives of all the surviving descendants of Meyer and Barbara. They are now legion and many are impossible to locate. With the exceptions we have noted, none are named Guggen-heim: they have surnames like Abeles, Agostini, Frank, Jacobs, Horn-stein, Kerby, Kohnstamm, Piven, and Shukman. From the data available, we conclude that their professions and interests do not veer far from those of other upper-middle-class college-educated men and women. They are entrepreneurs, stockbrokers, lawyers, real estate developers, computer experts, business managers, social workers, artists, perform-ers. Yet some have followed trajectories unusual for their kind. Timothy Loeb, son of Edwin, is a telemarketer. His brother, Peter, is a professor of mathematics. Their sister, Barbara, is a part-time translator. One of Peggy's granddaughters is an acupuncturist. A daughter of William III is a therapist who uses horses as her therapeutic tool. Two daughters of Daniel M. Guggenheim head private schools. Dana Draper's only son is a bartender. The European branches of the family, heirs of Pegeen and Sindbad, include scores of descendants of Meyer and Barbara. The whimsical family tree in Laurence Tacou-Rumney's 1996 biography of her husband's grandmother has spaces for more than twenty names of living descendants. Many are still too young to have careers, but several others, following their grandmother's lead, are members of the interna-tional art world as critics, historians, and dealers.

The high achievers are largely male. Many female Guggenheim descendants lead useful, significant lives in the traditional ways of upper

class women—as charity dispensers, civic leaders, political activists, board members. But there are also ordinary stay-at-home, middle-class housewives among them. Finally, like any large cohort derived from affluent forebears, the posterity of Meyer and Barbara includes men and women who float through life doing little of consequence, drifting from here to there, without firm anchorage to humdrum daily existence. Some of these *Luftmenschen* live comfortably on family money. Others survive barely above the poverty line.

But whatever course their lives have taken, few of Meyer and Barbara's descendants today are guided by a strong sense of shared family history. The 1984 reunion, as we have said, has not been repeated and will not be. Today the Guggenheims are bound, if at all, by frail ties. Those living close to New York and affiliated with the museums and foundations have retained a stronger interest in the clan than most of the others. Californian Daniel M. Guggenheim is the exception that proves the rule. Daniel's involvement in the Guggenheims, undoubtedly reinforced by his patronymic, inspired Oscar Straus II to appoint him a trustee of the Daniel and Florence Guggenheim Foundation. After some years, however, Daniel discovered, as we saw, that his distance from New York area made it difficult for him to contribute usefully to the foundation's affairs, and he resigned.

Could the family's fate be otherwise? Once the core businesses decayed and shared economic goals attenuated, the most powerful cement of the extended family ceased to bind. Ironically, some of the surviving family self-awareness derives from the efforts of historians and biographers to chronicle the Guggenheim past. Many descendants have learned whatever family lore they know, not from their parents or grandparents, but from the books of O'Connor. Lomask, and Davis. William Guggenheim III notes that his five children have read and are impressed with the works written about their family. And let us recall Patrick Stuart's discovery in the 1960s of his cousin Harry's eminence after reading Lomask. Perhaps our own work will provide future generations of the clan with some further understanding of their forebears and added pride in their lives and accomplishments.

Those forebears were a vivid, dramatic, enterprising, fallible, gener-

ous, lusty bunch. They were entrancingly, and at times appallingly, human. Selfish-charitable, dissolute-prudish, extravagant-frugal, loving-aloof, outgoing-withdrawn, they combined a profound Americanism with a large admixture of European ingredients. They brought with them to the New World the entrepreneurial reflexes of central European Jewry and with these ancestral skills adeptly rode the tides that carried the United States to international industrial preeminence in the early twentieth century. A vital part of their old world heritage was their religion. They were not notably pious but in the early years Judaism's constraints and burdens, as well as its inner virtues, molded their personal qualities and shaped their goals. Later, their need to escape from it and become "true Americans" colored their actions, often unconsciously, and propelled them in unexpected directions. Europe would also be the catalyst for transmuting wealth into cultural power. The Guggenheims were always drawn strongly to the old continent's art, music, and literature. This fancy came to dominate the family leaders' lives and, in the form of the museums and foundations, would provide whatever cohesion the family retained in the late twentieth century.

The Guggenheim contribution to technology was largely home-grown. One or two of the second generation had formal training in engineering or science, but their technologic know-how was largely borrowed. Their success in mining and in aviation came from hiring the best brains and following their lead. Yet without their patronage, many of the processes and devices that helped transform mineral extraction and the science and practice of flight would have lagged.

From Meyer on, the family's economic climb depended on its solidarity, as the patriarch so often pointed out. Its decline followed the family's unraveling. Harry Guggenheim sought to stem the decay. But his herculean struggles to hold the family together and at the same time reignite its entrepreneurial fires failed, and stagnation and dissolution followed. Individual descendants have displayed impressive business acumen. Peter Lawson-Johnston, Jr.'s attainments in money management, Daniel M. Guggenheim's success in real estate development, Roger Straus II's achievements in publishing are all examples of business savvy at a high level. But these successes do not accrue to the larger family as an entity.

In the end our memory of the Guggenheims as a family depends on their benefactions. Few today know of Harry's pioneer work in commercial aviation. Even Goddard's experiments with rocketry have been eclipsed by lunar landings, space telescopes, and Martian rovers. The Guggenheim name survives for its large imprint on the arts and humanities. Meyer Guggenheim loved music, but he could not have foreseen that the cluster of great museums and the world-renowned fellowship programs in the arts, social sciences, and humanities would become the ultimate memorial to the family's genius.

Notes

Chapter One: Beginnings

1. David Vital, *A People Apart: The Jews in Europe, 1789–1939* (Oxford: Oxford University Press, 1999), p. 35.
2. The words are Vital's. See ibid., p. 252.
3. Gatenby Williams (pseudonym for William Guggenheim) and Charles Monroe Heath, *William Guggenheim* (New York: Lone Voice, 1934), p. 165.
4. Peggy Guggenheim, *Out of This Century: Confessions of an Art Addict* (London: André Deutsch, 1979), p. 22.
5. Jacqueline Bograd Weld, *Peggy: The Wayward Guggenheim* (New York: E. P. Dutton, 1988), p. 37.
6. Milton Lomask, *Seed Money: The Guggenheim Story* (New York: Farrar, Straus, 1964), p. 9.
7. Hasia Diner, *A Time for Gathering: The Second Migration, 1820–1880* (Baltimore: Johns Hopkins University Press, 1992), p. 38.
8. Williams and Heath, *William Guggenheim*, p. 20.
9. Ibid., p. 17.
10. Leonard Dinnerstein, *Anti-Semitism in America* (New York: Oxford University Press, 1994), p. 19.
11. Williams and Heath, *William Guggenheim*, p. 19.
12. Lomask, *Seed Money*, pp. 169–70.
13. We wish to thank Ethel Gershman, archivist of Keneseth Israel, for this information.

14. Guggenheim, *Out of This Century*, p. 18.

15. Edward Blair, *Leadville: Colorado's Magic City* (Boulder, CO: Pruett Publishing, 1980), p. 102.

16. Rodman Paul, *Mining Frontiers of the Far West, 1848–1880* (New York: Holt, Rinehart and Winston, 1963), p. 128.

17. Harvey O'Connor, *The Guggenheims: The Making of an American Dynasty* (New York: Covici Friede, 1937), p. 55.

Chapter Two: Foundation

1. Don L. Griswold and Jean Harvey, *History of Leadville and Lake County, Colorado: From Mountain Solitude to Metropolis* (Denver: Colorado Historical Society, 1996), p. 572.

2. O'Connor, *Guggenheims*, p. 67.

3. Griswold and Harvey, *History of Leadville*, p. 1732.

4. Edwin P. Hoyt, Jr., *The Guggenheims and the American Dream* (New York: Funk and Wagnalls, 1967), pp. 51–52.

5. Isaac F. Marcosson, *Metal Magic: The Story of the American Smelting and Refining Company* (New York: Farrar, Straus, 1949), p. 41.

6. Hoyt, *Guggenheims and the American Dream*, p. 60.

7. Ibid., pp. 35–36.

8. Edwin Lefevre, "Meyer Guggenheim and His Seven Sons," *Cosmopolitan*, August 1903, p. 411.

9. This is one of several versions of this family story. It may be nothing more than family legend. See John W. Davis, *The Guggenheims (1848–1988): An American Epoch* (New York: Shapolsky Publishers, 1988), pp. 56–57. Actually, in the original Aesop story the father starts with the unbreakable bundle and then takes it apart to demonstrate how easily the individual sticks can be snapped.

10. Bernard Baruch, *Baruch: My Own Story* (New York: Henry Holt, 1957), p. 193.

11. Hoyt, *Guggenheims and the American Dream*, p. 67.

12. *Engineering and Mining Journal*, February 23, 1889.

13. *Engineering and Mining Journal*, March 16, 1889.

14. Williams and Heath, *William Guggenheim*, p. 54.

15. Marcosson, *Metal Magic*, p. 44.

16. Michael Meyer and William H. Beezley (eds.), *The Oxford History of Mexico* (New York: Oxford University Press, 2000), p. 407.

17. See *Engineering and Mining Journal*, March 15, 1890.

18. Marcosson, *Metal Magic*, p. 49.

19. Williams and Heath, *William Guggenheim*, p. 78.

20. *New York Times*, July 13, 1893.
21. Hoyt, *Guggenheims and the American Dream*, p. 172.

Chapter Three: New York

1. Baruch, *Baruch: My Own Story*, p. 59.
2. *New York Daily Tribune*, August 19, 1905.
3. John H. Davis, *The Guggenheims: An American Epic* (New York: William Morrow, 1978), p. 78.
4. Temple Emanu-El, Minutes of Special Meeting, December 20, 1925, p. 253.
5. Guggenheim, *Out of This Century*, p. 2.
6. As quoted in Edwin G. Burrows and Mike Wallace, *Gotham: A History of New York City to 1898* (New York: Oxford University Press, 1999), p. 1080.
7. Harold Loeb, *The Way It Was* (New York: Criterion Books, 1959), p. 20.
8. Lomask, *Seed Money*, p. 33.
9. Ibid.
10. Robert F. Van Benthuysen, "The Guggenheim Family at the Jersey Shore," typescript article in the Monmouth University Library, dated September 1978.
11. Loeb, *Way It Was*, pp. 18–19.
12. *Architectural Record*, September 1907, p. 253.
13. Daniel Guggenheim to M. Robert Guggenheim, n.p., August 2, 1918, Box 58, Harry Frank Guggenheim Mss., Library of Congress.
14. Hoyt, *Guggenheims and the American Dream*, p. 98.
15. Lomask, *Seed Money*, p. 80.
16. Guggenheim, *Out of This Century*, pp. 14–15.
17. Williams and Heath, *William Guggenheim*, p. 165.
18. Ibid., p. 168.
19. *New York Times*, April 27, 1902.
20. William Guggenheim to "my dear brothers," New York, June 2, 1914, Guggenheim Brothers Mss., Harry Frank Guggenheim Foundation Archives, New York.
21. Lomask, *Seed Money*, p. 39. In 1915 Grace sued four Guggenheim brothers—Isaac, Murry, Solomon, and Simon—for $45,000 of back alimony that, she claimed, they had agreed to pay her under a 1913 agreement. See *New York Times*, July 18, 1915.
22. This information was called to our attention by Ms. Laura Jacobs in her profile of Emily Post, the twentieth-century etiquette arbiter.
23. Guggenheim, *Out of This Century*, p. 10.
24. Lomask, *Seed Money*, p. 40.

25. *New York Times*, April 20, 1912.

26. Ibid. There are several versions of this story. See, e.g., Weld, *Peggy*, p. 29.

27. Lomask, *Seed Money*, p. 37.

28. Ibid., p. 36. John H. Davis ascribes somewhat different words to Solomon, and different listeners—his nephews Harold Loeb and Harry Guggenheim. See Davis, *Guggenheims* (1978 ed.), p. 204.

29. *Long Branch Daily Record*, June 14, 1904.

30. *New York Times*, June 14, 1904.

31. *New York Times*, March 20, 1905

32. Lefevre, "Meyer Guggenheim and His Seven Sons," pp. 408–10.

Chapter Four: ASARCO

1. Adam Smith, *The Wealth of Nations*, book 1, chapter 10.

2. Ida Tarbell, *History of the Standard Oil Company* (New York: McClure, Phillips and Company, 1904), vol. 2, p. 225.

3. *Engineering and Mining Journal*, March 11, 1899.

4. Marcosson, *Metal Magic*, p. 63.

5. *Engineering and Mining Journal*, March 11, 1899.

6. *Commercial and Financial Chronicle*, May 20, 1899, p. 975.

7. *Engineering and Mining Journal*, June 10, 1899.

8. Deposition of Theodore F. Allen, August 14, 1916, Guggenheim Brothers Mss., Harry Frank Guggenheim Foundation Archives, New York.

9. Solomon Guggenheim, "An Answer to the Attacks Made upon the American Smelting and Refining Company Delivered . . . April 6, 1921" (n.p., n.d.), p. 3.

10. *New York Daily Tribune*, February 17, 1901.

11. *New York Times*, March 5, 1901.

12. *New York Daily Tribune*, March 30, 1901.

13. *Engineering and Mining Journal*, December 4, 1909.

14. John Hays Hammond, *The Autobiography of John Hays Hammond* (New York: Farrar and Rinehart, 1935), vol. 2, p. 502.

15. Eugene P. Lyle, Jr., "The Ore Finders," *Hampton's Magazine*, January 1910, p. 63.

16. Hammond, *Autobiography*, 2, p. 503.

17. *New York Times*, November 19, 1906.

18. *New York Daily Tribune*, December 4, 1906.

19. *Engineering and Mining Journal*, December 15, 1906.

20. Hammond, *Autobiography*, 2, pp. 515–16.

21. *New York Times*, September 6, 1906.

22. Hoyt, *Guggenheims and the American Dream*, p. 158.

23. *Engineering and Mining Journal*, February 27, 1907.

24. Ibid., January 8, 1907.

24. *New York Times*, October 19, 1907.

25. *Engineering and Mining Journal*, February 13, 1909.

26. Ibid., January 25, 1908.

27. Ibid., May 16, 1908.

28. *New York Times*, August 14, 1908.

29. *Engineering and Mining Journal*, April 18, 1908.

30. Baruch, *Baruch: My Own Story*, p. 72.

31. Ibid., p. 199.

32. Ibid., p. 203.

33. Marcosson, *Metal Magic*, p. 82.

34. *New York Times*, May 30, 1925.

35. O'Connor, *Guggenheims*, p. 214.

36. *New York Times*, June 23, 1908.

Chapter Five: Malefactors

1. Loeb, *Way It Was*, p. 20.

2. Ibid., p. 23.

3. *New York Times*, April 3, 1906.

4. Robert Alden Stearns, "The Morgan-Guggenheim Syndicate and the Development of Alaska, 1906–1915" (doctoral dissertation, University of California at Santa Barbara, 1967), p. 212.

5. *Engineering and Mining Journal*, May 13, 1911.

6. Alpheus Thomas Mason, *Bureaucracy Convicts Itself: The Ballinger-Pinchot Controversy of 1910* (New York: Viking, 1941), p. 78.

7. Mason, *Bureaucracy Convicts Itself*, p. 86.

8. R. L. Glavis, "The Whitewashing of Ballinger," *Collier's*, November 13, 1909.

9. As quoted in "Benjamin Hampton," http://www.spartacus.schoolnet.co.UK/USA.hampton.htm, p. 1.

10. Benjamin B. Hampton, "The Vast Riches of Alaska," *Hampton's Magazine*, April 1910, p. 453.

11. Benjamin B. Hampton, "Shall Alaska Become a 'Morganheim' Barony?" *Hampton's Magazine*, May 1910, p. 631.

12. O'Connor, *Guggenheims*, p. 262.

13. Quoted from the *Nome Gold Digger*, November 24, 1907, in Stearns, "The Morgan-Guggenheim Syndicate," p. 18.

14. Hampton, "Vast Riches of Alaska," pp. 461–62.

15. *Current Literature*, March 1910, p. 273.

16. Stearns, "The Morgan-Guggenheim Syndicate," p. xxvi.

17. *New York Times*, March 26, 1910.

18. Ibid., March 27, 1910.

19. Ibid., March 26, 1910.

20. Ibid., May 30, 1910.

21. Ibid., May 31, 1910.

22. M. Nelson McGeary, *Gifford Pinchot: Forester-Politician* (Princeton, NJ: Princeton University Press, 1960), p. 209.

23. Ibid., p. 210.

24. Ibid., p. 184.

25. Alpheus Thomas Mason, *Brandeis: A Free Man's Life* (New York: Viking, 1946), p. 282.

26. *New York Times*, October 25, 1912.

27. Hoyt, *Guggenheims and the American Dream*, p. 173.

28. O'Connor, *Guggenheims*, p. 232.

29. Ibid., pp. 236–37.

30. Ibid., p. 239.

31. *Denver News*, January 12, 1907.

32. Ibid., January 14, 1907.

33. Ibid., January 15, 1907.

34. Ibid., January 16, 1907.

35. *Denver Post*, January 16, 1907.

36. Ibid.

37. O'Connor, *Guggenheims*, p. 239.

38. Ibid., p. 240.

39. Ibid., p. 245.

40. Hoyt, *Guggenheims and the American Dream*, p. 185.

41. Bernard De Voto (ed.), *Mark Twain in Eruption* (New York: Harper and Brothers, 1922), p. 82.

42. *Washington Post*, September 11, 1907.

43. Ibid., February 20, 1909.

44. *Congressional Record*, Senate, February 26, 1909, p. 3242.

45. *Denver Post*, October 20, 1908.

46. Ibid., October 27, 1908.

47. Ibid., November 1, 1908.

48. Ibid., October 15, 1908.

49. Charles Thomas, "Fifty Years of Political History," in James H. Baker and Le Roy Hafen (eds.), *History of Colorado* (Denver: State Historical Society of Colorado, 1927), vol. 3, p. 937.

50. Quoted in Lomask, *Seed Money*, p. 247 note.

Chapter Six: Profits and Patriotism

1. Thomas F. O'Brien, *The Revolutionary Mission: American Enterprise in Latin America, 1900–1945* (Cambridge, England: Cambridge University Press, 1996), p. 178.

2. Janet L. Finn, *Tracing the Veins: Of Copper, Culture, and Community from Butte to Chuquicamata* (Berkeley: University of California Press, 1998), p. 88.

3. Ibid., p. 89.

4. *New York Times*, March 26, 1915.

5. Ibid., September 13, 1916.

6. Ibid., March 25, 1917.

7. Baruch, *Baruch: My Own Story*, p. 195.

8. *New York Times*, May 25, 1917.

9. O'Connor, *Guggenheims*, p. 377.

10. Henry Ford, *The International Jew: The World's Foremost Problem*, vol. 2, chapter 27, NoonTide Press: Books on-Line, http://noontidepress.com/books/ford/ijtoc.html, pp. 4–9.

11. *New York Times*, June 22, 1916.

12. Daniel Guggenheim, Memo for "Mr. Steele," May 14, 1914, Guggenheim Brothers Mss., Harry Frank Guggenheim Foundation Archives, New York.

13. *New York Times*, July 3, 1916.

14. Will [Guggenheim] to "my dear brothers," [New York], March 14, 1923. Guggenheim Brothers Mss., Harry Frank Guggenheim Foundation Archives, New York.

15. *New York Times*, April 8, 1916.

16. Daniel Guggenheim to Harry Guggenheim, New York, June 5, 1923, Box 54, Harry Frank Guggenheim Mss., Library of Congress.

17. See the account dated August 11, 1914, in Box 54, Harry Frank Guggenheim Mss., Library of Congress.

18. Williams and Heath, *William Guggenheim*, pp. 196–97.

19. *New York Times*, March 8, 1918.

20. Ibid., June 8, 1917.

21. Ibid., October 13, 1918.

22. "Father" [Harry Frank Guggenheim] to "Dear Robert" [M. Robert Guggenheim], n.p., June 20, 1918, Box 58, Harry Frank Guggenheim Mss., Library of Congress.

23. "Father" [Harry Frank Guggenheim] to M. Robert [Guggenheim], n.p., [January 1918], Box 58, Harry Frank Guggenheim Mss, Library of Congress.

24. "Father" [Harry Frank Guggenheim] to M. Robert [Guggenheim], n.p., May 7, 1918, Box 58, Harry Frank Guggenheim Mss., Library of Congress.

25. "Father" [Harry Frank Guggenheim] to M. Robert [Guggenheim], n.p., May 31, 1918, Box 58, Harry Frank Guggenheim Mss., Library of Congress.

26. "Father" [Harry Frank Guggenheim] to M. Robert [Guggenheim], n.p., July 2, 1918, Box 58, Harry Frank Guggenheim Mss., Library of Congress.

27. "Father" [Harry Frank Guggenheim] to M. Robert [Guggenheim], n.p., March 8, 1918, Box 58, Harry Frank Guggenheim Mss., Library of Congress.

28. M. Robert [Guggenheim] to "My dear Parents," "Somewhere in France," April 18, 1918, Box 58, Harry Frank Guggenheim Mss., Library of Congress.

29. M. Robert [Guggenheim] to Solomon [Guggenheim], n.p., May 7, 1918, Box 58, Harry Frank Guggenheim Mss., Library of Congress.

30. M. Robert Guggenheim to Edward Ochs, Bordeaux, France, August 17, 1918, Box 58, Harry Frank Guggenheim Mss., Library of Congress.

31. John H. Davis, *The Guggenheims: An American Epoch* (New York: William Morrow, 1978), p. 293.

32. W. D. Connor to General James Harbord, Bordeaux, August 31, 1918, Box 58, Harry Frank Guggenheim Mss., Library of Congress.

33. *New York Times*, June 13, 1912.

34. Marcosson, *Metal Magic*, p. 145.

35. *New York Times*, December 27, 1914.

36. O'Connor, *Guggenheims*, pp. 319–20; *New York Times*, January 22, 1915.

37. *New York Times*, January 22, 1915.

38. Ibid.

39. O'Connor, *Guggenheims*, p. 322.

40. *New York Times*, May 16, 1917.

41. O'Connor, *Guggenheims*, pp. 382–83.

42. Ibid., p. 386.

43. *New York Times*, March 8, 1919.

44. Ibid., January 1, 1921.

45. Ibid., January 22, 1919.

46. Ibid., December 21, 1920.

47. Ibid.

48. *New York Times*, December 23, 1920.

49. Ibid., January 10, 1921.

50. Guggenheim, "Answer to the Attacks," passim.

51. *New York Times*, April 7, 1921.

52. Marcosson, *Metal Magic*, p. 123.

53. *New York Times*, May 19, 1922.

54. *New York Times*, June 27, 1922.

55. Daniel Guggenheim to Harry Guggenheim, New York, June 5, 1923, Box 54, Harry Frank Guggenheim Mss., Library of Congress.

56. From W. H. Auden's poem "September 1, 1939."

57. Simon Guggenheim to Dwight Morrow, New York, October 11, 1928, Morrow Mss., Amherst College.

58. *New York Times*, March 6, 1939.

59. Laurence Stern, "When Copper Goes Up So Will Kennecott," *Magazine of Wall Street*, December 21, 1935.

60. *Time*, October 19, 1931.

61. Edwin A. Barnes, "What's Behind the Move in Metal and Smelting Shares?" *Magazine of Wall Street*, November 23, 1933.

62. Laurence Stern, "Heading Back to Prosperity," *Magazine of Wall Street*, April 11, 1936.

63. J. C. Clifford, "American Smelting," *Magazine of Wall Street*, September 9, 1939.

64. Daniel Guggenheim to Dwight Morrow, New York, January 11, 1916, quoted in O'Brien, *Revolutionary Mission*, p. 187.

65. *New York Times*, February 14, 1927.

66. *Business Week*, May 21, 1930.

67. *New York Times*, April 12, 1931.

68. *Time*, July 27, 1931.

69. *Business Week*, June 15, 1932.

70. O'Brien, *Revolutionary Mission*, p. 193.

71. *New York Times*, November 11, 1931.

72. Michael Monteón, *Chile and the Great Depression: The Politics of Underdevelopment, 1927–1948* (Tempe: Arizona State University Center for Latin American Studies, 1998), p. 189.

73. *New York Times*, June 6, 1932.

74. Ibid., December 31, 1932.

75. *Economist*, July 9, 1932.

76. Monteón, *Chile and the Great Depression*, p. 144.

77. Florence Guggenheim to Harry Guggenheim, [New York], May 17, 1932, Box 58, Harry Frank Guggenheim Mss., Library of Congress.

Chapter Seven: Family Affairs

1. *New York Times*, June 21, 1932.
2. Roger Straus, Jr., interview by Robert Keeler, May 20, 1987, Keeler Tapes, in possession of Robert Keeler.
3. Roger Straus, Jr., interview, July 6, 1977, Columbia University Oral History Project.
4. "Father [Daniel Guggenheim]" to "Dear Harry [Guggenheim]," Evian-les-Bains, August 5, 1922, Box 54, Harry Frank Guggenheim Mss., Library of Congress
5. Rebekah Kohut, *My Portion: An Autobiography* (New York: Arno Press, 1975), p. 262.
6. *New York Times*, January 8, 1922.
7. Memo of Daniel Guggenheim for "the Brothers," Murry, Sol, and "the Senator," New York City, June 2, 1926, Guggenheim Brothers Mss., Harry Frank Guggenheim Foundation.
8. Memo of Daniel Guggenheim to the "Brothers," Murry, Sol and "the Senator," August 25, 1926, Guggenheim Brothers Mss., Harry Frank Guggenheim Foundation.
9. Daniel and Florence Guggenheim Foundation, Report of the President, 1974, p. 37.
10. Daniel [Guggeneheim] to Harry [Frank Guggenheim], [New York], March 11, 1930, Box 54, Harry Frank Guggenheim Mss., Library of Congress.
11. [Daniel Guggenheim] to Harry [Frank Guggenheim], n.p., June 5, 1930, Box 54, Harry Frank Guggenheim Mss., Library of Congress.
12. *New York Times*, September 29, 1930.
13. "Mother [Florence Guggenheim]" to Harry [Guggenheim], [New York], [November?] 1930, Box 54, Harry Frank Guggenheim Mss., Library of Congress.
14. *New York Times*, May 16, 1944.
15. Davis, *Guggenheims*, p. 291.
16. *New York Times*, July 10, 1915.
17. [Florence Guggenheim] to Robert [Guggenheim], n.p., March 12, 1941, Box 58, Harry Frank Guggenheim Mss., Library of Congress.
18. M. Robert Guggenheim to "Dear Mother [Florence Guggenheim]," n.p., June 2, 1932, Box 58, Harry Frank Guggenheim Mss., Library of Congress.
19. [Florence Guggenheim] to Robert [Guggenheim], n.p., October 4, 1933, Box 58, Harry Frank Guggenheim Mss., Library of Congress.
20. Davis, *Guggenheims* (1978 ed.), p. 296.

21. Frances (Morris) Lundgren to Harry Guggenheim, n.p., (1969), Box 60, Harry Frank Guggenheim Mss., Library of Congress.

22. Memorandum for Mr. O'Connor, Department of State, Office of the Secretary, April 7, 1953, Dwight D. Eisenhower Mss., Eisenhower Library.

23. *New York Times*, August 6, 1953.

24. Ibid., August 11, 1954.

25. M. Robert Guggenheim to Sherman Adams, Washington, DC, June 27, 1955, Dwight D. Eisenhower Mss., Eisenhower Library.

26. Daniel M. Guggenheim, interview by Irwin Unger, February 3, 2004.

27. Daniel Guggenheim to Harry Guggenheim, New York, June 5, 1923, Box 54, Harry Frank Guggenheim Mss., Library of Congress.

28. John A. Garraty and Mark C. Carnes, eds., *American National Biography* (New York: Oxford University Press, 1999), vol. 21, p. 5.

29. *New York Times*, December 15, 1912.

30. Daniel Guggenheim to M. Robert Guggenheim, [New York], August 16, 1918, Box 58, Harry Frank Guggenheim Mss., Library of Congress.

31. See Box 37 of Harry Frank Guggenheim Mss., Library of Congress, for assorted letters and memos.

32. *Commonweal*, April 17, 1936.

33. *New York Times*, November 19, 1948.

34. Ibid., April 3, 1936.

35. Ibid., April 17, 1940.

36. Ibid., March 15, 1980.

37. Ibid.

38. Lomask, *Seed Money*, p. 221.

39. Ibid., p. 25.

40. *School and Society*, June 29, 1929, p. 833.

41. *New York Times*, June 24, 25, 30, 1929.

42. Loeb, *Way It Was*, p. 147.

43. Lomask, *Seed Money*, p. 231.

44. *New York Times*, November 20, 1925.

45. Harry Frank Guggenheim to Jeanne and Edmond [Guggenheim], [New York], August 10, 1949, Box 55, Harry Frank Guggenheim Mss., Library of Congress.

46. Edmond Guggenheim to Harry Frank Guggenheim, Scottsdale, AZ, January 22, 1965, Box 55, Harry Frank Guggenheim Mss., Library of Congress.

47. [Marion Guggenheim] to [Robert Van Benthuysen], August 23, 1975, Monmouth University Library.

48. [Marion Guggenheim] to [Robert Van Benthuysen], [Scottsdale, AZ], December 27, 1975, Monmouth University Library.

49. *New York Times*, May 20, 1934.

50. Ibid., December 3, 1939.

51. Davis, *Guggenheims* (1978 ed.), p. 374.

52. William Guggenheim III, interview by Irwin Unger, January 26, 2004.

53. Davis, *Guggenheims* (1978 ed.), p. 253.

54. Ibid., p. 253.

55. *New York Times*, November 4, 1941.

56. Gordon Ray, Report of the President, 1980, p. xx.

57. Ibid.

58. *Foundation News*, May 1961, p. 8.

59. *John Simon Guggenheim Memorial Foundation, 1925–2000: A Seventy-fifth Anniversary Record* (n.p., n.d.), p. 26.

60. Quoted in Davis, *Guggenheims* (1978 ed.), p. 259.

61. Hilla Rebay to Rudolph Bauer, n.p., October 18, 1931, in Joan M. Lukach, *Hilla Rebay: In Search of the Spirit in Art* (New York: George Braziller, 1983), p. 67.

62. Lomask, *Seed Money*, p. 168.

63. Ibid., p. 170.

64. *New York Times*, December 17, 1920.

65. Davis, *Guggenheims* (1978 ed.), p. 381.

66. Ibid., p. 382.

67. Eleanor [Countess Castle Stewart] to Harry [Frank Guggenheim], Sussex, England, October 9, 1966, Box 29, Harry Frank Guggenheim Mss., Library of Congress.

68. Peter Loeb, inteview by Debi Unger, January 20, 2004.

69. Loeb, *Way It Was*, p. 33.

70. Ibid., p. 4.

71. "A New Literary Broom," *New York Times Book Review*, October 30, 1921.

72. Loeb, *Way It Was*, p. 147.

73. Ibid., p. 150.

74. Ibid., p. 155.

75. Ibid., p. 156.

76. *New York Times Book Review*, August 30, 1925, p. 22.

77. Weld, *Peggy*, p. 60.

78. Loeb, *Way It Was*, p. 211.

79. Davis, *Guggenheims* (1978 ed.), p. 358.

80. Harold Loeb, "Hemingway's Bitterness," *Connecticut Review*, October 1967, p. 95.

81. See Harold Loeb's entry in *The Bull: Class of 1913, 47th Reunion Book*, Seeley G. Mudd Manuscript Library, Princeton University.

82. Harold Loeb to "Dear Harry" [Harry Frank Guggenheim], New York, October 17, 1962, Box 90, Harry Frank Guggenheim Mss., Library of Congress.

83. Harold Loeb to Harry [Frank Guggenheim], Weston, CT, August 8, 1967, Box 90. See also Harry to Harold, n.p., August 14, 1967, Box 90. Both at the Harry Frank Guggenheim Mss., Library of Congress.

84. Harold Loeb, to "Dear Harry" [Harry Frank Guggenheim], New York, October 16, 1961, Box 90, Harry Frank Guggenheim Mss., Library of Congress.

85. Guggenheim, *Out of This Century*, p. 136.

86. Ibid., p. 136.

87. Peter Loeb, interview by Debi Unger, January 20, 2004.

88. Anton Gill, *Art Lover: A Biography of Peggy Guggenheim* (New York: HarperCollins, 2002), p. 40.

89. Weld, *Peggy*, p. 22.

90. Guggenheim, *Out of This Century*, p. 3.

91. Weld, *Peggy*, p. 16.

92. Ibid., p. 21.

93. Gill, *Art Lover*, p. 37.

94. Guggenheim, *Out of This Century*, p. 14.

95. Ibid., p. 21.

96. Weld, *Peggy*, p. 47.

97. Ibid., p. 79.

98. *New York Times*, October 23, 1928.

99. Ibid., October 28, 1928.

100. Ibid., October 27, 1928.

101. This was Julien Levy's phrase. See Weld, *Peggy*, p. 80.

102. Guggenheim, *Out of This Century*, p. 253.

103. Weld, *Peggy*, p. 314.

104. Guggenheim, *Out of This Century*, p. 167.

105. Gill, *Art Lover*, p. 176.

Chapter Eight: Harry Augustus

1. As reported in Kevin Phillips, *Wealth and Democracy: A Political History of the American Rich* (New York: Broadway Books, 2002), p. 56.

2. Ibid., pp. 72–73.

3. *New York Times*, January 23, 1971.

4. Dorothea Straus, "The Master of Finistère," *Showcases* (London: Bodley Head, 1973), p. 95.

5. Charles Lindbergh to Harry Guggenheim, n.p., March 25, 1936, Box 4, Harry Frank Guggenheim Mss., Library of Congress.

6. Charles Lindbergh to Harry Guggenheim, Les Monts-de-Corsier, Switzerland, December 25, 1967, Box 2, Harry Frank Guggenheim Mss., Library of Congress.

7. Harry Guggenheim to Charles Lindbergh, [New York], May 18, 1936, Box 90, Harry Frank Guggenheim Mss., Library of Congress.

8. [Daniel Guggenheim] to Harry Guggenheim, [Port Washington], March 23, 1923, Box 54, Harry Guggenheim Mss., Library of Congress.

9. [Daniel Guggenheim] to Harry Guggenheim, [Port Washington], March 23, 1923, Box 54, Harry Frank Guggenheim Mss., Library of Congress.

10. Straus, "Master of Finistère," p. 95.

11. Ibid., p. 94.

12. Madeleine Albright, *Madam Secretary* (New York: Miramax, 2003), p. 56.

13. The visitor was, improbably, Liam Clancy, of the singing group the Clancy Brothers (see chapter 9). Liam Clancy, *The Mountain of the Women: Memoirs of an Irish Troubador* (New York: Doubleday, 2002), p. 149.

14. Lomask, *Seed Money*, p. 74.

15. F. F. Everest to Harry Guggenheim, n.p., September 29, 1969, Box 46, Harry Frank Guggenheim Mss., Library of Congress. The "in grade" reference refers to the fact that some of the retirees were older than the military allowed for their rank.

16. Clipping, "Harry F. Guggenheim Retiring from Racing, to Sell Cain Hoy Stock," in Box 88, Harry Frank Guggenheim Mss., Library of Congress.

17. Robert F. Keeler, *Newsday: A Candid History of the Respectable Tabloid* (New York: Arbor House, 1990), p. 231.

18. George Fountaine, interview by Robert Keeler May 21, 1987, Keeler Tapes, in possession of Robert Keeler.

19. Lomask, *Seed Money*, p. 83. (Harry was alive in 1964, and Lomask interviewed him extensively.)

20. *New York Times*, June 15, 1925.

21. Lomask, *Seed Money*, p. 83.

22. Ibid., p. 85.

23. *New York Times*, February 3, 1926.

24. "Report Concerning Aeronautical Situation in Europe" (May 1, 1926), pp. 2–3. Dwight Morrow Mss., Amherst College.

25. Ibid., p. 8.

26. Harry Guggenheim to Dwight Morrow, New York, September 30, 1926, Dwight Morrow Mss., Amherst College.

27. Daniel Guggenheim Fund for the Promotion of Aeronautics, "Released for Publication in Newspapers of June 19, [1926]," p. 1. In Dwight Morrow Mss., Amherst College.

28. Richard Hallion, *Legacy of Flight: The Guggenheim Contribution to American Aviation* (Seattle: University of Washington Press, 1977), p. 52.

29. Walter S. Ross, *The Last Hero: Charles A. Lindbergh* (New York: Harper and Row, 1964), p. 105.

30. Charles Lindbergh, *Autobiography of Values* (San Diego: Harcourt Brace Jovanovich, 1977), p. 80.

31. A. Scott Berg, *Lindbergh* (New York: Berkley, 1998), pp. 161–63.

32. Harry Guggenheim to Dwight Morrow, Falaise, July 5, 1927, Dwight Morrow Mss., Amherst College.

33. Charles Lindbergh to "Mrs Guggenheim [Caroline (Carol) Guggenheim]," Pittsburgh, August 3, 1927, Box 2, Harry Frank Guggenheim Mss., Library of Congress.

34. Harry Guggenheim to ??, New York, July 11, 1927, Dwight Morrow Mss., Amherst College.

35. [Charles] Lindbergh to Harry Guggenheim, Helena, MT, August 7, 1927, Box 2, Harry F. Guggenheim Mss., Library of Congress.

36. [Charles] Lindbergh to Harry Guggenheim, Louisville, August 7, 1927, Box 2, Harry Frank Guggenheim Mss., Library of Congress.

37. Evangeline Lindbergh to Harry Guggenheim, Detroit, August 13, 1927, Dwight Morrow Mss., Amherst College.

38. Will MacCracken to Harry Guggenheim, Chicago, August 15, 1927, Dwight Morrow Mss., Amherst College.

39. Press Release, the Daniel Guggenheim Fund for the Promotion of Aeronautics, New York, August 17, 1927, Dwight Morrow Mss., Amherst College.

40. [Charles] Lindbergh to Harry Guggenheim, Milwaukee, August 20, 1927, Box 2, Harry Frank Guggenheim Mss., Library of Congress.

41. Dwight Morrow to Harry Guggenheim, New York, July 8, 1927, Dwight Morrow Mss., Amherst College.

42. Harry Guggenheim to Charles Lindbergh, [New York], October 18, 1927, Box 2, Harry Frank Guggenheim Mss., Library of Congress.

43. Harry F. Guggenheim, *The Seven Skies* (New York: G. P. Putnam's Sons, 1930), pp. 76–78.

44. Harry Guggenheim to Dwight Morrow, New York, September 7, 1929, Dwight Morrow Mss., Amherst College.

45. Harry Guggenheim, "Safety in the Air," *Saturday Evening Post*, June 25, 1927, p. 29.

46. *New York Times*, September 16, 1927.

47. Ibid., July 10, 1927.

48. Harry Guggenheim to Dwight Morrow, September 25, 1929, Dwight Morrow Mss., Amherst College.

49. *New York Times*, September 25, 1929.

50. Reginald M. Cleveland, *America Fledges Wings: A History of the Daniel Guggenheim Fund for the Promotion of Aeronautics* (New York: Pittman Publishing, 1942), p. 213.

51. Daniel and Florence Guggenheim Foundation, Report of the President, 1974, p. 16.

52. Lindbergh, *Autobiography*, pp. 342–43

53. Harry Guggenheim to R. H. Goddard, Port Washington, July 11, 1934, in Esther C. Goddard and G. Edward Pendray (eds.), *The Papers of Robert H. Goddard* (New York: McGraw-Hill, 1970), vol. 2, p. 874.

54. Harry Guggenheim to [R. H.] Goddard, Saratoga Springs, NY, August 16, 1935, in ibid., p. 928.

55. "Statement to the Press," September 24, 1935, in ibid., pp. 934–35.

56. Milton Lehman, *This High Man: The Life of Robert H. Goddard* (New York: Farrar, Straus, 1963), p. 268.

57. Charles Lindbergh to Milton Lehman, Braz, Austria, December 31, 1960, Box 2, Harry Frank Guggenheim Mss., Library of Congress.

58. Lehman, *This High Man*, p. 385.

59. Ibid., p. 363.

60. Tom D. Crouch, *Wings: A History of Aviation from Kites to the Space Age* (New York: W. W. Norton, 2003), p. 237.

61. Cuban Information Bureau, *Ambassador Guggenheim and the Cuban Revolt*, Pamphlet No. 1 (Washington, DC, September 1931), p. 8.

62. Carleton Beals, *The Crime of Cuba* (Philadelphia: J. B. Lippincott, 1933), pp. 329–30.

63. *New York Times*, August 15, 1931.

64. Ibid., August 18, 1931.

65. Ibid., August 26, 1931.

66. Quoted in Lomask, *Seed Money*, p. 68.

67. Harry F. Guggenheim, "Amending the Platt Amendment," *Foreign Affairs*, April 1934, p. 453.

68. Cuban Information Bureau, *Ambassador Guggenheim*, p. 3.

69. Daniel Guggenheim to Harry Guggenheim, [New York], March 11, 1930, Box 54, Harry Frank Guggenheim Mss., Library of Congress.

70. Harry Guggenheim to Fiorello La Guardia, New York, September 10, 1938, Citizens Committee on the Control of Crime in New York, La Guardia Archives, La Guardia College.

71. Charles Lindbergh to Harry Guggenheim, [Kent, England], May 22, 1937, Box 4, Harry Frank Guggenheim Mss., Library of Congress.

72. Harry Guggenheim to "Dear Slim" [Charles Lindbergh], [New York], June 10, 1937, Box 90, Harry Frank Guggenheim Mss., Library of Congress.

73. "Memorandum of Information for the Mayor," Citizens Committee on the Control of Crime in New York, La Guardia Archives, La Guardia College.

74. Arnold Beichman, interview by Robert Keeler, August 4, 1988, Keeler Tapes, in possession of Robert Keeler. Beichman worked for Beazell on the Citizens Committee.

75. Mary Stolberg, *Fighting Organized Crime: Politics, Justice and the Legacy of Thomas E. Dewey* (Boston: Northeastern University Press, 1995), p. 196.

76. [Fiorello La Guardia] to Henry Lustig, [New York], January 8, 1941, Citizens Committee on the Control of Crime in New York, La Guardia Archives, La Guardia College.

77. Press release from Mayor's Office, October 3, 1938, Citizens Committee on the Control of Crime in New York, La Guardia Archives, La Guardia College.

78. Harry Guggenheim to "Dear Slim" [Charles Lindbergh], [New York], May 6, 1937, Box 90, Harry Frank Guggenheim Mss., Library of Congress.

79. *New York Times*, May 13, 1940.

80. Fiorello La Guardia to Harry Guggenheim, [New York], January 9, 1941, Citizens Committee on the Control of Crime in New York, La Guardia Archives, La Guardia College.

81. Stolberg, *Fighting Organized Crime*, p. 197.

82. Richard Norton Smith, *Thomas E. Dewey and His Times* (New York: Simon and Schuster, 1982), p. 208.

Chapter Nine: "High Priest of the Clan"

1. Eleanor, Countess Castle Stewart, to Harry [Frank Guggenheim], Old Lodge, Nutley, Sussex, England, July 27, 1966, Box 29, Harry Frank Guggenheim Mss., Library of Congress.

2. [Harry Frank Guggenheim] to Gladys [Guggenheim], n.p., January 26, 1945, Box 121, Harry Frank Guggenheim Mss., Library of Congress.

3. [Leonie Guggenheim] to Harry Guggenheim, New York, April ?, 1951, Box 58, Harry Frank Guggenheim Mss., Library of Congress. At about the same time Harry sent Elizabeth Newell, his cousin William's widow, the same photo. See Harry [Frank Guggenheim] to Mrs. William Guggenheim, Jr., n.p., August 14, 1951, Box 58, Harry Frank Guggenheim Mss., Library of Congress.

4. Harry Guggenheim to "Dear Nancy [Williams]," n.p., March 6, 1959, Box 43, Harry Frank Guggenheim Mss., Library of Congress.

5. Harry Guggenheim to Edmond [Guggenheim], n.p., March 24, 1942, Box 55, Harry Frank Guggenheim Mss., Library of Congress.

6. "Asarco Bids to Be a Giant in Mining," *Business Week*, November 24, 1956, p. 98.

7. Harry Guggenheim to Edmond [Guggenheim], [New York], August 28, 1951, Box 55, Harry Frank Guggenheim Mss., Library of Congress.

8. William Guggenheim III, interview by Irwin Unger, January 22, 2004.

9. Harry Guggenheim to Dana [Draper], New York, July 20, 1956, Box 222, Harry Frank Guggenheim Mss., Library of Congress.

10. Davis, *Guggenheims* (1978 ed.), p. 23.

11. Rowley Bially, interview by Robert Keeler, December 6, 1988, Keeler Tapes, in possession of Robert Keeler.

12. Davis, *Guggenheims* (1978 ed.), p. 24.

13. Straus, "Master of Finistère," p. 96.

14. Roger Straus, Jr., interview, July 6, 1977, Columbia Oral History Research Office.

15. Joan Van de Maele, interview by Robert Keeler, November 11, 1988, Keeler Tapes, in possession of Robert Keeler.

16. George Tuckerman Draper, interview by Robert Keeler, December 9, 1987, Keeler Tapes, in possession of Robert Keeler.

17. Dana Draper, interview by Robert Keeler, October 10, 1987, Keeler Tapes, in possession of Robert Keeler.

18. Harry Guggenheim to Nancy [Williams], n.p., June 5, 1959, Box 43, Harry Frank Guggenheim Mss., Library of Congress.

19. Harry Guggenheim to Nancy [Williams], n.p., June 5, 1959, Box 43, Harry Frank Guggenheim Mss., Library of Congress.

20. Keeler, *Newsday*, p. 245. The story is confirmed by Harry's own letter to Dana in 1962 in which he admits to trying to bribe the boys' nurse when they were infants to put them "on the pot every morning before breakfast." See Harry [Frank Guggenheim] to Dana [Draper], [New York], May 31, 1962, Box 222, Harry Frank Guggenheim Mss., Library of Congress.

21. Harry Guggenheim to Nancy [Williams], n.p., January 20, 1959, Box 43, Harry Frank Guggenheim Mss., Library of Congress.

22. Harry Guggenheim to Nancy [Williams], June 5, 1959, Box 43, Harry Frank Guggenheim Mss., Library of Congress.

23. Harry Guggenheim to Nancy [Williams], n.p., January 28, 1959 [misdated "1969"], Box 43, Harry Frank Guggenheim Mss., Library of Congress.

24. Quoted in Keeler, *Newsday*, p. 246.

25. Tom Williams, interview by Robert Keeler, January 19, 1987, Keeler Tapes, in possession of Robert Keeler.

26. George Draper, Jr., interview by Robert Keeler, December 11, 1987, Keeler Tapes, in possession of Robert Keeler.

27. George Draper, Jr., interview by Debi Unger, February 18, 2004.

28. Ibid.

29. Peter [Lawson-Johnston] to Joan [Van de Maele], n.p., January 6, 1971, Box 88, Harry Frank Guggenheim Mss., Library of Congress.

30. Clancy, *Mountain of the Women*, p. 96.

31. Ibid., p. 100.

32. Ibid., p. 109.

33. Ibid., p. 115.

34. Ibid., p. 138.

35. Ibid., p. 167.

36. Harry [Frank Guggenheim] to Diane [Langstaff], Lexington, Kentucky, May 24, 1964, Box 222, Harry Frank Guggenheim Mss., Library of Congress.

37. Carol [Langstaff] to Harry [Frank Guggenheim], New York, October 18, 1937, Box 54, Harry Frank Guggenheim Mss., Library of Congress

38. Carol [Langstaff] to Harry [Frank Guggenheim], n.p., January 3, 1937, Box 54, Harry Frank Guggenheim Mss., Library of Congress.

39. Carol [Langstaff] to Harry [Frank Guggenheim], n.p., February 14, 1938, Box 54, Harry Frank Guggenheim Mss., Library of Congress.

40. Harry [Frank Guggenheim] to Carol [Langstaff], n.p., February 3, 1938, Box 54, Harry Frank Guggenheim Mss., Library of Congress.

41. Harry [Frank Guggenheim] to Carol [Langstaff], Falaise, Port Washington, NY, March 7, 1938, Box 54, Harry Frank Guggenheim Mss., Library of Congress.

42. Clancy, *Mountain of the Women*, p. 123.

43. Lomask, *Seed Money*, p. 77.

44. Keeler, *Newsday*, p. 35.

45. Ibid., p. 46.

46. Dorothy (Michelson) Livingston, interview by Robert Keeler, December 23, 1986, Keeler Tapes, in possession of Robert Keeler.

47. These reflections of Harry come from an interview given about 1960 to *Slug*, the in-house paper of *Newsday*'s employees. See *Newsday*, September 10, 1965, Twenty-fifth Anniversary Supplement, p. 66S.

48. Keeler, *Newsday*, p. 57.

49. Ibid., p. 65.

50. *Time*, September 13, 1954, p. 52.

51. Keeler, *Newsday*, p. 157.

52. Ibid., p. 187.

53. Ibid., p. 131.

54. Ibid., p. 132.

55. Ibid., p. 219.

56. Harry Guggenheim to Anne [Lindbergh], New York, April 19, 1960, Box 90, Harry Frank Guggenheim Mss., Library of Congress.

57. Berg, *Lindbergh*, p. 361.

58. Ibid., pp. 405–06.

59. "Speech at Des Moines," *New York Times*, September 12, 1941.

60. Charles A. Lindbergh to Harry F. Guggenheim, Long Barn, Weald [England], September 15, 1936, Box 4, Harry Frank Guggenheim Mss., Library of Congress.

61. Berg, *Lindbergh*, p. 393.

62. These were the words of the headmaster, a Mr. Northrop. See Dwight Morrow to Harry Guggenheim, New York, November 25, 1924, Dwight Morrow Mss., Amherst College.

63. Dwight Morrow to Harry Guggenheim, New York, January 23, 1925, Dwight Morrow Mss., Amherst College.

64. "Memorandum to Mrs. Harry," April 18, 1960, Box 54, Harry Frank Guggenheim Mss., Library of Congress.

65. Harry [Frank Guggenheim] to Anne [Lindbergh], New York, April 19, 1960, Box 90, Harry Frank Guggenheim Mss., Library of Congress.

66. Keeler, *Newsday*, p. 108.

67. Dorothy (Michelson) Livingston, interview by Robert Keeler, February 3, 1987, Keeler Tapes, in possession of Robert Keeler.

68. Keeler, *Newsday*, p. 109.

69. Dorothy (Michelson) Livingston, interview by Robert Keeler, February 3, 1987, Keeler Tapes, in possession of Robert Keeler.

70. Keeler, *Newsday*, p. 184.

71. Ibid., p. 185.

72. Ibid., pp. 175–76.

73. Ibid., p. 315.

74. Charles Lindbergh to Harry [Frank Guggenheim], [France], July 9, 1963, Box 2, Harry Frank Guggenheim Mss., Library of Congress.

75. Alice (Hoge) Arlen, interview by Robert Keeler, October 14, 1988, Keeler Tapes, in possession of Robert Keeler.

76. Keeler, *Newsday*, p. 339.

77. Joseph Albright, interview by Robert Keeler, July 8, 1988, Keeler Tapes, in possession of Robert Keeler.

78. Harry Guggenheim, "Latin America: Now or Never," typescript in Box 88 of the Harry Frank Guggenheim Mss., Library of Congress.

79. Harry Guggenheim to Gardner Cowles, n.p., September 24, 1962, Box 88, Harry Frank Guggenheim Mss., Library of Congress.

80. "Memorandum of Conference with President Kennedy on September 5, 1963 at 6:00 P.M. at the Executive Office in the White House," Box 88, Harry F. Guggenheim Mss., Library of Congress.

81. Keeler, *Newsday*, p. 344.

82. George [Draper], to [Harry Frank Guggenheim], n.p., May 6, 1965, Box 43, Harry Frank Guggenheim Mss., Library of Congress.

83. [Harry Frank Guggenheim] to George [Draper], [New York], May 12, 1965, Box 43, Harry Frank Guggenheim Mss., Library of Congress.

84. Harry Guggenheim to [Charles Lindbergh], [New York], October 9, 1967, Box 90, Harry Frank Guggenheim Mss., Library of Congress.

85. Charles Wertenbaker, "The Case of the Hot-Tempered Publisher," *Saturday Evening Post*, May 12, 1951, p. 113.

86. Albright, *Madam Secretary*, p. 55.

87. Dana Draper, interview by Robert Keeler, October 10, 1987, Keeler Tapes, in possession of Robert Keeler.

88. Marilyn Kirschner Draper, interview by Robert Keeler, December 7, 1987, Keeler Tapes, in possession of Robert Keeler.

89. [Harry Guggenheim] to Dana [Draper], n.p., September 13, 1965, Robert Keeler Transcripts, Binder 8, Harry Frank Guggenheim Mss., Library of Congress.

90. "Memo for My Executors and Trustees of the Harry Frank Guggenheim Foundation," February 18, 1966, Binder 8, Robert Keeler Transcripts, Library of Congress.

91. Harry Guggenheim to Dana [Draper], [New York], January 6, 1966, Box 222, Harry Frank Guggenheim Mss., Library of Congress.

92. Harry Guggenheim to Dana [Draper], [New York], May 2, 1967, Box 54, Harry Frank Guggenheim Mss., Library of Congress.

93. Dana Draper, interview by Robert Keeler, October 10, 1987, Keeler Tapes, in possession of Robert Keeler.

94. Ibid.

95. Harry Guggenheim to Dana [Draper], [New York], May 2, 1967, Harry Frank Guggenheim Mss., Library of Congress.

96. Dana Draper, interview by Robert Keeler, October 10, 1987, Keeler Tapes, in possession of Robert Keeler.

97. Keeler, *Newsday*, p. 391.

98. Ibid., p. 391.

99. Straus, "Master of Finistere," p. 101.

100. Keeler, *Newsday*, pp. 412–13.

101. Ibid., p. 413.

102. Ibid., p. 414.

103. Ibid., p. 460.

104. Ibid., p. 461.

105. Charles [Lindbergh] to Harry [Frank Guggenheim], Switzerland, March 16, 1960, Box 2, Harry Frank Guggenheim Mss., Library of Congress.

106. Charles Lindbergh to Harry Guggenheim, Switzerland, April 26, 1966, Box 2, Harry Frank Guggenheim Mss., Library of Congress.

107. "The Man's Relation to Man Program of the Harry Frank Guggenheim Foundation," undated publication, p. 8.

108. Peter Lawson-Johnston, interview by Robert Keeler, June 12, 1987, Keeler Tapes, in possession of Robert Keeler.

109. Peter Lawson-Johnston, interview by Robert Keeler, October 31, 1988, Keeler Tapes, in possession of Robert Keeler.

110. Peter Lawson-Johnston, interview by Robert Keeler, June 12, 1987, Keeler Tapes, in possession of Robert Keeler.

111. Bill Moyers, interview by Robert Keeler, August 14, 1989, Keeler Tapes, in possession of Robert Keeler.

112. Michael Dobbs, *Madeleine Albright: A Twentieth-Century Odyssey* (New York: Henry Holt, 1999), p. 226.

113. Keeler, *Newsday*, p. 473.

114. *New York Times*, March 13, 1970.

115. Keeler, *Newsday*, p. 475.

116. [Harry Frank Guggenheim] to Peter [Lawson-Johnston], n.p., December 5, 1966, Box 88, Harry Frank Guggenheim Mss., Library of Congress.

117. Peter [Lawson-Johnston] to Harry [Frank Guggenheim], n.p., May 12, 1970, Box 88, Harry Frank Guggenheim Mss., Library of Congress.

118. Joan Van de Maele, interview by Robert Keeler, June 11, 1987, Keeler Tapes, in possession of Robert Keeler.

119. Thomas Messer, interview by Robert Keeler, April 11, 1988, Keeler Tapes, in possession of Robert Keeler.

120. Joan [Van de Maele] to Peter [Lawson-Johnston], n.p., December 31, 1970, Box 88, Harry Frank Guggenheim Mss., Library of Congress.

121. Straus, "Master of Finistère," p. 104.

122. Will of Harry Frank Guggenheim, March 12, 1970, Nassau County Surrogate's Office, Mineola, New York.

123. Joan Van de Maele, interview by Robert Keeler, June 11, 1987, Keeler Tapes, in possession of Robert Keeler.

124. Tom Williams, interview by Robert Keeler, January 19, 1987, Keeler Tapes, in possession of Robert Keeler.

125. Straus, "Master of Finistère," p. 105.

126. Keeler, *Newsday*, p. 476.

Chapter Ten: "The Grand Old Man"

1. Bruce Brooks Pfeiffer (ed.), *Frank Lloyd Wright: The Guggenheim Correspondence* (Fresno: Press at California State University, 1986), p. 53.
2. Lukach, *Hilla Rebay*, p. 3.
3. Will Grohmann, *Wassily Kandinsky: Life and Work* (New York: Harry N. Abrams, Inc., n.d), p. 54.
4. Ibid., p. 67.
5. David Gascoyne, *A Short Survey of Surrealism* (London: Cobden-Sanderson, 1935), p. 23.
6. Jimmy Ernst, *A Not-So-Still Life: A Memoir* (New York: St. Martin's Press, 1984), p. 15.
7. Ibid., p. 21.
8. Weld, *Peggy*, p. 150.
9. Lukach, *Hilla Rebay*, p. 15.
10. Lomask, *Seed Money*, p. 167.
11. Lukach, *Hilla Rebay*, p. 61.
12. Ibid., p. 179.
13. Davis, *Guggenheims* (1978 ed.), p. 206.
14. Weld, *Peggy*, p. 111.
15. Ibid., p. 17.
16. Ibid.
17. Davis, *Guggenheims* (1978 ed.), p. 201.
18. Lukach, *Hilla Rebay*, p. 58.
19. Ibid., p. 59.
20. Ibid., p. 62.
21. Ibid., p. 74.
22. *Time*, February 15, 1937.
23. Lukach, *Hilla Rebay*, p. 90.
24. Ibid., p. 91.
25. Lomask, *Seed Money*, p. 171.
26. *New York Times*, June 29, 1937.
27. Ibid., July 4, 1937.
28. Lukach, *Hilla Rebay*, p. 127.
29. Gill, *Art Lover*, p. 186.
30. Ibid., p. 188.
31. [Yvanhoé] Rambosson to Solomon Guggenheim], Paris, March 9, 1940, in Lukach, *Hilla Rebay*, p. 131.
32. *New York Times*, June 4, 1939.
33. Lukach, *Hilla Rebay*, p. 142.

34. *New York Times*, June 4, 1939.
35. Davis, *Guggenheims* (1978 ed.), p. 209.
36. Solomon [Guggenheim] to [Hilla] Rebay, n.p., January 4, 1943, in Lukach, *Hilla Rebay*, p. 178.
37. Lukach, *Hilla Rebay*, p. 178.
38. Ibid., p. 179.
39. Pfeiffer, *Frank Lloyd Wright*, p. 4.
40. Ibid., p. 6.
41. Ibid., pp. 8–9.
42. Lukach, *Hilla Rebay*, p. 195.
43. [Frank Lloyd] Wright to Hilla Rebay, n.p., January 22, 1945, in ibid., pp. 193–94.
44. *New York Times*, September 21, 1945.
45. Solomon Guggenheim to Frank Lloyd Wright, n.p., August 20, 1946, in Pfeiffer, *Frank Lloyd Wright*, p. 86.
46. Harry Guggenheim to Edmond Guggenheim, [New York], April 2, 1948, Box 55, Harry Frank Guggenheim Mss., Library of Congress.
47. Lukach, *Hilla Rebay*, pp. 289–90.
48. Thomas Messer, interview, October 12, 1994, Smithsonian Archives of American Art, http://archives.si.edu/oralhist/messer94/htm, p. 18.
49. Lomask, *Seed Money*, p. 189.
50. [Frank Lloyd] Wright to Arthur [Holden], n.p., February 28, 1950, in Pfeiffer, *Frank Lloyd Wright*, p. 135.
51. Pfeiffer, *Frank Lloyd Wright*, p. 136.
52. *New York Times*, April 22, 1951.
53. Davis, *Guggenheims* (1978 ed.), p. 223.
54. Ibid., p. 224.
55. *New York Times*, May 30, 1954.
56. Lomask, *Seed Money*, p. 181.
57. *New York Times*, October 12, 1958.
58. Lomask, *Seed Money*, p. 185.
59. *New York Times*, December 12, 1956.
60. Davis, *Guggenheims* (1978 ed.), p. 226. His "jam factory" charge was almost certainly incorrect.
61. [Frank Lloyd] Wright to Harry [Frank Guggenheim], May 14, 1952, in Pfeiffer, *Frank Lloyd Wright*, p. 169.
62. [Frank Lloyd] Wright to Alicia and Harry [Frank Guggenheim], [Taliesin East], April 2, 1954, in Pfeiffer, *Frank Lloyd Wright*, p. 200.
63. Lomask, *Seed Money*, p. 186.
64. *New York Times*, January 11, 1930.
65. Davis, *Guggenheims* (1978 ed.), p. 225.

66. [Frank Lloyd] Wright to [James] Sweeney, March 9, 1956, in Pfeiffer, *Frank Lloyd Wright*, p. 224.

67. [Frank Lloyd] Wright to Harry [Frank Guggenheim], March 9, 1956, in Pfeiffer, *Frank Lloyd Wright*, pp. 224–25.

68. Pfeiffer, *Frank Lloyd Wright*, p. 245.

69. [Harry Frank Guggenheim to James Sweeney], June 23, 1958, in Lomask, *Seed Money*, p. 203.

70. [Harry Frank Guggenheim to Frank Lloyd Wright], July 8, 1958, in ibid., pp. 198–99.

71. Pfeiffer, *Frank Lloyd Wright*, p. 275.

72. Lomask, *Seed Money*, p. 205.

73. Ibid., pp. 206–07.

74. *New York Times*, May 8, 1960.

75. *New York Times*, July 31, 1960.

76. Lomask, *Seed Money*, p. 209.

77. Thomas Messer, interview by Andrew Decker, October 10, 1994–January 25, 1995, Smithsonian Archives of American Art, http://artarchives.si.edu/oralhist/messer94/htm, p. 19.

78. Thomas Messer, interview by Robert Keeler, April 11, 1988, Keeler Tapes, in possession of Robert Keeler.

79. Ibid.

80. Andrew Dekker Thomas Messer interview, p. 46.

81. John Richardson, "Go Go Guggenheim," *New York Review of Books*, July 16, 1992, p. 18.

82. Ibid.

83. Ibid.

84. Jerry Salz, "Downward Spiral," *Village Voice*, February 13–19, 2002.

85. Hilton Kramer, "Guggenheim Is Bust—Why Isn't Krens Getting the Boot?" *New York Observer*, December 23, 2002.

86. Hilton Kramer, " 'Abstraction' at the Guggenheim," *New Criterion*, March 1996.

Chapter Eleven: A Fool for Love

1. Virginia Dortch (ed.), *Peggy Guggenheim and Her Friends* (Milan: Berenice Art Books, 1994), p. 9.

2. Weld, *Peggy*, p. 68.

3. Ibid., p. 410.

4. Ibid., p. 95.

5. Ibid., p. 73.

6. Ibid., p. 37.

 7. Gill, *Art Lover*, p. 56.
 8. Ibid., p. 72.
 9. Guggenheim, *Out of This Century*, p. 27. (This is essentially a reprint of the 1946 version with the names named.)
10. Ibid., pp. 24, 27.
11. Ibid., p. 26.
12. Ibid., p. 33.
13. Gill, *Art Lover*, p. 308.
14. Guggenheim, *Out of This Century*, p. 40.
15. Ibid., p. 44.
16. Ibid., p. 47.
17. Gill, *Art Lover*, p. 99.
18. Ibid., p. 97.
19. Weld, *Peggy*, p. 64.
20. Guggenheim, *Out of This Century*, p. 82.
21. Weld, *Peggy*, p. 77.
22. Ibid., p. 86.
23. Ibid., p. 93.
24. Karole Vail, *Peggy Guggenheim: A Celebration* (New York: Guggenheim Museum Publications, 1999), p. 30.
25. Ibid., p. 31.
26. Karole Vail, interview by Irwin Unger, February 12, 2004.
27. Guggenheim, *Out of This Century*, p. 159.
28. Ibid., p. 50.
29. Ibid., pp. 161–62.
30. Ibid., p. 164.
31. Ibid., p. 183.
32. Weld, *Peggy*, p. 407.
33. Gill, *Art Lover*, p. 209.
34. Richardson, "Go Go Guggenheim," p. 20.
35. Guggenheim, *Out of This Century*, p. 220.
36. Ibid., p. 216.
37. Ibid., p. 237.
38. Ibid., p. 245.
39. Ernst, *Not-So-Still Life*, pp. 199–200.
40. Ibid., p. 201.
41. Weld, *Peggy*, p. 254.
42. Guggenheim, *Out of This Century*, p. 264.
43. Melvin Paul Lader, "Peggy Guggenheim's Art of This Century: The Surrealist Milieu and the American Avant-Garde, 1942–1947" (dissertation, University of Delaware, 1981), p. 99.

44. *New York Times*, October 25, 1942.

45. Lader, "Peggy Guggenheims's Art of This Century," p. 128.

46. Guggenheim, *Out of This Century*, p. 286.

47. Lader, "Peggy Guggenheims's Art of This Century," p. 166.

48. Weld, *Peggy*, p. 296.

49. Ibid., p. 297.

50. Gill, *Art Lover*, p. 320.

51. Weld, *Peggy*, p. 325.

52. Gill, *Art Lover*, p. 321.

53. Weld, *Peggy*, p. 323.

54. Ibid., pp. 400–01.

55. Ibid., p. 401.

56. Dortch (ed.), *Peggy Guggenheim and Her Friends*, p. 110.

57. Weld, *Peggy*, p. 315.

58. Ibid.

59. Ibid., p. 315.

60. Ibid., p. 347.

61. Ibid.

62. Ibid., p. 346.

63. Ibid., p. 355.

64. Dortch (ed.), *Peggy Guggenheim and Her Friends*, p. 11.

65. Weld, *Peggy*, p. 350.

66. Mary McCarthy, "The Cicerone," *Cast a Cold Eye* (New York: Harcourt Brace, 1950), pp. 110–11.

67. McCarthy, "Cicerone," p. 113.

68. Weld, *Peggy*, p. 364.

69. Dortch (ed.), *Peggy Guggenheim and Her Friends*, p. 7.

70. Guggenheim, *Out of This Century*, p. 329.

71. Truman Capote, *Answered Prayers: The Unfinished Novel* (New York: Random House, 1987), p. 65. Peggy did not resent Capote's unkind depiction, apparently, though she denied that she had false teeth. Weld, *Peggy*, p. 377.

72. "The Last Duchess," *Time*, December 16, 1957, p. 76.

73. Weld, *Peggy*, p. 379.

74. Ibid.

75. Ibid.

76. Dortch (ed.), *Peggy Guggenheim and Her Friends*, p. 18.

77. Weld, *Peggy*, p. 389.

78. Laurence Tacou-Rumney, *Peggy Guggenheim: A Collector's Album* (New York: Rizzoli International Publications, 2002), p. 161.

79. Weld, *Peggy*, pp. 411–12.

80. Guggenheim, *Out of This Century*, p. 370.

81. Weld, *Peggy*, p. 87.
82. Ibid., p. 366.
83. Ibid., p. 429.
84. Gill, *Art Lover*, p. 368.
85. Weld, *Peggy*, p. 429.
86. Thomas Messer, "The Guggenheim Story," *New York Review of Books*, November 19, 1992.
87. Thomas Messer, "The History of a Courtship," in Vail, *Peggy Guggenheim*, p. 128.
88. Messer, "Guggenheim Story."
89. Messer, "History of a Courtship," p. 135.
90. Weld, *Peggy*, p. 420.
91. Ibid., p. 422.
92. Dortch (ed.), *Peggy Guggenheim and Her Friends*, p. 90.
93. Robert Dahlin, "Out of This Century," *Publishers Weekly*, July 16, 1979.
94. Vail, *Peggy Guggenheim*, p. 122.
95. Weld, *Peggy*, p. 437.
96. Roger W. Straus, Jr., Interview by Robert Keeler, May 20, 1987, Keeler Tapes, in possession of Ribert Keeler.
97. Dortch (ed.), *Peggy Guggenheim and Her Friends*, p. 94.
98. Gill, *Art Lover*, p. 318.
99. Ibid., p. 278.
100. Weld, *Peggy*, p. 398.
101. Ibid.
102. Ibid., p. 329

Chapter Twelve: Unraveling

1. Peter Lawson-Johnston, interview by Irwin Unger, December 17, 2003.
2. *New York Times*, November 20, 1984.
3. William Guggenheim III, interview by Irwin Unger, January 22, 2004.
4. Dana Draper, interview by Robert Keeler, October 10, 1987, Keeler Tapes, in possession of Robert Keeler.
5. *New York Times*, November 20, 1984.
6. William Guggenheim III, interview by Irwin Unger, January 22, 2004.
7. Peter Lawson-Johnston, interview by Irwin Unger, December 17, 2003.
8. *New York Times*, November 17, 1978.
9. John H. Davis, *The Guggenheims (1848–1988): An American Epic* (New York: Shapolsky Publishers, 1988) p. 432.
10. Regan Hatfield, "Guru of the Guggenheim: Peter Lawson Johnston," *New Jersey Life*, October 2000.

11. Peter Lawson-Johnston II to Irwin Unger, e-mail, March 8, 2004.

12. Roger Straus II, interview, June 29, 1977, Columbia Oral History Research Office.

13. *Publishers Weekly*, January 12, 1946.

14. *New York Times*, February 24, 1946, section 7.

15. James Reginato, "Nobel House," *New York*, November 9, 1987.

16. See Straus's preface to Alan Williams (ed.), *Fifty Years: A Farrar, Straus & Giroux Reader* (New York: Farrar, Straus & Giroux, 1996), p. xiii.

17. *New York Times*, February 10, 1087.

18. *Current Biography*, 1980, p. 387.

19. N. R. Kleinfield, " "Roger Straus: Making It as an Independent," *New York Times Book Review*, March 23, 1980.

20. *Publishers Weekly*, September 9, 1996.

21. N. R. Kleinfield, "Roger Straus."

22. Dorothea Straus, *Under the Canopy*, (New York: George Braziller, 1982), p. 161.

23. Ibid., p. 72.

24. *Los Angeles Times*, October 31, 1994.

25. *Publishers Weekly*, April 16, 1979.

26. Ibid.

27. Ibid.

28. Ibid.

29. *Wall Street Journal*, September 24, 1993.

30. Ian Parker, "Showboat," *New Yorker*, April 5, 2002, p. 65.

31. Ibid., p. 65.

32. Oscar Straus II, interview by Irwin and Debi Unger II, January 29, 2004.

33. Oscar Straus Schafer, *Report of the President* (2004).

34. See Dan Baum, *Citizen Coors: An American Dynasty* (New York: William Morrow, 2000), p. 74.

35. *New York Post*, August 6 and 8, 1983.

36. This was Iris's remark. See Davis, *Guggenheims* (1988 ed.), p. 457.

37. Weld, *Peggy*, p. 35.

38. *New Yorker*, March 28, 1970.

39. Ibid.

40. Katherine Bouton, "A Reporter at Large: The Dig at Knidus," *New Yorker*, July 17, 1978.

41. Elisabeth Stevens, "An Archeological Find Named Iris Love," *New York Times Magazine*, March 7, 1971.

42. Stevens, "An Archeological Find."

43. John Keats, "The World's Greatest Warehouse Stuffed with Other People's Glories," *New York Times* (Travel and Resorts section), October 3, 1971.

44. Liz Smith, *Natural Blonde* (New York: Hyperion, 2000), p. 300.
45. Ibid.
46. *New York Times*, February 9, 2004.
47. Tape of Jean-Pierre Gibrat's *Guggenheim: Un Rêve Américain*, Trans-Europe Film, 2001.
48. *New York Times*, September 21, 1997.
49. Clancy, *Mountain of the Women*, p. 149.
50. Caitriona Nelson to Irwin Unger, e-mail, March 1, 2004.
51. "Bibliography, M. Robert Guggenheim, Jr.," April 12, 1948, Bos 58, Harry Frank Guggenheim Mss., Library of Congress.
52. *New York Times*, October 20, 1936.
53. Daniel M. Guggenheim, interview by Irwin Unger, February 2, 2004.
54. Ibid.
55. Daniel M. Guggenheim, interview by Irwin Unger, February 3, 2004.
56. M. Robert Guggenheim to Harry Guggenheim, Hollywood, January 22, 1952, Box 58, Harry Frank Guggenheim Mss., Library of Congress.
57. Harry Guggenheim to Daniel Guggenheim, [New York], August 8, 1955, Box 58, Harry Frank Guggenheim Mss., Library of Congress.
58. Daniel M. Guggenheim, interview by Irwin Unger, February 2, 2004.
59. Ibid.
60. These are the words of art critic Paula Weideger. See Weideger, "Getting to Know the Serious Peggy Guggenheim," *New York Times*, November 15, 1998.
61. *New York Times*, October 16, 1991.
62. Gill, *Art Lover*, p. 422.
63. Karole Vail, "Remembering Peggy," *Harper's Bazaar*, April 2002.
64. Karole Vail, interview by Irwin Unger, February 12, 2004.
65. Vail, *Peggy Guggenheim*, p. 9.
66. Janice C. Simpson, "Some Guggenheims Carry on Tradition of Eccentric Heirs," *Wall Street Journal*, May 31, 1979.
67. William Guggenheim III and Judy Guggenheim, *Hello from Heaven!* (New York: Bantam Books, 1995), p. 4.
68. Davis, *Guggenheims* (1988 ed.), p. 474.
69. Simpson, "Some Guggenheims."
70. William Guggenheim III, interview by Irwin Unger, January 22, 2004.
71. Davis, *Guggenheims* (1988 ed.), p. 477.
72. Ibid.

Acknowledgments

L IKE ALL AUTHORS we are grateful to many people for their help. Alex Hoyt, our enterprising agent, encouraged our plan to write a history of the Guggenheim family and secured the contract that enabled us to proceed. Our editor at HarperCollins, Hugh Van Dusen, read each of the chapters in draft and by his wise use of both praise and criticism improved the manuscript immeasurably. Also at HarperCollins, David Semanki expedited the preparation of the manuscript and helped transform it with dispatch into an attractive book. We appreciated the painstaking and intelligent copy editing of Eleanor Mikucki.

We are grateful to all those who helped us round out our sources. First, we thank Robert Keeler of *Newsday* for generously allowing us to use the tapes of many interviews he conducted in the course of writing his fine book on the Long Island newspaper. Several of our predecessors in Guggenheim biography, notably Milton Lomask and John H. Davis, were able to speak to people now deceased and record their views. We have at times—suitably acknowledged—relied on these interviews as source documents in themselves. We are, of course, grateful to all the participants in the Guggenheim saga who allowed us to speak to them in person, or by phone, or who responded to our queries by e-mail. Our

particular thanks to Peter Lawson-Johnston, who is now truly "High Priest of the Clan."

We also would like to thank the following people for their generous professional help: Michael Banick, Overseer of Special Collections, Monmouth University Library; James Bongiovani, Assistant at Special Collections, Monmouth University Library; Ethel Gershman, archivist of Keneseth Israel, Elkins Park, Pennsylvania; Elke Deitch, who served in the same capacity at Temple Emanu-El in New York; Tom Gilbert of the Associated Press picture archive; Brian and Patricia Shannon of WordStation in Avon, New Jersey, who rescued us when in technical extremis; Jerry Cooper, Corporate Communications executive of ASARCO; Joseph Koenigsberger, Treasurer of the Harry Frank Guggenheim Foundation; Mary-alice Yates, Corporate Secretary of the same foundation; Mary Donat, secretary to Peter Lawson-Johnston; Peggy Miller, secretary of Roger Straus Jr. of Farrar, Straus & Giroux; Michael Hannan of the interlibrary loan office of NYU's Bobst Library; Miriam Gross and David Smith of the New York Public Library; Tara Craig of the Rare Book Reading Room, Butler Library, Columbia University; the librarians of the Manuscript Room of the James Madison Memorial Building at the Library of Congress; author Laura Jacobs; and Jerry Bauer, our charming and skilled photographer. Karol Vail helped us secure pictures of her grandmother and her family.

Friends, too, contributed in many ways to our enterprise, providing information, contacts, comfort, and encouragement, and graciously accepting scholarly chores. We would especially like to thank Dr. Edith Jacobs, Hans Trefousse, Ralph Dannheisser, Richard Lieberman, Martin Stricks, Robin and Joe Pollack, Lillian Cohen, Marie Jacolow, Libby and Arnie Friedman, Norma and David Schechner, and Phyllis and Jerry Reich.

Index

Sweeney, James Johnson, 377–86, 444
Sweeney, Laura, 380–81
Swift, Lewis, 238
Switzerland, 398, 403, 404
 art in, 354, 355, 364
 embroidery and lace industry in,
 18–21, 28, 33–34, 35, 96
 Guggenheim sons in, 20–21, 75, 139,
 290
 Jews in, 1–8, 20–21, 68

Tabor, Horace, 24–26
Tacou-Rumney, Laurence, 488, 494
Taft, Robert, 320
Taft, William Howard, 106–7, 108, 113,
 114, 125, 185, 271
 as Guggenheim mediator, 156, 158
Tanguy, Yves, 409, 411, 412, 417, 421,
 426, 427
Tanning, Dorothea, 428–29
Tarbell, Ida, 149
Tate Gallery, 445
Teller, Henry Moore, 116
Temple Emanu-El, 53–54, 60, 178, 192,
 194, 200, 464, 469
 funerals at, 67, 183, 184, 196, 204, 237,
 345–46, 373
Territorial Imperative (Ardrey), 338
Thiele, Albert, 287, 343, 374, 375
Thomas, Charles S., 117, 121, 125
Thompson, William Boyce, 84, 85, 89
Time-Life, 339–40
Times-Mirror, 340–42
Titanic, 65–66, 136, 192*n*, 230, 392
Trillora Court, 210, 352, 356, 373, 453
Truman, Harry, 319, 320, 323
Twain, Mark, 122
Twysden, Duff, 222, 223
Tzara, Tristan, 354

United Metals Selling Company, 72,
 78–79
United States Commission on Industrial
 Relations, 148–49, 151
United States and Cuba, The (Harry
 Guggenheim), 276
Untermeyer, Samuel, 78–79, 95, 137, 183

Utah Copper, 83, 87–89, 128, 133,
 134–35, 138, 151–52, 196

Vail, Apple, 406, 413, 422, 443
Vail, Clotilde, 396, 398, 399, 404, 436
Vail, Clover, 406, 413, 422
Vail, Clovis, 443, 490
Vail, Eugene, 396
Vail, Gertrude, 396, 397, 398
Vail, Jean Connally, 435, 436
Vail, Julia, 443, 490
Vail, Karole, 409, 443, 450, 487–90
Vail, Kathe, 413
Vail, Laurence, 231, 236, 393, 395–406,
 409, 413, 422, 427, 433, 435, 436,
 440–43
 marriages of, 217, 218, 221, 397–98,
 406, 435
 violence of, 399, 400, 403, 404, 405
 in World War II, 416–19
 writings of, 219, 398, 401, 403
Vail, Marc, 443, 490
Vail, Pegeen Jezebel, 234, 236, 413, 424,
 440–43, 487
 as artist, 351, 427, 441, 443, 487, 488
 childhood of, 403, 405–8
 death of, 442–43, 445
 education of, 407, 422
 marriages of, 435, 440–41
 Peggy's relationship with, 392, 393,
 405, 440–43
 sexual behavior of, 403, 440, 441
 World War II and, 416, 417, 419
Vail, Sindbad, 236, 408, 413, 422, 424,
 433, 453–54, 487
 childhood of, 399–400, 403, 405, 406
 marriages of, 443–44
 Peggy's relationship with, 392, 393,
 405, 406, 443–44, 448, 449, 450, 489
 World War II and, 416, 417, 419, 435
Van Benthuysen, Robert, 201–2
Van de Maele, Albert, 287, 289, 298, 299,
 344, 347, 348, 453–54
Vanderbilt, Alfred, 244–45
Vanderbilt, William, 238
Venice, 393, 435–42, 444–49, 451,
 487–88, 489